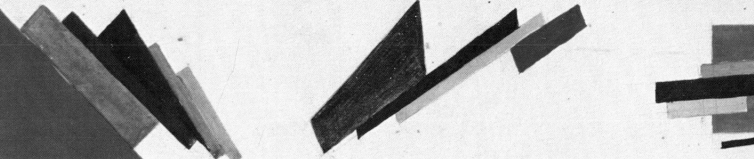

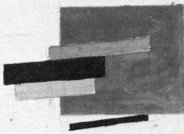
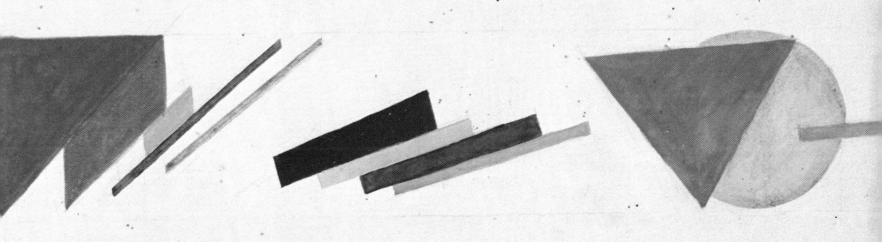

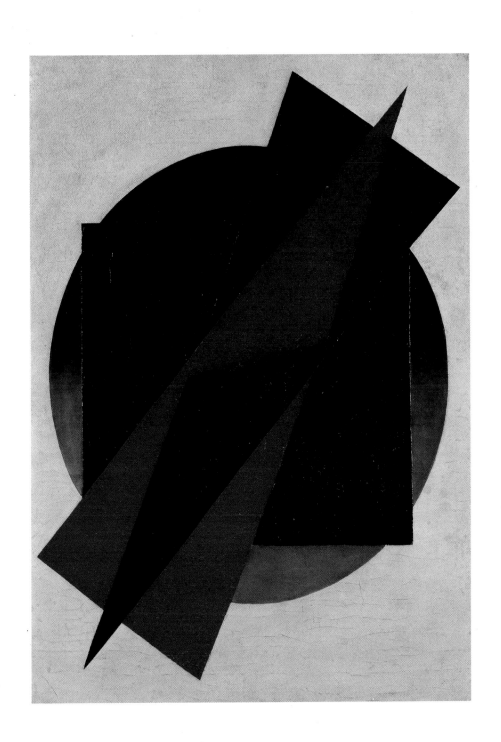

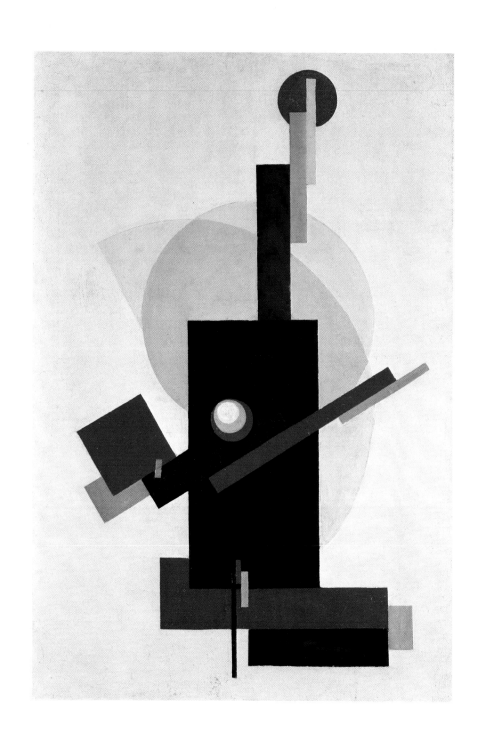

THE GEORGE COSTAKIS COLLECTION

RUSSIAN AVANT-GARDE ART

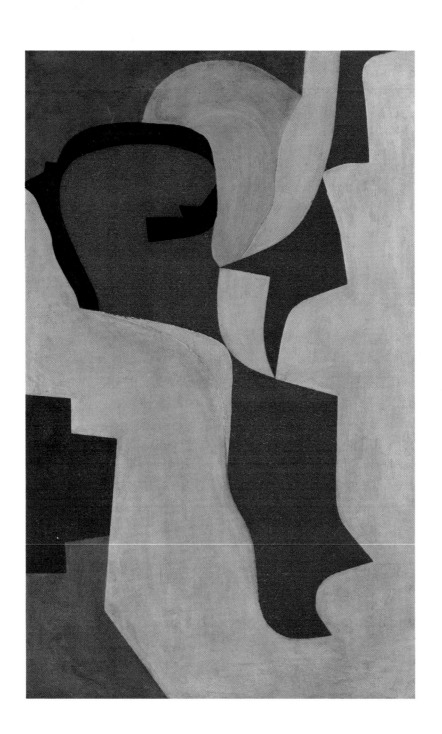

General Editor
ANGELICA ZANDER RUDENSTINE

Introduction by
S. FREDERICK STARR

Collecting Art of
the Avant-Garde by
GEORGE COSTAKIS

HARRY N. ABRAMS, INC., PUBLISHERS, NEW YORK

CONTENTS

Preface and Acknowledgments

 by Angelica Zander Rudenstine 9

Notes for the Reader 10

Introduction

 by S. Frederick Starr 12

Collecting Art of the Avant-Garde

 by George Costakis 54

The George Costakis Collection 78

 Biographies by Vasilii Rakitin

 Documentation

 by Angelica Zander Rudenstine

Chronology

 by John E. Bowlt 500

Index 520

Photographs of the Kliun sketchbooks (pp. 175–95): Mary Donlon
All other photographs: Stanislav Zemnokh, Geoffrey Clements

Endpapers: Adapted from Ivan Kudriashev. *Design for the First
 Soviet Theater in Orenburg,* 1920 (plate 408)
Page 1: Kliment Redko. *Suprematism,* 1921 (plate 999)
Page 2: Georgii Riazhsky. *Suprematism,* 1920 (plate 1008)
Page 4: Boris Ender. *Composition,* 1921 (plate 538)
Page 6: Alexandr Rodchenko. *Linearism,* 1920 (plate 1016)

Editor: Phyllis Freeman
Designer: Bob McKee

Library of Congress Cataloging in Publication Data
Main entry under title:

Russian avant-garde art.

 Includes index.
 1. Art, Russian. 2. Art, Modern — 20th century — Soviet
Union. 3. Avant-garde (Aesthetics) — Soviet Union.
4. Costakis, Georgi — Art collections. 5. Art — Private
collections — Soviet Union. 6. Artists — Soviet Union —
Biography. I. Costakis, Georgi. II. Rudenstine,
Angelica Zander. III. Starr, S. Frederick.
N6988.R85 709'.47'074 81-1406
ISBN 0-8109-1556-1 AACR2

Illustrations © 1981 George Costakis

Published in 1981 by Harry N. Abrams, Incorporated, New York
All rights reserved. No part of the contents of this book may be
reproduced without the written permission of the publishers

Printed and bound in Japan

PREFACE AND ACKNOWLEDGMENTS

The George Costakis Collection of Russian and Soviet art of the avant-garde, published here for the first time, was assembled in Moscow over a period of thirty years. By the time Costakis left his Moscow home in 1977 to settle in Athens, his collection had become the single most comprehensive "museum" of such art in the world.

As the Soviet art historian Vasilii Rakitin has testified, the mere existence of such a collection played a commanding role in the artistic life of Moscow, particularly during the 1960s. In the Soviet Union, the collection served as a visible and living documentation of an otherwise buried past; it stimulated creativity and gave courage to innumerable contemporary Soviet artists who continuously visited the Costakis home.

The way in which this extraordinary collection came into being is told in the following pages. The publication of it in this volume is as comprehensive as possible under current conditions, although a great many works from the entire original collection cannot be included at this time. When Costakis left Moscow, he donated the greater part of his holdings to the Tretiakov Gallery. Under his supervision, photographs were made of one hundred twenty-two of the works in this gift, but not of the remainder. Thus, the Tretiakov works published here necessarily represent only a selection from the full Costakis collection held by that museum.

The extraordinary scope and range of the materials that are in fact presented in this volume pose a considerable number of interesting and important scholarly problems. The temptation existed to delay publication for several years, while much more detailed art historical research was carried forward. But this temptation had to be balanced against the strong concern to make this unique material visually available at the earliest feasible moment. We have chosen the latter course, in spite of the limitations it imposes, precisely because of the scarcity and inaccessibility of works in this field.

I am indebted to a great many people for help in preparing this material for publication. Vasilii Rakitin wrote the biographies of the artists and provided a basic checklist of many of the works in the collection; information supplied by him has been incorporated in many of the captions to the illustrations. Translations were undertaken by Sarah Bodine, Christina A. Lodder, Tatyana Feifer, Arina Malukov, Marian Schwartz, Eleanor Sutter, and Steven Wolin. Research and other help was also provided by Sophie Consagra, Cleve Gray, and Anne Williams. Several scholars have generously shared their knowledge of the Russian field with me, and I am especially indebted to Sarah Bodine, John E. Bowlt, Jean Chauvelin, Alma H. Law, Christina A. Lodder, Marc Martin Malburet, Zoia Ender Masetti, Andrei B. Nakov, and Margit Rowell.

Phyllis Freeman, editor, and Bob McKee, designer, for Harry N. Abrams have shown more than plausible patience and care with a project of more than usual complexity; I am most grateful to them both.

Angelica Zander Rudenstine

Notes for the Reader

Organization
Most of the book is arranged alphabetically by artist. Exceptions are: 1. The Inkhuk Portfolio (pp. 110–27), a group of works dating from 1920–21. 2. The works of Matiushin and his school (Guro, the Ender family, and Grinberg), on pp. 268–323. 3. Works grouped under Posters and Propaganda, pp. 421–32.

Inscriptions
Inscriptions, unless otherwise indicated, have been translated from the Russian. Signatures and dates, unless otherwise indicated, have been transcribed from Cyrillic to Latin characters. The transliteration used is a modified version of the Library of Congress system; the soft and hard signs have been omitted or have been rendered by "i" (e.g., Vasilievich). In the case of certain proper names the spelling given is that adopted by the Russians themselves during their stay in the West (e.g., Wassily Kandinsky, Alexei Jawlensky, etc.). The following abbreviations have been used to indicate positions of inscriptions: II = lower left; uI = upper left; c = center; r = right, etc.

Dimensions
Dimensions are given in centimeters, height preceding width.

Inventory numbers
The numbers appearing in parentheses directly after the dimen-sions refer to an inventory prepared by the Solomon R. Guggenheim Museum in New York, in connection with Mr. Costakis's loan to that museum of his collection. As a supplement to that inventory, a list has been prepared of those works given by Mr. Costakis to the Tretiakov Gallery in Moscow which were photographed prior to the donation. This list (the works bearing TR inventory numbers) does not reflect the much larger size of his total donation to the Moscow museum. It also, of course, bears no relation to the Tretiakov's own acquisition procedures.

Dates
Russian dates in the biographies, chronology, and other text sections follow the so-called Old-Style calendar in use in Russia before January 1918 and are, therefore, thirteen days behind the Western calendar.

St. Petersburg
The city of St. Petersburg underwent a series of name changes: until 1914 it was St. Petersburg; in August 1914 it was renamed Petrograd; following Lenin's death, January 21, 1924, it received its present name, Leningrad.

Exhibition sponsors
A distinction is made, in listing exhibition sponsors, among artists' associations, periodicals, and ad hoc exhibiting groups:
 Associations are set in Roman type: Soiuz molodezhi.
 Sponsoring periodicals are italicized: *Mir iskusstva*.
 Ad hoc groups are set within quotation marks: "Bubnovyi valet."

Acronyms

AKhRR
 Assotsiatsiia khudozhnikov revoliutsionnoi Rossii
 Association of Artists of Revolutionary Russia

ASNOVA
 Assotsiatsiia novykh arkhitektorov
 Association of New Architects

FOSKh
 Federatsiia obedineniia sovetskikh rabotnikov
 Federation of the Association of Soviet Workers in the Spatial Arts

GAKhN
 Gosudarstvennaia akademiia khudozhestvennykh nauk
 State Academy of Artistic Sciences

Ginkhuk
 Gosudarstvennyi institut khudozhestvennoi kultury
 State Institute of Painterly Culture (Leningrad)

Glavnauka
 Glavnoe upravlenie nauchnymi, nauchno-khudozhestvennymi, muzeinymi i po okhrane prirody uchrezhdeniiami
 Main Science Administration

Inkhuk
 Institut khudozhestvennoi kultury
 Institute of Painterly Culture (Moscow)

IZO
 Otdel izobrazitelnykh iskusstv
 Department of Visual Arts of Narkompros

IZORAM
 IZO rabochaia molodezh
 Young Visual Arts Workers

LEF
 Levyi front iskusstv
 Left Front of the Arts

Narkompros
 Narodnyi komissariat prosveshcheniia
 People's Commissariat for Enlightenment

NOZh
 Novoe obshchestvo zhivopistsev
 New Society of Artists

Obmokhu
 Obshchestvo molodykh khudozhnikov
 Society of Young Artists

OMKh
 Obshchestvo moskovskikh khudozhnikov
 Society of Moscow Artists

OST
 Obshchestvo khudozhnikov-stankovistov
 Society of Studio Artists

Petrosvomas
 Petrogradskie gosudarstvennye svobodnye khudozhestvennye masterskie
 Petrograd State Free Art Studios

Proletkult
 Proletarskaia kultura *or* Proletarskie kulturno-prosvetitelnye organizatsii
 Proletarian Culture *or* Proletarian Cultural and Educational Organizations

Proun
 Proekt utverzhdeniia novogo
 Project for the Affirmation of the New

Rabfak
 Rabochii fakultet
 Faculty for Workmen

RAKhN
 Rossiiskaia akademiia khudozhestvennykh nauk
 Russian Academy of Artistic Sciences

RAPKh
 Rossiiskaia assotsiatsiia proletarskikh khudozhnikov
 Russian Association of Proletarian Artists

RAPP
 Rossiiskaia assotsiatsiia proletarskikh pisatelei
 Russian Association of Proletarian Writers

R.S.F.S.R.
 Rossiiskaia Sovetskaia Federativnaia Sotsialisticheskaia Respublika
 Russian Soviet Federal Socialist Republic

Svomas
 Svobodnye gosudarstvennye khudozhestvennye masterskie
 Free State Art Studios

TsDRI
 Tsentralnyi dom rabotnikov iskusstv
 Central House of Workers in the Arts

TsGALI
 Tsentralnyi gosudarstvennyi arkhiv literatury i iskusstva
 Central State Archive of Literature and Art

Unovis
 Utverditeli (*also* Utverzhdenie) novogo iskusstva
 Affirmers (*also* Affirmation) of the New Art

Vkhutein
 Vysshii gosudarstvennyi khudozhestvenno-tekhnicheskii institut
 Higher State Art-Technical Institute

Vkhutemas
 Vysshie gosudarstvennye khudozhestvenno-tekhnicheskie masterskie
 Higher State Art-Technical Studios

Vsekokhudozhnik
 Vserossiiskii kooperativ khudozhnikov
 All-Union Cooperative of Artists

Zorved
 Zorkoe vedanie
 (See-Know, literally, "sharp-sighted knowing")

INTRODUCTION

BY S. FREDERICK STARR

Vernadsky prospekt is one of those depressing boulevards lined with gray apartment buildings of prestressed concrete that epitomize the "new Moscow" as it was conceived in the 1960s. Although it is scarcely a mile from the spot from which Napoleon viewed the city that was to defeat him, the new suburban thoroughfare has no visible link with the past. A mile away in the opposite direction handsome new apartments are being built that would pass muster in many leading cities abroad; Vernadsky Prospekt has no tie to that world either. Were it not for the large numbers stenciled on the outer walls, the apartment buildings would have no more identity in space than they do in time.

In the living room of a fifteenth-floor apartment in building No. 58 a most curious event took place over several afternoons in August 1977. The entire floor of the twenty-by-twenty-six-foot room was strewn with drawings and watercolors, singly and in piles of several hundred each. Stacked against three walls were row after row of paintings. Amid this chaos sat several people, two of them curators from Moscow's Tretiakov Gallery, a third the host and owner, Georgii Dionisevich Kostaki or, as he is known in the West, George Costakis. From time to time tea would be served by Zinaida Panfilova, Mrs. Costakis, a handsome and serene native of Moscow. Two of Costakis's three Mediterranean-looking daughters were also present, watching intently as their heavyset, sixty-four-year-old father chain-smoked and presided over the strange process.

Over a two-day period the Tretiakov was receiving one of the largest and most important gifts of art that any museum has received in the twentieth century. Since no record was kept of the transaction, it is impossible to determine the exact size of Costakis's gift to the Soviet museum. Nor did Costakis ever bother to catalogue his collection during the three decades he devoted to assembling it. But the sheer quantity of works involved was staggering by any measure. Several years before these 1977 sessions, some fifteen

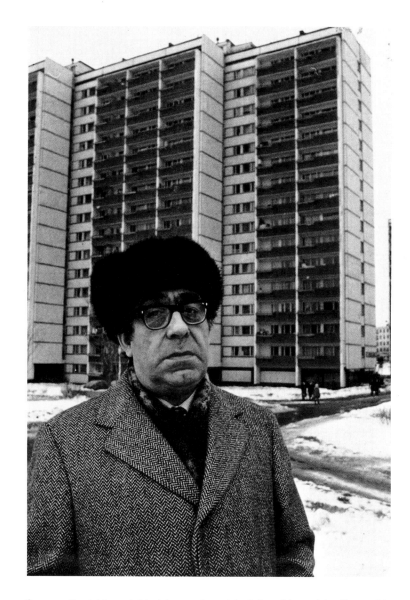

George Costakis outside his apartment building, Vernadsky Prospekt, 1973.

hundred works on paper were stolen from the apartment, but their loss did not significantly weaken the collection as a whole. Many times that number had to be dealt with now, not to mention some four hundred canvases, several score icons of the highest quality, and many manuscripts and catalogues, some of which included original prints, sketches, and paintings.

In number of works the collection far outstripped that of Gertrude and Leo Stein, Peggy Guggenheim, Katherine Dreier's Société Anonyme, or the entire Armory Show of 1913. Yet it was not the quantity but the focus of the works arrayed in the Costakis living room that made the gift so noteworthy. With the exception of the icons, all were works by Russian artists of the first part of the twentieth century, and all were drawn exclusively from the so-called avant-garde movement that preceded and immediately followed the Russian Revolution of 1917. In this area the collection was incomparable, surpassing every public or private collection in the

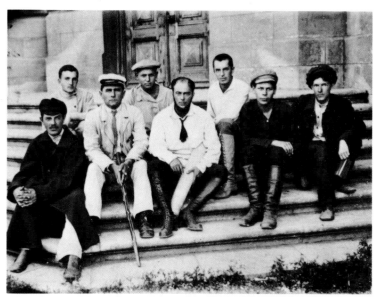

West and rivaled within the U.S.S.R. only by the collection of the Tretiakov Gallery itself and the Russian Museum, in Leningrad. And if these museums had managed to supplement their own holdings of avant-garde paintings in the previous decade, it was in good measure in response to Costakis's collecting activity.

In the rigorous focus of his collecting, George Costakis bears comparison with figures such as Dr. Albert C.

Members of the Unovis group at Vitebsk, c. 1919. Front row: Kazimir Malevich (second from left), El Lissitzky (third from left).

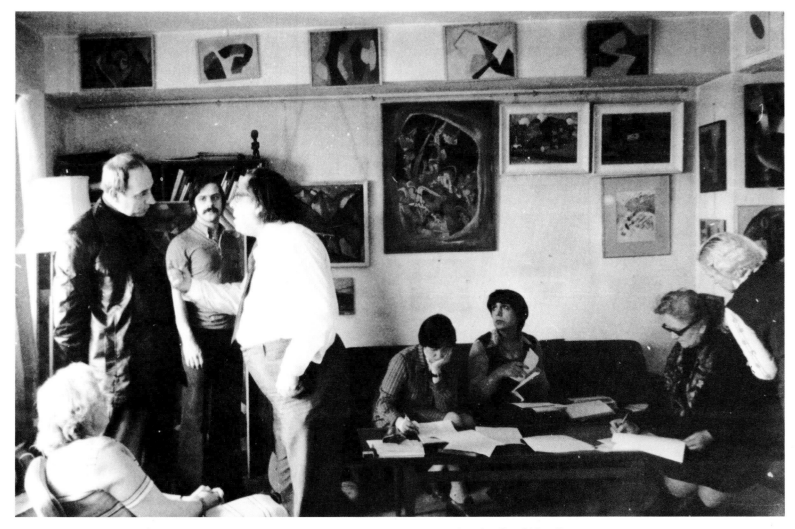

George Costakis and members of the Tretiakov Gallery staff in his living room, discussing details of his gift to the museum, 1977.

Barnes, with his concentration on French Impressionists and Post-Impressionists, or Robert Scull, with his enthusiasm for postwar American art, or the turn-of-the-century Russian merchant princes Sergei Shchukin and Ivan Morozov, with their passion for Post-Impressionists, Fauves, and early Cubists.

Merely to recite these comparisons is to raise numerous questions. Who is George Costakis, and why was he turning most of his collection over to this Soviet museum? How was it possible for a person living in the Soviet Union to amass so vast a private art collection? In a different vein, what was it about the work of Russia's nearly forgotten avant-gardists that attracted Costakis's fanatical devotion? And finally, what role did his collection play in bringing to light the movement as a whole, and in stimulating interest in the U.S.S.R. and abroad?

Comments in the visitors' book that Mr. and Mrs. Costakis began in 1961, after Igor Stravinsky's visit to their collection, indicate that many of those who have been received there left with the same queries in mind. They have also been raised in the dozens of articles on Costakis that have appeared in the Western press. Fortunately, the publication of this book on the Costakis collection provides an appropriate opportunity to address them.*

The Russian Avant-Garde

George Costakis was not new to art collecting in 1946, the year he stumbled across his first work of avant-garde art. His interests had yet to coalesce around a single medium or period, but he was thoroughly initiated into the world of art. With the acquisition of his first avant-garde paintings, Costakis found a focus and purpose for his collecting: to bring out of obscurity the achievements of a pleiad of Russian experimental painters who had been active during the period 1910 to 1930. When Costakis began collecting, only two of them — Marc Chagall and Wassily Kandinsky — were at all well known, and they because of successes achieved in the West. The others were either unknown or forgotten. He took it as his task to rescue them from obscurity.

Who were these avant-garde artists? They certainly did not consider themselves to be a movement or school. Some twoscore men and women in all, they were drawn predominantly from the families of small-time provincial merchants and tradesmen, were educated in St. Petersburg or Moscow, studied abroad, and then came together again in Russia between 1910 and 1923. Most of them were ethnic Russians, many were Jews, and there was a sprinkling of Poles, Latvians, Ukrainians, and Georgians as well.

Virtually from the moment the various groups emerged in Moscow, St. Petersburg, and a few provincial centers, their members were at odds with one another. The two leading figures, Vladimir Tatlin and Kazimir Malevich, feuded incessantly, notwithstanding their similar ethnic roots in the Polish-Ukrainian borderlands of western Russia. So much at odds were these two giants that they actually came to blows in 1915, at "The Last Futurist Exhibition of Pictures: 0.10," and they never missed an opportunity to insult one another thereafter. Malevich also engineered a coup against Chagall at the Unovis* school in Vitebsk, and managed to fall out with Kandinsky as well.

Many other artists to whom we now assign secure places within "the movement" were among the most

*The author wishes to acknowledge the cooperation of Mr. Costakis, the great assistance of Wynona Burmaster, and also the advice of John E. Bowlt, Christina M. Kraus, Angelica Rudenstine, and numerous former members of the diplomatic staffs of the Moscow embassies of Canada and the United States.

*For an explanation of acronyms and other special terms, see the Notes for the Reader, p. 10. — Ed.

ruthless critics of its members. Nowhere did Russian Futurism find a more scathing critique than among the Suprematists, led by Malevich, and Suprematism in turn was attacked more savagely by later Constructivists, with Tatlin at their head, than by the conservative critics. Constructivism itself exploded into at least two mutually antagonistic groupings within months after the term was coined. In addition to these internal tensions, the so-called avant-garde was also torn by apostasy. The band of experimenters was constantly under siege by those who had resigned from its ranks and wished to justify their decision — beginning with Vera Pestel about 1916 and extending from then until the full demise of abstraction in Russia, in the early thirties. (Although Pestel's action is often said to have taken place in 1920, Costakis learned from her daughter and others that she had abandoned the avant-garde by 1916.)

It is no wonder that the identity of the avant-garde as a movement is more discernible to us in hindsight than it was to any of the participants. The term "avant-garde" was applied to them retrospectively by Western critics, and even the more politically charged term "artists of the left" was applied to them far more frequently by their opponents than by the artists themselves. Theirs was a movement of movements, each seeking to define itself *against* every other movement. Its characteristic organizational format was the *gruppirovka* (informal grouping) that arose around a single exhibition. The Russian avant-garde was a composite of antagonistic groups, each with its own aims. Symbolism, Cubo-Futurism, Rayonism, Suprematism, Constructivism, Productivism, Concretism, and Engineerism were all invented to prove that a minority of the experimental artists were correct and the overwhelming majority wrong. The few efforts at presenting a united front were weak and ineffectual. A "discussional" exhibition organized in 1924 succeeded only in bringing forth eight new groupings, four of them with their own manifestoes and none of them eager to collaborate with the others. Even the famed Vkhutemas

Poster for the "1st Discussional Exhibition of the Unions of Active Revolutionary Art," May 11, 1924.

schools (Higher State Art-Technical Studios), which dwarfed the Bauhaus in size and ambition and rivaled it in achievement, was an umbrella organization comprising warring factions rather than the embodiment of a single ideal.

Far from proving that the Russian avant-garde movement did not exist, however, the massive evidence of factionalism attests to the presence of a true avant-garde in Russia. "Each avant-garde movement is always on the verge of going to war with itself," Harold Rosenberg observed.* The great volatility and fractiousness of Russia's experimental artists of the era 1920–25 is the clearest proof that they constituted an avant-garde.

Of what, beyond this contentiousness, does the Russian avant-garde consist? It is tempting to say that the

*"Collective, Ideological, Combative," in Thomas B. Hess and John Ashbery, eds., *Avant-Garde Art* (New York, 1967), p. 88.

common link was hostility to the "academy" and the sentimental and didactic realism it espoused. A half century earlier, in 1863, a group of fourteen students had withdrawn from the Imperial Academy of Arts in St. Petersburg with the intention of establishing their own exhibition salon. Unlike the Paris artists they emulated, the young Russians had no immediate audience at hand in the capital and had instead to carry their wares to the merchant-collectors of provincial Russia. Their combination of populism and nationalism was, however, precisely in tune with the times, and by the time they reached their fifties, the so-called Wanderers had been invited back into the academy with specific permission to continue their own exhibitions. By 1900 it was they who had come to constitute the academic establishment in Russia. Since most of the avant-garde artists studied either at the Academy of Arts in St. Petersburg, at one of its provincial affiliates, or at the Moscow Institute of Painting, Sculpture, and Architecture, the Wanderers who taught there provided them with a common and vulnerable target for polemics. Nor did the conservative academic painters emigrate after the Bolshevik Revolution. Thrown out of their jobs temporarily, they eventually triumphed over the avant-garde upstarts and reorganized the profession in their own image.

For all its intensity, the campaign against the academy did little to define the aesthetic program of the avant-garde, nor did it even define the membership, since many young critics of the academy stopped well short of espousing radical forms of art. A more accurate definition of the experimentalists' movement as a whole might turn on the striving toward a nonobjective (or nonrepresentational) art before 1915 and the elaboration of the potential of that form of art in diverse mediums down to 1930.

This is in fact what was occurring in Russian art in the decades following the appearance in 1890 of the epochal canvas *The Demon Seated* by Mikhail Vrubel. This erratic genius, whose work is still little known in the West, was acknowledged by avant-garde artists to have provided, even in the details of his backgrounds, provocative intimations of the potential of a pure painting stripped of its representational links with nature. Over the succeeding decades Wassily Kandinsky moved toward his first nonobjective canvases, and Kazimir Malevich developed in Suprematism a medium for communicating an art wholly divorced from representation, perspective, horizon, and even gravity. From this point on the challenge was no longer to discover nonobjective art but to explore its inner potential and apply its vision in other mediums.

The path to nonobjective art took Russian artists to the advanced studios of Munich, where Kandinsky painted and the sculptor Naum Gabo studied, and to Paris, which was visited by many of the leading experimental artists of Russia in the decade after 1905. The French capital was rendered particularly accessible by the recently concluded Franco-Russian alliance, by which the Romanov dynasty for the first time acknowledged republican France as an equal among nations. The intense intercourse with Paris, coupled with the Russian press's extensive coverage of exhibitions there, made the latest developments in Fauvism, Futurism, and Cubism as available to artists in Moscow and St. Petersburg as anywhere else in Europe or America.

The widely repeated but apocryphal story of the twenty-eight-year-old Vladimir Tatlin playing his accordion for Picasso and offering to sweep his studio reflects the popular notion of Moscow as an artistic colony of Paris. Reacting against this view, some specialists have advanced the opposite thesis — that everything about the Russians' drive toward abstraction was uniquely and remarkably their own. Both are caricatures, though the historical record is replete with evidence that would seem to support each position. Thus, when Sergei Diaghilev and Alexandre Benois organized the first *Mir iskusstva* (World of Art) exhibition in 1898, they did everything in their power to draw Paris and Moscow closer together. On the other side, Natalia

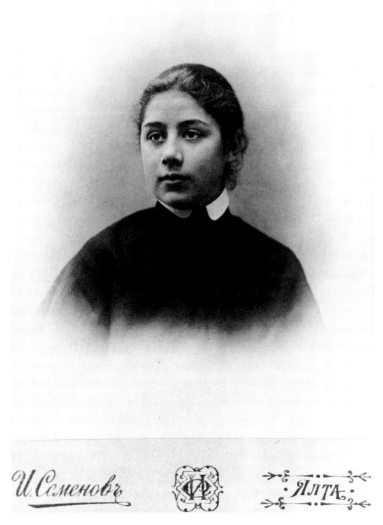

Liubov Popova. Photograph by I. Semienov, Yalta.

Goncharova, a pillar of the Russian avant-garde, declared on the eve of her departure for Paris in 1914 that the West "is of no use to us" and that Russia's artistic path now leads "toward the source of all the arts, the East."*

Common to the two extreme views is the treatment of both Russia and the West as symbols rather than realities. By 1913 many Russian artists facilely linked the West with a composite notion of the academy, rationalism, individualism, and cultural conservatism, as if to say that no true Russian could hold such principles. In the same breath they declared that inspiration, free creativity, boldness, and the ideal of community were

*In A. Guber et al., eds., *Mastera iskusstva ob iskusstve* (Moscow, 1970), 7:487.

"Asian," thus using the classic strategy of presenting outsiders — themselves — as the true insiders.

Putting aside the argument over symbols, it seems clear that a central aspect of the avant-garde, namely, the intense urge toward abstraction, might not have arisen among Russian artists, and certainly would not have been so creatively channeled, without the initial inspiration of German and French art. At the same time, only the urgent desire to prove their own autonomy pushed Russia's experimental artists to carry their innovations as far as they did. In fact the new artists of Russia not only absorbed fully the insights of Paris and Munich, but did so in a way that strengthened, rather than weakened, their own identity. This process of creative assimilation, essential to the development of nonobjective art before 1915, can be sensed in works exhibited by the Soiuz molodezhi (Union of Youth) group, in 1910; and at the exhibitions "Bubnovyi valet" (Jack of Diamonds), also in 1910; "Oslinyi khvost" (Donkey's Tail), in 1912; "Mishen" (Target), in 1913; and "Tramvai V" (Tramway V), in 1915.

In their collective striving toward a nonobjective art, in their creative use of foreign and domestic precedents, and no less, in their sheer numbers, the Russian innovators constituted a movement. More than any previous movement in Russian art, this one included substantial numbers of women. Most of these women were "self-made" — the aristocratic (but not wealthy) Natalia Goncharova being a rare exception. More typical was Liubov Popova, who came from a merchant's family, attended proper girls' schools in the Crimea and then in Moscow, and began serious work as an artist only when she enrolled in private art classes on her own initiative. The avant-garde cannot claim priority in bringing such talented female artists as Popova or Goncharova into the professional art world in Russia, but it did give women an unprecedented central place within that world.

Szymon Bojko, the Polish art historian, has noted the absence of a distinctly feminine element in the work of

these artists.* Swept along by the tide of women's liberation that had been gaining momentum in Russia since the turn of the century, the generation of Popova, Nadezhda Udaltsova, Alexandra Exter, and Varvara Stepanova contributed significantly to every phase of the avant-garde, and not least to its expansion into utilitarian production and industrial design. Indeed, three of the boldest applications of abstract art to practical life were the work of women: Popova's mechanistic stage set for Vsevolod Meierkhold's production of Fernand Crommelynck's *The Magnanimous Cuckold* (1922), Alexandra Exter's huge counterreliefs for the exposition buildings at the First All-Union Agricultural and Home Industries Exhibition (1923), and Popova and Varvara Stepanova's astonishingly bold fabric designs made under contract to the First State Textile Print Factory in Moscow in 1924.

As suggested earlier, the quest for a "pure" art dominated and defined the avant-garde down to 1915. The second period in the history of the movement began as the artists sought a future course for the new art they had pioneered. During this phase, sharp differences developed among them. These differences became the focus of a passionate dialogue within the movement, and hence the source of much of its dynamism. The debate dwelt on the future, but also had its roots in the past, unacknowledged to be sure, but important nonetheless. In fact, the wrenching feuds in which the artists were embroiled at the time of the Revolution were nothing less than an attempt to resolve basic philosophical and aesthetic questions raised but not answered by the Russian Symbolists before 1910.

The importance of Russian Symbolism to the avant-garde cannot be gauged by its originality. The Moscow-based Blue Rose group, which was active as an organized coalition between 1907 and 1908, was not lacking in innovation, but even its finest achievements pale by comparison with the works of the German and French artists from whom members of the Blue Rose took their cues. The great contribution of Russia's Symbolists was that they broke the monopoly of didactic Realism in Moscow and St. Petersburg, if not in the provinces; having broken that monopoly, they apprised Russians of the accomplishments of the French Impressionists and Post-Impressionists and the entire Germanic Jugendstil current. In the process, art lost the chains tying it to immediate political issues and rediscovered its older links with universal questions and redemptive aspirations.

This much the avant-garde inherited from the Symbolists. More important for the post-1915 phase of Russian experimental art, however, they also inherited an unresolved tension between two very different strivings within the Symbolist movement. On the one hand, Symbolism had propelled artists deep into the spiritual and psychological realm, at the expense of the earthbound concerns that preoccupied the Realists. On the other hand, in its effort to embrace life directly, Symbolism had cast doubt on the validity of easel painting and pointed out new vistas in the applied arts.*

This dualism within the Symbolist movement anticipated and defined the great schism that dominated avant-garde art after 1915. The fundamental conflict represented by the exchange of blows between Malevich and Tatlin is a kind of replay of the Symbolists' own debate over the question, "What does one do with pure art?" The second phase of the avant-garde's brief life addressed this question, first within the context of a semiconstitutional monarchy and then within the framework of a Communist state. It is this phase particularly, extending from 1915 to approximately 1925, that is documented in such depth by the Costakis collection.

*In *Russian Women Artists of the Avant-Garde, 1910–1930* (Cologne: Galerie Gmurzynska, 1979), pp. 14ff.

*See, for example, E. Kirichenko, "Interer russkogo moderna (1900–1910 gg.)," *Dekorativnoe iskusstvo*, 1971, no. 7, pp. 40–47.

At the two extremes of avant-garde thinking on this issue stood the Suprematists and the Constructivists. On one level the opposition was the ancient one between spirit and body, idealism and materialism. The Suprematists' program called for nothing less than the reconstruction of physical reality in the image of pure art. The Constructivists, or Productivists, as they came to call themselves after the defection of the idealists in their midst, wanted to destroy art as such and reconstruct civilization according to the possibilities opened up by modern materials—especially glass, steel, and plastic. Never mind that the flamboyant rhetoric concealed similarities in the aesthetic perceptions of the two groups. At bottom theirs were absolutely polar conceptions of art and life. The Suprematists were metaphysicians, platonic philosophers fascinated by the mysteries of abstract science. For all their rhetorical use of the word "revolution," the revolution in which they believed was spiritual, not political, and its purpose was to liberate man from time and mortality, not from any specific political or social order. The Constructivists and Productivists, by contrast, were craftsmen at heart, wishing to plunge into the real world of things whether with the instruments of the traditional artisan or the machines of modern technology. They, too, wished for a total transformation of life, but their utopia (like that of the American Shakers) was to be discerned more in the character of daily life it made possible than in any changes in the spiritual realm.

What neither group could have predicted in 1915 was the extent to which its inner development would be affected by the growing pressure in Russia for revolution in the political and economic spheres. Independent of any political party or specific program, the followers of Malevich and Tatlin, and the unconverted Futurists as well, gradually became caught up in the dangerous excitement of war, revolution, counterrevolution, and civil strife around them. As this occurred, both factions turned increasingly to practical and even utilitarian mediums to achieve their different utopian ends. Even

before the 1917 Revolution Malevich had begun constructing three-dimensional architectural forms, while his disciple El (Lazar) Lissitzky was also, in his own words, "changing trains from painting to architecture." On the other side, Tatlin, who had long been experimenting with bold planar sculpture of wood, metal, and glass, turned his attention to architecture in his justly renowned tribute to the new order, the *Monument to the Third International*, of 1919—20. Within the next few years, Gabo was to be drawing radio towers, Popova designing simple fashions for mass production, Gustav Klucis creating propaganda posters, the Chichagova sisters planning children's books, and the Stenbergs laying out typographical designs for newspapers. What began as the search for a further direction for the new "pure" art movement in painting culminated in the large-scale colonization of such diverse mediums as photography, book design, architecture, and even advertising.

By no means all the artists took this route. Some—Mikhail Matiushin, the Enders, and others in their Leningrad circle—preferred to forge ahead to new realms in easel painting. The resulting compositions of subtly balanced color anticipate American abstract color painting by forty years. No less important were the numerous experimental artists who backed away from the initial insights of Malevich and Tatlin and sought to build a new art with the language of Expressionism, or an entirely unprecedented language of their own. This current within the avant-garde found its master in the aloof Leningrad visionary Pavel Filonov, whose figurative canvases bring together historical, biological, and psychological motifs in a disturbing idiom owing more to Hieronymus Bosch than to Picasso. Another artist whose visual language defies ready categorization was the Christian mystic Vasilii Chekrygin, who rejected Cubism and its legacy, became a convert to the views of the scientistic mystic Nikolai Fedorov (a friend of Dostoevsky), and spent the rest of his short life on a cycle of works entitled "The Resurrection of the Dead." And

beyond Filonov and Chekrygin were a number of other artists trying to express the deepest psychological reality in two-dimensional compositions. Nor were Dadaist tendencies absent from the Russian avant-garde, as one can see in Malevich's *An Englishman in Moscow*, in many of Mikhail Larionov's early drawings, or in some of the productions of the Burliuk brothers.

However great the diversity among these artists, it was the Suprematists and Constructivists who dominated the internal life of "left" art after 1917 and who were viewed by both the new government and the educated public as representing the current as a whole. The avant-garde as a group were profoundly revolutionary, viscerally committed to overturning the entire cultural legacy of the past. The Futurists in particular stood violently opposed to most of the values essential to a liberal society. Far more than most of the other artists, the experimentalists greeted the overthrow of the Romanov dynasty by the Social Democrats, in February/March 1917, with passionate enthusiasm. If all but a handful of them were wholly ignorant of Marxist ideology and few ever joined the Communist Party, they nonetheless hailed the subsequent Bolshevik Revolution, which followed in October/November, seeing it as just one more step toward the eventual triumph of "pure" art over politics. During the bloody civil war that raged to 1920 the new Bolshevik government was preoccupied with the military struggle and asked of artists only that they create monumental works of propaganda, which they did very ably.* Not until the civil war ended did the new government have time to face the question of avant-garde art directly.

The Bolsheviks arrived in power with no defined program for the arts. Friedrich Engels had accepted a diversity of styles as appropriate to Communism, and the anarchist Petr Kropotkin had explicitly lauded the usefulness of abstract art for revolutionary movements.

Karl Marx, however, had—tentatively, to be sure—opted for Realism, a view that was shared by Lenin but not by several of his leading collaborators in the Bolshevik Party. It fell to Lenin's Commissar of Public Enlightenment, Anatolii Lunacharsky, to devise a policy for the arts. Holder of a doctorate from the University of Zurich and a former Russian-language tour guide at the Louvre, "our soft-hearted Anatolii,"* as Lenin termed him, knew many of the experimental artists personally and respected their efforts. In the last analysis, however, he could not accept either the Suprematists' insistence that pure art is an end in itself or the Constructivists' belief that artists rather than politicians or officials should design the future life of mankind. In an important 1920 tract entitled *The Revolution and Art*, he claimed, like Lenin, to oppose all coercion in art, but his conviction that "complete absence of content has been very characteristic of bourgeois art of recent times" pointed unmistakably toward some form of interventionism. Art has a didactic purpose, he argued, for it "brings the whole content of propaganda to white heat and makes it glow." Lunacharsky was similarly blunt about the aesthetic forms appropriate to such a task. "The Revolution," he held, "with its vast ideological and emotional content, requires a more or less realistic, self-evident expression saturated with ideas and feelings."†

There was no ambivalence in Lunacharsky's analysis, but his softheartedness, combined with the very real limits of his power, caused him to support, or at least tolerate, many artists who were unsympathetic to the Realism he espoused. Indeed, a series of new organizations and schools that he set up provided a relatively secure institutional home for scores of experimental

*See *Agitatsionno-massovoe iskusstvo pervikh let Oktiabria*, ed. E. A. Speranskaia (Moscow, 1971).

*Quoted in Sheila Fitzpatrick, *The Commissariat of Enlightenment* (Cambridge, Eng., 1970), p. 131.

†"Revoliutsiia i iskusstvo," *Kommunisticheskoe prosveshchenie*, 1920, no. 1; in John E. Bowlt, ed. and trans., *Russian Art of the Avant-Garde: Theory and Criticism 1902–1934* (New York, 1976), pp. 191, 192, and 194.

artists who might otherwise have found no patrons. Among these new foundations were Jnkhuk (Institute of Painterly Culture), which Kandinsky headed until he fell out with his colleagues and students; the Svomas (Free Art Studios) of Petrograd, which replaced the Academy of Arts; and the former Institute of Painting, Sculpture, and Architecture in Moscow (which in 1920 was renamed Vkhutemas). Not all these schools and institutes were dependent upon Lunacharsky for funds; Vkhutemas and others were fully supported by the trade unions, which were still semiautonomous under the New Economic Policy, instituted in 1921 to improve economic conditions by restoring some measure of free enterprise. But Lunacharsky at least refrained from acting against the experimentalists, and even helped several of them to emigrate.

The commissar's relative tolerance was not appreciated by Lenin, who had no use for the avant-garde and declared flatly that "Lunacharsky should be flogged for his Futurism."* In fact, most of the budget of Lunacharsky's commissariat was devoted to the support of eminently conservative groups in the arts. And it was "our soft-hearted Anatolii" who authorized the closing of the Svomas and the reestablishment of the Academy of Arts in 1920, who implemented the ban against the bold Proletkult (Proletarian Culture) movement, and who strongly supported the formation of AKhRR (Association of Artists of Revolutionary Russia) in 1922. The latter group in particular was squarely opposed to all that the avant-garde stood for. It declared itself in favor of "heroic realism," harshly criticized the left as being the last, decadent manifestation of the French school of Picasso and Cézanne, and by 1924, was gloating over "the already evident collapse of the so-called leftist tendencies in art."†

It cannot be denied that AKhRR represented the mainstream of Russian painting as it had existed since the Wanderers' secession from the Academy of Arts a half century earlier. Nor did the conservatives show any greater intolerance toward the avant-garde than members of the avant-garde showed toward one another. Precisely because of their status as an unpopular minority, however, the avant-garde artists were a convenient scapegoat for the problems of the moment.

In a fit of antiaestheticism, the pioneer theoretician of Constructivism, Alexei Gan, had declared in 1922 that "Art is indissolubly linked with theology, metaphysics, and mysticism.... Death to art!"* This refrain, repeated by the chorus of Constructivists associated with the journal *LEF* (Left Front of the Arts), justified the general avant-garde turn toward industrial design in the years 1922–24. This move, which was defended at the time as the logical result of the inner development of modernism and of its embrace of the Revolution, had the paradoxical effect of leaving the realm of "art" to the conservatives. The Realist majority could now claim to be the sole spokesmen for the traditional values of art, which they did with great effectiveness throughout the last half of the 1920s. Meanwhile, some of the avant-garde artists emigrated, others abandoned the movement, and a few continued to work, protected, but at the same time isolated, by the few institutions that still offered them patronage. Long before the 1932 decree abolishing independent organizations in the arts, the avant-garde movement had begun to die, except in the ateliers of a few individuals who kept alive the old flame. A Union of Artists of the U.S.S.R. was proposed to rally everyone to march together under the common banner of Socialist Realism.

*Quoted in Louis Fischer, *Life of Lenin* (New York, 1964), p. 496.

†I. M. Gronskii and V. N. Perelman, eds., *Assotsiatsiia khudozhnikov revoliutsionnoi rossii, sbornik vospominanii, statei, documentov* (Moscow, 1973), pp. 268ff.

Konstruktivizm (Tver, 1922), p. 19; trans. in Bowlt, *Russian Art of the Avant-Garde*, p. 221.

Art Collecting in Russia

The avant-garde in Russia was born and buried in a society that was trying to master the entire history of art and culture. Situated on the periphery of Europe and by no means confident about their place in the annals of world civilization, Russians over the centuries have compensated for these facts of geography and psychology by acquiring whatever in their eyes epitomized the best ideals of European culture. Indeed, the burden of tradition created by the effort to warehouse Western civilization helped significantly to fire the avant-garde passion to break free of the past.

If the process of collection and creation are related, it is worth pointing out that Russians yield to no nation in their passion for art collecting. The Hermitage itself is a vast collection of collections, each one of them a monument to one person's avarice. "Ce n'est pas l'amour de l'art; c'est la voracité: je ne suis pas amatrice, je suis gloutonne" ("It is not love of art; it is greed: I am not a lover, I am a glutton"), wrote Empress Catherine II, describing her life as a collector. Literally thousands of Russians have shared this passion, and many have refined it to a rare degree of connoisseurship. George Costakis stands directly in this Russian tradition of collecting, which stretches back far before the Revolution.

Art collecting in Russia began as an imperial hobby. Peter the Great purchased whole collections of Dutch landscapes and marine subjects in Danzig and Hamburg. Catherine II, a minor German princess who had usurped her husband's Russian throne at the height of the Enlightenment, pursued different interests but with the same uncompromising avarice. Art symbolized wealth and power, as well as culture, and had an advantage over money in that it was unique. Catherine used this currency to establish her credentials in the salons of Europe. Impatient to the extreme, she assigned her ambassadors abroad the task of buying whole collections, bidding fiercely at James Christie's recently established auction rooms in Pall Mall and at Le Brun's and Gersaint's in Paris.

Once established through Catherine's example, art collecting became *de rigueur* for the wealthier members of Russia's aristocracy. At his ambassadorial residence in Vienna, Prince Razumovsky assembled a whole room full of works by the popular eighteenth-century sculptor Antonio Canova. In Florence, Prince Gagarin built up a private collection that constituted the greatest repository of contemporary art in Europe during the 1830s and 1840s. Other Russian grandees amassed comparable collections, and shipped them home to St. Petersburg and Moscow. Soon even minor functionaries understood that a painting or two might enhance their standing in a culturally acquisitive society.

While establishing the pattern of large-scale collecting, Catherine and her aristocratic successors followed practices that differed sharply from those of the merchant-collectors who came to dominate the scene by the mid-nineteenth century and from their twentieth-century successors as well.

First, because imperial and aristocratic collections were created in order to fill the obligatory picture gallery included in newly built country houses and urban mansions, they were generally assembled with great speed through the help of hired middlemen. Often whole collections were purchased at one time, especially when the French Revolution forced major private collectors to part with their holdings. The individualization of taste that accompanied the rise of Russia's merchant class in the late nineteenth century brought about a change in this practice. Even when he worked through a dealer such as Vollard, Kahnweiler, or Bernheim-Jeune in Paris, the bourgeois collector from Moscow (like his counterpart in London or New York) wanted to make his own decisions or at least give the appearance of doing so. There were very few substantial dealers in Russia anyway, and no centralized auction houses comparable to the Hôtel Drouot, founded in Paris in 1854.

The second area in which the royal and aristocratic collectors differed from their middle-class successors was in the former's bias in favor of West European artists. The neglect of Russia's indigenous painters ended with the abolition of serfdom in 1861. Not only did this break up many landed fortunes and open the field of art to the rapidly forming group of merchants and industrialists in Moscow and St. Petersburg, but it spurred a wave of nationalism that expressed itself in the passion to "buy Russian." Along with other motives, the nationalistic merchants who collected Russian art were impelled by the desire to demonstrate symbolically that Russia possessed all that was needed to modernize itself without resorting to foreign resources.

The merchant-collector represented a new type in Russia, but his counterpart existed in all the industrial nations and was everywhere the object of gentle ridicule. "It is difficult to write about Victorian collectors without condescension," wrote Frank Davis.* Flamboyance, gigantomania, dubious taste, and a penchant for canvases of a crassly programmatic nature characterized nineteenth-century merchant-collectors. New money could be recycled into old art, just as a baronial dwelling place could disguise one's modest birth.

Russia's merchant princes held their own in such company. They built Spanish, French, Italianate, and Germanic palaces, romanticized their roots in fantastic genealogies, and generally behaved as if money could buy everything. The playwright A. N. Ostrovsky describes a provincial merchant's wife who "collects amazing foreign wonders, from stuffed parrots to pictures." The novelist Maxim Gorky describes another merchant, Prokhor Khrapov, who buys up old castles "because nobody else is collecting them."† Gorky did not exaggerate. In the second half of the nineteenth century the ranks of Russian collectors swelled to such an extent that even the most arcane objects were being sought out by some specialist. Such figures as Khludov, Alekseev, Naidonov, Bakhrushin, Tsvetkov, and Stieglitz, to name but a few, bear comparison with the most avaricious collectors in Western Europe and America. A few of these new collectors, like M. P. Botkin, a specialist in European antiquities and curator of the Stieglitz Museum in St. Petersburg, were sophisticated connoisseurs, comparable to Charles Eastlake of the National Gallery in England. One, Pavel Tretiakov, probably had no equal anywhere in terms of the size or clarity of focus of his collection.

Brusque by temperament, yet sincerely drawn to art, Tretiakov began by purchasing a collection of Dutch paintings, several of them copies. Filled with nationalistic ardor by Russia's humiliation in the Crimean War, however, Tretiakov sold off his Dutch paintings and for the rest of his life concentrated on works by his Russian contemporaries the Wanderers. He viewed his collecting in pedagogical terms, the purpose being to awaken Russians to the glories of their own national culture. Within five years of the start of his Russian collection, Tretiakov had conceived the idea of donating it to the city of Moscow.

Today Russia's Realist painters are so firmly established that it is difficult to appreciate how bold was Tretiakov's decision to back them. Yet there can be no doubt that Pavel Tretiakov—and his brother, Sergei—genuinely loved their work and admired them personally as friends, correspondents, and guests at table. Indeed the Tretiakovs' timely patronage gave a center of gravity to what might otherwise have become a rather diffuse achievement. In Pavel Tretiakov's home intellectuals of Dostoevsky's and Mussorgsky's generation encountered the range and depth of contemporary Russian painting in a way that would otherwise have been impossible. The Tretiakov legacy was nothing less than to mold the public and private taste of the Russian and Soviet middle class.

Victorian Patrons of the Arts (London, 1963), p. 13.

†Quoted in A. P. Botkin, *Pavel Mikhailovich Tretiakov v zhizni i iskusstve* (Moscow, 1951), pp. 7–8.

The self-reliance, independence of choice, and purposefulness of Russia's merchant-collectors reached its apogee in the figures of Sergei Shchukin and Ivan Morozov, two of the world's boldest twentieth-century collectors.* Superficially, it would seem that the Russian patrons of Matisse, Denis, Cézanne, and Picasso stood poles apart from Tretiakov. But if their cosmopolitan ideal is diametrically opposed to Tretiakov's exclusive nationalism, they shared his notion of collecting with a mission. And Shchukin, like Tretiakov, early conceived the idea of making his collection accessible to the Russian public. After the Revolution, when Paris friends suggested to the émigré Shchukin that he institute legal proceedings to regain his paintings from the Bolshevik government, which had nationalized them, he reacted with indignation. "You know I collected not so much for myself as for my country and its people," he declared, much to the chagrin of his own heirs. "No matter what has become of Russia, that is where my collection belongs."

Many other traits united Shchukin with Tretiakov, and anticipate several leading collectors of the Soviet era, including Costakis. Both were devout Christians in an increasingly secularized world. Both abjured ostentation in their personal lives, were quick and absolute in their aesthetic judgments, and, though newcomers to the cultural vanguard, were all but oblivious to the fads of the moment. The quality of sharp focus that characterized Tretiakov's collection was to be found in Shchukin's, and with the same pedagogical impact. But whereas Tretiakov opened his collection to the entire public, Shchukin concentrated his attention on younger artists, whom he received without invitation on weekends. As a result of this attitude, the struggling young artists in Moscow had direct access to the latest achievements of the Paris vanguard.

It would be wrong to suppose that Shchukin and Morozov typified collectors and patrons of Russian art in the early twentieth century. Had others been as receptive to artistic innovation as they were, there would have been little for avant-garde artists to react against. But modern Russian art was born in a country celebrating the tricentennial of its ruling Romanov dynasty and witnessing an unprecedented period of industrialization and economic growth. Shaken by the disastrous war against Japan and the Revolution of 1905, tsarist society was now experiencing a brief period of relative tranquillity under the semiconstitutional monarchy, a tranquillity reflected in the self-contented tastes of most collectors.

The new prosperity of recent decades had released an avalanche of art collecting. J. P. Morgan succeeded in buying the Botkin collection of Byzantine enamels in St. Petersburg, but Russians were usually themselves on the purchasing end. Whole trainloads of second-rate French art were being shipped to the Russian capital by French dealers eager to make rapid profits. Tretiakov's gift of his museum to Moscow in 1892, the establishment of the Stieglitz Museum in St. Petersburg in 1896, and the opening of the Russian Museum in St. Petersburg two years later attest to the new passion for art. Exhibitions that formerly drew hundreds now brought thousands of visitors, many of them buyers. A single exhibition as early as 1898 attracted thirty thousand paying viewers.* Major shows became social events, replete with gypsy orchestras and champagne. In *fin-de-siècle* Russia, major artists dressed like princes, smoked the best cigars, and bought country estates.

Such conditions in no way·explain the mood of spiritual searching that infused the younger generation of painters, but they form the essential background for the emergence of a new bohemianism after 1905. The

*The best study in English of these two figures is Michael Ginsburg, "Art Collectors of Old Russia: The Morozovs and the Shchukins," *Apollo*, December 1973, pp. 461–85.

*See G. Y. Sternin, *Khudozhestvennaia zhizn Rossii na rubezhe XIX–XX vekov* (Moscow, 1970), especially pp. 51ff.

young Futurists who insulted audiences across the country in 1913–14 could take for granted that stolid burghers would pay money for the experience. Hence the element of showmanship in the avant-garde, the aggressive manifestoes, the eccentricity of personal behavior, and at times, the pure bombast in which the artists indulged. To be sure, their deliberately provocative projects had profound implications for fields as diverse as poetics and typography. But there can be no doubt that the artists acted with an eye on the market as it then existed. Referring contemptuously to the strategy of conservatives who "end their days as innovators before they are barely thirty, and then turn to rehashing," Olga Rozanova wrote that "there is nothing more awful in the World than an artist's immutable Face, by which his friends and old buyers recognize him at exhibitions."* Anticipating Andy Warhol by half a century, the young Russians of 1913 realized that the art world could be conquered as easily by insult as by flattery.

The differing professional circumstances of the avant-garde and the Establishment help explain their different responses to political revolution. Speaking of the majority of established painters, Commissar of Enlightenment Lunacharsky observed that

artists can complain about, rather than bless, the Revolution....

The ruin of the rich Maecenases and patrons was felt less, of course, by the young, unrecognized artists, especially the artists of the left who had not been successful in the market.†

Lunacharsky's observation was particularly true for the civil war period, when the art market utterly collapsed amid general chaos and fears of nationalization. Seeing the need to make a gesture toward the artists, he wisely moved to substitute the state for the absent collector, setting up a Purchasing Commission in 1918 to buy paintings for the three dozen museums established or reorganized at the initiative of his commissariat. This measure, along with the various studios into which the old art institutes were transformed, assured the livelihood of many avant-garde artists at precisely the moment when the majority of more traditional painters were suffering most heavily. Crucial in the new web of collector-patrons were the trade unions, which sponsored such dens of experimentation as Vkhutemas until they were suppressed, in the late 1920s.

The nationalization of the major private collections in 1918 and the trauma of civil war effectively suspended private collecting for several years. With the institution of Lenin's New Economic Policy in 1921, however, private collecting revived with a vengeance. Pre-Revolutionary collectors such as E. G. Schwartz began rebuilding their holdings, while prosperous technicians such as the Odessa engineer Mikhail Braikevich established new collections. Useful advice was now provided by the journal *Sredi kollektsionerov* (Among the Collectors), which flourished between 1921 and 1923. Everyone lauded the apparent return to normal, and collectors' taste reflected the Thermidorean mood by becoming even more nostalgic and conservative than it had been ten years earlier. Since Russia's art market had never been dependent upon private dealers and auctioneers, it could now bounce back quickly even without them. The abolition of the Purchasing Commission in 1921 hurt the avant-garde but nobody else, since private outlets for the more salable art were everywhere at hand. In the next year the Realist Wanderers held their forty-seventh exhibition, and in the following years a whole series of exhibiting organizations were established with the aim of wedding the public's traditional partiality for Realism to a more contemporary subject matter.

*"Osnovy novogo tvorchestva...," *Soiuz molodezhi*, 1913, no. 3, p. 21; trans. in Bowlt, *Russian Art of the Avant-Garde*, p. 109.

†"Revoliutsiia i iskusstvo," *Kommunisticheskoe prosveshchenie*, 1920, no. 1; trans. in Bowlt, *Russian Art of the Avant-Garde*, p. 193.

This is not to say that by the early twenties the avant-garde artists were completely without patronage or prospects. Many members of the movement held salaried teaching positions and a few found employment in commercial establishments such as publishing houses, newspapers, or technical design studios. There were even exhibitions in which they could show their work. In 1923, for example, the Tashkent experimentalist Alexandr Volkov held a one-man show of abstract work in Moscow; a posthumous show of Vasilii Chekrygin's last work was mounted in Moscow, newly proclaimed Russia's capital; and a larger exhibition embracing Malevich, Tatlin, Filonov, Paul Mansurov, Mikhail Matiushin, and the Ender family was organized in the Petrograd Museum of Painterly Culture. Other shows of the avant-garde continued throughout the 1920s. Typical was a 1927 exhibition at the Tretiakov in which numerous drawings by Kandinsky, Popova, Stepanova, and Alexandr Rodchenko were presented.* But the public mood had definitely become more conservative. After enduring the hardships of revolution and civil war, the educated public was no longer eager to be shocked and titillated by artists. The extensive innovation that occurred in such fields as film, architecture, and music in the teens had dwindled to the affair of a minority in the 1920s. Suffice it to say that none of Eisenstein's epochal films was a success at the box office, and they would not even have been produced were it not for the diversion to avant-garde studios of profits on Russian showings of films by Charlie Chaplin, Buster Keaton, and Harold Lloyd. The avant-garde gradually lost its market in the 1920s, and the painters' turn to commercial design was perhaps in part an effort to find a new source of patronage. Thus, Lenin's New Economic Policy enabled avant-garde artists to survive and gain access to limited patronage, but by no means to pros-

per. There was more activity after this than is generally appreciated in the West, but the movement as a whole was dying.

Paradoxically the long-term effects of this situation were more positive. To begin with, a number of major paintings and drawings by avant-garde artists were preserved by artists themselves rather than sold to an unappreciative public. Many of the works sold at exhibition, by contrast, were later to perish during the anxiety engendered by Stalin's purges. In addition, the revival of private collecting after 1921 provided a link between the pre-Revolutionary traditions of connoisseurship and those that were to spring up in the more prosperous decade of the 1930s. Even if the major collectors of the era ignored the avant-garde, they at least perpetuated and lent new respectability to the passion for art collecting that had existed in Russia for two centuries. Without the human link provided by the collectors of the 1920s, George Costakis's initiation into art collecting would never have been so intense or so thorough.

Costakis's Introduction to Collecting

Like many other great collectors, George Costakis was always interested in promoting his collection rather than himself. For most of his life in the U.S.S.R. he lived modestly and devoted his energy almost entirely to collecting and to sharing his collection with guests. Yet news of the existence of his collection on the Bolshaia Bronnaia (later Leninsky Prospekt, and then Vernadsky Prospekt) gradually spread to thousands of people who did not know anything about Costakis himself other than that he was Greek, not Russian, by nationality.

Actually Costakis had been born in tsarist Russia, his parents having both emigrated from Greece. He is a

*A comprehensive listing of these exhibitions is in Vasilii Rakitin's excellent "Khronika: istoriia sovremennykh dvizhenii v russkom iskusstve" (unpublished ms., Moscow, 1978), pp. 34ff.

second-generation immigrant and thoroughly Russified, in spite of his having retained a Greek passport. Until his own emigration, in 1978, Costakis had scarcely visited Greece.

George's father, Dionysius, was born into a family of woodworkers on the island of Zakinthos. Like many other Greeks since ancient times, the elder Costakis decided to seek his fortune in the far-flung and intricate Greek commercial world rimming the Mediterranean. His first efforts were in Cairo, where he set up a small pension. The business did not prosper, however, and he soon returned to Greece, where the failure of a second venture drove him into bankruptcy. It was at this point, about 1907, that Dionysius Costakis decided to try his luck in Russia.

It was no great step for a Greek to immigrate to tsarist Russia. There were Greek commercial colonies in every major port on the Black Sea, and thriving Hellenic communities existed in both St. Petersburg and Moscow. The elder Costakis went to Moscow, where he joined the Bastanzhoglu Company, a tobacco firm that processed and sold the produce of large Greek-owned plantations in Russia's Central Asian territories. Demand for tobacco was high in Russia's booming cities and the company prospered. Even before the "guns of August" boomed in 1914, the immigrant from Zakinthos had become a wealthy man, the owner of the entire business. He installed his growing family in a twelve-room apartment on Gnezdnikovsky Alley in the fashionable Tverskoi Boulevard district in the heart of Moscow. Eight servants looked after the family's needs. It was into this milieu that Georgii Dionisevich Costakis was born in 1912, the third of five children.

Unlike George's father, his mother was quite accustomed to comfortable surroundings. Her father, a Greek by the name of Papachristoduglu, had built up a substantial fortune in the tobacco business in Tashkent and then married into the aristocratic Sarris family. George's mother was born while the Papachristoduglu family still lived in Tashkent. Disaster struck when her father lost all

his money at cards or, as family legend holds, on a ballerina, and then simply disappeared while on a business trip to France. Thanks to the wife's connections, the children were taken under the wing of a Greek official resident in Moscow, who gave them a thorough education in various practical subjects, including foreign languages, of which George's mother spoke six.

Members of the Costakis family had no reason to welcome the Bolshevik Revolution but even less reason to abandon their property and flee. Instead, they stayed on in Moscow throughout the civil war, even when famine and political strife reduced the city's population by half. Like many opponents of revolution everywhere, Dionysius Costakis did not expect the insurgent regime to last, and when it did, he had already accommodated himself to the new order. The entire Costakis family therefore remained in Russia, where all but the father and eldest son had been born.

With the establishment of the New Economic Policy in 1921, life returned somewhat to normal. The Costakis family kept the apartment on Gnezdnikovsky Alley until the editors of the magazine *Ogonek* (Flame) decided they wanted it for their offices, at which point the family moved to a villa at the dacha community of Nemchinovka. Four servants still attended to the family's needs, and George's father still boasted five suits.

The Costakises' opposition to the Bolsheviks was less economic than religious. The parents later confided to George their conviction that however much they personally had benefited under the tsarist regime, they felt it could never have survived, given the desperate plight of many of the poor in the cities. Hence, their opposition focused on the Bolsheviks' antireligious policies. Deeply pious, the members of the family were communicants of the Church of St. Dmitrii of Salonika, which had stood on Strastnoi Square. Georgii Dionisevich served there as an altar boy for four years during the 1920s. "Even now, Russians are more devoutly Christian than any of the other Orthodox peoples," he asserts.

Considering Costakis's later passion for avant-garde Russian art, it is surprising that neither he nor his family seems to have had the slightest contact with the cultural awakening occurring around them. "We had paintings on our walls," he recalls, "but they were nothing more than Oriental knickknacks in bamboo frames. Neither my mother nor my father had any direct relationship to art." The family's sole contact with any of the leading cultural figures of the day was with the great opera bass Fedor Chaliapin. But Chaliapin's visits to the Costakis dacha at Nemchinovka were in his capacity as an active Christian layman rather than as a musician. George still recalls with pride the arrival in their home of Chaliapin, accompanied by a retinue of Orthodox priests who had come to attend a meeting of the district's church council, of which Dionysius Costakis was president.

The infinitely varied means by which sons and daughters of the educated professional classes of tsarist Russia accommodated themselves to the Soviet regime have never been thoroughly described. Tens of thousands continued in the same calling for which their families had groomed them. Others broke sharply with the past. George's oldest brother, Spiridon, for example, threw himself into the new and very fashionable sport of motorcycle racing. By the late 1920s he had become champion of the U.S.S.R., with posters throughout Moscow announcing in bold letters every one of his appearances. "Just being his brother made me a hero," George reminisces. The rest of the family was equally proud. When Spiridon died in a race in 1930 (and under circumstances that raised questions of foul play), his father's hair turned white in one night, and Dionysius Costakis was dead within the year.

Open admissions policies introduced after 1917 and punitive admissions quotas directed at the old bourgeoisie threw Russian education into confusion during the 1920s. George Costakis had reached the fifth grade by 1922, the year the family moved to Nemchinovka. For three more years he commuted to the local village school on foot or on a peasant neighbor's horse. Each year saw him further behind than the year before. Hoping to compensate for this lag in his education, his parents sent him to school in the city. But the setbacks had taken their toll. George was able to finish the tenth grade, but with difficulty.

Whatever education he managed to acquire was due more to his family than to formal schooling. He learned French through a governess, and acquired English under the influence of his aristocratic Greek brother-in-law, Fedor Metaxa, who had lived in England and now shared the house at Nemchinovka. In addition to having a wardrobe of fifty suits, Metaxa owned an extremely valuable stamp collection. After his premature death, his widow gave the stamps to George, who promptly sold them for a few rubles to buy a bicycle, only to discover later that they were worth many thousands of pounds sterling.

After leaving school, George enrolled at an institute for automobile mechanics, but failed to complete the course. It was in 1929, Stalin's cultural revolution was gaining momentum, and the seventeen-year-old youth was without work. Fortunately his brother Spiridon rescued him by getting him a job as chauffeur at the Greek legation, where he himself was employed. This provided sufficient security for George, in 1931, to marry Zinaida Panfilova, then a bookkeeper at the Java tobacco factory in Moscow. They were married at the now defunct Greek Orthodox Church on Nikolsky Boulevard.

The steps by which a nineteen-year-old chauffeur at the Greek mission in Moscow became one of the world's major art collectors are difficult to reconstruct. George was a stranger to connoisseurship, and his education had in no way inclined him toward it. But by 1931 he had put his immigrant heritage behind him and had, through his own endeavors, gained a toehold in the life of the Russian capital. And like many other outsiders who had established themselves there, Costakis seems to have celebrated his "arrival" by acquiring the

accoutrements of high culture. He began his collection by purchasing a vase ornamented with an equestrian portrait of Napoleon.

For all the gentility of his new interest, Costakis's material state in 1931 was very moderate. He and his wife were living in one room. The communal washing and kitchen facilities were also used by the building's dozens of other tenants, as was the common outhouse in the courtyard. The city beyond their doors was overwhelmed by poverty-stricken immigrants from the countryside, and the most basic provisions were all but nonexistent. Thousands of homeless waifs (*bezprizorniki*) whose parents had perished in the savage whirlwind of collectivization in 1929–30 or in the subsequent famine, roamed the street by day and at night slept in conduits.

So desperate was the government's financial plight that, beginning in 1928, the export agency Antikvariat was ordered to begin the massive sale of paintings and antiques to foreign bidders willing to pay in hard currency. The stakes were high on both sides. For the Soviets it meant obtaining money with which to purchase the Western machinery crucial to economic recovery. For Western art collectors it meant access to the single greatest untapped storehouse of antiques on the European continent.

George Costakis portrays the antique market of Moscow and Leningrad in the 1930s as a Klondike. This assessment is confirmed by Germain Seligman, who described a sale of collections drawn from the holdings of the Hermitage in the following terms:

One room was an extraordinary sight—a vast hall which gave the impression of being a great cave of ormolu and gilt bronze, with stalactites and stalagmites of gold and crystal. Hanging from the ceiling, standing on the floor or on tables, was an incredible array of chandeliers and candelabra, small, large, or huge, all glittering, for they seemed to have been well cared for, with gilded ornaments and glass or crystal pendants.

Nor were the tables they stood on less resplendent, with ormolu ornaments and tops of marble, onyx, agate, or that vivid green malachite of which Russians are so fond. *

Soviet citizens rarely entered those antiquarian shops that dealt only in hard currency, which Soviets were forbidden by law to own. But along with these establishments the government also set up state-owned pawnshops, or "commission stores," in the major cities. These were open to Soviet citizens and tourists alike, and were packed with the treasures of upper-class families that had been brought to ruin by the general upheaval. The quantities of paintings and antiques put up for sale were staggering. The results of the Napoleonic expropriations in France, Germany, and Italy or of the 1882 Settled Lands Act in Britain pale by comparison. Nowhere in recent times had there been an art and antique market more opulent than that of Stalin's Moscow.

Even this bonanza might not have led to the resurgence of collecting had there not been a further series of favorable circumstances. First, the "great leap forward" induced by collectivization in agriculture and the forced-march drive for industrialization required managerial and technical leadership. Recognizing this, the Communist Party in 1932 reintroduced the concept of differential wages based on merit. This in turn spawned the emergence of a new elite of specialists whose favored position was now defended by the Soviet government. Such people had no need to apologize for their relative prosperity, their education, their aspirations to culture, or the art collections through which they expressed these attainments.

Second, the period of the First Five-Year Plan (1928–32) marked a watershed in official Russian taste. Throughout the 1920s it had been assumed that the

Merchants of Art: Eighty Years of Professional Collecting, 1880–1960 (New York, 1961), p. 172.

new society would eventually forge for itself a new form of art that would become pervasive throughout the land. The debates concerned the nature of that art rather than its impending existence, which all sides accepted as inevitable. As a result, all earlier traditions of painting were somewhat under a cloud, though, to be sure, public taste remained staunchly conservative. The rise of an eclectic Socialist Realism as the one officially sanctioned art had the paradoxical effect of opening the door to the sympathetic reappraisal of many earlier ages in figurative painting, including Russia's own artists of the eighteenth and early nineteenth centuries, and also the masters of Western art beginning with the Renaissance. The reestablishment of virtually all the professors from the Imperial Academy of Arts hastened the acceptance of the classics of the past both in the halls of state museums and in the homes of private collectors.

A further element conducive to Costakis's collecting efforts in the 1930s was the legal position of art collecting as such. Strange as it may seem to Westerners, who are familiar with the massive expropriations of private collections in the early days of Soviet rule, the small collector was actually protected by Soviet law. To be sure, he had to avoid flamboyance and practice discretion, but within those bounds he was free to indulge his acquisitive impulses. This, coupled with the widespread desire to put one's money into goods that would survive currency fluctuations, unleashed a tide of collecting unparalleled in Russia since the turn of the century. "There is nothing which somebody in Moscow was not collecting in the 1930s," Costakis reports, "be it paintings, porcelain, oriental rugs, snuffboxes, drawings, engravings, or crystal. It was an epidemic."

With access to domestic antique shops and the commission stores, George Costakis chose to concentrate on the antiques that were readily available. He did not become a collector of avant-garde art in the 1930s because he scarcely knew of its existence at the time and because of the bewilderingly expansive possibilities that existed in other directions. That abstract art was by then the object of official contempt played no role in his choice of direction.

Costakis began modestly enough. After his porcelain vase depicting Napoleon on a white horse, he added two figurines, which later turned out to be of Meissen ware. Both were purchased from commission stores. Then he added several rare Caucasian carpets, some sixteenth- and seventeenth-century Russian silver, and about forty paintings by Dutch and Flemish artists. By a judicious process of trading and buying, he had by 1939 acquired as large a collection as could possibly be crammed into his new two-room apartment. Anticipating his later practice, he literally covered every inch of his walls with paintings hung all the way to the ceiling, and used the precious space under the beds to store other objects. In all this Costakis was typical of dozens of collectors of the day.

Since the general patterns of postwar art collecting in the Soviet Union were formed in the 1930s, it is worth pausing to consider the practices that prevailed. Then, as in the nineteenth century, most Russian collectors dealt directly with the seller, without either advisers or middlemen. Costakis, with his wide range of contacts, had no need for the services of dealers. He did manage to meet a few unofficial dealers and "arrangers" of the day, among whom Felix Evgenevich Vyshnevsky was certainly preeminent. Costakis first met him in 1935 and found him living in such squalor that "I wanted to give him money for some tea." The son of a wealthy Russian ironmonger, Vyshnevsky used every kopeck remaining from his family's fortune and all his excellent connections to form one of the biggest art collections of the Stalin era. Like most collectors of the time, he was extremely catholic in his taste, accumulating Russian portraits, foreign works, and also imperial treasures. Thanks to his broad knowledge of the field, he was widely esteemed as an unofficial appraiser and middleman in the private art market.

Filip Pavlovich Toskin filled an equally crucial role in the Moscow art market. Toskin's great specialty was

the nineteenth-century Russian sea painter Ivan Konstantinovich Aivazovsky, and his judgments on general questions of attribution, dates, and quality were considered final in the 1930s. His social roots, like Vyshnevsky's, were in the pre-Revolutionary world, and he now held down a minor bureaucratic post in order to give himself freedom to work the art market. With his fur hat and beaver collar, he was universally acclaimed as the archetypal "Moscow baron."

Costakis knew these figures of the art trade but had neither the money nor the inclination to deal through them. Instead, like most collectors, he arranged his own trades and purchases and haunted the commission stores on Stoleshnikov Alley and on the Stretinka. "Since one could walk into the Stoleshnikov shop and buy a fifteenth-century Persian vase for only a few rubles, there was little reason for me to rely on others," he explains.

Costakis's Greek passport also helped him in this period, although it was later to prove a serious liability in his avant-garde collecting. Because of the emergence of Moscow as the new capital, prices on the private art market soared there in the 1930s. Meanwhile, the contents of hundreds of great houses in the former capital, now Leningrad, were coming on the market there, and at much lower prices. With his Greek passport, Costakis was occasionally permitted to travel and avail himself of opportunities outside Moscow.

All Russian collectors in the 1930s were at a severe disadvantage relative to foreigners connected with the embassies, legations, trade missions, and international press corps in Moscow. With their hard currency or rubles, often obtained at foreign banks at a fraction of the official rate, foreigners not only could patronize the antique stores reserved for their use, but could outbid most Russian collectors in the domestic market. Costakis knew many avid diplomat-collectors and stood in awe of their ability to buy out whole stores.

Soviet museums were also buying in the open market, and although their prices could never compete with those offered by private collectors in the 1930s, their mere presence in the market heightened the quest for the exceptionally fine piece. As a result, the collector whose basis of selection centered on the size of the gilt frames was squeezed from the center stage. Conversely, a true connoisseur such as Vyshnevsky rose in importance. Because of his specialized knowledge, he could turn up many canvases that the major museums had missed.

The group of private collectors of which Costakis was a junior member equaled and sometimes surpassed the staffs of the great museums in specialized knowledge. Stepan Petrovich Yaremich had been collecting since before the turn of the century in St. Petersburg, and both he and his collection continued to set a high standard into the 1930s. Andrei Molchanov, who had edited the elegant pre-Revolutionary antiques journal *Antikvar*, also stayed on in the old capital and communicated his refined taste to many younger collectors there. Pavel Ettinger, another pre-Revolutionary collector and art historian, remained active up to his death in 1948. His collection in Moscow included major sketches by Rembrandt and his contemporaries.

The high standards and specialized competence of these older collectors were communicated to a new generation in the 1930s. To be sure, there were innumerable collectors whose primary interest was in using the soaring art prices as a means of building personal fortunes in one of the few forms of collateral which Soviet inheritance law permitted to be passed on to one's heirs. But a few collectors were impelled by other motives too, particularly the ideal of preserving cultural values that were everywhere threatened during the years of Stalin's brutal and capricious rule. Those who owned great paintings often gave them outright to responsible private collectors simply to protect them until the return of better times. It was with this motive that Anna Andreevna Somova-Mikhailova, the daughter of a turn-of-the-century curator at the Hermitage, Andrei Somov, gave many pieces from her father's own

collection of drawings to the Moscow collector and literary critic Ilia Zilbershtein, and that the artist Anna Ostroumova-Lebedeva gave many of her finest pre-Revolutionary works to the collector Alexandr Chegodaev.* Scores of priceless paintings were passed on to private collectors in this fashion for safekeeping. In part George Costakis built up his own collection of works by avant-garde artists through gifts from the artists and their families, and to that extent he perpetuated this tradition, which is well-nigh incomprehensible to many Western critics and observers.

Although George Costakis devoted every bit of his free time to art, his collecting activity remained on the margin of his existence due to other demands placed upon him. First, he had to earn a living. His younger brother, Dmitrii, was training to become a construction engineer in order to take a position in one of the many new factories being built on the fringes of Moscow. George's older brother Nikolai, meanwhile, had followed Spiridon in going to work for the Greek legation, where he stayed until 1939. George remained in his post as chauffeur until 1935, by which time he was not only moderately secure financially but had established himself as a young and knowledgeable collector of antiques and other works of art. The years 1933–35 were a time of relative calm between the grim tragedy of collectivization and the mass purges. The comparative stability of both his personal life and the public environment emboldened the twenty-three-year-old Costakis to put up a vehement resistance when he considered that a colleague at the legation had insulted him. Against the urgings of his family, he addressed himself to the head of the legation, announcing his intention to resign and fully expecting the diplomat to plead with him to stay. Much to Costakis's chagrin, his superior informed him that "If you want to go, you should go!" For the next three years Costakis worked as an automobile and

motorcycle mechanic at the Velozavod service station in Moscow. Harley-Davidsons were his specialty.

Only in 1938 did Costakis return to the Greek legation. By this time he had settled down considerably, and quickly regained the respect of the head of the legation. Costakis would doubtless have stayed on indefinitely had it not been for the pact between Stalin and Hitler that was concluded on August 23, 1939. Within days the Greek diplomats were withdrawn, and Costakis's job disappeared with it. Worse, internment camps swallowed thousands of Greek nationals resident in the U.S.S.R. The departing legation head generously offered to arrange for Costakis and his immediate family to leave the Soviet Union for the United States, where he himself was going. The necessary visas were actually obtained, though Zina and their two children were told that they could not leave with Costakis but could follow him later. Uncertain about the fate of the other members of his family, and deeply attached to the country of his birth, Costakis chose to stay.

No sooner had he made his decision than an opportunity presented itself to him in the person of Hitler's ambassador, Count von der Schulenburg. Costakis had frequently seen the tall bald-headed and mustachioed Schulenburg at the commission stores. Because of their shared interest in antique porcelains, they had struck up an acquaintance. When the Greek legation was closed, Schulenburg, through his chauffeur, offered to give the young collector a position. After consulting with his brother Nikolai, Costakis declined the well-intentioned proposal, convinced that the friendship of Hitler and Stalin would not endure.

With the closing of the Greek legation, Nikolai Costakis accepted an invitation to join the staff of the British embassy, where he stayed until his retirement. George, meanwhile, accepted an invitation from the Swedish government to house-sit for the Finnish embassy, which had been closed with the outbreak of the Soviet-Finnish War in 1939. The arrangement provided Costakis and his family with excellent living quarters in the embassy building near Zubov Square, but it offered no

*Pushkin Museum, *Risunki russkikh i sovetskikh khudozhnikov iz sobraniia prof. A. D. Chegodaeva* (Moscow, 1973), n.p.

the nineteenth-century Russian sea painter Ivan Konstantinovich Aivazovsky, and his judgments on general questions of attribution, dates, and quality were considered final in the 1930s. His social roots, like Vyshnevsky's, were in the pre-Revolutionary world, and he now held down a minor bureaucratic post in order to give himself freedom to work the art market. With his fur hat and beaver collar, he was universally acclaimed as the archetypal "Moscow baron."

Costakis knew these figures of the art trade but had neither the money nor the inclination to deal through them. Instead, like most collectors, he arranged his own trades and purchases and haunted the commission stores on Stoleshnikov Alley and on the Stretinka. "Since one could walk into the Stoleshnikov shop and buy a fifteenth-century Persian vase for only a few rubles, there was little reason for me to rely on others," he explains.

Costakis's Greek passport also helped him in this period, although it was later to prove a serious liability in his avant-garde collecting. Because of the emergence of Moscow as the new capital, prices on the private art market soared there in the 1930s. Meanwhile, the contents of hundreds of great houses in the former capital, now Leningrad, were coming on the market there, and at much lower prices. With his Greek passport, Costakis was occasionally permitted to travel and avail himself of opportunities outside Moscow.

All Russian collectors in the 1930s were at a severe disadvantage relative to foreigners connected with the embassies, legations, trade missions, and international press corps in Moscow. With their hard currency or rubles, often obtained at foreign banks at a fraction of the official rate, foreigners not only could patronize the antique stores reserved for their use, but could outbid most Russian collectors in the domestic market. Costakis knew many avid diplomat-collectors and stood in awe of their ability to buy out whole stores.

Soviet museums were also buying in the open market, and although their prices could never compete with those offered by private collectors in the 1930s, their mere presence in the market heightened the quest for the exceptionally fine piece. As a result, the collector whose basis of selection centered on the size of the gilt frames was squeezed from the center stage. Conversely, a true connoisseur such as Vyshnevsky rose in importance. Because of his specialized knowledge, he could turn up many canvases that the major museums had missed.

The group of private collectors of which Costakis was a junior member equaled and sometimes surpassed the staffs of the great museums in specialized knowledge. Stepan Petrovich Yaremich had been collecting since before the turn of the century in St. Petersburg, and both he and his collection continued to set a high standard into the 1930s. Andrei Molchanov, who had edited the elegant pre-Revolutionary antiques journal *Antikvar*, also stayed on in the old capital and communicated his refined taste to many younger collectors there. Pavel Ettinger, another pre-Revolutionary collector and art historian, remained active up to his death in 1948. His collection in Moscow included major sketches by Rembrandt and his contemporaries.

The high standards and specialized competence of these older collectors were communicated to a new generation in the 1930s. To be sure, there were innumerable collectors whose primary interest was in using the soaring art prices as a means of building personal fortunes in one of the few forms of collateral which Soviet inheritance law permitted to be passed on to one's heirs. But a few collectors were impelled by other motives too, particularly the ideal of preserving cultural values that were everywhere threatened during the years of Stalin's brutal and capricious rule. Those who owned great paintings often gave them outright to responsible private collectors simply to protect them until the return of better times. It was with this motive that Anna Andreevna Somova-Mikhailova, the daughter of a turn-of-the-century curator at the Hermitage, Andrei Somov, gave many pieces from her father's own

collection of drawings to the Moscow collector and literary critic Ilia Zilbershtein, and that the artist Anna Ostroumova-Lebedeva gave many of her finest pre-Revolutionary works to the collector Alexandr Chegodaev.* Scores of priceless paintings were passed on to private collectors in this fashion for safekeeping. In part George Costakis built up his own collection of works by avant-garde artists through gifts from the artists and their families, and to that extent he perpetuated this tradition, which is well-nigh incomprehensible to many Western critics and observers.

Although George Costakis devoted every bit of his free time to art, his collecting activity remained on the margin of his existence due to other demands placed upon him. First, he had to earn a living. His younger brother, Dmitrii, was training to become a construction engineer in order to take a position in one of the many new factories being built on the fringes of Moscow. George's older brother Nikolai, meanwhile, had followed Spiridon in going to work for the Greek legation, where he stayed until 1939. George remained in his post as chauffeur until 1935, by which time he was not only moderately secure financially but had established himself as a young and knowledgeable collector of antiques and other works of art. The years 1933–35 were a time of relative calm between the grim tragedy of collectivization and the mass purges. The comparative stability of both his personal life and the public environment emboldened the twenty-three-year-old Costakis to put up a vehement resistance when he considered that a colleague at the legation had insulted him. Against the urgings of his family, he addressed himself to the head of the legation, announcing his intention to resign and fully expecting the diplomat to plead with him to stay. Much to Costakis's chagrin, his superior informed him that "If you want to go, you should go!" For the next three years Costakis worked as an automobile and

motorcycle mechanic at the Velozavod service station in Moscow. Harley-Davidsons were his specialty.

Only in 1938 did Costakis return to the Greek legation. By this time he had settled down considerably, and quickly regained the respect of the head of the legation. Costakis would doubtless have stayed on indefinitely had it not been for the pact between Stalin and Hitler that was concluded on August 23, 1939. Within days the Greek diplomats were withdrawn, and Costakis's job disappeared with it. Worse, internment camps swallowed thousands of Greek nationals resident in the U.S.S.R. The departing legation head generously offered to arrange for Costakis and his immediate family to leave the Soviet Union for the United States, where he himself was going. The necessary visas were actually obtained, though Zina and their two children were told that they could not leave with Costakis but could follow him later. Uncertain about the fate of the other members of his family, and deeply attached to the country of his birth, Costakis chose to stay.

No sooner had he made his decision than an opportunity presented itself to him in the person of Hitler's ambassador, Count von der Schulenburg. Costakis had frequently seen the tall bald-headed and mustachioed Schulenburg at the commission stores. Because of their shared interest in antique porcelains, they had struck up an acquaintance. When the Greek legation was closed, Schulenburg, through his chauffeur, offered to give the young collector a position. After consulting with his brother Nikolai, Costakis declined the well-intentioned proposal, convinced that the friendship of Hitler and Stalin would not endure.

With the closing of the Greek legation, Nikolai Costakis accepted an invitation to join the staff of the British embassy, where he stayed until his retirement. George, meanwhile, accepted an invitation from the Swedish government to house-sit for the Finnish embassy, which had been closed with the outbreak of the Soviet-Finnish War in 1939. The arrangement provided Costakis and his family with excellent living quarters in the embassy building near Zubov Square, but it offered no

*Pushkin Museum, *Risunki russkikh i sovetskikh khudozhnikov iz sobraniia prof. A. D. Chegodaeva* (Moscow, 1973), n.p.

pay. Instead, the Swedes gave him a diplomatic card, which enabled him to obtain provisions through shops open only to foreigners. With no income, Costakis had to sell off carpets, porcelain, and silver in order to keep the family together. By these means he survived down to the spring of 1943, at which time the diplomatic missions were evacuated as Hitler's army attempted to break through the Kursk salient.

The diplomatic corps was moved back to the capital in August. Just at this time the chief of the Canadian legation, Dana Willgress, was looking for a chauffeur. Costakis applied for the position. As Willgress describes it:

He wanted to know if, in addition to salary, he could receive food rations. When I told him this was impossible, since we had only enough food for ourselves, he proposed that he work for us during regular office hours instead, and offered to find us a suitable chauffeur. I was impressed by his frankness and transparent honesty; I also knew that his brother worked...for the British Embassy. I decided to give him a trial and took him on. Immediately our troubles were over. When any difficulty arose, Costakis would be advised and somehow or other he always found the solution. *

Rising rapidly, Costakis soon found himself with responsibility for hiring Russian staff for the legation, for purchasing food, equipment, and supplies, and for making all practical arrangements of a nondiplomatic character with Soviet agencies. Throughout his years with the Canadians, he worked in tandem with a Canadian administrator to provide for the management and well-being of the embassy. "We were terribly dependent upon him," recalls Canadian diplomat Marshall A. Crowe, in words that are echoed by all those who worked with Costakis over the years.

*Dana Willgress, *Memoirs* (Toronto, 1967), p. 132.

The Canadians' high estimation of Costakis's ability was obviously shared throughout the diplomatic community. In October 1943, when Winston Churchill came to Moscow to attend the Conference of Foreign Ministers, the British embassy asked Willgress if he could attach Costakis to it in order to help with the arrangements for the prime minister's visit. Costakis transferred to the British embassy and made all arrangements for the banquet with which Churchill honored his hosts and fellow conferees. Fortunately, Costakis knew that the necessary silverware and china could be obtained from the suburban Khimki Restaurant, which had wrapped it all away and hidden it in face of the Nazi advance on Moscow two years earlier. The dinner was a success.

For the next thirty-four years George Costakis remained in the employ of the Canadian embassy. During that time he served under five ambassadors and worked with dozens of junior officials. His responsibilities placed him in constant contact with hundreds of persons from other embassies and the foreign community generally, not to mention Soviet officials and agencies. While his art collecting was eventually to surround him with a certain aura of romance, if not mystery, his management of the Canadian embassy earned high praise from all those who respect honesty, steadiness, and directness. These qualities were rewarded in 1967 when Costakis was among the small group of non-Canadian personnel of Canadian embassies abroad who were invited to attend the Montreal Expo in reward for their outstanding service to the Canadian government.

Discovering the Avant-Garde

Thanks to his industry as a collector, George Costakis by 1945 had a range of acquaintances in Moscow's world of buyers and sellers of paintings and fine arts that was

probably unsurpassed by anyone of his generation. His periodic trips to Leningrad and other cities extended that range still further. Notwithstanding the extent of this network, he recalls (with some wonderment), "I had no conception of the avant-garde until after the war, not even a suspicion of its former existence, though members of that movement lived in the same neighborhood with me and we doubtless passed one another on the sidewalk." Given this lack of familiarity, it is the more surprising that by 1947 Costakis was rapidly dispersing his antiques and Old Master paintings and devoting all his formidable energies to acquiring works by Russian abstractionists of the period 1913–23.

What had brought about this reversal? The question bears close examination, for it touches not only on Costakis's motives as a collector but no less directly on the place of art collecting in the history of Soviet culture. The most tempting explanation would be that during the 1930s Costakis managed somehow to familiarize himself with the works of Russia's nineteenth-century Realists, and then with those of its Impressionists and Post-Impressionists. It would thus be inevitable that he—and others as well—would eventually have followed the path to its end and hit upon the abstractionists, and probably have done so earlier had the war not intervened.

In reality, Costakis's interest arose in quite a different way. During the 1930s he paid practically no attention to Russian art of any era and certainly did not collect it. Far from being a natural outgrowth of his previous collecting, then, Costakis's approach to the avant-garde occurred as a result of his alienation from the emerging doctrine of Socialist Realism. The manner in which the Soviet cultural establishment sought to impose the doctrine of Socialist Realism and to deny all legitimacy to other tendencies called forth a contrary desire in many quarters, not least of all in Costakis. The formation of the Costakis collection and the rediscovery of the avant-garde were in some sense direct reactions to the doctrine of Socialist Realism as it was understood between 1934 and the death of Stalin, in 1953.

If a form of heroic realism had existed in Russia since the 1860s and had been rehabilitated when AKhRR was formed, in 1922, the term Socialist Realism was coined only in 1929. By 1934, however, it was enshrined in literature by the First All-Union Congress of Writers of the U.S.S.R. In addition, national congresses in art, architecture, and music were announced for the purpose of adopting the concept in those fields as well. It fell to the "rehabilitated" Igor Grabar (he had been director of the Tretiakov Gallery in the last days of tsardom) to speak for painting at the 1934 Writers' Congress. His speech, very much out of character for a rather retiring and scholarly man, bristled with militancy and intimidating allusions to "total harmony on the visual arts front." In practice this meant that public patronage was denied to all but those artists accepting Socialist Realism. The museums at once fell into line, and refused to acquire works of living artists working in other styles. This is not to say, of course, that modern art fared much better in Western Europe and America during these years. Mondrian, among others, was also suffering from the public's apathy toward his earlier experiments. But in Russia this reversal of taste was far more complete, if only because it was backed by political might.

This policy inevitably affected private collecting as well. We have noted the relative tolerance extended to the more conservative traditions of the past from the Renaissance down to the late nineteenth century. To be sure, the classicizing painters of the turn-of-the-century World of Art circle still enjoyed a certain vogue, and a few works of the somewhat bolder Blue Rose group found their way into private collections. But if the earlier canvases by Mikhail Vrubel and his successors were "safe," their later works were not, and the paintings of the avant-garde were even less so. Indeed, the later works were increasingly forgotten entirely.

George Costakis explains that members of his generation were unaware of Russia's revolutionary avant-garde since even the artists themselves "adopted an attitude of condescension, embarrassment, or outright scorn toward the avant-garde era. . . . [Very often,] the avant-garde works were simply thrown out."

Another factor contributing to the utter obscurity of the avant-garde was fear. A series of *Pravda* articles in 1936 denounced "formalism" and threatened its adherents with dire consequences. Not that the avant-garde artists ceased to exist, of course. El Lissitzky, Stepanova, and Rodchenko all joined the design staff of the journal *The U.S.S.R. in Construction*, and Tatlin found solace in theater design. But the needs of survival dictated that the old innovators seek to become as nearly invisible as possible.

If there was no discernible underground revival of the avant-garde during the 1930s, still less was there in the immediate postwar years. Between 1945 and 1953 it was subject to attacks of unprecedented ferocity. In August and September 1946, the Central Committee issued stern warnings against the dangers of formalism and decadence in drama and film. In August 1947, *Pravda* attacked modern Western painting, especially Picasso and Matisse, though Picasso had joined the French Communist Party only three years before. Later in the same year the All-Union Society for Cultural Relations published ringing attacks on Henry Moore, Jacques Lipchitz, Cézanne, Mondrian, and—significantly—Malevich for their "belligerent anti-Realism, their hostility to objective knowledge and to the truthful portrayal of life through art." These various measures, undertaken during the reign of the cultural boss Andrei Zhdanov, were capped with the establishment of an Academy of Arts of the U.S.S.R. in 1947 and the liquidation of the Museum of Modern Western Art, which housed the former Shchukin and Morozov collections and which had been closed since the start of World War II. Through this period the major official organs attacked

"cosmopolitanism and antipatriotic philistinism" by linking those vices with the names of critics who had evinced sympathy toward experimentation in the arts.*

Just as these somber events were taking place, Costakis was seeking a new focus for his art collection. The reason for this reorientation (in 1945–46) is very much worth examining. The grinding hardship of the war years had forced members of the old and new managerial classes alike to sell off their dearest possessions for food and heat. In Leningrad, where eight hundred thousand people perished during the siege, this situation was particularly acute, and by war's end hundreds of collections—some dating back to the nineteenth century—had been dispersed. By 1946–47 the cream of these collections was appearing on the Moscow market, where it gave rise to a fresh epidemic of collecting fever.

Costakis had also sold off much of his collection. The biggest Moscow collectors, however, had not done so, and were able to pick up where they had left off, enriching their holdings with the best of the new pieces on the market. Costakis had, by this time, really lost interest in the fields that then attracted Moscow's top specialists. Porcelains, Old Master paintings, and rugs no longer intrigued him, and he also knew that he could not expect to find a distinctive place in the unofficial society of collectors if he stayed in these fields. Thus he was prompted to think of new areas in which to continue his collecting.

At this point the standards of taste reflected in works of art fostered by the doctrine of Socialist Realism came into play. Whatever its accomplishments in the didactic sphere, Socialist Realism had obviously managed to

*These events of the years 1945–53 are reviewed and documented in Donald Drew Egbert's "Social Radicalism and the Arts: Russia" (unpublished ms., Princeton, 1971), chap. 5.

purge art of real inventiveness. A flood of wartime posters and satirical prints had established a mood of gloomy earnestness. Somber tones predominated, even in the illustrations for so lively a subject as a translation of *The Canterbury Tales*. This trend, along with the deepening grayness of life in a country where a decade of austerity had been followed by an awesome war, made Costakis—an exuberant and energetic person—unusually susceptible to any art embodying vitality, boldness, and the play of powerful color. One day in an artist's studio he encountered a forgotten abstract painting by Olga Rozanova. Costakis responded spontaneously and wholeheartedly. "Up to this time," he recalls, "I had known only the Cubist paintings of Picasso, and assumed that everything in that vein must be in brown or black. I was dazzled by the flaming colors in this unknown work, so unlike everything I had seen before." Tentatively, almost as a diversion, he began seeking out other such paintings. Within months he was firmly committed to building his new collection around this little-known and despised art.

None of the traditional channels of the Moscow art market was of much use to him in his new quest. Since avant-garde paintings were considered worthless, they rarely if ever turned up in the commission stores. Through the director of a new commission store on the Arbat, Costakis learned of one small Kandinsky oil, a Goncharova, and a Tatlin that were for sale privately, but otherwise he obtained no pieces from these sources. Nor was the network of private collectors of much use. A few masterpieces, such as Malevich's epochal *Portrait of Matiushin* (plate 482), came from collectors, in most cases friends of the artists themselves. Such "finds" were rare exceptions. For the most part, Costakis's new collection was formed by going directly to the surviving artists themselves and to their families and heirs.

It is difficult today to comprehend the strange climate in which his collection was formed. Visiting Rodchenko in his apartment adjoining the former Vkhutemas build-

ings, Costakis found the artist totally skeptical about the value of his own work. It seemed to Costakis that Rodchenko had genuinely, and of his own will, lost all faith and interest in his experiments of 1915–20. Rodchenko's daughter still recalls her father's bemused surprise at Costakis's interest, and his disbelief that anyone might be grateful for the gift of oils and watercolors from the World War I era. Rodchenko's single surviving plywood construction of c. 1920 (plate 1019), now acknowledged to be one of the major extant works of the entire movement, was found dismantled and partly broken in a heap of old newspapers and sketch pads. Had Costakis not discovered it, it is likely that it would ultimately have suffered the same fate as Rodchenko's other constructions of the period—all now lost or destroyed.

It is vain to try to list the number of cases in which Costakis simply arrived too late. The elusive but gifted Leningrad experimenter in analytic art Vsevolod Sulimo-Samuilo was a leading disciple of Pavel Filonov and for that reason was of great interest to Costakis. Many of his paintings from the 1920s had already been lost by the time Costakis contacted Sulimo-Samuilo's widow, the artist Nina Petrovna Neratova. One of his few surviving works was a fragment cut from a huge canvas that had been commissioned by a Leningrad library but then rejected as unacceptable. Costakis bought the fragment—and later learned that Filonov himself had collaborated on the work.

Some artists' disenchantment with their earlier work bordered on bitterness. Costakis's meetings with Vladimir Tatlin frequently occurred on a bench in Petrovsky Park near the Dynamo Stadium. By this point, in the period 1949–52, Tatlin had become introverted and isolated from most of his old friends. His conversation dwelt on his ancient feud with Malevich, by then dead some fifteen years, and he even found fault with his former collaborator Rodchenko. Tired and seemingly bored, Tatlin had good words only for a young contemporary painter named Alexandr Vasilievich Shchipitsyn,

a figurative artist of modest talent whose naïve paintings on primitive themes somehow attracted the master. Tatlin's contemporary and friend Kornelii Zelinsky, whom Costakis located in the Crimea, did not share Tatlin's bitterness, welcomed Costakis's interest in the great sculptor, and even made available to him a graceful fragment of Tatlin's fantastic flying machine, the *Letatlin* (plates 1118–21).

The extent of Costakis's contact with artists of the avant-garde period was by no means a function of the number or quality of works he might acquire from them, or even of his assessment of the importance of their work. For instance, Costakis had only superficial contact with the small, bearded Ivan Kliun before the painter died, though he later came to admire Kliun's work greatly. Conversely, Costakis was a close friend of Robert Falk, though Falk had always been skeptical about the experiments of his avant-garde contemporaries and was openly critical of Kandinsky's abstractions.

By the late 1940s few of the pioneers of Russian abstraction were still living. Kazimir Malevich, Georgii Stenberg, Mikhail Matiushin, Gustav Klucis, Alexandr Drevin, and others had died in the 1930s, while Lissitzky, Filonov, and Mariia Ender all died during the war, as did Kandinsky in France. In order to discover the work of avant-garde artists, therefore, it was necessary for Costakis to seek out the surviving spouses and children. Merely to locate them sometimes required great diligence.

Only occasionally, as in the case of the supremely talented Latvian Klucis, did the widow fully appreciate her husband's achievement — probably because Valentina Kulagina was herself an artist who had always worked closely with her husband. Another exception was the family of the Georgian painter David Kakabadzé, whose works were quietly being collected and preserved in Tbilisi in the hope that a museum in his memory might one day be established there. Similar motives prompted Pavel Filonov's sister to preserve almost his entire *oeuvre* and place much of it in Lenin-

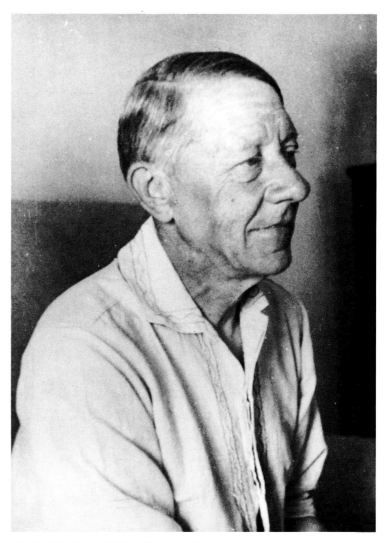

Vladimir Tatlin, c. 1940s. Photographer unknown.

grad's Russian Museum for safekeeping and eventual exhibition.

When Costakis displayed interest in avant-garde painting, it sparked the curiosity of many artists' families. Fully two years after Costakis had met with Nadezhda Udaltsova and discovered that she had destroyed most of her own abstract work out of fear following the arrest of her husband, Alexandr Drevin, their son contacted Costakis to see if he had any interest in Drevin's remaining works. He had found them neglected in a cupboard; Costakis bought several at once. In the ensuing years the heirs came to appreciate their father's achievements and even to discriminate among his paintings, at least partly thanks to Costakis.

Within ten years of his first exposure to works of the Russian avant-garde, George Costakis had amassed the single greatest private collection of their paintings and drawings in existence. Before another decade had passed, curators, collectors, dealers, and art historians throughout the world had come to realize the value of

Gustav Klucis. Date and photographer unknown.

the collection, in both aesthetic and monetary terms. This realization eventually led to a good deal of speculation and rumor concerning the way in which Costakis had assembled his collection, especially in view of the fact that he had only a civil servant's modest salary. A careful examination of the actual circumstances, however, makes clear the fact that Costakis was given a great many works in trust, that he constantly traded in order to improve the range and quality of his collection, and that he also bought hundreds of works, strictly on this very modest salary of a minor civil servant.

The key to Costakis's ability to buy so many paintings merely on his salary was the policy of the Canadian embassy to pay its non-Soviet employees in hard currency (*valiuta*), rather than in overpriced rubles, and then to convert that *valiuta* to rubles at a very favorable rate. The purpose of this policy was to give diplomats sufficient funds to attend cultural events, travel, and enter-

tain friends within the U.S.S.R. After the war this was considered particularly desirable because Canadian-Soviet relations had cooled considerably following a spy scandal involving personnel at the Soviet embassy in Ottawa. Hence, Canada's Moscow embassy established itself as a kind of exchange bank for its Canadian employees, offering not the official rate of ten rubles to the dollar but twenty-five. Because Costakis's passport was Greek rather than Soviet, the policy could be extended to him as well.

Thanks to this boon, which lasted through the years of Costakis's most intensive collecting, he could effectively outbid virtually any Soviet collector, and he did not hesitate to do so. This effort was relatively easy, especially during the early years, because he encountered very little competition for avant-garde art. Thus, in a typical month he could afford about one hundred twenty-five dollars for art after putting aside the money needed to maintain his family. This translated into more than three thousand rubles — a sum far in excess of the entire monthly salary of a typical worker. To have comparable resources in North America today, he would have to be able to set aside more than twenty thousand dollars per month for art. Even this comparison is inaccurate, however, because of the extremely low prices commanded by avant-garde art in Moscow in the 1940s and 1950s. When Costakis began collecting, there was no market for avant-garde art at all; rather it was denounced both by professional critics and by persons prominent in the art world. As a consequence, he found himself in a situation similar to Shchukin's when the earlier collector declared that "Good pictures are cheap."

If Costakis's Greek passport and connection with the Canadian embassy in some respects facilitated his collecting, they were a powerful liability in most others. From the aftermath of the German invasion, Russia endured a period of almost paranoid suspicion of foreigners. The fact that this particular "foreigner" might have been born in Moscow and passed his entire life

there meant nothing. Indeed, Costakis's native fluency in Russian only made matters worse, in light of his alien passport and link with a foreign embassy. People feared foreign contact to a degree that had been unknown even in the 1930s. Costakis recalls Russians who refused outright to see him and others who at first received him hospitably and agreed to sell him paintings but then reversed themselves after learning of his alien nationality. As long as this nativist suspicion persisted, it obviously made Costakis's work as a collector far more difficult.

The Collector's Taste

When Joseph H. Hirshhorn and George Costakis met at the Smithsonian Institution in 1973, the small group of people in their party were struck by their close resemblance to one another. Both are short, black-haired, overweight, and extremely vigorous. They immediately fell into an animated discussion punctuated by four arms waving in the air at once.

Both Costakis and Hirshhorn are completely self-educated in art, and absolutely sure of their opinions. To walk through a museum with Costakis is to experience a rapid-fire series of such pronouncements as "Good," "Bad," or "Derivative." Hirshhorn's biographer quotes him as saying, "I don't ask the advice of anybody." Even less did Costakis, who, unlike Hirshhorn, did not have a curator in his employ.

It is undeniable that Costakis's collection has helped to shape Western conceptions of the Russian avant-garde. Because of this, it is important to appreciate the distinctive tastes and qualities of the man who built that collection. These tastes were formed through direct exposure to the art and through conversations with people who were part of the milieu in which it was created. They were not formed through the study of criticism or of the rich polemical literature produced by the artists themselves. Costakis's confrontation with art has always been direct, spontaneous, and consistently nonverbal.

George Costakis collects avant-garde art because he likes it, and he likes it because through contemplating it, he is made to feel happy and at peace. To this extent he sees art as fulfilling a utilitarian function. Beyond this, however, he is a purist and a believer in *l'art pour l'art*. This bias is reflected in the collection. While it contains representative works of virtually every tendency within the avant-garde from Primitivism to Expressionism, it is definitely thin in its representation of the practical utilitarian objects of the Productivists. To the extent that it includes any such works, they are almost all in the form of the initial design or project, rather than the final artifact.

In other respects, Costakis is surprisingly catholic in his tastes. In his later years he has come to acknowledge that even Socialist Realism, which he had heretofore despised, has produced in certain of its thematic works — portrayals of official meetings, deeds in Stalin's life, etc. — an art that was bound someday to experience a revival, much as Russian *lubki* (woodcut prints) had done. In this, and in his collecting generally, Costakis shows a boldness of judgment to which specialists often respond with as much interest as surprise.

At the heart of Costakis's approach to the Russian avant-garde is his strong emphasis on the complete individuality of each of its members. This individualist bias, both a cause and an effect of his disinterest in their doctrines and collective manifestoes, has done much to transform what was once perceived as a "movement" into a series of highly personal, though obviously interrelated enterprises. Costakis's greatest joy as a collector has been to expand the ranks of artists worthy to be considered pacesetters. He has accomplished this to an impressive degree. When he began, Liubov Popova was virtually unknown. By bringing to light several dozen major canvases by "Liubochka," as he refers to her, he has helped her to win a firm place in the first rank

of the avant-garde. In addition he "discovered" Malevich's friend Ivan Kliun, whom he considers "a far greater experimenter even than Popova." Another figure whose works Costakis has rescued from obscurity is Gustav Klucis. Seeing Klucis's paintings for the first time, some observers have compared him with El Lissitzky, whose travels and activities in the West brought him early recognition. Costakis considers Klucis to have been the greater talent, however, and in fact assigns him a preeminent position in the avant-garde pantheon. Since Costakis's holdings of works by both Kliun and Klucis are unmatched in scope, further publication and study of the collection will make it possible to see to what extent his judgment of them is warranted.

Costakis delights in making extravagant claims for the significance of five virtually unknown artists: the Ukrainian Kliment Redko and the leaders of the Leningrad Zorved (Zorkoe vedanie, or Sharp Vision) group— Boris, Ksenia, Mariia, and Yurii Ender. After training at the school of icon painting at the ancient Kievo-Pechersk Monastery, Redko made his way after the Revolution to Moscow, where he was among the initiators of the Elektroorganizm (Electroorganism) group. His complex work of 1923–25, *Uprising* (plate 1007), is among Costakis's favorite paintings—"a world masterpiece that radiates heat like an oven," in his words. That Redko's highly idiosyncratic work has little resonance in later modern art does not affect Costakis's admiration for him. By contrast, Costakis's high regard for the Enders is increased by his view that they anticipated by half a century the main lines of Color Field painting and Abstract Expressionism in the West. The fact that Boris Ender persisted in his experiments to the end of his life, without yielding to external pressures, clearly adds to his significance in Costakis's eyes.

As his collection grew, Costakis became more scholarly in his approach, seeking to fill gaps wherever possible. He readily acknowledges the numerous areas in which he failed. With the exception of Alexandra Exter, the lively circle of experimenters working in Kiev are scarcely represented in his collection, and such Leningrad giants as Mikhail Matiushin and Ilia Chashnik are represented by only a few works each. There are gaps even among Moscow artists—only two works by Malevich's student Sergei Senkin, for example—but these are far rarer.

Costakis's collection broadened considerably when he began to seek out catalogues, manuscripts, and documentary material. Eventually he accumulated several large trunks full of such archival documents, many of them unique and all of them invaluable to the scholar wishing to gain a fuller understanding of the avant-garde.

When he began collecting, Costakis was more interested in the avant-garde movement as a whole than in any specific artist. But as the individual personalities gradually emerged, he adopted the policy of tracing the major figures through each of their periods, including the post-avant-garde. Hence, the collection includes figurative paintings in the spirit of Derain by Vera Pestel, who became perhaps the first apostate from the avant-garde movement when she denounced Malevich. The later representational studies by Rodchenko, Kudriashev, and Kliun may be inherently less interesting than their earlier work, but their presence in the collection adds immeasurably to its value as a documentary resource. These, along with the later works of such complex figures as Solomon Nikritin (who left behind a large trunk full of manuscripts in cipher), will eventually enable scholars to gain a deeper understanding of the causes of the decline of the avant-garde in Russia. A preliminary perusal of these problematic works suggests that the turn away from abstraction was often the result of complex changes within the artist himself, as well as more obvious external pressures to conform to the new line.

Curiously, Costakis never showed a similar interest in exploring the pre-1913 roots of the Russian avant-garde in Post-Impressionism, Symbolism, and Primitivism. He now regrets this oversight but sees it as inevitable.

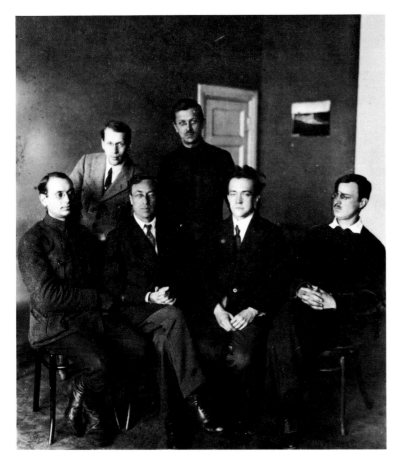

Photograph taken in the State Academy of Artistic Sciences, Moscow, 1921. Left to right: Robert Falk, painter; Shor, violinist; Wassily Kandinsky; Alexandr Shenshin, composer; Petr Uzbensky, physicist; Pavlov, choreographer.

"After all, I was groping my way in uncharted territory. Besides, it turns out that many fine collections of art of Russia's 'silver age' already existed."

Though he worked more by instinct than design, Costakis showed a remarkable capacity to discover and collect precisely those works that most closely embodied his emerging interests and tastes at each phase of his career. His turn to Russian icons clearly reveals the inner logic of his collecting. The link between avant-garde Russian art and the Orthodox Christian icon has often been noted, by the sculptor Naum Gabo among others. The brilliant colors, admired by Matisse, and the nature-defying reverse perspective (according to which remote objects are larger because they are illuminated by lines of vision radiating outward from the eye) recommended these objects of veneration to secular artists of the twentieth century. Avant-garde artists had access to the finest icons because of the work of such late-nineteenth-century collectors as A. M. Postnikov, V. M. Vasnetsov, and especially I. S. Ostroukhov, long a director of the Tretiakov. During the early Revolutionary period the policy of atheism resulted in the wanton destruction of tens of thousands of ancient icons. Though very fine icons were readily available in the 1930s, only foreigners dared collect them. The situation was finally changed by the limited wartime détente with the Church. Beginning with the artist Pavel Korin and followed by others, such as the Bolshoi Opera's director, Nikolai Golovanov, and the Greco-Russian Leningrad enthusiast Fiona, a number of splendid collections were formed. Every one of them, Costakis notes, was the work of a believer, for whom collecting was an act of Christian faith. Costakis bought his first icons in 1940, but did not begin collecting them in earnest until 1948, by which time he had been led to this timeless art by his interest in the avant-garde. Eventually his collection numbered some one hundred twenty pieces, among them some of the finest icons of the fifteenth and sixteenth centuries.

This same intuitive logic informed Costakis's great interest in Moscow's young experimental artists of the late 1950s. Members of the first post-Stalin generation not only revived the tradition of artists' bohemianism that had been dead since the early 1920s, but also undertook to reassess the entire artistic legacy in their efforts to open a path out from Socialist Realism. Beginning in 1953, Costakis made his collection available to all younger artists searching for a usable past. For them his collection was to play a role analogous to that of the Shchukin and Morozov collections for an earlier generation of aspiring modernists.

Among this group were nearly all the Moscow artists who were later to achieve notoriety in the West as dissidents. In the late 1950s, however, they were simply experimenters. Soon after making the acquaintance of this lively group of young painters, Costakis began buying their works. Beginning with the "grandfather" of the circle, the disturbingly original Vasilii Sitnikov, and then branching out to include such divergent talents as Oskar Rabin, Vladimir Weisberg, Ilia Kabakov, Oleg Tselkov, Vladimir Yankelevsky, Vladimir Nimukhin, and about fifteen others, Costakis became one of their principal

supporters. Like many of Russia's nineteenth-century connoisseurs, he had crossed the bridge from collecting to direct patronage.

What particularly attracted Costakis to members of this younger generation was their independence. They were not enslaved by the orthodox styles they had been taught, and some of them, like Kharitonov, were self-trained. And although they studied the old avant-garde, they did not imitate it; they were not "epigones," to use one of Costakis's favorite terms. Instead, they gravitated toward Surrealism as the one idiom capable of expressing the dramatic contradictions in their world. Costakis's own literary tastes had led him in the same direction. His passion for the grotesque in Gogol ("He's an avant-garde writer") and his decided coolness toward the more classical Pushkin suggest that his appreciation for Moscow's young Surrealists was more than visual. This same inclination underlay his interest in the postabstract experiments of the earlier modernists.

Of the several dozen young painters whose work Costakis added to his collection, his favorite is Anatolii Timofeevich Zverev. Born in Moscow in 1931 and a graduate of the Moscow Regional College of Art, Zverev has an Expressionistic gift that has led to startling results, whose importance Costakis recognized at the very start of his career. Another artist whom Costakis esteems highly is Dmitrii Mikhailovich Krasnopevtsev, who developed his weirdly Surrealistic style in private over the quarter century he was employed in advertising.

Costakis was certainly not the only collector patronizing those younger artists searching for an alternative to Socialist Realism. In Leningrad, for example, by the early 1960s there were at least four collectors of comparable inclinations, including the Academician Perfilov, who assembled a rich collection of the works of the younger painter Mikhail Chemiakin. Another collector with similar inclinations was Father Alipii, abbot of the Monastery of the Caves in Pskov, a former cavalry captain and Communist Party member who took monastic vows after the war. Costakis's distinction was not so much in his recognition of talent but in the disinterestedness with which he promoted his young friends. He never missed a chance to bring Zverev's or Krasnopevtsev's works to the attention of visiting foreigners, and he frequently acted as middleman for commissioned works. Mrs. Blair Seaborn, wife of the counselor at the Canadian embassy, recalls being swept into the home of the pianist Sviatislav Richter in order to see several of Krasnopevtsev's most recent canvases. Costakis undertook this mission without any desire for personal gain. "George had absolute faith in these guys," Mrs. Seaborn recalls. By the mid-1960s Costakis distanced himself somewhat from his young protégés, convinced that by then their careers were well underway. But the personal ties endured. When the Costakis family emigrated from the U.S.S.R. in 1978, Dmitrii Krasnopevtsev was among the party at the airport, and in tears.

The Avant-Garde Gains Recognition

In the first years after George Costakis's turn to avant-garde art, he worked almost in complete privacy, drawing as little attention as possible to his collecting. Since he knew full well that abstract art was under an official cloud, he did not publicize the extent of his collection to either Russian or foreign friends, and he did not encourage the curious to visit. Without secretiveness, he proceeded with understandable caution and tact. Nonetheless, even with reasonable carefulness, he experienced various kinds of pressure, particularly during the last two years before Stalin's death, in 1953. Once Stalin was gone, however, the need to shield the collection from public view lessened. In the mid-1950s, Costakis, who had always made efforts to share his collection with others, began to think of the collection as a tribune for the dissemination of knowledge and understanding

about Russian culture in the period 1910–30. Costakis's collection now assumed the character of an educational institution of which he himself was director and professor; he began to conceive of the entire educated public of the U.S.S.R., Western Europe, and North America as a potential audience for this still unknown art.

People meeting George Costakis for the first time are often amazed at the single-mindedness with which he pursues his self-imposed mission. During a visit to New Orleans in 1980 he delivered an impassioned and sustained apologia for Kliment Redko to a loft full of people, many of whom were learning of that artist's existence for the first time. Costakis's advocacy is surprisingly free of egotism. In a century in which collectors threaten to become more important than artists, and in which the biography or autobiography of a Joseph Duveen, J. Paul Getty, or Peggy Guggenheim can approach best-seller status, Costakis focuses his listeners' attention on the artists themselves. To speak of the process by which knowledge of the Russian avant-garde has become widespread in the U.S.S.R. and the West is therefore to speak, at least in part, of Costakis's lifework as he has defined it.

However fervent Costakis's missionary activities after the mid-1950s, obviously they did not take place in a vacuum, or in a world that was totally unreceptive to them. In fact, a host of subtle changes within the U.S.S.R. made it quite reasonable for Costakis to have thought that he was merely keeping in step with Soviet policy as a whole. True, Socialist Realism remained the official doctrine, but various hints of a softening of that policy were already discernible. As early as 1950, Georgii Malenkov, speaking for the Central Committee of the Communist Party, called on art critics to speak out more boldly than they had in the past. This note of moderation after the death of cultural boss Andrei Zhdanov was followed in 1952 by another statement by Malenkov, in which he lauded the virtue of what he called "critical realism." In practice, this meant little more than a reining in of the tendency toward misty-

eyed idealization, but even this was a significant step at the time. Then, on March 5, 1953, the very day of Stalin's death, Malenkov affirmed the principle of "long coexistence and peaceful emulation of two different systems — capitalist and socialist." This, followed by Anastas Mikoyan's October 1953 attack on those who ignored foreign achievements and refused to study them, hinted that the way was open to reassessing Western accomplishments in art as well as other spheres.

This current was reinforced by more practical considerations. A renewed drive for technological innovation gave respectability to the ideal of functionalism in art as well as in engineering. The florid ornamental style that had long prevailed in architecture and design gradually yielded to more austere technological forms. This new emphasis could not help but be reflected in the art world, where such long-forgotten notions as Purism and functionalism were again debated. Without gaining official approval, Constructivism, Productivism, and other movements of the Revolutionary era ceased to be treated as pariahs. This is not to say that all attacks on modernism ceased. In fact, in some areas criticism intensified, but now at least the polemic was part of a two-sided debate. Costakis himself avoided all participation, preferring instead to continue expanding his collection and showing it to a select number of visitors. But he could not help but think that time was on his side.

By 1956 the growing desire for more functionalism in design had combined with the notion of peaceful coexistence with the West to open the way for the beginnings of a general, if tentative, reassessment of modern Western art. In November 1955, three months before the momentous Twentieth Congress of the Communist Party, the Pushkin Museum, in Moscow, presented an exchange exhibition of French art from the fourteenth to the twentieth centuries in which the Impressionists were shown for the first time since the early 1930s. When the same show opened at the Hermitage, in Leningrad, it included a number of early Picassos, as

well as nineteen paintings and seven drawings by Matisse. Thirty-seven other Picassos formerly in the Shchukin collection were sent to an exhibition in Rome as early as 1953. October 1956 witnessed a major Picasso exhibition at the Pushkin Museum in honor of the artist's seventy-fifth birthday. Half the show was drawn from Picasso's own collection in France. In addition other modern artists — admittedly with left-wing sympathies — were shown at this time, among them the Mexican painters David Siqueiros and Diego Rivera.

These initial steps toward reassessing West European modernism anticipated the analogous revival of official interest in Russia's indigenous avant-garde by several years. Meanwhile, however, there were two developments of significance to Costakis's collection. First, in early 1956 Moscow's new generation of experimental artists made its debut with a show that began the process of lifting Stalinist taboos. Costakis had already begun to collect paintings by the young artists, but now his efforts were redoubled. That he was in step with the times rather than in defiance of official policies is evidenced by the fact that even bolder abstract paintings by contemporary West European and American artists were approved for inclusion in the official exhibition at the 1957 World Youth Festival in Moscow; more abstract works by East European artists appeared in the 1958 exhibition "Paintings from the People's Democracies."

The second by-product of the shifts in policy in the mid-1950s was the significant expansion of collectors' interest in the Russian avant-garde. Whereas ten years before Costakis had been the only collector intensively interested in the avant-garde, now several new figures entered the field, many of them under the direct inspiration of Costakis himself. The first to do so was Abram Filipovich Chudnovsky, a professor of physics in Leningrad and for many decades the leading collector of works of such pre-avant-garde Russian painters as Robert Falk. Professor Chudnovsky visited Costakis frequently, took extensive notes on the paintings, and then set out to build his own collection of avant-garde art.

"He began late but succeeded brilliantly; his collection is one hundred percent good," according to Costakis.

Some years later Yakov Evseevich Rubenshtein also began concentrating on the Russian modernists, and with considerable success, particularly with the major names. Rubenshtein, a pensioner, was later to open up his own collection to numerous visitors. Others who followed this policy included Professor Alexandr Miasnikov, director of the Cardiological Institute in Moscow, as well as Professor Dmitrii Sarabianov, Moscow University's distinguished and kindly specialist on Russian art.

As word of Costakis's activities spread among Soviet collectors, interest in the avant-garde spread from Moscow to other cities. The Leningrad film director Solomon Shuster, who had long collected fine antiques, now began to seek out the works of his city's long-forgotten avant-garde. Most of the major new collectors were in regular communication with Costakis and frequently brought major works to his attention.

When Costakis began buying avant-garde paintings, he recalls contemptuous older collectors saying, "Stupid Greek — collecting junk!"

"At that time, I was like a fisherman in a lake full of fish — alone in a boat — while everyone else was looking for meat," he relates. "There was no competition for the fish." By the end of the 1960s an entire network of Russian collectors specializing in the avant-garde had been formed. Prices soared and word began to spread beyond the small community of cognoscenti.

The process by which the Costakis collection and the Russian avant-garde in general gained recognition around the world is a monument to the interest and taste of many amateurs in the visual arts. Most of them were diplomats and journalists, among whom Costakis's collection acquired a unique status as a "must" for prominent visitors to the Soviet capital, almost equal, in its way, to the Hermitage in Leningrad. Undoubtedly, it was the Canadian diplomats who did most for George Costakis. The generous rate of exchange that they extended to him made possible his collection in the first

place. They had maintained him on the staff during the difficult postwar decade, even when Soviet-Canadian relations were so tense that ambassadors were withdrawn. Most important, it was the Canadians who first took an interest in the collection and made it known to other diplomats in Moscow.

As administrator, Costakis maintained an office in the embassy building where the three chief Canadian diplomats also resided. Max Yalden, a second secretary during the late 1950s, recalls frequent coffee breaks and late afternoon drinks with Costakis. To be sure, members of the embassy who did not know Russian and took little interest in Soviet life sometimes viewed this intimacy with skepticism. But the friendships that the informal atmosphere of the small embassy made possible were genuine. As Mrs. Seaborn puts it, "George is a dear friend. We all admire him as a person, his warmth, humanity, and especially his great achievement at self-education." "We have warm and fond memories of George," recalls Albert Hart, counselor to the embassy in the early 1960s, "and we were very dependent upon him; he was absolutely indispensable."

In such surroundings it was natural that his Canadian friends should have taken an interest in Costakis and his art collection. Among the first to do so was Arnold Smith, who had been instrumental in bringing Costakis to Dana Willgress's attention back in 1943 and who returned to Moscow in 1961 as the Canadian ambassador. During his two tours in Moscow, Smith developed a keen interest in Russian art and frequently joined Costakis in visiting young artists in their studios. According to Smith, Costakis's "intelligence, cultural savvy, and his splendid art collection made him an enormous social asset to the Canadian embassy." The late John B. C. Watkins, who served as ambassador from 1951 to 1954, also became a student of Russian art, with Costakis's encouragement. A scholar who had translated Icelandic sagas, an excellent pianist, a gifted linguist, and a bachelor who lived in the embassy, Watkins spent much time with Costakis and they became close friends. Watkins was among the first foreigners to appreciate

the full significance of what Costakis was doing, and he successfully shielded him from problems down to the end of his own tour of duty.

Until the late 1950s Costakis was obviously reluctant to attract too much attention. But in 1959, when the Canadian government suspended its practice of converting rubles at two and one-half times the official rate, and when prices for avant-garde art on the Moscow market began rising so precipitously as to make further large-scale acquisitions virtually impossible, Costakis decided to open his house to visitors. By showing his collection to prominent guests from abroad, he hoped to help legitimize avant-garde art at home.

Unflustered by their anomalous position in the diplomatic world, George and his wife, Zina, accepted invitations from the leading diplomats in Moscow and unhesitatingly reciprocated by inviting ambassadors and heads of legations to their crowded flat. Mrs. Llewellyn Thompson, widow of the American ambassador, recalls an exuberant dinner there, at which formal protocol was thrown to the winds as the diplomats were treated with the best of Russian and Greek hospitality and entertained by their host's gypsy ballads, sung to his own accompaniment on the guitar. Such gatherings continued throughout the rises and falls of Soviet-Western relations, the one exception being in 1960, when the Russians shot down a U.S. U-2 reconnaissance plane and convicted its pilot of spying. At that time Costakis closed his doors for several months, moved the avant-garde paintings to the bedroom, and covered the living room walls with Russian icons.

As word spread, visitors from the world of art began seeking out Costakis's collection. One of the first was Alfred H. Barr, Jr., of the Museum of Modern Art in New York, who paid a visit in 1956 while in Moscow to arrange cultural exchanges. Barr was the ideal person to rediscover Russia's avant-garde for the Western art world, since he had spent the winter of 1927–28 in Moscow and Leningrad and had formed a high regard for such innovators as Rodchenko, Lissitzky, Shterenberg, and Tatlin. Costakis recalls Barr's ecstatic expres-

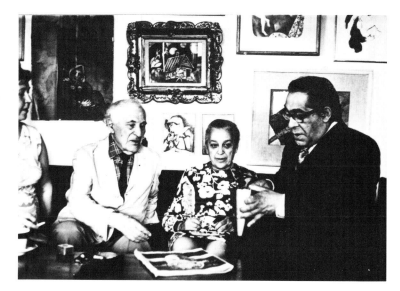

Marc Chagall and his wife, Vava, visiting Zina and George Costakis in Moscow, 1973.

sion as he reacquainted himself with the works of his old friends, and he still expresses his gratitude to Barr for encouraging him to pay particular attention to the achievement of Rodchenko. Costakis also remembers his own disappointment at Barr's difficulty in appreciating the work of such a figure as Kliun, whom he had not met during his 1927 visit.

Shortly after Alfred Barr's visit came those of the directors of London's Tate Gallery, the Louvre, and several of the other leading European museums. Exhibitions were proposed, negotiations conducted with the Ministry of Culture, toasts drunk, and embraces exchanged. Then, just as the excitement was mounting, Camilla Gray published her seminal book, *The Great Experiment: Russian Art 1863–1922*, in 1962. Costakis had opened his collection to the English art historian on several occasions and provided several photographs of lost works in the book. In Europe and America the impact of this publication was enormous: it transformed the arcane interest of a few diplomats and experts into a keen, more widespread curiosity. The reemergence of paintings from the former Shchukin and Morozov collections at the same time gave rise to the intriguing notion that the hidden collections in the Soviet Union were more important than the visible ones.

Visitors to Costakis's collection saw the submerged part of the iceberg. Even though his collection had been formed entirely legally and was maintained with the knowledge of the Soviet authorities, there was just enough public disapproval of abstract art in the Soviet press to lend an element of clandestine excitement to such visits. There was, of course, much sensationalism involved. But this was understandable in light of Westerners' long exclusion under Stalin from direct contact with Soviet cultural life, and their desire during the "thaw" to make contact with an idealized and romanticized sphere of what they saw as "true" Russian culture.

These were some of the events that ignited the explosion of journalistic interest in the Costakis collec-

tion during the 1960s. The wide publicity given to the sentimental journeys to Moscow of Igor Stravinsky in 1961 and Marc Chagall in 1973—both of whom visited Costakis—reinforced the hope that the thread of avant-garde culture that had been dropped in the 1920s might now be rewoven into Soviet life. Nikita Khrushchev's fulminations against abstract art and the various responses from the Soviet intelligentsia added an additional political element to a visit to Costakis. From total obscurity, the Costakis collection was thrust into the category of "big story," the kind of piece through which the ambitious young journalist from abroad could prove that he was *engagé* in Moscow.

The first stories on Costakis and his collection reached West European and American readers in the early 1960s. By 1966 even readers of the *Yukon Daily News* had been introduced to the affable Moscow collector and the art he espoused. "They don't laugh at George anymore," the Yukon paper observed in its headline.* Some stories in the Western press featured visits by Rockefellers or Kennedys to the collection, while others conjured up David and Goliath images to describe Costakis's relations to the Soviet government; others speculated on the likely price of the collection at auction.

Fortunately such lurid accounts were more than offset by thoughtful discussions of the art by veteran Moscow correspondent Hermann Pörzgen in the *Frankfurter Allgemeine Zeitung* (May 1, 1972), by Bruce Chatwin in *The Sunday Times* of London (May 6, 1973),

Yukon Daily News, December 12, 1966.

by Douglas Davis in *Newsweek* (January 20, 1975), by Lya Cardoza in *La Cultura en México* (February 13, 1974), and by both Hedrick Smith and Hilton Kramer in *The New York Times*. Several periodicals published splendid reproductions of major works from the collection; Western students and curators were quick to use these as sources for slides of hundreds of previously unknown paintings.

The massive press coverage abroad was paralleled by an excellent Russian-language article on Costakis published in the American USIA magazine *Amerika* and distributed in the U.S.S.R., and by radio interviews with the collector beamed to the U.S.S.R. by the Voice of America and BBC. By 1975 the educated public in most countries of the European world, including the Soviet Union, had had some exposure to the Russian avant-garde.

For all his eagerness to proselytize the world about the importance of the Russian avant-garde, George Costakis was disquieted by much of this publicity. When *Life* in 1960 juxtaposed a radically avant-garde head of Christ with a soberly realistic, old-fashioned—and in the Soviet Union much-beloved—portrait of Lenin, Costakis was deeply upset. To his Canadian and American friends he explained that such reporting was often provocative and exposed not only himself but all supporters of modern art in the Soviet Union to wrathful outbursts from Russian cultural officials. Costakis believed that avant-garde art of both the Revolutionary era and the contemporary period had made far more progress toward official acceptance than most Western journalists and writers appreciated.

The rehabilitation of the Russian avant-garde within the U.S.S.R., which is not yet complete even today, began in the late 1950s with a series of modest exhibitions in Moscow, Leningrad, and provincial centers. Rodchenko, for example, was shown in 1957, 1961, and 1962 in Moscow; in Leningrad in 1962; in Kostroma in 1970; and in the scientific center at Dubna in 1973. The Maiakovsky Library-Museum in Moscow organized an exhibition of works by Gustav Klucis in 1961 and exhibi-

tions of works by Mikhail Matiushin and Boris Ender at about the same time. Vladimir Tatlin was shown for the first time since the war at the Maiakovsky Library-Museum in 1962, followed by major exhibitions organized by the House of Architects in 1966 and by the Union of Writers of the U.S.S.R. in 1977.* To be sure, these exhibitions were organized by enthusiasts from the fields of literature, architecture, and even physics, rather than by the major museums. The museums were not wholly recalcitrant, however, and in the late 1960s they began slowly to reintroduce avant-garde artists in their shows, usually through individual works drawn from their pre-avant-garde figurative periods. As part of the same trend, articles on individual members of the avant-garde began to appear in the major art journals. Soviet scholars—Dmitrii Sarabianov, Larisa Shadowa, Vladimir Kostin, and Vasilii Rakitin—published a number of essays that were the more significant because each of them dealt with a specific key work or problem and hence whetted the readers' appetite for more. Before the end of the 1960s avant-garde art of the Revolutionary period was appearing in practically every issue of publications such as the Estonian journal *Kunst* (Art). Of course, each step forward intensified the debate, and there were many reversals. But to see only the denunciations and ignore the mounting drive for rehabilitation is to distort the picture.

Convinced that the art in his collection would someday be recognized as a major achievement of Russian culture, Costakis continued to show it at every opportunity. Soviet artists and musicians came in numbers, and some of the bolder writers, such as the poet Evgenii Yevtushenko, declared themselves publicly in favor of abstract art. Museum directors came as well. "When Vasilii Pushkariev of the Russian Museum saw the walls of my apartment, his eyes were like saucers," relates Costakis. Whereas at the start of the Revolution the

*The catalogue for this exhibition, *V. E. Tatlin, 1885–1958* (Moscow, 1977), is particularly noteworthy, in spite of its failure to list certain major Western exhibitions of Tatlin's works.

funds of Commissar Lunacharsky's Purchasing Commission had enabled the Russian Museum to buy a half dozen works each by the artists of this era, these same artists were represented by several dozen works each in the Costakis collection. Leading Soviet museums now attempted to make up for lost ground. But Costakis and other private collectors had outdistanced them, prices were soaring, and it proved almost impossible to catch up.

Other factors were driving up prices of avant-garde art in the internal Soviet market, among them the growth of interest in collecting among members of the U.S.S.R.'s own elite. Vladimir Semenov, a principal Soviet negotiator at the SALT talks in Geneva, was an avid collector of pre-avant-garde paintings by Aristarkh Lentulov, Robert Falk, and Pavel Kuznetsov; with Costakis's help, he succeeded in adding works by Drevin to his collection. Soviet scientists were also extremely active as collectors, and the shows they mounted at the prestigious Kurchatov Institute in Moscow and at the atomic research laboratories at Dubna drew from a number of their own collections, as well as from Costakis's. Whatever the policies of Soviet museums, leading members of the intelligentsia had come out publicly for the avant-garde.

The Ministry of Culture's direct dealings with George Costakis date from 1958, when the Musée National d'Art Moderne in Paris approached the ministry with a request to exhibit the entire Costakis collection. This was not permitted, but the minister, Ekaterina Furtseva, did become keenly interested in the collection. Though she never actually visited Costakis, she went out of her way on several occasions to praise him and his collection to visiting foreign dignitaries. When Fernand Léger's widow, Nadia, came to Moscow in 1975, Furtseva introduced Costakis to her as "the most significant collector in the Soviet Union," and proceeded to speak in detail about the contents of his collection, *which, to be sure, she had never seen*.

Thanks to this degree of patronage, or at least tolerance, Costakis was permitted to send several paintings by Chagall to an exhibition in Hamburg as early as 1959. Small selections were subsequently loaned to the Metropolitan Museum, The Tate Gallery in London, the Los Angeles County Museum of Art, and galleries in Japan, Italy, and Germany. Precisely because the collection as a whole was never permitted to leave the country, the mystique surrounding it grew. Costakis's own travels enhanced this. Between 1956, when he traveled to France to meet the artists Larionov, Goncharova, and Chagall, and 1973, when he carried some of his finest pieces by Tatlin and Rodchenko around a circuit of university campuses and museums in the United States, he made a half-dozen trips to Western Europe and North America. The thousands of people who met him during these expeditions recall his single-minded and tireless propaganda in behalf of the avant-garde. As a result, within a decade and a half after he opened his collection to public view, it had become widely known.

Emigration

The great publicity given to George Costakis and his collection, the increasing prices for avant-garde Russian art in Western Europe and America, and the stream of distinguished visitors to the Costakis apartment could not help but arouse envy in some quarters. This was not an issue among the leading Soviet art collectors of the older generation, whose relations with one another were on the whole cordial. It was different with the smaller collectors who entered the field in the 1960s. Many were tempted to use art to promote their economic or social advancement within the Soviet bourgeoisie. To such people, Costakis's success was perhaps a galling reminder of the comparative modesty of their own efforts. Naturally, there were some among them who inclined to dissipate their envy by denigrating the Costakis collection.

An analogous undercurrent was also perceptible among a small number of Western academics who had

developed an interest in the Russian avant-garde. To some, Costakis's decided opinions on the history or aesthetics of the movement were offensive, since they were not based on conventional art-historical training. That these persons were at the same time dependent upon Costakis for direct access to important works in their own field doubtless added to their professional sensitivity.

Far more serious were rumors regarding Costakis's circumstances vis-à-vis the Soviet government, and the possibility that he was profiteering from his collection. Such rumors probably originated in the effort to explain not only how an administrator in the Canadian embassy could have amassed so valuable an art collection, but also how he could maintain that collection intact over three decades during which the art remained under an official ban.

The question was inevitably raised whether Costakis was perhaps linked closely to the Soviet government and was therefore given special favors. Knowledgeable foreigners resident in Moscow during the period are unanimous in dating these rumors to the early 1950s. In those days, it was generally assumed that *any* Russian or "local" employee of a foreign embassy in Moscow would be interviewed regularly by Soviet intelligence officers. It would not have been exceptional — so the argument runs — for Costakis, as a lifelong resident of Russia, to have been interviewed in this way, just as his Canadian superiors and foreign visitors could have been asked by their country's security personnel to communicate information about their Moscow contacts.

Yet even those who speculate about such possibilities admit that Costakis's Greek passport and his family's well-established tradition of strictly professional dealings with their employers at foreign embassies would have kept him far freer of such pressures than anyone else in his position. Moreover all the Canadian professional diplomats with whom he maintained close ties over many years emphatically rule out the possibility of Costakis's collusion with the Soviet government. "Besides," recalls Marshall A. Crowe, who had two tours of duty in the Canadian embassy, "no one in George's position could possibly have had access to any classified information. The strictest division between diplomatic and local administrative functions is always observed at our embassies. The rumor is as insulting to Canada as it is to Costakis himself."

There are two reasons for the charge of profiteering through sales abroad of paintings: a general ignorance of the Canadian embassy's policy of exchanging currency at more than twice the normal rate, and the refusal to believe how negligible were the prices that Costakis originally paid for most of his paintings. Lacking this knowledge, a few people jumped to the conclusion that Costakis could have financed his collection only by the clandestine sale of scores of paintings to foreigners at inflated prices. In fact, Costakis *did* arrange for the sale — at modest prices — of many paintings by the younger Moscow artists whom he was promoting, even as he was also buying some of their own work for himself. Beyond that, he occasionally mediated the sale of a few avant-garde paintings to foreign friends resident in Moscow. These occurrences were very rare, however, and the extremely low prices gave these arrangements more the character of a gift. In a few cases these same works were later sold by the new owners at high prices in the West, but usually without Costakis's knowledge and certainly without any gain to him.

The announcement by Sotheby's in 1967 that it would offer a few pieces for sale from Costakis's holdings touched off a flurry of rumors that either he or, according to some journalists, the Soviet government was about to auction off the entire collection to the highest bidder. Actually Costakis had arranged the sale with the consent of Ekaterina Furtseva, minister of culture of the U.S.S.R., for the purpose of providing a legacy for his four children. In 1973, when Costakis visited the United States and spoke at Princeton University and the Guggenheim Museum, such speculation was renewed. The conjectural sale never materialized, but rumors of Costakis's and the ministry's purportedly venal inten-

tions by now had a life of their own, defying the fact that Costakis had anonymously donated some fine works to museums in the West. Costakis himself declared publicly during his 1973 visit that the ministry was going to permit him to send three hundred canvases abroad for exhibition, and this announcement only made matters worse. Inspired by this hope, the Kennedy Center in Washington announced its intention to show the entire collection at the opening of its next season. When plans for the show collapsed, a fresh crop of rumors sprang up.

Meanwhile, the Costakis collection was being treated with even greater suspicion in the U.S.S.R. As members of the younger group of Muscovite artists moved from bohemianism to open dissent, Costakis distanced himself from them. He did not share many of the views of their generation, nor would he have risked danger to his collection under any circumstances. Some of the artists became openly critical of his "conservatism." Worse, a few of them now charged Costakis with having used his purported "official" connections to exert pressure on persons from whom he had wished to acquire avant-garde works. Not realizing the actual circumstances in which his collection had been formed and convinced from their own experience of the pervasiveness of police power in the U.S.S.R., they spread this rumor at precisely the time that Costakis was being attacked from a very different quarter. Nationalistic Russians, ignorant of the fact that Costakis had saved hundreds of works of art from neglect and even destruction, charged him with pilfering their national heritage. As an anonymous visitor to his collection expressed it in the visitors' book: "Why is this Greek allowed to steal our culture?"

Nothing better illustrates Costakis's position in the eyes of Soviet officialdom than the attitude of the major museums toward his collection. On the one hand, the minister of culture has, on several occasions, spoken warmly of his collection to foreign guests. Directors and curators have accepted Costakis's hospitality and even to some extent redirected their acquisitions in the light of his collection. On the other hand, the complex ideological and political issues posed by nonobjective art still made it impossible for them to allow works from his collection to be shown in their museums.

There may also have been an element of snobbism involved. It was one thing to permit A. A. Sidorov to publish his *Zapiski sobiratelia* (Memoirs of a Collector; Leningrad, 1969), or Ilia Zilbershtein to write his reminiscences and thoughts on collecting for a volume (issued in 1973 by the Pushkin Museum) on his West European drawings and paintings. Sidorov, after all, was a corresponding member of the Academy of Sciences, and Zilbershtein was a widely published critic. Even had Costakis's avant-garde art been fully acceptable, his lack of formal education and his modest post as administrator in a foreign embassy might have worked to disqualify his collection from consideration for a special showing or publication. This neglect stung Costakis, the more so because he knew that, as Sir Norman Reid put it in his introduction to Costakis's 1973 lecture at The Tate Gallery, "If George Costakis had done for Great Britain what he has done for the Soviet Union, he would now be Sir George."

It must also be admitted that Costakis sometimes bargained with the Soviet museums. For example, when the director of the Tretiakov proposed to purchase Kandinsky's Murnau landscape from Costakis for ten thousand rubles, Costakis countered with an offer to donate the painting to the museum if the director would agree to show it immediately. The director refused. Even Costakis's gift to the Pushkin Museum of a major canvas by Kees van Dongen had a touch of the Duveen style. Some years before, when the painting had come up for sale in the private market, Costakis had outbid the Pushkin with twelve thousand rubles against the museum's offer of eight thousand. That he then offered it as a gift was perhaps too vivid a reminder to the curators of the limits of their own power.

The soaring interest in avant-garde art within the Soviet Union in the 1970s placed all private collections under constant danger of theft. The inevitable occurred

George Costakis. *Russian Village*. 1979. Oil on canvas.

George Costakis. *Island of Rhodes*. 1979. Oil on canvas.

in 1974 when, within the span of a few weeks, thieves broke into the Costakis apartment and into the home of Professor Chudnovsky in Leningrad. In 1976 the thief or thieves struck again, this time scooping up hundreds of watercolors and drawings by Kliun, Popova, Ender, and even Kandinsky. Many of these have since turned up for sale abroad, in various places. Scarcely a month elapsed after the second robbery when Costakis's suburban dacha at Bakovka was also the target of thieves. As in the earlier thefts, large folders full of drawings and watercolors were stolen, as well as major icons. The dacha was burned to the ground, apparently deliberately, and thus one of the largest and most select collections of paintings by experimental artists of the 1950s was destroyed.

Until these misfortunes, Costakis had had no intention of leaving the U.S.S.R. Now, with part of his collection burned and another part stolen, and with friends in several Western countries inviting him to take up residence there, he reluctantly decided to emigrate. Of the fate of the majority of the paintings in his collection there could be no question: he had long since adopted Shchukin's motto that "The pictures belong in Russia." What was not clear was whether the Soviet government would authorize him to take a small portion of the collection with him, partly for his own enjoyment, partly to help Western scholars, students, and art lovers to understand and appreciate the art of the avant-garde, and partly, through some limited sales, to enable him to provide a source of income for himself in retirement with his extensive family. These matters were resolved

through negotiations in 1977, resulting in the bizarre episode described at the beginning of this essay. In addition to permitting Costakis to leave with part of the collection, the Soviet authorities also gave assurances that they would place on public view major paintings from among those remaining in the U.S.S.R., and acknowledge Costakis's generous bequest in shows and catalogues in which pieces from his collection were exhibited.

Finally, Costakis, his wife, and three of his four children bade farewell to their Moscow friends and boarded an Aeroflot jet for Rome. They spent several months there and Costakis took up painting. With characteristic speed and intensity he began turning out a canvas a day in an engagingly individualistic Primitivist style with no trace of the influence of the avant-garde art that had surrounded him for thirty years. The family eventually settled in a comfortable Byzantine-style villa on the ancient hills above Kifisia, a suburb of Athens. There George Costakis continues to paint, receive his friends, write a detailed memoir of his life, and enjoy those avant-garde paintings that he still retains from his former collection.

Tulane University, New Orleans, Louisiana

COLLECTING ART OF THE AVANT-GARDE

BY GEORGE COSTAKIS

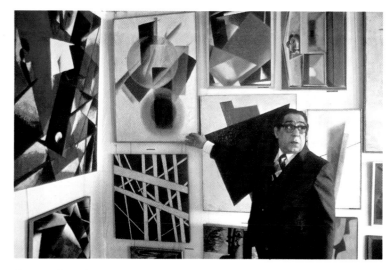

George Costakis in his apartment in Moscow, 1973.

I **began to collect** art in the 1930s. In the early years I collected Western Old Masters, Russian silver, rugs, and antique fabrics, very beautiful, very rich to the eye and the hand. But after about ten years I found that I had begun to tire of these things. My paintings by masters such as Teniers, Berchem, and Kalf gradually faded in my mind to a gray-brown blur; the walls of my apartment looked drab, despite these many canvases with their ornate gilt frames. I felt that I was getting richer in my pocket but not richer in my heart.

Then, shortly after the end of the Second World War, by accident, I encountered some avant-garde art. The painting I saw first (plate 1067) was done in 1917, yet it might easily have been a revolutionary work of about 1950. Indeed it might almost have been mistaken for a canvas by Barnett Newman, who, to be sure, had no knowledge of its existence. Olga Rozanova was the artist, and she had died in 1918. It was her work that opened my eyes to the existence and compelling power of the avant-garde.

When I put avant-garde works next to my Old Masters, the dark windows seemed to be opened wide and the sun came in. The avant-garde works pulsed with unusual forms, sound, and movement; I was struck by their variety and daring. Later I began to notice their healing powers; they could restore spiritual strength and even lift a person out of depression. There seemed to be no repetition in these works. In each creative period of this or that artist, I felt a drive to express something new.

A second factor that led me to abandon my Old Masters was the realization that with them I would be unable to bring anything new to the history of collecting. The Louvre, the Hermitage, and hundreds of other museums and private collections had preceded me; in this company of grand ocean liners, I would be left to float in my own little skiff. I had to find my own craft in which to fish and sail.

During the first ten years of my attempt to collect avant-garde art I was confronted by very powerful obstacles: it was difficult to find the works themselves and no less difficult to convince the people who owned them that I was serious about wanting to buy them. Many people, including the artists themselves or their surviving relatives, had grave doubts about the validity of these works. They had to a large extent lost confidence in the achievements of the era.

There were times when I too began to doubt that I had chosen the right path; it seemed as though I were challenging everyone else's good judgment. The low value of the pictures, the absence of the usual gilt frames, the total disregard of Moscow collectors, the critical comments of my friends (who thought it a great error to part with my strong collection for the sake of the dubious avant-garde)—all this made me feel somewhat like the captain of a sinking ship. All my Kalfs and Tenierses, together with all my antiquarian art, had been lost. Had I made a terrible mistake?

The Avant-Garde in Pre-Revolutionary Russia

Few people realized in 1947 that the avant-garde was not really dead; it had merely fallen into a deep sleep. The reasons for this temporary oblivion lay in the early years of this century, before the Revolution, when these innovative artists were just beginning their careers.

In 1913 two giants, Vladimir Tatlin and Kazimir Malevich, began to define a course of independence for the Russian avant-garde, breaking with traditional and Expressionist European art and with Paris Cubism. In

St. Petersburg and Moscow the avant-garde burst upon the scene everywhere, but during the following two or three years — despite exhibitions that were often free, generous press coverage, artists' cooperative organizations, manifestoes, and catalogues — the movement won no critical acclaim. Exhibitions were hooted down with hostility, reviews were crushing. In a December 1915 issue of *Day*, a Petrograd newspaper, B. Lopatin wrote a review, hitherto unpublished in English, of "The Last Futurist Exhibition of Pictures: 0.10," which he entitled "Futurism-Suprematism":

I was preparing to review an art exhibition when N. E. Dobychina walked into the office; when she left I was sitting down to write an obituary. Futurism is gone; Suprematism has arrived. I had never been an ardent supporter of Futuristic eccentricities, but I felt sorry for the deceased. Its daring gave birth to Suprematism while its honesty was a snicker at the public's perception of it. Not a trace remained of its painting. Nothing but tin!

The Futurists painted in colors — and with brushes. The Suprematists create — if I am expressing myself correctly — in tin, nails, cardboard. Color with them is incidental. I miss good old Futurism. You could walk among their works at exhibitions and watch unfettered artists give rein to their instincts for color. Real art may be sensed glimmering unexpectedly in the corners of their canvases. Not so with the Suprematists. Everything is dry and monotonous, without art and without individuality. Malevich is like Popova, Popova like Puni, Puni like Udaltsova, and one cannot tell one from another. Unless I am mistaken, Puni's most successful picture is The Man in the Bowler Hat, *which consists essentially of a table fork stuck to a piece of cardboard and a pocket ruler hung on a nail.*

The ideology of this exhibition is best expressed by a manifesto by Puni and Boguslavskaia, distributed free to lovers of art: "A picture is a new conception of abstracted real elements stripped of meaning. The object /the world/, freed from meaning, collapses into the real basic elements of art." Having thus unburdened themselves, the Suprematists proceed to sketch in a simplified manner and in total disorder anything that may pop into their heads: a lamp; the silhouette of an umbrella; the face of a clock; a row of red, green, and gray disks; half of a frock coat; unclear intersections of something or other; fragments of inscriptions. Then they hammer nails into cardboard, or bent pieces of tin, painted or unpainted, along with wooden plankings, ladies' buttons, newspaper clippings, bricks, and so on.

The captions under these creations read: Artistic Masses in Movement, A Salver and Concrete, Window Washing, A Communications Student, My Portrait, Folded Gambit, Landscape Rushing By, *and so forth. You can switch the captions around and nothing will change.*

This is a complete description of the exhibit.

I miss merry old Futurism. The funniest, absurdest colors are gayer than newspaper clippings, pieces of tin, and wire denuded of meaning.

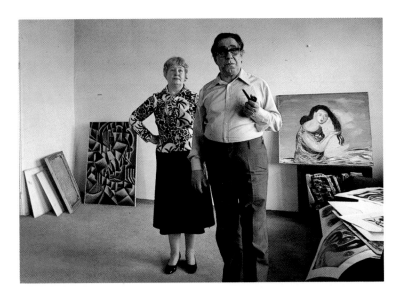

Zina and George Costakis in their apartment, 1977. Left: *Landscape* by Popova (upside down), right: *Woman with Long Hair* by Drevin.

I dip my pen into mourning-black ink and on Catalogue No. 0.10 *I write: "Futurism — rest in peace!"*

The *Petrograd Bulletin* took a similar tone:

A Futurist Exhibition
Last year a warmhearted company of unknown "celebrities" set up an ambush-exhibition they called "Tramway." A great many people fell for the bait of these Futurists (?!), and the price they paid was their fifty-kopeck pieces.

Last year's experiment apparently pleased this warmhearted company; they have "dipped their nets" again, this time with the exhibition "0.10," hoping to catch a few more fifty-kopeck pieces (the entrance fee).

This year's exhibition (?) differs in no respect from last year's: we see the same formless daubings, the same cardboard-and-tin top hats, the cones and the bricks hammered onto boards and given the same unexpected appellations in the catalogue: Portrait of Uncle, A Street, The Synthesis of Beauty, The Suffering of Skyblue Joy, The Suprematism of Art, *and so on. In general, this exhibition is not the delirium of sick children; it is, rather, the mincing and grimacing of street hawkers trying to fleece the public of the change in its pocket.*

An exhibition of the Jack of Diamonds group in Moscow evoked this outcry in the *Russian Word* of November 8, 1916:

And the exhibition had its curiosities. Malevich and Kliun contributed a number of examples of "nonobjective art," which they bombastically dubbed "the Suprematism of art."

A row of colored geometric figures, some crude daubings alternating with lines that exhaust the eyes — these are the fruits of "nonobjective art." Messieurs Malevich and Kliun cannot be taken seriously, nor can the numerous canvases of D. Burliuk, who is addicted to the "philosophical" drawings of incomprehensible panels.

Mr. Burliuk, however, has appended to his pictures some explanatory notes for those who have a desire for such.

Unfortunately these artists have pretty well overloaded the exhibition with their pretentious compositions.

In February 1916 Tatlin organized an exhibition in Moscow that drew another barrage of devastating reviews.

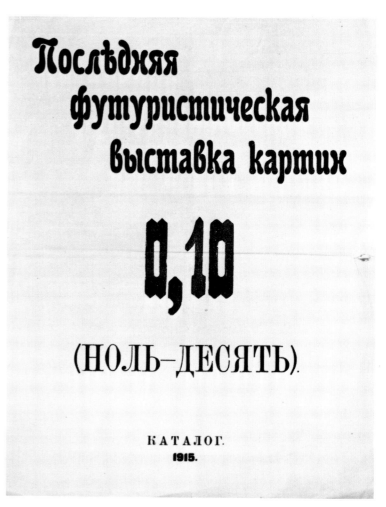

Cover of the catalogue for "The Last Futurist Exhibition of Pictures: 0.10," 1915.

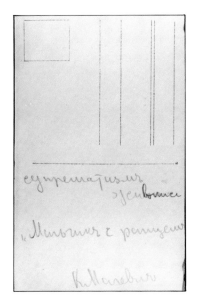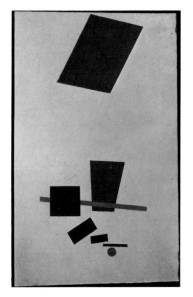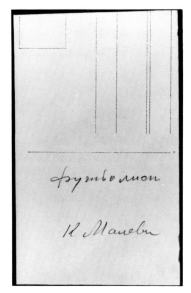

A postcard reproducing *Boy with Knapsack* by Kazimir Malevich. This composition is visible in installation photographs of the ''0.10'' exhibition. On the reverse of the postcard, in pencil: ''Suprematist Composition 'Boy with a Knapsack' K. Malevich.'' Malevich himself probably did not write this, but since this postcard (and the one at right) were given to Costakis by the widow of V. D. Bobrov, who had acquired them during the Inkhuk years, their inscriptions are surely contemporary. The inscription in this instance provides the only evidence hitherto located for the identification of this work with the title in the ''0.10'' catalogue: ''No. 41. Painterly realism boy with knapsack—color masses of the 4th dimension.''

A postcard reproducing *Football Player* by Kazimir Malevich. Like the preceding one, this composition is visible in installation photographs of the ''0.10'' exhibition. On the reverse of the postcard in pencil: ''Football player K. Malevich.'' No. 40 in the exhibition catalogue is ''Painterly realism football player—color masses of the 4th dimension.'' The painting is now in the collection of the Stedelijk Museum, Amsterdam.

This one appeared in *Early Morning*, March 26, 1916:

The Futurist exhibition "Store" will hardly arouse real interest in Futurism. If the Petrograd Futurists named their exhibitions "Tramway V" and "0.10" out of sheer mischief, the Moscow exhibition is called "Store" simply because it is being held in a hall set up like a store.

The Moscow public, which has seen everything and has been treated to every kind of exhibition, is indifferent to the Futurists' showing.

As before, there are "pictures" hanging on the walls adorned with spoons, thermometers....

On one of the pictures with a wooden spoon there is written: "I, an apostle of new conceptions in art and a surgeon of reason, have seated myself on the throne of creative pride, and hereby announce that the academy is a philistine stable." The public reads this illiterate proclamation with indifference, and studies the works of this "surgeon of reason" (who has marked his forehead with a badge) with similar indifference. Over the picture is placed the caption: A Partial Eclipse.

Almost no one has remained from the old group of Futurists. Five or six new figures have made their appearance; they have repudiated the old group and create new "nonobjective art." It is not worth my time to

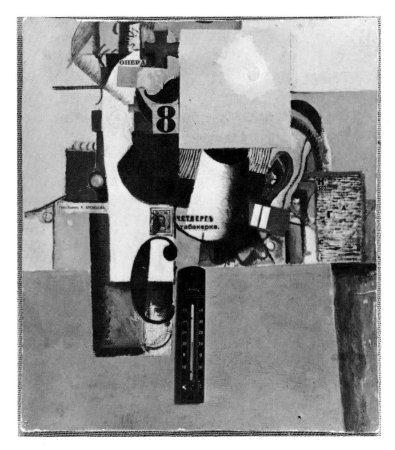

Photograph of *Warrior of the First Division* (1914) by Kazimir Malevich, given to George Costakis by the widow of V. D. Bobrov, who had acquired it during the Inkhuk years. The painting now belongs to the Museum of Modern Art, New York. Although not listed in the catalogue of ''The Store'' exhibition, the painting may have been shown there.

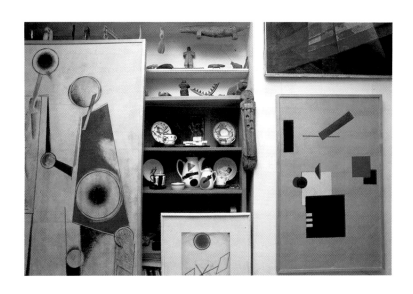

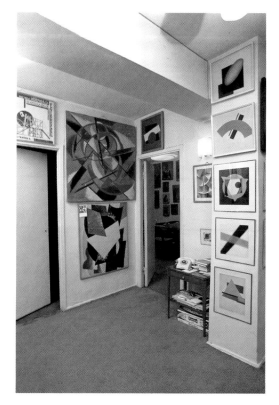

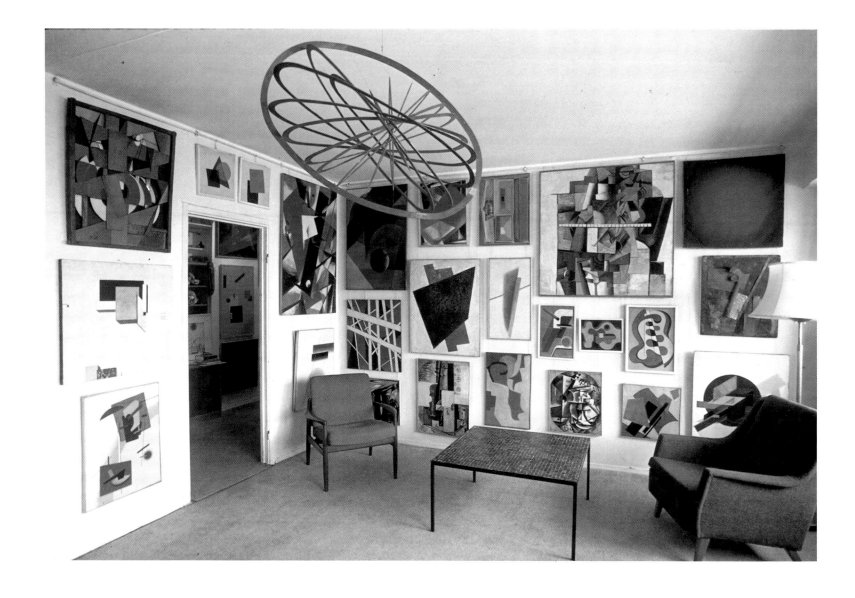

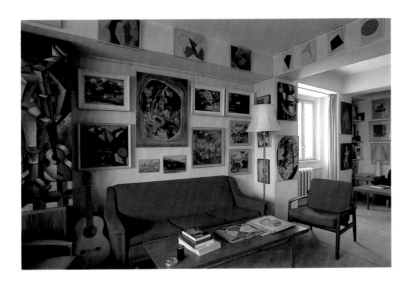

The Costakis apartment, Moscow, 1973.

give their names; they have only one end in mind — to make as big a sensation as possible.

But among the Futurists there are a few sincere fanatics, for example, V. E. Tatlin, M. Vasilieva, and A. Exter.

They have stumbled into a cul-de-sac, not knowing that they renounced art long ago. What they are doing is perhaps essential to them. Their works produce absolutely no impression on the viewer as they are beyond human perception. They are a zero in art.

Herein lies the tragedy not only of individual members of this school but of Futurism itself, which is doomed to extinction.

The same exhibition reviewed in the Russian News, March 29, 1916:

Young artists, as before, in the grip of a senile and conservative stubbornness, are cultivating the beauty of machines, cones, and cylinders and wasting their powers building armored reliefs and arrogant self-portraits; in cross section the heads of these portraits are crammed with a storehouse of iron!

May we not say honestly that this "Futurism" is now boring, outmoded, passé, evoking in the viewer only pity?…

A few reviews such as this went a long way. Even the artist who is a fearless innovator in his studio may feel intimidated when he faces the relentless ridicule of the critics. A wife or husband chides: "You are making a fool of yourself. People are laughing at you — and at me!" After these early episodes, many an artist never dared to take a risk again.

Many people believe that the avant-garde artists in Russia were despised only by the Bolsheviks. But in fact these artists were neglected and scorned (as was also often the case in the West) before the Revolution, as well as after.

The artists themselves were often their own worst enemies. Sour relationships and competition among them led frequently to severe attacks on the worth of this one's new work or that one's originality. Although Malevich himself thought highly of some of the artists who had left his Suprematist circle (such as Gustav Klucis), many in the circle considered Klucis and others to be only imitators. In addition, even Malevich himself was often biased in his relations with his colleagues, and he conducted a heated debate with his close friend Ivan Kliun, who had abandoned Suprematism. Kliun eventually sought to dissolve opaque color into a translucent veil, in order to permit the interaction of color and form. By contrast, Malevich at this time was removing all color from his compositions. Meanwhile, the other towering figure of the avant-garde, Vladimir Tatlin, who had no pupils, was skeptical of all contemporary Russian artists — except for Alexandr Rodchenko.

The Avant-Garde in Revolutionary Russia

In those days when patronage had already been flourishing under the Shchukins and the Morozovs, who had fattened their collections with French canvases, Russian avant-garde artists managed to sell only an occasional picture. This continued until 1917. The February Revolution produced a period of introspection and vacillation for artists: some tended toward the right, others toward the left. But later, the October (Bolshevik) Revo-

Varvara Stepanova (left) and Liubov Popova, c. 1922–23. Photograph by Alexandr Rodchenko.

lution united nearly all of them; they trusted in it as their only hope, and they assumed it would be receptive to them. "Who will the new regime recognize as artists if not us?" The new artists were correct — they were precisely attuned to the spirit of the times. Leaving the despised bourgeois culture, they hoped to be embraced by the culture of the proletariat. And, at first, the authorities went quite far: they opened the doors of the sanctum sanctorum, permitting the artists to decorate Red Square and to participate in formal celebrations all over the nation. This receptive spirit lasted for several years, but during the "golden age" the artists were actually as misunderstood as before the Revolution, and they were often simply used as tools of the regime. The authorities condoned and supported them. There was even a short-lived interest on the part of the museums, which began to acquire examples of the work of many artists — works which would soon be stored in the cellars. Paradoxically, in this way the government saved many works of the avant-garde. Even if this art was not displayed, it was nonetheless protected from the elements, and once a work was assigned an accession number, no bureaucrat would destroy it.

The art of the avant-garde was, however, not generally understood. In some people it provoked shock, in others hatred; the protests against it often verged on personal insult.

Faced with such abuse or, worse, neglect, artists began — or continued — to doubt themselves, and their energy began to flag. In 1916, Vera Efimova Pestel, the first apostate, announced that she was breaking with nonobjective art because she was convinced that the people would never accept what the avant-garde had created. Other artists also were persuaded that they had taken the wrong course, and some even destroyed their work.

In the "calm" period from 1917 to 1920 artists labored as they could, without apparent government pressure. After that, as official attitudes began to shift, the artists were steered toward the creation of more "useful"

objects. Malevich made his final entry in the ledgers of Suprematism, and then returned to figurative art. His former pupil Nadezhda Udaltsova followed his example. Vladimir Tatlin abandoned his reliefs. In 1922 Liubov Popova completed her last "spatial force" constructions and then designed the stage sets for *The Magnanimous Cuckold* (1922) and *Earth in Turmoil* (1923).

Even before this, once the first hope and enthusiasm of the Revolution had begun to dissipate, a lack of solidarity began to develop among members of the avant-garde. Conflict among the professors at Vkhutemas* was one of several events that made it easier for the authorities to nudge avant-garde artists onto a more "approved" course. Little by little, and without any exceptional pressure, the authorities began to advise artists to use their "little cubes and squares" for utilitarian ends in the service of the people. Worn and disheartened by years of uncertainty and lack of recognition, the artists welcomed an outlet for their creative energy in utilitarian art. Stepanova and Popova, for example, had begun to do textile designs. When Popova's fabrics were put on display in a shop in a factory district, the longest line was to be found at the counter displaying her designs, as opposed to those with the standard, traditional fabrics. Popova was overjoyed. She told her friends how much it meant to her to have won the approval of these simple, untutored women.

Some artists, however, including Kudriashev and Kliun, persisted in doing abstractions long after 1920,

*For an explanation of acronyms and other special terms, see the Notes for the Reader, p. 10. — Ed.

though in the late twenties and early thirties Kliun's style became close to the Paris Purism of Ozenfant and Le Corbusier (plates 216–17, 223–25, and 231). In the 1930s he developed a new organic abstract style which is still little known (plates 226–28). During the thirties and beyond, Pavel Filonov and Boris Ender continued to work in their individual styles. The early spirit was still warm in the posters of Klucis, Dolgorukov, Rodchenko, and the Stenbergs. If we add to this list the names of the architects Leonidov, Melnikov, Ginzburg, Vesnin, and others who founded or continued new traditions, it is clear that up to 1930 the avant-garde sun had not yet been completely obscured; its rays were still reflected here and there. Even beyond 1930, avant-garde works by these artists were still being shown. The last exhibition that included Malevich, Kliun, Suetin, and others of the Suprematist circle was in fact held as late as 1932–34 in Leningrad and Moscow. As described by Kliun in an unpublished 1938 article, the "abstract and Suprematist works" were hung in a small dark passageway in the Historical Museum in Moscow; but the fact remains that these works were still shown, even as late as 1934.

In view of all these contradictory events, it is no mistake to describe the slow death of the avant-garde as being both artificial and natural. The "natural" death of the avant-garde in Russia parallels its fate in other countries where it was also frequently neglected or misunderstood. But the one great difference was that in the West artists were not finally subjected to government persecution, were not herded into jails or physically liquidated. Rather, the avant-garde was often simply not noticed.

Paul Mansurov, who had emigrated to Paris, was living almost like a beggar, in penury. Sonia Delaunay was looking after him. In her garage there were about twelve or fifteen works by Mansurov, which he had exported from Russia — small, mostly on panel, in bad condition. When I met him, in 1956, he explained that the ideas that stirred Russian artists left French artists and art lovers indifferent.

Goncharova and Larionov, whom I met in France at that time, also complained about the French. "They don't understand us.... They don't buy anything."

One wonders how it could come to pass that the West, which hosted so many avant-garde exhibitions, did not pay due attention to the works of the Russian avant-garde and failed to acquire them for museums. Nobody — in the East or in the West — gave Malevich his due. I myself paid only the three thousand rubles (three hundred dollars) asked of me for Malevich's *Portrait of Matiushin* (plate 482). Today this picture (now in the Tretiakov Gallery) would probably be valued at more than a million dollars. I should add that I bought it more than twenty years ago from a close friend of Malevich, who thought that Malevich was a superb artist but also that there was no chance that his genius would be recognized. The avant-garde had lost hope, just as others lost hope with the coming of the Bolsheviks that tsarist money would ever be redeemable. At least they could use the banknotes for decoration and card games. The incident with the Matiushin portrait is yet another proof that not only the avant-garde artists but also those

Detail of a wall of Konstantin Melnikov's own house, 10 Krivoarbatskii Pereulok, Moscow, 1927.

close to them were convinced that the movement was dead and buried.

In fact, one must look upon the Russian avant-garde as well as the new movements that developed subsequently in the West primarily as premature births. The avant-garde made its appearance at a time when society and art critics, with few exceptions, were unprepared to comprehend it, and when conservatism, that assassin of creative belief, sowed confusion in the ranks of the artists. The great upsurge waned. It is untrue to assert that the fate of the Russian avant-garde was unique; the avant-garde everywhere was in a cul-de-sac. Since no one understood it, in effect it ceased to exist. Many developments in the last twenty years have helped to remove the shroud from the mystery of this movement, and after its long hibernation, it showed itself to be a true creation of the contemporary world. One cannot ignore the fact, moreover, that abstract art in the West from 1950 to 1970 was surely influenced by the Russian avant-garde. In the last few years this movement has traveled from the narrow corridors of private galleries and collections onto the highways of international attention. The greatest museums of the world have opened their doors, and the works of its masters are now coveted.

It is important to note how our understanding of the movement's time span has changed. In *The Great Experiment*, the first important book on the Russian avant-garde, Camilla Gray limited its duration to the years 1863 to 1922. In the exhibitions that followed in the West—largely in private galleries—a year or two was timidly added each time; now exhibitions everywhere extend the period to 1930.

Charting the Avant-Garde

When I started to collect this art, I found that no one knew exactly when it began or ended, or even which artists really were members of the movement. For example, names such as Kandinsky and Chagall did not excite the interest of curators, scholars, or collectors. Everyone mentioned at most ten artists. A small group of Soviet experts considered Malevich and Tatlin to be unquestionably major figures. Others whom they ranked high were Larionov, Goncharova, Chekrygin, Guro, Matiushin, Exter, Rozanova, and two or three others. But few if any went beyond this very limited group. There were generals in these lists, but no lieutenants or ordinary soldiers, who, after all, made up an important part of the whole army.

Gradually, as I began to understand my material, I realized what I considered essential for my collection. In addition to the ten or twelve names suggested by others, I soon had forty-five or more. And it is now clear that by widening my scope, I have discovered for myself larger purposes and meanings in the avant-garde as a whole. Not only did I press forward to find all these initiators, but I had to try to understand their environment and try to make sense of the complicated tangles of relationships among these artists, some of whom were no more than names to me. And all this had to be done over the abyss of the decades that separated me from those stormy years that were by then part of history.

My search was complicated by the fact that often the very people who owned the works of art were prejudiced against the avant-garde. I sometimes had to work very hard to gain people's trust enough to permit them to show me abstract works. Many artists or their relatives concealed the existence of works, especially those of artists who had suffered in one way or another. How many times have I heard the comment: "You know, I only found these after he had died." The very dear Tatiana Fedorovna, widow of Kliment Redko, told me that her husband's work of the twenties, including the large canvas *Uprising* (plate 1007), was discovered only after his death as she was dismantling some sleeping boards. "My husband never mentioned these paintings. He always said he had reached his peak in his late, figurative period. But do you actually like these abstract pictures? What do you see in them?" Her amazement

was sincere. It seemed to me that many artists and their relatives believed that what had been created during these years was insubstantial, a dead end.

Much worse was the fear of discovery. When Udaltsova's husband, Alexandr Drevin, was arrested, fear for him and for herself drove her to destroy nearly all her previous work. If others did not express any outright fear, they rarely if ever expressed any regret that avant-garde art had ceased to exist.

Pictures that had survived were often preserved in inaccessible places, where they died slow deaths. I recall going to a dacha in Zvenigorod (about thirty-five miles from Moscow), where the stepson of Liubov Popova's brother kept some works of art. But how he kept them! He was using one of her "spatial force" constructions painted on plywood to close up a window. The edges were pierced all around with tiny nails. I asked him to let me have the painting. He said he needed it to keep out the winter cold and snow. "I will bring you the same size piece of new plywood," I promised. "When you bring it, then I will give you the old one," he replied. I raced back to Moscow, found the plywood, and dashed back to Zvenigorod before he could change his mind. Plywood must have been a little wider in 1918–20, because my substitute left a little gap all around. I had to use my ingenuity to fill in the space.

Another of Popova's relatives was an artist, and it later came to light that he had painted over many of her works because he was short of fresh canvas. He did not consider his actions destructive, but merely a rational way to utilize canvases condemned to oblivion. Fortunately, many of Popova's best paintings were preserved by her brother, among others, and it was from him that I acquired most of her work.

Much of Ivan Kliun's work also suffered a hard fate. Kliun lived in a wooden house in Sokolniki, on the outskirts of Moscow near a big park. At the time of the Second World War, before he was evacuated, Kliun found a woman—a musician—who promised to stay there and look after his pictures and personal property. According to Serafima Ivanovna, the artist's daughter, this musician stored some of the pictures on the glassed-in terrace. Neighborhood children came there and little by little carted them off as playthings. She added that the lodger probably used some of the paintings as firewood. In this way, more than half of Kliun's legacy was destroyed.

Kliun himself thought that the greatest loss was that of a large suitcase crammed with his correspondence with Malevich; it disappeared when Kliun left it alone for a moment at a local train station.

It is bitter for me to realize that much art perished in such absurd ways, but even more bitter is the realization that many of the artists destroyed their works with their own hands. As a result, much of the history of Russian art is lost forever. In thirty-five years I succeeded in finding only three canvases by Rozanova and one by Senkin—despite the fact that I had almost no competition. But it may be that the works of these artists are not lost forever. I hope some may be with relatives, awaiting their hour of discovery.

Alexandr Rodchenko's career summarized many of the great advances as well as the deep tragedies of the avant-garde. One of the greatest innovators of the movement, he believed that every artist ought to be strict and self-critical:

One must have the courage to reveal one's whole creative development, hiding nothing, neither errors, nor false starts, nor dead ends.... A great many artists destroy their mediocre works out of fear, boasting that they were always the kind of artist they are now. One must have the courage to keep all those works, and also the greater courage to reveal them without shame, to proclaim proudly: "Here are my dead ends, and here is the broad road of my present work."

In fact, Rodchenko lived up to his words fully. He had been a founder of geometric abstraction, and during his relatively brief abstract period (1915–20), he conducted experiments that attracted the attention of both Kandinsky and Tatlin. In these five years he turned out geometric, linear constructions using compass and

ruler, paintings with dotted blots of color that set off retinal vibrations, revolving hanging mobiles, standing wooden constructions, and canvases in the spirit of Abstract Expressionism decades later.

He abandoned abstract art in 1920, and turned to the camera, working out photomontages and brilliant combinations of typography and photographs. In the thirties he did a cycle of figurative works entitled "Circus and Acrobats." When I met him in the 1940s, he was returning to abstract art, this time with a Surrealist bent. In 1943–44 he produced a work that seems to prefigure Jackson Pollock's poured paintings. Then he developed the idea toward the end of his life of decorating flat roofs so that they would be beautiful when seen from airplanes and, for their users, lofty pleasure parks with trees, grass, and swimming pools. He found an appropriate image for the scale of his ideas: "Literature and philosophy are for specialists. I invent new discoveries out of art. Christopher Columbus was neither a writer nor a philosopher; he was a discoverer of new lands."

Because Rodchenko's daughter, Mula, transcribed his writings, much of his thinking has been preserved, but his wooden constructions have suffered a less kind fate. Only one of his ten mobiles survives—purely by accident. It was stored in his attic, among old newspapers, covered with dust, and lying flat, without the wires that hold it open. "Take it, George," Rodchenko said to me. "It will be safe with you." That is how I became the owner of this unique construction. I owned one relief by Tatlin, which has now joined two more in the Tretiakov Gallery. One can only guess at the fate of the others.

The dazzling insights and breathtaking leaps of thought of some aspects of the Russian avant-garde remain largely uncharted on the maps. There are few references in art-historical texts to the Leningrad Zorved (Zorkoe vedanie, or See-Know) group, led by Mikhail Vasilievich Matiushin, though a group of fine Soviet scholars, including E. Kovtun, A. Povelikhina, and others, have been studying the contributions of these artists. Matiushin's wife, Elena Guro, was brilliant,

greater even than Popova or the others. She blew life into Matiushin, but she died in 1913. Her ideas were marvelous, and she is said to have painted abstractions as early as 1908.

In 1918 Matiushin organized the experimental studio in Spatial Realism at the Petrograd Svomas. His research and that of his students (Nikolai Grinberg and Boris, Ksenia, Mariia, and Yurii Ender) was later continued at the State Institute of Painterly Culture. The directors of the institute, in addition to Matiushin, were Malevich, Filonov, Tatlin, and Mansurov.

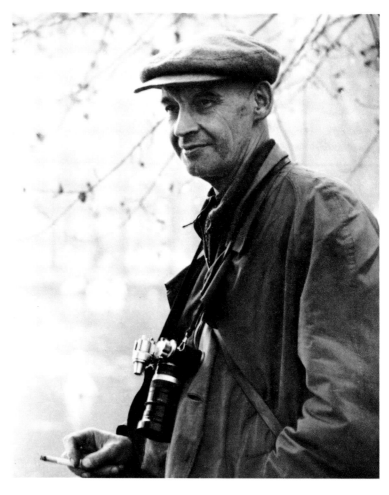

Alexandr Rodchenko, 1948. Photograph by V. V. Kovrigin.

Alexandr Rodchenko. *Oval Hanging Construction No. 12*, c. 1920. The artist is visible in the background.

In the institute's laboratory these artists studied the special capacity of the human organism — aided by the senses of vision, hearing, and touch, and by alertness and human cognition — to perceive space. Matiushin explored the question of whether one could control one's perceptions fully: to see above oneself, below oneself, and even around and behind oneself without moving the body. In my opinion, they were really studying a form of clairvoyance. But in about 1925–26 parapsychology was abandoned under pressure from the regime, which favored concentration on utilitarian problems. The institute then began working on the composition of color schemes for facades of buildings and on other problems of decoration.

By the thirties Zorved was dying out, and on October 14, 1934, Matiushin himself died. He was a person who had dared to explore areas hitherto unknown and unrecognized — the art of the future. The legacy of Matiushin awaits its historians and in the future will also have its followers. He was surely among the greatest innovators of the era.

Kliun, too, who started out closely allied to the orbit of Malevich's Suprematism, eventually sought entirely new directions of his own. His spherical constructions (plates 195–96), severely criticized by Malevich as a step backward, were years ahead of their time. Likewise Rozanova, though dead by 1918, had produced work in the preceding year which went totally beyond the confines of its time, and can be seen as prophetically close to the developments of postwar American art.

The Nature of Collecting

There is a special relationship between a collector and his collection. The collection — at least for me — is an organism. If it is a truly personal collection, it carries as it were the spiritual imprint of its founder and is built with a love which can become a strong passion. I have often felt the impulse to go to one of my paintings and caress it, give it a smile, or somewhat like a Chukchi tribesman, exhale smoke upon it as a sign of love. (I have never gone as far as a Chukchi out of fear of damaging my paintings.)

I recall one day returning home to my wife and children after a long absence. Though I had missed them very greatly, I turned first to greet the children who stared at me from the walls of my home — my paintings. As I studied them ecstatically, I heard my wife grumble to no one in particular as she set the table: "Just think, he's been gone more than a month, and instead of spending time with the children, he runs to his little pictures." "Don't worry," I answered silently, "the children's turn will come, and so will yours." I confess this incident just in order to give some sense of a collector's soul — he is in love with his collection and devoted to it.

At times we collectors are like madmen who have forgotten everything else in the world. A collector is capable of committing a crime for the sake of a coveted work, not to mention sacrificing the material welfare of his family. Anyone who imagines that collecting is a pleasant and inoffensive little hobby is deeply mistaken; it is, in its own way, a genuine illness, which manifests itself in various ways.

One collector friend of mine told me a very pathetic story. He was a guest in the home of a deceased collector. As soon as he entered the house, he felt an atmosphere of anguish and despair, which he naturally assumed was the result of the collector's death. He thought that it would be tactless to discuss buying and

selling works of art with a family crushed by grief. He was preparing to leave when one of the collector's daughters asked him whether he might like to purchase something from her father's collection. He named several items that interested him, and at once there opened before him a family tragedy in all its pathos. "Take it all," cried the widow, in a strangled voice. "Take everything. He tortured us. All these years he kept us in poverty. Our poor girls couldn't even buy decent dresses. Everything went into those cursed paintings." In tears the poor woman took down one painting after another, in haste to get rid of them.

One day someone who had not contacted me for a long time offered me several works at once, all quite valuable, and with a deadline for purchase. As usual I did not have the money, but was incapable of refusing the pieces I had been offered. I had to get the money, but where, and from whom? The previous time a similar thing had happened — when Robert Falk offered me a large oil by Kandinsky and Chagall's *Peasant with a Basket* (plate 7) — I had ended up selling a car I had just purchased. On another occasion I had taken a new fur cape from my wife's shoulders (jewelry, of course, had almost entirely gone long before). My wife had given up all these possessions with great good will, but the loss of the car, in which we had planned to make a trip to the country, had been a terrible disappointment. All these experiences were in the past, and now I needed money again.

For days my mind was consumed by one thought. My brain worked just as hard when I was sleeping; when I opened my eyes in the morning, the agony continued. But strangely, I took no action to find the money, and perhaps this is a character trait. What was I waiting for? My wife (my friend and assistant — not all collectors are so fortunate) offered her few remaining pieces of jewelry and suggested that I sell a few of my smaller pictures to finance the bigger ones. This was impossible for me — I felt at the time that it would have been like selling my own children; it was not time for them to leave my house.

A day before the deadline I came to a decision. I went to see a friend. He opened the door and at once inquired whether something terrible had happened at home. Breathing heavily, I sank into a chair, and stammering from fear that I would be turned down, I began my explanations, and told him of my needs. My friend gave a sigh of relief. "You really gave me a fright when you came in. You're not yourself at all. Just look at the circles under your eyes." And then this dear friend walked to his desk, took out the money I needed, set it out in three bundles, and gave it to me. When at last my new pictures were at home, I was granted peace of mind.

There were many such incidents in my career. Many times I grew haggard with deep depression because I had failed to acquire a work I wanted. More than once I humiliated myself and asked for loans from people less well off than myself, justifying the act in my own mind by claiming that the money could not be as important to them at that moment as to me. In spite of all this, I thank the stars that I am a collector; the joy of the hunt eclipses all difficulties.

Five Rules for the Collector

In order to make his work productive and his life more or less tranquil, it seems to me that the collector ought to observe some rules of thumb which I found helpful as I put together my large collection. These precepts cannot be panaceas for all, especially those whose characters simply cannot be changed: no greedy man can be made kind, no calculator can become generous, and dishonor never melts into honor. But nonetheless, in the name of his worthy goal, the collector might follow these rules — even if at times they contradict his instincts. My precepts may at first glance seem strange, but I attribute much of my success to having followed them.

1. A real collector must feel like a millionaire even when he is penniless; he must act as though he has

money coming out of his ears. If he understands and loves a work, and is sure of himself, he must not be afraid to buy it. A work of high artistic quality is literally priceless to the collector, worth twenty times any casually mentioned amount of money. For such a work he will always find that he has paid less than it is worth; the passage of years will show that it has risen in value not merely twenty times, but one hundred times, five hundred times, and more. This I affirm from personal experience without exaggeration. (What I say pertains to people who collect by examining works in person and not by hearsay.)

2. Rationalization is the collector's greatest enemy.

3. The real collector is ready to give up everything he has for a work he covets. It is easier for him to endure material hardship than to lose his new find. Sometimes this may mean sacrificing a month's salary or perhaps savings set aside for a vacation, or it may mean passing up a new home or a car. No one dies from this kind of self-denial. The house will wait, and a way out of the dilemma always turns up. Best of all, the work of art endures. So when success depends on the collector himself, he ought to move decisively and keep to my rules.

4. A collector must not haggle. It is more advantageous for him to pay too much than not to pay enough. This golden rule has been tested time and again over many years. If the collector tries to wheedle down the price, he may lose a work to someone else, but it is even worse if the seller gives way under pressure. Some time later, after the seller has spent his money, he will regret that he gave in and he may never offer the collector anything again. And the worst consequence of all is that the dissatisfied seller may warn others of the collector's tactics. The money saved thus turns against the collector.

5. One of the most important precepts for the collector is that he must precisely, even ruthlessly define the limits of his collection, and he must resolutely remind himself that—on this particular matter—his reach should never exceed his grasp.

Tracking My Quarry

In the building formerly occupied by the news agency Tass on Tverskoi Boulevard, in a first-floor apartment, there lived Madame Anastasiia Pavlovna Pototskaia, the widow of Solomon Mikhoels, a famous actor and theater personality associated with the Jewish Theater. Many artists worked in the Jewish Theater right up until it was closed, in 1949. In 1919 Marc Chagall had created several panels for its walls. As I knew about these panels, I decided to try to find Mikhoels's widow to see whether any works by Chagall or by others remained in her possession.

I found Pototskaia and made her acquaintance. After a few visits I learned that in fact she did have some of Chagall's works. She offered me two small watercolors from his French period that had been given by the master to Mikhoels; I bought them at once. As we talked further, she told me that she had many of his works—sketches and panels from the Jewish Theater. Buoyed by my discovery and in hopes of adding more of his pieces to my collection, I began clearing space on my walls, which were already crammed.

When I arrived at the appointed time to examine the additional Chagalls, I found no one there. I waited about an hour, thinking that A. P. was perhaps delayed in a grocery line (which can take a great deal of time). At last I went home disappointed. I telephoned the next morning: A. P. regretted that I had not waited longer; she had arrived five minutes after I had given up.

We made an appointment for the next day; the same thing happened. For the following several days attempts to reach her by telephone were fruitless; the phone was dead. Finally she answered: "Where have you disappeared to? Everything has been ready for a long time. I keep expecting you and you never come." I left on the spot to see her, and though she was at home this time, I was frustrated again. She explained that she had not been able to organize the contents of the trunk in which the Chagalls lay, since an acquaintance had dropped by and distracted her. I suggested we look into

the trunk then and there. "No, no. That will take a great deal of time, and I'm expecting someone soon. Come tomorrow."

This agonizing "come tomorrow" went on literally for several more months. Only a collector, a hunter, or a passionate lover can comprehend the unbearable agony of expectation. What she put me through was unimaginable; I am putting down only one-tenth of the story. Finally another appointment was set.

When she opened the door, I did not recognize her. She stood there in a white hospital gown with her head in bandages. She limped over to a bed, lay down upon it, and wrapped herself from head to foot in a blanket. She told me in a weak voice that she had been struck by an automobile and survived only by a miracle. She proceeded to embellish her tale while I cast greedy glances at the trunk in the corner of the room. "So you see," she said, "there can't be any question of looking through the works while I'm in such a condition."

I went wild. For a moment I wanted to kill her, but instead, without asking her permission, I threw myself on the trunk and began to go through it like a character in *Treasure Island*. I feverishly dug out dusty magazines and newspapers and tossed them on the floor. A. P., apparently resigned to what was happening, told me in a suddenly firm voice not to litter the floor. I worked my way to the bottom and found nothing by Chagall, not even a single sketch, not to speak of paintings. I began to stuff the disordered papers back into the trunk as my torturess tried to console me, saying she would try to recall where she had put the materials I sought.

Two or three days later I ran into a mutual acquaintance on Tverskoi Boulevard and learned that A. P. had visited her the day before, unhurt and perfectly healthy. This was the ignominious end of my Chagall hunt.

Nonetheless, there *were* works in this woman's possession, a fact her daughter confirmed in one of our conversations. What happened to most of these works remains a mystery, but a year later I did eventually manage to buy two gouaches from her that had been done by Chagall in America in 1943. The artist had entrusted them to Mikhoels, who had been sent to the United States on a mission to reassure Jews there that their fellow Jews in the U.S.S.R. were not being mistreated. Chagall told him to present the pieces to the Tretiakov Gallery, but the offer was declined. In January 1948 Mikhoels died in an automobile accident said to have been staged by order of Stalin. The Chagall gouaches, meanwhile, had remained in the Mikhoels home.

As I was leaving A. P.'s house on the ill-fated day I have described above, I mentioned the Chagall gouaches and asked A. P. to let me know if she should ever want to sell them. Precisely a year later her daughter called to say that her mother wanted to see me. I went, and she offered me the two works for a sum that she said would cover the cost of a memorial monument she was commissioning for her husband. It was only half what I was prepared to pay, and so I paid double her price.

I parted from her pleased with my purchase and also my conduct. Later on I was repaid a hundredfold; Anastasiia Pavlovna Pototskaia Mikhoels was a prominent figure and let it be known in the circles of the intelligentsia that I was a collector with whom one could confidently deal. In the end her good word helped me to acquire many new works.

During these many years of art collecting I have made the acquaintance of many interesting and remarkable people. One of the latter was Nevzorov, whom I met in his youth. He had a remarkable collection of Dutch, French, and English paintings of the sixteenth to eighteenth centuries. At that time he lived on one of the streets off Bolshaia Dmitrovka. I mounted four flights of stairs and found myself in a high-ceilinged pre-Revolutionary antechamber where the walls were covered with works of art; three walls were filled from ceiling to floor with paintings in their original gilt frames.

"This is Reynolds," Nevzorov said, pointing to the portrait of a youth. "And this Kalf is reproduced here in this book."

When my new friend went off to make tea, I glanced into the next room; every centimeter of wall space was occupied. I mentally reviewed the walls of my own apartment, regretting that in my whole lifetime I would not be able to amass a collection close to the size of Nevzorov's.

Nevzorov wanted to sell me something, and we sat down to "deal." Our discussion lasted until three o'clock in the morning. To this day I remember those hours of captivity with a shudder. I had promised my young wife to be home by midnight, but it was as though I were under arrest. The collector named sky-high prices and offered some rather dubious pieces. He hinted that as I had come to visit him, I was obliged to make a purchase on the spot. He brushed aside my objections and my desire to consult with my wife, sinking his pincers into me, and offering me another cup of tea. He wouldn't let me telephone home and forced me to buy back my freedom in the form of a picture. Released, I arrived home after three to find my wife in tears, imagining me run over by a trolley and already cold in the morgue.

Collections of the size of Nevzorov's were a rarity in Moscow, although many other Muscovites collected eighteenth- and nineteenth-century Russian art. Icon collectors were centered chiefly in Leningrad.

The more venerable collectors often did not even consider me a collector, though I did have some older works. Most of those who rode their artistic high horses over me owned works by Aivazovsky, Konstantin Korovin, and V. Makovsky. In these collections, the works of Nikolai Roerich, Somov, Kustodiev, and Vrubel were considered "ultra left," and Vrubel was valued especially highly. Works by Kandinsky and Chagall, not to mention other avant-garde artists, were entirely absent.

A few years after I began to collect works of the avant-garde, I resolved to find out whether some of their paintings might not be in the private collections of artists and their families. I received only one answer to my letters of inquiry. A certain Dedenko told me he had

his eye on two Chagalls and would be willing to consider an exchange if ever I should run into any others. But no Chagalls or Kandinskys turned up. Dedenko showed me his two Chagall oils and he set a combined price for them of forty-five hundred rubles (four hundred fifty dollars). These were the small oils *Lilies of the Valley* (plate 16) and the second version of *Forward!* (plate 18), which I then purchased (for three hundred and for one hundred fifty dollars, respectively). To give an idea of prices then current on the Western market, a Chagall oil of the same dimensions was for sale in a Stockholm art gallery for five thousand kronor (one thousand dollars).

In 1959, at Chagall's request, I lent twelve of his works from my collection to the retrospective exhibition at the Kunsthalle in Hamburg. Among them was *Lilies of the Valley*, and Chagall himself recounted to me the history of its creation. It had been painted at the request of his wife, Bella, from a bouquet Chagall had presented to her on their daughter's birth.

Chagall had succeeded in exporting the bulk of his early work, but a significant number of paintings remained in Russia. He was interested in what might have happened to them, and wrote me several letters with sketches of paintings he had left behind. In one he mentioned a man named Antokolsky, who operated a Petrograd studio that did photography and framing, and sold pictures on the side. As a very young man, Chagall had applied to him for help in selling some small works, and left some pictures with him—gouaches and the like. A few days later, when Chagall came back, Antokolsky denied that he had any of the works and brusquely showed the young artist the way out. A large number of early Chagalls disappeared by falling into the clutches of this fellow, and at Chagall's request, I made several attempts to locate them. In Leningrad I discovered that Antokolsky and his family had moved to Serpukhov; there, after prolonged searches, I learned that Antokolsky was dead and his family's whereabouts unknown. Not a single item from this period has yet turned up either in Russia or in the West; one may

hazard the guess that they are gathering dust in someone's attic, or that they are living a new life under an assumed name.

This time-honored practice of fraud did not initially affect the Russian avant-garde, simply because no one was interested in dealing with their works. Later on, when the artists began to gain recognition, cases of fraud occurred. Names such as Popova, Kliun, and Rodchenko had become known to a fairly small group of gallery owners, and they resolved to explore this new field, since interest in it was beginning to grow.

Interest alone did not guarantee success, however, and it was often difficult to tell the counterfeits from the originals. As a consequence, forgeries made their way into corporate collections, private collections, and finally, even museum collections. Once a forgery has been published in a catalogue, it acquires a certain certificate of approval, and it then makes its way into other exhibitions and into journals. Fortunately, curators, museum directors, and dealers are now becoming more knowledgeable in the field, and there are greater efforts to determine the authenticity of works. The movement has achieved greater recognition in the West, thus fostering research and study by art historians and curators in the leading universities and museums of the world. I have hopes, in addition, that cultural exchanges will become easier between experts in Russian icon art and the avant-garde on the one hand, and experts in Western art on the other. The recent Moscow exhibition "Moscow-Paris" (and its earlier Western counterpart in the Beaubourg in Paris) are encouraging signs of potential development.

In the earlier days, almost nothing from the avant-garde was considered to have "artistic merit." Chagall and Kandinsky did enjoy some respect — some people knew their names — but their legacy was viewed with disdain. This attitude explains how three irreplaceable canvases by Kandinsky were lost in the 1960s. Two had been in the possession of the Kandinsky family nurse, and one was in the Kazan Museum. The first two became victims of human ignorance — which annoyed me greatly. Why, I asked myself, had I not been on the scene to prevent this? But who could guess that invaluable pictures might be thrown into the ashcan simply because they were too large, or because "there was nothing drawn on them," as their onetime owners tried to explain, when they saw the agony I was suffering. The fate of the large Kandinsky in the Kazan Museum did not hurt me quite so much: the canvas had been declared too severely deteriorated to be restored, and so the curator agreed to its destruction.

As I have said, the life of a collector is a series of both successes and failures. After recovering from the shock of the Kandinsky disasters, I suddenly received a reward for my sufferings. As a preface to this anecdote, I should say that a collector, no matter how exhausted or busy he may be, must never neglect the opportunity to meet people connected with art. At that time, a particular man had made over-frequent visits to my collection; he asked to come once again, and I agreed. Shortly afterward, my grateful visitor telephoned with an offer to introduce me to the widow of Vasilii Dmitrievich Bobrov, Kandinsky's secretary. He took me to visit the lady, who lived in the house that Kandinsky had owned before the Revolution. She turned out to have a group of watercolors by the master. Judging by the casual way she showed me these works, I guessed that she did not have the slightest inkling of their value. When I named a figure, she was openmouthed. The next day when I arrived to claim my purchases, she offered me a splendid oil, the famous so-called *Red Square* (plate 112), which belonged to her daughter. She told me that the previous year a man who described himself as a representative of the Tretiakov Gallery had visited her and offered her a figure one-fourth as high as I had named. In this way, I won her confidence. I also suggested that the "representative" was perhaps an impostor, since (as far as I knew) the museum's director had no interest in such work.

Vasilii P. Pushkariev, the director of the Russian Museum, however, was another story. In the late 1960s

Pushkariev began secretly buying works by avant-garde artists. Although he was a strong supporter of Socialist Realism and a great admirer of eighteenth- and nineteenth-century Russian art, as well as of Russian icon painting, he became aware of the avant-garde at a comparatively early date. There could be no official sanction of the purchase of such art for a state museum, but rumors were rampant that Pushkariev was doing so, hiding the works in the cellars together with the avant-garde collections that had already been stored there since the early 1930s. Though his colleagues and staff approved of his activities, and did what they could to keep his acquisitions secret, the Ministry of Culture must eventually have heard what was going on. Similarly they cannot have been unaware of the Kuznetsov scandal that had erupted between the Russian Museum and the Tretiakov Gallery, almost costing Pushkariev his job.

This is what apparently took place. After the death of the Moscow artist Pavel Kuznetsov, who was highly respected by both left and right, his family offered his works for sale to the two leading museums — the Tretiakov Gallery and the Russian Museum. In both museums commissions were set up to arrange the purchase. Since the Tretiakov was right in Moscow, it sent five representatives, while the Russian Museum, being in Leningrad, sent only Pushkariev. The discussions went on for several hours. With its larger bargaining group, the Tretiakov managed to override Pushkariev and win the most valuable pieces. At the conclusion of the session Pushkariev said that he would come back the following morning for the few works he had acquired. A short time later he reappeared at the Kuznetsov family apartment with a request to spend the night, saying that he had been unable to obtain a hotel room and would like permission to sleep in the studio. The family warned him that the studio was full of bedbugs, but he shrugged this off and said that he was used to this inconvenience in his own home.

The next morning the family found the studio ransacked and Pushkariev gone. A list of the pictures taken by the "thief" was discovered in the studio; it included all the works sold to Pushkariev for the Russian Museum, as well as seventy percent of the works sold to the Tretiakov Gallery. Most amusing of all is the fact that prices were included on the list, but they differed considerably from those agreed upon the previous day: if the Tretiakov had agreed to pay three thousand rubles for a painting, this figure was crossed out and two thousand was substituted. In this fashion all the prices were reduced.

It is not difficult to deduce that the author of this bold escapade was none other than Pushkariev himself. Complaints and protests led to nothing; the major works of Pavel Kuznetsov landed in the Russian Museum and remain there. The reason is clear: at that time the minister of culture was Ekaterina Alexeevna Furtseva.

Madame Furtseva was an intelligent woman of unusual capability. I made her acquaintance at a reception for the Danish minister of culture at the Danish embassy in Moscow, when she amazed me by knowing the names of all the most important artists of the Russian avant-garde. I also met her on the occasion of the French loan of the Mona Lisa to an exhibition in Moscow. About thirty people were assembled in the office of Irina Antonova, director of the Pushkin Museum, for a champagne reception. Madame Furtseva, a sturdily built woman, raised her glass and delivered a splendid toast, eloquently thanking the French for the honor of exhibiting the Mona Lisa in Moscow. As she continued her remarks, she grew more and more effusive until finally she sank to her knees before the director of the Louvre in order to give full expression to her gratitude. The director, a Frenchman to the marrow, also got down on his knees, and the two embraced and exchanged kisses. It was this extraordinary, intelligent, unpredictable, quixotic woman who protected Pushkariev and concealed his underground escapades.

The examination of museum archives — where avant-garde works were kept — was strictly forbidden after 1960. There had in fact been some relaxation of

access in the 1950s, but then a blow was dealt by the thoughtless action of a Westerner named Alexander Marshack. He called on me when he came to Moscow in 1960. Since he presented himself as the nephew of the well-known Russian poet and translator Samuil Marshak, I welcomed him. He was interested in my collection and asked for some photographs. I thought it a bit premature to encourage publication in the West, since in those years such moves were still dangerous.

He also requested introductions to the young unofficial artists who worked in Moscow. He intended to collect and publish materials on this topic in America, hoping to encourage the development of the young artists' movements by publicizing them in the West. Long-standing friendships linked me with the young artists; we would often meet at my home or in their studios to examine new works or discuss art over a glass of vodka. I bought quite a few of their works, along with those of the Russian avant-garde, and felt a kind of personal responsibility for the welfare of some of them. At that time, there was the hint of a thaw in the intellectual atmosphere; a few timid exhibitions appeared, and we all had real hopes for the future. Since the situation was fragile, I felt that I had to decline Marshack's request for introductions. Nonetheless, he found his way quite easily without any help.

Marshack's visits to Moscow and Leningrad cost us all dearly. After his departure an article based on his investigations appeared in *Life* magazine of March 28, 1960. In it he published a photograph of the interior — and the holdings — of one of the museum storage areas. Needless to say, the result was devastating. All the archives were instantly bolted shut, and several veterans of twenty and thirty years' museum service lost their jobs. Not only did Marshack use his information about the avant-garde as anti-Soviet propaganda, but he also published confidential conversations with artists who had been candid with him, but had begged him to keep their identities secret. Yurii Vasiliev, one of the artists implicated, suffered a heart attack.

Before his departure from Moscow, I had invited Marshack to supper. He had shown me a great number of slides and photographs of the archival holdings of both the Russian Museum and the Tretiakov Gallery. Some of the photographs showed paintings poorly kept and in great disorder. The publication of these pictures would certainly unleash a storm of official protest; on top of this, Marshack had slides of works by the young unofficial artists.

When I had looked through these materials, I told Marshack that he was indeed fortunate: no one had ever been permitted to see so much, and he was the first foreigner to overcome an official ban that had stood for decades. I also implored him to exercise great caution in their use. Perhaps he should incorporate some of them in a general cultural introduction to Russian art, including discussions of the classics of eighteenth- and nineteenth-century art, of the ballet, and of Socialist Realism. The unofficial artists and their paintings might be included at the end, with the avant-garde carefully mixed into the dough. In this way the conservative forces might be appeased and little harm done. Marshack actually followed my advice in an article he later published in the *Atlantic Monthly*. But by then the terrible damage caused by the article in *Life* had been done.

The first person to express his indignation was Nikita Khrushchev, who had recently defended the rights of young artists before a group of venerable academicians. The academicians, however, opposed Khrushchev's views, and lay in wait for the right moment to strike back at Khrushchev's "democratization," which they saw as fatal to their own interests. They vividly remembered Nikita's famous visit to the newly designed Palace of the Pioneers on the Vorobiev (or Lenin) Hills. I learned about this incident from my friend Igor Lavrov, whose daughter and son-in-law participated in the project. Although they had a "leftist" reputation, they were entrusted with this quite orthodox commission. It would be an exaggeration to say that they

created a masterpiece, but they set out adventurously to include references to every "ism" in fashion. Alongside pieces of pure abstraction there were elements of Surrealism, Op art, Pop art, and so on. The architects had received permission to work with a completely free hand. They did not expect a great success, but they hoped at least not to be severely criticized or to be ordered to rework their design. A miracle took place! They were nominated for the Lenin Prize. Khrushchev came to visit the palace before its unveiling, and he was extremely pleased with it. He answered the disparaging remarks of his retinue with the words: "Maybe some people won't like it, but I do." This remark settled quite a few opinions.

The Lenin Prize, however, was not to be awarded to these two, and the cause was that very ill-fated publication by Marshack. The academicians now had a trump card — the *Life* article. They sat down with Nikita and opened to a two-page spread, featuring Valentin Serov's *Lenin Speaking at Smolny* on the left; and — on the right — a bespattered Christ-like *Self-Portrait* by a young (then unknown) artist named Anatolii Timofeevich Zverev. They got what they wanted. This juxtaposition seemed blasphemous to an orthodox Communist like Khrushchev; he was enraged. It was as if a pious believer of the Christian faith had been asked to admire, on equal terms, twin portraits of the Savior and Satan.

The Marshack incident caused a great storm. By giving such sensational "exposé" publicity to avant-garde and postwar modern Russian art, it provoked a conservative official reaction in Moscow, and drove the government to reassert its conservative stance. For the moment at least, the official thaw was over. Nonetheless it was still possible — if one acted discreetly — to carry on some collecting in a quiet way, and it was still possible to enjoy one's own collection in the privacy of one's own home. By about 1961 the number of people who wished to see my collection began to increase, and I decided to keep a visitors' book in which to record their reactions. The first entry was made by Igor Stravinsky. In time, remarks were added by a wide range of visitors — artists, students, museum directors, diplomats, scholars, and even government functionaries. By 1978 I had five volumes.

The period from about 1955 to 1974 was thus perhaps the most intense and pleasurable in my collecting life; there were meetings with Chagall, Goncharova, Larionov, Serge Poliakoff, and many other artists, Russian and foreign. There was the major retrospective Chagall exhibition in Hamburg in 1959; there were the other exhibitions to which I sent contributions from my own collection, and there were visits from innumerable interested people, including Edward Kennedy, David Rockefeller, the Shriver family, and many others.

But by the end of 1974, difficulties began. Just before a trip to Cologne — where I had been invited to the opening of an exhibition of Russian avant-garde works at the Galerie Gmurzynska — my granddaughter Katya and I visited the notorious "bulldozer exhibition" on an unoccupied site in Beliaevo Bogorodskoe near Ostrovetianovo Street on September 15, 1974. We appeared on the scene at the very height of the outrages inflicted by Yagodkin's* drunken bodyguards: they drenched the defenseless visitors with water, and destroyed the artists' pictures. I saw in the surging crowd some familiar faces of acquaintances from the arts, some of whom rushed to me with complaints about what was going on. I was powerless to help and could only express my anger. Katya was near hysterics when we finally left. "Grandfather, I'm frightened!" she said, as we got into our car. Then, continuing to cry, she burst out: "Grandfather, I'm afraid that someday they'll come and destroy all your beautiful pictures." And in part, the prophecy of this ten-year-old began to come true. That very evening I flew to Cologne; ten or twelve days later when I

*Vladimir N. Yagodkin was head of the ideological section of the Moscow Party Committee. — Ed.

returned to Moscow, I learned from my daughter that my collection was indeed in danger. One of our acquaintances had told her in strictest confidence that the scandal following the "bulldozer exhibition" was quite serious, that I was accused of being one of its organizers and would suffer recriminations. The acquaintance suggested that I should follow the time-honored method of Soviets who were in disfavor: I should enter a hospital or go abroad until the storm had passed.

The source of these threats was Yagodkin, the initiator of the "pogrom." Yagodkin did indeed blame me for the bulldozer exhibition, citing instances of my moral and financial support of young artists. On top of that, I had of course helped to propagandize the avant-garde, and was now accused of perverting young talent by exposing it to my collection. After some time, to the satisfaction of everyone concerned, Yagodkin was dismissed and punished for his acts in the affair, but the incident left an indelible mark on me. Had this been the only incident, I might have succeeded in ignoring it and continuing quietly with my private life. But others followed: I was robbed twice, my dacha was burned to the ground, and I began to think that the time had come to initiate a plan which the late Furtseva and I had worked out some years before: to transfer the bulk of my collection to a museum. Thus, I opened discussions with the Ministry of Culture.

After many delays, complexities, and difficulties, agreement was reached. A special Selection Committee from the Tretiakov, led by Deputy Director Vitalii Manin, made its appearance in my apartment. The process of dismantling my collection turned out to be less painful than I had expected: the committee behaved most discreetly and without any rapaciousness. On the whole they let me select the works which were to be left in Russia, and those which were to be exported. Their attitude in turn encouraged me to be as generous as possible, and to give the museum the most significant and the rarest pieces.

Soon afterward, a large group of Western curators and museum directors arrived in Moscow for an International Council of Museums conference. It had been decided that the visitors would be allowed to see an exhibition of Russian avant-garde works. A large room was prepared in the Tretiakov Gallery for eighty-two important canvases, forty-two of which had been in my collection, the others from the museum's storage rooms. A day before the opening (which was restricted to ICOM delegates), I was fortunate enough to view this unique exhibition, the first of its kind in Russia since the 1930s.

The Russian authorities were clearly entering a more complicated and more receptive phase in their attitude to the avant-garde. Those truly interested in Russian culture privately admired this art, and they could not help but be affected by its growing international reputation. They also recognized that much of this art had been produced in support of the Revolution — and they had even carefully preserved important collections of it in the basements of their own museums. Altogether, they were in an increasingly difficult ideological and psychological position, oscillating between some moments of great tolerance, and other moments of great opposition. In general, however, it seemed as if they were gradually trying to find a way to accept this art officially, as part of their true Russian and even Revolutionary heritage.

Meanwhile, throughout the preceding years my own collection had become better and better known. The first substantial article about the collection was written in 1972 by a German newspaper correspondent, Hermann Pörzgen, of the *Frankfurter Allgemeine Zeitung*. Publicity about the collection, nurtured by other articles, Voice of America broadcasts, and increasing numbers of Western exhibitions of Russian avant-garde art, continued to grow. In this and many other ways, the reputation of the avant-garde — and knowledge about its achievements — increased throughout the world. As of this moment, the avant-garde has still not attained offi-

cial sanction in Russia, but the possibility for this acceptance is now greater than ever before. Barring unforeseen circumstances, I feel certain that this art will one day be recognized in its native land, and will become the pride of Russia.

In conclusion, I would like to say that, were I to do it all over from the beginning, I would repeat what I have done, with but one change. I would pay greater attention to the sources of the avant-garde while continuing to explore its later periods in the unending hope of finding something new.

There are so many people who have been helpful to me, in so many different ways, over the last years that it would be impossible to do justice adequately to my feelings about them. But in a brief way I want to recognize, within the context of this book, the quite special contribution of a few, both for what they may have done to help support the cause of the avant-garde, and more personally for me and my family.

Judith and Samuel Pisar began in the 1960s to visit us in Moscow, to bring all kinds of interesting visitors, and to encourage the publication of articles about the avant-garde in the West. Their contributions have been incalculable.

Through the generous intervention of German friends, Dr. Christians and Dr. Dintelmann of the Deutsche Bank, and Dr. Günter Geisseler and Dr. Karl-Heinz Hering of the Kunstverein für die Rheinlande und Westfalen, the collection I now still own was brought to Düsseldorf in 1977. There Wend von Kalnein, the director of the Kunstmuseum, and his staff kindly agreed to mount the first exhibition in the West of my collection, a moving event for me and an important beginning.

Thomas Messer, the director of the Guggenheim Museum in New York, and Angelica Rudenstine, one of the museum's curators, had visited me in Moscow, during the famous 1977 ICOM conference, and Mr. Messer had on that occasion spontaneously offered to accept the collection for safekeeping under his roof after its showing in Düsseldorf. Angelica Rudenstine and her colleague Margit Rowell would prepare an exhibition and a publication on the collection. I am deeply grateful to them all for their commitment to the avant-garde and their belief in its importance.

Vasilii Rakitin, Soviet art historian and friend, has contributed much through his knowledge and understanding of the field. The Soviet restorers Mr. and Mrs. Nikolai Knore and Mr. Mikhail Grichishnikov have generously given their time and expertise in order to preserve the collection for posterity. Michael Haltzer, of Hamilton College, invited me to lecture in the United States in 1973. All these people, together with Douglas Davis, Marshall Shulman, Hedrick Smith, S. Frederick Starr, and many others, have worked consistently over many years to further understanding of what I have tried to do. I can never thank them enough.

THE GEORGE COSTAKIS COLLECTION

ALEXEI VASILIEVICH BABICHEV

Born Moscow, March 2, 1887; died Moscow, May 1, 1963.

From 1905 to 1906 studied in the Department of Mathematics of Moscow University and simultaneously at the private studios of Ivan Dudin and Konstantin Yuon. From 1907 to 1913 attended the Moscow Institute of Painting, Sculpture, and Architecture; and in 1913 participated in the *Mir iskusstva* (World of Art) exhibition. Upon graduation visited Vienna, Berlin, and Paris, where he studied briefly with Antoine Bourdelle, and in 1914 visited Greece. After returning to Moscow, in 1915, opened his own studio.

From 1918 to 1920 taught at the Svomas in Moscow and from 1920 to 1921 was a professor at Vkhutemas. From 1919 to 1920 was a member of the Monolith group of sculptors, which was dedicated to the realization of monumental propaganda. From late in 1920 until 1923 was a member of Inkhuk in Moscow, where he came in contact with the Constructivists and emerged as a methodologist and theoretician. From 1923 was art department head of Rabfak at Vkhutemas. Entered the polemical battle against social extremism in art, rejecting in particular the formulation of Boris Arvatov and Osip Brik regarding the substitution of functional design for all art.

From 1926 to 1929 participated in AKhRR exhibits; returned to representational sculpture and painted in a Cézannesque manner.

All the Babichevs in the collection were acquired from Natalia Babicheva, the artist's widow.
See also page 112.

1 *METAL ARCHES FOR A PROJECTED MONUMENT TO Y. M. SVERDLOV (MAQUETTE), 1924. Metal. 39.5 x 70 x 47 (314.80). Acquired from N. Babicheva, widow of the artist.* The project was submitted to a competition under the title *Arch*. The final arch, which was to be made of glass and metal, was to be placed in front of the Bolshoi Theater in Moscow. In an explanatory note the sculptor wrote: "The facade of the Bolshoi Theater should not be obstructed. Since the two rigid intersecting arches are transparent, they leave the theater's facade untouched." The monument, which was never realized, was to include a statue of Sverdlov (a leading activist of the early years of the Revolution), the arch (symbolizing the new technological era), and a crowning figure (symbolizing the "Spirit of Revolution"). (See D. Sarabianov, *A. V. Babichev* [Moscow, 1974].)

2 *PLAN FOR A CONTEMPORARY AGIT-THEATER, 1926. Pencil, ink, and watercolor on paper. 35 x 43.5 (Tretiakov Gallery TR1). Five pages of these drawings were acquired by Costakis from Babichev's widow; the other three were also given to the Tretiakov Gallery.* The agit-theater, like Tatlin's *Monument to the Third International,* Gabo's radio station, and Rodchenko's news kiosks, was intended to provide a vehicle for dissemination of information to mass audiences. The construction of the movable theater was supposed to be simple, cheap, and comfortable. The theater, when folded up, was to be moved on two vans with trailer hitches; it could then be quickly reassembled. A large stage could be erected on a thin metal frame between the vans. Under the stage were dressing rooms for the performers. The stage platform could serve as a rostrum or be rearranged and its dimensions changed to accommodate a variety of performances: a circus, a sports event, or a film screening. The showing of a film could be combined with theatrical events, an innovation designed to encourage the development of synthetic theater.

3 *PLAN FOR A CONTEMPORARY AGIT-THEATER, 1926. Pencil, ink, and watercolor on paper. 44 x 64 (Tretiakov Gallery TR2).*

2

3

VASILII DMITRIEVICH BOBROV

Kandinsky's student and secretary during the Inkhuk years and until the day of Kandinsky's departure for Germany, in 1921. Additional biographical information has been unobtainable.

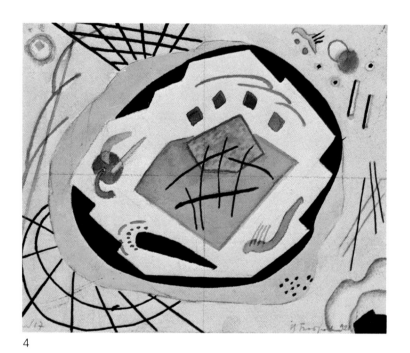

4

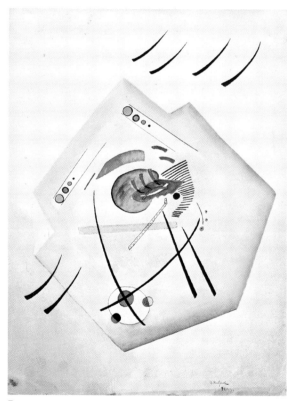

5

The five works by Bobrov in the Costakis collection, two of which are reproduced here, were acquired by Costakis directly from the artist's widow. The influence of Kandinsky, with whom Bobrov worked very closely, is evident throughout his work.

4 *UNTITLED, 1921. Ink and watercolor on paper mounted on paper. 10.1 x 12.2 (1.78a). Dated l r: "921."*

5 *UNTITLED, 1921. Watercolor and ink on paper. 24.9 x 33.3 (1.78b). Dated l r: "921."*

VLADIMIR DAVIDOVICH BURLIUK

Born Chernianka, Ukraine, March 15, 1886; killed in action
Salonika, Greece, 1917.

Studied in Kazan at the Odessa Art School and with Anton Ažbé in Munich in 1903, but was educated primarily in the artistic milieu of his own family of three brothers and three sisters. His older brother, David, was one of the most active organizers of the scattered forces of modernism and Futurism in Russia before and during World War I. His younger brother, Nikolai, was a poet and prose writer and a participant in the Futurist movement; his essay "Vladimir Davidovich Burliuk" appeared in the third *Soiuz molodezhi* (Union of Youth) almanac of 1913, and was devoted to Vladimir's aesthetics. Vladimir participated, along with his sister Ludmila, in various exhibitions, including "Venok-Stefanos" (Wreath-Stephanos) in 1907 and "Zveno" (Link) in 1908, both organized by their brother David; another sister, Nadezhda, illustrated, with Vladimir and Tatlin, the Futurist miscellany *Trebnik troikh* (The Missal of the Three), to which David and Nikolai contributed writings and which also contained portraits of all the Burliuks.

Vladimir emerged actively during the period 1908–10. Was a member of the "Bubnovyi valet" (Jack of Diamonds) and the Soiuz molodezhi (Union of Youth) groups and contributed to their numerous exhibitions. Also participated in the 1908 Moskovskoe tovarishchestvo khudozhnikov (Moscow Association of Artists) exhibition. In 1910 contributed to Nikolai Kulbin's "Treugolnik" (Triangle) exhibition in St. Petersburg and to the Izdebsky salon in Odessa, and made illustrations for *Sadok sudei* (Trap for Judges), published by David. At this time Vladimir was close to Larionov and Lentulov.

In 1913–15 illustrated many Futurist publications, including the two volumes of *Dokhlaia luna* (Croaked Moon), in 1913 and 1914, published in Moscow, and *Moloko kobylits* (Milk of Mares), also published in Moscow, in 1914. During this time was a member of the Munich Neue Künstlervereinigung (New Artists' Association) and showed works in their exhibitions and those of *Der blaue Reiter* (The Blue Rider) in Munich. Took part in the 1913 "Erste deutsche Herbstsalon" (First German Autumn Salon), at Der Sturm gallery in Berlin. Participated in the "Vystavka zhivopisi 1915 god" (Exhibition of Painting: 1915) in Moscow. From 1915 until his death was on active duty with the army in the Balkans.

6 *LANDSCAPE WITH TREES, 1912. Oil on cardboard. 63 x 84 (Tretiakov Gallery TR3). Acquired from the collection of L. V. Gornukh, Moscow.*

MARC CHAGALL (MARK ZAKHAROVICH SHAGAL)

Born Liozno, Vitebsk Province, Byelorussia, July 7, 1887; lives France.

First art lessons at Yurii Pen's private school in Vitebsk. In 1907 entered the school of the Society for the Encouragement of the Arts in St. Petersburg. From 1908 to 1909 attended the Zeidenberg and Zvantseva private art schools, studied with Mstislav Dobuzhinsky and Leon Bakst.

In 1910 moved to Paris, eventually to La Ruche. Participated in the 1912 exhibitions at the Salon des Indépendants and the Salon d'Automne. Sent work to exhibitions in Russia, including Larionov's "Oslinyi khvost" (Donkey's Tail) of 1912 and "Mishen" (Target) of 1913. In 1913 met Apollinaire.

In 1914 had a one-man show at Der Sturm gallery in Berlin. Returned to Russia at the outbreak of World War I and went to Vitebsk, where in 1915 he married Bella Rozenberg. Moved to Petrograd later that year and participated in exhibitions organized by the collector and gallery owner Nadezhda Dobychina. Contributed to the "Vystavka zhivopisi 1915 god" (Exhibition of Painting: 1915) and the 1916 "Bubnovyi valet" (Jack of Diamonds) in Moscow. Worked on scenery for Nikolai Evreinov's theatrical productions in Petrograd, particularly plays by Nikolai Gogol. Also worked in Jewish book illustration.

In 1918 returned to Vitebsk to head the Art Institute; decorated the city for celebrations and designed scenery for agitational-theater satires. In late 1919, after violent philosophical arguments with Malevich, left the institute for Moscow. Participated in the "I. gosudarstvennaia svobodnaia vystavka proizvedenii iskusstv" (First State Free Exhibition of Works of Art) in Petrograd that year. Continued to work in the Theater of Revolutionary Satire and Granovsky's State Jewish Theater; in 1920 painted friezes for the walls of the latter.

Chagall's Expressionistic work, together with the early work of Larionov, Goncharova, Lissitzky, Malevich, and Chashnik, stands practically alone in the avant-garde period in Russia. It is closely tied to the traditional Russian peasant *lubok* (woodcut) and Russian fairy-tale illustration.

In 1922 emigrated to Berlin, via Kaunas, Lithuania; that same year exhibited at the "Erste russische Kunstausstellung" (First Russian Art Exhibition), at the Galerie van Diemen in Berlin. Settled in Paris in 1923.

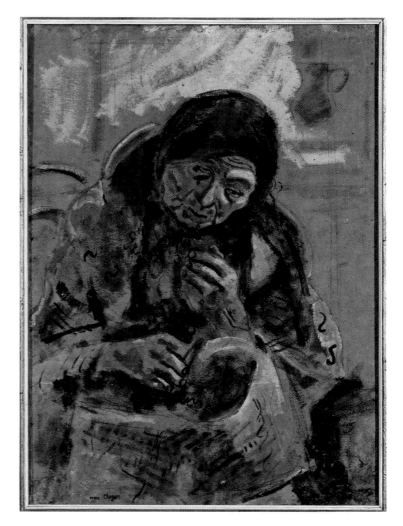

7 *PEASANT WITH A BASKET, 1906–07. Oil or gouache on cardboard. 66.5 x 49 (Tretiakov Gallery TR144). Signed ll: "Marc Chagall" (signature added later). Acquired through R. Falk from the widow of the art historian A. G. Romm. Chagall worked with Romm in Vitebsk in 1917–19. This work dates from the period when Chagall was studying with Y. Pen in Vitebsk.*

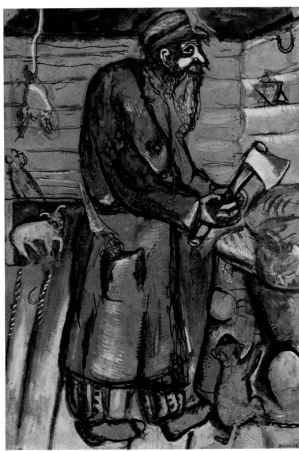

8

9

8 *BUTCHER, 1910. Gouache on cardboard. 34 x 24 (Tretiakov Gallery TR149). Signed l r: ''Chagall.'' Acquired from the widow of the art historian Y. Tugendkhold, Moscow.* Painted while Chagall was in Paris—one of a series of works reminiscent of his Russian origins.

9 *STUDY FOR ''RAIN,'' 1911. Gouache on cardboard. 22.5 x 30 (Tretiakov Gallery TR147). Signed u r: ''Marc Chagall.'' Acquired from the collection of I. Viner, an art critic and specialist on painting media and conservation.* The painting for which this is the study is in the Peggy Guggenheim Collection, Solomon R. Guggenheim Foundation, Venice. It is signed and dated 1911.

10 *MUSICIANS, 1911. Gouache. 18.8 x 18.5 (Tretiakov Gallery TR148). Signed l r: ''Chagall.'' Acquired from N. E. Dobychina, who had an art gallery in Petrograd.*

10

11

12

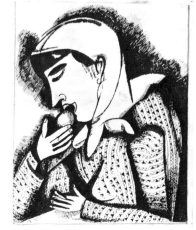

13

15

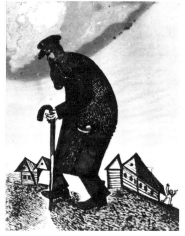

14

16

11 *OLD MAN, c. 1914–16. Lithograph. 31.5 x 23 (Tretiakov Gallery TR150).*

12 *WOUNDED SOLDIER, 1914. Pencil and india ink. 22 x 17.5 (Tretiakov Gallery TR24). Signed and dated l r: "Chagall 914." Acquired from the widow of the art historian A. M. Efros, Moscow.* Chagall did not serve in the army during the First World War, but he had a desk assignment in Vitebsk. He did a series of small works related to the war, some of which were exhibited at the "Exhibition of Painting: 1915" organized by Kandaurov in the Mikhailova Art Salon in Moscow.

13 *WOMAN WITH AN APPLE, 1914. India ink on paper. 21.9 x 18.4 (3.78). Signed twice l c: "Chagall." Acquired from the widow of A. M. Efros, Moscow.*

14 *OLD MAN WITH STICK, 1914. India ink on paper. 22 x 17.5 (Tretiakov Gallery TR25). Signed u l: "Chagall." Acquired from the widow of A. M. Efros, Moscow.*

15 *SELF-PORTRAIT WITH BELLA NEAR THE STOVE, 1915–16. Oil on paper mounted on canvas. 49.3 x 34.7 (5.78). Signed l r: "Chagall." Purchased from S. Shuster, Leningrad.* One of a number of interiors painted between the winter of 1915–16 and the summer of 1916 in Vitebsk.

16 *LILIES OF THE VALLEY, 1916. Oil on cardboard. 41 x 32.5 (Tretiakov Gallery TR146). Signed l l: "M. Chagall 1916." Acquired from Dedenko, Moscow.*

17 *THE PAINTER: TO THE MOON, 1917. Ink, gouache, and pencil on paper. 28.9 x 31.2 (7.78). Signed l r: "Chagall." Acquired from a private collection, Moscow.*

17

18 *FORWARD!, 1919–20. Oil and pencil on cardboard. 31 ′x 44 (6.78). Signed l r: "Marc Chagall." Acquired from Dedenko, Moscow.* An earlier version of this composition (in the Sachs collection, Toronto), dated 1917, lacks the Suprematist background of this later example. Franz Meyer has suggested that the composition is related to Chagall's work for the theater in the spring of 1919—specifically for Gogol's *Card Players* and *Wedding* (*Chagall* [New York, 1959], p. 289). Denis Milhau describes the 1919 version as the maquette for a decorative banner to be used in Vitebsk on the occasion of the first anniversary of the Revolution (*Chagall et le Théâtre* [Paris, 1967]).

18

19

19 *BIBLICAL FIGURE, 1956. India ink on paper. 36.5 x 27 (ATH80.11). Signed, dated, and inscribed l r: "To George Costakis, in friendship, Vence 1956. Marc Chagall." Gift of the artist.*

20 *BURNING VILLAGE, 1943. Gouache on cardboard. 62 x 50. Signed l r: "Marc Chagall."*

21 *THE WAR: MOTHER AND CHILD, 1943. Gouache on cardboard. 62 x 50. Signed l l: "Chagall." This and Burning Village were offered as gifts by Chagall to the Tretiakov Gallery* in 1946. A leading actor of the Jewish Theater, Mikhoels, who visited New York that year, was asked by Chagall to take them back to Moscow and present them to the museum. They were turned down, and Costakis later bought them from the widow of Mikhoels (see pp. 67–68).

22 *CIRCUS, 1919–20. Oil (or watercolor?) on cardboard. 31.5 x 51.5 (Tretiakov Gallery TR145). Signed l l: "Chagall Marc." Acquired from a friend of R. Falk, Moscow.*

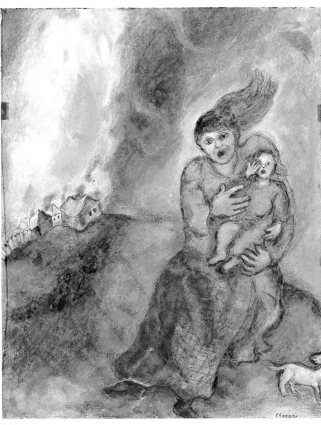

20

21

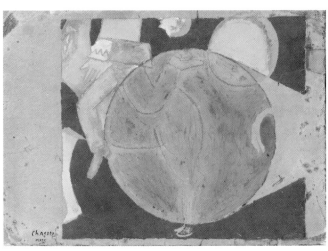

22

ILIA GRIGORIEVICH CHASHNIK

Born Lyucite, Latvia, June 20, 1902; died Leningrad, December 4, 1929, after an appendectomy.

Spent childhood in Vitebsk, where his parents moved soon after his birth. Apprenticed to an optico-mechanical workshop in Vitebsk and simultaneously, from 1917 to 1919, studied art with Yurii Pen. In 1919 attended Vkhutemas in Moscow but soon transferred to the Vitebsk Art Institute to study under Chagall, then switched his allegiance to Malevich, who took control of the school in the winter of 1919–20. Participated in the organization of the Posnovis (Followers of the New Art) group, which was later renamed Unovis (Affirmers of the New Art).

In November 1920 wrote the editorial for the group's first almanac, *Unovis*, in which his propaganda rostrum, *Tribuna oratora* (Orator's Platform), for Smolensk appeared. With Lazar Khidekel published the journal *Aero*, under the Unovis imprint. Participated in all exhibitions of the Unovis group.

In 1922, when Unovis was forced out by the local authorities, Malevich left Vitebsk and was soon followed by Chashnik, Suetin, Ermolaeva, and Yudin, who joined him in Petrograd. Worked as a designer with Suetin at the Lomonosov State Porcelain Factory, and in 1923 became a researcher at the Museum of Painterly Culture, which was closed later that year. In 1923 exhibited in the "Vystavka kartin petrogradskikh khudozhnikov vsekh napravlenii" (Exhibition of Paintings of Petrograd Artists of All Tendencies). From 1924 worked at Ginkhuk as assistant to Malevich in his work on architectural models. In 1925 was a research associate at the Decorative Institute, and from 1925 to 1926 worked with Suetin and the architect Alexandr Nikolsky.

All the Chashniks came from the son of the artist, in Leningrad.

23 SUPREMATISM, c. 1924–25. Oil on canvas. 80 x 127 (Tretiakov Gallery TR22).

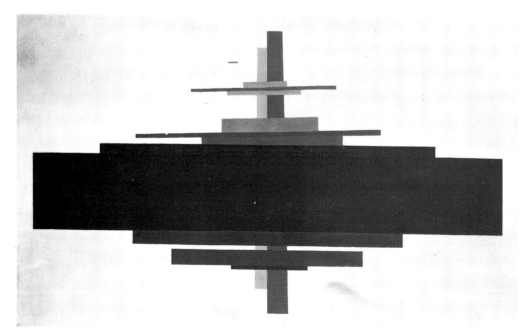

24 *SUPREMATISM, c.1924. Oil on canvas. 71 x 50 (Tretiakov Gallery TR34).*

25 *SUPREMATISM, c. 1922–23. Oil on canvas. 85 x 57 (Tretiakov Gallery TR20).*

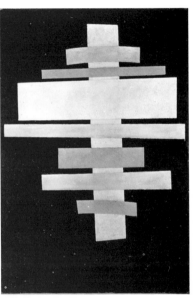
25

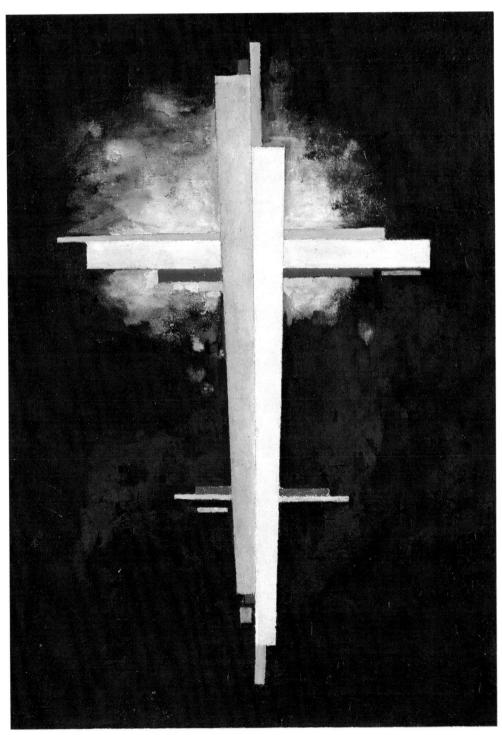
24

26 *SUPREMATIST CROSS, 1923. Oil on canvas. 133.2 x 133.4 (795.79). Signed, dated, and inscribed on reverse: ''Unovis Il[ya] Chashnik, 23.''*

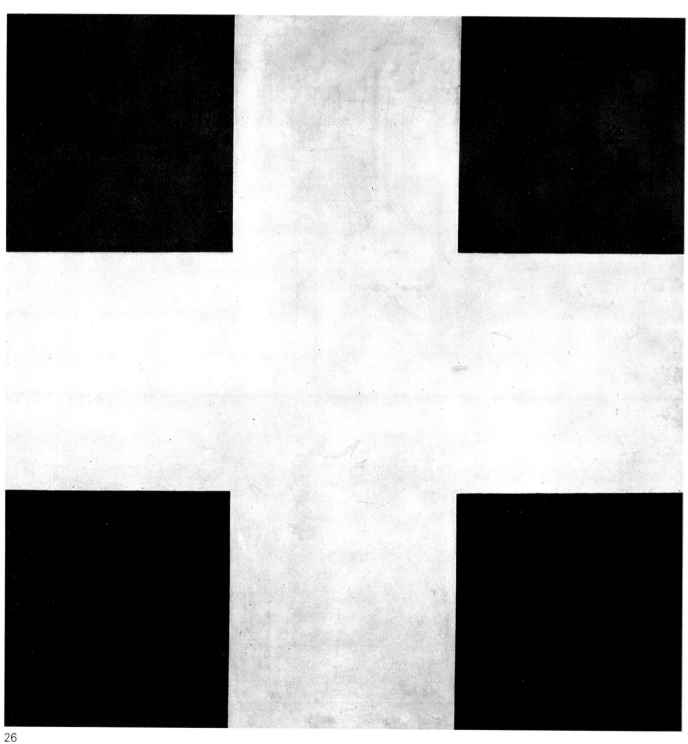

VASILII NIKOLAEVICH CHEKRYGIN

Born Zhizdra, Kaluga Province, January 18, 1897; died near Moscow, June 3, 1922, after being struck by a train.

From 1906 student at the icon-painting school at the Kievo-Pechersk Monastery, and from 1910 attended the Moscow Institute of Painting, Sculpture, and Architecture; resigned over a matter of principle in February 1914 without having completed the course of studies. In 1913, through his school friends Vladimir Maiakovsky and Lev Zhegin (Shekhtel), became close to the Larionov group and participated in Futurist evening events. In 1913 with Zhegin illustrated Maiakovsky's book of poems entitled *Ya!* (*Me!*). In 1914 participated in the "No. 4" exhibition in Moscow, organized by Larionov.

In the summer of 1914 toured Germany and France with Zhegin, returning to Russia by way of London at the start of World War I. Left for the front as a volunteer in the winter of 1915–16. In 1917–18 served on the Commission for the Protection of Art Treasures in Moscow; in 1918 taught at the Sokolniki House of Arts, Moscow. From the fall of 1918 to early 1920 worked in Kiev for the theater and as a city planner.

From 1920 on lived in Moscow. Rejected Cubist analysis in painting. Turned to the romantic ideas of the Russian philosopher Nikolai Fedorov — the philosophy of "the common cause" — on the migration of souls, and worked on the cycle "Voskresenye mertvykh" (The Resurrection of the Dead).

In 1922 cofounder of the Makovets group, supported by the philosopher Pavel Florensky. (Makovets is the hill that is the site of the monastery of Sergei Radonezhsky, a Russian saint of the fourteenth century, to whom the Holy Trinity – Saint Sergius Monastery at Zagorsk was dedicated.) At the first Makovets exhibition, April 1922, in Moscow, two hundred one works by Chekrygin were shown. In 1922 a posthumous exhibition of one hundred fifty-one works was held at the Tsvetkov Gallery in Moscow. In 1922 Chekrygin's work was also sent to the "Erste russische Kunstausstellung" (First Russian Art Exhibition), at the Galerie van Diemen in Berlin. The Makovets group continued, holding a second exhibition in 1924 and an exhibition of drawings in 1925, both in Moscow.

All the works by Chekrygin were acquired from L. F. Zhegin (Shekhtel), a close friend of Larionov and Maiakovsky and himself a painter.

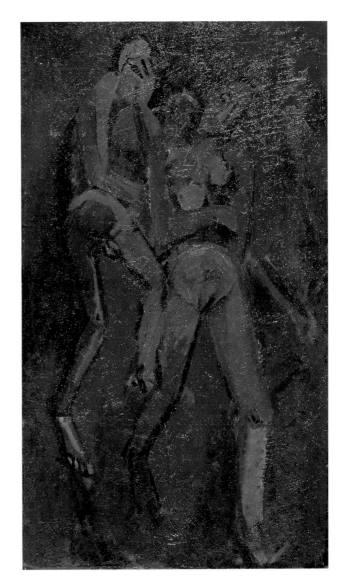

27 *ADAM AND EVE, 1914–15. Oil on canvas. 71 x 41 (Tretiakov Gallery TR33).*

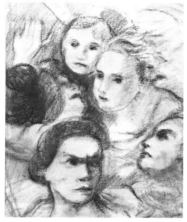

28

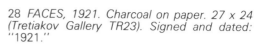

28 *FACES, 1921. Charcoal on paper. 27 x 24 (Tretiakov Gallery TR23). Signed and dated: "1921."*

29 *SEATED WOMAN, 1918. Oil on canvas. 66.1 x 51.7 (274.78). Signed, dated, and inscribed on reverse: "Study for a fresco painting by V. I. Chekrygin, 1918."*

30 *RESURRECTION, 1918. Oil on canvas. 79.4 x 89.1 (275.78).*

29

30

ALEXANDR DAVIDOVICH DREVIN

Born Vendene (Ventspils), Latvia, July 15, 1889; died in exile in the Altai region, 1938.

Son of a worker, graduated from the Riga Maritime School in 1908. From 1908 to 1913 attended art school in Riga under Wilhelm Purvit and from 1913 participated in art exhibitions there. Moved to Moscow in late 1914.

Participated in 1919 in the "Fifth State Exhibition: From Impressionism to Nonobjective Art." From 1918 to 1922 worked in both figurative and abstract styles and wrote poetry.

From 1920 to 1921 member of Inkhuk; left, with Kandinsky, Udaltsova, and Kliun, in disagreement over the rejection by the Constructivist-Productivists of pure "easel art." Corresponding member of GAKhN, and from 1920 to 1930 professor of painting at Vkhutemas/Vkhutein; his close association with Udaltsova there led to their marriage. In 1921–22 participated in the *Mir iskusstva* (World of Art) exhibitions in Moscow. In 1922 sent work to the "Erste russische Kunstausstellung" (First Russian Art Exhibition), at the Galerie van Diemen in Berlin.

In the late 1920s returned to landscape and naturalistic painting; in 1926 contributed to the AKhRR exhibition, Moscow; in 1928 contributed to the Society of Moscow Artists exhibition.

Beginning in 1930 spent much time in Armenia and Kazakhstan.

All the works by Drevin came from the artist's son, Andrei A. Drevin, Moscow.

31 *FREE COMPOSITION OF COLORED MASSES, 1920. Oil on canvas. 95 x 142 (8.78b).*

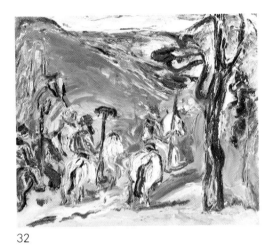

32

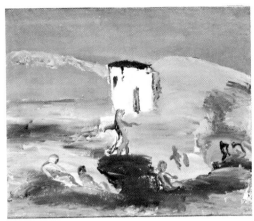

33

32 *RIDING TO WORK (STUDY), 1929. Oil on canvas. 60 x 70 (Tretiakov Gallery TR132).*

33 *BATHERS, 1930–31. Oil on canvas. 68.1 x 82.5 (9.78).*

34 *NUDE, 1930. Oil on canvas. 95 x 142 (8.78a). On reverse of plate 31.*

35 *TWO BATHERS, 1930–31. Oil on canvas. 76.5 x 92.5 (Tretiakov Gallery TR133).*

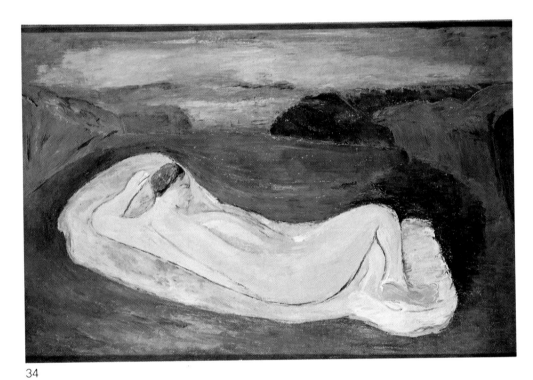

34

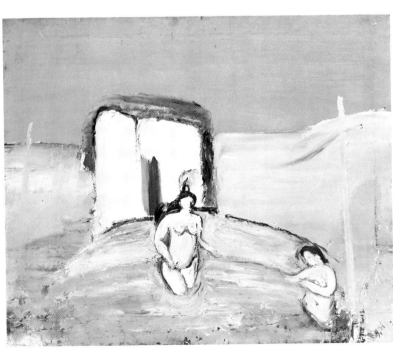

35

36 *THE GAZELLES, 1930–31. Oil on canvas. 67.5 x 89.5 (Tretiakov Gallery TR134).* In 1933 Osip Beskin published a book in Moscow titled *Formalism in Painting* in which Drevin's work of this period was severely criticized for its "formalist" and hence degenerate tendencies.

37 *LANDSCAPE, 1931. Oil on canvas. 58 x 79 (11.78b). Signed l r. On reverse of plate 40.*

38 *LANDSCAPE WITH TWO FIGURES, 1930. Oil on canvas. 68.7 x 84.6 (10.78).*

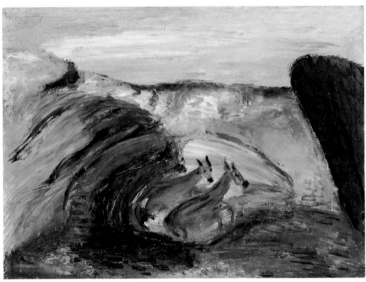

36

37

38

39 *WOMAN WITH LONG HAIR, 1930–31. Oil
on canvas. 73.8 x 90.4 (12.78).*

40 *BOAT, 1931. Oil on canvas. 58 x 79 (11.78a).*

39

40

ALEXANDRA ALEXANDROVNA EXTER

*Born near Kiev, January 6, 1882; died Fontenay-aux-Roses,
near Paris, March 17, 1949.*

Graduated from the Kiev Art School in 1906 and in 1908 married a lawyer, Nikolai Exter, and took the first of many trips to France, where she attended the Académie de la Grande Chaumière under Carlo Delvall. Showed in 1908 in St. Petersburg in the "Sovremennye techenia" (New Trends) and in Kiev in the "Zveno" (Link) exhibitions. In 1908–09 showed works at the New Society of Artists in St. Petersburg. In 1908 participated in the "Venok" (Wreath) exhibition in St. Petersburg and in 1909 in the "Venok-Stefanos" (Wreath-Stephanos). In 1909 also set up a studio in Paris and became acquainted with the French Cubists Picasso and Braque and with Apollinaire and the fledgling Italian Futurists Filippo Tommaso Marinetti and Giovanni Papini. Was also interested in the work of Nicolas Poussin. From 1909 to 1914 traveled to Rome, Kiev, Moscow, and Paris. Exhibited in the first and second Izdebsky salons in 1909–10 and 1910–11 in Odessa. Also participated in all the "Bubnovyi valet" (Jack of Diamonds) exhibitions between 1910 and 1916.

Participated in the Soiuz molodezhi (Union of Youth) exhibitions in 1910 in Riga and in 1913–14 in St. Petersburg. In 1912 participated in the Section d'Or salon in Paris and in 1912 and 1914 exhibited with the Artistes Indépendants in Paris. In Russia in 1914 sent works to the exhibitions "Koltso" (The Ring) in Kiev and "No. 4" in Moscow. Also in 1914 participated in the exhibitions of the Salon des Indépendants in Paris and the Galleria Sprovieri's "Esposizione Libera Futurista Internazionale" in Rome.

Between 1914 and 1924 participated in almost all the important exhibitions of the Russian avant-garde, including "Tramvai V. Per-vaia futuristicheskaia vystavka kartin" (Tramway V: First Futurist Exhibition of Paintings) in 1915 in Petrograd and "Magazin" (The Store) in 1916 in Moscow. During these years made the transition from Post-Cubist and Futurist compositions and experiments with collage to nonrepresentational painting.

In 1916 began theater work, doing stage sets and costumes for Innokentyi Annensky's *Thamira Khytharedes* (Tamira of the Cittern) in 1916, Oscar Wilde's *Salomé* in 1917, and Shakespeare's *Romeo and Juliet* in 1921, all produced by Alexandr Tairov at the Moscow Kamernyi (Chamber) Theater. Contributed to the idea of scenery and costumes based on Cubist spatial conceptions.

From 1917 to 1918 in Odessa, and from 1918 to 1920 in Kiev, conducted courses at her own studio, where she numbered among her students future masters of theatrical decor, including Isaak Rabinovich (see plates 1138 and 1139), Pavel Chelishchev (Tchelitchew), Alexandr Tyshler, Nisson Shifrin, and Anatolii Petritsky. From 1920 to 1922 taught at Vkhutemas and in 1921 participated in the "5 × 5 = 25" show in Moscow, but in general did not support the extremist tendencies of Moscow Constructivism, which rejected easel painting altogether.

In 1923 began work with Isaak Rabinovich on the scenery and costumes for the film *Aelita*, directed by Yakov Protazanov, based on a fantastic novel by Alexei Tolstoi. Was also active as an exhibition designer.

In 1924 emigrated to France, where she continued to design theater productions in Paris, London, Vienna, and Cologne, and to illustrate books.

41 *COMPOSITION (GENOA), 1912–14. Oil on canvas. 115.5 x 86.5 (Collection Antonina Gmurzynska, Cologne; formerly Costakis collection). Acquired from the collection of A. G. Koonen, actress and wife of the director Alexandr Tairov. The work is reproduced in D. Burliuk, V. Kamensky, V. Khlebnikov, and V. Maiakovsky, Futuristy. Pervyi zhurnal russkikh futuristov* (Futurists. First Journal of Russian Futurists) 1–2 (Moscow, 1914), following p. 80.

42 *COMPOSITION, 1914. Oil on canvas. 91 x 72 (Tretiakov Gallery TR125). Acquired from a private collection, Moscow.*

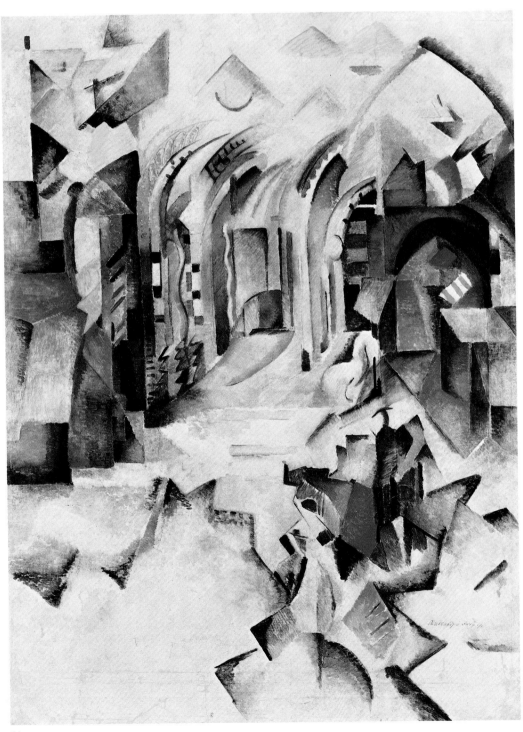

41

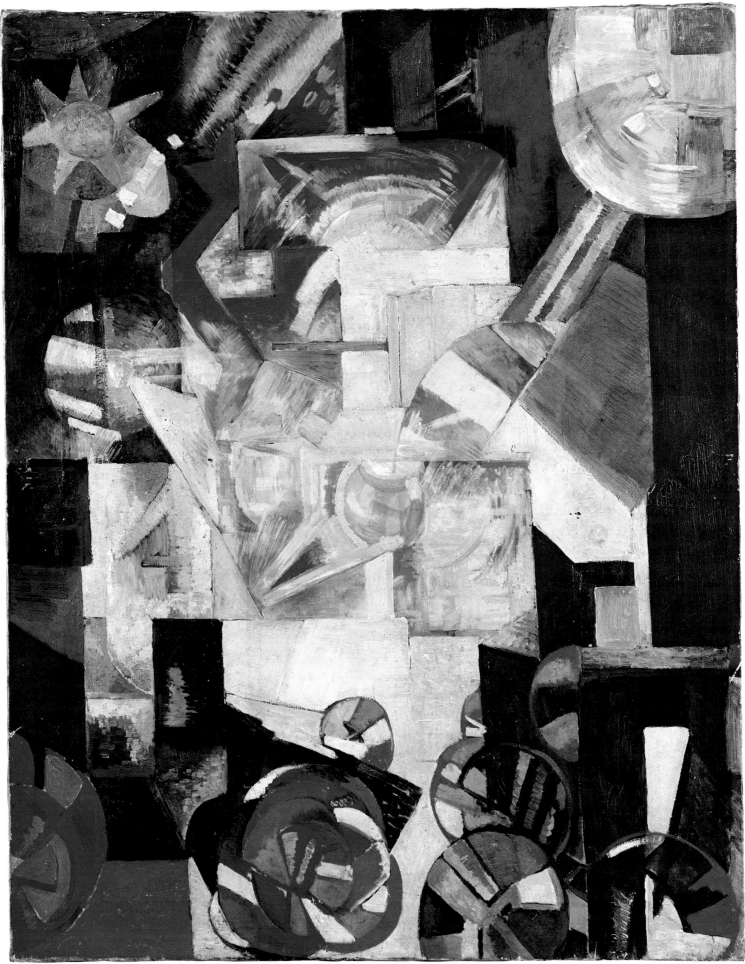

43 *FIRENZE, 1914–15. Oil on canvas. 109 x 145
(Tretiakov Gallery TR124). Acquired from a pri-
vate collection, Leningrad.*

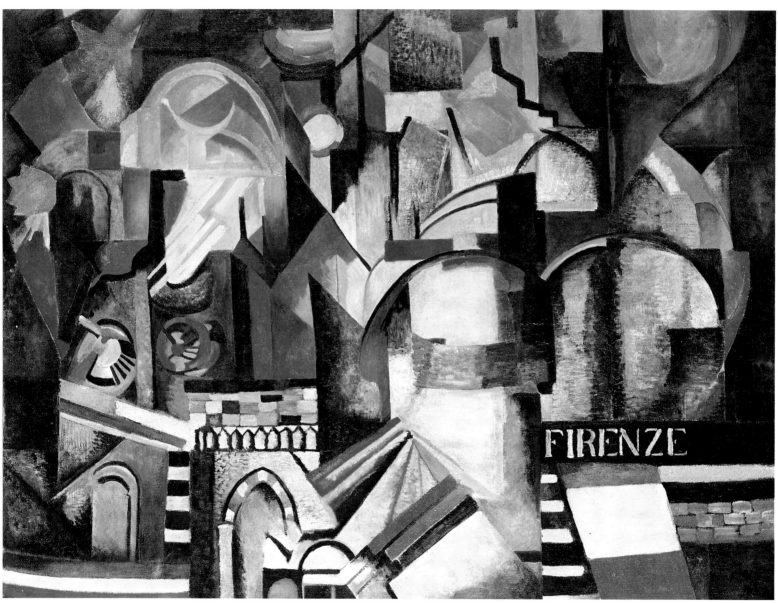

43

44 *COSTUME DESIGN, 1916. Gouache on cardboard. 48.5 x 31 (Tretiakov Gallery TR126). Signed and dated l l: "Alexandra Exter, 3/16." Acquired from the collection of A. G. Koonen, Moscow.*

45 *COSTUME DESIGN FOR "SALOMÉ" BY OSCAR WILDE (?), 1917. Gouache on cardboard. 70.2 x 40 (56.78). Acquired from the collection of A. G. Koonen, Moscow. The production of Salomé directed by Tairov had its premiere at the Kamernyi Theater October 9, 1917. Although it has not been possible to establish definitely that this costume was used in the production, it is stylistically compatible with those that were.*

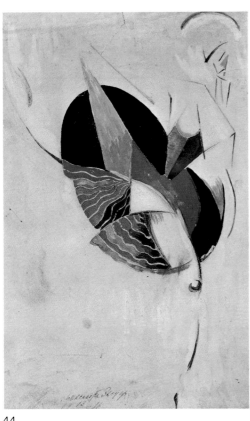

44

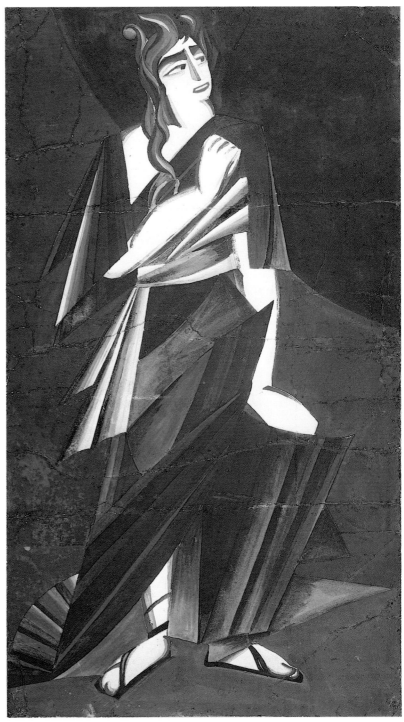

45

46 COSTUME FOR SHAKESPEARE'S "RO-
MEO AND JULIET," 1920–21. Oil and gouache
on board. 56.4 x 43.7 (sight) (55.78). Acquired
from the collection of A. G. Koonen, Moscow.
The production, directed by Tairov, had its pre-
miere at the Kamernyi Theater May 17, 1921.

47 SKETCH FOR A COSTUME FOR SHAKE-
SPEARE'S "ROMEO AND JULIET" (?), n.d. Col-
lage and gouache on paper. 51 x 33.5 (Tretiakov
Gallery TR127). Inscribed by the artist l l: "To a
cruel patron . . ." (Tairov). Acquired from the col-
lection of A. G. Koonen, Moscow. Although it
has not been possible to establish definitely
that this costume was used in the production,
it is stylistically compatible with those that were.

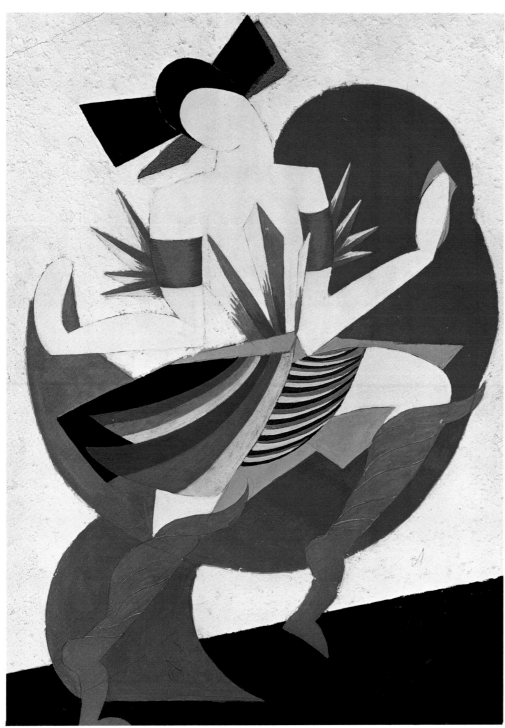

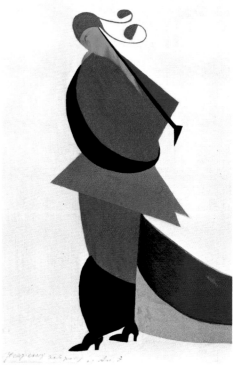

47

46

PAVEL NIKOLAEVICH FILONOV
Born Moscow, January 8, 1883; died Leningrad, December 3, 1941.

Parents — his father was a coachman and laundry deliveryman — both died when he was very young, and from the age of six he performed as a dancer at entertainment booths and embroidered towels for sale. Moved to his married sister's apartment in St. Petersburg in 1896, and for four years did housepainting and decorating work. From 1898 attended evening classes at the school of the Society for the Encouragement of the Arts. From 1903 to 1908 studied at the studio of Lev Dmitriev-Kavkazsky and from 1908 to 1910 audited classes at the St. Petersburg Academy of Arts.

Was a member of the Soiuz molodezhi (Union of Youth) group and participated in their 1910, 1912, and 1913–14 exhibitions in St. Petersburg. Also participated in the 1913 "Vnepartiinoe obshchestvo khudozhnikov" (Nonparty Society of Artists) exhibition in St. Petersburg and "Oslinyi khvost" (Donkey's Tail) in Moscow.

In 1913, with Iosif Shkolnik, designed the decor for Maiakovsky's tragedy *Vladimir Maiakovsky.* In 1914 began to illustrate Futurist books, including *Futuristy. Rykaiushchii Parnas* (Futurists: Roaring Parnassus); published a book of *zaum* (transrational, alogical) poems with his own illustrations entitled *Propoved o prorosli mirovoi* (Sermon on the Universal Flowering); and worked on his manifesto *Sdelannye kartiny* (Painted Pictures). At this time formulated the first ideas in his theory of Analytical Art.

From 1916 to 1918 served on the Romanian front. Back in Petrograd in 1919, was represented at the "I. gosudarstvennaia svobodnaia vystavka proizvedenii iskusstv" (First State Free Exhibition of Works of Art). In 1921, 1922, and 1924 showed work at the exhibitions of the Obshchina khudozhnikov (Community of Artists) in Petrograd. In 1922 participated in the "Erste russische Kunstausstellung" (First Russian Art Exhibition), at the Galerie van Diemen in Berlin and in 1923 in the "Vystavka kartin petrogradskikh khudozhnikov vsekh napravlenii" (Exhibition of Paintings of Petrograd Artists of All Tendencies). From 1923 taught at

the Petrograd Academy and briefly headed the General Ideology department at the Museum of Painterly Culture. From 1924 was associated with Ginkhuk. In 1925, with a group of students and followers, established the Collective of Masters of Analytical Art, the Filonov school in Petrograd, which lasted formally until 1932, when, because of mounting pressure from conservative artists and administrators, it was dissolved.

In 1933 supervised the illustrations for the edition of the *Kalevala* undertaken by his students and published by Academy, Moscow. From 1934 until 1941 continued to paint according to his theory of Analytical Art.

48 UNTITLED, n.d. Ink on paper. 26.4 x 21.7 (203.80). Gift of the artist's sister, E. N. Glebova, Leningrad.

49 *DRAWING FOR "DEREVIANNYE IDOLY"* *(WOODEN IDOLS) BY V. KHLEBNIKOV, 1914.* *Ink on paper. 18.4 x 12.6 (57.78). Page dedicated to "PERUN" (God of Thunder).* In *Wooden Idols*, his only contribution to the book production of the Futurist group, Filonov broke new ground in the nature of the relationship between text and illustration. His expressive illumination of the text was intended to capture in visual form the actual character of the poetic sound. As E. Kovtun has noted, Filonov's transformation of individual letters into drawings which visually symbolize the word as a whole was unique. In this sense his intention was to suggest the ideographic possibilities for an essentially phonic handwriting.

50 *DRAWING FOR "DEREVIANNYE IDOLY"* *BY V. KHLEBNIKOV, 1914. Ink on paper. 18.3 x 12.2 (58.78).*

51 *HEAD, 1925—26. Oil and gouache on paper backed with cardboard. 86.7 x 60.7 (sight) (59.78). Purchased from the artist's sister, E. N. Glebova, Leningrad.*

52 *UNTITLED (FIRST SYMPHONY OF D. SHOSTAKOVICH), 1925—27. Oil on paper. 99 x 67 (Tretiakov Gallery TR35). Purchased from the artist's sister, E. N. Glebova, Leningrad.*

49

50

51

NATALIA SERGEEVNA GONCHAROVA

*Born Ladyzhino, Tula Province, June 4, 1881; died Paris,
October 17, 1962.*

Member of an ancient noble family, father an architect. Enrolled at the Moscow Institute of Painting, Sculpture, and Architecture in 1898; studied sculpture with Pavel Trubetskoi and Sergei Volnukhin. In 1900 abandoned sculpture for painting. That year met her lifelong companion, Mikhail Larionov, with whom she studied modern European art (beginning with Impressionism), as well as the icon and Russian primitive and peasant art.

Out of school, first exhibited at the Literary and Artistic Circle in Moscow in 1904. From 1905 to 1907 sent works to the exhibitions of the Moskovskoe tovarishchestvo khudozhnikov (Moscow Association of Artists), and in 1906, with Larionov, participated in the Salon d'Automne in Paris. From 1907 to 1910 participated in the three exhibitions of the *Zolotoe runo* (Golden Fleece), organized by Nikolai Riabushinsky. In 1907–08 joined the "Venok-Stefanos" (Wreath-Stephanos) exhibition in Moscow and in 1908 the "Zveno" (Link) exhibition in Kiev, both organized by David Burliuk.

In December 1910 helped Larionov and Lentulov with the organization of the first "Bubnovyi valet" (Jack of Diamonds) exhibition in Moscow. Also exhibited at the 1911–12 Soiuz molodezhi (Union of Youth) shows and was a collaborator with Larionov on the "Oslinyi khvost" (Donkey's Tail) exhibition. From 1909 to 1911 showed at the Izdebsky salon exhibitions in Odessa, the first of which traveled to Kiev, Riga, and other cities, and sent works to the *Mir iskusstva* (World of Art) exhibitions, held in Moscow, St. Petersburg, Kiev, and other cities. In October 1912 participated in the "Second Post-Impressionist Exhibition" at the Grafton Galleries in London and showed with *Der blaue Reiter* (The Blue Rider) in Munich.

Also in 1912 started to illustrate books by Futurist writers, including Velimir Khlebnikov and Alexei Kruchenykh, notably the latter's *Igra v adu* (Game in Hell), republished in 1914 with illustrations by Olga Rozanova and Kazimir Malevich; *Mirskontsa* (World-backward) with Larionov and others; and *Pustynniki* (Hermits) of 1913. Also that year with Larionov created and acted in the only known Russian Futurist film, *Drama in the Futurists' Cabaret No. 13*.

From 1912 to 1914 Goncharova worked in a variety of styles but moved further from Neo-Primitivism toward Rayonism and Futurism, frequently combining a number of styles on one canvas. In 1913 organized the "Mishen" (Target) exhibition in Moscow with Larionov; with ten other painters, including Larionov, signed "Luchisty i budushchniki. Manifest" (Rayonists and Futurists: A Manifesto), which was published in the *Oslinyi khvost i mishen* (Donkey's Tail and Target) almanac of 1913. That same year exhibi-

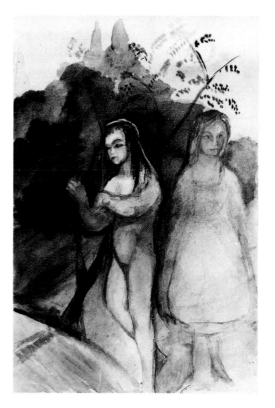

53 *TWO MAIDENS, c. 1904–05. Watercolor on paper. 29.3 x 19.2 (204.80). Acquired from the collection of L. F. Zhegin (Shekhtel), Moscow.* On the reverse is a charcoal drawing (not reproduced).

ted with the *Mir iskusstva* (World of Art) and the Soiuz molodezhi (Union of Youth) in St. Petersburg and sent works to the "Erste deutsche Herbstsalon" (First German Autumn Salon), at Der Sturm gallery in Berlin.

In the fall of 1913 at the Art Salon on the Bolshaia Dmitrovka in Moscow and in February 1914 at Nadezhda Dobychina's gallery in St. Petersburg, Goncharova held large one-woman retrospective exhibits. In April 1914 participated in the "No. 4" exhibition in Moscow, organized by Larionov, and in June with Larionov had a joint exhibition at the Galerie Paul Guillaume in Paris. Also in 1914 designed the scenery for Nikolai Rimsky-Korsakov's *Le Coq d'Or*, produced in Paris by Sergei Diaghilev. Upon her return to Moscow in 1915 sent works to the "Vystavka zhivopisi 1915 god" (Exhibition of Painting: 1915) and designed the scenery for Carlo Goldoni's *The Fan*, directed by Alexandr Tairov at Moscow's Kamernyi (Chamber) Theater.

That year, at Diaghilev's invitation, left with Larionov for Lausanne, Switzerland, to spend the next few years working for the Diaghilev ballet company. Designed sets for Maurice Ravel's *Espagne*, in 1916, Modest Mussorgsky's *Night on Bald Mountain*, in 1923, and Igor Stravinsky's *The Firebird*, in 1926. Continued to design books and work on stage sets and costumes for theaters around the world after she moved permanently to Paris, in 1917. Continued painting but exhibited little.

54 *DRAWING FOR "PUSTYNNIKI" (HERMITS) BY A. KRUCHENYKH, 1912. Pencil on paper. 19 x 14.1 (C393). Acquired from the collection of L. F. Zhegin (Shekhtel), Moscow.*

55 *DRAWING FOR "PUSTYNNIKI" BY A. KRUCHENYKH, 1912. Pencil on paper. 19 x 14.8 (C396). Acquired from the collection of L. F. Zhegin (Shekhtel), Moscow. Pustynniki was published in St. Petersburg, 1912; Moscow, 1913, with sixteen lithographs by Goncharova. The style of the illustrations is clearly influenced by icon painting.*

56 *BOY WITH A COCK, 1913. Pencil on paper. 22 x 17.7 (C395). Acquired from the collection of L. F. Zhegin (Shekhtel), Moscow. Study for a painting, dated 1913, now in the museum in Erevan.*

57 *MOSCOW STREET, 1911. Oil on canvas. 64.9 x 78.8 (60.78). Inscribed on reverse: "Street in Moscow, 300 rubles." Acquired from a private collection, Moscow.*

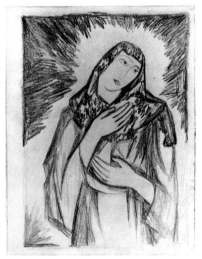

54

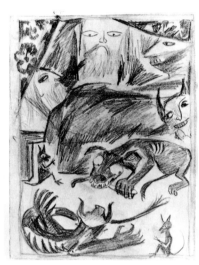

55

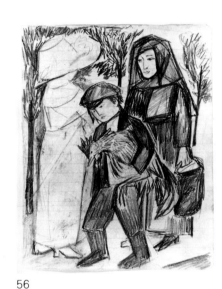

56

57

58 *ICON PAINTING MOTIFS, 1912. Watercolor on cardboard. 49.5 x 34.5 (Tretiakov Gallery TR123). Acquired from the collection of K. M. Zdanevich, Tbilisi and Moscow.*

58

59 *TWO SPANISH LADIES, 1916?. Pencil on paper. 50.5 x 33 (C199). Signed l l, and inscribed: ''To dear Georgii Dionisovich, so that he and others, when they look at this drawing, may remember me. 1956.'' The inscription was added when Goncharova gave the work to Costakis in Paris.* The drawing is a study for the painting *Les Espagnoles* (oil on canvas, 260 x 199, c. 1916) and, like several other similar works, was inspired by Goncharova's trip to Spain in July of that year.

It is difficult to date these Spanish pictures precisely, since she continued to develop the themes for almost a decade after she returned from Spain.

60 *CHANDELIER (RAYONIST COMPOSITION), c. 1913. India ink on paper. 20.5 x 31 (Tretiakov Gallery TR4). Signed l r: ''N G'' (monogram). Acquired from the collection of L. F. Zhegin (Shekhtel), Moscow.*

61 *TICKET NO. 1059 FOR THE ''BAL BANAL''* organized by the Union des Artistes Russes, Paris, March 14, 1924. Brown and gray print on cream paper. Image: 20.4 x 14 (144.80). Print of two Spanish ladies (signed and dated 1923) and lettering. Seal of the Union des Artistes Russes à Paris rubberstamped onto top and bottom. Acquired from the collection of L. F. Zhegin (Shekhtel), Moscow. At least three other tickets for this same event survive (see *Ex Libris* 6, 272a–c).

60

59

61

INKHUK PORTFOLIO

The following group of twenty-two drawings was acquired by Costakis from Natalia Babicheva, widow of Alexei Babichev. The drawings were contained in a single portfolio and were said to be derived from a single project dating from Babichev's association with Inkhuk (Institut khudozhestvennoi kultury—Institute of Painterly Culture).

Though the archives of Inkhuk are not yet available, it is possible to advance a hypothesis about the origin and function of this group of works. Most, but not all, carry on their verso the stamp of Inkhuk (plate 62) and a number. Gaps in the numbering and the absence of the stamp in certain instances suggest that the portfolio is not complete and that some of the works now grouped within it did not originally belong to it.

Inkhuk was founded in May 1920 and was based initially in Moscow under Kandinsky. The aim of the institute was to formulate an ideological and theoretical approach to the arts based on scientific research and analysis. The questionnaire circulated by Kandinsky (plates 63 and 64) focuses on the relationship between form and color, and the subjective nature of aesthetic experience, thus illustrating his own strong orientation toward the psychological dimension. In investigating the effects of certain colors and forms on the psyche, he was attempting to formulate scientific principles that could explain intuition and the creative process. The insistence on the psychological or subjective content in art led to violent disagreements with other founding members of Inkhuk, and by the end of 1920 Kandinsky had left. The administration was reorganized by Rodchenko, Stepanova, Babichev, and Nadezhda Briusova, and the main focus of Inkhuk became the Group for Objective Analysis.

Babichev drew up a new program (see *Russkoe iskusstvo*, no. 2–3, 1923, p. 85), the fundamental aspects of which were:

1. *Theoretical:* the analysis of the work of art, the conscious definition of the basic problems of art (color, *faktura*, material, construction, etc.).

2. *Laboratory:* group work according to independent initiative or according to a task (for example, all members were assigned work on the theme "Composition and Construction").

Within this program, the Group for Objective Analysis gradually developed toward a Constructivist theory of art. Important debates and discussions took place at Inkhuk in the early part of 1921 and some clear differences of opinion arose regarding conceptions of "composition" and "construction." By the fall of 1921 a considerable reorganization had taken place. Kliun, Udaltsova, and Drevin, among others, had left, and the members who remained proposed the publication of a collection to put forward their new ideas. It was to be titled "From Figurativeness to Construction"; though some articles were written for it, it was never published.

The present portfolio throws interesting and important light on the notions of "composition" and "construction" within the context of Babichev's laboratory group work. Five of the drawings are dated April 1921, when debates within Inkhuk about the definition of "composition" and "construction" were at their height. It seems clear that the portfolio constituted a part of this process of definition and that the drawings were produced by the members in the "laboratory" context. It is also possible that some of them were to be included in the projected publication.

(For a full, detailed discussion of Inkhuk and its program based on unpublished materials, see C. A. Lodder, *Constructivism: From Fine Art into Design, Russia 1913–1933*, Yale University Press, 1982; also A. Nakov, *2 Stenberg 2* [Paris, 1975]; John E. Bowlt, ed. and trans., *Russian Art of the Avant-Garde:Theory and Criticism 1902–1934* [New York, 1976].)

62 *THE INKHUK STAMP as it appears on the reverse of plate 83.*

Институт Художественной Культуры.
(ИНХУК)
При Отделе Изо Н. К. П.

СЕКЦИЯ МОНУМЕНТАЛЬНОГО ИСКУССТВА.

Препровождая вам опросный лист, выработанный Секцией соответственно программе ее работ, Секция просит вас сообщить ей в письменной форме ответы на поставленные в листе вопросы. Равным образом Секция обращается к вам с просьбой передать опросный лист лицам, интересующимся затронутой в листе областью или сообщить имена и адреса таких лиц Секции (Зубовская пл., д. 8, кв. 22, В. В. Кандинскому).

Опросный лист.

1. Какое искусство наиболее действует на Вас и вызывает в Вас наиболее сильные переживания.
2. Что в этом искусстве действует на Вас.
3. Случалось ли вам наталкиваться на вопрос о самодовлеющем воздействии средств выражения искусства на психику (напр., в живописи цвета, как такового, в музыке звука и т. п.)
4. Делались ли Вами какия нибудь опыты в этом направлении.
5. Как делались эти опыты: по какому принципу и как они обставлялись на практике.
6. Делали ли Вы эти опыты одни или при участии других лиц и если да, то с кем и при каких условиях.
7. Были ли Ваши работы в этом направлени где нибудь опубликованы и где.

Живопись

I-я Группа. 1. Замечали ли Вы в себе какия нибудь (ясные или хотя бы смутные) переживания от созерцания или специального наблюдения элементарных или сложных рисуночных форм (напр., точка, прямая, гнутая, угловатая линия, треугольник, квадрат, круг, трапеция, элипсис и т. п. или свободная рисуночная форма, не поддающаяся геометрическому определению).

2. Действовали ли как нибудь на Вас технические чертежи (архитектурные, инженерные планы, проэкты, кальки) и, если действовали, то как. Запишите возможно точно, какие это были впечатления, а также постарайтесь об'яснить вызываемые в Вас чувства параллельно с чувствами, вызываемыми другими предметами: как Вам представляется, напр., треугольник — не кажется ли Вам, что он движется, куда, не кажется ли он Вам более остроумным, чем квадрат; не похоже ли ощущение от треугольника на ощущение от лимона, на что похоже больше пение канарейки — на треугольник или круг, какая геометрическая форма похожа на мещанство, на талант, на хорошую погоду и т. д. и т. д.

3. Считаете ли Вы возможным выразить какия нибудь Ваши чувства графически, т. е. какой нибудь прямой или гнутой линией, какой нибудь геометрической фигурой или произвольно очерченой плоскостью или целой комбинацией линий, плоскостей и пятен (черных или белых). Попробуйте это сделать и заняться такими упражнениями. Присоедините эти попытки к Вашему ответу на опросный лист. Попытайтесь выразить графическими формами Ваши впечатления, переживания и представления о науке вообще, о каких нибудь науках в частности (химии, анатомии, политической экономии и т. п.), о явлениях жизни вообще или в частности о явлениях жизни человека в ее проявлениях в областях духовной, физиологической, паталогической и т. п., о явлениях астрономических, метеорологических и т. п. и т. п. Дайте к Вашим рисункам об'яснения, почему Вам кажется, что именно таким рисунком Вы всего точнее выражаете Ваши чувства, впечатления и т. п.

4. Обратите особое внимание на то, не изменится ли выражение одной формы от соседства ее с другой и запишите Ваше впечатление.
Прибавляйте все дальше форму к форме и наблюдайте изменения.

5. Обратите внимание на указанные изменения в зависимости от того, стоят ли формы рядом, друг над другом, одна к другой на искосок и т. д.

63

6. Ставьте изолированные формы на их основание, а потом наклоняйте их и отмечайте свои впечатления. Ставьте их вверх ногами и т. д.

7. Делайте сочетания форм геометрических с формами свободными — сначала острых с острыми, круглых с круглыми, потом перебалтывайте их. Изобретайте сами комбинации.

8. Обратите внимание на то, не изменится ли впечатление, если Вы поставите одну форму или группу форм в центр бумаги, наверху или внизу, в правом или левом углу и т. п. и т. п.

9. Переверните Ваш рисунок вверх ногами, на бок и т. д. и следите за происшедшим.

10. Если у Вас есть какие нибудь свои соображения по поводу устройства анкеты в духе нашего плана или ином, если бы Вам захотелось пополнить нашу анкету, то сообщите обо всем этом по вышеуказанному адресу.

II-я Группа. 1. Замечали ли Вы на себе какое нибудь особое действие цвета. Было ли это воздействие физическим или психическим. Опишите его.

2. Как действует на Вас цвет: желтый, синий, красный. Какой из них действует сильнее — приятно или неприятно. Есть ли из этих трех цветов какой нибудь для Вас невыносимый. Особо обворожительный. Какой из них Вам кажется особенно сильным, плотным, активным, двигающимся (в какую сторону), плоским, глубоким, непокорным, устойчивым и т. п.

3. Замечали ли Вы действие цвета, когда он нанесен на какой нибудь предмет (на какой), или и тогда, когда Вы видите его изолированным.

4. Действует ли на Вас какой нибудь цвет, когда Вы его не видите, а только себе его представляете. Кажется ли Вам этот мыслящийся цвет лучше всех его видимых форм. Какой цвет Вам легче всего себе представить. Почему именно этот.

5. Ответьте на те же вопросы по отношению к цветам: зеленому, оранжевому фиолетовому.

6. Перечтите пункты 2 и 3 1-й группы и ответьте по аналогии на те же вопросы, но в отношении к цвету. Напр., какой цвет более всего похож на пение канарейки, на мычание коровы, на свист ветра, кнута, человека, на талант, на грозу, на отвращение и т. п. Можете ли Вы передать цветом Ваши переживания от науки, от явлений жизни и т. п.

7. Какой цвет по Вашему чувству наиболее подходит к треугольнику, квадрату, кругу. Сделайте рисунки и раскрасте их.

8. Если какой нибудь основной цвет не подходит по Вашему чувству ни к одной геометрической форме, то попробуйте найти подходящую к нему не геометрическую форму, а свободную. Нарисуйте и раскрасте ее. Если можете, напишите, почему так лучше.

9. Смешивайте последовательно основные цвета между собою: введите, напр., в желтое пятно или в какую нибудь часть его синий цвет, в красное — желтый и т. д., наблюдайте Ваши впечатления и записывайте их. Делайте сначала пятна неопределенных форм, а потом геометрических, далее свободных, но точных форм. Постарайтесь полученные результаты описать всеми возможными способами, приведите все возможные параллели, поступайте так, как это было указано для рисуночной формы.

10. Применяйте пункты от 4 до 10 1-й группы к цветовой форме.

11. Сделайте длинную тетрадь, врисовывайте в нее все формы (как рисуночные без цвета, так и рисуночные расцвеченные) указанные здесь и изобретенные Вами с левой стороны, оставляя с правой много места для Ваших замечаний, об'яснений и параллелей с впечатлениями от других переживаний. Попробуйте составить точные таблицы по системе здесь предложенной, а кроме того и по какой нибудь другой, которая покажется Вам более подходящей. Если Вы найдете такую другую систему, то сообщите ее нам с об'яснением, почему она Вам кажется более подходящей. Ответы же по нашей системе очень желательны, так как наша анкета предполагается в большом масштабе и мы стремимся собрать массовые материалы. Именно большое количество ответов по одной системе даст возможность установить, как часто встречаются одинаковые ответы, и установить, следовательно, известную закономерность во впечатлениях и наблюдениях. Таким путем может быть найден корень общего закона.

Так как к анкете по живописи будут приобщены анкеты и по другим искусствам, то откроется возможность установить связь закона живописного с законом музыки, скульптуры, поэзии, архитектуры, танца и т. д.

Бюро Секции.

64

63, 64 *INKHUK QUESTIONNAIRE, 1920 (138.80).* This hitherto unpublished document must have been devised by Kandinsky very soon after Inkhuk was established. It covers a wide range of theoretical issues, including questions such as: Which art form has the most effect on you and your feelings? What affects you in this art form? Have you ever found that art could influence you psychologically? How do you experience geometric form and free form in drawing? How do you react to architectural and engineering drawings? Don't you think that a triangle has a greater sense of humor than a square? Could you express your personal feelings graphically (by line, by many lines, by composition)? How does color affect you, physically or psychologically? Describe how certain colors affect you: yellow, blue, red. Is there a color you cannot stand among these or a favorite?

The questionnaire also assigns specific exercises, and the respondents are urged to carry out the directions in full detail so that the results will be maximally useful in the development of mass educational materials. A full study of this important document, both in the context of Kandinsky's own theoretical development and in relation to the theoretical framework of Inkhuk, remains to be undertaken.

For biography of Kandinsky see page 130.

65 ALEXEI VASILIEVICH BABICHEV. CON-STRUCTION, c. 1921. Ink, gouache, and pencil on paper. 52.1 x 28.2 (C169). Not signed or dated. Inkhuk stamp no. 20.

66 ALEXEI VASILIEVICH BABICHEV. COMPO-SITION, 1921. Pencil on paper. 49.5 x 34.5 (C170). Dated on reverse: "April 22, 1921." In-scribed on reverse by N. Babicheva: "According to the Inkhuk Archives, this work is entitled 'Composition' and is dated 22/iv/21." Inkhuk stamp no. 19.

For biography see page 78.

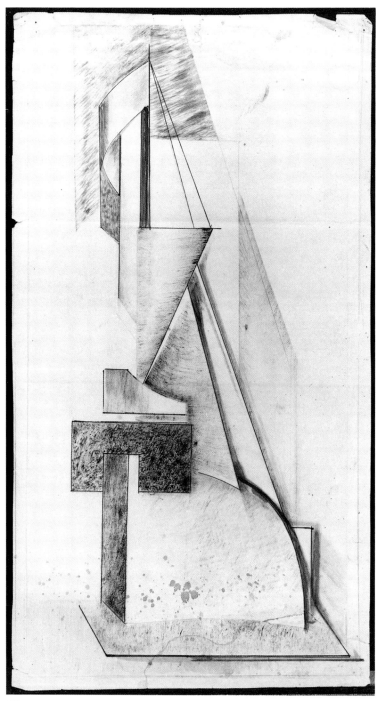

65

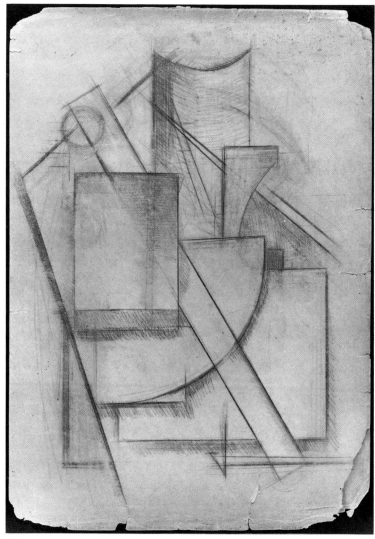

66

67

67 KAREL IOGANSON. *CONSTRUCTION, 1921.*
Colored pencil and pencil on paper. 31.8 x 24.3
(C185 recto). Dated on reverse: "April 7, 1921."
Inkhuk stamp no. 17.

68 KAREL IOGANSON. *VERSO OF PLATE 67*
(C185 verso). Inscribed: "The graphic repre-
sentation of a construction of a complete cold
structure in space./ Construction./ The construc-
tion of a complete cold structure in space or
any cold combination of hard materials is a
cross, either right-angled (a' a'' a'''') or obtuse-
and acute-angled (a''')."

No biographical information about Io-
ganson has been located.

68

69

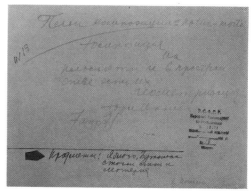

70

69 KAREL IOGANSON. *COMPOSITION, 1921.* Colored pencil, ink, and pencil on paper. 24.1 x 32.3 (C186 recto). Signed and dated on reverse: "Karel Ioganson April 7, 1921." *Inkhuk stamp no. 18.*

70 KAREL IOGANSON. *VERSO OF PLATE 69 (C186 verso). Inscribed:* "Plan for a composition: Nature-morte./ The composition on a plane and in space is their geometrization. Objects: Apple, bottle, glass, table, and fabric."

An installation photograph of the third Obmokhu exhibition (plate 71) shows in the foreground three linear constructions by Karel Ioganson. Plate 67 and its verso inscription are clearly related to these sculptures.

71 *THIRD OBMOKHU EXHIBITION, 1921. In the foreground, three sculptures by Ioganson. In the center rear, oval hanging construction by Rodchenko now in the Costakis collection (see plate 1019).*

71

BORIS DANILOVICH KOROLEV
Born Moscow, December 28, 1884; died Moscow, June 18, 1963.

From 1902 to 1905 studied in the scientific section of the physics and mathematics faculty at the University of Moscow, from which he was expelled for his participation in revolutionary activities. From 1907 to 1910 studied at the private studios of Fedor Rerberg, Nikolai Ulianov, Ilia Mashkov, Vasilii Meshkov, and Mariia Blok in Moscow. From 1910 to 1913 studied at the Moscow Institute of Painting, Sculpture, and Architecture under Sergei Volnukhin. In 1913 traveled to England, Italy, Austria, Germany, and France, where he worked in Alexander Archipenko's studio. Studied the work of Auguste Rodin and visited the studios of younger contemporary sculptors.

Became a member of the Society of Moscow Artists about 1922, was a member of the Society of Russian Sculptors, and in 1928 joined AKhR. From 1918 to 1924 taught at Vkhutemas in Moscow and from 1929 to 1930 at the Leningrad Academy.

72 BORIS DANILOVICH KOROLEV. *COMPOSITION. Pencil and gouache on paper. 16.1 x 10.6 (C176). Signed l r; signed and dated on reverse: "April 8, 1921." Inkhuk stamp no. 3.*

73 BORIS DANILOVICH KOROLEV. *CONSTRUCTION, 1921. Pencil on paper. 35.4 x 25.9 (C177). Signed l r; inscribed, signed, and dated on reverse: "Construction for Inkhuk, B. Korolev, April 19, 21." Inkhuk stamp no. 4.*

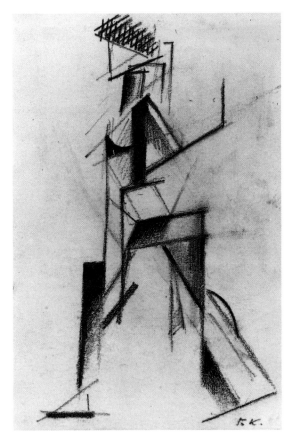

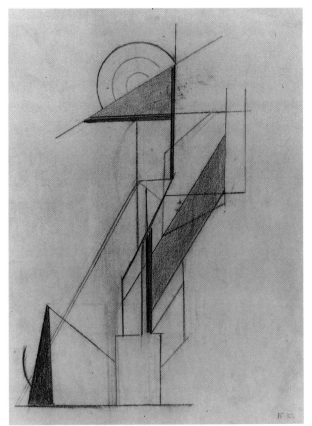

72

73

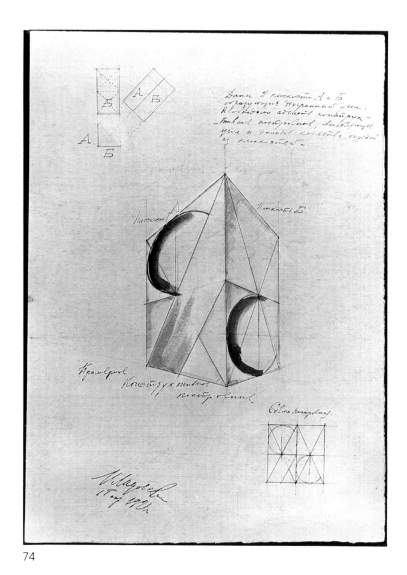

74

NIKOLAI ALEXANDROVICH LADOVSKY

Born Moscow, 1881; died Moscow, 1941.

From 1914 to 1917 attended the Moscow Institute of Painting, Sculpture, and Architecture. From 1919 to 1920 created experimental architectural projects with a group of young architects including Konstantin Melnikov. In 1919–20 was a founding member of Zhivopisno-skulpturno-arkhitecturnyi sintez, or Zhivskulptarkh (Commission of Painterly-Sculptural-Architectural Synthesis). In 1920 helped found and then taught at Vkhutemas/Vkhutein; member of Inkhuk. In 1923 founded the "formalist" group of new architects called ASNOVA. In 1924 designed a project for the Soviet Pavilion at the Exposition des Arts Décoratifs et Industriels Modernes in Paris that was never built. Went on to design and build monuments, theaters, and a metro station in Moscow. In 1929 won the competition for the plan of a "green city," and some units were built before the project was dropped.

74 NIKOLAI ALEXANDROVICH LADOVSKY. *MODEL OF A CONSTRUCTIVE STRUCTURE. Ink, pencil, and wash on cardboard. 38 x 27.3 (C174). Signed and dated l l: "April 15, 1921." On reverse, circular Inkhuk stamp with no number.*

75 *Diagrammatic rendering and translation of plate 74.*

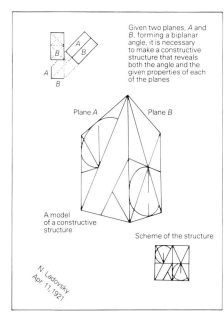

Given two planes, A and B, forming a biplanar angle, it is necessary to make a constructive structure that reveals both the angle and the given properties of each of the planes

Plane A Plane B

A model of a constructive structure

Scheme of the structure

N. Ladovsky
Apr. 11, 1921

75

These two drawings are closely related to Ladovsky's "Basis of the Construction of a Theory of Architecture" and the problems assigned by him at the architecture faculty of Vkhutemas in October 1920.

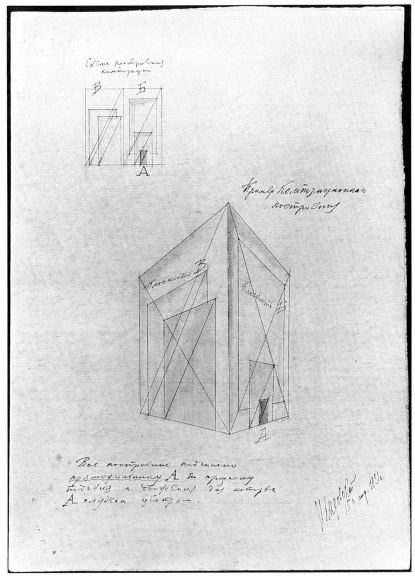

76

77

76 NIKOLAI ALEXANDROVICH LADOVSKY. *EXAMPLE OF A COMPOSED STRUCTURE. Ink, pencil, and wash on cardboard. 38 x 27.5 (C175). Signed and dated l r: "April 15, 1921." On reverse, circular Inkhuk stamp with no number.*

77 *Diagrammatic rendering and translation of plate 76.*

78 IVAN VASILIEVICH KLIUN. *WORK NO. 2 FOR THE TASK CONSTRUCTION, c. 1920. Pencil on paper. 23 x 19.8 (180.80). Inscribed u l:* "Work No. 2 for the Task Construction"; *l r:* "Ivan Kliun." *On reverse, Inkhuk stamp no. 25.* An almost identical work, similarly inscribed but of slightly different dimensions, is in the collection of the Grosvenor Gallery, London. Kliun's studies for a memorial to Rozanova and the related studies for constructions (plate 293) are closely linked to this work, which he submitted to Inkhuk but which may date from slightly earlier.

For biography see page 139.

78

KONSTANTIN KONSTANTINOVICH MEDUNETSKY

Born Moscow, 1899; died c. 1935.

In 1914 studied at the Stroganov Art Institute in Moscow, specializing in stage design. In 1919 was a founding member of Obmokhu and contributed to its first, second (1920), and third (1921) group exhibitions. In the second Obmokhu exhibition showed his pure "laboratory work" done in close association with the Stenberg brothers. Became a member of Inkhuk in 1920. In January 1921, with the Stenbergs, organized an exhibition of sixty-one nonutilitarian constructions entitled "The Constructivists" at the Poets' Café in Moscow. Was represented in the 1922 "Erste russische Kunstausstellung" (First Russian Art Exhibition), at the Galerie van Diemen in Berlin. In 1924 worked with the Stenbergs on stage sets for Alexandr Tairov's Kamernyi (Chamber) Theater in Moscow and also contributed to the "Pervaia diskussionaia vystavka obedinenii aktivnogo revoliutsionnogo iskusstva" (First Discussional Exhibition of the Associations of Active Revolutionary Art) in Moscow. Also designed film posters. In 1925 sent work to the Exposition Internationale des Arts Décoratifs et Industriels Modernes in Paris. In the 1930s continued to exhibit at home and abroad.

79

79 KONSTANTIN KONSTANTINOVICH MEDUNETSKY. *CONSTRUCTION, 1920.* Brown ink on paper. 27 x 19.1 (C178). Signed, titled, and dated l r: "1920." On reverse, Inkhuk stamp no. 27.

80 KONSTANTIN KONSTANTINOVICH MEDUNETSKY. *COMPOSITION, 1920.* Pencil and orange crayon on paper. 26.8 x 23.4 (C179). Signed l r. On reverse, Inkhuk stamp no. 26.

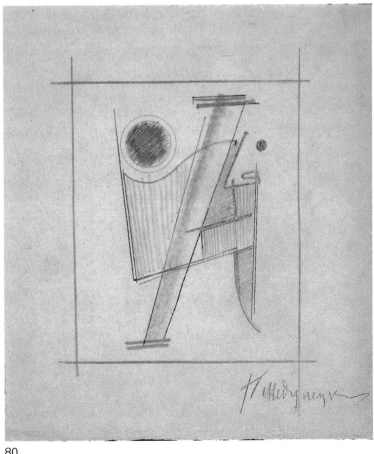

80

81 LIUBOV SERGEEVNA POPOVA. *SPATIAL CONSTRUCTION, c. 1921. Gouache on cardboard. 33.5 x 27 (Tretiakov Gallery TR76).*

82 LIUBOV SERGEEVNA POPOVA. *COMPOSITION, 1921. Gouache on paper. 34.3 x 27.5 (190.80). Signed and titled on reverse: "L. Popova Composition." Inkhuk stamp no. 2.* An almost identical work of the same dimensions (formerly in the Costakis collection, now in the Tretiakov Gallery, plate 866) is dated 1921.

For biography see page 344.

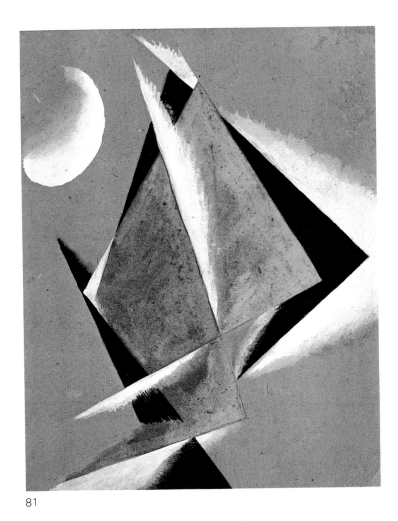

81

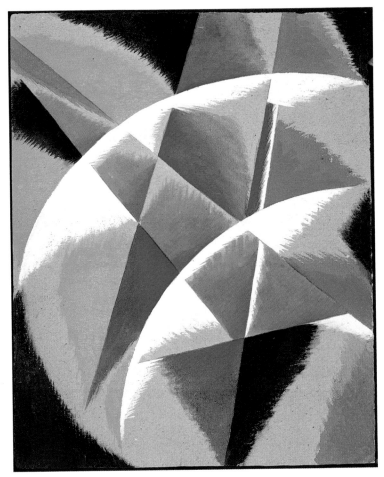

82

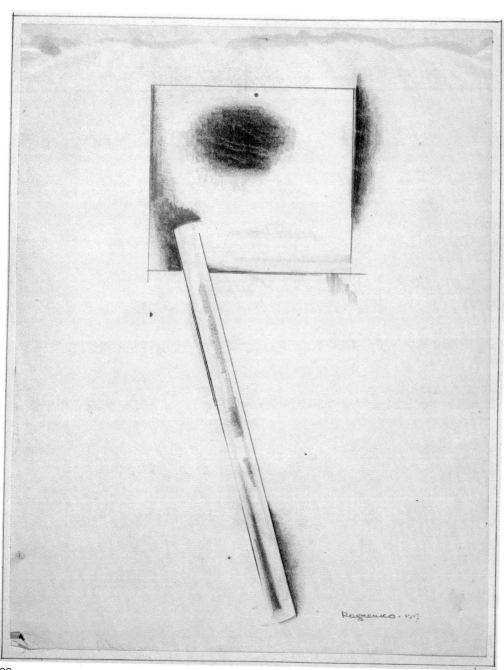

83 ALEXANDR MIKHAILOVICH RODCHEN-KO. *COMPOSITION. Pencil and colored crayon on paper mounted on paper. 26.6 x 21.5 (C171). Signed and dated l r: ''Rodchenko 1917.'' Inkhuk stamp no. 11.* This drawing is one of a series of designs for lamps that Rodchenko made for the Café Pittoresque in 1917. Yakulov supervised the project, which was intended as a synthesis of fine arts, literature, and theater (see plate 1167). It is plausible that Rodchenko would have submitted this earlier work to Inkhuk in the ''construction''-''composition'' context in view of the group's concern for the creation of production art. During 1921–22, Rodchenko was centrally involved in the formulation of a theory of Productivist art at Inkhuk.

For biography see page 446.

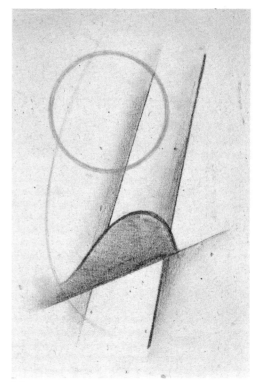

84

VLADIMIR AVGUSTOVICH STENBERG

Born Moscow, April 4, 1899; lives Moscow.

Born to a Swedish father and a Russian mother; grew up and worked closely with his younger brother, Georgii (1900—33). From 1912 to 1917 studied at the Stroganov Art Institute in Moscow. From 1918 to 1919 attended the Svomas in Moscow in the "Studio without a Supervisor," with Medunetsky and others. In 1918 worked on the agit-decorations for both the May Day and the October Revolution celebrations in Moscow. Upon graduating from Svomas in 1919, he and Georgii became members of Obmokhu. Their work, along with that of Medunetsky, soon deviated from the Productivist tenets of social functionalism; it was considered research or "laboratory work." They showed this work in the second Obmokhu group exhibition in May 1920. That year, with Medunetsky, they became members of Inkhuk. In January 1921 at the Poets' Café they organized an exhibition of their own nonutilitarian constructions entitled "The Constructivists."

As early as 1915 the brothers were also involved in designing stage sets and film posters, the latter often carrying the joint signature "2 Sten" or "2-Stenberg-2." From 1922 to 1925 they designed stage sets for Alexandr Tairov at the Kamernyi (Chamber) Theater in Moscow.

They exhibited works at the 1922 "Erste russische Kunstausstellung" (First Russian Art Exhibition), at the Galerie van Diemen in Berlin, and at the 1925 Exposition Internationale des Arts Décoratifs et Industriels Modernes in Paris.

From 1929 to 1932 taught at the Architecture Construction Institute in Moscow; after Georgii's death, Vladimir continued to work on poster design.

84 VLADIMIR AVGUSTOVICH STENBERG. *COMPOSITION, 1920. Colored pencil on paper. 21 x 13.9 (182.80). Signed, titled, and dated on reverse: "Composition 1920 V. Stenberg." Inkhuk stamp no. 5.*

85 VLADIMIR AVGUSTOVICH STENBERG. *CONSTRUCTION, 1920. Ink on paper. 25.4 x 19.3 (C165). Signed l r; not dated. Inkhuk stamp no. 6.*

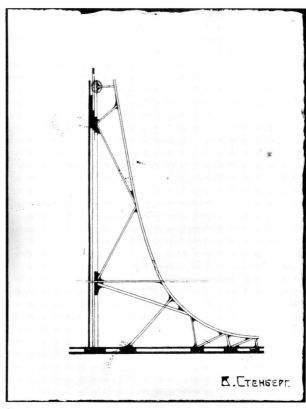

85

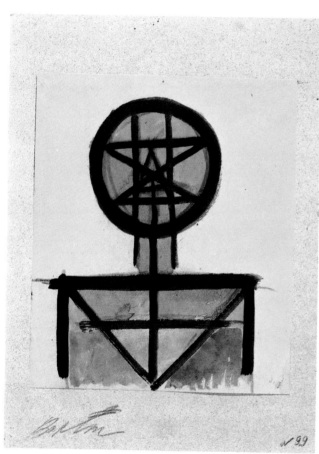

86

86 VARVARA FEDOROVNA STEPANOVA.
*COMPOSITION. Gouache on paper mounted
on gray paper. 22.3 x 18.5 (C172). Signed l l on
mount: ''Varst''; not dated. Inkhuk stamp
no. 15.*

87 VARVARA FEDOROVNA STEPANOVA.
*CONSTRUCTION. Collage on paper. 35.9 x 22.9
(C173). Signed on reverse: ''Varst''; not dated.
Inkhuk stamp no. 16.*

For biography see page 467.

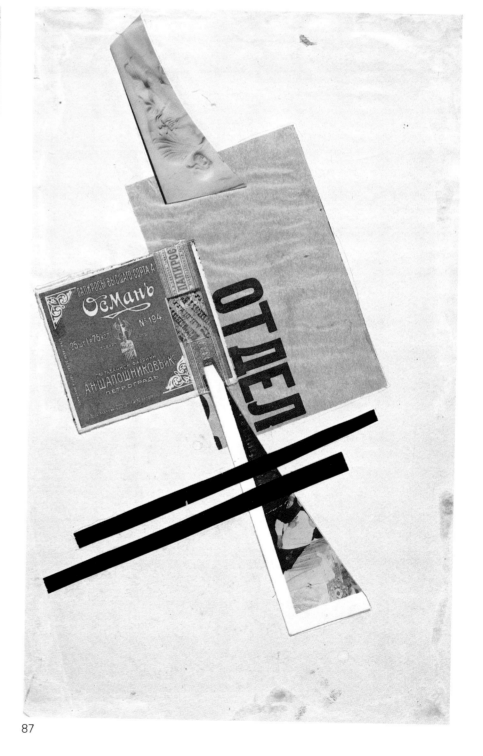

87

NIKOLAI MIKHAILOVICH TARABUKIN

Born Moscow, 1899; died Moscow, 1956.

Before 1918 studied at Moscow University, specializing in history and philosophy. From 1920 was secretary of Inkhuk and took an active part in the debates on Construction and Production art in the group, which included Brik, Lissitzky, Rodchenko, and Stepanova. Wrote theoretical works on art, such as *Opyt teorii zhivopisi* (For a Theory of Painting), and *Ot molberta k mashine* (From the Easel to the Machine), both published in Moscow in 1923, and *Iskusstvo dnia* (The Art of Today), published in Moscow in 1925, which were the first theoretical commentaries on the problem of artistic representation and its limits. After his article on the artist Konstantin Bogaevsky (published in *Iskusstvo*, Moscow, 1928, Book 1/2), he ceased to appear in print and was accused increasingly of "formalism." His name has been rehabilitated recently with the posthumous publication of his study of the artist Mikhail Vrubel (Moscow, 1974).

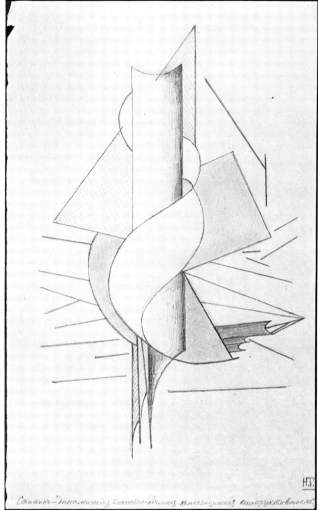

88

88 NIKOLAI MIKHAILOVICH TARABUKIN. *UNTITLED, c. 1921. Pencil on paper. 35.8 x 22.2 (C180). Signed l r: "N.T."; not dated. Inkhuk stamp no. 14. Inscribed along lower edge:* "Static-dynamic planar-volumetrical compositional constructiveness."

89 NIKOLAI MIKHAILOVICH TARABUKIN. *LINEAR COMPOSITION, c. 1921. Pencil on paper. 22 x 17.9 (C181). Signed l r: "N.T."; on reverse, in N. Babicheva's hand: "N. Tarabukin"; not dated. Inkhuk stamp no. 13. Inscribed along lower edge:* "Linear composition."

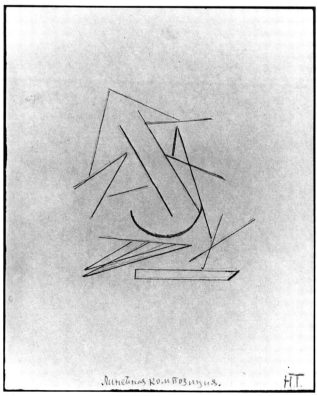

89

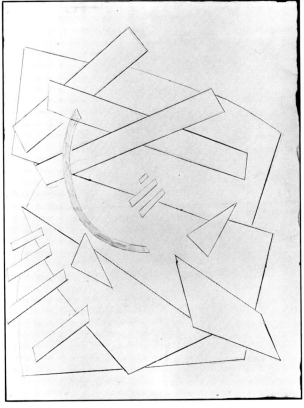

90

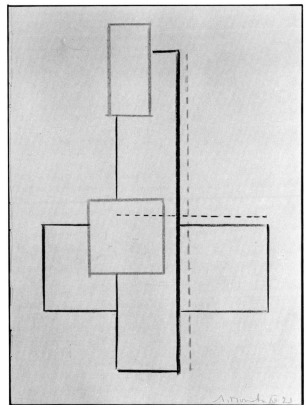

91

90 NADEZHDA ANDREEVNA UDALTSOVA. *UNTITLED. Blue ink and pencil on paper. 34.5 x 25.5 (C189). Not signed or dated; on reverse, in N. Babicheva's hand: "Udaltsova." Inkhuk stamp no. 24.*

For biography see page 484.

The following seven works by Popova, Bubnova, and Ioganson, though carrying no Inkhuk stamp, were acquired by Costakis as part of the Inkhuk portfolio. They should therefore be considered in that context.

91 LIUBOV SERGEEVNA POPOVA. *UNTITLED, 1921. Red and black crayon on paper. 27.6 x 20.7 (C188). Signed and dated l r: "L. Popova XII 21."*

92 LIUBOV SERGEEVNA POPOVA. *UNTITLED, 1921. Red and black crayon on paper. 27.6 x 20.7 (C187). Dated u r, not in the artist's hand: "1922." On the reverse, a drawing closely related in composition to plate 869.*

92

93

95

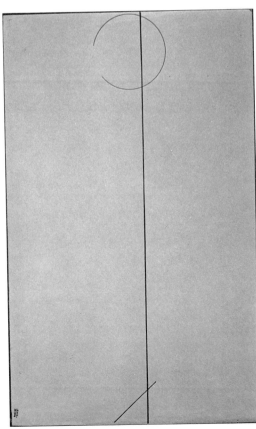

94

VARVARA DMITRIEVNA BUBNOVA

Born St. Petersburg, May 4, 1886; lives Sukhumi, Abkhazian Republic.

From 1907 to 1914 studied at the school of the Society for the Encouragement of the Arts, taking lessons from Nikolai Dubovskoi. From 1914 participated in numerous shows, including the Sixth, Eighth, and Ninth State Exhibitions in Moscow (all 1919) and the "Erste russische Kunstausstellung" (First Russian Art Exhibition), at the Galerie van Diemen, Berlin (1922). Around 1920 began to take an active part in the administration of IZO Narkompros in Moscow. Lived in Japan from 1922 to 1958, painting local scenes and also illustrating Japanese translations of Russian literature.

93 VARVARA DMITRIEVNA BUBNOVA. *UNTITLED. Ink on paper. 35.6 x 22.1 (C183). Signed l r: "V. B."; numbered u l: "II"; not dated.*

94 VARVARA DMITRIEVNA BUBNOVA. *UNTITLED. Ink on paper. 35.6 x 22 (C184). Signed l l: "V. B."; numbered u l: "I"; not dated.*

95 VARVARA DMITRIEVNA BUBNOVA. *UNTITLED. Ink on paper. 21.9 x 35.6 (C182). Signed l l: "V. B."; numbered u l: "III"; not dated.*

96

97

96 KAREL IOGANSON. *CONSTRUCTION, 1922.*
Paper collage, graphite, and colored pencil on
paper. 45.5 x 33.7 (196.80). Signed and dated l l:
"*Feb. 23, 1922.*" *Inscribed at top:* "Construction
by Ioganson/Depiction"; *on reverse:* "Ioganson.
23. II. 22. Moscow."

97 KAREL IOGANSON. *ELECTRICAL CIRCUIT*
(DEPICTION), 1922. Paper collage, graphite, and
colored pencil on paper. 45.4 x 33.6 (197.80).
Signed and dated l l: "February 23, 1922." *In-*
scribed at top: "Electrical Circuit/Depiction"; *on*
reverse: "Karel Ioganson. Moscow. 23. II. 22."

ALEXEI GEORGIEVICH JAWLENSKY

Born Torzhok, Tver Province, March 13, 1864; died Wiesbaden, March 15, 1941.

The son of a colonel in the Russian Imperial Army, Jawlensky attended military schools in Moscow from 1877 to 1884. Commissioned as a lieutenant in the army, stationed in Moscow from 1884. In 1889 requested a transfer to St. Petersburg; attended the Academy of Arts and in 1890 became a student there of Ilia Repin. In 1891 met Marianna Werefkin, also a student of Repin; formed an alliance with her that lasted more than twenty years. Withdrew from the academy in 1893. In 1896 resigned from the army and traveled to Munich to study at the school of Anton Ažbé, where he met Kandinsky. In 1899 visited Venice with Ažbé's class and that year left the school. In 1903 participated in the exhibition of the Munich Secession. In 1905 traveled to France (Brittany, Provence, Paris); met Matisse; participated in the Salon d'Automne. Exhibited in Russia in 1906 in the *Mir iskusstva* (World of Art) exhibition, St. Petersburg; at the Soiuz russkikh khudozhnikov (Union of Russian Artists) in the winter of 1906–07 and in 1909, and in the 1908 "Venok" (Wreath), in St. Petersburg. Also showed work in Izdebsky's salon of 1909, in Odessa, Riga, Kiev, and other cities, and in the 1910 salon, in Odessa; and in the 1910 "Bubnovyi valet" (Jack of Diamonds) exhibition in Moscow.

In 1909 was among the founders of the Neue Künstlervereinigung (New Artists' Association) in Munich with Kandinsky, Gabriele Münter, Werefkin, and others; participated in its exhibitions from 1909 to 1912. In 1912 showed works at the "Erste deutsche Herbstsalon" (First German Autumn Salon), at Der Sturm gallery in Berlin. In 1914 made his last visit to Russia and fled to Switzerland at the outbreak of the war. That year exhibited with *Der blaue Reiter* (The Blue Rider) in Scandinavia.

In 1921 settled in Wiesbaden. In 1924 was a founder of Die blauen Vier (The Blue Four), whose other members were Paul Klee, Kandinsky, and Lyonel Feininger.

Both the Jawlenskys were purchased from the son of a close friend of the artist.

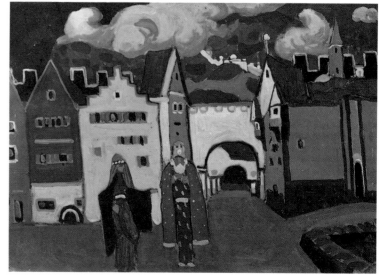

98

98 *ORIENTAL CITY, 1908. Oil on cardboard. 30 x 43.5 (Tretiakov Gallery TR27).*

99 *HOUSE IN THE MOUNTAINS, c. 1912. Oil on canvas. 49.5 x 53 (Tretiakov Gallery TR31).*

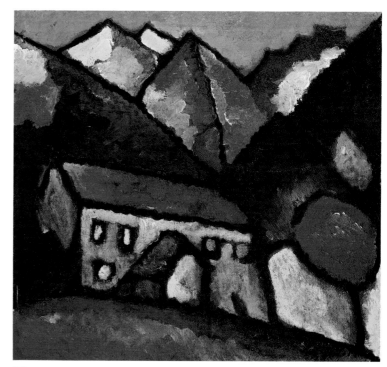

99

DAVID NESTOROVICH KAKABADZÉ

Born Kukhi, near Kutaisi, Georgia, August 20, 1889; died Tbilisi, May 10, 1952.

Studied at Paevsky's private school with Vasilii Krotkov in Kutaisi; did magazine illustrations and designed stage sets. From 1910 to 1916 attended the natural sciences division of the physics and mathematics faculty at the University of St. Petersburg and simultaneously, from 1910 to 1915, studied at the private studio of Lev Dmitriev-Kavkazsky. Member of the St. Petersburg Soiuz molodezhi (Union of Youth), where he had contact with Pavel Filonov.

In 1918 returned to Georgia and emerged as a leading figure; studied the history of folk ornament; met Russian Futurist poets Alexei Kruchenykh, Ilia Zdanevich, and Igor Terentiev, living in Tbilisi at the time.

From 1918 to 1927 lived in Paris; created a series of nonrepresentational works — paintings and reliefs; was an engineer-inventor in the field of stereoscopic cinema.

Returned to Georgia permanently in 1927, exhibited abstract paintings of the Paris period in a one-man show in Tbilisi in May 1928. Was a professor at the Academy of Arts in Tbilisi and continued painting and work on theater designs.

100 *PAINTING, 1922. Oil on cardboard. 51.5 x 61.5 (Tretiakov Gallery TR142). Signed and dated l l: "D. Kakabadzé 1922." Acquired from the widow of the artist.*

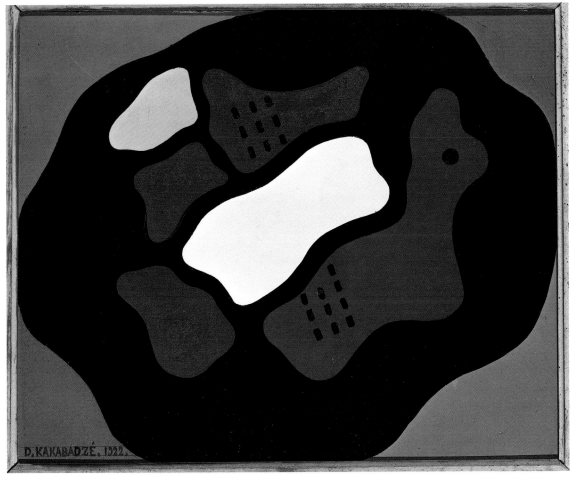

WASSILY (VASILII) VASILIEVICH KANDINSKY

*Born Moscow, December 5, 1866; died Neuilly-sur-Seine,
France, December 13, 1944.*

Spent his childhood in Moscow and Odessa. In 1886 began to study law and economics at Moscow University. In 1889 traveled with an ethnographic expedition to Vologda Province; in 1893 was appointed to the Department of Law at Moscow University. In 1896 declined an offer to teach at Dorpat (now Tartu) University in Estonia, and decided to dedicate himself entirely to art. From 1897 to 1899 studied in Munich at the school of Anton Ažbé, where he met Jawlensky, and in 1900 entered the studio of Franz Stuck at the Munich Academy. In 1901 founded the Munich Phalanx group. In 1902 formed the Phalanx school, where Gabriele Münter was one of his pupils; from 1903 to 1906 traveled intermittently in Europe with Münter. In 1909 cofounded the group Neue Künstler-vereinigung (New Artists' Association). Lived in Germany until the beginning of World War I, but visited Russia regularly. Participated in 1907 and 1908 in the exhibits of the Moskovskoe tovarish-chestvo khudozhnikov (Moscow Association of Artists) and in 1909 in Vladimir Izdebsky's salon in Odessa and elsewhere. In winter 1910 participated in the first "Bubnovyi valet" (Jack of Diamonds) exhibition in Moscow. In 1911 published "Kuda idet 'novoe' iskusstvo" (Whither the "New" Art), in Odessa. The Russian version of *On the Spiritual in Art* was read on his behalf by Nikolai Kulbin at the All-Russian Congress of Artists in St. Petersburg in 1911. Was Munich correspondent for the St. Petersburg magazine *Apollon.*

Participated in the 1913 "Postoiannaia vystavka sovremennogo iskusstva" (Permanent Exhibition of Contemporary Art) and in the "Vystavka graficheskikh iskusstv" (Exhibition of Graphic Art), both in St. Petersburg.

From late 1914 to 1921 lived in Moscow (except for the period December 1915 – March 1916, which he spent in Stockholm). Participated in exhibitions of Russian art in Malmö, Sweden; the "Vystavka zhivopisi 1915 god" (Exhibition of Painting: 1915) in Moscow; and the 1916 – 17 "Vystavka sovremennoi russoi zhivo-pisi" (Exhibition of Contemporary Russian Painting) in Petrograd. In 1917 married Nina Andreevskaia. From 1918 onward was one of the chief organizers of artistic life in Russia, a member of the collegium of IZO Narkompros, author of plans for a network of contemporary art museums, professor at Moscow University and, from 1920 on, at Vkhutemas. Both Inkhuk (1920) and GAKhN (1921) began their operations according to plans developed by Kandinsky. From 1919 to 1920 was in constant contact with Rod-chenko, Stepanova, and other members of the Russian avant-garde. From 1918 to 1927 contributed to many exhibitions in Moscow, Leningrad, and Vitebsk, including the "Fifth State Exhi-bition: From Impressionism to Nonobjective Art," the "Nine-teenth State Exhibition," and the "Exhibition of Four" (with Rod-chenko, Stepanova, and Nikolai Sinezubov), all in Moscow. Kandinsky's pedagogical and theoretical activity during the years 1918 to 1921 became the basis for his later work at the Bauhaus.

At the end of 1921 left for Germany. Showed work at the 1922 "Erste russische Kunstausstellung" (First Russian Art Exhibition), at the Galerie van Diemen in Berlin, and that same year had a one-man show in several German cities, as well as in Stockholm and New York. From 1922 to 1933 was a professor at the Bauhaus. From 1933 onward lived in France. Was active as a painter and writer until his death.

Unless otherwise indicated, all the Kandinskys came either from the collection of E. I. Krylov, Nina Kandinsky's mother, or from the widow of Vasilii Dmitrievich Bobrov, Kandinsky's student and later secretary.
See also pages 110 and 111.

101 *ETCHING 1916 NO. VI, 1916. Drypoint. Sheet size: 32.5 x 24.6; image: 12.4 x 9.8 (66.78). Dated l l: "1916 No VI 2/10"; signed l r: "Kandinsky." One of ten numbered and signed examples, made in Stockholm early in 1916. H. K. Röthel, Kandinsky: Das graphische Werk (Cologne, 1970), no. 158.*

102 *CRINOLINE, 1917. Watercolor on paper. 37.8 x 27.4 (65.78). Not signed or dated.*

103 *FAREWELL, 1903. Woodcut on paper. 69 x 69 (C371). Not signed or dated. Röthel, Kandinsky: Das graphische Werk, no. 20.*

104 *SONGS WITHOUT WORDS, 1903. Fifteen woodcut prints. Various dimensions (sheet size: 32.6 x 25.6) (167.80). Röthel, Kandinsky: Das graphische Werk, no. 10.*

105 *GREEN LADIES, 1907. Color linocut. 11.9 x 23.6 (C87). Stamped on reverse with Kandinsky's Munich address: "Millerstrasse 36." Röthel, Kandinsky: Das graphische Werk, no. 57.*

106 *THE BOUQUET, 1904. Woodcut on paper. 5.5 x 10.7 (C498). Signed in pencil: "Kandinsky." Röthel, Kandinsky: Das graphische Werk, no. 36.*

103

104

101

105

102

106

107 *MURNAU, 1908. Oil on cardboard. 31 x 43 (formerly Costakis collection).*

108 *CHAPEL NEAR MURNAU, 1908. Oil on cardboard, 31 x 43 (formerly Costakis collection).*

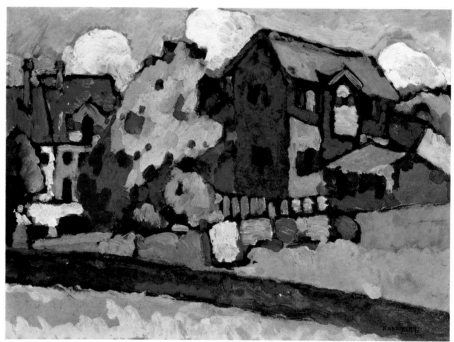

107

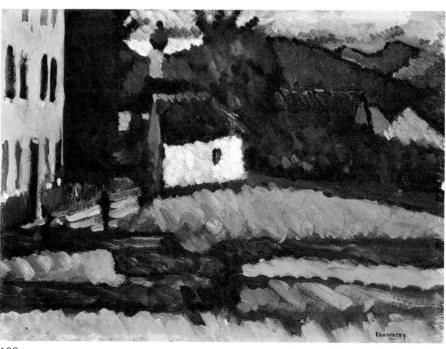

108

109 *MUNICH, 1901. Oil on cardboard. 17 x 26.5 (Tretiakov Gallery TR116).*

110 *KOCHEL, 1902. Oil on cardboard. 24 x 33 (Tretiakov Gallery TR117).*

111 *MURNAU, 1908. Oil on cardboard. 31 x 43 (Tretiakov Gallery TR115).*

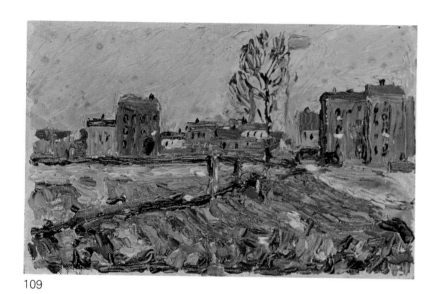

109

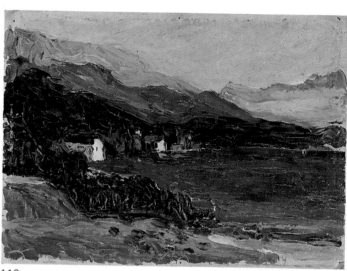

110

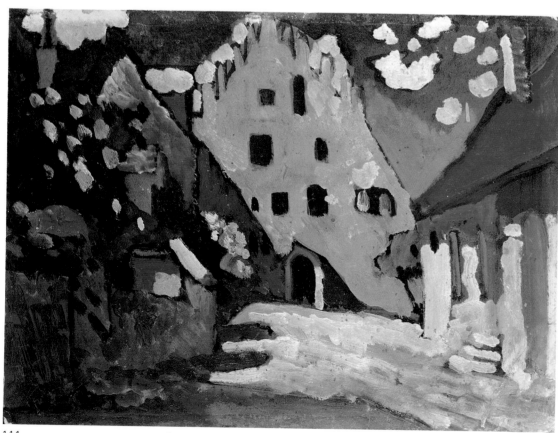

111

112 *UNTITLED (RED SQUARE), c. 1917. Oil on
cardboard. 51.5 x 49.5 (Tretiakov Gallery TR118).*

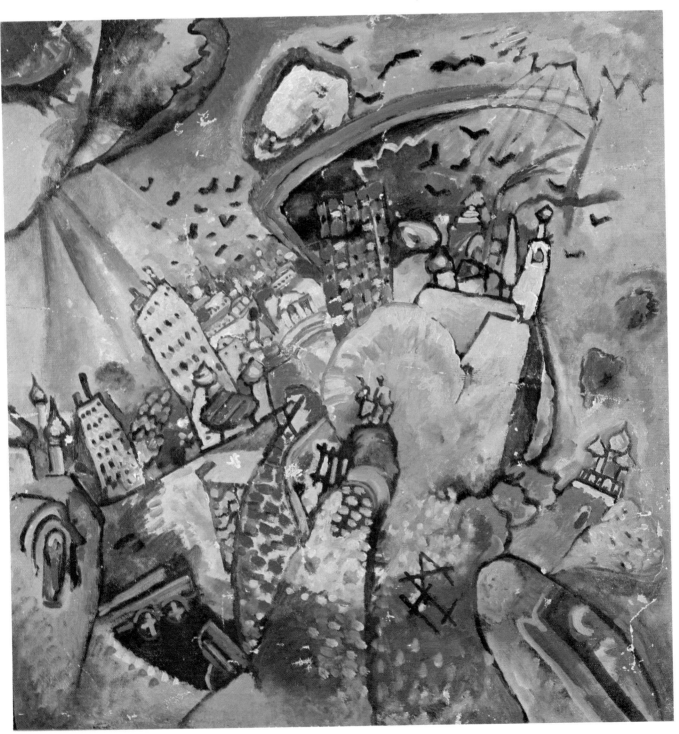

113 *LADIES IN CRINOLINES, 1917. Gouache on cardboard. 28 x 57 (Tretiakov Gallery TR119). The first Kandinsky purchased by Costakis, this came from the collection of Budkevich, Moscow.*

114 *LADIES IN CRINOLINES, c. 1917. Painting on glass. 25 x 41 (Tretiakov Gallery TR120).*

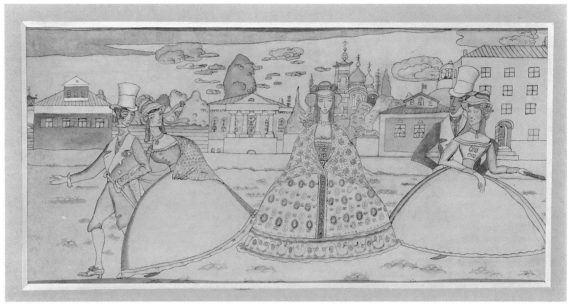

113

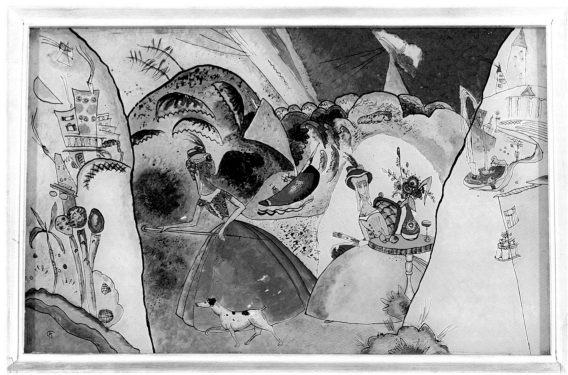

114

115 *BOATS, 1920. Watercolor and ink on paper. 32.2 x 24.9 (70.78). Signed and dated l l: ''K 20.''*

116 *UNTITLED, 1919. Ink on paper. 34.2 x 25.3 (64.78). Signed and dated l l: ''K 19.''*

117 *ABSTRACTION, 1918. India ink on paper. 24 x 15.5 (Tretiakov Gallery TR5). Signed and dated l l: ''K 18.''*

118 *ETCHING 1916 NO. III, 1916. Drypoint. Sheet size: 39.9 x 29.9; image: 13.5 x 16 (Tretiakov Gallery TR61). Signed l r: ''Kandinsky''; dated l l: ''1916 no. III.'' Röthel, Kandinsky: Das graphische Werk, no. 155.*

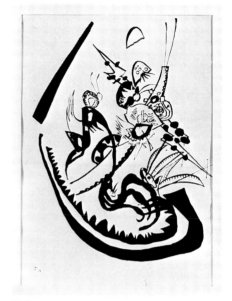

116

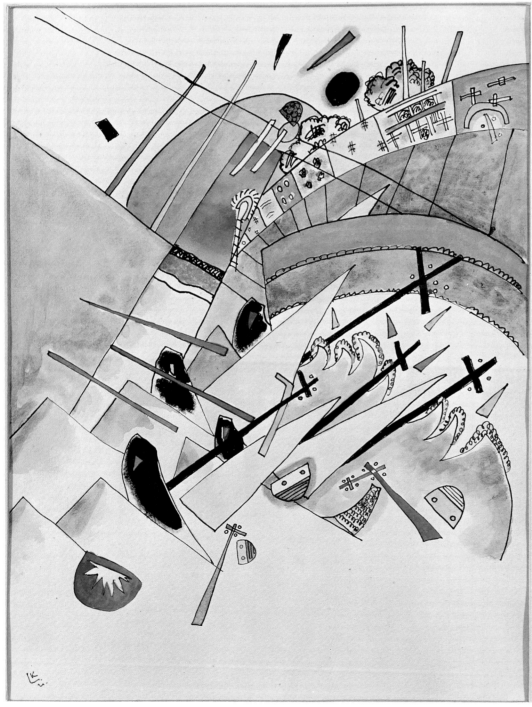

115

117

118

119 *RED EDGE, 1919. Oil on canvas. 92 x 70 (formerly Costakis collection). Inscribed on reverse, not in the artist's hand: "No. 219/1919." Acquired through R. Falk from the widow of the art historian A. G. Romm, Moscow.*

120 *WINTER DAY, SMOLENSK BOULEVARD, MOSCOW, 1919. Oil on cardboard. 26.5 x 32 (Tretiakov Gallery TR114).*

120

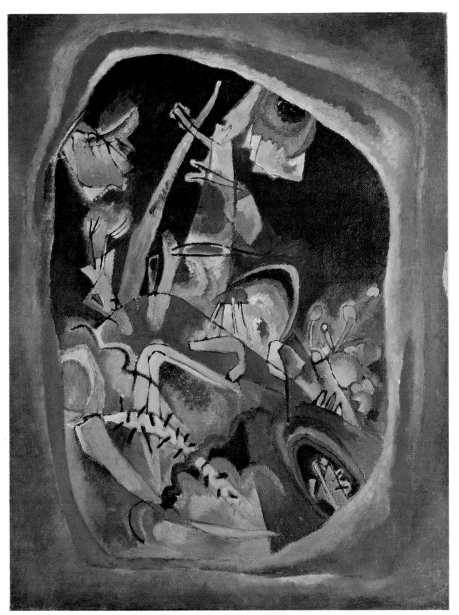

119

121 *ABSTRACTION, c. 1920–21. Gouache on paper. 32.5 x 25 (Tretiakov Gallery TR121).*

122 *KLEINE WELTEN* III, 1922. *Color lithograph. Sheet size: 36 x 28; image: 27.8 x 23 (C534). Signed in pencil on mount:* "Kandinsky." Röthel, *Kandinsky: Das graphische Werk,* no. 166.

123 *LITHOGRAPH NO. III, 1925. Sheet size: 47.8 x 33.9; image: 26.4 x 19 (C521). Signed, dated, and numbered on mount:* "Kandinsky. 1925 no. III, 37/50." Röthel, *Kandinsky: Das graphische Werk,* no. 187.

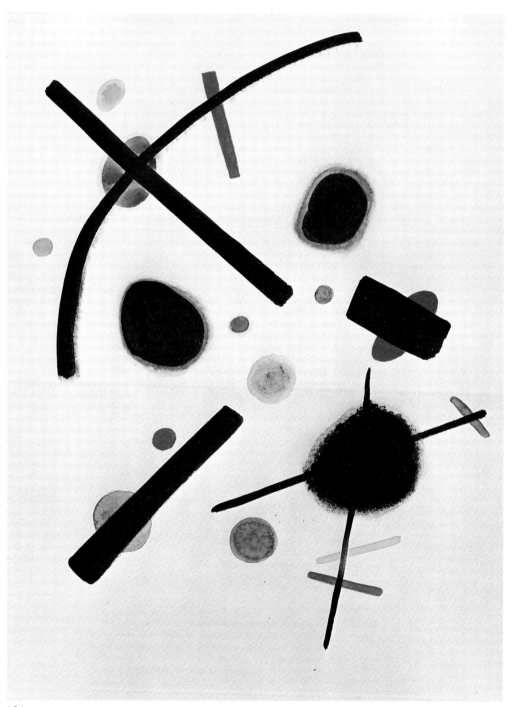

121

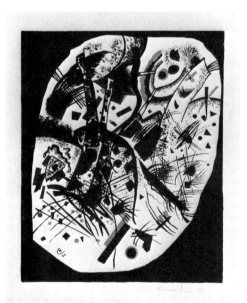

122

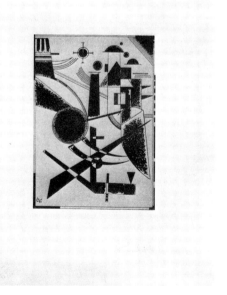

123

IVAN VASILIEVICH KLIUN (KLIUNKOV)

Born Kiev, 1873; died Moscow, late 1942.

During the 1890s studied art in Warsaw and Kiev, while earning a living as a bookkeeper. In the early 1900s attended private studios in Moscow, including those of Fedor Rerberg and Ilia Mashkov. In 1907 met Malevich. In 1910 cofounded the Moscow Salon, an exhibiting society. In 1913 was in close contact with Malevich, Matiushin, and Kruchenykh and made his first attempts at painted sculptural relief compositions. Contributed to the last Soiuz molodezhi (Union of Youth) exhibition in 1913–14 in St. Petersburg. From 1914 to 1916 created a series of reliefs and spatial sculptures.

In 1915 supported Malevich's Suprematism and illustrated Kruchenykh's literary polemic *Tainye poroki akademikov* (Secret Vices of Academicians); essays by Malevich and Kliun concluded the book. Also that year contributed to the "Tramvai V. Pervaia futuristicheskaia vystavka kartin" (Tramway V: First Futurist Exhibition of Paintings) in Petrograd. Worked on the problem of color in painting.

In 1915–16 participated in the major avant-garde exhibitions, including "The Last Futurist Exhibition of Pictures: 0.10" in Petrograd, "Magazin" (The Store) in Moscow, and the "Bubnovyi valet" (Jack of Diamonds) in Moscow. In 1916–17 contributed to the first issue of *Supremus*, the journal of the group of the same name, which never appeared.

In 1917 was named director of the Central Exhibition Bureau of Narkompros. From 1918 to 1921 was professor of painting at Svomas, later Vkhutemas; in 1921 was a member of Inkhuk and also a corresponding member of GAKhN. Participated in the 1919 Fifth ("From Impressionism to Nonobjective Art") and Tenth ("Nonobjective Creation and Suprematism") State Exhibitions in Moscow.

During the 1920s and 1930s created a series of still lifes with geometric forms and color relationships. In 1922 sent work to the "Erste russische Kunstausstellung" (First Russian Art Exhibition), at the Galerie van Diemen in Berlin. In 1923 designed a series of Futurist publications, including Kruchenykh's *Faktura slova* (Verbal Texture). In 1925 was a member of the Four Arts group and turned to a Purist style.

All the works by Kliun were acquired directly from the artist's daughter.

124 *IVAN KLIUN.* Photographer unknown.

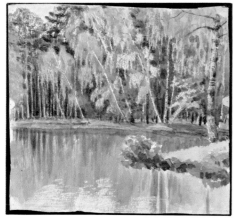

125

Kliun's origins in Russian Symbolism are clearly evident in these three works, which demonstrate an affinity with Nikolai Milioti, Mikhail Vrubel, Viktor Borisov-Musatov, and Pavel Kuznetsov, and also with the Lithuanian Mikalojaus Čiurlionis. Kliun's own strikingly developed sensibility is comparable to Malevich's: at this early stage in their friendship the two artists share aesthetic compatibilities that were to become strong during the development of Suprematism five years later (see for example Malevich's *Woman in Childbirth*, plate 478).

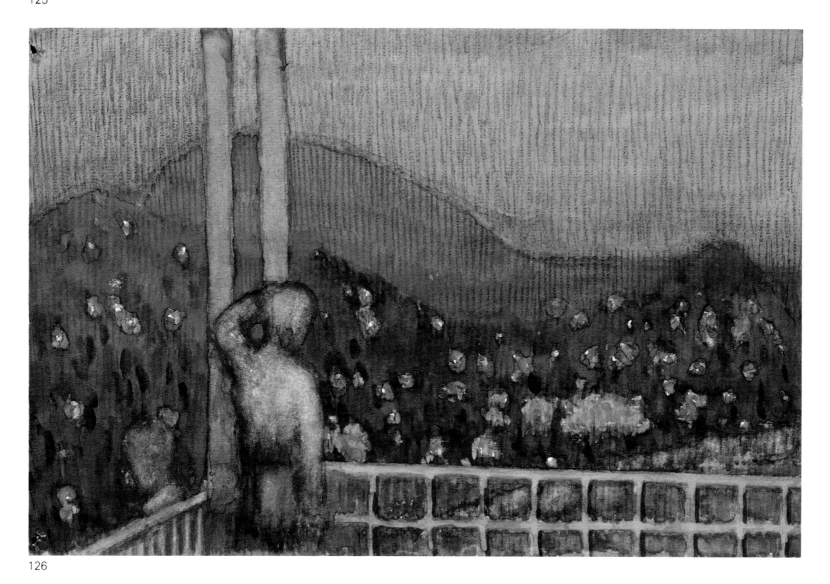

126

125 *UNTITLED, 1905. Watercolor and pencil on paper. 23.3 x 25.4 (C369). Dated on reverse:* "1905."

126 *UNTITLED, 1908. Watercolor, gouache, and pencil on paper. 17 x 25.3 (804.79). Inscribed on reverse by the daughter of the artist:* "I guarantee that this is the work of my father, I. Kliun. S. S."

127 *PORTRAIT OF THE ARTIST'S WIFE (CONSUMPTION), 1910. Watercolor, charcoal, and pencil on paper. 34.2 x 29.1 (C549). Dated l c:* "1910." This Symbolist composition portrays Kliun's wife near the end of her final illness. In the center background, in white, he has depicted a premonition of her death.

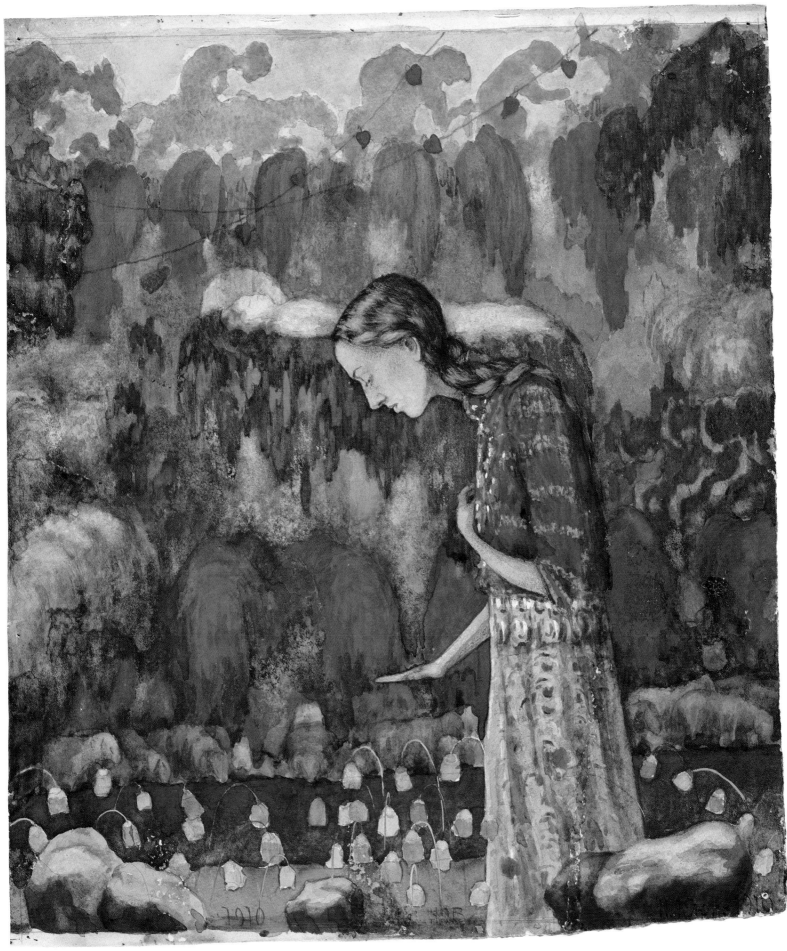

128 *SELF-PORTRAIT, 1909–10. Pencil on paper. 26.4 x 20.6 (808.79 recto). Dated on reverse: "1910." There is another pencil version of the self-portrait on the verso.*

129 *SELF-PORTRAIT, 1909–10. Oil on cardboard. 39 x 21 (Tretiakov Gallery TR95).*

130 *FAMILY, 1911. Oil on board. 46.4 x 36.3 (85.78). Signed l l: "I. Kliun"; signed, titled, and dated on reverse: "I. Kliun 'Family' 1911."* Two earlier studies for this work are on *oeuvre catalogue,* sheets 2 and 3 (plates 250 and 251).

128

129

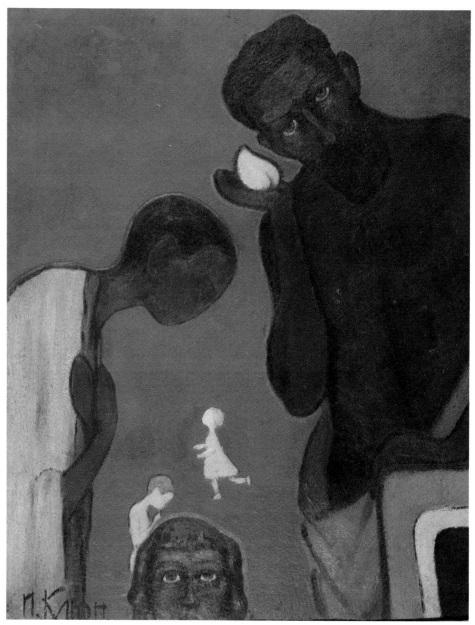

130

131 *LANDSCAPE, 1911. Oil on cardboard. 35.5 x 46.5 (Tretiakov Gallery TR98). Signed l l: "I. Kliun"; dated l r: "1911."*

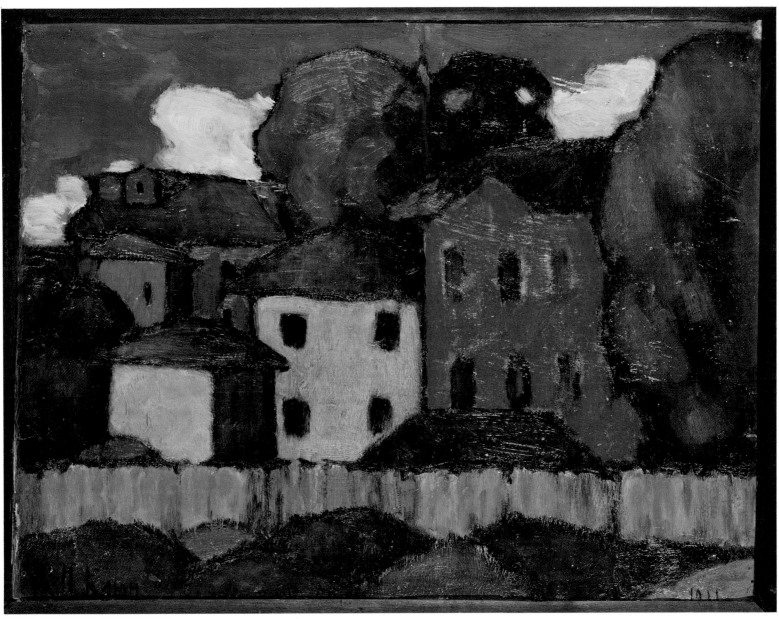

131

132 *UNTITLED. Wash on paper. 16 x 14.8 (274.80). Not signed or dated. Inscribed across center: "POKROV."* This and the next two plates are studies for *Landscape Rushing By* (plate 135).

133 *UNTITLED. Pencil on paper. 19.7 x 25.2 (283.80). Not signed or dated. Inscribed across center: "POKROV."*

134 *UNTITLED, n.d. Ink on paper. 13.4 x 8.7 (273.80). Signed l r: "I. Kliun."*

135 *LANDSCAPE RUSHING BY, c. 1914–15. Oil on wood, wire, metal, and porcelain. 74 x 58 (Tretiakov Gallery TR96). Signed l l: "I. K." (In a 1916 publication the initials with signature and date appear in the center. At some subsequent point Kliun moved them to the left.)* This sculpture was shown in 1915 in "The Last Futurist Exhibition of Pictures: 0.10" (no. 23) together with fourteen other pieces of sculpture by Kliun. The relief, while clearly expressing Italian Futurist concepts of speed and motion, is original in both medium and style. The porcelain fragments and wire from telephone poles, wood panels and disks, brilliant color, and repetition of forms lend the work a physical immediacy contrasting with its essentially conceptual nature. Though lacking the more rigorously abstract formulation of Rozanova's *Automobile* and *Bicyclist*, which appeared in the same exhibition (see plates 1036–40), the landscape does represent a departure from Kliun's more anecdotal *Cubist at Her Dressing Table* (shown in plate 1040), which was also exhibited. (Drawings for this apparently lost work appear on *oeuvre catalogue*, sheets 7 and 9, plates 257 and 261.)

132

133

134

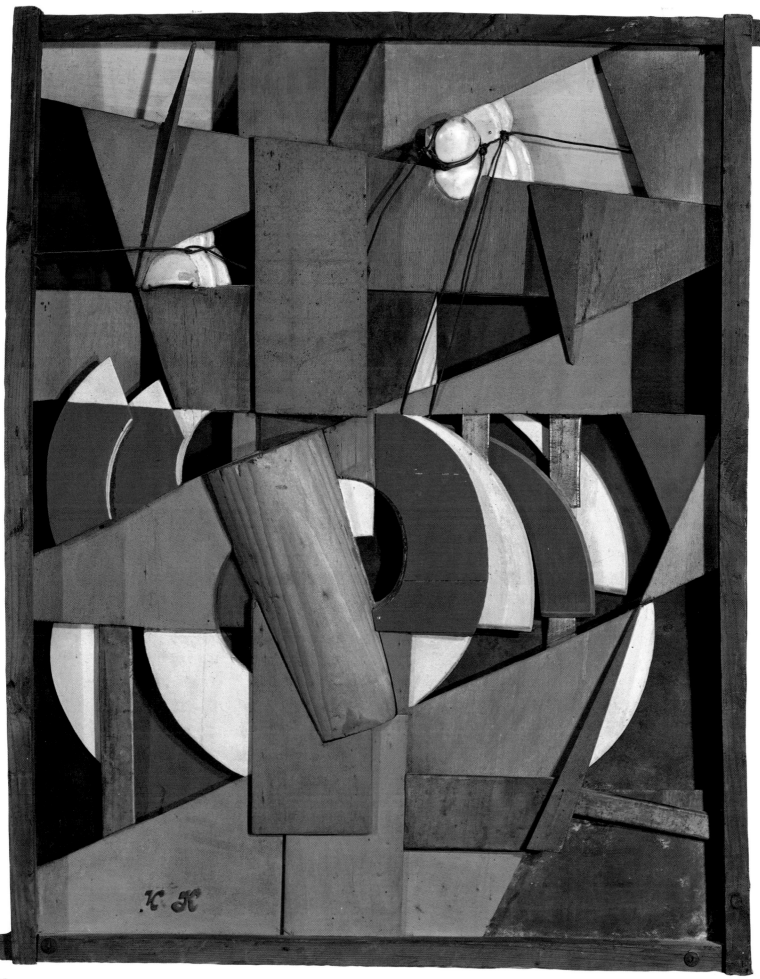

According to V. Rakitin, all the works shown on these two pages except plates 142, 143, and 144 were exhibited in the 1917 "Jack of Diamonds" exhibition, in Moscow.

136 *UNTITLED, c. 1917. Gouache, ink, and watercolor on paper. 31.3 x 22.5 (sight) (74.78). Not signed or dated.*

137 *UNTITLED, c. 1917. Watercolor and ink with pencil on paper. 30.5 x 26 (sight) (75.78). Not signed or dated.*

138 *SUPREMATISM, c. 1917. Oil on canvas. 35.3 x 35.8 (76.78). Not signed or dated.*

139 *SUPREMATISM, c. 1917. Oil on canvas. 35.6 x 35.7 (77.78). Not signed or dated.*

140 *SUPREMATISM: 3 COLOR COMPOSITION, c. 1917. Oil on board. 35.4 x 35.6 (82.78b). Signed and titled on reverse: "I. Kliun/ Suprematism/ 3 color composition." Not dated.*

141 *SUPREMATISM: 3 COLOR COMPOSITION, c. 1917. Oil on board. 35.7 x 35.2 (82.78a). Signed and titled on reverse: "I. Kliun/ Suprematism/ 3 color composition." Not dated.*

142 *UNTITLED, 1915. Pencil on paper. 15.4 x 11 (267.80). Signed and dated l r: "I. Kliun 1915." This image, which also appears in plate 281, was later used by Kliun to illustrate A. Kruchenykh's Turnir poetov (Tournament of Poets), Moscow, 1929, p. 12.*

143 *UNTITLED. Gouache on paper. 35.1 x 35.2 (183.80). Not signed or dated.*

144 *UNTITLED, c. 1917. Pencil on paper. 13.6 x 12 (C622). Not signed or dated.*

136

139

142

137

140

143

138

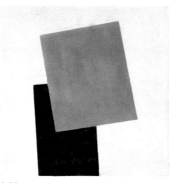

141

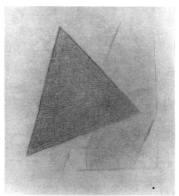

144

145 *UNTITLED, c. 1917. Oil on paper. 27 x 22.5 (87.78). Not signed or dated.*

146 *UNTITLED, c. 1917. Oil on paper. 27 x 22.5 (90.78a). Not signed or dated.*

147 *UNTITLED, c. 1917. Oil on paper. 27 x 22.5 (89.78). Not signed or dated.*

148 *UNTITLED, c. 1917. Oil on paper. 27 x 22.5 (86.78). Not signed or dated.*

149 *UNTITLED, c. 1917. Oil on paper. 27 x 22.5 (90.78b). Not signed or dated.*

150 *UNTITLED, c. 1917. Oil on paper. 27 x 22.5 (90.78c). Not signed or dated.*

151 *UNTITLED, c. 1917. Oil on paper. 27 x 22.5 (88.78). Not signed or dated.*

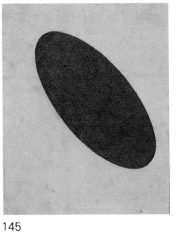

145

146

147

148

149

150

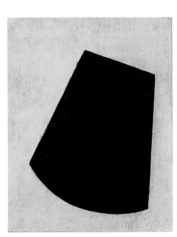

151

152 *UNTITLED, c. 1917. Gouache on paper.*
17.6 x 11 (281.80b). Not signed or dated.

153 *UNTITLED, c. 1917. Gouache on paper.*
17.6 x 13.3 (280.80). Not signed or dated.

154 *UNTITLED, c. 1917. Gouache on paper.*
11.1 x 8.5 (281.80a). Not signed or dated.

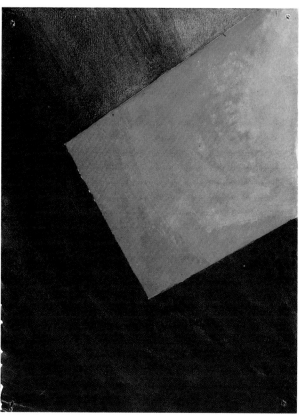

153

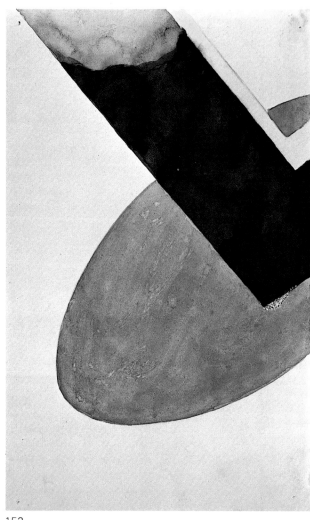

152

154

155 *SELF-PORTRAIT WITH SAW, 1922?.* Oil on canvas. 67 x 54 (Tretiakov Gallery TR97). A 1914 oil version of this composition exists, whereabouts unknown. The date of the present work is difficult to establish; V. Rakitin has suggested that it was painted over several years between 1917 and 1922.

156 *STUDY FOR "SELF-PORTRAIT WITH SAW," c. 1914?.* Pencil on paper. 22.5 x 18.2 (822.79). Signed l l: "I. K." A watercolor study is on *oeuvre catalogue*, sheet 12 (plate 266).

157 *UNTITLED, 1920.* Watercolor on paper. 17 x 11.2 (261.80). Signed and dated l r: "I. Kliun. XX." This is a study for plate 158.

158 *COMPOSITION, 1920.* Oil on cardboard. 73 x 39 (Tretiakov Gallery TR107).

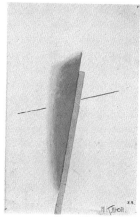

157

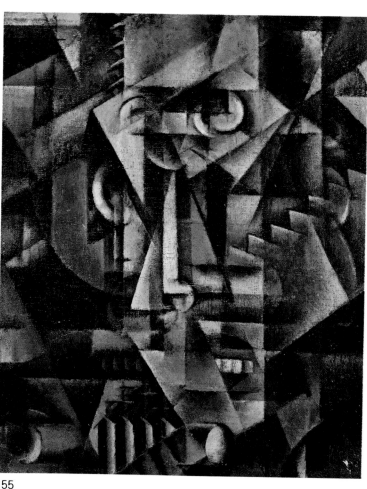

155

156

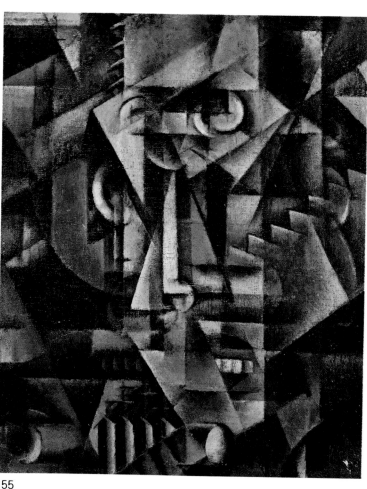

158

159 *UNTITLED, c. 1920–21. Oil on board. 73.6 x 60.9 (81.78). Not signed or dated.*

160 *BLUE LIGHT, 1923. Oil on canvas. 54.8 x 47.5 (79.78). Signed, titled, and dated on reverse: "I. Kliun, VII/1923, Blue Light."*

161 *LINEAR CONSTRUCTION, 1922. Oil on cardboard. 55 x 42 (Tretiakov Gallery TR99).*

162 *RED LIGHT, SPHERICAL COMPOSITION, c. 1923. Oil on canvas. 69.1 x 68.9 (84.78). Not signed or dated.*

159

160

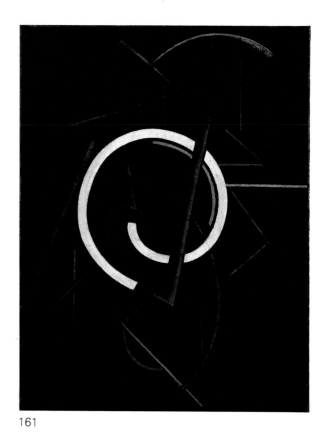

161

162

163 *UNTITLED, 1918–19. Watercolor and pencil on paper. 18.3 x 16.2 (255.80). Not signed or dated.* Study for the painting *Suprematism*, oil on canvas, 89 x 71, Tretiakov Gallery, Moscow (repr. color, *Paris-Moscou* [Paris, 1979], p.156).

164 *UNTITLED, c. 1922. Charcoal and gouache on paper. 25.4 x 27 (181.80). Not signed or dated.*

165 *COMPOSITION WITH THREE CENTERS, 1932. Oil on canvas. 65 x 46.5 (Tretiakov Gallery TR103). Not signed or dated.* After a watercolor of 1919 (*oeuvre catalogue*, sheet 6, plate 255).

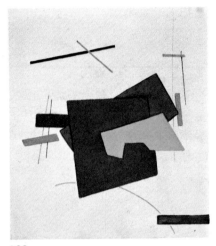

163

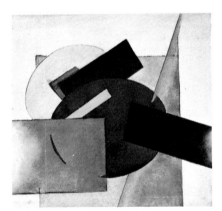

164

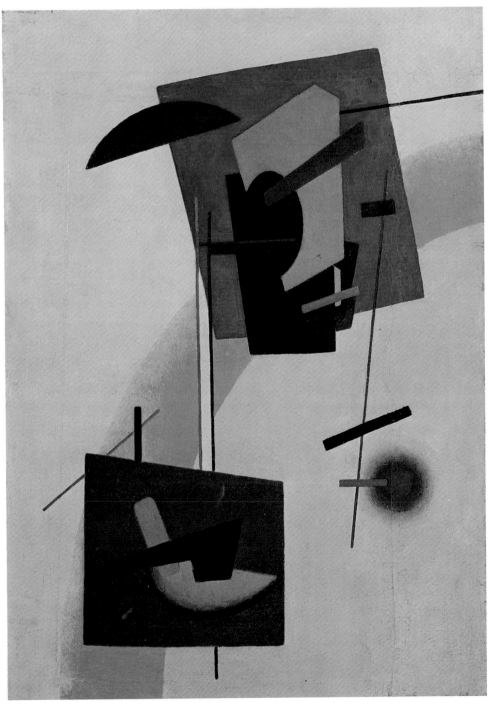

165

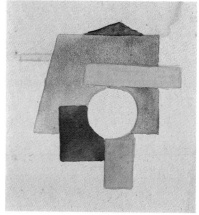

166

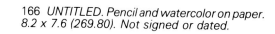

166 UNTITLED. Pencil and watercolor on paper. 8.2 x 7.6 (269.80). Not signed or dated.

The next five works are pages from a dismembered 1922 sketchbook.

167 Gouache and pencil on paper. 11.8 x 21.3 (801.79).

168 Watercolor and gouache on paper. 11.8 x 21.3 (290.80).

169 Watercolor and pencil on paper. 11.8 x 21.3 (259.80).

170 *Watercolor, colored pencil, pencil, and gouache on paper. 11.8 x 21.3 (292.80). On the right side of the page is a study for plate 175.*

171 Gouache and pencil on paper. 11.8 x 21.3 (295.80).

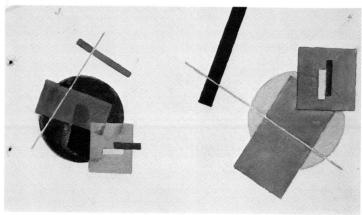

167

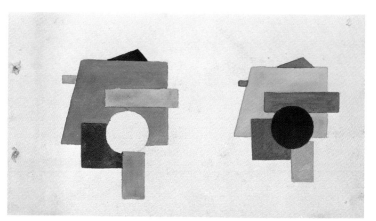

168

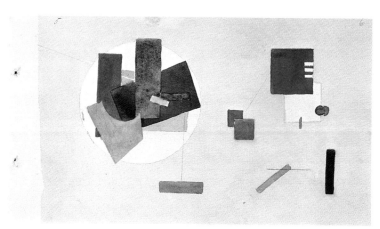

170

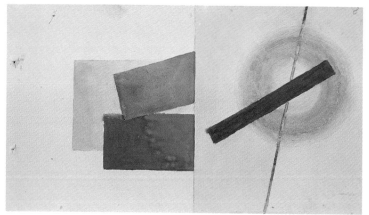

169

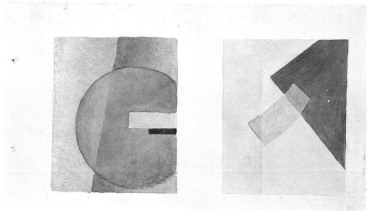

171

172 *UNTITLED, c. 1921–22. Gouache on paper.
38 x 29.3 (178.80). Not signed or dated.*

173 *UNTITLED, 1921–22. Gouache and water-
color on paper. 35.4 x 26.6 (179.80). Not signed
or dated.*

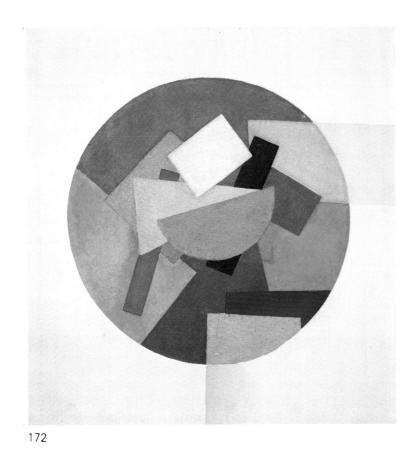

172

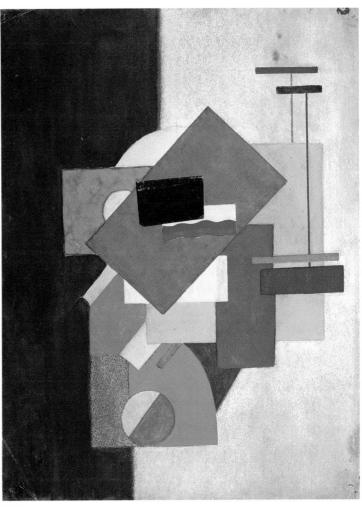

173

174

174 *UNTITLED, 1921–22. Pencil and colored pencil on graph paper. 11.1 x 7.9 (265.80). Signed l l: "KL." Not dated.* A detailed study for plate 175. A watercolor study also appears in the dismembered sketchbook of which Costakis owns several pages (plate 170).

175 *SUPREMATISM, 1922. Oil on canvas. 88 x 54.5 (Tretiakov Gallery TR101).*

176 *UNTITLED, c. 1922. Pencil on sketchbook page. 12.7 x 18.9 (799.79 recto). Not signed or dated.* A closely related drawing is on the verso.

177 *UNTITLED, c. 1921. Ink on paper. 8.7 x 13.8 (293.80). Signed u l: "I. Kliun."* Study (?) for plate 178. A pencil and gouache study is on *oeuvre catalogue,* sheet 9 (plate 261).

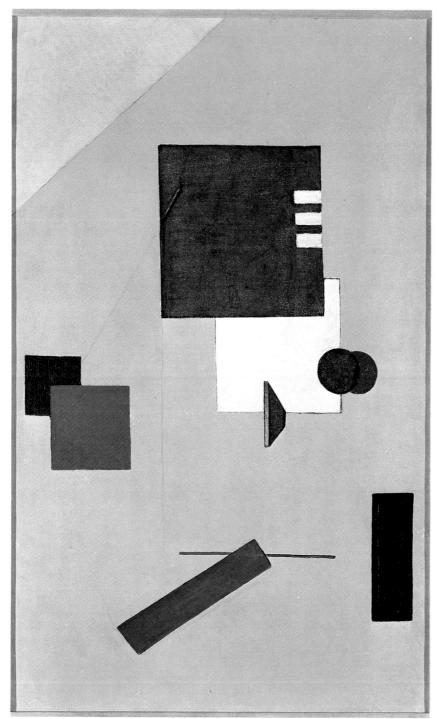

175

176

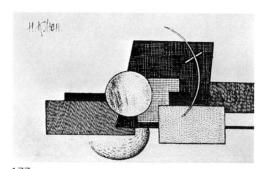

177

178 *SUPREMATIST COMPOSITION NO. 6,
1921. Oil on wood (?). 38 x 53.5 (Tretiakov
Gallery TR102). Signed u l: "I. Kliun."*

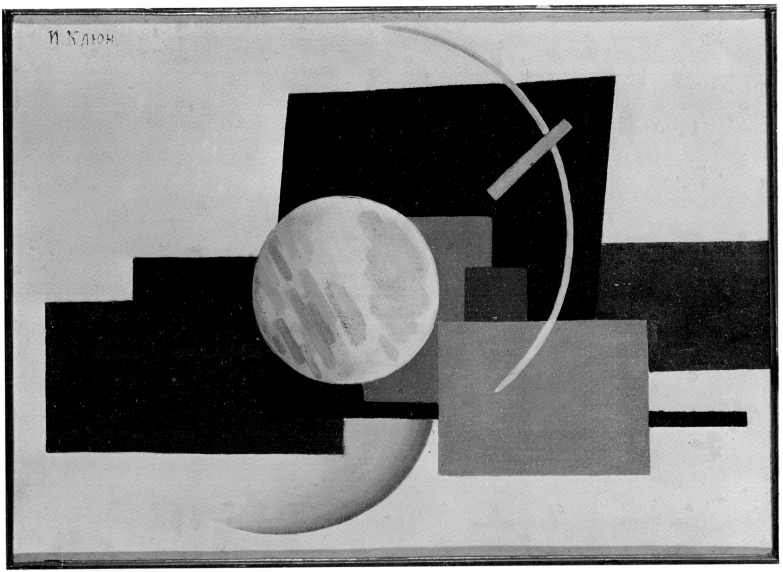

178

179 *UNTITLED. Pencil on paper. 19.8 x 15.8 (798.79). Not signed or dated.*

180 *UNTITLED. Pencil on paper. 13.2 x 15 (C611). Not signed or dated.*

181 *UNTITLED. Pencil on paper. 18.5 x 15 (270.80). Not signed or dated.*

182 *UNTITLED, 1922. Pencil on paper. 22.6 x 18.4 (C351). Not signed or dated.* Study for *Spherical Construction* (plate 184).

179

181

180

182

183 *UNTITLED, 1922. Gouache on paper. 21.3 x 11.9 (278.80). Not signed or dated.* Study for, or variation on, plate 184. This page probably comes from the same 1922 sketchbook as those reproduced on p. 152.

184 *SPHERICAL CONSTRUCTION, 1922. Oil on canvas. 59.5 x 53.5 (Tretiakov Gallery TR100). Signed and dated l l: "Kliun IV/ 22."*

185 *SPHERICAL COMPOSITION, 1923. Oil on canvas. 64.1 x 64.4 (72.78). Signed l r: "I. Kliun"; signed and dated on reverse: "I. Kliun, 1923/ VIII."*

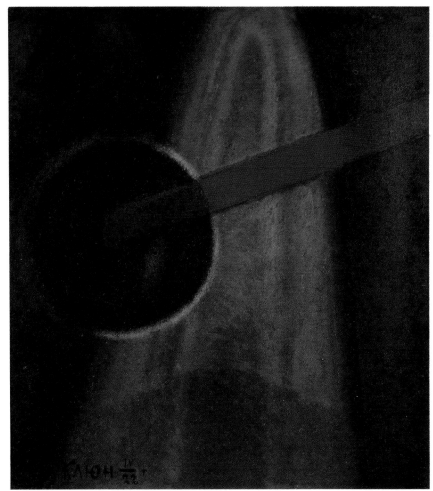

184

183

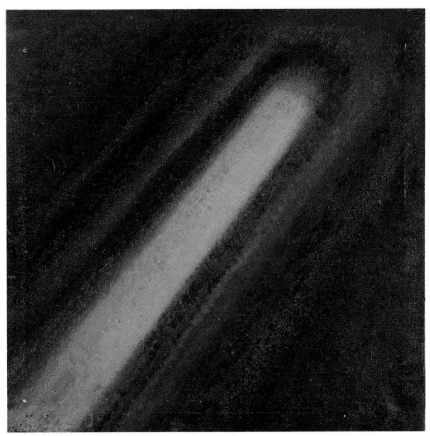

185

186

186 *UNTITLED, c. 1920. Colored pencil on paper. 8 x 6.4 (C363). Not signed or dated.*

187 *UNTITLED, 1920. Pencil on paper. 17.3 x 10.6 (254.80). Inscribed along lower edge: "Wire sculpture 1920."*

188 *UNTITLED, 1920. Pencil on paper. 12.6 x 16.6 (257.80). Inscribed along lower edge: "Wire sculpture 1920." This was later used by Kliun as a book illustration for the 1923 volume of critical essays by A. Kruchenykh, Sdvigologiia russkogo stikha (Shiftology of Russian Verse), Moscow.*

189 *UNTITLED, 1920 or 1921. Pencil on paper. 18.8 x 11.5 (256.80). Dated u r: "1920"; l l: "1921." Study for plate 191.*

187

189

188

190

190 *UNTITLED, 1920. Pencil on paper. 21.7 x 17.4 (253.80). Dated l r: "July 7, 1920."*

191 *COMPOSITION: THE UPPER PORTION A CONSTRUCTION ACCORDING TO THE OR-GANIC PRINCIPLE; THE LOWER PORTION A CONSTRUCTION ACCORDING TO THE DECO-RATIVE PRINCIPLE, 1920–23. Oil on cardboard. 68 x 32 (Tretiakov Gallery TR108).* The title was provided by V. Rakitin, and may be inscribed on the reverse.

192 *SPHERICAL CONSTRUCTION, c. 1921–25. Oil on canvas. 71.5 x 43.5 (sight) (80.78). Signed l r: "I. Kliun."*

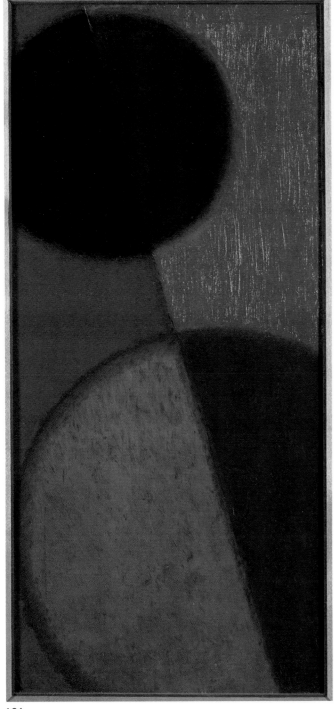

191

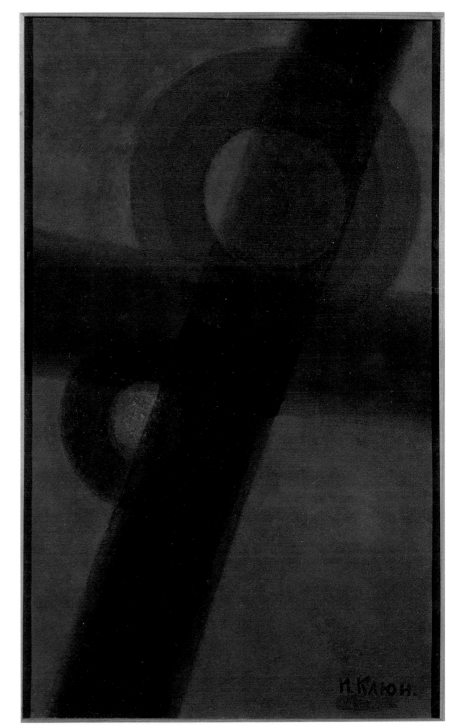

192

160 KLIUN

193 *UNTITLED, 1923. Watercolor, pencil, and chalk on paper. 41.9 x 31.3 (184.80). Signed and dated l r: "I. Kliun 1923."*

194 *UNTITLED, 1922. Pencil on paper. 18.4 x 23.1 (264.80). Not signed or dated.* On the left, a study for plate 196; on the right, a study for plate 195.

195 *SPHERICAL SUPREMATISM, c. 1923–25. Oil on canvas. 102.1 x 70.2 (71.78). Signed l l: "Kliun."*

196 *SPHERICAL NONOBJECTIVE COMPOSITION, 1922–25. Oil on canvas. 101.8 x 70.7 (83.78). Signed, titled, and dated on reverse: "I. Kliun, Spherical nonobjective composition, VI/ 1922–II/ 1925."*

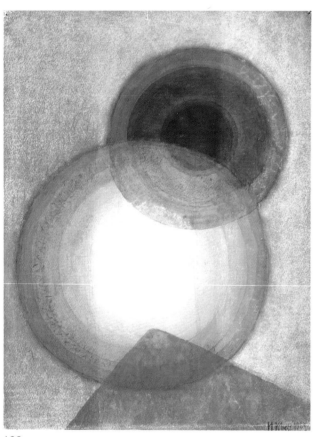

193

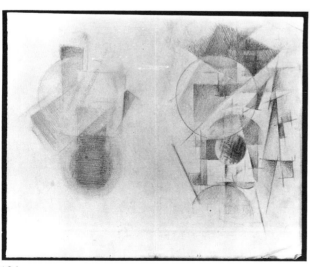

194

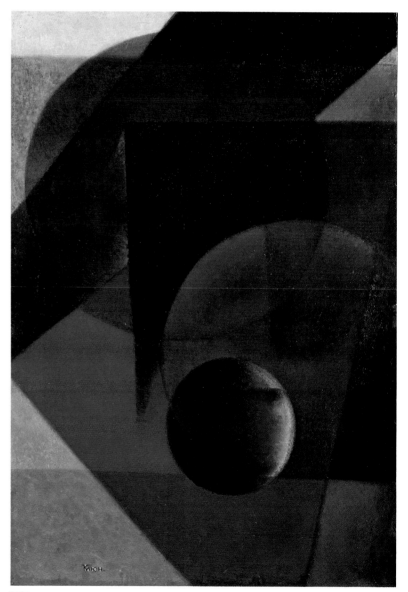

195

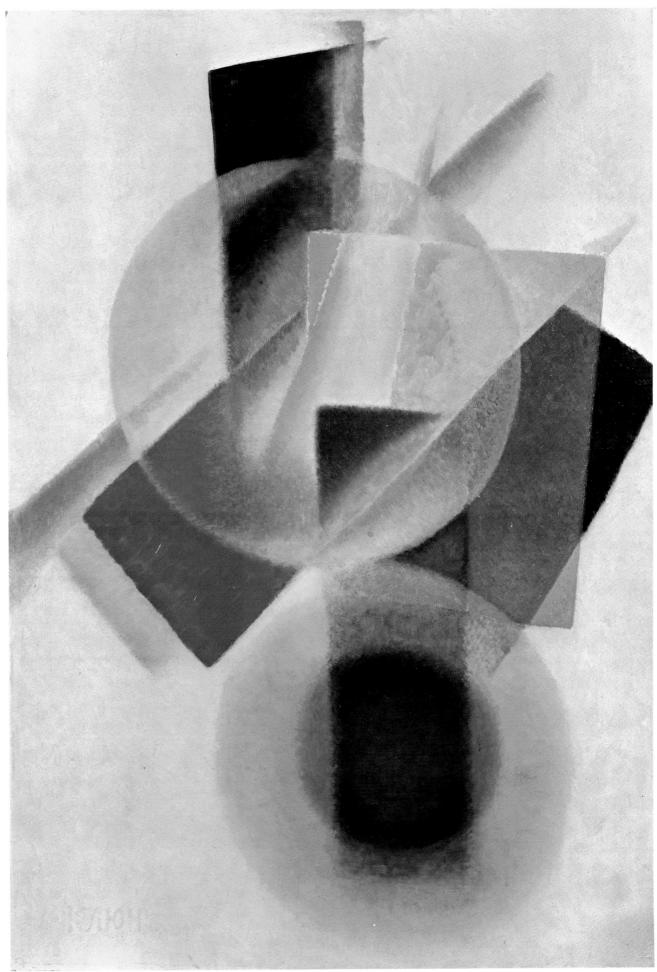

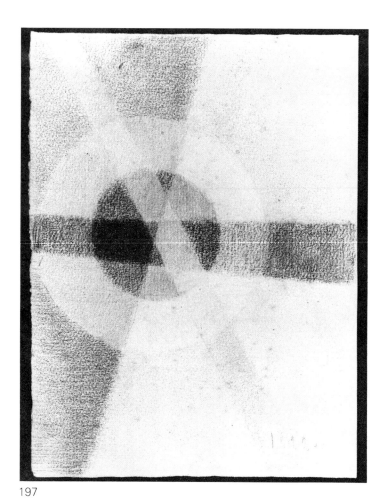

197

197 *UNTITLED, 1922. Pencil and charcoal on paper. 16.1 x 12 (260.80). Dated l r: "1922."*

198 *UNTITLED, 1922. Watercolor on paper. 35.8 x 26.8 (C382). Dated l r: "1922."*

199 *UNTITLED, 1922. Charcoal, pastel, and pencil on paper. 17.8 x 13.4 (279.80). Not signed or dated.*

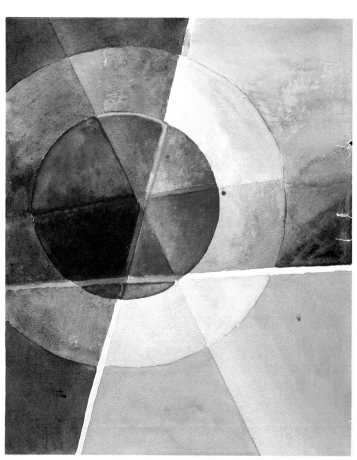

198

199

200 *UNTITLED, 1920. Colored pencil on paper. 18 x 13.3 (800.79). Dated l r: ''1920.''*

201 *UNTITLED, 1920. Pencil on paper. 12.3 x 19.8 (258.80). Not signed or dated.*

202 *UNTITLED, c. 1920. Pencil on paper. 12.1 x 23.8 (266.80). Not signed or dated.*

201

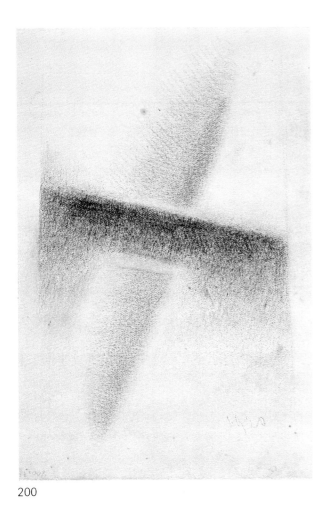

200

202

203 *SPACE DIAGONALS, c. 1922–23. Water-
color and chalk on paper mounted on board.
26.8 x 24.4 (73.78). Not signed or dated.*

203

During the mid-1920s, Kliun made a number of copies after other artists. He was especially interested in Juan Gris, Picasso, Ozenfant, and Jeanneret, and his sources were largely publications such as *L'Esprit Nouveau*, *Cahiers d'Art*, and Ozenfant and Jeanneret's *La Peinture Moderne*, though he also undoubtedly saw an article on Purism published in *Veshch/Gegenstand/Objet* 3 (1922). The Costakis collection includes thirty of these copies, a selection of which is published here.

204 *COPY AFTER FERNAND LÉGER. Watercolor on paper. 12.6 x 17.1 (C586). Repr. L'Esprit Nouveau, no. 20.*

205 *COPY AFTER PABLO PICASSO. Watercolor and gouache on paper. 15.8 x 18.4 (C580). Repr. L'Esprit Nouveau, no. 13.*

206 *COPY AFTER PABLO PICASSO. Watercolor and pencil on paper. 19.8 x 21.1 (C584). Repr. L'Esprit Nouveau, no. 21.*

207 *COPY AFTER GEORGES BRAQUE. Pencil on paper. 18.1 x 9.3 (C576). Repr. L'Esprit Nouveau, no. 23.*

208 *COPY AFTER JUAN GRIS. Pencil on paper. 18.7 x 10.2 (C574). Repr. L'Esprit Nouveau, no. 25.*

209 *COPY AFTER PABLO PICASSO. Pencil on paper. 19.8 x 13.4 (C587). Repr. Cahiers d'Art, 1931, no. 2.*

210 *COPY AFTER JUAN GRIS. Pencil on paper. 19 x 10.2 (C577). Repr. L'Esprit Nouveau, no. 25.*

204

205

206

207

208

209

210

211

211 *COPY AFTER AMÉDÉE OZENFANT. Pencil on paper. 14 x 14.4 (C592). Repr. L'Esprit Nouveau, no. 27.*

212 *COPY AFTER AMÉDÉE OZENFANT. Watercolor and pencil on paper. 14.4 x 11.2 (C598). Source not located.*

213 *COPY AFTER CHARLES JEANNERET. Watercolor and pencil on paper. 11.2 x 14.4 (C601). Source not located.*

214 *COPY AFTER AMÉDÉE OZENFANT. Watercolor on paper. 11.2 x 14.4 (C585). Source not located.*

215 *COPY AFTER FRIEDRICH VORDEM-BERGE-GILDEWART. Watercolor on paper. 7.6 x 5.8 (C658). Repr. Cahiers d'Art, 1930, no. 1, p. 27.*

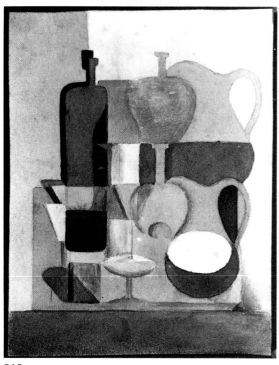

212

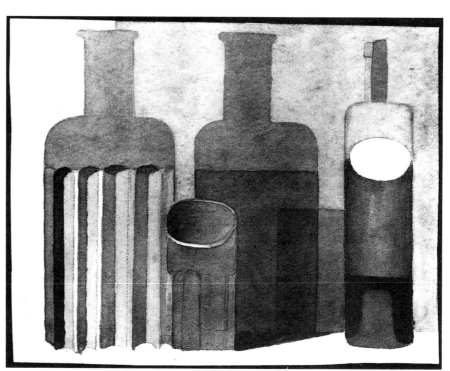

214

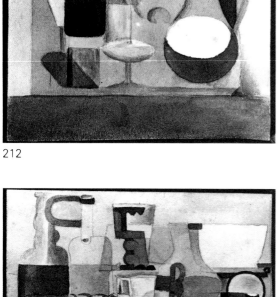

213

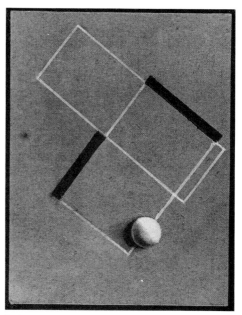

215

Kliun's Purist style of the late twenties and the thirties (plates 216–17 and 231) clearly developed in the wake of his studies of French models.

216 *UNTITLED, 1925. Oil on canvas. 69.1 x 51.2 (C538). Signed l r: "I. Kliun"; signed and dated on reverse: "I. Kliun, VII/ 1925."*

217 *2ND INTERIOR, 1925–32. Oil on canvas. 48.8 x 48.9 (C789). Signed l r: "I. Kliun"; signed, titled, and dated on reverse: "I. Kliun/ 2nd Interior/ 1925–32."*

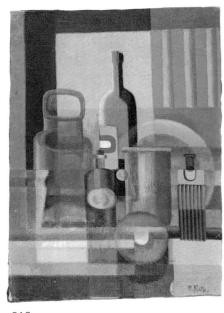

216

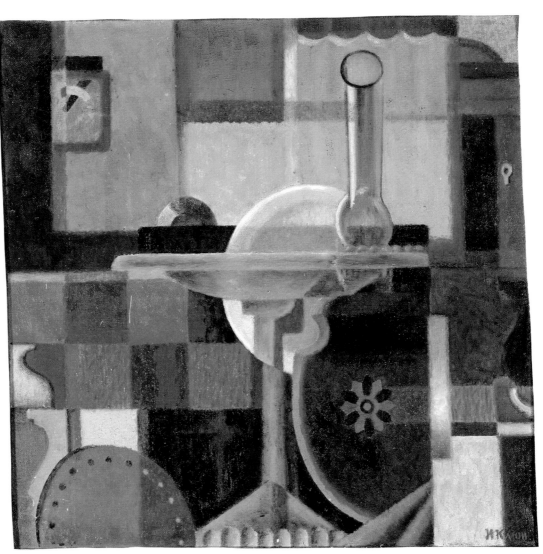

217

218 *UNTITLED, 1925. Watercolor, charcoal, and pencil on paper. 26.6 x 21.9 (91.78). Dated l l: "1925."*

219 *UNTITLED, 1924. Watercolor and pencil on paper. 19.4 x 24 (C625). Dated on reverse: "Nov. 1924."*

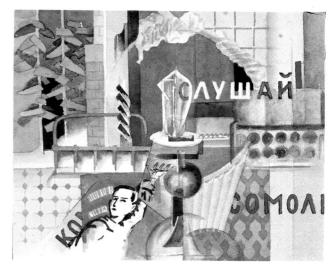

219

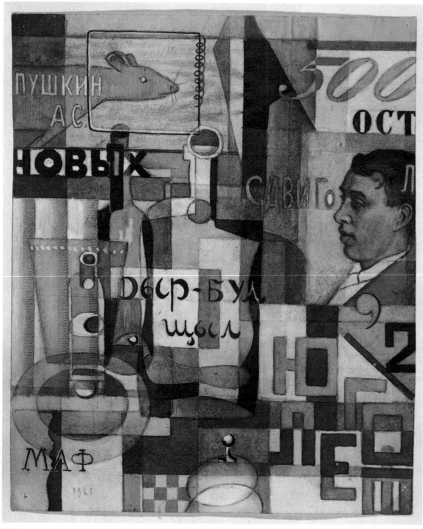

218

220 *UNTITLED. Watercolor and charcoal on paper. 18 x 10.1 (276.80). Not signed or dated.*

221 *UNTITLED, c. 1930s. Watercolor and pencil on paper. 17 x 15 (C599). Signed l r: "I. Kliun."*

222 *UNTITLED. Watercolor and pencil on paper. 14.2 x 14.1 (C624). Not signed or dated.*

223 *COMPOSITION, 1932. Oil on canvas. 90.5 x 56.5 (Tretiakov Gallery TR104). Signed l l:* "I. Kliun"; *not dated.* Several variants of this composition exist.

224 *UNTITLED. Gouache, watercolor, pencil, and paper collage on paper. 25.5 x 20.1 (275.80 recto). Not signed or dated.* This and its verso are studies for plate 223.

225 *UNTITLED. Gouache, watercolor, pencil, and paper collage on paper. 25.5 x 20.1 (275.80 verso). Not signed or dated.*

223

220

221

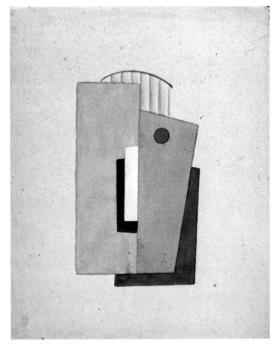

224

222

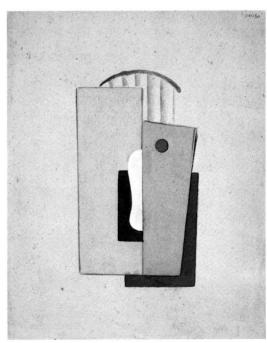

225

226 *UNTITLED, 1933. Gouache on paper. 39.8 x 33 (186.80). Signed and dated l r: ''I. Kliun 1933.''*

227 *UNTITLED, 1933. Watercolor and charcoal on paper. 30.9 x 21.8 (93.78 recto). Signed and dated l l: ''I. K. 1933.''*

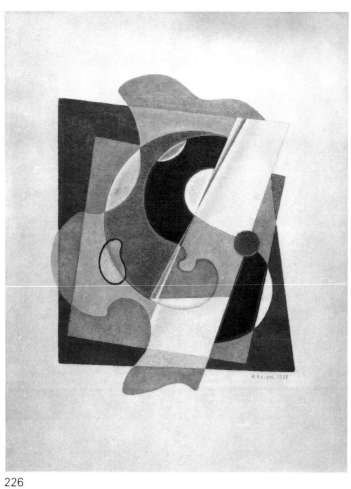

226

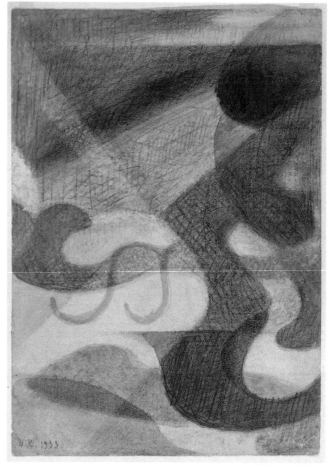

227

228 *UNTITLED, 1930s. Watercolor and pencil on paper. 28.4 x 20.4 (C629). Not signed or dated.*

229 *UNTITLED, 1930s?. Watercolor and pencil on paper. 17.2 x 15.7 (185.80). Not signed or dated.*

230 *UNTITLED, 1924. Watercolor, gouache, colored pencil, and pencil on paper. 14.5 x 11.3 (291.80). Dated on reverse: "1924."*

229

228

230

231 *STILL LIFE, 1934. Oil on canvas. 75 x 60* (Tretiakov Gallery TR105). Signed l r: "Kliun."

232 *UNTITLED, late 1920s. Pencil on paper. 16 x 10.8 (C616). Not signed or dated.* This drawing and plates 234–37 are from the same sketchbook dating from the late 1920s.

233 *UNTITLED. Watercolor and pencil on paper. 29.2 x 13.4 (287.80). Not signed or dated.*

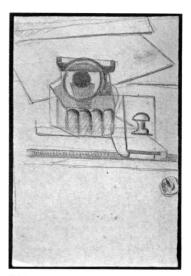

232

231

233

234 *UNTITLED, late 1920s. Pencil on paper.*
16 x 10.8 (C617 recto). Not signed or dated.

235 *UNTITLED, late 1920s. Pencil on paper.*
16.1 x 10.8 (C619). Not signed or dated.

236 *UNTITLED, late 1920s. Pencil on paper.*
17.9 x 11.3 (C618 verso). Not signed or dated.

237 *UNTITLED, late 1920s. Pencil on paper.*
17.9 x 11.3 (C618 recto). Not signed or dated.

238 *UNTITLED. Pencil on folded paper. 22.3 x*
17.8 (797.79 recto). Not signed or dated.

239 *UNTITLED. Pencil on paper. 16.1 x 10.8*
(C614 verso). Not signed or dated.

240 *UNTITLED. Pencil on paper. 16 x 10.7*
(C612). Not signed or dated.

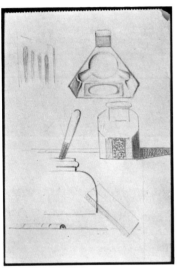

234

235

236

237

238

239

240

241 *UNTITLED. Pencil on paper. 16.1 x 10.8
(C614 recto). Not signed or dated.*

242 *UNTITLED. Pencil on paper. 11.6 x 18.7
(C621). Not signed or dated.*

243 *UNTITLED. Pencil on paper. 18.2 x 8.2
(C608). Not signed or dated.*

PAGES FROM A SKETCHBOOK, 1920s?
244 Pencil on paper. 21.2 x 11.8 (C354).
245 Pencil on paper. 21.2 x 11.8 (C352 recto).
246 Pencil on paper. 21.2 x 11.8 (C352 verso).
Possibly ideas for costumes.

241

242

243

244

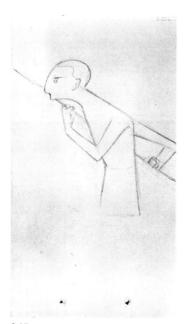

245

246

SIXTEEN DOUBLE-SIDED SHEETS OF SKETCHES

Sketches dating from all periods of Kliun's career are attached to these sheets, numbered here 1 to 32. The order shows no regard for chronology. The Costakis collection originally contained approximately a dozen more such sheets, which are now lost. Their function and purpose are not clear, though it seems plausible that they may constitute part of an *oeuvre catalogue* assembled by the artist fairly late in his career.

Many of the works recorded here are otherwise unknown; especially interesting are the drawings for constructions on sheets 27–32. Although it is known (from exhibition records) that Kliun made a good many sculptures and constructions, almost none has survived, even in photographs. Whether these drawings record actual works, or studies for pieces that were never in fact executed, is impossible to establish, but it is clear that their survival in the present form throws important new light on Kliun's originality and development. Similarly, Kliun's Symbolist beginnings are almost totally unknown, but these sheets include a number of early Symbolist drawings (especially sheets 1, 3, 4, and 6) which help to some extent to elucidate his origins.

A good many of the sheets seem to contain preparatory drawings for known compositions, although it cannot be ruled out that they are "records" of completed paintings. Little is known about Kliun's working methods, and these drawings, together with the other extensive holdings of the Costakis collection, clearly offer important new opportunities for study. Also reproduced here are additional individual drawings which are directly related to works attached to the sheets.

247 *SHEET OF 7 SKETCHES, OEUVRE CATALOGUE, sheet 1. Pencil on paper; ink on paper; pencil, ink, and crayon on paper. Sheet size: 37.2 x 22.5 (C555 verso).* The sheet includes a Symbolist landscape of c. 1908, a version of the 1911 *Family* (plate 130), and works of c. 1922–25 (see, for example, plates 194 and 195).

247

248 *Pencil on paper. 14 x 11.1 (C609). Not dated.*

249 *Pencil on paper. 26.2 x 6.9 (C620). Not dated.*

250 *SHEET OF 4 SKETCHES, OEUVRE CATA-LOGUE, sheet 2. Pencil on paper; ink on paper. Sheet size: 36.7 x 22.3 (C553 recto).* Lower left, a satirical drawing of the art critic Sergei Glagol (pseud. Sergei Goloushev) at an exhibition of "Impressionists and Modernists." Also a variant of (or early study for?) *Family* (plate 130).

251 *SHEET OF 4 SKETCHES, OEUVRE CATA-LOGUE, sheet 3. Pastel on paper; ink on paper; pencil and colored pencil on paper; pencil on paper. Sheet size: 37.1 x 22.4 (C561 recto).* Included here are an ink drawing for the 1910 Symbolist portrait of his consumptive wife (plate 127), a variant of *Family* (plate 130), and a pencil study for one of the lithographs for A. Kruchenykh, I. Kliun, and K. Malevich, *Tainye poroki akademikov* (Secret Vices of Academicians), Moscow, 1916.

248 249

250

251

252 *SHEET OF 6 SKETCHES, OEUVRE CATA-*
LOGUE, sheet 4. Pencil on paper; ink and crayon
on paper. Sheet size: 36.8 x 22.5 (C554 recto).
A Symbolist work, reminiscent of the 1910 por-
trait of his wife (plate 127), two drawings of
1921, and one of the late 1920s.

253 *Charcoal and pencil on paper, 1921. 13.1 x*
11.1 (C350).

254 *SHEET OF 5 SKETCHES, OEUVRE CATA-*
LOGUE, sheet 5. Ink on paper; pencil on paper.
Sheet size: 36.4 x 22.2 (C368 recto).

252

253

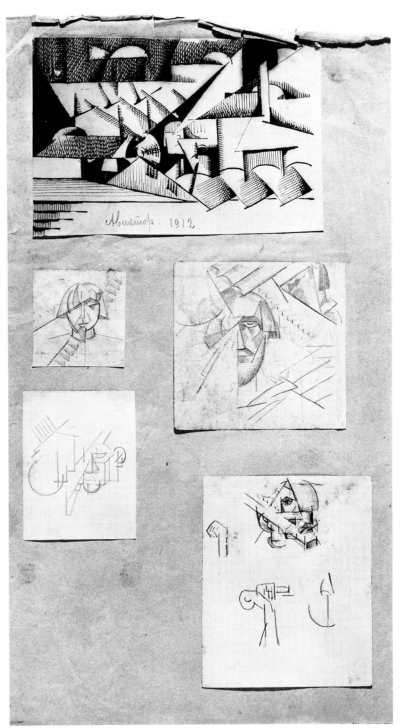

254

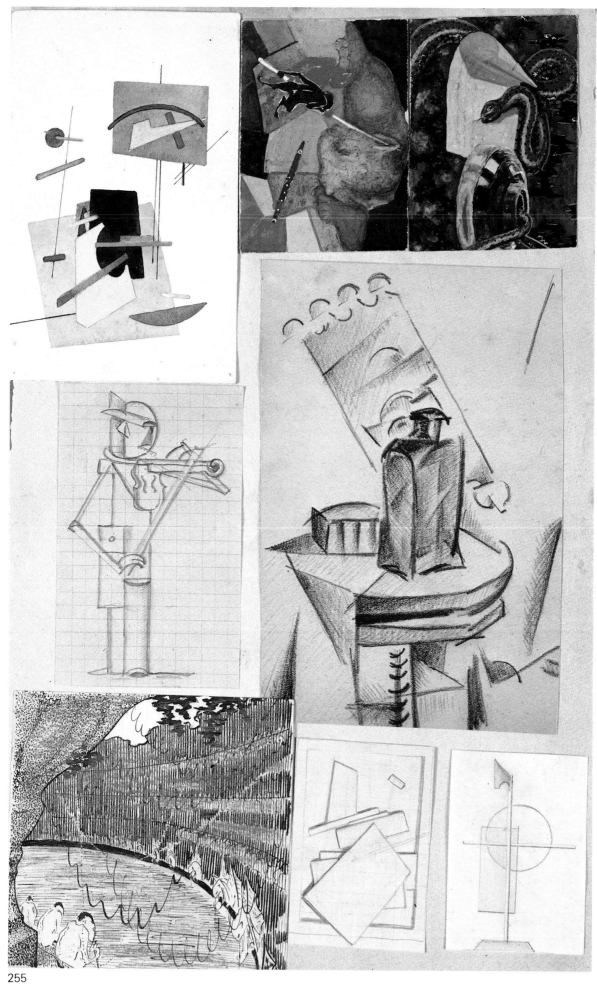

255

255 *SHEET OF 8 SKETCHES, OEUVRE CATA-LOGUE, sheet 6. Pencil on paper; watercolor on paper; charcoal on paper; ink on paper. Sheet size: 36.6 x 23 (C559 recto).* Notable here are two otherwise unknown Symbolist works and two studies for constructions. There is also a study for Kliun's Cubist sculpture of 1917, *The Musician*. This and the studies appearing on plates 257 and 258 indicate an original plan for a violinist and demonstrate the construction of the piece in some detail.

256 *Early photograph of Kliun's "The Musician."* Taken at an unidentified exhibition, this photo-graph shows the sculpture in its present form. The label attached to the work carries the date 1917. On the reverse of the photograph the medium of the sculpture is given as wood, metal, glass, celluloid, and copper.

257 *SHEET OF 5 SKETCHES, OEUVRE CATA-LOGUE, sheet 7. Pencil on paper. Sheet size: 36.8 x 20.6 (C552 recto).*

258 *SHEET OF 7 SKETCHES, OEUVRE CATA-LOGUE, sheet 8. Pencil on paper. Sheet size: 36.8 x 20.6 (C552 verso).* The drawing upper right indicates that *The Musician* was originally conceived with arms and head transposed, left to right.

256

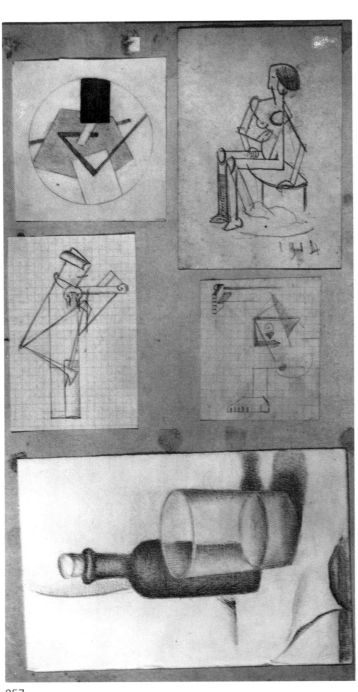

257

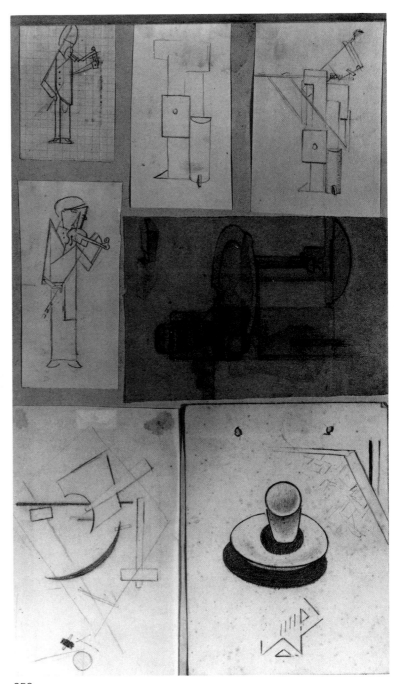

258

259 *Pencil on paper. 6.7 x 16.8 (C610).*

260 *Watercolor on paper, 1933. 11.1 x 9.5 (268.80). Dated on reverse: "1933."*

261 *SHEET OF 5 SKETCHES, OEUVRE CATA-LOGUE, sheet 9. Pencil and watercolor on paper; watercolor on paper; pencil on paper. Sheet size: 36.3 x 22.4 (C556 recto).*

259

260

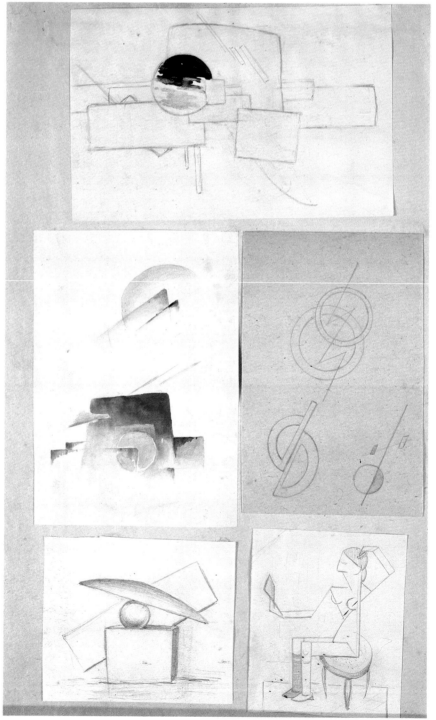

261

262 *SHEET OF 9 SKETCHES, OEUVRE CATA-LOGUE, sheet 10. Pencil on paper; ink on paper. Sheet size: 36.9 x 22.4 (C562 verso).* An other-wise unknown Symbolist figure composition of 1908 and several studies relating to Kliun's 1914 Cubist work *Ozonator* (oil on canvas, 76.5 x 66.5, Russian Museum, Leningrad).

263 *Watercolor and ink on paper, 1914. 13.3 x 8.9 (262.80). Signed l r: "I. Kliun."*

264 *Watercolor, ink, and pencil on paper, 1914. 14.1 x 8.8 (285.80).*

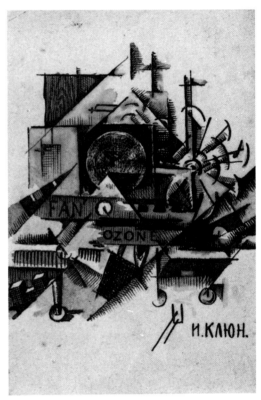

263

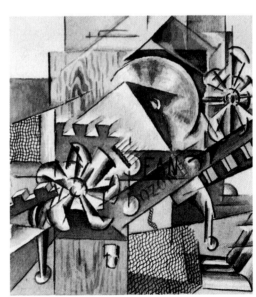

264

262

265 *SHEET OF 5 SKETCHES, OEUVRE CATA-
LOGUE, sheet 11. Pencil on paper. Sheet size:
36.9 x 22.4 (C562 recto).*

266 *SHEET OF 6 SKETCHES, OEUVRE CATA-
LOGUE, sheet 12. Watercolor and pencil on
paper; pencil on paper. Sheet size: 36.6 x 23
(C559 verso).* A watercolor study for the *Self-
Portrait with Saw* (plate 155) is at lower left.
See also the pencil drawing for this work
(plate 156).

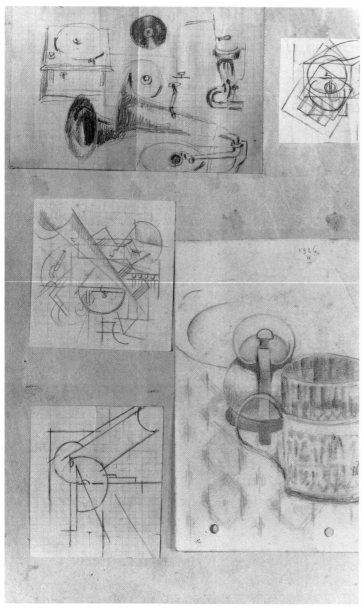

265

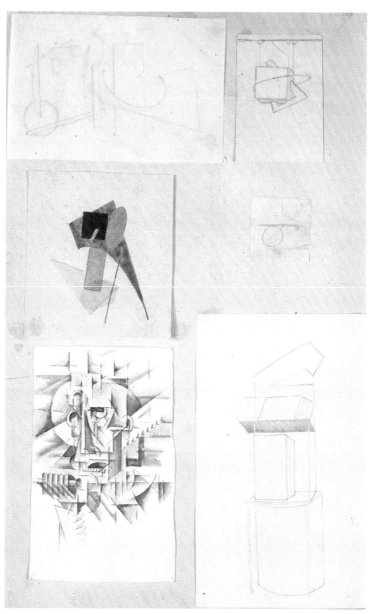

266

267 *SHEET OF 3 SKETCHES, OEUVRE CATA-LOGUE, sheet 13. Ink on paper; pencil on paper. Sheet size: 36.4 x 22.2 (C368 verso).*

268 *Color lithograph. 22.5 x 17 (282.80). Inscribed u r: "Design 1. Pertains to the article of Kliun. L.N. M.D. 1931." These inscriptions are not in Kliun's hand.*

269 *SHEET OF 8 SKETCHES, OEUVRE CATA-LOGUE, sheet 14. Watercolor on paper. Sheet*

size: 22.8 x 37 (C557 recto). This sheet is closely related to Kliun's studies of color and form of 1917 (plates 145–51). The lithographic diagram (plate 268) that further illustrates this problem was apparently intended to be published in connection with an unlocated article on color theory.

270 *SHEET OF 2 SKETCHES, OEUVRE CATA-LOGUE, sheet 15. Pencil on paper. Sheet size: 22.8 x 37 (C557 verso).*

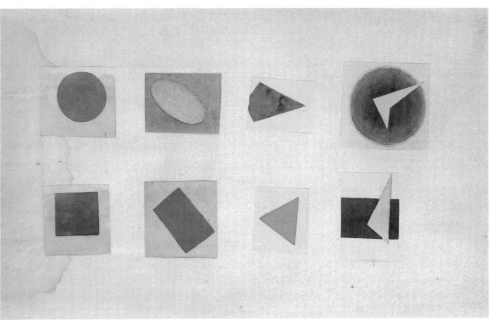

269

267

270

268

271

271 *Pencil on paper. 15.6 x 15.5 (C613).*

272 *SHEET OF 6 SKETCHES, OEUVRE CATA-
LOGUE, sheet 16. Pencil on paper. Sheet size:
36.3 x 22.7 (C558 recto).*

273 *SHEET OF 6 SKETCHES, OEUVRE CATA-
LOGUE, sheet 17. Pencil on paper. Sheet size:
36.3 x 22.7 (C558 verso).*

274 *SHEET OF 7 SKETCHES, OEUVRE CATA-
LOGUE, sheet 18. Watercolor on paper; pencil
on paper. Sheet size: 37.2 x 22.5 (C555 recto).*

272

273

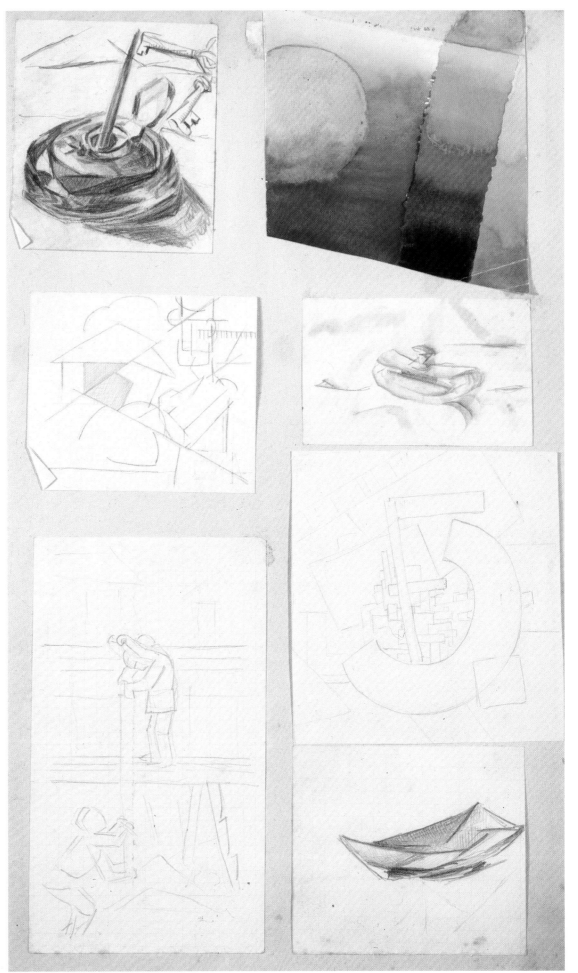

274

275 *SHEET OF 5 SKETCHES, OEUVRE CATA-*
LOGUE, sheet 19. Watercolor on paper; char-
coal and watercolor on paper. Sheet size: 36.3 x
22.4 (C556 verso).

276 *Gouache on paper, 1918. 30.8 x 28.8*
(177.80). Signed and dated: "1918."

277 *Ink on paper mounted on paper. 13.8 x 8.8*
(289.80). Signed l r.

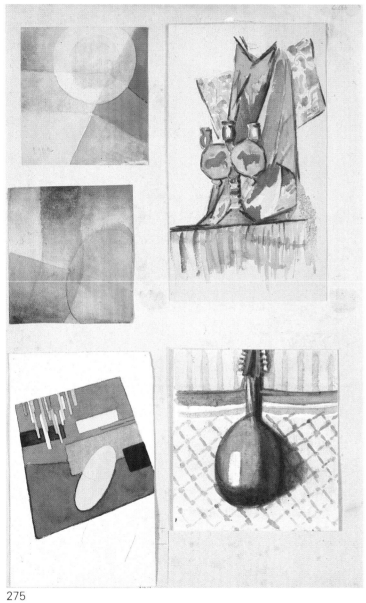

275

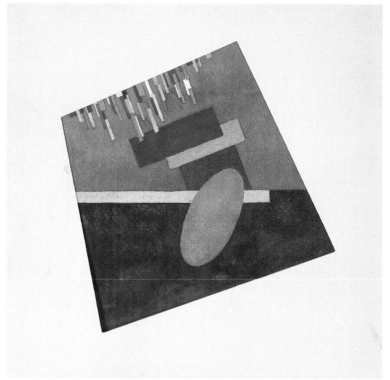

276

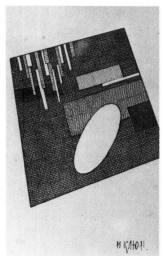

277

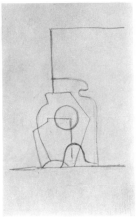

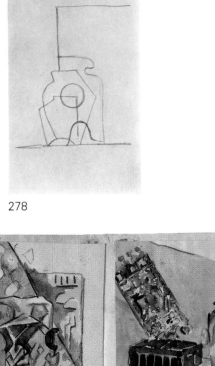

278

278 Pencil on paper. 17.3 x 10.9 (C615).

279 *SHEET OF 5 SKETCHES, OEUVRE CATA-LOGUE, sheet 20. Watercolor and pencil on paper; pencil on paper. Sheet size: 37.1 x 22.4 (C561 verso).*

280 *SHEET OF 6 SKETCHES, OEUVRE CATA-LOGUE, sheet 21. Pencil on paper. Sheet size: 36.8 x 22.5 (C554 verso).*

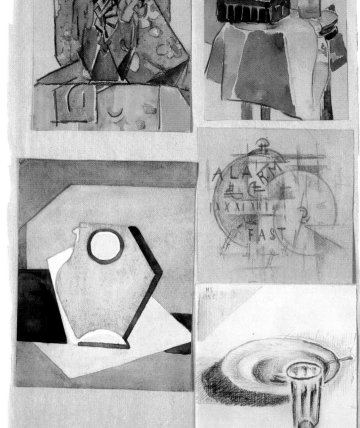

279

280

281 *SHEET OF 5 SKETCHES, OEUVRE CATA-LOGUE, sheet 22. Pencil on paper; gouache, watercolor, and silver paint on paper. Sheet size: 36.9 x 22.5 (C560 verso).* The Suprematist cross, u l, is a study for the 1924 *Composition* (now in the Staatsgalerie, Stuttgart, oil on cardboard, 41.2 x 41.2).

282 *SHEET OF 3 SKETCHES, OEUVRE CATA-LOGUE, sheet 23. Pencil on paper; colored pencil and pencil on paper. Sheet size: 36.9 x 22.5 (C560 recto).*

281 282

283 *SHEET OF 3 SKETCHES, OEUVRE CATA-LOGUE, sheet 24. Pencil on paper; gouache and watercolor on paper. Sheet size: 36.9 x 22.8 (284.80 recto).*

284 *SHEET OF 5 SKETCHES, OEUVRE CATA-LOGUE, sheet 25. Pencil on paper; charcoal and watercolor on paper. Sheet size: 36.7 x 22.3 (C553 verso).*

283

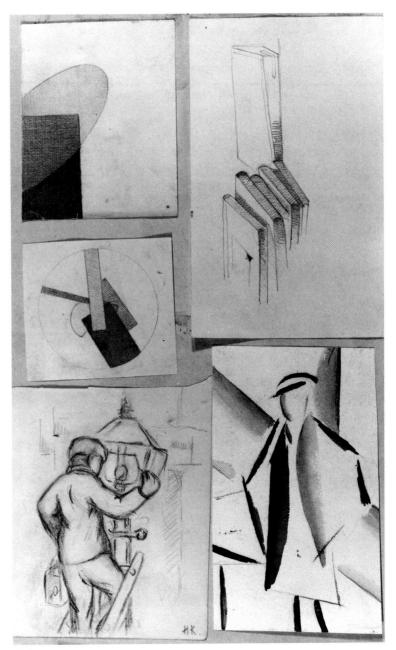

284

285 *Watercolor and charcoal on paper. 16.4 x 9 (271.80).*

286 *Watercolor and charcoal on paper. 19.2 x 9.8 (272.80).*

287 *SHEET OF 10 SKETCHES, OEUVRE CAT-ALOGUE, sheet 26. Pencil on paper. Sheet size: 36.9 x 22.8 (284.80 verso).*

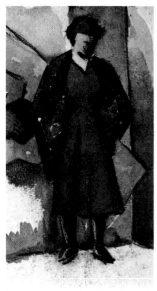

285

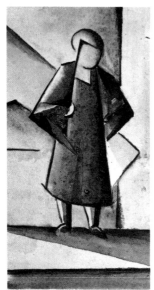

286

287

Many of the drawings on the following four sheets are directly related to Kliun's projected memorial for Rozanova, who died in 1918 (see plates 288 and 294). The memorial was never built, and it is not clear whether these drawings record the existence of actual sculptures and constructions, or merely ideas for them.

288 *Colored pencil and pencil on paper. 17.7 x 11.1 (294.80). Monument dated 1918, though the drawing probably dates from 1919.*

289 *SHEET OF 15 SKETCHES, OEUVRE CATALOGUE, sheet 27. Pencil on paper; ink on paper. Sheet size: 36.5 x 23.2 (C564 recto).*

290 *SHEET OF 12 SKETCHES, OEUVRE CATALOGUE, sheet 28. Pencil on paper; ink on paper. Sheet size: 36.5 x 23.2 (C564 verso).*

288

289

290

291 *Pencil on paper. 10.3 x 9 (C595).*

292 *SHEET OF 13 SKETCHES, OEUVRE CAT-
ALOGUE, sheet 29. Pencil on paper. Sheet
size: 36.4 x 23.5 (C551 verso).*

291

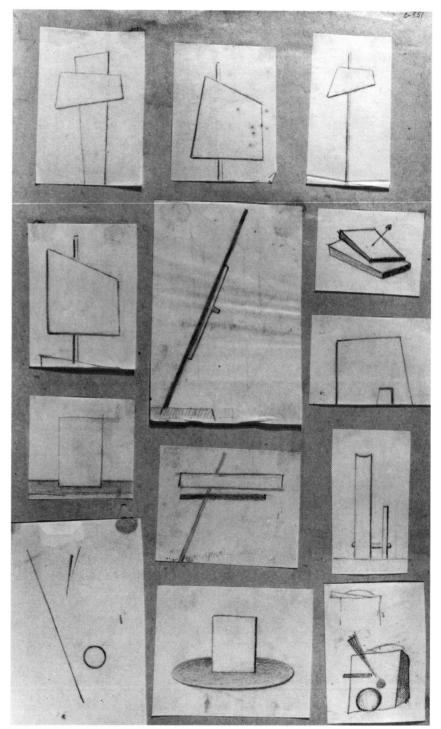

292

293 *SHEET OF 7 SKETCHES, OEUVRE CATA-LOGUE, sheet 30. Pencil on paper; colored pencil and pencil on paper. Sheet size: 36.7 x 23.7 (C563 verso).*

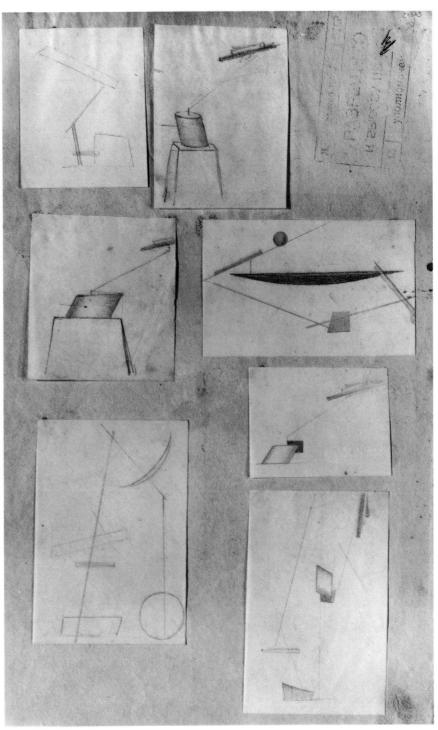

294 *Pencil on paper. 18.2 x 17.3 (252.80). Dated on monument 1918, but the drawing probably dates from 1919.*

295 *SHEET OF 12 SKETCHES, OEUVRE CAT-ALOGUE, sheet 31. Pencil on paper; pencil and ink on paper. Sheet size: 36.4 x 23.5 (C551 recto).* The juxtaposition on this sheet of Su-prematist paintings and constructions demon-strates the pictorial nature of Kliun's sculptural sensibility.

294

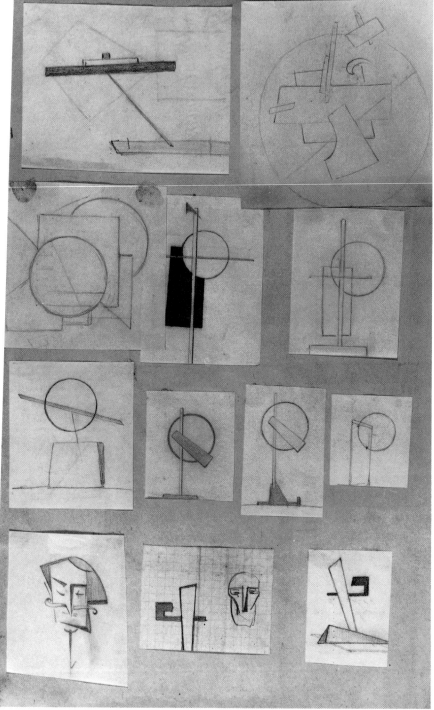

295

296 *SHEET OF 8 SKETCHES, OEUVRE CATA-LOGUE, sheet 32. Pencil on paper. Sheet size: 36.7 x 23.7 (C563 recto).* Three elaborate drawings for Suprematist hanging constructions. These highly pictorial, planar works, which would have been the earliest known mobiles, survive only in the form of these drawings (see also plates 297 and 298). They are closely related to a number of Kliun's Suprematist paintings and drawings.

297 *Pencil on paper. 10 x 6.7 (C672 recto).*

298 *Verso of plate 297.*

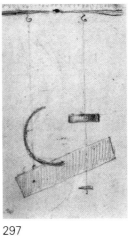

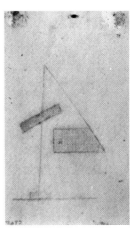

297 298

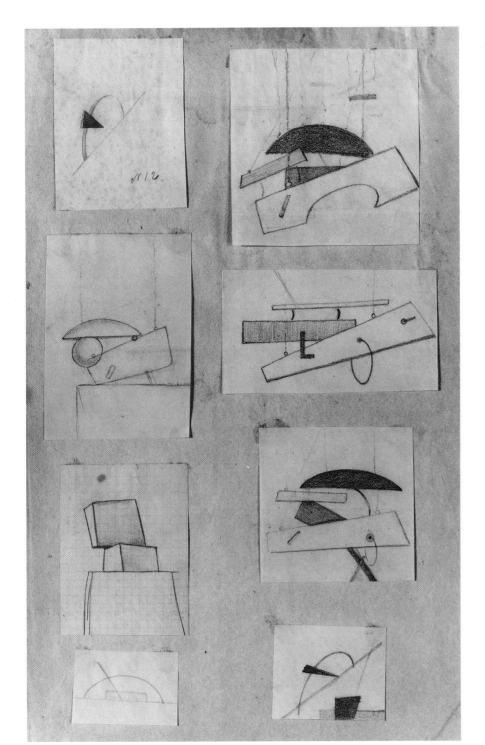

296

299 *TABLE I. ABOUT THE PROBLEM OF COMPOSITION: CONSTRUCTION FOLLOW-ING DECORATIVE AND ORGANIC PRINCI-PLES, 1942. Watercolor on paper. 36.9 x 47.3 (C88). Signed and dated l l: "Kliun 1942."* Though this sheet does not belong to the *oeuvre catalogue* series, it records to a considerable extent Kliun's repertory of forms used over a period of more than two decades. The sheet was clearly intended as an illustration for a theoretical or pedagogical volume, though apparently no such volume was published.

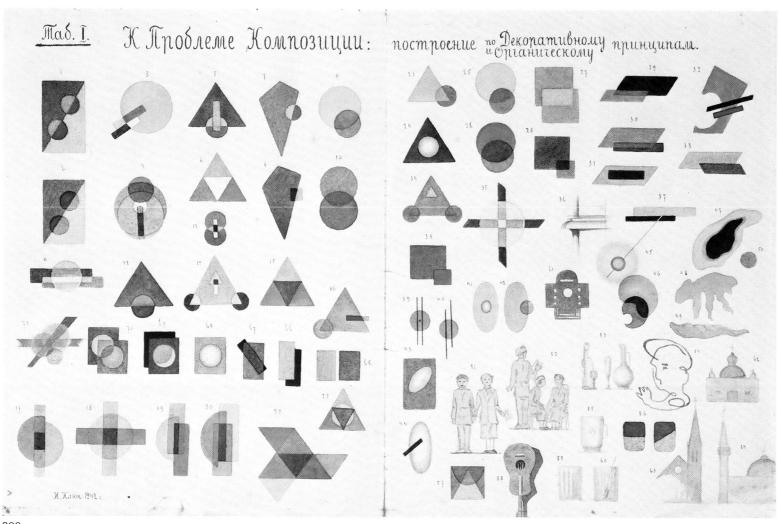

300 *UNTITLED, 1907. Gouache on paper. 17.6 x 28.4 (806.79). Signed l r: "I. Kliunkov"; dated on reverse: "1907."*

301 *UNTITLED, 1907. Pencil, colored pencil, and gouache on paper. 17.6 x 16.9 (286.80). Signed l r: "I. K."; dated and inscribed with name of place l l: "Marit 1907."*

302 *LANDSCAPE WITH HOUSES, 1908. Gouache on paper. 20.8 x 21 (807.79). Not signed or dated; inscribed by artist's daughter on reverse: "This is the work of my father, I. Kliun. S.S. 25/ I/ 78."*

Throughout his life, Kliun painted landscapes *en plein air,* recording the countryside in which he was living. The style of these paintings offers a striking contrast with that of his major work. Thus in 1914–15, while creating an advanced personal idiom in constructions and reliefs (see, for example, plate 135), he was also painting landscapes in a Gauguinesque or Nabis mode (plates 311 and 312). In addition, there are "Impressionist" and "Neo-Impressionist" landscapes which date from the period of his most mature Suprematist works, while an almost Whistlerian manner emerges in some of the landscapes of 1920 (see, for example, plate 317). These works, combined with those of the late twenties and thirties (clearly indebted to the French) and those which are actual copies from French works (see plates 204–15), suggest the extent to which Kliun remained interested in (and influenced by) a representational idiom, while producing abstract art of real originality.

301

300

302

303 *SOKOLNIKI LAKE, 1908. Gouache on paper. 23.9 x 36.5 (226.80). Signed l r: "I. Kliun"; dated on reverse: "1908."*

304 *UNTITLED, 1908. Charcoal on paper. 23.3 x 19.3 (805.79 verso). Dated u l: "1908"; inscribed by artist's daughter: (see plate 302).*

305 *UNTITLED, 1908. Pencil, watercolor, and gouache on paper. 23.3 x 19.3 (805.79 recto). Dated on reverse: "1908"; inscribed by artist's daughter on reverse: (see plate 302).*

303

304

305

306 *UNTITLED. Watercolor and pencil on paper. 18.6 x 21.1 (802.79). Not signed or dated; inscribed by artist's daughter on reverse: (see plate 302).*

307 *UNTITLED. Watercolor and pencil on paper. 21.1 x 23.8 (216.80). Not signed or dated.*

308 *UNTITLED. Watercolor and charcoal on paper. 21.1 x 25.4 (215.80). Not signed or dated.*

309 *UNTITLED, 1909. Watercolor on paper. 13.4 x 16.2 (C565). Signed l r: "I. K."; dated on reverse: "1909."*

310 *BARNS, 1909. Watercolor and pencil on paper. 13.3 x 17.3 (809.79). Signed and titled l r: "I. Kliun, 'Barns'"; dated on reverse: "1909."*

306

309

307

308

310

311 *UNTITLED, 1914. Watercolor and pencil on tinted paper. 28 x 25.3 (803.79). Dated on reverse: "1914"; inscribed by artist's daughter on reverse: (see plate 302).*

312 *UNTITLED, 1915. Gouache on paper. 19.5 x 23.9 (205.80 recto). Inscribed l l: "Sokolniki 1915"; signed l r: "I. K."*

313 *UNTITLED, 1915. Gouache and pencil on paper. 19.5 x 23.9 (205.80 verso). Landscape with portrait of his wife.*

312

311

313

314

314 *UNTITLED, n.d. Watercolor and pencil on paper. 11.5 x 9.8 (C607 recto). Signed l r: "I. K."*

315 *UNTITLED, 1918. Pastel on paper. 18.7 x 25.6 (298.80). Dated on reverse: "January 25, 1918"; inscribed by artist's daughter on reverse: (see plate 302).*

316 *UNTITLED, 1926. Colored pencil on paper. 19.6 x 26.6 (206.80). Inscribed l l: "Sokolniki 30/ VII/ 1926."*

317 *UNTITLED, 1920. Watercolor and pencil on paper. 17.5 x 13 (208.80). Dated on reverse: "1920."*

318 *GURZUF: SURF, 1923. Watercolor on paper mounted on paper. 16.1 x 23.1 (mount: 22.5 x 28) (C566). Signed on reverse: "I. Kliun"; inscribed l l: "Gurzuf 1923. Surf." (Gurzuf is a resort in the Crimea.)*

315

317

316

318

319

319 *UNTITLED, 1927. Ink on paper. 17.2 x 18 (C763). Inscribed and dated l l: "On the way to Ovchinino 1927."*

320 *UNTITLED, 1930. Pencil on paper. 14.2 x 10 (796.79). Dated on reverse: "II/ VIII 1930."*

321 *UNTITLED, 1936. Colored pencil on paper. 20 x 30 (209.80). Signed, dated, and inscribed l r: "Village of Great Gorki. Morning Mist on the Meadow, 1936, I. Kliun."*

322 *UNTITLED, 1928. Watercolor and pencil on paper. 19.4 x 24.6 (207.80 recto). Signed l l: "I. Kliun"; dated on reverse: "1928."*

323 *UNTITLED, 1930. Ink and watercolor on paper. 20.4 x 30 (296.80). Dated l c: "October 2, 1930"; inscribed l l: "Bolshegoretsky collective farm October 10."*

324 *UNTITLED, 1931. Gouache and pencil on paper. 24.9 x 32 (212.80). Dated and inscribed l r: "My village. Gorki. 1931."*

320

322

323

321

324

325 *UNTITLED, 1932. Watercolor on paper. 20.3 x 29.6 (297.80 recto). Inscribed and dated l l: "Gorki 1932." On reverse, ink and pencil sketches of linear designs, with inscription: "Build a triangle, build a square, build a hexagon, a pentagon." Both drawing and inscription are undated.*

326 *UNTITLED. Watercolor and pencil on paper. 12.6 x 22.5 (C750). Not signed or dated.*

327 *UNTITLED. Pastel on paper. 15.7 x 23.6 (C749). Not signed or dated.*

328 *UNTITLED, 1932. Watercolor on paper. 27.2 x 17.7 (213.80). Signed l r: "I. K."; inscribed and dated on reverse: "Grave of my father in the cemetery. 1932."*

329 *UNTITLED, 1933. Gouache on paper. 22 x 19 (211.80). Signed l r: "I. Kliun"; inscribed and dated on reverse: "Darkness, 1933."*

325

326

327

328

329

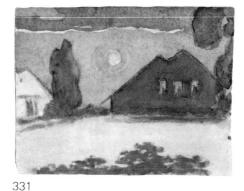

330 *UNTITLED. Watercolor and pencil on paper. 13.4 x 18.3 (C734). Inscribed l l: "Shrine near Gorki." Not signed or dated.*

331 *UNTITLED. Watercolor on paper. 14 x 18.5 (214.80). Not signed or dated; inscribed by artist's daughter on reverse: (see plate 302).*

332 *UNTITLED, 1933. Gouache on paper. 25.1 x 31.9 (210.80). Signed, dated, and inscribed l r: "'Full Moon,' I. Kliun 33"; inscribed on reverse: "Village of Gorki. In front of my house. Full Moon."*

330

331

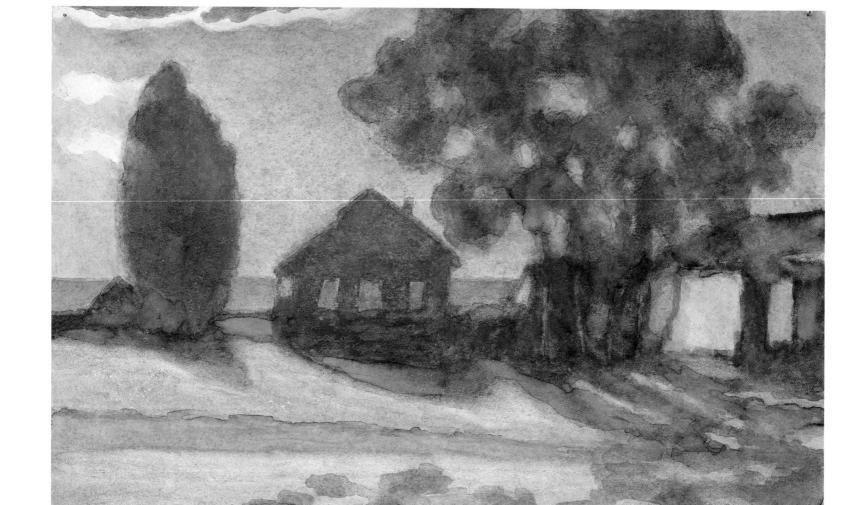

332

333

334

335

336

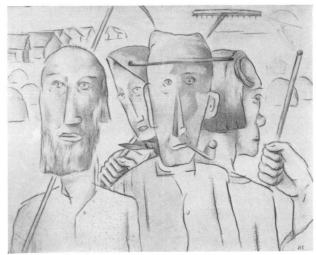

337

333 *UNTITLED, 1941. Ink and wash on paper. 26.6 x 18 (288.80). Dated and inscribed on reverse: ''1941, Ufa.'' Design for a monument for the 1941 Agricultural Exhibition. Kliun had been evacuated to Ufa as a wartime measure.*

334 *UNTITLED, 1930. Ink on paper. 26.6 x 23.4 (217.80). Dated and inscribed on reverse: ''Burial of my father, 1930.''*

335 *THE SOWER. Charcoal on paper. 36.1 x 27 (92.78). Not signed or dated.*

336 *UNTITLED, 1930s. Watercolor and pencil on paper. 34 x 25.7 (C347). Not signed or dated.*

337 *UNTITLED, 1931. Pencil and charcoal on paper. 30.2 x 38.4 (187.80). Signed l r: ''I. K.''; dated on reverse: ''1931.''*

GUSTAV GUSTAVOVICH KLUCIS

Born near Volmar (Valmiera), Latvia, January 4, 1895; died 1944
in a labor camp.

Son of a worker; from 1911 to 1913 studied at a teachers' seminary in Volmar and from 1913 to 1915 attended the Riga Art Institute. Moved to Petrograd and from 1915 to 1917 attended the school of the Society for the Encouragement of the Arts and was simultaneously a scene painter at the Okhtensky Workers' Theater. Participant in the February and October revolutions of 1917. In Moscow from the spring of 1918 onward; summoned there during the civil war as a rifleman in the Ninth Latvian Infantry Regiment.

From 1918 to 1921 studied in Moscow at the Svomas, later Vkhutemas, under Malevich and Antoine Pevsner. In August 1920 participated with Pevsner and his brother Naum Gabo in a show at the Tverskoi Boulevard pavilion in Moscow. In 1921, with other students of Malevich, contributed to the Unovis exhibition in Moscow.

Was an active participant in the Moscow avant-garde movement beginning in the early 1920s. Produced paintings, prints, and photomontages and designed posters, exhibitions, installations, and typography. From 1921 to 1925 was a member of Inkhuk. In the early 1920s traveled to Denmark and in 1922 contributed to the "Erste russische Kunstausstellung" (First Russian Art Exhibition), at the Galerie van Diemen in Berlin.

From 1924 to 1930 taught a course in color at Vkhutemas. By then was involved with the Productivist group, including Popova, Rodchenko, Stepanova, and Vesnin, at Inkhuk, and worked extensively on poster and book design. With the group, aimed to combine design experiments with the demands of social propaganda. Proposed for Vkhutemas the creation of a single studio for propaganda art, a "Studio of the Revolution," to take the place of traditional faculties. In 1928 was a founding member of the October group, contributing to its exhibition in 1930.

Klucis's abstract paintings, together with the compositions of Senkin and the Prouns of Lissitzky, form a distinct group within the Suprematism of the 1920s, separable from the framework of Malevich's philosophical program.

All the works by Klucis came from the artist's wife, V. I. Kulagina.
See also pages 431–32.

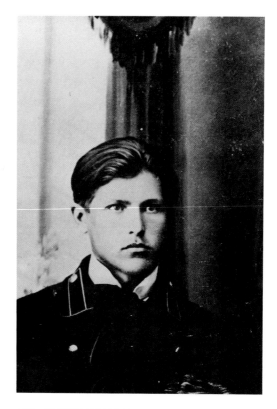

338 *GUSTAV KLUCIS.* Photographer unknown.

339 *DYNAMIC CITY, 1919–21. Oil with sand and concrete on wood. 87 x 64.5 (94.78). Signed on reverse:* "G. Klucis." According to V. Rakitin, this work was shown at the Moscow Unovis exhibition of 1921.

The gouache and photomontage which probably preceded this composition (collection V. Kulagina) dates from c. 1919 and was described by Klucis as the first photomontage ever made.

In 1928 Klucis retitled the painting *A Plan for the City of the Future*, reflecting his developing convictions concerning the utopian potential of the modern technological age. Many of the architectural designs and constructions by Klucis in the Costakis collection belong to his development of these ideas.

340 VALENTINA KULAGINA. *DYNAMIC CITY, 1923. Lithograph on paper. 26.4 x 18.4 (101.78).* This lithograph, directly based upon Klucis's work of 1919–21, was made by his wife (b.1902). Costakis owns a second copy of the lithograph (C481). (For a discussion of these works, see L. Oginskaia, "Khudozhnik-agitator," *Dekorativnoe iskusstvo*, no. 5 [1971], pp. 34–37.)

340

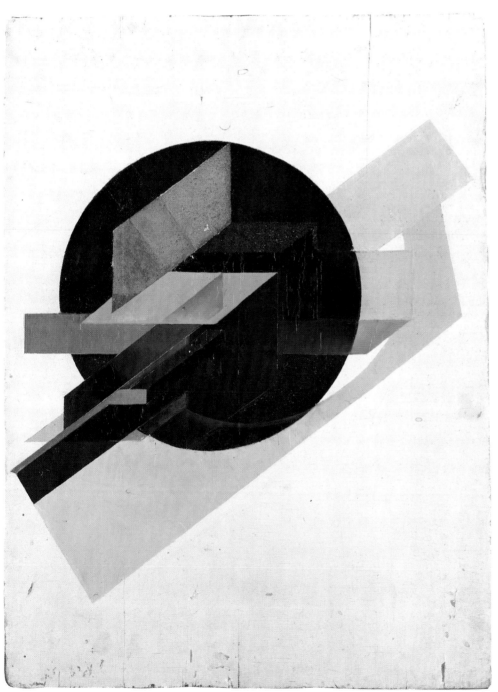

339

341 *RED MAN, winter 1919. Oil on canvas. 84.5 x 44 (Tretiakov Gallery TR6).*

342 *UNTITLED, c. 1921–22. Wax crayon and pencil on paper. 23.6 x 35.5 (115.78). Not signed or dated.*

343 *UNTITLED, c. 1921–22. Watercolor and pencil on paper. 35.3 x 27.7 (C488). Not signed or dated.*

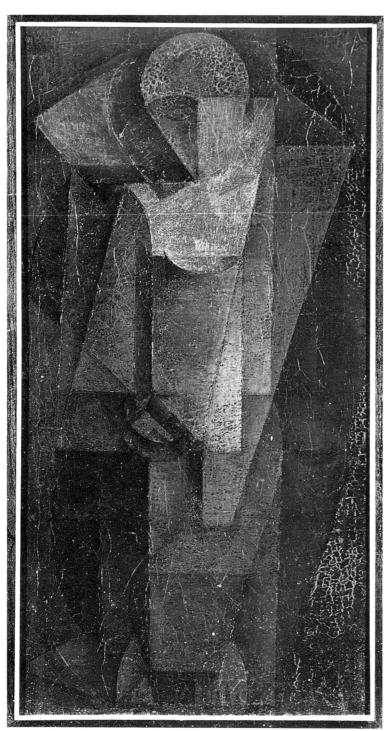

341

342

343

344 *DESIGN FOR EXHIBITION CONSTRUC-TION, c. 1924. Gouache, ink, and paper collage on paper. 48.2 x 34.8 (125.78). Not signed or dated.*

345 *DESIGN FOR A CONSTRUCTIVIST PAINT-ING (?), 1921–22. Colored ink on paper. 33.7 x 22 (250.80 verso). Not signed or dated.*

346 *STUDY FOR AN AGIT-PROP STAND, 1921–22. Pencil, gouache, and ink on paper. 33.7 x 22 (250.80 recto). Not signed or dated.*

347 *CONSTRUCTION, c. 1920–21. Pencil and gouache on paper. 28.5 x 23.7 (sight) (95.78). Not signed or dated.*

344

345

346

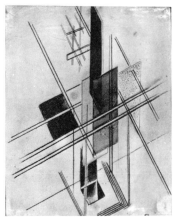

347

348 *SKETCHES FOR "SPATIAL STRUCTURE,"* *1921.* Pencil on paper. 18.6 x 32.3 (C376). Not signed or dated. A painting and a lithograph based on these drawings are known (see plate 351).

349 *CONSTRUCTION, 1920–21?.* Colored ink and pencil on paper. 28.5 x 37.9 (sight) (99.78). Not signed or dated.

350 *SKETCHES FOR RADIO TOWER OR ARCHITECTURAL PROJECT (?), c. 1921.* Pencil on paper. 33.1 x 20.6 (C384). Not signed or dated.

351 *SPATIAL STRUCTURE, 1921.* Lithograph on paper. 13.5 x 19.8 (C485). Inscribed in the artist's hand on reverse: "1st Period, Spatial Structure, G. Klucis, 1921." The painting from which this print derives is in the Tretiakov Gallery, Moscow (purchased probably from Klucis; repr. *Paris-Moscou* [Paris, 1979], p.192, as "Peinture axonométrique. 1920. Oil on canvas, 96 x 57"). The drawings reproduced here (plate 348) and the painting probably all date from 1921.

352 *SPATIAL STRUCTURE, 1921.* Glass print with ink and watercolor on paper. 16.7 x 21.5 (104.78). Dated u r: "1921."

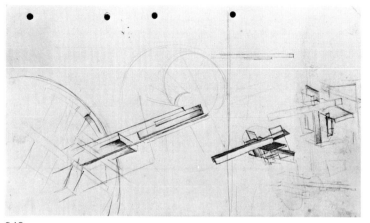

348

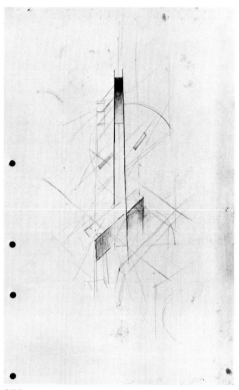

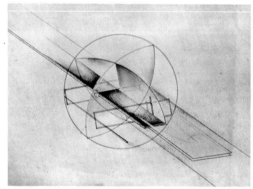

349

350

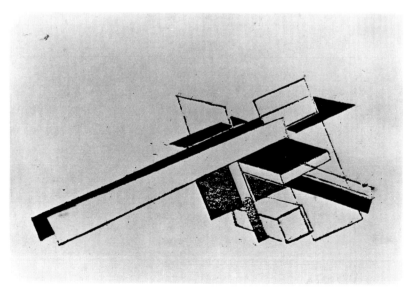

351

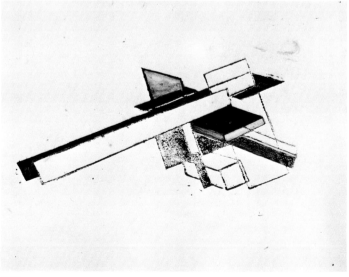

352

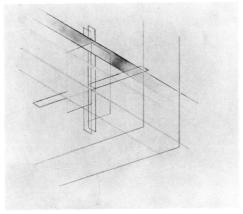

353

353 *ARCHITECTURAL DRAWING, c. 1921?. Pencil and red crayon on paper. 23.5 x 26.9 (C480). Not signed or dated.*

354 *ARCHITECTURAL CONSTRUCTION, c. 1921– 22?. Pencil on paper. 43.2 x 33.3 (102.78). Signed l r: "Klucis."*

355 *CONSTRUCTION, 1921. Pencil and ink on paper. 37.2 x 16.6 (96.78). Not signed or dated.*

356 *CONSTRUCTION, c. 1920–21. Gouache, ink, and pencil on paper. 29.1 x 22.1 (97.78). Not signed or dated.*

357 *CONSTRUCTION, 1921–22. Ink on paper. 29.1 x 19.3 (105.78). Not signed or dated.*

358 *CONSTRUCTION, c. 1921–22. Ink, gouache, pencil, and watercolor on paper. 26.8 x 21.3 (98.78). Not signed or dated.*

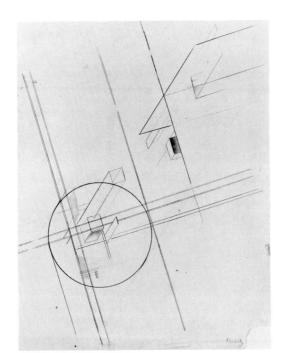

354

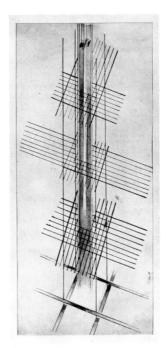

355

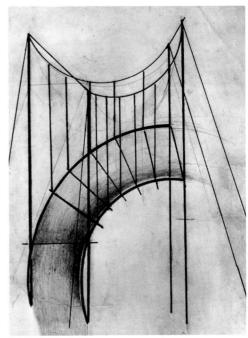

356

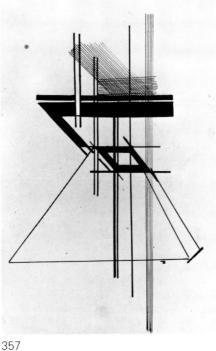

357

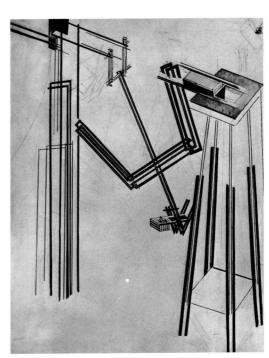

358

Working at Inkhuk as a member of the Productivist group, Klucis designed some dozen Radio Orators in the summer and fall of 1922 in connection with Moscow's preparations for the Fourth Comintern Congress. Following the Constructivist credo, the assemblage of the kiosks showed an economy of material and construction, with each nut and bolt exposed. They were light and collapsible. A skeletal cage

held the propaganda apparatus—a loudspeaker, a screen for the projecting of films, a speaker's rostrum, and rectangular signboards for announcements and slogans.

Only two of the kiosks were actually built, including the "International," which was installed on Tverskoi Boulevard by the Hotel Nerenzee, where the Comintern delegates were staying. Wood and paper models of the others were

prepared for the convening of the congress in November 1922, and all were published as separate lithographic editions. The plans have been reproduced in various Soviet publications including *Lef*, no. 4, Moscow, 1924.

The Radio Orators by Klucis owe a formal debt to the Stenbergs' 1920 KPS (Konstruktsiia prostranstvennogo sooruzheniia—Construction of a Spatial Apparatus).

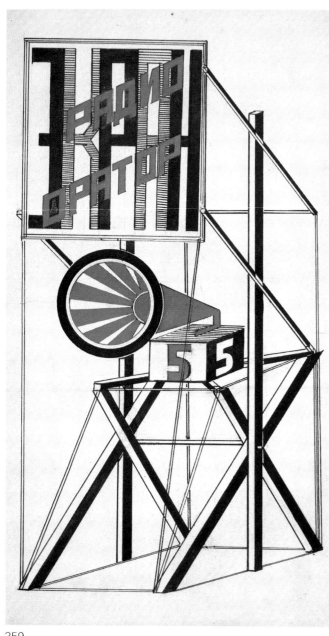

359

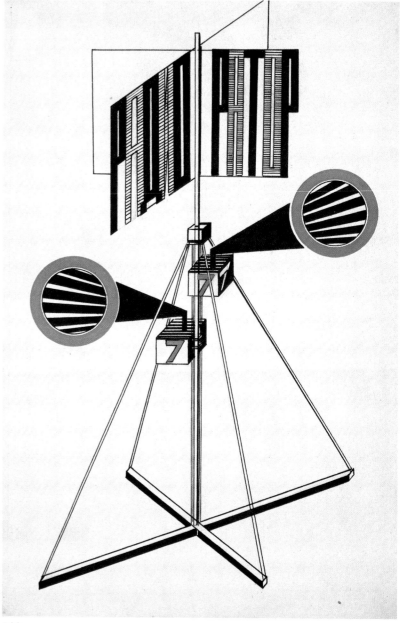

360

359 *DESIGN FOR SCREEN-RADIO ORATOR NO. 5, 1922. Colored inks and pencil on paper. 26.6 x 14.7 (106.78c).*

360 *DESIGN FOR RADIO ORATOR NO. 7, 1922. Gouache, ink, and pencil on paper. 26.9 x 17.7 (106.78b).*

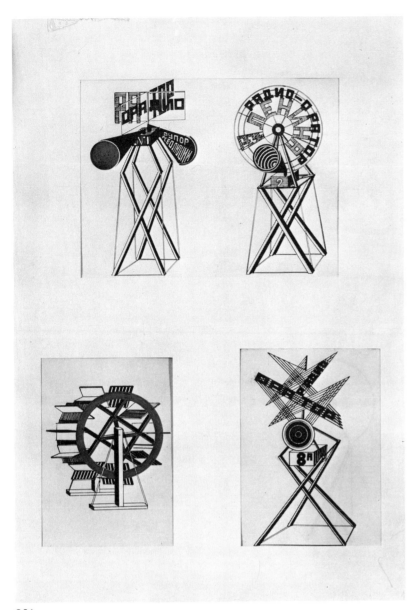

361

361 *DESIGNS FOR RADIO ORATORS AND PROPAGANDA KIOSK, 1922. Ink and gouache on paper. Top: 17.8 x 24.3 (100.78a and b); bottom left: 17.4 x 12.6 (100.78c); bottom right: 17.7 x 13.8 (100.78d).*

362 *DESIGN FOR RADIO ORATOR NO. 3, 1922. Watercolor and ink on paper. 17.9 x 13.5 (C385).* Inscribed: "Speech of Comrade Zinoviev."

363 *DESIGNS FOR RADIO ORATORS NO. 3 AND 4, 1922. India ink on paper. Dimensions unknown (two on one page) (Tretiakov Gallery TR151).* Inscribed I: "Radio Orator. Lenin's Speech."

364 *DESIGN FOR SCREEN AND ROSTRUM, 1922. Watercolor and ink on paper. 23.8 x 17.7 (C386).* Inscribed in pencil along lower edge: "Klucis, 'Screen-Rostrum Comintern,' 1922."

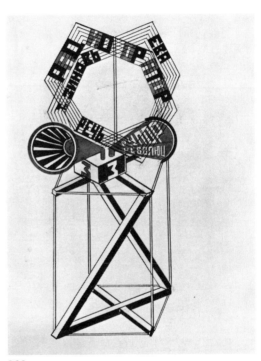

362

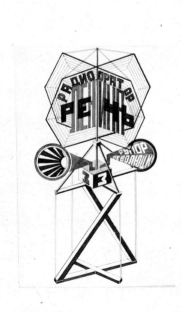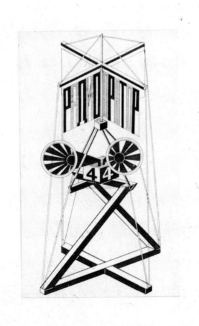

363

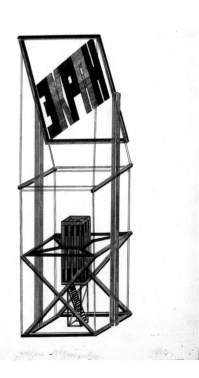

364

365 *DESIGN FOR SCREEN, ROSTRUM, AND PROPAGANDA STAND, 1922. Watercolor, pencil, and ink on paper. 34.3 x 18.9 (109.78). Inscribed in pencil along lower edge: "'Screen-Rostrum IV Comintern Congress,' 1922."*

366 *DESIGN FOR SCREEN, 1922. Watercolor and ink on paper. 24.6 x 16.5 (116.78 recto). Signed and dated l l: "G. Klucis 1922."*

367 *Inscribed in Klucis's hand on reverse of the preceding: "Screen-Rostrum-Kiosk/ for the*

5th anniversary of the October Revolution and the IV Congress of Comintern./ Size: height 6 meters; with the screen (in the vertical position) 7.2 m; width 2.1 m. Material: wood, rope, canvas."

368 *DESIGN FOR SPEAKER'S PLATFORM, 1922. Gouache and colored inks on paper. 26.8 x 17 (112.78). Slogan on the platform:* "Long live the anniversary of the October Revolution."

369 *CONSTRUCTION PROJECT—ROSTRUM, SCREEN, AND PROPAGANDA KIOSK, 1922. Linocut on paper mounted on paper. 23.3 x 10.5 (C345 recto). Signed and dated l r: "Klucis 22."*

370 *Inscribed in Klucis's hand on reverse of the preceding: "Construction Project. Rostrum-Screen-Kiosk for the 5th anniversary of the October Revolution and for the IV Comintern Congress. Gustav Klucis."*

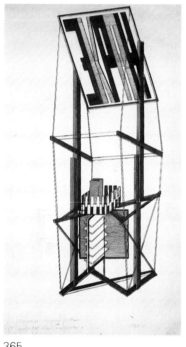

365

366

367

368

369

370

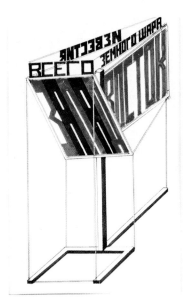

371 *ROSTRUM, 1922. India ink on paper. Top:
22.5 x 15.7; bottom: 15.7 x 22.5 (Tretiakov
Gallery TR152).*

372 *DESIGN FOR PROPAGANDA STAND,
1922. Ink and gouache on paper. 26.5 x 17.2
(113.78). Inscribed: ''Agit-prop for Communism
of the proletariat of the whole world.''*

373 *DESIGN FOR ROSTRUM, 1922. Ink, pen-
cil, and gouache on paper. 26.7 x 17.6 (114.78).*

374 *DESIGN FOR PROPAGANDA KIOSK, 1922.
Ink and gouache on paper. 26.3 x 17.4 (111.78).
Inscribed: ''Down with art. Long live agitational
propaganda.''*

375 *DESIGN, 1922. Gouache, ink, and pencil
on paper. 27.1 x 17.8 (110.78). Inscribed across
center of circle: ''International.''*

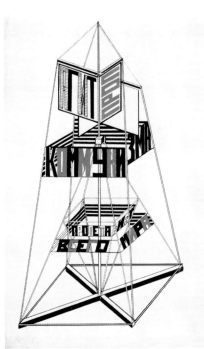

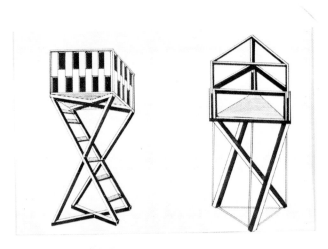

371

372

373

374

375

376 *DESIGN FOR PROPAGANDA KIOSK,*
SCREEN, AND LOUDSPEAKER PLATFORM,
1922. Watercolor, ink, and pencil on paper. 32.9
x 24 (108.78). Inscribed: "Workers [of the] world
unite. The salvation is the development of in-
dustry. Screen."

377 *DESIGN FOR PART OF PROPAGANDA*
KIOSK, 1922. Linocut on paper mounted on
paper. 22.9 x 13.2 (249.80). Signed and dated
l r: "Klucis 1922." Another example of this lino-
cut in the Costakis collection (107.78) is signed
and dated 1923. The design was later used as
an illustration for Kruchenykh's *Priemy lenin-*
skoi rechi (Methods of Lenin's Language), Mos-
cow, 1925.

376

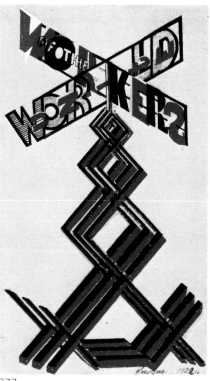

377

378 *CONSTRUCTION, 1922–23. Lithograph on paper. 15.5 x 22.1 (121.78). Not signed or dated.*

379 *CONSTRUCTION, c. 1921–22. Linocut on paper. 23.6 x 15.1 (117.78). Not signed or dated.*

380 *LITHOGRAPH FOR COVER OF A. KRU-CHENYKH'S "CHETYRE FONETICHESKIKH ROMANA" (FOUR PHONETIC NOVELS). Lithograph. 12.4 x 11.4 (C348). Signed ll: "G. Klucis."* Book published by Author's Press, Moscow, 1927. Costakis owns a second copy of the same lithograph (123.78).

381 *CONSTRUCTION, 1920–22. Lithograph on paper. 19.7 x 15 (C476). Not signed or dated.*

382 *CONSTRUCTION, 1921–22. Linocut on paper. 24.6 x 16.8 (118.78). Not signed or dated.*

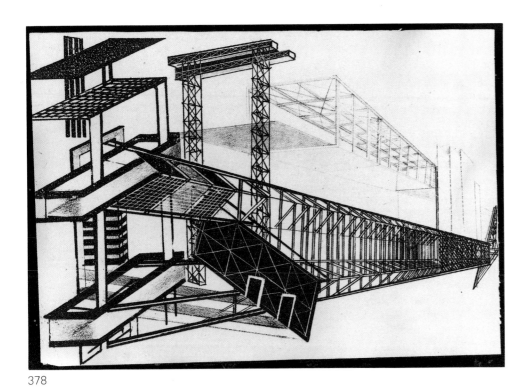

378

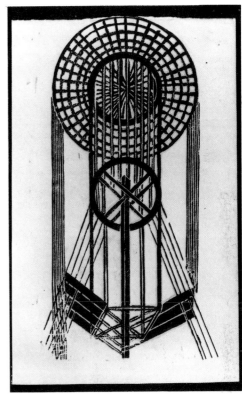

379

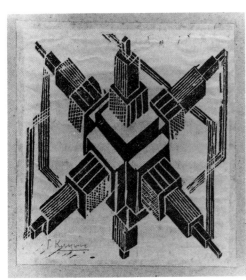

380

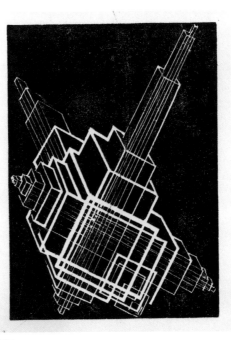

381

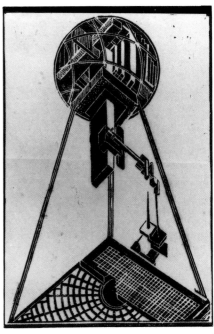

382

383 *CONSTRUCTION, 1922. Linocut on paper. 22.2 x 17.5 (119.78). Not signed or dated.*

384 *UNTITLED. Lithograph on paper. 21.4 x 14.3 (120.78). Not signed or dated. Costakis owns a second copy of this lithograph (C483).*

385 *WORKER OF THE FUTURE (?), 1922–23. Linocut on paper. 24.1 x 15.4 (103.78). Not signed or dated.*

386 *CONSTRUCTION PROJECT, c. 1922–23. Linocut on paper. 21.5 x 14.2 (122.78). Not signed or dated.*

387 *CONSTRUCTION, c. 1922. Linocut on paper mounted on board. 21.5 x 15.1 (124.78). Not signed or dated. Costakis owns two other examples of this linocut (C375 and C482).*

388 *WORKER OF THE FUTURE (?), 1922–23. Blue linocut on paper mounted on board. 24.4 x 15.4 (251.80). Not signed or dated.*

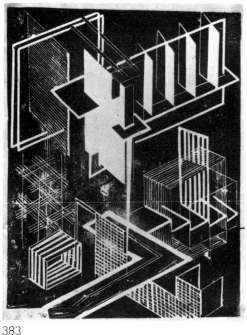

383

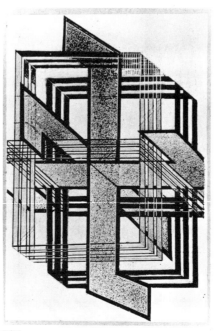

384

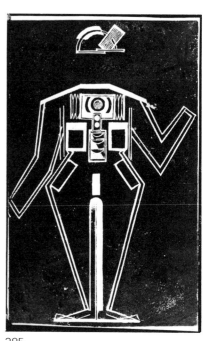

385

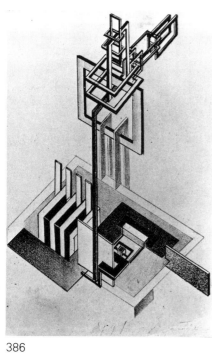

386

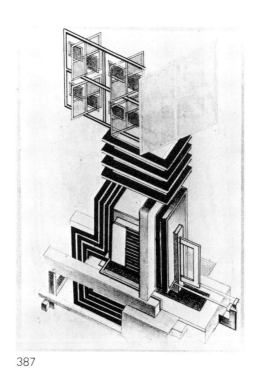

387

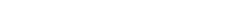

388

At Vkhutemas after 1924 Klucis shared responsibility with Sergei Kravtsov for teaching the course on color in the woodworking section. The Costakis collection includes a number of examples of color studies from this period which probably illustrate aspects of his method. The curriculum included historical theo-ry, physical properties and princi-ples, the action of color on various surfaces, mixing of colors, and in-teraction of colors. (For a detailed discussion of Vkhutemas and its curriculum, see C. A. Lodder, *Con-structivism: From Fine Art into De-sign, Russia 1913–1933*, Yale Uni-versity Press, 1982.)

389 *Gouache, pencil, and ink on folded paper. 20.3 x 17 (C499). Not signed or dated.*

390 *Gouache, pencil, and ink on folded paper. 20.6 x 16.6 (C388 verso). Not signed or dated.*

391 *Gouache and pencil on folded paper. 20.6 x 16.6 (C388 recto). Not signed or dated.*

392 *Paper collage and ink on paper. 30.9 x 20.8 (126.78). Not signed or dated.*

393 *Gouache and pencil on paper. 29.9 x 25 (C389). Not signed or dated.*

389

390

391

392

393

394 *Watercolor, pencil, and ink on folded paper. 22.3 x 17.9 (C478 recto). Not signed or dated.*

395 *Gouache and pencil on paper. 20.4 x 16.7 (C486). Not signed or dated.*

396 *Paper collage on folded paper. 22.3 x 17.9 (C478 verso). Not signed or dated.*

397 *Watercolor on paper. 13.5 x 17.8 (C378). Not signed or dated.*

398 ARTIST UNKNOWN. *Mid-1920s. Gouache and ink on paper. 16.4 x 20.4 (C477). Not signed or dated.* This work, which may belong to the group of pedagogical color studies of the Klucis course, has not been attributed.

394

395

396

397

398

During the late 1920s and the 1930s Klucis was extremely active producing agitational posters and other materials, often making use of his powerful gifts in the medium of photomontage. These 1928 postcards, published in connection with the All-Union Spartakiada under the Central Communist International of the U.S.S.R., demonstrate the ideological association of physical prowess, youth, and the worker with the success of the Revolution.

399 *PHOTOCOLLAGE. 12.7 x 9.6 (C356). Not signed or dated.*

400 *PHOTOMONTAGE PRINTED IN COLORS ON POSTCARD, 1928. 14.6 x 9.1 (1089.80). Signed as part of the image: "Klucis." Text: "Spartakiada, Moscow 1928."*

401 *PHOTOMONTAGE PRINTED IN COLORS ON POSTCARD, 1928. 15.1 x 10.6 (1090.80). Signed as part of the image: "Klucis." Text: "Every sportsman must be a sharpshooter—Spartakiada, Moscow 1928."*

399

400

401

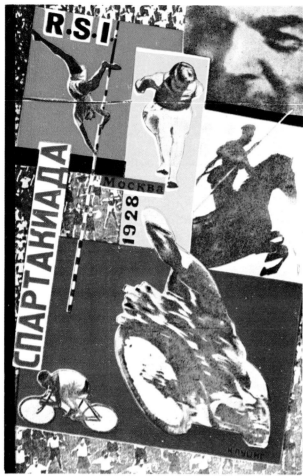

402

403

402 *PHOTOMONTAGE PRINTED IN COLORS ON POSTCARD, 1928. 14.4 x 9.4 (1091.80). Signed as part of the image:* "Klucis." *Text:* "Spartakiada, Moscow 1928."

403 *PHOTOMONTAGE PRINTED IN COLORS ON POSTCARD, 1928. 14.9 x 10.2 (1087.80). Signed as part of the image:* "Klucis." *Text:* "Our physical-cultural greetings to the worker sportsman from all over the world—Spartakiada, Moscow 1928."

404 *PHOTOMONTAGE PRINTED IN COLORS ON POSTCARD, 1928. 15.3 x 10.1 (1088.80). Signed as part of the image:* "Klucis." *Text:* "For healthy tempered youth—Spartakiada, Moscow 1928."

404

IVAN ALEXEEVICH KUDRIASHEV

Born Kaluga, 1896; died Moscow, 1972.

From 1913 to 1917 attended the Moscow Institute of Painting, Sculpture, and Architecture, and from 1918 to 1919 studied with Malevich at the Svomas in Moscow; met Kliun, Antoine Pevsner, and Naum Gabo. From 1918 onward, under the influence of the ideas of the space scientist Konstantin Tsiolkovsky (conveyed to Kudriashev by his father, a carpenter who made rockets and other devices for Tsiolkovsky), turned to the problems of cosmic abstract painting, as perceived through Suprematism. In 1918 in Moscow worked on propaganda designs for automobiles for the first anniversary of the Revolution.

In 1919 was sent to Orenburg to establish the Svomas there. Participated in the First State Exhibition in Orenburg, showing sketches for the mural of the First Soviet Theater and other abstract works. In 1920 worked on the Summer Red Army Theater interior and organized a branch of the Unovis group in Orenburg.

In 1921, as supervisor of a train for the evacuation of starving children, Kudriashev arrived in Smolensk, where he met Katarzyna Kobro and Wladyslaw Strzeminski, Polish followers of Malevich.

Returned to Moscow, and from late 1921 worked as a designer. In 1922 sent work to the "Erste russische Kunstausstellung" (First Russian Art Exhibition), at the Galerie van Diemen in Berlin. From 1925 to 1928 showed his abstract works at the first, second, and fourth OST exhibitions. After 1928 stopped exhibiting in the Soviet Union.

All the works by Kudriashev came from the artist.

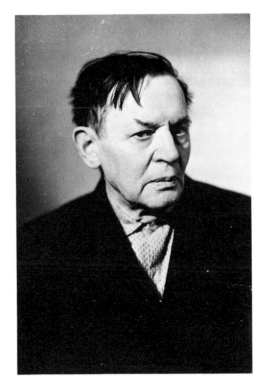

405 *IVAN KUDRIASHEV.* Photographer unknown.

Kudriashev was sent to Orenburg in 1919 to establish the Svomas (Free Art Studios) there. His designs for the First Soviet Theater were exhibited in the First State Exhibition in Orenburg and are visible in the installation photograph. The city theater was opened originally in 1856 and renamed the First Soviet Theater in 1920. It has not been possible to establish whether Kudriashev's redecoration of the interior was ever carried out.

406 *FIRST STATE EXHIBITION. Installation photograph, 1920. Inscribed on reverse: "Exhibition at Orenburg. 1920. Works by Kudriashev, Kalmakov, Timofeeva."*

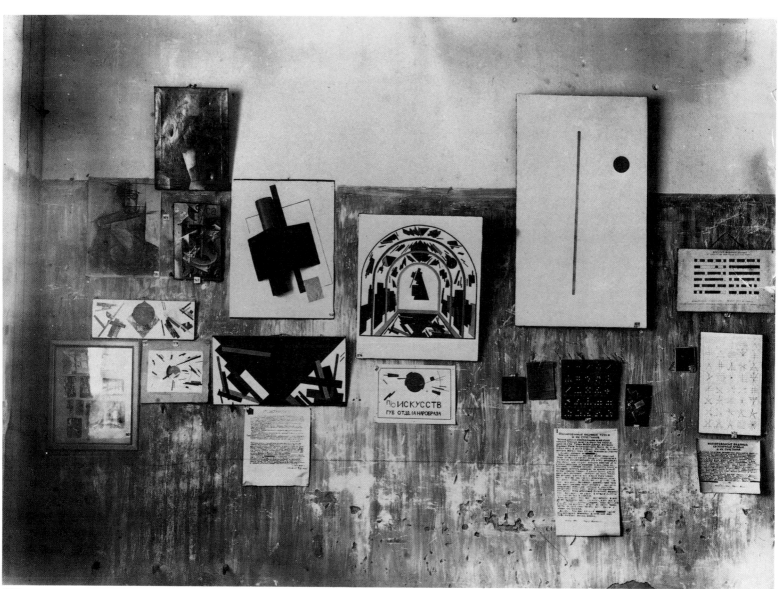

407 *GENERAL PLAN FOR THE INTERIOR DEC-*
ORATION OF THE FIRST SOVIET THEATER
IN ORENBURG, 1920. Oil on canvas. 103 x 89
(Tretiakov Gallery TR113). Signed and dated on
reverse: "I. A. Kudriashev 1920." Costakis's
gift to the Tretiakov included some gouaches
for this project.

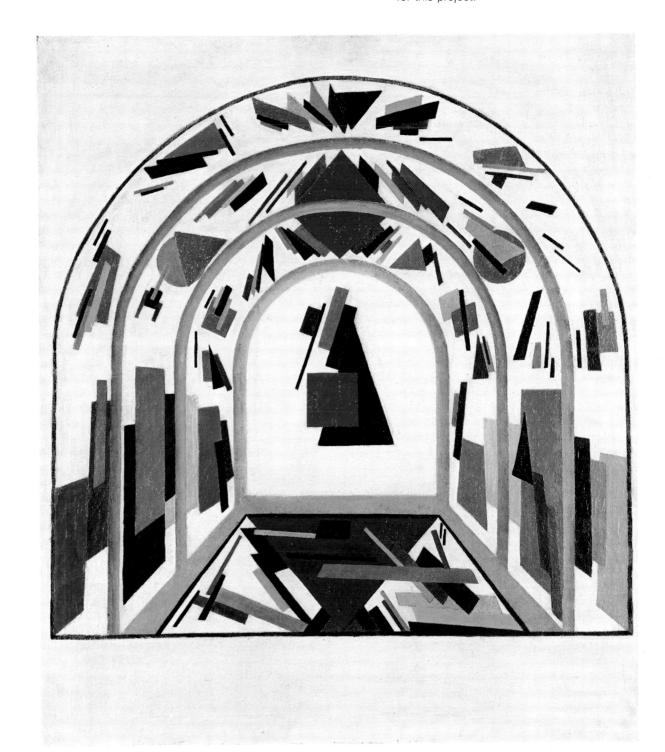

407

408

409

410

408 *DESIGN FOR THE FIRST SOVIET THEATER IN ORENBURG, 1920. Pencil and gouache on paperboard. 33 x 102.5 (127.78).*

409 *DESIGN FOR THE FIRST SOVIET THEATER IN ORENBURG, 1920. Watercolor, gouache, and paper collage on paper. Image: 13.3 x 39 (132.78).*

410 *DESIGN FOR THE FIRST SOVIET THEATER IN ORENBURG, 1920. Watercolor, ink, and pencil on paper mounted on board. 21.2 x 53.4 (133.78).*

411 *UNTITLED, 1919–20. Gouache on paper. 28.5 x 38.5 (Tretiakov Gallery TR7).* Though not specifically identified as such, this work probably formed a part of Kudriashev's preparations for the First Soviet Theater.

412 *FOLDED SHEET OF SIX SKETCHES, c. 1918–19. Pencil on paper. Sheet size: 36 x 35.6 (C64b).* Not signed or dated.

413 *TWO SKETCHES, c. 1918–19. Pencil on paper mounted on paper. Upper image: 6 x 5.8; lower image: 19.2 x 8.9 (C63).* Not signed or dated.

414 *Pencil on paper. Sheet size: 36 x 35.6 (C64a).*

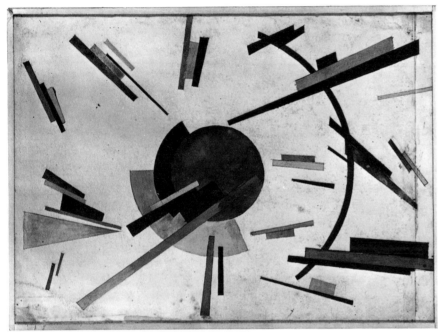

411

412

413

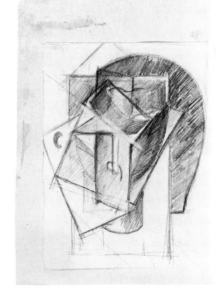

414

415 *UNTITLED, 1922. Pencil on paper. 22.2 x 13.6 (C504). Signed and dated c r: "I. Kudria-shev 22."*

416 *UNTITLED, 1921. Watercolor, pencil, and paper collage on paper. 23.8 x 31.5 (C501). Signed and dated l l: "I. Kudriashev 21."*

417 *UNTITLED, 1922. Pencil on paper. 22.6 x 18.8 (C506). Not signed or dated.*

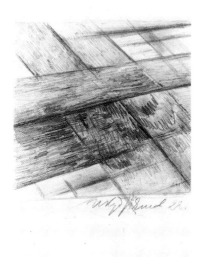

415

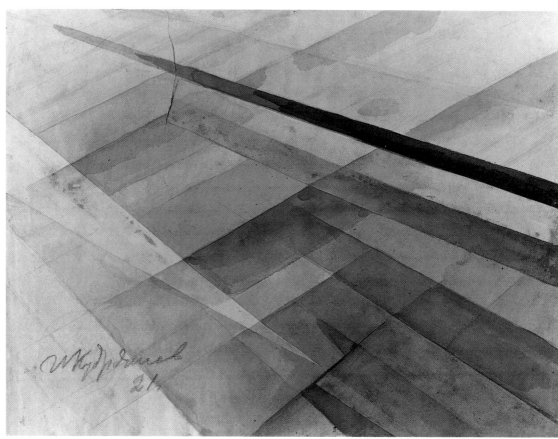

416

417

418 *UNTITLED, 1924. Pencil on paper. 23.2 x 22 (C502). Signed and dated l r: "1924. I. Kudriashev."*

419 *CONSTRUCTION OF A RECTILINEAR MOTION, 1925. Oil on canvas. 90 x 75.5 (Tretiakov Gallery TR112). Signed and dated l r: "1925 I. Kudriashev."*

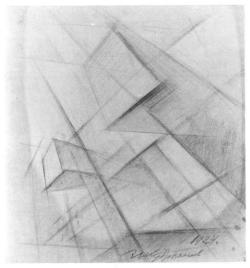
418

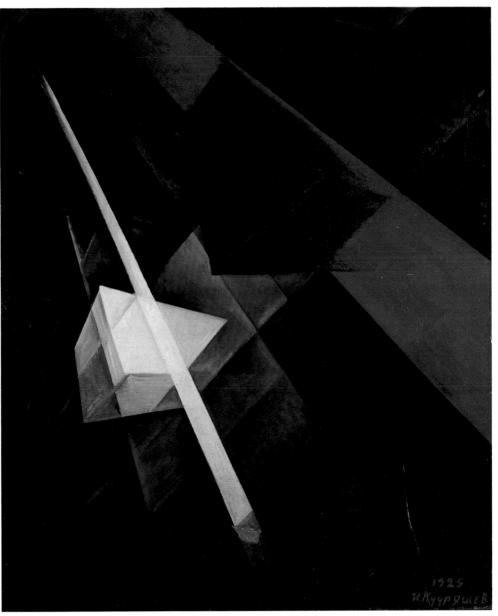
419

420 *LINEAR CONSTRUCTION, 1922. Oil on canvas. 72.6 x 67 (131.78). Inscribed on reverse, probably by the artist:* "Kudriashev, I. A. 'OST.' 1922."

421 *CONSTRUCTION OF A RECTILINEAR MOTION, 1923. Oil on canvas. 75 x 83 (Tretiakov Gallery TR111). Signed and dated l r:* "1923 I. Kudriashev."

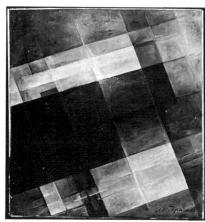

420

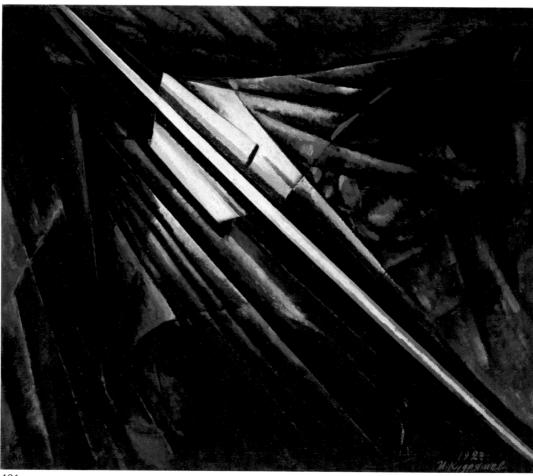

421

422 *CONSTRUCTION OF A RECTILINEAR MO-TION, 1925. Oil on canvas. 66.3 x 70.7 (129.78). Inscribed on reverse, probably by the artist: "Kudriashev I. A. 'OST' exhibition 1925, Construction of a rectilinear motion."*

423 *UNTITLED, 1925. Pencil on paper. 31 x 17.7 (C503). Signed and dated l r: "1925. I. Kudriashev."*

424 *LUMINESCENCE, 1926. Oil on canvas. 106.6 x 71 (128.78). Signed and dated l r and on reverse: "I. Kudriashev 1926."*

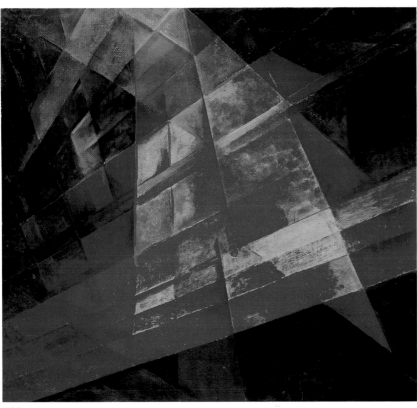

422

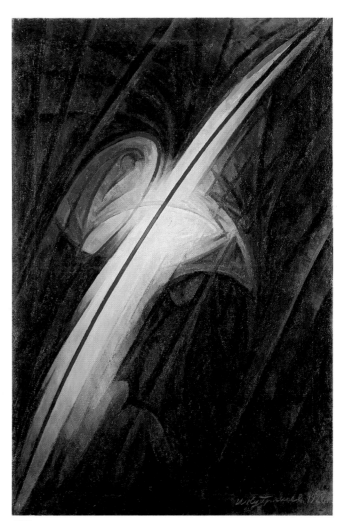

424

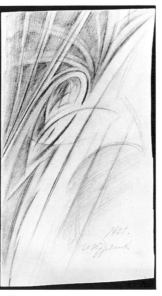

423

425 *CONSTRUCTION (SPATIAL PAINTING),
1926. Oil on canvas. 76 x 52 (Tretiakov Gallery
TR110).*

426 *UNTITLED, 1927. Pencil on paper. 19.2 x
20.8 (C505). Signed and dated l c: "I. Kudriashev
27."*

427 *COMPOSITION, c. 1931. Oil on plywood.
60.6 x 61.3 (130.78). Backed with newspaper
of 1931 on which is painted: "Kudriashev, I. A.
'OST.'"*

428 *LIGHT REFRACTION, c. 1930. Oil on ply-
wood. 55 x 56 (Tretiakov Gallery TR109).*

426

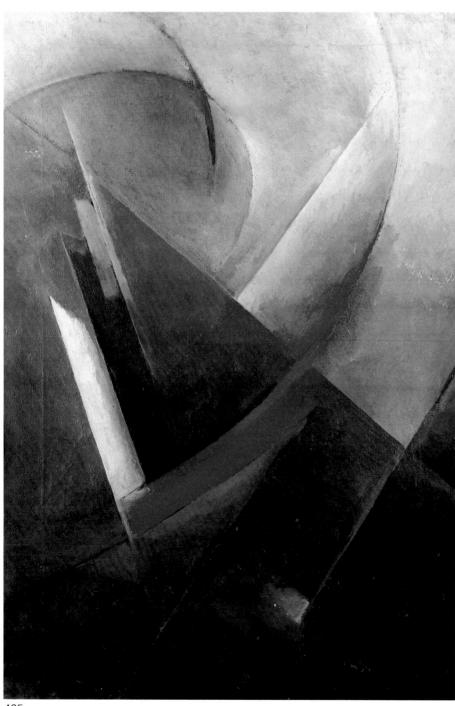

425

427

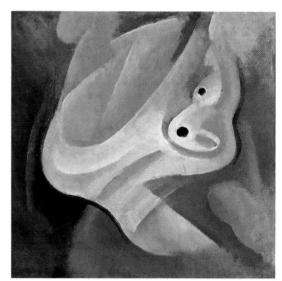

428

MIKHAIL FEDOROVICH LARIONOV

Born Tiraspol, May 22, 1881; died Fontenay-aux-Roses, near Paris, May 10, 1964.

Entered the Moscow Institute of Painting, Sculpture, and Architecture in 1898; attended intermittently because of three expulsions; received his diploma in 1908. Met Natalia Goncharova, his lifelong companion, in 1900. Prior to 1905 experimented with Impressionism. In 1906 participated in the Salon d'Automne in Paris, traveling there with Sergei Diaghilev. In 1906, 1911, 1912, and 1913 showed works in the *Mir iskusstva* (World of Art) exhibitions, and in the Seventh Venice Biennale, in 1907. In 1907–08 showed in the "Venok-Stefanos" (Wreath-Stephanos) exhibition in Moscow, the "Venok" (Wreath) exhibition in St. Petersburg, and the "Zveno" (Link) in Kiev in 1908.

From 1907 to 1910 was associated with Nikolai Riabushinsky, millionaire founder and editor of the magazine *Zolotoe runo* (Golden Fleece). Was instrumental in organizing the three exhibitions under the auspices of the magazine, which took place between 1908 and 1909 and in which French Impressionist painters were shown along with Russian artists. The third *Zolotoe runo* exhibition, held in December 1909, introduced Russian Neo-Primitive art (allied to folk art, woodcuts—*lubki*—and icons), including works by David Burliuk, Goncharova, and Larionov.

In the winter of 1906–07 and in the winter of 1909–10, showed work at the exhibitions of the Soiuz russkikh khudozhnikov (Union of Russian Artists) in St. Petersburg. In April 1907 participated in the Moskovskoe tovarishchestvo khudozhnikov (Moscow Association of Artists) exhibition along with Goncharova, Malevich, Kandinsky, and others.

Entered military service in 1908 and produced a series of works on military themes. In St. Petersburg in March 1910 participated in the first Soiuz molodezhi (Union of Youth) exhibition, which traveled to Riga in June, and also showed in the 1911 and 1912 Soiuz molodezhi exhibitions. In 1909–10 participated in the salons of Vladimir Izdebsky, the first of which traveled from Odessa to Kiev, Riga, St. Petersburg, and other cities. Also in December 1910, together with Lentulov and Goncharova, organized the first exhibition of the "Bubnovyi valet" (Jack of Diamonds) group. Broke with group in 1911 because of its division into Russian and French factions, and in March 1912 organized the "Oslinyi khvost" (Donkey's Tail) exhibition in Moscow. On December 8, 1911, had a one-day, one-man retrospective exhibition at the Obshchestvo svobodnoi estetiki (Society of Free Aesthetics) in Moscow; in October 1912 participated in the "Second Post-Impressionist Exhibition," at the Grafton Galleries in London.

In 1912 to 1913 began to work on Rayonist paintings and to illustrate books by Futurist writers—particularly Velimir Khlebnikov and Alexei Kruchenykh—such as *Starinnaia liubov* (Old-Time Love) and *Mirskontsa* (Worldbackward) with Goncharova and others. In 1913 published "Luchisty i budushchniki. Manifest" (Rayonists and Futurists: A Manifesto), which was signed by ten other painters, including Goncharova, and was published in the *Oslinyi khvost i mishen* (Donkey's Tail and Target) almanac. That same year in April organized the "Mishen" (Target) exhibition, where Rayonism was publicly introduced. Also participated with Goncharova in the production of an experimental film, *Drama in the Futurists' Cabaret No. 13*, and sent works to the "Erste deutsche Herbstsalon" (First German Autumn Salon), at Der Sturm gallery in Berlin, where the Italian Futurists were well represented.

In April 1914 organized the "No. 4" exhibition in Moscow, and in June participated in a joint show with Goncharova at the Galerie Paul Guillaume in Paris. Before the war returned to Russia and was mobilized as an ensign; suffered a concussion and was discharged in 1915. In March–April showed some rapidly created reliefs at the "Vystavka zhivopisi 1915 god" (Exhibition of Painting: 1915). That year, at Diaghilev's invitation, left with Goncharova for Switzerland, where Larionov became, unofficially, chief artistic adviser for the Diaghilev ballet. Designed a series of productions, including Igor Stravinsky's *Le Renard* (1922). Among his book illustrations of that time are those for Alexandr Blok's *Dvenadsat* (The Twelve), published in 1920 in Paris, and Maiakovsky's *Solntsu* (To the Sun), published in 1923 in Berlin. Moved to Paris permanently in 1917.

Unless otherwise indicated, all the Larionovs were acquired from L. F. Zhegin (Shekhtel) of Moscow, architect, poet, artist, and friend of Maiakovsky, Larionov, and Goncharova. His collection of Larionov's work was extensive.

429 *THE CAPTAIN'S DAUGHTER: EXECUTION,*
c. 1900. Oil on board. 36 x 47 (Tretiakov Gallery
TR9). It has not been established whether an
edition of Pushkin's *The Captain's Daughter*
illustrated by Larionov was ever planned.

430 *UNTITLED, 1900. Gouache and bronze*
paint on paper. 25.8 x 34.2 (C519). Dated on
reverse: "1900."

431 *UNTITLED, 1900. Watercolor and silver*
paint on paper. 15.8 x 23.9 (C516). Dated on
reverse: "1900."

429

430

431

432 *UNTITLED, 1900. Ink on paper. 20.8 x 26 (C568 verso). Dated on reverse: "1900."*

433 *UNTITLED, 1900. Ink on paper. 20.8 x 26 (C568 recto). Inscribed l r: "Drawing by M. Larionov 1900. Guaranteed by L. Zhegin 1963."*

434 *UNTITLED, 1903. Ink on paper. 35.5 x 22.3 (220.80). Dated on reverse: "1903."*

435 *UNTITLED, 1900. Sepia on paper. 21.7 x 13.4 (221.80). Dated on reverse: "1900."*

432

433

434

435

436 *UNTITLED, 1900. Sepia on paper. 21.7 x 13.5 (218.80). Dated on reverse: "1900."*

437 *UNTITLED, c. 1900–03. Pastel and charcoal on paper. 26 x 14.2 (219.80 recto). Signed l r: "M. L."*

438 *LAUNDRESSES, 1903. Pastel on cardboard. 26 x 34 (Tretiakov Gallery TR11).*

439 *DANCE, c. 1900. Watercolor on cardboard. 22 x 26 (Tretiakov Gallery TR8).*

436

437

438

439

440

440 *CHURCH, 1904. Oil on canvas. 41 x 29 (Tretiakov Gallery TR91).*

441 *NUDE IN ARMCHAIR, WASHING HER FEET, c. 1905. Pastel on cardboard. 29 x 34.5 (Tretiakov Gallery TR10).*

442 *UNTITLED, c. 1905. Pastel and charcoal on paper mounted on paper. 15.2 x 14.8 (C394).*

443 *NUDE, 1907. Gouache on cardboard. 24 x 33.5 (Tretiakov Gallery TR92).*

441

442

443

444 *LANDSCAPE WITH RIVER, 1908. Oil on canvas. 69 x 69 (Tretiakov Gallery TR93). Acquired from the Ribakov collection, Moscow.*

445 *VENUS, 1912. Pencil on paper. 22 x 28.6 (C522). Inscribed on composition: "Venus Mikhail."* Probably a study for the painting in the Russian Museum, Leningrad (oil on canvas, 68 x 85.5, repr. *Paris-Moscou* [Paris, 1979], p. 106). The date at the l l of the painting is 1912 (rather than 1812 as here).

446 *FEMALE PORTRAIT, n.d. Oil on canvas. 32.2 x 31 (135.78).* This work was probably painted late in Larionov's career.

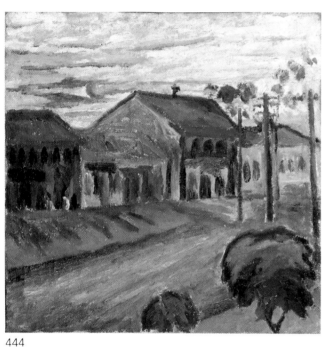

444

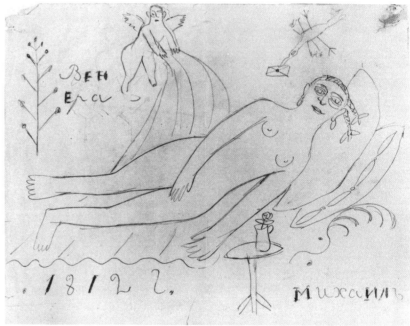

445

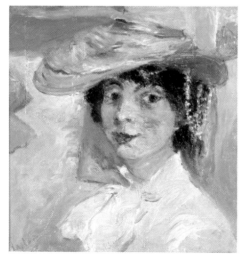

446

447 *RAYONISM, 1912–13. Oil on wood. 30.5*
x 35.5 (134.78). Not signed or dated.

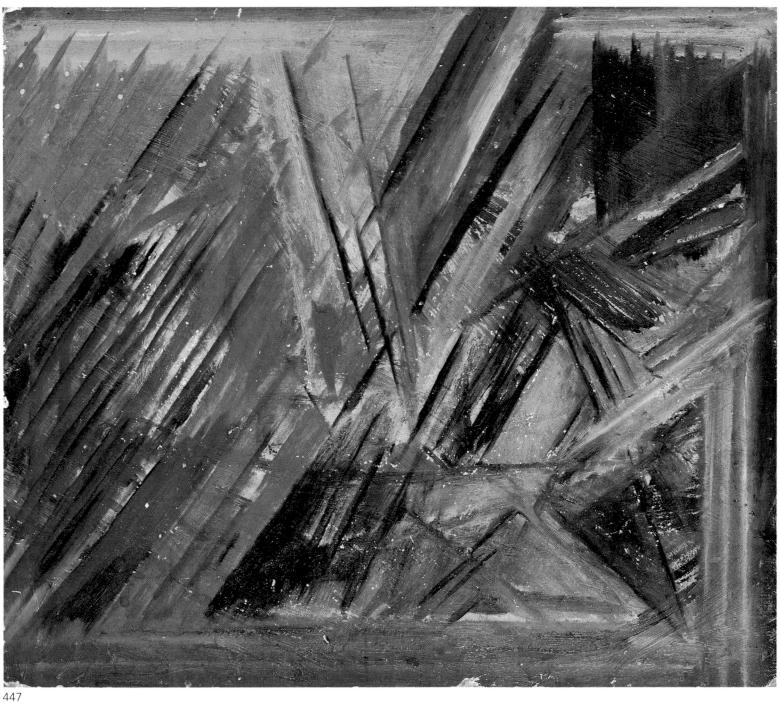

447

ARISTARKH VASILIEVICH LENTULOV

Born Nizhnee Lomovo, Penza Province, January 16, 1882; died Moscow, April 15, 1943.

While attending religious school from 1897 to 1903 (he was the son of an Orthodox priest), studied at the Penza Artistic Drawing Institute. Studied at the Kiev Art School from 1903 to 1905, and again at the Penza Artistic Drawing Institute from 1905 to 1907. Starting in 1908 was a pupil at the private studio of Dmitrii Kardovsky in St. Petersburg. In 1908 exhibited professionally at the "Sovremennoe tvorchestvo" (Contemporary Creation) exhibition in Moscow and St. Petersburg and in the 1907 – 08 and the 1909 "Venok-Stefanos" (Wreath-Stephanos) exhibitions in Moscow and St. Petersburg. In 1908 participated in the "Zveno" (Link) exhibition in Kiev and in 1909 and 1910 showed at the Izdebsky salons.

In Moscow, from 1910 onward, one of the founders and leaders with Larionov and Goncharova of the "Bubnovyi valet" (Jack of Diamonds) group. In 1911 journeyed to France and Italy, worked at Le Fauconnier's Paris studio. Illustrated Futurist miscellanies in 1915 and 1916. Participated in the "Vystavka zhivopisi 1915 god" (Exhibition of Painting: 1915), where he showed a self-portrait entitled *A Great Artist*, painted in icon style and inserted in a golden frame.

From 1918 to 1922 returned to a Cubist and Cézannesque structure, but in his theater designs retained strong elements of the decorative. From 1918 to 1920 professor at the Svomas and in 1919 formed, with Georgii Yakulov, the Obmokhu group. From 1920 to 1930 taught at Vkhutemas/Vkhutein in Moscow. In 1926 was one of the organizers of the Society of Moscow Artists (OMKh).

His first one-man show, held in Moscow in 1933, contained two hundred fifty-four works.

The two Lentulovs were acquired from the artist's daughter, M. A. Lentulova, Moscow.
See also page 424.

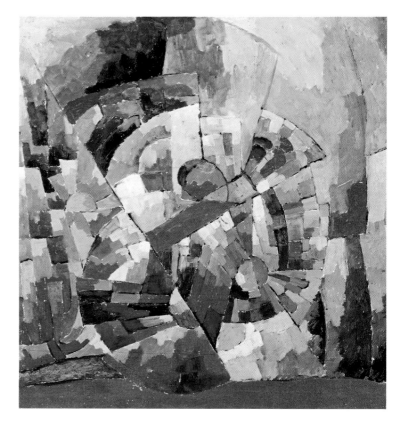

448 *COMPOSITION (ASTERS), 1913. Oil on canvas. 101 x 96 (Tretiakov Gallery TR89).*

449 *LANDSCAPE (KISLOVODSK), 1913. Oil on
canvas. 102 x 99.5 (Tretiakov Gallery TR90).*
Painted during the summer of 1913 at Kislo-
vodsk, a health resort in the Northern Caucasus.

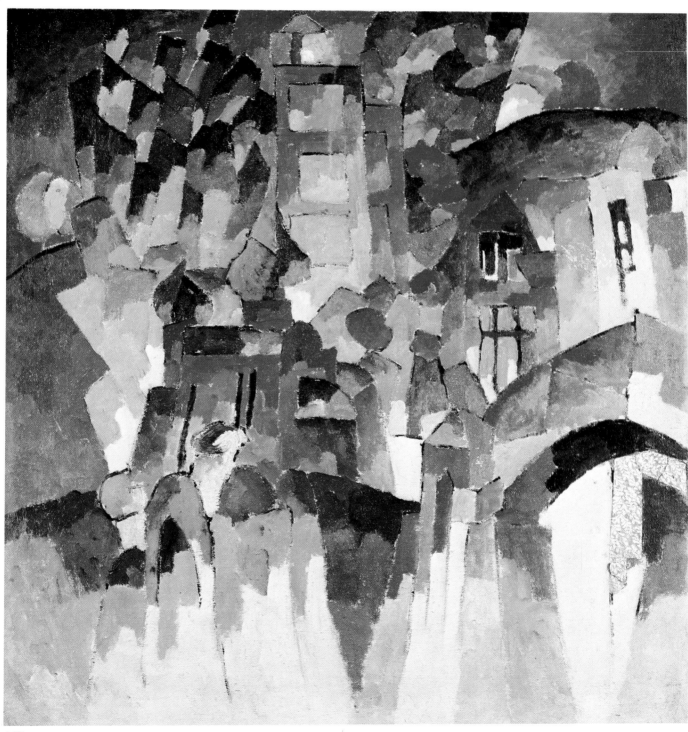

449

EL LISSITZKY (LAZAR MARKOVICH LISITSKY)

Born Polchinok, Smolensk Province, November 23, 1890; died Moscow, December 30, 1941.

Grew up in Vitebsk; attended technical high school in Smolensk. After graduation, in 1909, entered the Technische Hochschule in Darmstadt. Spent the summer of 1910 in Vitebsk and Smolensk; in other summers up to 1914 traveled to France, Italy, and Belgium. Returned to Russia in 1914, and in 1916 received a diploma in engineering and architecture from Riga Technological University. In 1916 started work at Boris Velikovsky's architectural atelier in Moscow. From 1917 to 1924 illustrated Yiddish picture books, notably *Chad Gadya* (One Kid), published in Kiev.

In 1919 was invited by Marc Chagall, director of the Vitebsk Art Institute, to become professor of graphics and architecture. In a philosophical conflict that arose at the school that autumn, sided with Malevich and under his influence began to work in a Suprematist manner. Member of Posnovis and Unovis. In the winter of 1919 – 20 created his first Proun. In 1921 lectured in the architecture department of Vkhutemas in Moscow. In 1922 started to publish the journal *Veshch/Gegenstand/Objet* with Ilia Ehrenburg in Berlin; published his *Pro 2 kvadrata* (About 2 Squares), which he had prepared for press in 1920 in Vitebsk; and exhibited a Proun and other works at the "Erste russische Kunstausstellung" (First Russian Art Exhibition), at the Galerie van Diemen in Berlin and created his Proun Room for the "Grosse Berliner Kunstausstellung" (Great Berlin Art Exhibition) of 1923.

In 1923 had an exhibition under the auspices of the Kestner Society in Hanover. Also in that year Vladimir Maiakovsky's *Dlia golosa* (For the Voice), designed by Lissitzky, was published; a folio of mechanical figures was designed for Alexei Kruchenykh and Mikhail Matiushin's opera *Pobeda nad solntsem* (Victory over the Sun); and six Proun lithographs were published in a Kestner Society portfolio.

In 1925 published *Die Kunstismen (Les Ismes de l'art / The Isms of Art)*, compiled in collaboration with Hans Arp — a pioneering survey of modern art tendencies. The same year, with the help of Emil Roth, designed "horizontal" skyscrapers for Moscow; returned to Moscow in June. From 1925 to 1930 taught in the wood- and metalwork department of Vkhutemas/Vkhutein in Moscow. In 1926 his first exhibition room design was shown at the Internationale Kunst (International Art) exhibition, in Dresden, and in 1927 his *Raum der Abstrakten* (Abstract Room) was presented at the Niedersächsisches Landesmuseum in Hanover. In 1928 planned and directed the installation of the Soviet Pavilion at the "Pressa" (International Press Exhibition), in Cologne; he regarded the design of exhibitions as a new synthesizing art form.

450 *COVER DESIGN FOR "SOLNTSE NA IZ-LETE: VTORAIA KNIGA STIKHOV 1913–16"* (THE SPENT SUN: SECOND BOOK OF POEMS 1913–16), BY KONSTANTIN BOLSHAKOV, 1916. Black ink on paper. 17.1 x 12.8 (441.80). Dedication along lower edge: "To a friend, a poet, Konst. Arist. Bolshakov, a bundle of visions, as a memento—Lazar Lissitzky." *Acquired from N. Babicheva, widow of Alexei Babichev.* The book was published in 480 copies (with a lithographic cover by Lissitzky) by Tsentrifuga, Moscow, 1916. Dimensions of the book cover, printed in ocher and black on gray stock: 23.4 x 18.8 (repr. color, Susan P. Compton, *The World Backwards. Russian Futurist Books 1912–16* [London: The British Library, 1978], pl. 18). This is Lissitzky's first mature project in book design, and it is clearly influenced by Italian Futurist imagery.

In 1929 designed sets for the poet Sergei Tretiakov's play *Khochu rebenka* (I Want a Child) for the Meierkhold Theater (never staged). In 1930 published his treatise on modern architecture, *Russland: Architektur für eine Weltrevolution* (Russia: Architecture for a World Revolution). In the 1930s continued to work as a book and exhibition designer.

During his adult life suffered from tuberculosis and spent time in sanatoriums in Switzerland and in Russia; the disease claimed his life in 1941.

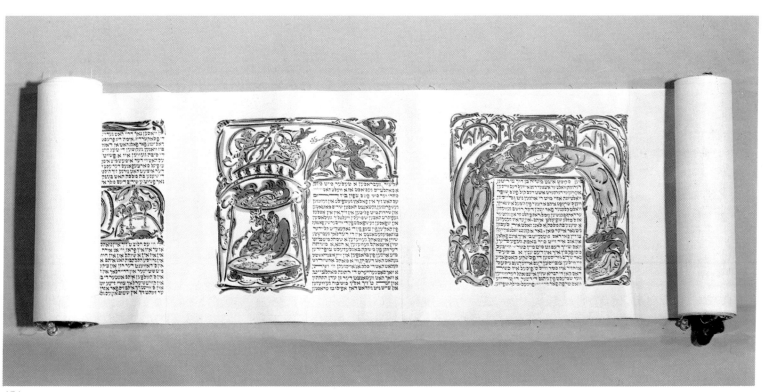

451

451, 452 *WOODEN CASKET SHAPED LIKE A TORAH CONTAINING A SCROLL OF "SIHAT HOLIN" (AN UNHOLY STORY, OR THE LEGEND OF PRAGUE), IN YIDDISH, BY MOSHE BRODERSON, 1917. Total length of scroll: 495; length of casket: 34.9; diameter of casket: 10.9 (281.80). Acquired from a private collection, Moscow.* Each page is a self-enclosed block of Hebrew lettering (written by a synagogue scribe), with watercolor illuminations by Lissitzky. The book was published in Moscow, in an edition of 110 copies; 20 were published in scroll form and hand-colored by the artist.

452

453 *PROUN 1*C*, 1921. Lithograph on paper. Sheet size: 36 x 45.4; image: 23.1 x 23.1 (C533). Printed l r of image: "P 1*C*." Inscribed l l in pencil on mount: "P 1*C*"; not signed or dated. Acquired from N. Babicheva. Included in the first Proun portfolio, Moscow, 1921. Costakis owns a second version of this lithograph, also acquired from N. Babicheva (144.78).*

Lissitzky's first Prouns probably date from late in 1919, though the precise dating of this entire group of works remains to some extent unresolved. He delivered a lecture at Inkhuk on the subject on September 23, 1921, and although the original Russian text has apparently not been published, Lissitzky did publish essays presumably based on the lecture in the journals *Veshch/Gegenstand/Objet* and *De Stijl* in 1922. In these essays he described the Prouns as an intermediary step between painting and architecture, created out of a sense of the limitations imposed by the format of the painter's canvas.

The term, which he invented, is an abbreviation of the Russian *Proekt utverzhdeniia novogo* (Project for the Affirmation of the New). In the Prouns he was intent upon destroying the conventional expectations created in the mind of the viewer when confronted with a painting. The Suprematist canvas remained for him an easel painting in spite of its "revolutionary force." Thus, "like any painting in a museum, it possessed a specific perpendicular axis . . . and for this reason, if hung any other way would give the impression of being upside down." In the Prouns, on the other hand, the picture and the viewer are "carried beyond the confines of this sphere and in order to comprehend

[them] fully the viewer must circle like a planet round the picture which remains immobile in the center." (See A. Nakov, *The Suprematist Straight Line* [London: Annely Juda Fine Art, 1977].)

In the Proun lithographs and subsequent paintings Lissitzky developed these ideas further. For example, in *Construction Floating in Space*, he created a composite image in which four examples of a single print are juxtaposed, each viewed from a different direction (repr. Nakov, op. cit., p. 26). His own theoretical argument, articulated most fully in a lecture delivered October 23, 1924, elucidates his purpose, in which architecture, which "is the central issue of modern times," plays a crucial part: "[The surface of the picture] . . . has become a construction and . . . you have to walk round it, to look at it from above, to study it from beneath. . . . We have made the canvas rotate. And as we rotated it, we saw that we were putting ourselves in space. Space, until now, has been projected onto a surface by a conditional system of planes. We began to move on the surface of the plane towards an unconditional distance. We multiplied the axes of projections in this rotation. . . . If Futurism put the spectator inside the canvas, we take him via the canvas into real space. . . . When we saw

453

that the content of the canvas was no longer a pictorial one, that it had now begun to rotate . . . we decided to give it an appropriate name. We called it PROUN" (transl. John E. Bowlt, *Lissitzky* [Cologne: Galerie Gmurzynska, 1976], pp. 59–72).

In a 1924 article on Lissitzky, the Hungarian critic Ernst Kállai wrote of the Proun paintings: "The colors: uncompromisingly white, gray, black. The steely, incisive precision of their execution and outline bears witness to the depth of feeling that lies behind them. . . . [Their] spatial, formal, and tonal equilibrium, the significance of their rhythmic composition and their total effect, make them indisputably the greatest achievements of Constructivism" (*Der Cicerone,* vol. 16 [1924], pp. 1058–63).

454 *PROUN 1ᶜ, 1919. Oil and collage on wood. 67.5 x 67.5 (Antonina Gmurzynska, Cologne; formerly Costakis collection). Signed and dated on reverse:* "Proun 1ᶜ El Lissitzky. 1919." *Acquired from the collection of S. Lissitzky-Küppers, Novosibirsk.* According to V. Rakitin, this work was shown in the Unovis exhibition in Vitebsk in 1920. Another version, slightly different in format, belonged to the museum in Hanover in 1924 and is presumed destroyed (repr. E. Kállai, "El Lissitzky," *Der Cicerone,* vol. 16 [1924], p. 1059). A lithograph of the composition was included in the first Proun portfolio published in Moscow (see plate 453). The dating of the Proun lithographs and their appearance as independent works as well as in portfolio editions remains problematic. The dating offered here is thus of a tentative nature.

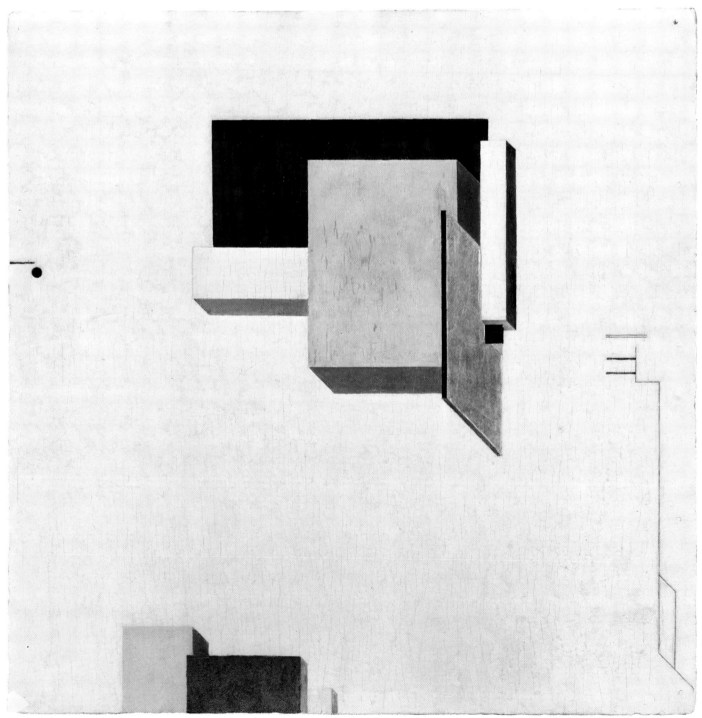

454

455 *PROUN 1, 1919–21. Lithograph on paper mounted on paper. Sheet size: 34.4 x 45.5; image: 25.5 x 34.4 (148.78). Inscribed in pencil, one word on each of three sides: "along the path of a circle"; l l: "P 1." Acquired from N. Babicheva.* Lissitzky has enclosed the framing rectangle of this composition in a penciled circle, and has written instructions with directional arrows indicating that the composition is to be rotated so that it can be viewed from each of its four sides. In this, and the following print, the "architectural" forms are depicted as if floating in space, and this effect is intensified by the additional device of instructing the viewer to turn (or float) the entire print itself.

456 *PROOF FOR "CONSTRUCTION FLOATING IN SPACE," 1919–21. Lithograph on paper. Sheet size: 17.4 x 25.5; image: 13.1 x 17.8 (442.80). Inscribed in pencil l r, probably not in the artist's hand: "el lissitzky." Acquired from a private collection, Moscow.* For a discussion of Lissitzky's unique composite print made from this image see Nakov, *The Suprematist Straight Line*, pp. 24–27.

457 *PROUN 1ᴬ, 1919–20. Lithograph on paper mounted on paper. Sheet size: 34.4 x 45.4; image: 17.4 x 30.5 (152.78). Inscribed in pencil on mount: "P 1ᴬ" Acquired from N. Babicheva.* Included in the first Proun portfolio, Moscow, 1921. The original gouache of this composition, *Bridge I*, 1919 (8.5 x 15), is in the collection of Eric Estorick, London.

458 *PROUN 2ᶜ, 1919–21. Lithograph on paper mounted on paper. Sheet size: 45.9 x 34.1; image: 30.3 x 20.4 (143.78). Inscribed l l in pencil on mount: "P 2ᶜ." Acquired from N. Babicheva.* Included in the first Proun portfolio, Moscow, 1921.

459 *PROUN 2ᴰ, 1919–21. Lithograph on paper mounted on paper. Sheet size: 46.2 x 34.4; image: 35.8 x 22.4 (149.78). Inscribed l l in pencil on mount: "P 2ᴰ." Acquired from N. Babicheva.* Included in the first Proun portfolio, Moscow, 1921.

460 *PROUN 2ᴮ, 1919–21. Lithograph on paper mounted on paper. Sheet size: 34.5 x 45.5; image: 26.7 x 20.9 (147.78). Inscribed l l in pencil on mount: "P 2ᴮ." Acquired from N. Babicheva.* Included in the first Proun portfolio, Moscow, 1921.

455

458

459

456

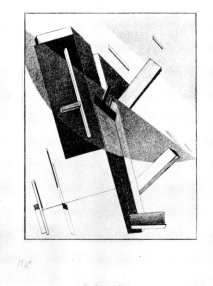

460

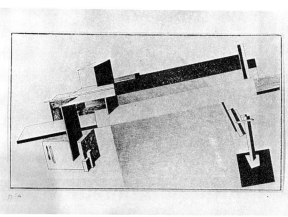

457

461 *PROUN 3ᴬ, 1919–21. Lithograph on paper. Sheet size: 28.5 x 27.8; image: 27.6 x 26.2 (142.78). Inscribed l l in pencil below image: "P 3ᴬ" Acquired from N. Babicheva.* Included in the first Proun portfolio, Moscow, 1921. A painting of this composition is in the collection of the Sidney Janis Gallery, New York.

462 *PROUN 5ᴬ, 1919–21. Lithograph on paper mounted on paper. Sheet size: 46.2 x 34.4; image: 27.5 x 26.1 (145.78). Inscribed l l in pencil on mount: "P 5ᴬ" Acquired from N. Babicheva.* Included in the first Proun portfolio, Moscow, 1921. A 1919 watercolor of this composition in reverse (17.5 x 22) was in the collection of the artist's widow (repr. S. Lissitzky-Küppers, *Lissitzky* [London, 1980], p. 26).

463 *SKETCH FOR PROUN 6ᴮ, c. 1919–21. Gouache and pencil on paper. Sheet size: 34.6 x 44.7; diameter of image: 24.6 (438.80). Signed: "el lissitzky." Penciled title in three places: "P 6ᴮ," indicating that the piece should be seen from all directions. From the collection of S. Lissitzky-Küppers.* The circular painting which closely follows this study was exhibited at the International Art Exhibition in Dresden in 1926, and then entered the collection of Ida Bienert. It is presumed lost (repr. Lissitzky-Küppers, *Lissitzky*, pl. 192).

464 *PROUN 6ᴮ, c. 1919–21. Circular lithograph on paper mounted on paper. Sheet size: 46.1 x 34.3; diameter of image: 25.2 (150.78). Inscribed l l in pencil on mount: "P 6ᴮ"; not signed. Acquired from N. Babicheva.* Included in the first Proun portfolio, Moscow, 1921.

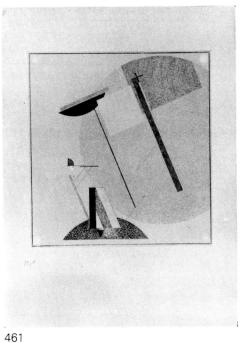

461

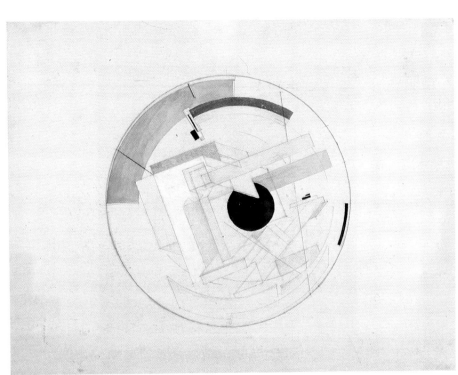

463

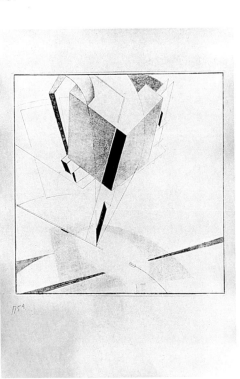

462

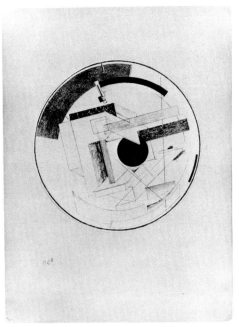

464

465 *RADIO ANNOUNCER, 1920–21. Color lithograph on paper. 53.5 x 46.1 (242.80). Signed l r in pencil:* "E. Lissitzky." *Acquired from the collection of S. Lissitzky-Küppers.* One of ten color lithographs titled *Die plastische Gestaltung der elektro-mechanischen Schau—Sieg über die Sonne*, published in an edition of 75 by R. Leunis and Chapman, Hanover, 1923. Lissitzky designed these figures for an electromechanical puppet show of A. Kruchenykh's opera *Victory over the Sun*, but it was never staged.

466 *PROUN, 1920–21. Lithograph on paper mounted on paper. Sheet size: 36.7 x 31.4; image: 26.8 x 21.5 (153.78). Acquired from a private collection, Moscow.*

467 *PROUN 1E, THE TOWN, 1920–21. Lithograph on paper mounted on paper. Sheet size: 34.4 x 46.1; image: 22.5 x 27.4 (151.78). On mount l l:* "P 1E"; *l r:* "plan of a city square." *Acquired from N. Babicheva.* Included in the first Proun portfolio, Moscow, 1921.

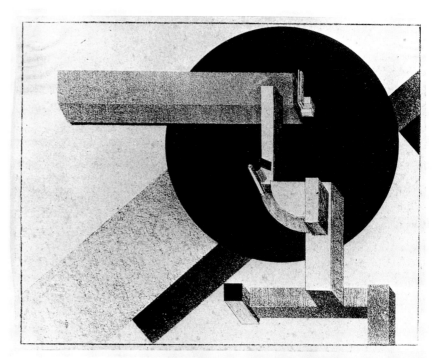

466

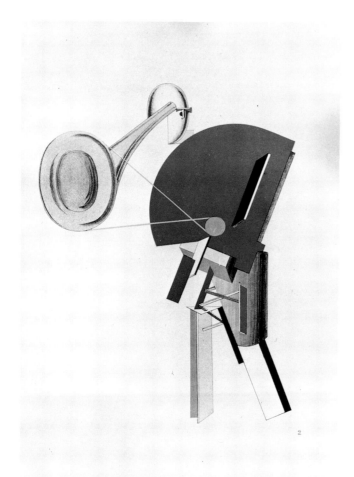

465

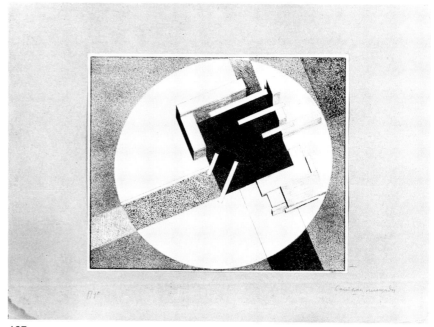

467

468 *UNTITLED, 1919–20. Gouache, pencil, and ink on paper. Sheet size: 10 x 10; image: 9.7 x 9.7 (440.80). Not signed or dated. Written across center of black square and red circle, barely visible: "ROSA LUXEMBURG." From the collection of S. Lissitzky-Küppers.* A larger version of this composition, lacking the Rosa Luxemburg inscription, is in the collection of the van Abbemuseum, Eindhoven (no. 2.0271.L24, gouache, 52 x 50). Rosa Luxemburg and Karl Liebknecht were assassinated in January of 1919. As part of the Plan for Monumental Propaganda initiated by Lenin in May 1918, artists had been encouraged to create monuments of all kinds to major revolutionary figures. In this connection a 1919 issue of *Iskusstvo kommuny* (Art of the Commune) carried the announcement of a competition for a monument to Luxemburg and Liebknecht. Whether Lissitzky initially contemplated a response to this competition or was creating a more private memorial has not been established.

469 *DESIGN FOR COVER OF THE PUBLICATION "PROUNS: A LECTURE READ AT THE GENERAL MEETING OF INKHUK, SEPTEMBER 23, 1921." Black and red gouache, ink, and pencil on gray folded paper. Sheet size: 37.7 x 24; diameter of image: 11.5 (C518). From the collection of S. Lissitzky-Küppers. Inscribed in gray ink around edge of circle: "May the overthrow of the Old World be imprinted on the palms of your hands"; signed in black ink: "El Lissitzky." In parentheses along diameter line in black ink: "In overcoming art."* *Below title in black ink: "Lecture read at the general meeting of Inkhuk Sept. 23, 1921." Acquired from N. Babicheva.*

470 *COVER DESIGN FOR PROUN PORTFOLIO, 1921. Gouache, watercolor, and pencil on paper. Sheet size: 48.5 x 35.7; image: 16 x 16.5 (146.78). Signed l l in gray within composition: "EL." Acquired from the collection of S. Lissitzky-Küppers.* A lithographic proof for the front and back covers, with pencil corrections, is in the collection of the van Abbemuseum, Eindhoven (no. 3.0232.L14a). The front image is directly based on the Costakis sketch. The back image is a square enclosed within a circle; at the base of the square, within the confines of the circle, is the word UNOVIS.

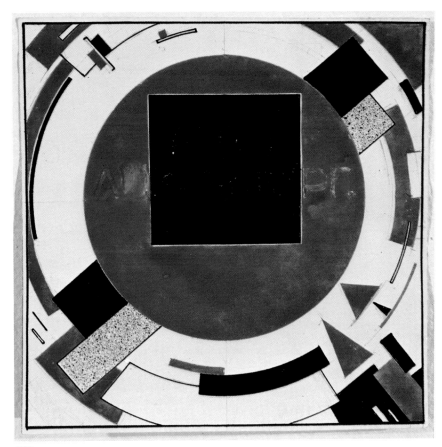

468

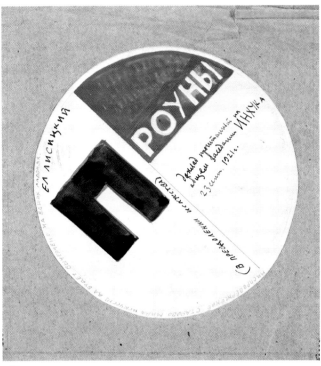

469

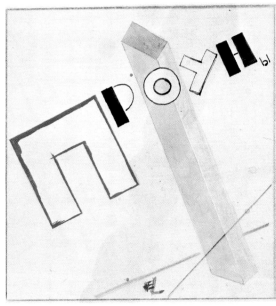

470

471 *DESIGN FOR COVER OF "BROOM," 1922. Watercolor and ink on paper. 13.4 x 10.5 (C500). On reverse, a second study for the same cover. From the collection of S. Lissitzky-Küppers.* Lissitzky designed several covers for the magazine *Broom*, which was edited and published by Matthew Josephson, spokesman for a radical left group and a friend of the artist. Three further studies for this number are in the collection of the van Abbemuseum, Eindhoven.

The final cover (repr. Lissitzky-Küppers, *Lissitzky,* plate 68) retains the principle, explored in the studies, of allowing the cover to be read from top or bottom.

472 *PROUN 10^0, c. 1919–21. Gouache and pencil on buff paper. Sheet size: 27.9 x 23.1; image: 21.1 x 18.5 (439.80). Inscribed in pencil u l: "No[v.] 21"; l l: "PROUN 10^0." Not signed or dated. Acquired from N. Babicheva.*

471

472

KAZIMIR SEVERINOVICH MALEVICH

Born near Kiev, February 26, 1878; died Leningrad, May 15, 1935.

Lived in Kursk from 1898 to 1901. Moved to Moscow in 1902, when his father died. Attended the Moscow Institute of Painting, Sculpture, and Architecture in 1903. States in his autobiography that he exhibited works from 1898 on; the first available record, however, is the 1907 exhibition of the Moskovskoe tovarishchestvo khudozhnikov (Moscow Association of Artists). Showed works in their subsequent exhibitions of 1908 and 1909. In 1910 was invited by Larionov to show in the first "Bubnovyi valet" (Jack of Diamonds) exhibition and participated in many avant-garde exhibitions thereafter.

After the "Oslinyi khvost" (Donkey's Tail) exhibition of 1912, broke with Larionov. Associated with the Soiuz molodezhi (Union of Youth) group and took part in their exhibitions in 1911 to 1914 and in the "Mishen" (Target) exhibition in Moscow in 1913. Designed the scenery for Alexei Kruchenykh and Mikhail Matiushin's opera *Pobeda nad solntsem* (Victory over the Sun) in 1913. Met the Italian Futurist Filippo Tommaso Marinetti in Russia in 1914.

Malevich's Suprematist canvases were shown for the first time at "The Last Futurist Exhibition of Pictures: 0.10" in December 1915 in Petrograd. That year he exhibited also at "Tramvai V. Pervaia futuristicheskaia vystavka kartin" (Tramway V: The First Futurist Exhibition of Paintings), also in Petrograd, and published the first of his major theoretical essays: *Ot kubizma i futurizma k suprematizmu. Novyi zhivopishnyi realizm* (From Cubism and Futurism to Suprematism: The New Painterly Realism). In 1916 participated in "Magazin" (The Store) in Moscow. From 1916 to 1917 organized the Supremus group in Moscow, and with his colleagues — Popova, Udaltsova, Rozanova, Kliun, Pestel, and others — prepared the group's journal for publication; it never appeared.

After the February Revolution of 1917 became active politically; chaired the art section of the Moscow Council of Soldiers' Deputies. From the autumn of 1918 was professor at the Svomas in Moscow and was active in IZO Narkompros. Designed and executed the sets and costumes for Maiakovsky's *Misteriia-buf* (Mystery-Bouffe) in Petrograd.

In 1919 wrote *O novikh sistemakh v iskusstve* (On New Systems in Art), and in September of that year began teaching at the Vitebsk Art Institute, where, after philosophical disputes, soon replaced Chagall as director. Organized the Unovis group there, including El Lissitzky and Vera Ermolaeva and his students Chashnik, Suetin, and Yudin. Branches opened in Orenburg, Smolensk, and Moscow, and a number of exhibitions took place in these cities with Malevich's participation. In 1919–20 held a one-man show of one hundred fifty-three works in Moscow at the "Sixteenth State Exhibition: K. S. Malevich, His Path from Impressionism to Suprematism."

473 IVAN KLIUN. *PORTRAIT OF KAZIMIR MALEVICH, 1933. Watercolor, pencil, and chalk on paper. 31.3 x 41.9 (C548). Signed and dated l r: "I. Kliun 1933."*

In 1922 showed at the "Erste russische Kunstausstellung" (First Russian Art Exhibition), at the Galerie van Diemen in Berlin. Since Unovis had been ousted from the Vitebsk institute because of tension between the group and local authorities, left for Petrograd, accompanied by followers, including Chashnik and Suetin. In Petrograd joined the new branch of Inkhuk, formed by Tatlin. Became head of its FTO (Formal-Technical Department), and conducted theoretical research and worked on architectural models there.

In 1927 traveled to Poland for a one-man exhibition in Warsaw and to Germany, where his work was shown in a separate section at the "Grosse Berliner Kunstausstellung" (Great Berlin Art Exhibition). In 1929 held a one-man show at the Tretiakov Gallery in Moscow. In the late 1920s and the 1930s returned to a figurative style.

See also pages 425–26.

474 *CHURCH, 1903. Oil on cardboard. 60.3 x 44 (sight) (136.78). Not signed or dated. Acquired from M. S. Malevich, the artist's brother.*

475 *UNTITLED, 1902–03. Oil on canvas. 21.2 x 27.7 (C86). Not signed or dated. Gift of Malevich to I. Kliun; from the Kliun family to Costakis.*

476 *UNTITLED, 1904–05. Oil on board. 30.8 x 19 (C508). Signed l r: "KM." Inscribed on reverse, not in the artist's hand: "K. Malevich N2–5p." Acquired from M. S. Malevich.*

475

474

476

477 *LANDSCAPE WITH WINDMILLS. Watercolor and pencil on board. 23.9 x 52 (139.78). Not signed or dated. Acquired from M. S. Malevich.* A preparatory drawing (pencil, 12.2 x 11.8) is in the Musée National d'Art Moderne, Paris (repr. *Malévitch, 1878–1978. Actes du colloque internationale . . . 4 et 5 mai 1978* [Lausanne, 1979], no. 22).

478 *WOMAN IN CHILDBIRTH, 1908. Oil and pencil on board. 24.7 x 25.6 (138.78). Signed and dated l l: "Kazimir Malevich 1908." Acquired from M. S. Malevich.* A study for this work is in the collection of the Musée National

d'Art Moderne, Paris (repr. *Malévitch . . . colloque,* no. 33). In the pencil study the woman's head is surrounded by the same fragmentary limbs, but in the final work the red background has become a tapestry of tiny fetuses. Malevich's explicitly Symbolist imagery and style at this moment are comparable to Kliun's (see, for example, plate 127).

479 *SHROUD OF CHRIST, 1908. Gouache on cardboard. 23.3 x 37.4 (Tretiakov Gallery TR84). Signed and dated l l: "Kazimir Malevich 1908." Acquired from I. Sanovich, Moscow.*

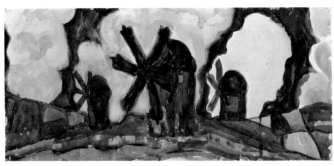

477

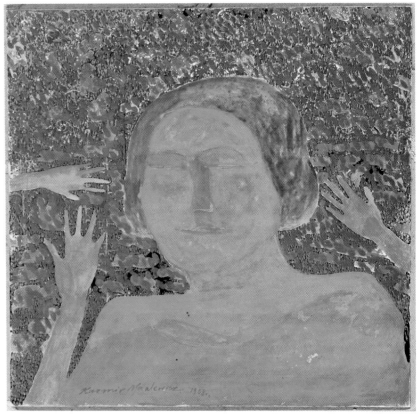

478

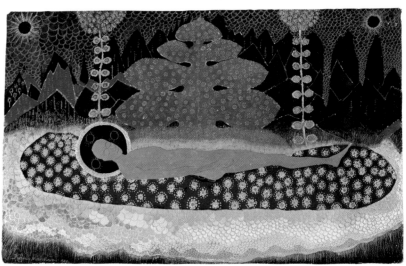

479

480 *SELF-PORTRAIT, c. 1910. Gouache on cardboard. 27 x 27 (Tretiakov Gallery TR85). Signed l l: "Kazimir Malevich." Acquired from M. S. Malevich.* According to V. Rakitin, the work was exhibited in the first Moscow salon of 1910–11.

481 *PORTRAIT, c. 1910. Gouache on paper. 27.7 x 27.7 (140.78). Acquired from M. S. Malevich.* In both this work and plate 480 Malevich's strong response to the work of Matisse and Gauguin is evident. By 1910 Shchukin's collection in Moscow contained striking Fauve Matisses and canvases of Gauguin's Tahitian period. Malevich's conceptions of space and color are clearly indebted to both.

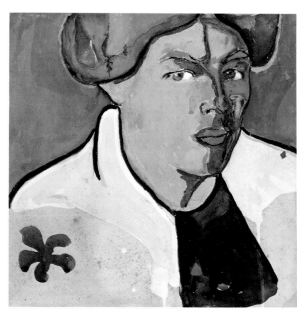

481

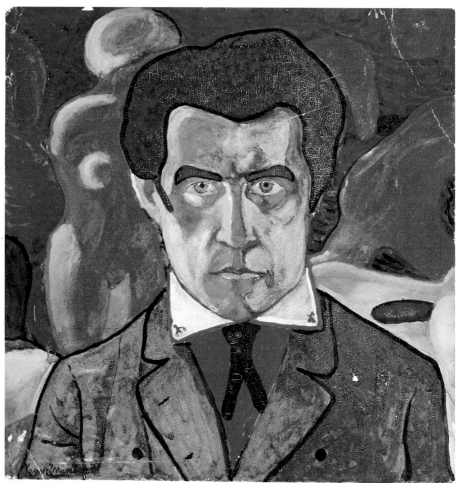

480

482 *PORTRAIT OF MATIUSHIN, 1913. Oil on canvas. 106.5 x 106.5 (Tretiakov Gallery TR88). From the collection of O. Matiushina, Leningrad, to N. Khardzhiev; purchased by Costakis from Khardzhiev.* Shown in the ''Jack of Diamonds'' exhibition, Moscow, 1914; ''Tramway V,'' Petrograd, 1915; and Malevich's one-man show in Moscow, 1929. The portrait was painted in the autumn of 1913 while Malevich and Matiushin were working together on the opera *Victory over the Sun.* (See A. Nakov, *Kazimir Malevich: Scritti* [Milan, 1977], p. 47.) As Nakov cogently argues, Malevich's imposition of the starkly articulated white ''metric'' line across the surface of the canvas creates a strong disruption of the Cubist conventions which govern the painting as a whole. Though still deeply embedded in the Cubist idiom, the painting signals the radical break Malevich was soon to make.

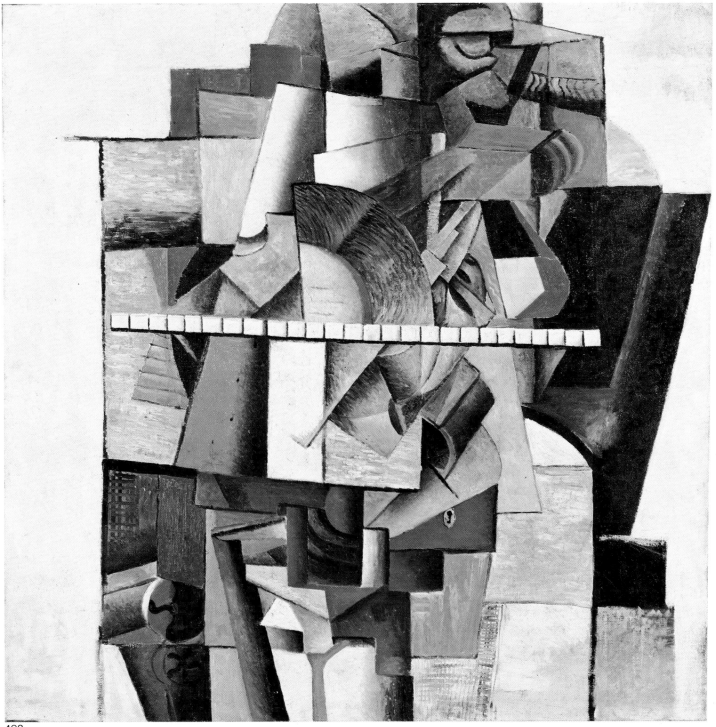

482

483 *PRAYER, 1913. Lithograph. 17.5 x 11.5 (C528). Signed and titled in the stone:* "Prayer K. Malevich." *Gift to Costakis from A. Kruchenykh.* Illustration from A. Kruchenykh's *Vzorval* (Explodity), second edition, St. Petersburg, 1914. The page, which shows no evidence of having been cut or torn from a copy of the book, may have been one of a number of proofs in Kruchenykh's possession.

484, 485 *ILLUSTRATION FOR "IGRA V ADU" (A GAME IN HELL) BY A. KRUCHENYKH, 1914. Lithograph. 12.4 x 18.1 (C524). Inscribed on reverse:* "Autolithography by K. Malevich for the second edition of 'A Game in Hell.' A. Kruchenykh." (Autolithography was a technique which used manual printing.) *Igra v adu* was first published in St. Petersburg in 1914, this illustration appearing on page 21. There are slight discrepancies between this lithograph and those appearing in the first edition. Kruchenykh's inscription on the reverse identifies this as a lithograph for the second edition.

486 *PROOF(?) FOR THE SECOND EDITION OF "IGRA V ADU" BY A. KRUCHENYKH, 1914. Lithograph on paper mounted on paper. 17.8 x 12.3 (C527 recto). Gift to Costakis from A. Kruchenykh.* As published in the second edition of the 1914 book, this figure appears on the left side of page 20, which has text on the right. In the present example, however, the figure is cut out and mounted on a blank page which has part of the text of the book on the verso. It seems likely, therefore, that it represents a proof page of the book, for which Rozanova wrote out Kruchenykh's text.

487 *PAGE OF TEXT FOR "IGRA V ADU" (verso of C527). Inscribed in pencil around edge in Kruchenykh's hand:* "For the second edition of 'A Game in Hell,' 1914." *Text written by the hand of O. Rozanova. On the back:* "Autolithography by K. Malevich. A. Kruchenykh."

483

484

485

486

487

488

490

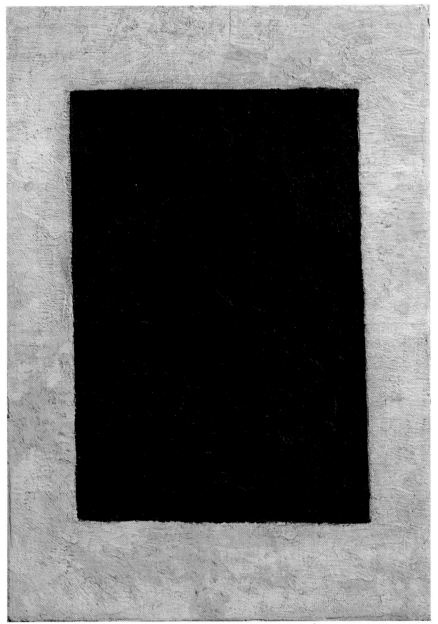

489

488 *RED SQUARE, n.d. Gouache on lined paper. 6.1 x 5.7 (C755). Gift to Costakis from N. Khard-zhiev, who identified it as a Malevich.*

489 *BLACK QUADRILATERAL, n.d. Oil on canvas. 24 x 17 (ATH80.10). Gift to Costakis from a close friend of the artist.* Malevich's first *Black Quadrilateral* was exhibited in December 1915 at the "0.10" exhibition, in Petrograd. Several other versions of the square and rectangle were made by him later, and it is difficult to date these precisely.

490 *Poster announcing a lecture to be given at Orenburg by Malevich, "a visiting artist from Moscow," proceeds to be sent to the soldiers at the front, c. 1917 (132.80).*

491 *Installation photograph of Malevich's first one-man exhibition, Moscow, winter 1919–20. Hitherto unpublished. From the Inkhuk archives; gift of the widow of V. D. Bobrov.*

492 *Installation photograph of Malevich's first one-man exhibition, Moscow, winter 1919–20. From the Inkhuk archives; gift of the widow of V. D. Bobrov.*

493 *SINGLE-PAGE AUTOGRAPH MANU-SCRIPT, dated July 1, 1916. Colored inks, crayon, and pencil on paper. 26.3 x 16.2 (164.80). Page numbered u r: p. 27. Acquired from the collection of S. Lissitzky-Küppers, Novosibirsk. This single page in Malevich's hand is apparently* part of a longer manuscript or diary. Some passages are recognizably taken from Malevich's essay "From Cubism and Futurism to Suprematism: The New Realism in Painting," which appeared in conjunction with the December 1915 "0.10" exhibition and was published in its most complete form (third edition) in Moscow in January 1916. Other passages are also closely related to Malevich's concepts and ideas of this period. Malevich was drafted into the armed forces about the middle of July, and apparently did not write again for some time. The sequence of thoughts recorded here, their relationship to Malevich's other writings, and the context and purpose of this text are questions which require further study.

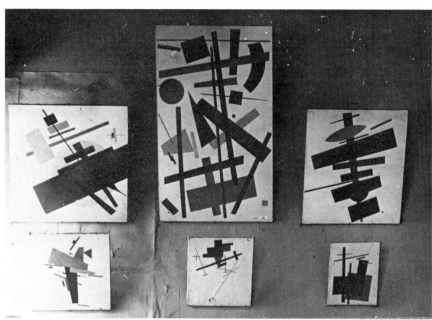

491

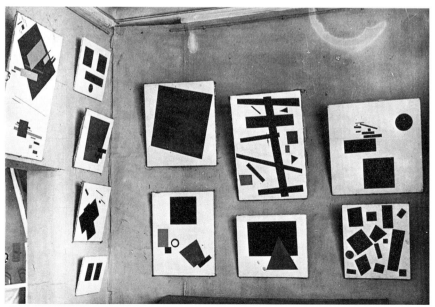

492

493

494 VIOLIN. Oil on canvas. 70.3 x 53.4 (282.78). Inscribed on reverse: ''Mal.'' Not dated. Acquired from Andrei Drevin, the son of Alexandr Drevin and Udaltsova. The attribution to Malevich is by E. Kovtun and the sister of Udaltsova. According to Kovtun, there is a closely related work, similarly signed on the reverse, in the collection of the Russian Museum, Leningrad.

Several works in the Costakis collection date from Malevich's 1919–22 Vitebsk period, and though not all have yet been attributed to specific hands, their provenance from this period and environment is clear. During the time that he was teaching in Vitebsk, Malevich gave some courses in Cubism in which he set specific analytical problems for students to solve. An exhibition of student assignments of this nature was held in Vitebsk in May 1920, and would probably have included works such as plates 495 and 496.

495 ARTIST UNKNOWN. STILL LIFE WITH PIANO, c. 1919–20. Watercolor, charcoal, pencil, and ink on paper. 39.6 x 22.6 (C167).

496 EVGENIA MAGARIL. UNTITLED, c. 1919–20. Gouache on board. 35.3 x 21.9 (141. 78). Signed on reverse: ''Magaril.'' Acquired from the artist's family. Magaril was a student whom Malevich appears to have especially respected. As Nakov has pointed out, when Malevich left Vitebsk in 1922 he gave her a copy of his pamphlet Bog ne skinut (God Is Not Cast Down), with a dedication reading: ''Each member of Unovis must remember the unity of Suprematism and must affirm it everywhere as nonobjectivity'' (Nakov, Kazimir Malevich: Scritti, p. 375).

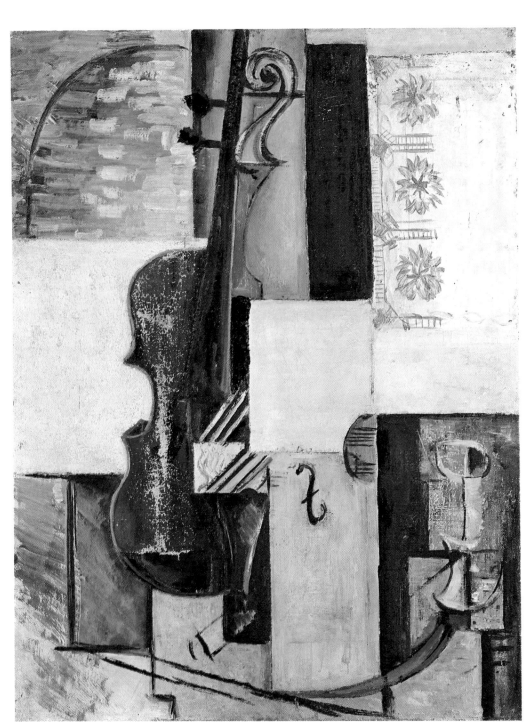

494

495

496

The creation of the Committees for Peasant Poverty in late 1917 and early 1918 marked the beginning, in Lenin's words, "of the Revolution in rural districts." The preparations for the first conference, to be held in Petrograd, were elaborate, and a competition was held for the decoration of the Winter Palace and for the design of the program covers. Malevich, who was at that time probably the leading figure in the artistic avant-garde, won first place, signaling perhaps the only moment in his career when his aesthetic position "could be identified with an official platform." (For these facts and a cogent analysis of this work and its significance, see A. Nakov, in *The Print Collector's Newsletter* 8:1 [March–April 1976].) N. Khardzhiev has suggested that the cover was destined only for the programs of the official delegates, and that it would have been printed in a very small edition. This might explain its rarity.

The lithograph is notable both for its originality and for its extraordinary impact on the development of typography and design in the years that followed. The influence was to be felt in Suetin's and Chashnik's porcelain designs, in Lissitzky's graphic work, in Malevich's own *Planits*, and in the whole development of his Suprematist vocabulary at Vitebsk in the 1920s. (For further discussion of this work see D. Karshan, in *Suprématisme* [Paris: Jean Chauvelin, 1977], pp. 56–60; J. Bowlt, in *Art in America* 65:1 [January–February 1977], p. 73.)

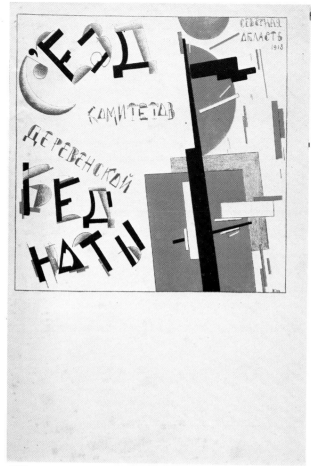

497

FRONT AND BACK PROGRAM COVERS FOR THE FIRST "CONFERENCE OF THE COMMITTEES FOR PEASANT POVERTY, NORTHERN REGION, 1918." Colored lithograph on heavy folded paper. Sheet size: 48.5 x 64.8; recto image: 29 x 29; verso image: approx. 20.1 x 19.7 (C161). Signed in the stone, within the image, l r: "KM." Size of edition not known, but less than half a dozen copies are recorded.

497 *Front cover:* "Conference of the Committees for Peasant Poverty, Northern Region, 1918."

498 *Back cover:* "Proletarians of all nations unite!"

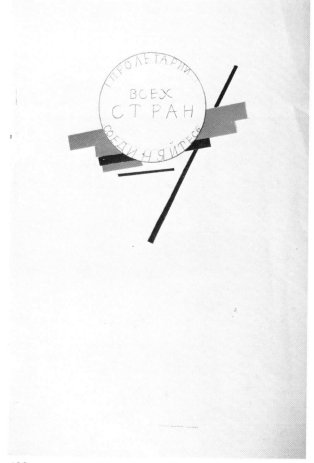

499 *UNTITLED, n.d. Pencil on paper. 18.1 x 9.7 (C526). Inscribed on reverse: "Sketch for victory over the sun 1913." Acquired from I. Kudriashev, who attributed the work to Malevich.*

Agit-prop trains traveled across the country during the civil war, distributing Bolshevik propaganda. Malevich was among the artists sent by the Moscow section of IZO to help the Red Army with various aspects of its propaganda effort in 1918. (See *Agitatsionno-massovoe iskusstvo pervykh let Oktiabria,* ed. E. A. Speranskaia [Moscow, 1971], p. 96.) Although examples of his work there have not been identified hitherto, it is possible that he supervised the design of such trains.

500 *SKETCH FOR AGIT-PROP TRAIN, c. 1920. Pencil on paper. 17.9 x 21.5 (C525 recto). Acquired as a gift from I. Kudriashev, who attributed the work to Malevich.*

501 *SKETCH FOR AGIT-PROP TRAIN, c. 1920. Pencil on paper. 17.9 x 21.5 (C525 verso).*

499

500

501

502 *UNTITLED, n.d. Pencil on paper. 15.7 x 9.2 (193.80a). Acquired as a gift from I. Kudriashev, who attributed the work to Malevich.* The composition appears in a Malevich drawing of 1917 in the collection of the Stedelijk Museum, Amsterdam (pencil on paper, 41 x 29.5, repr. T. Andersen, *Malevich* [Amsterdam, 1970], no. 78).

503 *UNTITLED, n.d. Gouache and pencil on paper. 22 x 17.6 (193.80b). Acquired from the collection of S. Lissitzky-Küppers.*

504 *UNTITLED, n.d. Pencil on paper. 14.8 x 10.7 (193.80c). Acquired as a gift from I. Kudriashev, who attributed the work to Malevich.* The composition appears in a Malevich draw-

ing from 1917 in the collection of the Stedelijk Museum, Amsterdam (pencil on paper, 46 x 29.5, repr. Andersen, *Malevich*, no. 77).

505 *UNTITLED, n.d. Gouache and ink on paper. Sheet size: 17.5 x 21.9; image: 13.2 x 9 (192.80). Acquired as a Malevich from the collection of S. Lissitzky-Küppers.* Another drawing of this composition is in a private collection (repr. *Malévitch* [Paris: Musée National d'Art Moderne, Centre Georges Pompidou, 1978], no. 105). A painting of the subject is in a private collection in Moscow.

506 *UNTITLED, c. 1920. Lithograph. 22.5 x 15.5 (C531).* This composition is hitherto unpublished and is attributed to Malevich by Costakis.

507 *UNTITLED, n.d. Pencil on paper. 19.7 x 15.8 (C529). Acquired as a gift from I. Kudriashev, who attributed the work to Malevich.*

508 *UNTITLED, n.d. Pencil on squared paper. Sheet size: 10.4 x 13.1; image: 9 x 11.5 (C523). Acquired as a gift from I. Kudriashev, who attributed the work to Malevich.*

509 *UNTITLED, c. 1928–32. Pencil on paper. 18.5 x 26.6 (C530). Acquired as a gift from I. Kudriashev, who attributed the work to Malevich.*

502

505

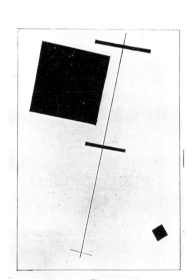

506

503

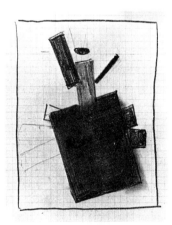

507

508

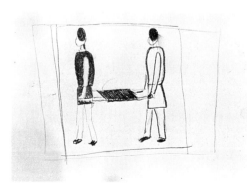

504

509

510 ARTIST UNKNOWN. *UNTITLED, 1920–21.*
Pencil on cardboard. 14.1 x 14.6 (C509 recto).
Acquired from I. Kudriashev.

511 *Inscription in an unidentified hand on reverse of above (C509 verso), undersigned by Vittvorkom (the Vitebsk Creative Committee) of Unovis. Text:* "A model diagram of the axes and the development of the Suprematist plan. The intersection of the main movement forms the center of energy. The forms arrange themselves along the main dynamic lines. Further arrangement occurs in *faktura* and tone according to distance. . . ." *A second inscription in Costakis's hand along the lower edge reads:* "A drawing by Malevich received from I. Kudriashev."

512 *UNOVIS QUESTIONNAIRE (137.80).* Addressed to each new member, and printed in the lithographic workshop of Unovis. Size of edition unknown but undoubtedly large since the number of candidates—aged between fifteen and seventeen—was well over a thousand.

The candidate is asked for factual information about his age, educational background, etc., but is also asked to express his views on matters of aesthetics and ideology. For example: "5. Are you ready to fight for the affirmation of an idea and a form in art? 6. Are you aware of the conception of Unovis? (a) its ideology, (b) its ties with the contemporary world, (c) its politics of action in art as politics of life? . . . 8. Are you ready to affirm the conception of Uno-

vis entirely or any one of its truths in life?"

The artistic and ideological orientation of the questionnaire clearly betrays Malevich's involvement in its formulation. (For a full translation of the questionnaire see A. Nakov, *The Suprematist Straight Line* [London: Annely Juda Fine Art, 1977], p. 45.)

513 *UNOVIS MANIFESTO "WE WANT" (135.80).* *Signed by the Art Committee in Vitebsk.* (For a translation into German see L. Shadowa, *Suche und Experiment: Russische und sowjetische Kunst 1910 bis 1930* [Dresden, 1978], pp. 297–98.)

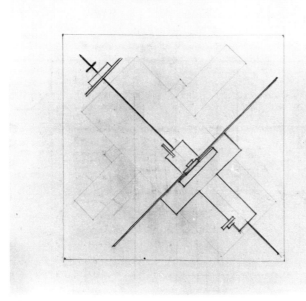

510

511

512

513

The following eight drawings are stylistically related to the work of the Malevich school in Vitebsk and were probably produced there about 1920–21. The penciled notations on the drawings ("1st room," "2nd room," "3rd room," "ceiling," "top," "bottom") identify the series as studies for a Suprematist interior. A 1919 manuscript text by Malevich, partially published by L. Shadowa, outlines principles for the decoration of a wall or interior according to the Suprematist system. It is clearly within this context that the present series was produced (Shadowa, *Suche und Experiment*, p. 317. See also plate 157, a related sketch by V. Ermolaeva). All eight drawings were acquired by Costakis from I. Kudriashev.

514 ARTIST UNKNOWN. *Gouache and pencil on paper. 37.9 x 57.8 (C203). Inscribed:* "2nd room."

515 ARTIST UNKNOWN. *Gouache and pencil on paper. 37.8 x 53.6 (C204). Inscribed:* "3rd room."

516 ARTIST UNKNOWN. *Gouache and pencil on paper. 37.4 x 57.7 (C202). Inscribed:* "1st room."

517 ARTIST UNKNOWN. *Gouache and pencil on paper. 37.5 x 28.7 (C200).*

518 ARTIST UNKNOWN. *Gouache and pencil on paper. 37.9 x 28.9 (C201). Inscribed:* "top," "bottom."

519 ARTIST UNKNOWN. *Watercolor and pencil on paper. 37.9 x 57.6 (C205). Inscribed:* "1st room."

520 ARTIST UNKNOWN. *Watercolor and pencil on paper. 37.5 x 57.6 (C206). Inscribed:* "1st room."

521 ARTIST UNKNOWN. *Watercolor and pencil on paper. 37.7 x 57.8 (C207). Inscribed:* "1st room/ ceiling."

514

515

516

517

518

519

520

521

522 *LANDSCAPE NEAR KIEV, 1930. Oil on canvas. 49 x 63.5 (Tretiakov Gallery TR86). Gift of Malevich to L.Y. Kramarenko, a well-known Ukrainian artist; acquired by Costakis from I. Zhdanko, widow of Kramarenko.* According to V. Rakitin, this work was painted in April 1930. Malevich was teaching in Kiev in 1929–30 and during the spring an exhibition of his work was held in the city museum.

523 *PORTRAIT OF UNA, c. 1930–33. Oil on canvas. 52 x 42.4 (137.78). Not signed or dated. Acquired from M. S. Malevich.*

524 *PORTRAIT OF THE SCULPTOR PAVLOV, 1933. Oil on canvas. 45.5 x 36 (Tretiakov Gallery TR87). Signed l r: "K Malevich." From a private collection, Moscow.* Pavlov was an admirer of Malevich and a person of some authority and power. Costakis relates that Pavlov was one of the people involved in the organization of Malevich's funeral, in the construction of his coffin according to the artist's specifications, and in the location of his grave under an oak tree. On the reverse of the portrait Malevich had originally inscribed the name "Pavlov." He later added a dative ending ("to Pavlov") and "from Malevich."

522

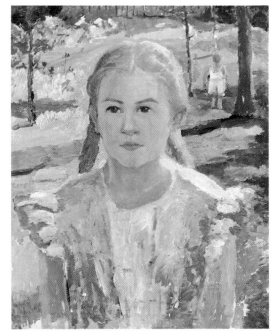

523

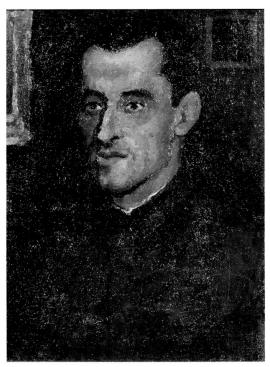

524

PAUL (PAVEL ANDREEVICH) MANSUROV

Born St. Petersburg, March 25, 1896; lives southern France.

From 1909 attended the Stieglitz School in St. Petersburg, then the school of the Society for the Encouragement of the Arts. Served in the military from 1915 to 1917. After 1917 had contact with Filonov, Malevich, Matiushin, and Tatlin. In 1919 contributed to the "I. gosudarstvennaia svobodnaia vystavka proizvedenii iskusstv" (First State Free Exhibition of Works of Art) in Petrograd. In 1922 participated in the "Erste russische Kunstausstellung" (First Russian Art Exhibition), at the Galerie van Diemen in Berlin. Contributed to the 1923 "Vystavka kartin petrogradskikh khudozhnikov vsekh napravlenii" (Exhibition of Paintings of Petrograd Artists of All Tendencies) in Petrograd. In 1924 helped organize Ginkhuk in Petrograd with Tatlin, Malevich, Matiushin, and others; headed the experimental section.

Published two declarations in the journal *Zhizn iskusstva* (Life of Art), and in 1924 contributed to the Fourteenth Venice Biennale. In 1928 emigrated to Italy and later to France, where he continued to work in a nonrepresentational style.

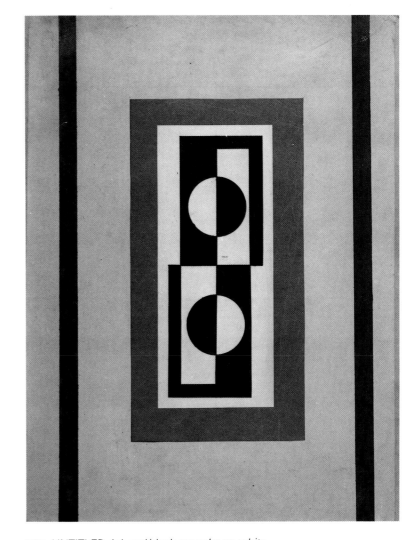

525 *UNTITLED. Ink and black gouache on white paper, mounted on gray paper, mounted on buff. 43.2 x 30.5 (C197). Not signed or dated. Gift to Costakis from the collector and artist Lev Kropivnitzky (d.1979).* A variation of this composition appeared in an exhibition of Mansurov's 1918–23 works under the auspices of the Museum of Painterly Culture, at the Winter Palace, Petrograd, 1923 (installation photo in *The Isms of Art in Russia* [Cologne, 1977], p. 21).

THE MATIUSHIN SCHOOL

MIKHAIL VASILIEVICH MATIUSHIN

Born Nizhnii Novgorod, 1861; died Leningrad, October 14, 1934.

From 1878 to 1881 attended the Moscow Conservatory of Music and worked from 1881 to 1913 as a violinist in the Court Orchestra in St. Petersburg. Studied at the school of the Society for the Encouragement of the Arts until 1898. From that year until 1906 he studied at the private studio of Yan Tsionglinsky, where he met his future wife, Elena Guro. At the school also met Vladimir Markov (pseudonym of Waldemars Matvejs), artist and theoretician, author of "Printsipy novogo iskusstva" (The Principles of the New Art), published in 1912. From 1906 to 1908 studied with Leon Bakst and Mstislav Dobuzhinsky at the Zvantseva School of Art.

In 1909 joined Nikolai Kulbin's Impressionists group in St. Petersburg and contributed to their exhibitions — the "Impressionists" of 1909 and "Treugolnik" (Triangle) of April 1910. In late 1909 broke with Kulbin and helped to found the Soiuz molodezhi (Union of Youth), but showed only sporadically in the group's numerous exhibits, including those of December 1911 – January 1912 and November 1913 – January 1914 in St. Petersburg. Also showed in the first Izdebsky salon, 1909. In 1910 contributed to the first volume of the Futurist almanac *Sadok sudei* (Trap for Judges) and was the publisher of the second volume.

In 1912 met Kazimir Malevich and Alexei Kruchenykh; in 1913 collaborated with them and Velimir Khlebnikov to publish *Troe* (The Three) — under his own imprint, Zhuravl (Crane) — in memory of Guro, who had died that year. Also in 1913 wrote the music for the Futurist opera *Pobeda nad solntsem* (Victory over the Sun), with libretto by Kruchenykh and stage sets by Malevich.

Went on to publish a number of books under his Zhuravl imprint, including a translation of *Du Cubisme* by Albert Gleizes and Jean Metzinger and, in 1915, Malevich's *Ot kubizma i futurizma k suprematizmu* (From Cubism and Futurism to Suprematism). Wrote an article on *Du Cubisme* that appeared in the third *Soiuz molodezhi* almanac of 1913.

From 1918 to 1922, at the Petrosvomas, conducted a studio in Spatial Realism for his group, known as Zorved (Zorkoe vedanie, See-Know). From 1920 to 1922 mounted, with his students, a series of theatrical productions based on Guro's works, including *Osennii son* (Autumn Dream), published in 1912, and *Nebesnye verbluzhata* (Baby Camels in the Sky), published in 1914. In 1922 directed a laboratory at the Museum of Painterly Culture and from 1924 headed the Department of Organic Culture at Ginkhuk, where he conducted research with his assistants, led by Boris and Mariia Ender. Malevich, who traveled abroad in 1927, demonstrated the color study tables of Matiushin's group; these are now in the collection of the Stedelijk Museum in Amsterdam. From 1929 to 1932, with his students, prepared a handbook on the study of color — *Zakonomernost izmeniaemosti tsvetovykh sochetanii. Spravochnik po tsvetu* (The Rules of the Variability of Color Combinations: A Color Manual), published in Moscow and Leningrad, in 1932. From 1933 to 1934, with Mariia Ender, prepared tables for the second part of the handbook.

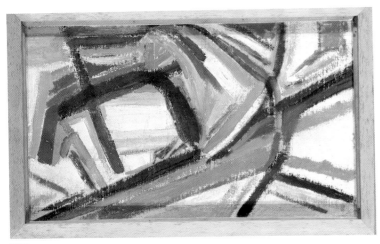

526 *ABSTRACTION, 1918. Oil on canvas. 25.7 x 42.4 (284.78). Acquired from the Ender family, Leningrad.*

527 *CRYSTAL, 1919–20. Oil on canvas. 68 x 50 (Tretiakov Gallery TR83). Acquired from N. Khardzhiev, who bought it from O. Matiushina, Leningrad.*

526

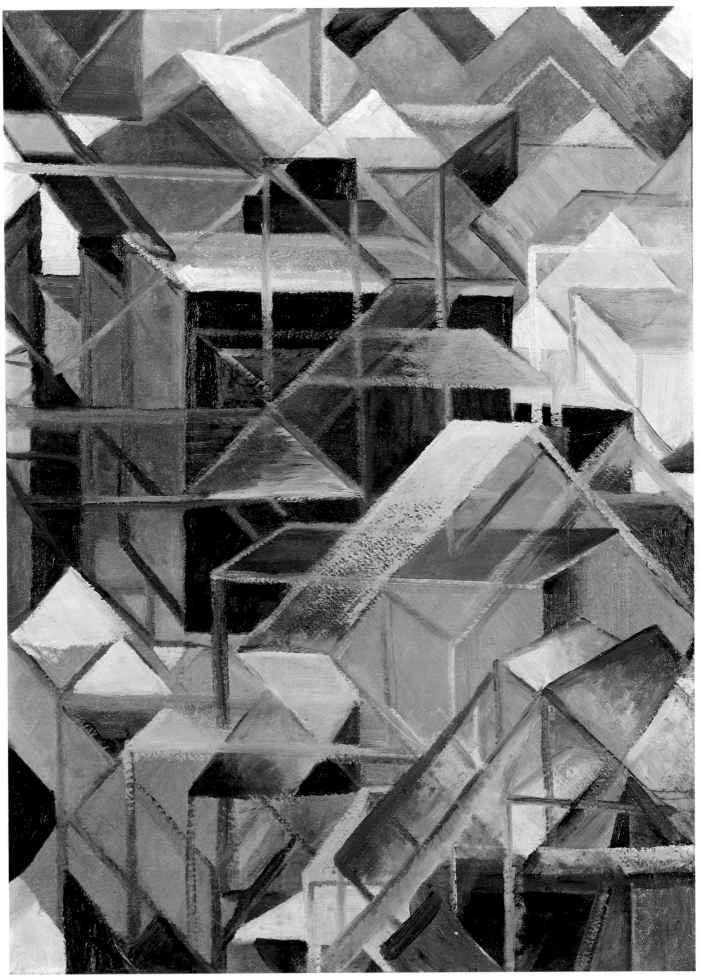

527

528 *PAINTERLY-MUSICAL CONSTRUCTION,*
1918. Oil on board. 51 x 63 (155.78). Acquired
from the Ender family, Leningrad.

528

529 *PAINTERLY-MUSICAL CONSTRUCTION, 1918. Gouache on cardboard. 51.4 x 63.7 (154.78). Acquired from the Ender family, Leningrad.*

529

ELENA GURO

Born St. Petersburg, 1877; died Usikirkko, Finland (now in the U.S.S.R.), May 6, 1913, of leukemia.

Daughter of a general. From 1890 to 1893 studied at the school of the Society for the Encouragement of the Arts; from 1903 to 1905 studied at the private studio of Yan Tsionglinsky, where she met her future husband, Mikhail Matiushin, and from 1905 to 1906 studied with Leon Bakst and Mstislav Dobuzhinsky at the Zvantseva School of Art.

Guro and Matiushin were both members of Nikolai Kulbin's Impressionists group and exhibited in its shows of 1909–10. Her paintings were shown first at Kulbin's "Vystavka sovremennikh techenii v iskusstve" (Exhibition of Contemporary Trends in Art) in 1908. She also participated in the Soiuz molodezhi (Union of Youth) exhibitions; her 1913–14 posthumous exhibit in St. Petersburg was under its auspices.

A professional writer as well as painter, published her first story, "Ranniaia vesna" (Early Spring), in *Sbornik molodikh pisatelei* (An Anthology of New Writers), in St. Petersburg, in 1905. Later her work was published in five Futurist miscellanies, including *Sadok sudei* (Trap for Judges) of 1910 and *Troe* (The Three), published posthumously in St. Petersburg, in 1913. Also illustrated her own writings, interspersing the text with tiny drawings of leaves, fir trees, stars, and circles.

Her first book, *Sharmanka* (The Hurdy-Gurdy), was published in 1909. In 1912 published the book *Osennii son* (Autumn Dream); after her death the play of the same name was mounted by Matiushin in 1921, at the apartment of Mariia Ender. Guro's third book, *Nebesnye verbluzhata* (Baby Camels in the Sky), was published in 1914. At the time of her death she was working on a new book, "Bednyi rytsar" (Poor Knight).

In her writing used themes of childhood and children's language as well as a stream-of-consciousness technique to achieve a closeness to nature, a freshness, and a blurring of the distinction between prose and verse.

Owned a dacha in Finland that was the scene of many Futurist gatherings.

530 *LANDSCAPE SKETCH, 1904. Oil on canvas. 31.8 x 42.8 (C535). Signed and dated on reverse: "Guro 1904." Acquired from S. Shuster, Leningrad.*

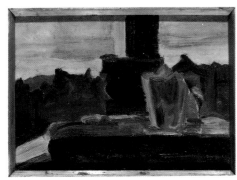

531

531 *LANDSCAPE, 1905. Oil on canvas. 29 x 42 (Tretiakov Gallery TR156). Acquired from S. Shuster, Leningrad.*

532 *LANDSCAPE SKETCH (MARTYSHKINO), 1905. Oil on canvas. 24.8 x 23.8 (62.78). Signed, dated, and inscribed on reverse: "1905. Martyshkino. Guro." Acquired from a private collection, Leningrad. (Martyshkino is a suburb of Leningrad.)*

533 *UNTITLED, c. 1908–10. Ink on paper mounted on paper. 23.9 x 16.5 (63.78). Acquired from N. Khardzhiev, who dated it 1908. V. Rakitin has dated it c. 1910.*

532

533

THE ENDER FAMILY

Most of the works in the Costakis collection by the four Enders date from the years when they worked with Mikhail Matiushin on the problems of color, form, and perception, as well as the concept of "expanded seeing" and the possibilities of transposing sounds into visual form. His aesthetic slogan, "Zorkoe vedanie" (See-Know, sight and cognition), was based on the conviction that it was important to expand the normal physical process of seeing. Boris Ender created a visual table of speech sounds for A. Tufanov's book *K Zaumi* (About Zaum, Petrograd, 1924), in which Matiushin's theories about the relationship between image and sound were expounded in some detail. Every member of the group produced works exploring the "transcription of sound" (see plates 629 and 631), and extensive research was carried out not only in physics and biology, but also in Eastern religions. The goal was to formulate what Matiushin called "the sensation of the Fourth Dimension." The focus of their color studies was the nature of color in its environment and colors in motion.

Because of the collaborative character of the Ginkhuk enterprise, in which the artists worked closely with one another to solve a set of common problems—and because few of their works are signed—it is often difficult to make confident attributions. Many works in the Costakis collection carry signatures or inscribed names on the verso, though it is not always possible to establish when these were added. In some cases, the attributions were made by Andrei Ender, the son of Yurii. The attributions and dates offered here are, therefore, to some extent tentative. Further study of the Ender, Grinberg, and Matiushin holdings in the Soviet Union and elsewhere will be necessary in order to arrive at a clear definition of the individual hands.

For illuminating discussions of the work of Matiushin and this group see L. Shadowa, "Il sistema cromatico di Matjušin," *Rassegna Sovietica*, 1975, no. 1, pp. 122–30; A. Povelikhina, "Matiushin's Spatial System," *The Structurist,* 15/16 (1975–76), 64–71, trans. J. Bowlt; M. Matiushin, "An Artist's Experience of the New Space," ibid., pp. 74–77; Z. Ender Masetti, E. C. Masetti, and D. A. Perilli, *Boris Ender* (Rome, 1977); Z. Ender and C. Masetti, "Gli esperimenti del gruppo di Matjušin," *Rassegna Sovietica*, 1978, no. 3, pp. 100–07; B. Ender, "Materiali per lo studio della fisiologia della vista complementare," *Rassegna Sovietica*, 1978, no. 3, pp. 108–25; Z. Ender, "Elena Guro: Profilo biografico," *Rassegna Sovietica*, 1978, no. 5, pp. 67–93.

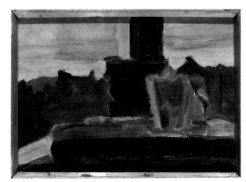

531

532

531 *LANDSCAPE, 1905. Oil on canvas. 29 x 42 (Tretiakov Gallery TR156). Acquired from S. Shuster, Leningrad.*

532 *LANDSCAPE SKETCH (MARTYSHKINO), 1905. Oil on canvas. 24.8 x 23.8 (62.78). Signed, dated, and inscribed on reverse: ''1905. Martyshkino. Guro.'' Acquired from a private collection, Leningrad. (Martyshkino is a suburb of Leningrad.)*

533 *UNTITLED, c. 1908–10. Ink on paper mounted on paper. 23.9 x 16.5 (63.78). Acquired from N. Khardzhiev, who dated it 1908. V. Rakitin has dated it c. 1910.*

533

THE ENDER FAMILY

Most of the works in the Costakis collection by the four Enders date from the years when they worked with Mikhail Matiushin on the problems of color, form, and perception, as well as the concept of "expanded seeing" and the possibilities of transposing sounds into visual form. His aesthetic slogan, "Zorkoe vedanie" (See-Know, sight and cognition), was based on the conviction that it was important to expand the normal physical process of seeing. Boris Ender created a visual table of speech sounds for A. Tufanov's book *K Zaumi* (About Zaum, Petrograd, 1924), in which Matiushin's theories about the relationship between image and sound were expounded in some detail. Every member of the group produced works exploring the "transcription of sound" (see plates 629 and 631), and extensive research was carried out not only in physics and biology, but also in Eastern religions. The goal was to formulate what Matiushin called "the sensation of the Fourth Dimension." The focus of their color studies was the nature of color in its environment and colors in motion.

Because of the collaborative character of the Ginkhuk enterprise, in which the artists worked closely with one another to solve a set of common problems—and because few of their works are signed—it is often difficult to make confident attributions. Many works in the Costakis collection carry signatures or inscribed names on the verso, though it is not always possible to establish when these were added. In some cases, the attributions were made by Andrei Ender, the son of Yurii. The attributions and dates offered here are, therefore, to some extent tentative. Further study of the Ender, Grinberg, and Matiushin holdings in the Soviet Union and elsewhere will be necessary in order to arrive at a clear definition of the individual hands.

For illuminating discussions of the work of Matiushin and this group see L. Shadowa, "Il sistema cromatico di Matjušin," *Rassegna Sovietica*, 1975, no. 1, pp. 122–30; A. Povelikhina, "Matiushin's Spatial System," *The Structurist,* 15/16 (1975–76), 64–71, trans. J. Bowlt; M. Matiushin, "An Artist's Experience of the New Space," ibid., pp. 74–77; Z. Ender Masetti, E. C. Masetti, and D. A. Perilli, *Boris Ender* (Rome, 1977); Z. Ender and C. Masetti, "Gli esperimenti del gruppo di Matjušin," *Rassegna Sovietica*, 1978, no. 3, pp. 100–07; B. Ender, "Materiali per lo studio della fisiologia della vista complementare," *Rassegna Sovietica*, 1978, no. 3, pp. 108–25; Z. Ender, "Elena Guro: Profilo biografico," *Rassegna Sovietica*, 1978, no. 5, pp. 67–93.

BORIS VLADIMIROVICH ENDER

Born St. Petersburg, 1893; died Moscow, 1960.

Born into the family of a horticulturist; 1905–07 student in the studio of Ivan Bilibin. Was interested in painting, poetry, and music. In 1917 studied in Matiushin's studio. In 1918 studied under Petrov-Vodkin in the Petrograd Svomas and studied also with Malevich. In 1919–21 was a member of Matiushin's studio in Spatial Realism. In 1923 became a member of the Zorved (Zorkoe vedanie, See-Know) group, with other Matiushin students, including his sister Ksenia. From 1923 to 1927 was a researcher at the Department of Organic Culture of the Museum of Painterly Culture (later Ginkhuk) in Leningrad; there lectured on "Issledovanie tsvetoformy v rashirennom smotrenii na shirokikh prostranstvakh prirodi" (Studies of Colorforms in the Amplification of Vision in Regard to Broad Expanses of Nature).

From 1925 to 1927 directed the painting section in the studio of color- and sound-movement. In 1928 moved to Moscow. In addition to continuing his painting, from 1930 to 1931 worked on polychrome architecture with, among others, Hinnerk Scheper, a German artist from the Bauhaus. Also worked as an interior, exhibition, book, and costume designer.

His works were rarely exhibited but he did show at the 1923 "Vystavka kartin petrogradskikh khudozhnikov vsekh napravlenii" (Exhibition of Paintings of Petrograd Artists of All Tendencies); at the Fourteenth Venice Biennale, in 1924; and at the "Exhibition of Soviet Art" in Tokyo in 1927, curated by Nikolai Punin. In 1937 helped Suetin on the latter's design for the Soviet pavilions at the Exposition Internationale in Paris in 1937 and the New York World's Fair of 1939.

All the works by Boris Ender were acquired from the family of Ksenia Ender.

534 *ABSTRACT COMPOSITION, c. 1919–20?.*
Oil on canvas. 104 x 100 (13.78 verso).

535 *UNTITLED, 1920. Watercolor on paper. 22.8 x 24 (C473). Inscribed on reverse in the hand of Andrei Ender: ''Boris Ender 1920, cer- tified by A. Ender, 1972.''*

536 *MOVEMENT OF ORGANIC FORM, 1919. Oil on canvas. 104 x 100 (13.78 recto).*

535

536

537 *UNTITLED, n.d. Watercolor on paper. 28.5 x 35.9 (48.78).*

538 *COMPOSITION, 1921. Oil on canvas. 66 x 41 (Tretiakov Gallery TR131).*

539 *UNTITLED, n.d. Watercolor on paper. 43.4 x 32.2 (45.78). Inscribed on reverse in the hand of Andrei Ender: ''Boris Ender.''*

537

538

539

540 *EXTENDED SPACE, 1922–23. Oil on canvas. 69.1 x 97.8 (14.78). Signed on reverse: "Boris Ender." Exhibited in the 1924 Venice Biennale, no. 1456.*

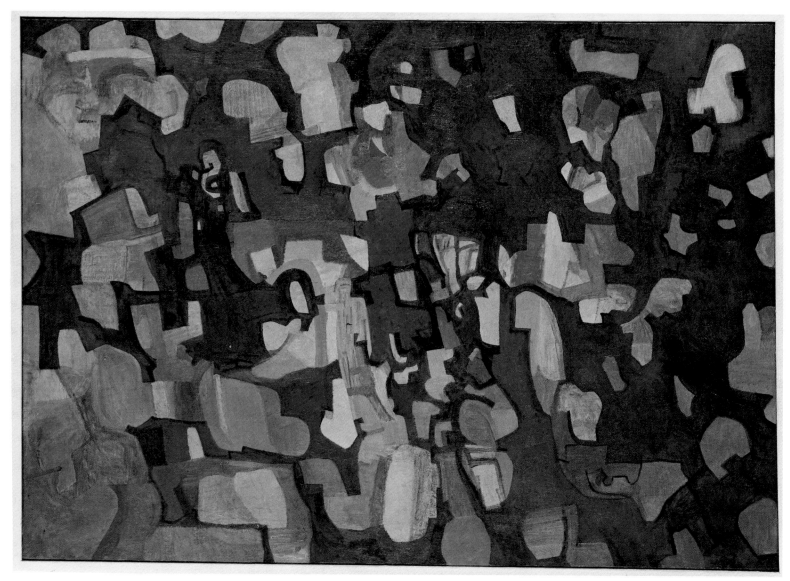

540

541 *UNTITLED, 1924. Pencil on paper. 20.1 x 19.2 (C272). Signed and dated on reverse:* "July 19, 1924 B. Ender."

542 BORIS ENDER? *UNTITLED, n.d. Watercolor on paper. 27.6 x 35.7 (C287).*

543 *UNTITLED, 1925. Watercolor on paper. 24.1 x 22.2 (C474). Dated l r:* "Aug[ust] 17, [19]25, V[askelovo]." *On reverse, probably in the artist's hand:* "August 17, 25: B. E. 'pine tree.'" *In the hand of Andrei Ender:* "Boris Ender 1925, certified by A. Ender, 1972."

541

542

543

KSENIA VLADIMIROVNA ENDER

Born St. Petersburg, 1895; died Leningrad, 1955.

Her artistic growth was influenced by the atmosphere of her family, where her father was a horticulturist and her two brothers, Boris and Yurii, and her sister, Mariia, were also artists; all were actively involved in music, poetry, and the theater. From 1919 to 1922 she studied in Matiushin's studio at Petrosvomas and worked with his Zorved (Zorkoe vedanie, See-Know) group, which included her brother Boris. From 1920 to 1922 participated in performances organized by Matiushin's students and friends in honor of Guro.

Between 1923 and 1926 was a researcher in the Department of Organic Culture of the Museum of Painterly Culture (later Ginkhuk), headed by Matiushin. Exhibited at the 1923 "Vystavka kartin petrogradskikh khudozhnikov vsekh napravlenii" (Exhibition of Paintings of Petrograd Artists of All Tendencies), and at the Fourteenth Venice Biennale, in 1924. From the mid-1920s worked with Matiushin and Boris and Mariia Ender on further research into the study of color.

All the works by Ksenia Ender were acquired from the artist's family.

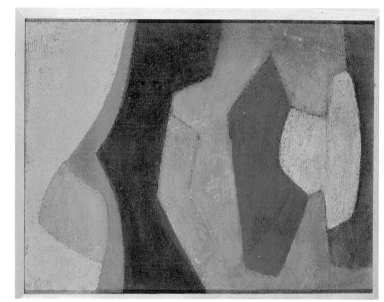

544

544 *UNTITLED, c. 1920. Oil on canvas. 31.3 x 40.6 (18.78).*

545 *UNTITLED, c. 1920. Oil on canvas. 37.3 x 23.9 (17.78).*

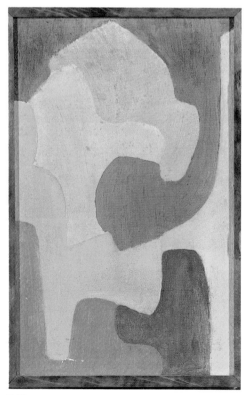

545

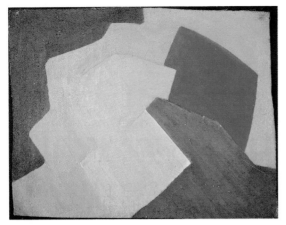

546

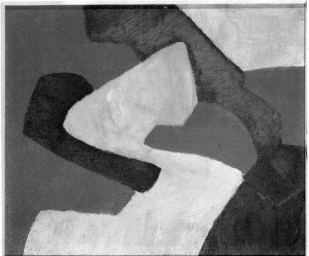

547

548

549

546 *UNTITLED, c. 1920. Oil on canvas. 30.8 x 39.9 (C432).*

The next two works appear in an installation photograph (printed in reverse) of an exhibition held in Petrograd c. 1920 (repr. *Russian Women Artists of the Avant-Garde, 1910–1930* [Cologne: Galerie Gmurzynska, 1979], p. 94).

547 *ABSTRACTION, 1920. Oil on canvas. 30 x 35.5 (Tretiakov Gallery TR128).*

548 *UNTITLED, 1920. Oil on canvas. 23.4 x 34.4 (19.78).*

549 *UNTITLED, n.d. Oil on canvas. 24 x 27.7 (C453).*

550 *UNTITLED, n.d. Oil on canvas. 24.8 x 28.3 (16.78).*

551 *UNTITLED, n.d. Oil on canvas. 39.8 x 29.8 (15.78).*

552 *UNTITLED, n.d. Watercolor on paper mounted on board. 20.2 x 12.6 (174.80a). On reverse: "K. Ender."*

553 *UNTITLED, n.d. Watercolor on paper mounted on board. 20.2 x 12.6 (174.80b).*

554 *UNTITLED, n.d. Watercolor on paper mounted on board. 12.6 x 20.2 (174.80c). On reverse: "K. Ender."*

550

551

552

553

554

555

556

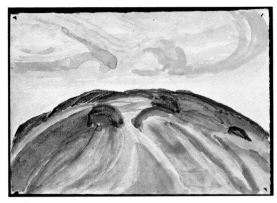

557

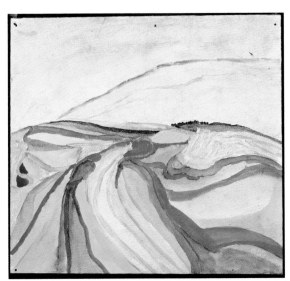

558

559

560 *UNTITLED, 1924. Watercolor on paper. 13.8 x 20.6 (C270). On reverse: "K. Ender/ July 29, 1924."*

561 *UNTITLED, n.d. Watercolor on paper. 20.3 x 25.2 (C471). Signed u r: "Ksenia."*

562 *UNTITLED, n.d. Watercolor on paper. 15.4 x 16.7 (C465). On reverse: "K. Ender/ July 30."*

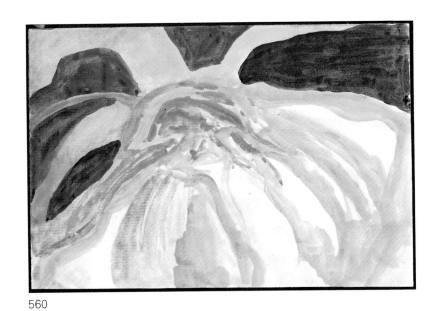

560

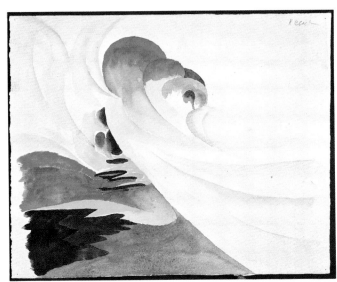

561

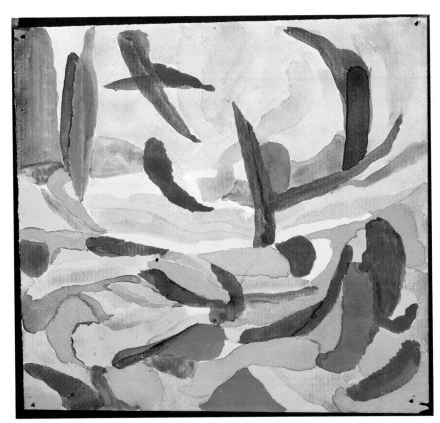

562

563

563 *UNTITLED, n.d. Watercolor on paper. 20.5 x 40.5 (26.78). On reverse: "K. Ender."*

564 *UNTITLED, 1921–22. Mixed media. 13 x 18 (ATH80.26).*

565 *UNTITLED, 1921–22. Watercolor on paper. 30 x 37 (ATH80.25).*

566 *UNTITLED, 1921–22. Watercolor on paper. 30 x 37 (ATH80.27).*

564

565

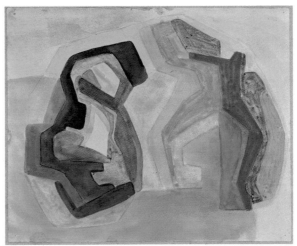

566

567 *UNTITLED, n.d. Watercolor on paper. 21.7 x 26.6 (33.78).*

568 *UNTITLED, n.d. Watercolor on paper. 29.4 x 28.7 (25.78).*

569 *UNTITLED, 1925. Watercolor on paper. 33.6 x 34.1 (36.78). Dated on reverse: "July 24, 1925."*

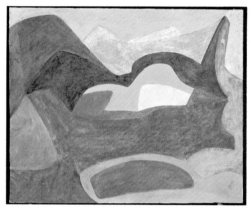

567

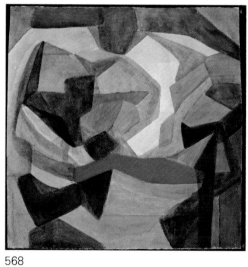

568

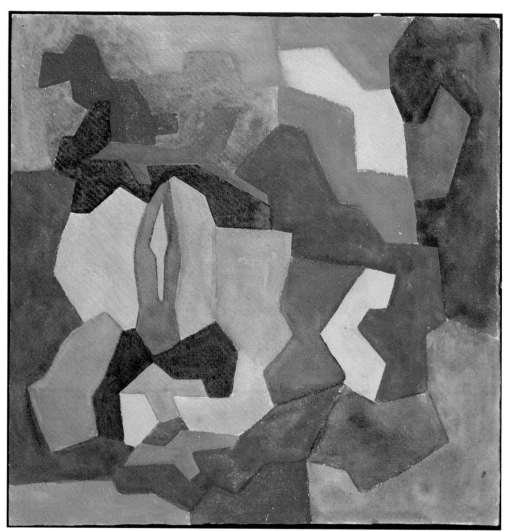

569

570 *UNTITLED, n.d. Watercolor on paper. 19.1 x 15.4 (27.78).*

571 *UNTITLED, n.d. Watercolor and pencil on paper. 21.4 x 27.4 (23.78).*

572 KSENIA ENDER?. *UNTITLED, 1925. Watercolor and pencil on paper. 34.3 x 33.7 (C271). Dated on reverse: "July 24, 1925."*

573 KSENIA ENDER?. *UNTITLED, 1925. Watercolor (?) on paper. 33.8 x 37.2 (C451). Dated on reverse: "August 9, 1925."*

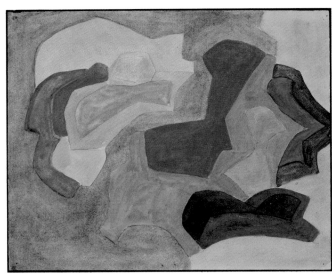

571

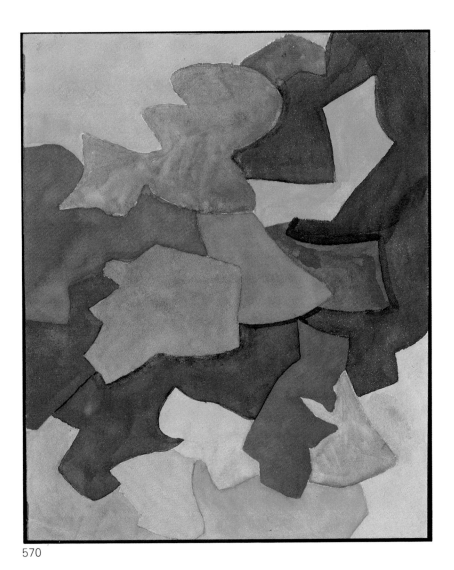

570

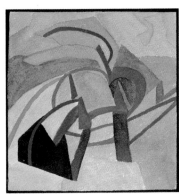

572

573

574 *UNTITLED, c. 1924–26. Paper collage on paper. 31.8 x 27.2 (C120).*

575 *UNTITLED, c. 1924–26. Paper collage on paper. 26.5 x 18.7 (37.78).*

576 *UNTITLED, c. 1924–26. Paper collage on paper. 17.4 x 28.7 (38.78).*

575

574

576

577 *UNTITLED, c. 1924–26. Paper collage on paper. 31.3 x 27.6 (C420).*

578 *UNTITLED, c. 1924–26. Paper collage on paper. 32 x 27.9 (C119).*

579 *UNTITLED, c. 1924–26. Paper collage on paper. 32.2 x 28.2 (C419).*

577

578

579

580 *UNTITLED, c. 1924–26. Paper collage on paper. 39 x 34.5 (C121).*

581 *UNTITLED, c. 1924–26. Paper collage on paper. 40.3 x 34.6 (C122).*

582 MARIIA ENDER. *UNTITLED, c. 1924–26. Watercolor on paper. 17.7 x 11.4 (C448). Signed and dated on reverse: "July 23, 1924." A watercolor subsequently used by Ksenia as a study for plate 583.*

583 *UNTITLED, c. 1924–26. Paper collage on paper. 39.4 x 34.5 (C123).*

582

580

583

581

584 *DESIGNS FOR A TOBACCO BOX, 1926.*
Paper collage on paper. 23.5 x 27.7 (39.78).
Dated u l: "January 1926." Inscribed: "Govern-
ment Decorative [Arts] Institute. Dept. Organic
Culture. Work by the artist Ksenia Ender. 'To-
bacco Box.' Teacher M. Matiushin. January
1926."

585 *DESIGNS FOR A CIGARETTE BOX, 1926.*
Paper collage on paper. Sheet size: 23 x 38;
each image: 11 x 7.8 (40.78–42.78). Dated u l:
"January 1926." Inscribed: "Government Dec-
orative [Arts] Institute. Dept. Organic Culture.
'Cigarette Box.' Work by the artist Ksenia Ender.
Teacher M. Matiushin. January 1926."

584

585

586 *UNTITLED, n.d. Oil on canvas. 30.9 x 40.2 (20.78).*

587 *UNTITLED, n.d. Watercolor on paper. 26.5 x 23.9 (C430).*

588 *UNTITLED, 1924. Watercolor on paper. 13.8 x 17.4 (C279). Dated on reverse: "July 29, 1924."*

589 *UNTITLED, n.d. Watercolor on paper. 24.8 x 29.1 (C452).*

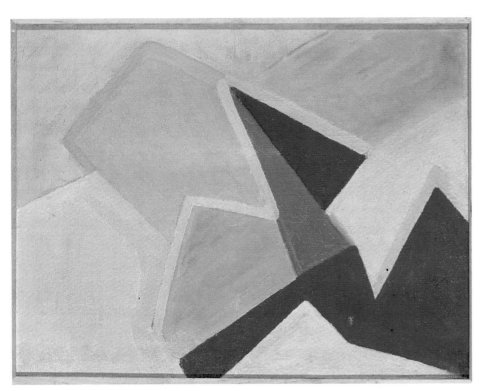

586

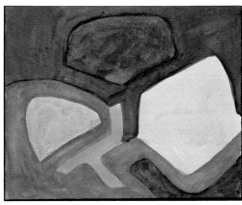

588

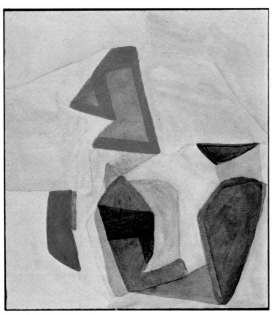

587

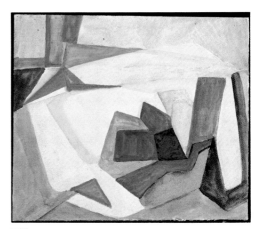

589

590 *UNTITLED, n.d. Watercolor on paper mounted on board. 21.5 x 24.9 (172.80a).*

591 *UNTITLED, n.d. Watercolor on paper mounted on board. 21.9 x 25 (172.80b).*

592 *UNTITLED, n.d. Watercolor on paper mounted on board. 21.7 x 27.6 (173.80a). On reverse:* ''K. Ender.''

592

590

591

593 *UNTITLED, n.d. Watercolor on paper
mounted on board. 20.3 x 21.6 (172.80c).*

594 *UNTITLED, n.d. Watercolor on paper
mounted on board. 20.7 x 21.6 (172.80d).*

595 *UNTITLED, n.d. Watercolor on paper
mounted on board. 20.6 x 21.4 (172.80e).*

593

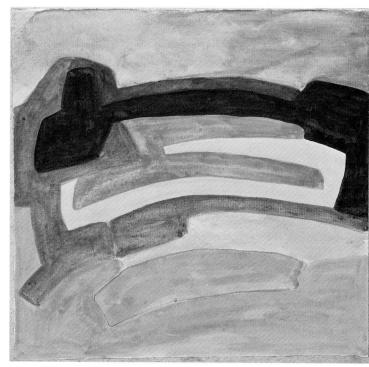

594

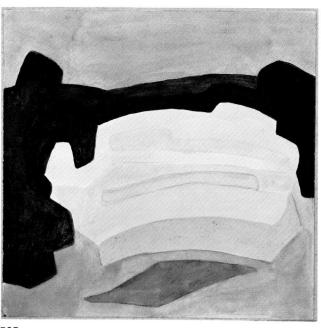

595

596 *UNTITLED, n.d.* Watercolor on paper mounted on board. 18.3 x 12.6 (175.80a). On reverse: "K. Ender."

597 *UNTITLED, n.d.* Watercolor on paper mounted on board. 17.8 x 12.6 (175.80b). On reverse: "K. Ender."

598 *UNTITLED, n.d.* Watercolor on paper mounted on board. 12.6 x 17.2 (175.80c). On reverse: "K. Ender."

599 *UNTITLED, n.d.* Watercolor on paper mounted on board. 21.4 x 25.4 (35.78).

600 *UNTITLED, n.d.* Watercolor on paper mounted on board. 24.3 x 33.8 (34.78). On reverse: "K. Ender."

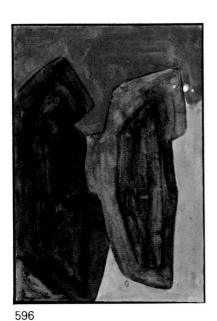

596

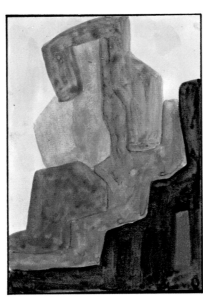

597

598

599

600

601 *UNTITLED, 1925. Watercolor on paper. 29.2 x 32.9 (C265). Dated on reverse: ''July 25, 1925.''*

602 *UNTITLED, n.d. Watercolor on paper. 22.2 x 35.6 (C460).*

603 *UNTITLED, 1926. Watercolor on paper. 31.6 x 33.2 (51.78). Dated on reverse: ''July 12, 1926.''*

604 *UNTITLED, n.d. Watercolor on paper. 30.6 x 36.3 (52.78).*

601

602

603

604

605 *LAKE, 1925. Watercolor and pencil on paper. 22.1 x 26.9 (C278). Inscribed on reverse: "Tarchovka Lake 1925."*

606 *LAKE, 1925. Watercolor on paper. 22.1 x 26.8 (22.78). Inscribed on reverse: "Tarchovka Lake 1925."*

607 *LAKE, 1925. Watercolor on paper. 22.2 x 26.9 (28.78). Inscribed on reverse: "Tarchovka Lake 1925."*

605

606

607

608 *LAKE, 1925. Watercolor on paper. 23.9 x 27 (29.78). Inscribed on reverse: "Tarchovka Lake 1925."*

609 *LAKE, 1925. Watercolor on paper. 24 x 27 (C269). Inscribed on reverse: "Tarchovka Lake 1925."*

610 *LAKE, 1925. Watercolor on paper. 24.4 x 27.7 (31.78). Inscribed on reverse: "Tarchovka Lake 1925."*

608

609

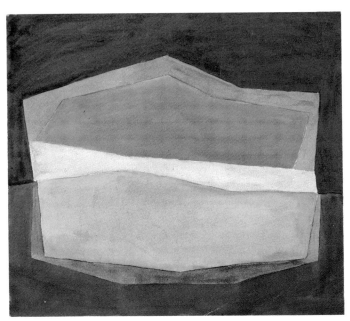

610

611 *LAKE, 1925. Watercolor on paper. 22.2 x 27 (21.78). Inscribed on reverse: "Tarchovka Lake 1925."*

612 *LAKE, 1925. Watercolor and pencil on paper. 22.1 x 26.8 (24.78). Inscribed on reverse: "Tarchovka Lake 1925."*

613 *LAKE, 1925. Watercolor on paper. 21.9 x 26.8 (C276). Inscribed on reverse: "Tarchovka Lake 1925."*

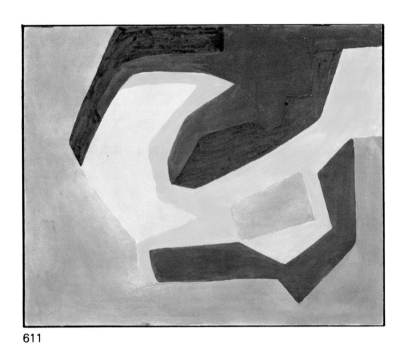

611

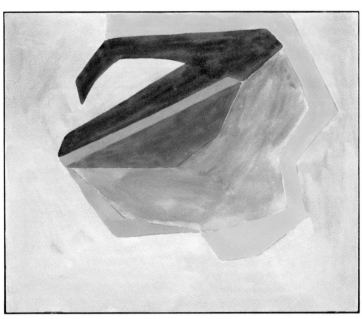

612

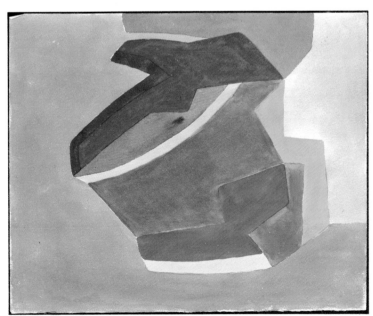

613

614 *LAKE, 1925. Watercolor and pencil on paper. 24.2 x 27.4 (30.78). Inscribed on reverse: "Tarchovka Lake 1925."*

615 *LAKE, 1925. Watercolor on paper. 24 x 27 (43.78). Inscribed on reverse: "Tarchovka Lake 1925."*

616 *LAKE, 1925. Watercolor and pencil on paper. 24 x 26.8 (44.78). Inscribed on reverse: "Tarchovka Lake 1925."*

617 *LAKE, 1925. Watercolor on paper. 22.1 x 27.1 (32.78). Inscribed on reverse: "Tarchovka Lake 1925."*

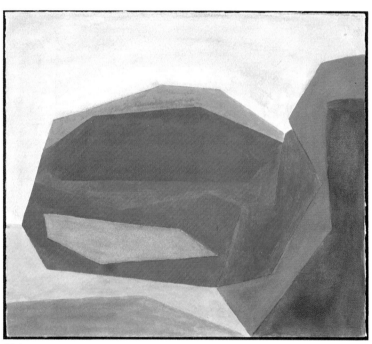

614

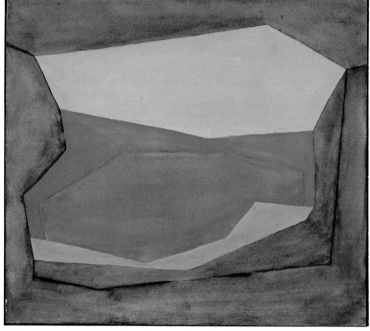

615

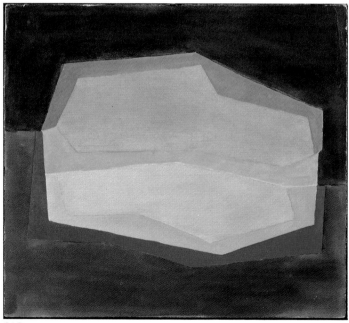

616

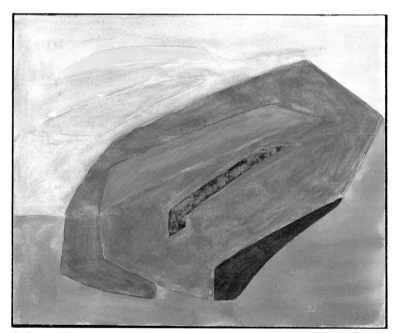

617

MARIIA VLADIMIROVNA ENDER

Born St. Petersburg, 1897; died Leningrad, 1942.

Daughter of a horticulturist; in 1919 studied at Petrosvomas in Matiushin's studio. In 1923 became a member of the Museum of Painterly Culture in Petrograd and participated in its Department of Organic Culture (later under Ginkhuk), directed by Matiushin. In 1924 exhibited at the Fourteenth Venice Biennale. From 1925 to 1926 directed the laboratory on form-color perception at Ginkhuk. In 1927, after the closing of Ginkhuk, entered the Art History Institute in Leningrad. From 1929 to 1932 taught the theory of color in the Department of Painting, Sculpture, Architecture, and Graphics at the Fine Arts Academy in Leningrad. In 1932 helped compile Matiushin's *Zakonomernost izmeniaemosti tsvetovykh sochetanii. Spravochnik po tsvetu* (The Rules of the Variability of Color Combinations: A Color Manual).

Continued to devote herself to the problems of color in architecture; participated with her brother Boris on the color details of the Soviet pavilions for the world's fairs held in Paris in 1937 and New York in 1939.

All the works by Mariia Ender were acquired from the artist's family.

Note: On the reverse of several works by Mariia Ender are notations such as "To Natasha from M," "To Natasha from Mulenki," "To Galia from M." These were apparently added by one of the daughters of Ksenia Ender during the process of distributing the works among the members of the family. I am indebted to Zoia Ender Masetti for this, as well as for other information regarding the Enders in the Costakis collection.

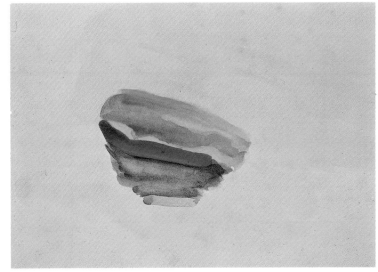

618

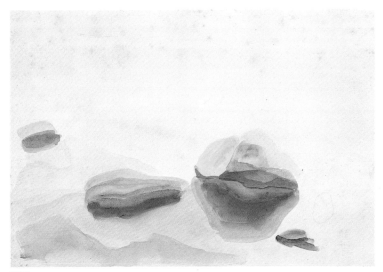

619

618 *UNTITLED, n.d. Watercolor on paper. 21.9 x 30 (C446). Inscribed on reverse: "Martysh-kino."*

619 *UNTITLED, n.d. Watercolor and pencil on paper mounted on paper. 25.7 x 37.4 (C458). Signed on reverse: "M. Ender"; inscribed: "Martyshkino/ To Galia from M., N 21."*

620 *UNTITLED, n.d. Watercolor on paper. 25.5 x 34.7 (C447). Signed on reverse: "M. Ender."*

621 *UNTITLED, n.d. Oil on canvas. 41.6 x 53 (C539).*

622 *UNTITLED, n.d. Watercolor and pencil on paper. 20 x 30.2 (C442).*

623 *UNTITLED, n.d. Watercolor on paper. 27.5 x 27.9 (C445). Signed on reverse: "M. Ender/ N 25."*

620

621

622

623

624 *UNTITLED, 1920. Watercolor and pencil on paper. 19.5 x 22.5 (C273). Signed and dated on reverse:* "M. Ender/ July 27, 1920."

625 *UNTITLED, 1920. Watercolor on paper. 33 x 24 (C429). Dated u l:* "Dec. 2, 1920." *Signed on reverse:* "M. Ender."

626 *UNTITLED, n.d. Watercolor and pencil on paper. 25.8 x 29.9 (C462). Signed on reverse:* "M. Ender"; *inscribed:* "To Natasha from Mulenki, N 36."

627 *UNTITLED, n.d. Watercolor on paper. 26 x 37.6 (C425). Signed on reverse:* "M. Ender/ Martyshkino."

624

625

626

627

628 *UNTITLED, 1921. Watercolor on paper. 40.1 x 29.1 (C455). Signed and dated on reverse:* ''M. Ender/ Dec. 12, 1921.''

629 *TRANSCRIPTION OF SOUND, 1921. Watercolor on paper. 22.4 x 23.1 (47.78). Inscribed on reverse:* ''Transcription of sound. Dec. 14, 1921.''

630 *UNTITLED, c. 1921? Watercolor and pencil on paper. 5.1 x 17.5 (C266). Signed and dated on reverse:* ''M. Ender/ August 20.'' Probably one of the works related to Matiushin's theory of the transcription of sound.

631 *TRANSCRIPTION OF SOUND, 1921. Watercolor on paper. 22.2 x 30.5 (49.78). Signed, dated, and titled on reverse:* ''M. Ender/ Dec. 14, 1921/ Transcription of sound.''

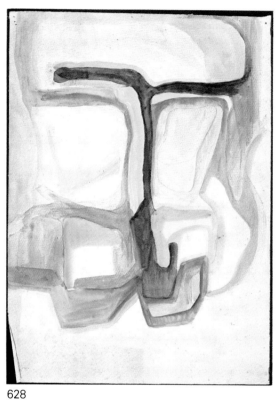

628

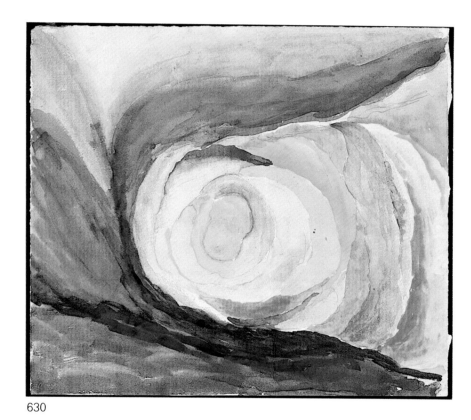

630

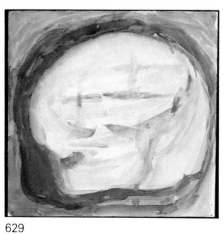

629

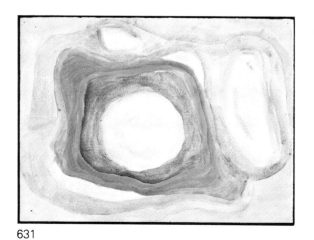

631

632 *UNTITLED, n.d. Watercolor on paper. 23 x 27.7 (C277). Signed on reverse: "M. Ender."*

633 *UNTITLED, n.d. Watercolor on paper. 33.5 x 28.3 (C282). Signed on reverse: "M. Ender."*

634 *UNTITLED, n.d. Watercolor and pencil on paper. 27.4 x 36 (C421). Signed on reverse: "M. Ender/ Martyshkino."*

635 *UNTITLED, n.d. Watercolor on paper. 24 x 32.8 (C427). Signed on reverse: "M. Ender."*

632

633

634

635

636

636 *UNTITLED, n.d. Watercolor on paper. 37.4 x 25.8 (C456). Signed on reverse:* ''M. Ender''; *inscribed:* ''Martyshkino/ To N from M. N 32.''

637 *UNTITLED, n.d. Watercolor on paper. 20.2 x 17.9 (C263). Signed and dated on reverse:* ''M. Ender/ August 1.''

638 *UNTITLED, n.d. Watercolor and pencil on paper. 15.1 x 15.2 (C436). Signed and dated on reverse:* ''M. Ender/ August 18.''

639 *UNTITLED, 1922. Watercolor on paper. 44.2 x 30.6 (C449). Signed and dated on reverse:* ''M. Ender/ 19 VIII 22.''

638

637

639

640 *UNTITLED, n.d. Watercolor on paper. 18.8 x 28.2 (C463). Signed on reverse: "M. Ender."*

641 *UNTITLED, n.d. Pencil on paper. 14.9 x 15.4 (C468).*

642 *UNTITLED, n.d. Pencil on paper. 22.3 x 15.3 (C469).*

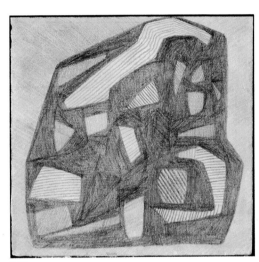

641

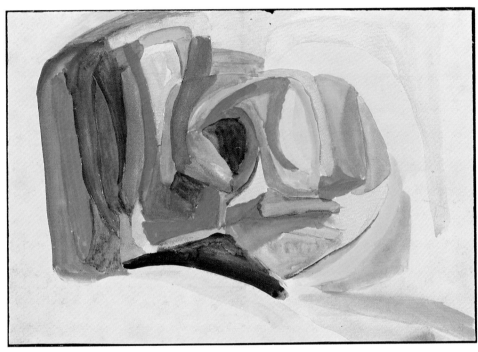

640

642

643 *UNTITLED, n.d. Watercolor on paper. 24.8 x 22.3 (C283). Inscribed on reverse: "N 34."*

644 *UNTITLED. Watercolor on paper. 36.2 x 30.7 (C466). Inscribed l r: "January,/ perception of the whole." Signed on reverse: "M. Ender."*

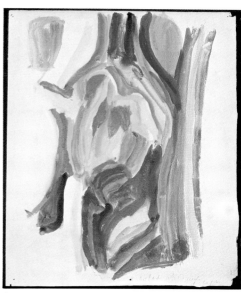

644

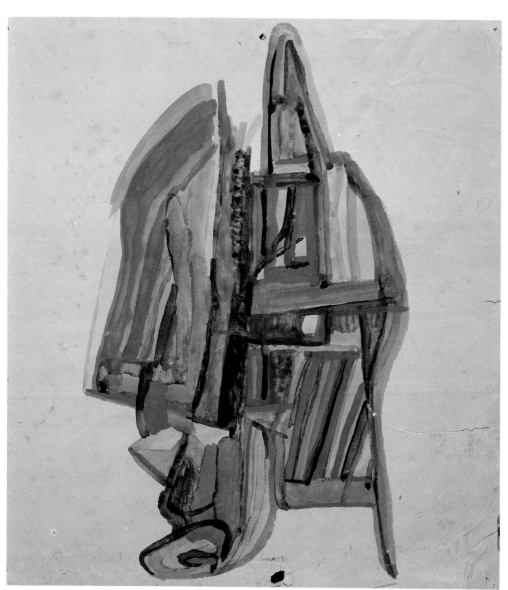

643

645 *UNTITLED, n.d. Watercolor on paper. 33.5 x 28.4 (C428). Signed on reverse: "M. Ender."*

646 *UNTITLED, n.d. Watercolor on paper. 36 x 30.6 (50.78). Signed on reverse: "M. Ender."*

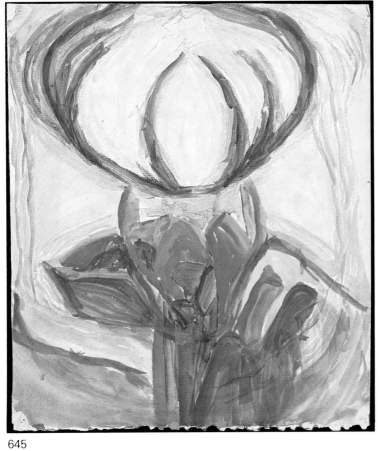

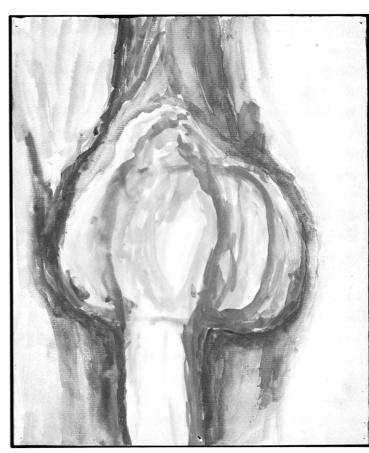

645

646

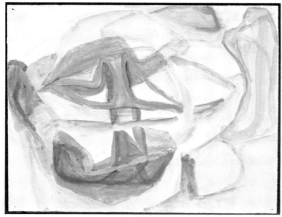

647

647 *UNTITLED, n.d. Watercolor on paper. 26.4 x 35.3 (C423). Signed on reverse: "M. Ender"; inscribed: "July 1, Kurort [spa]."*

648 *UNTITLED. Watercolor on paper. 22.3 x 21.4 (C459). Signed and dated on reverse: "M. Ender/ July 28."*

649 *UNTITLED, n.d. Watercolor on paper. 25.5 x 21.1 (C281). Signed on reverse: "M. Ender."*

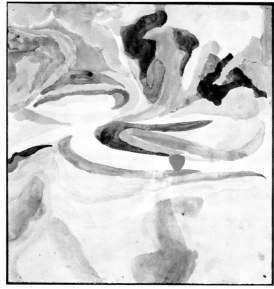

648

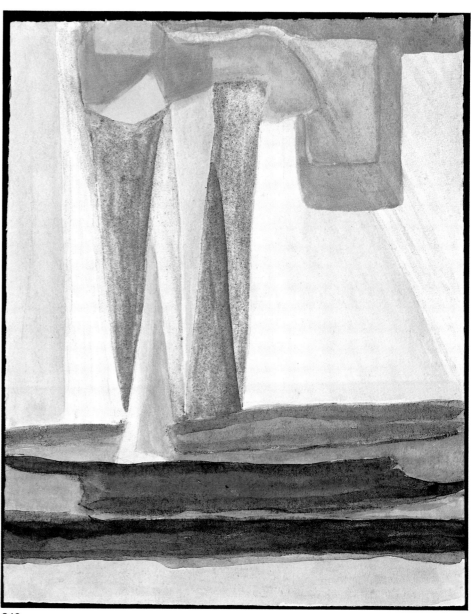

649

650

651

650 *UNTITLED, n.d. Watercolor on paper. 23.8 x 32.8 (C262). Signed on reverse: "M. Ender."*

651 *UNTITLED, n.d. Watercolor on paper mounted on board. 30.5 x 22.1 (C457). Signed on reverse: "M. Ender."*

652 *UNTITLED, 1923. Pencil on paper. 15.3 x 17.9 (C444). Inscribed on reverse: "July 8, 1923/ N 2."*

653 *UNTITLED, n.d. Watercolor on paper. 25.8 x 37.6 (C424). Signed on reverse: "Martyshkino/ M. Ender"; inscribed: "To Galia from M., N 19."*

652

653

654 *UNTITLED, n.d. Watercolor and pencil on paper. 20.8 x 25.7 (C275).*

655 *UNTITLED, n.d. Watercolor on paper. 23.8 x 32.8 (C433). Signed on reverse: "M. Ender."*

656 *UNTITLED, n.d. Watercolor on paper. 18.9 x 25.7 (C470).*

654

656

655

657 *UNTITLED, n.d. Watercolor on paper. 25.9 x 27.7 (46.78). Signed on reverse:* "M. Ender/ Solntsedar"; *inscribed:* "To Galia from M., N 24." (Solntsedar was a resort on the Black Sea which the Enders visited.)

658 *UNTITLED, n.d. Watercolor on paper. 25.9 x 37.4 (C461). Signed on reverse:* "M. Ender/ Solntsedar"; *inscribed:* "To Natasha from Mulenki."

659 *UNTITLED, 1927. Watercolor and pencil on paper. 24.1 x 32.9 (C260). Inscribed on reverse:* "Odessa 1927."

657

658

659

660 *UNTITLED, n.d. Watercolor on paper mounted on board. 11 x 15.3 (C426).*

661 *UNTITLED, n.d. Watercolor on paper mounted on board. 22.7 x 28.7 (C464). Signed on reverse:* "M. Ender."

662 *UNTITLED, n.d. Watercolor and pencil on paper. 11.2 x 15.3 (C267).*

663 *UNTITLED, n.d. Watercolor on paper. 19.x 15.2 (C268).*

664 *PORTRAIT, n.d. Watercolor and pencil on paper. 43.3 x 31 (C450). Signed on reverse:* "M. Ender"; *inscribed:* "To Galia from M., N 2." Probably after 1930. The sitter has not been identified.

665 *UNTITLED, n.d. Watercolor on paper mounted on board. 22.1 x 30.6 (C467). Signed on reverse:* "M. Ender."

666 MARIIA ENDER?. *UNTITLED, 1927. Watercolor and pencil on paper. 21.9 x 28.7 (C431). Inscribed on reverse:* "August 14, 1927/ Odessa." This work is extremely close in style to watercolors by Nikolai Grinberg (see plate 682), and may be by his hand.

667 *UNTITLED, n.d. Watercolor on paper. 25.9 x 37.5 (C261). Signed on reverse:* "M. Ender."

660

663

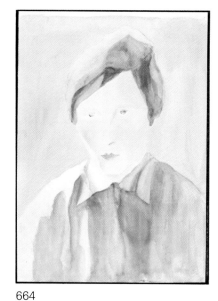

664

661

665

662

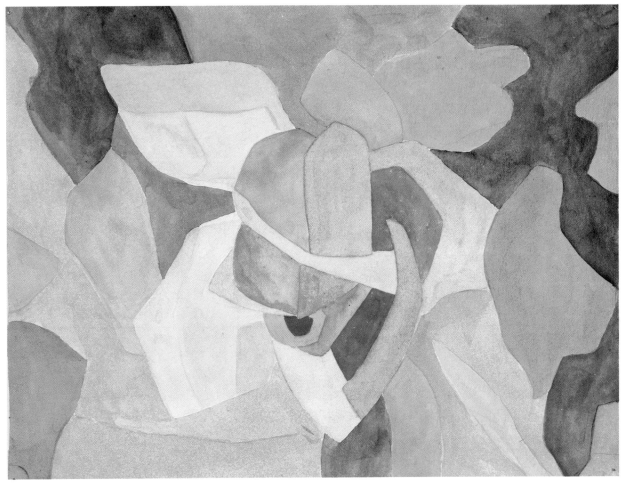

666

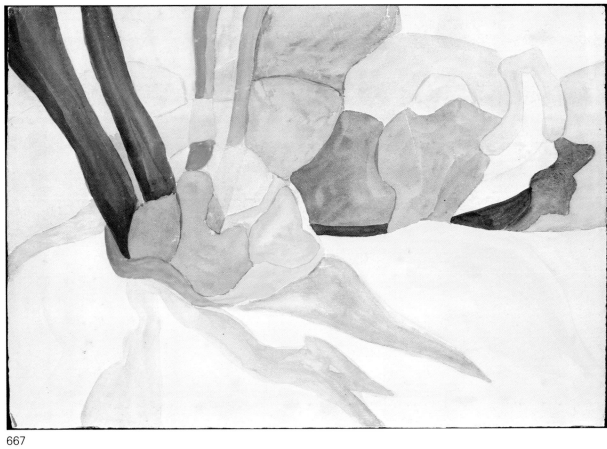

667

YURII VLADIMIROVICH ENDER

Biographical information has not been located, though he was represented at the "Vystavka kartin petrogradskikh khudozhnikov vsekh napravlenii" (Exhibition of Paintings of Petrograd Artists of All Tendencies), in 1923.
All the works by Yurii Ender were acquired from Andrei Ender, the artist's son, Leningrad.

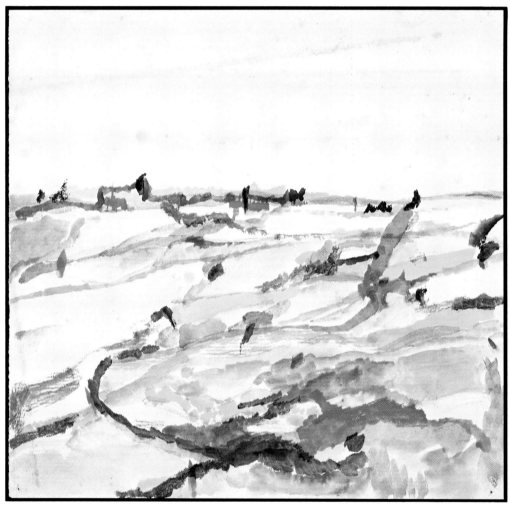

668

668 *UNTITLED, 1920. Watercolor on paper. 21.1 x 21.9 (C437). Signed, dated, and inscribed on reverse:* "Yu. Ender/ to Mariia July 22, 1920."

669 *UNTITLED, n.d. Watercolor on paper. 17.9 x 22.3 (C443). Signed and dated on reverse:* "Yu. Ender/ May 25."

670 *UNTITLED, 1921. Watercolor on paper. 15.4 x 22.3 (C435). Signed and dated on reverse:* "Yu. Ender/ July 24, 21. Yur. Lakhta."

671 *UNTITLED, n.d. Watercolor on paper. 22.2 x 30.6 (C439). Signed on reverse:* "Yu. Ender."

669

670

671

672 *UNTITLED, 1921. Watercolor on paper.*
20.6 x 28.4 (C284). Signed and dated on re-
verse: "July 29, 21. Yur. Lakhta."

673 *UNTITLED, 1922. Pencil on paper. 10.3 x*
17.7 (C440). Signed and dated on reverse:
"30.VII.22/ Sestoretsk/ Yu. Ender."

672

673

674

674 *UNTITLED, n.d. Watercolor and pencil on paper. 24 x 32.8 (C259). On reverse: "After riding in a boat on the sea. August 13."*

675 *UNTITLED, n.d. Watercolor on paper. 19.2 x 16.1 (C286). Signed on reverse: "Yur. Ender."*

675

676 YURII ENDER?. *UNTITLED, 1927. Water-color and pencil on paper. 33 x 25.9 (C472). Dated: I I: "May 3, 1927."*

677 *UNTITLED, n.d. Watercolor on paper. 19.1 x 24.9 (C438). Signed and dated on reverse: "Yu. Ender/ March."*

676

677

678

678 *UNTITLED, n.d. Watercolor and pencil on paper. 27.3 x 27.8 (53.78). Signed on reverse: "Yu. Ender."*

679 *UNTITLED, n.d. Watercolor on folded paper. 22.1 x 30.4 (C422).* This work is closely related to the style of Matiushin, especially in the period of his concern with the transcription of sound into visual form, c. 1921–23.

679

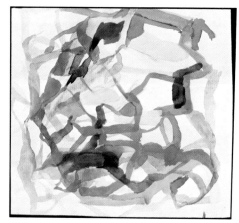

680

680 *UNTITLED, n.d. Watercolor on paper. 16.9 x 18.3 (C285). Signed and dated on reverse: "Yur. July 17."*

681 *UNTITLED, n.d. Watercolor on paper. 22.8 x 27.2 (C264). Dated on reverse: "Sept. 5."*

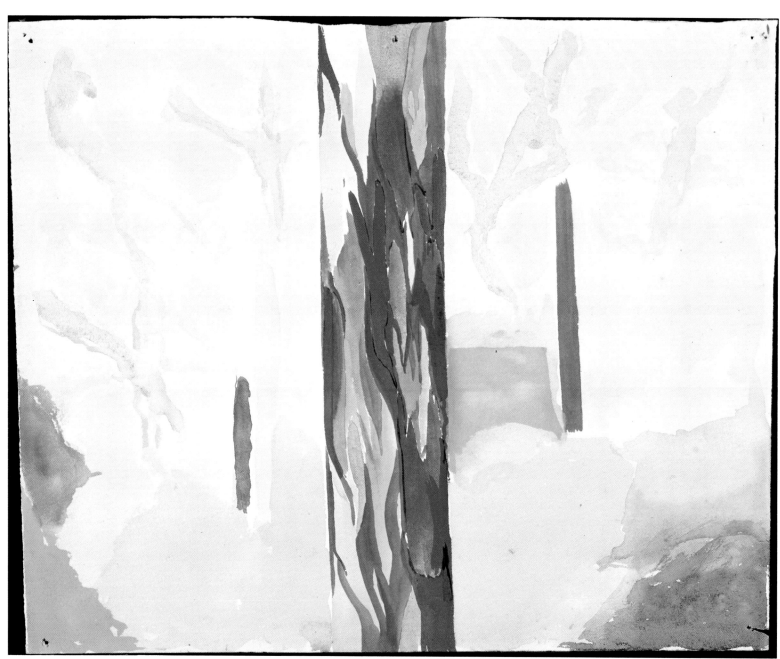

681

NIKOLAI IVANOVICH GRINBERG
Born St. Petersburg, 1897.

In 1918 was a student of Malevich, and from 1919 to 1922 studied with Matiushin. Was a member of the Zorved (Zorkoe vedanie, See-Know) group, and shared with Matiushin's school a lyrical style strongly linked to theories of music. Exhibited in the "Vystavka kartin petrogradskikh khudozhnikov vsekh napravlenii" (Exhibition of Paintings of Petrograd Artists of All Tendencies), in 1923. Also sent work to the Fourteenth Venice Biennale, in 1924.

From 1923 worked at the Petrograd Museum of Painterly Culture, which in 1924 became Ginkhuk, and exhibited at its shows. During the late 1920s ceased artistic activity, and almost none of his work has survived; his fate is unknown.

682 *COMPOSITION, 1920–21. Gouache on cardboard. 28.4 x 53.2 (61.78). Acquired from the Ender family.*

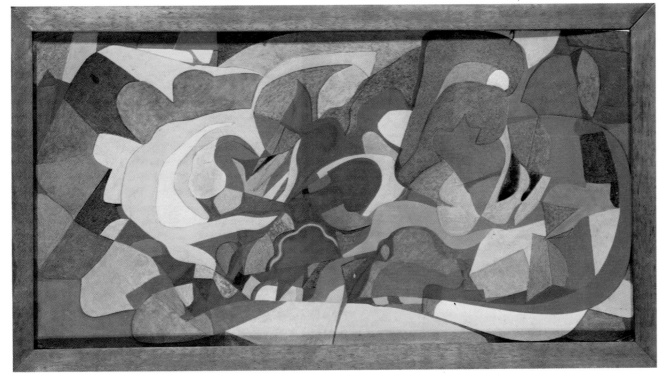

682

PETR VASILIEVICH MITURICH

Born St. Petersburg, September 12, 1887; died Moscow,
October 27, 1956.

From 1899 to 1905 studied at Pskov Military School. From 1906 to 1909 attended the Kiev Art Institute, where he was influenced by the work of Mikhail Vrubel; from 1909 to 1915 studied battle painting under Nikolai Samokish at the Academy of Arts in St. Petersburg. Having finished military engineering school, entered military service. During World War I was wounded at the front while serving as a signalman for the Eleventh Siberian Division, and in 1917, during the October Revolution, was again wounded and discharged. He then began to participate actively in avant-garde artistic life in Petrograd.

Contributed to the "Vystavka zhivopisi 1915 god" (Exhibition of Painting: 1915), in Moscow; the 1916 "Vystavka sovremennoi russoi zhivopisi" (Exhibition of Contemporary Russian Painting), in Petrograd; and the *Mir iskusstva* (World of Art) exhibitions from 1915 to 1918, in Petrograd. From 1914 on was interested in mechanics and technology in relationship to nature, which led him to design an apparatus combining several principles of movement. He called his invention *Volnovoi* (Undulator).

In 1921 became friendly with the poet Velimir Khlebnikov; made "graphic spatial" constructions. From 1920 to 1922 designed covers for the music of Artur Lurie (Arthur Lourié), such as *Roial v detskoi* (The Piano in the Nursery), and for literary works of Khlebnikov, such as *Zangezi*. In 1922 contributed to the "Erste russische Kunstausstellung" (First Russian Art Exhibition), at the Galerie van Diemen in Berlin.

From 1923 on was professor in the graphics and architecture departments at Vkhutemas. From 1925 to 1929 was a member of the Four Arts Society in Moscow, along with Pavel Kuznetsov, Vladimir Lebedev, Kuzma Petrov-Vodkin, and others. The group held four exhibitions, to which members of the avant-garde, including Kliun, Lissitzky, and Puni, contributed.

From 1930 on painted mainly landscapes and portraits.

683 *COVER DESIGN FOR V. KHLEBNIKOV'S POSTHUMOUSLY PUBLISHED BOOKLET "DOSKI SUDBY" (THE BOARDS OF DESTINY), c. 1927. Pencil and crayon on paper. 36.2 x 26.2 (237.80). Gift of M. Miturich, son of the artist.* Khlebnikov's mathematical calculations, according to which all phenomena in the universe might be explained, continued until his death, in 1922. Not long before his death he revised his entire system, concluding that everything could be reduced to the numbers two and three in various powers. The results of these calculations were published in 1922–23 in three consecutive booklets entitled *A Fragment from the Boards of Destiny* (V. Markov, *Russian Futurism* [1968], p. 302). The inscriptions on this cover design ("Hours of Events," "Even and Uneven," "Variable Power") refer directly to the mathematical theories propounded in the text. The "1914/22/27" suggests that this design was for an edition which appeared later than that cited by Markov. No evidence of a 1927 edition with cover by Miturich has been located.

684 *TEN CUBES, 1919–21. Cardboard cubes with gouache. Each approx. 5.6 x 5.6 x 5.6 (313.80). Gift of M. Miturich, son of the artist.* Miturich's cubes are closely related to his spatial paintings of the same period. In both, his interest in volume and in the relationship between volume and space is explored extensively. The surfaces in these works were often painted with hatching strokes, the painted shading competing with the shadows cast by the shapes themselves. By creating these cubes in which each of the sides was of equal importance and thus forcing a shifting viewpoint in relation to the work, Miturich was exploring the means by which graphic elements interact with those that are experienced spatially. (For a detailed and illuminating discussion of Miturich's work see C. A. Lodder, *Constructivism: From Fine Art into Design, Russia 1913–1933*, Yale University Press, 1982.)

684

ALEXEI ALEXEEVICH MORGUNOV

Born Moscow, 1884; died Moscow, February 1935.

In the early 1900s studied at the Stroganov Art Institute in Moscow and at the private studios of Sergei Ivanov and Konstantin Korovin. Frequented the salon of Konstantin Krakht in Moscow. From 1904 to 1910 exhibited at the Moskovskoe tovarishchestvo khudozhnikov (Moscow Association of Artists), where he met Malevich and Kliun. Married the daughter of the landscape painter Alexei Savrasov.

From 1909 to 1910 traveled to Europe — Germany, Austria, Italy, and France, where he became familiar with the work of Manet, Courbet, and Cézanne. Back in Moscow in 1910, joined the "Bubnovyi valet" (Jack of Diamonds) group, and participated in its exhibitions of 1910, 1913, and 1914 in Moscow. Also showed with the *Mir iskusstva* (World of Art) group in 1911–12, in Moscow and St. Petersburg. In 1912 contributed to the "Oslinyi khvost" (Donkey's Tail) exhibition in Moscow; but unlike its organizer, Larionov, continued to follow French influences in painting. Participated in three Soiuz molodezhi (Union of Youth) exhibitions in St. Petersburg, in 1911, 1912, and 1913–14. During 1913–14, worked with Malevich to develop alogism in painting. In 1915 contributed to "Tramvai V. Pervaia futuristicheskaia vystavka kartin" (Tramway V: First Futurist Exhibition of Paintings) in Petrograd and in 1916 to "Magazin" (The Store) in Moscow.

From 1918 to 1920 was professor of painting at the Svomas in Moscow. In 1918 was a member of the collegium of IZO Narkompros and participated in designing decorations for the city's celebration of the Revolution. Member of Proletkult. Exhibited at the 1918–19 "Fifth State Exhibition: From Impressionism to Nonobjective Art" in Moscow. Entered the Obektivnyi analiz (Objective Analysis) group at Inkhuk in Moscow, and from 1927 to 1930 was a member of OMKh. In the last years of his life turned to Socialist Realism in painting.

All the works by Morgunov were acquired from the artist's daughter.

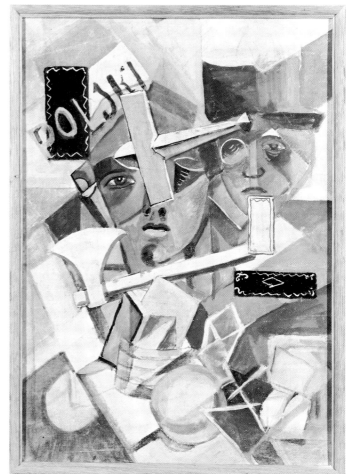

685

685 *AVIATOR'S WORKROOM, 1913. Gouache on canvas (relined). 50.5 x 36 (159.78).* Exhibitions: "Union of Youth," St. Petersburg, 1913–14, no. 85 (*Aviator's Study*); "Tramway V," Petrograd, 1915, no. 3 (*Aviator*).

686 *LANDSCAPE, 1910–11. Oil on canvas. 64 x 52 (Tretiakov Gallery TR79).*

687 *STANDING FIGURE (AVIATOR), 1912–13. Oil on canvas. 72.2 x 44.2 (158.78).*

686

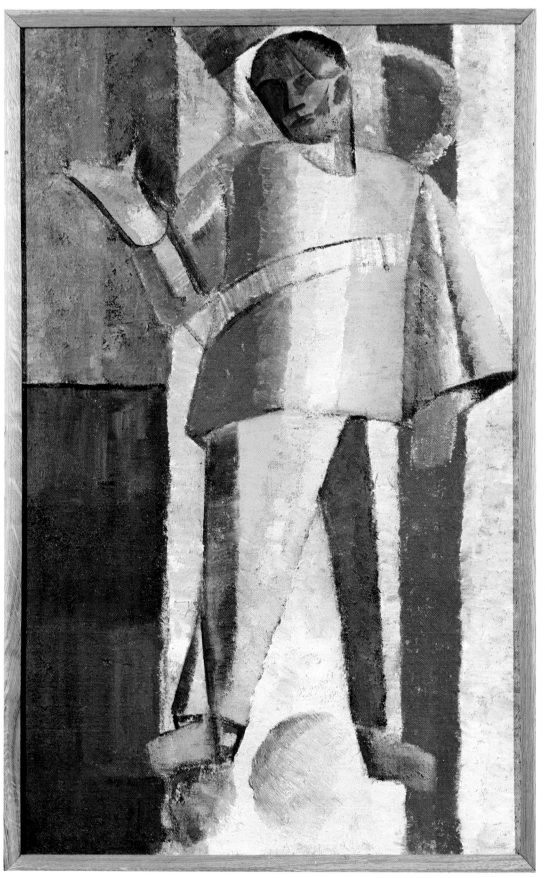

687

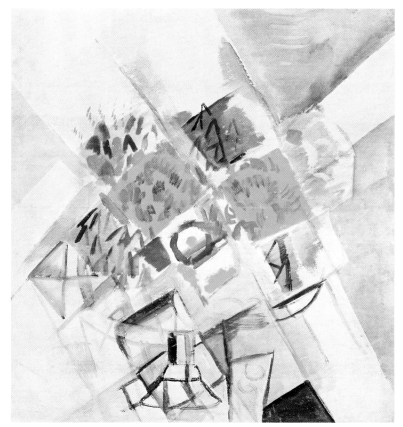

688

688 *COMPOSITION WITH LAMP, 1914. Oil on canvas. 51 x 49 (Tretiakov Gallery TR80).*

689 *STILL LIFE WITH WHEEL (42), 1914. Oil on canvas. 52.2 x 50.4 (157.78).*

690 *STILL LIFE WITH COMB, 1914. Oil on canvas. 52.7 x 50.4 (156.78).*

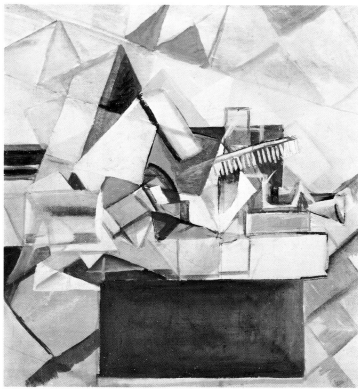

690

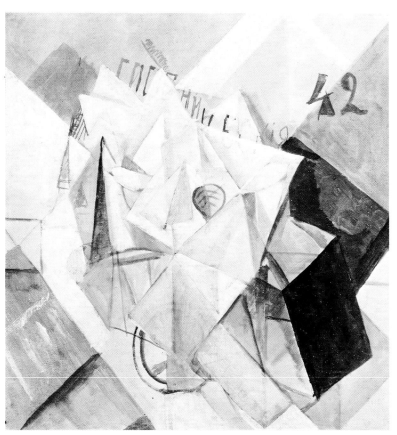

689

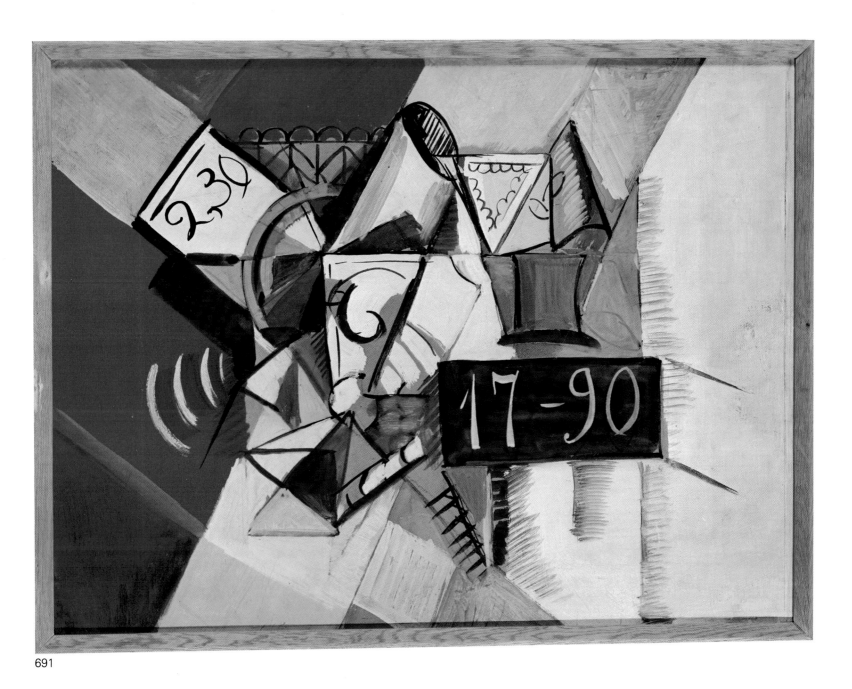

691

691 *COMPOSITION, 1914–15. Gouache on cardboard. 57.5 x 43.5 (Tretiakov Gallery TR82).*

692 *PORTRAIT, 1914–15. Oil on canvas. 70.5 x 52 (Tretiakov Gallery TR81). Exhibition: "Tramway V," Petrograd, 1915.*

692

SOLOMON BORISOVICH NIKRITIN

*Born Chernigov, December 3, 1898; died Moscow,
December 3, 1965.*

Graduated from the Kiev Art School in 1914. In 1916 designed the
scenery for the production of *Zelenoe koltso* (The Green Ring) at
the second studio of the Art Theater in Moscow. That year made
his debut as a painter at the last "Sovremennaia zhivopis" (Con-
temporary Painting) exhibition in Moscow. From 1917 to 1920 was
a decorator for Revolutionary celebrations for the city of Kiev.
From 1920 to 1922 completed his artistic education at Vkhutemas
in Moscow. In 1921, with Redko, Plaksin, Alexandr Tyshler, Sergei
Luchishkin, and Alexandr Labas, organized the Elektroorganizm
(Electroorganism) group, which held an exhibition at the Museum
of Painterly Culture in Moscow in 1922. (From 1922 to 1925 was
chairman of the Art Research Council of the Museum of Painterly
Culture.) Also in 1922 sent work to the "Erste russische Kunstaus-
stellung" (First Russian Art Exhibition), at the Galerie van Diemen
in Berlin. In 1923 – 24 produced, with the troupe of the Projection-
ists theater he created in Moscow, nonrepresentational perform-
ances by Anatolii Mariengof, including *Tragedia A,O,U* (A,O,U
Tragedy) and *Zagovor durakov* (Conspiracy of Fools). In 1923
formed the Projectionists group called Metod (Method). Partici-
pated in the "Pervaia diskussionaia vystavka obedinenii aktivnogo
revoliutsionnogo iskusstva" (First Discussional Exhibition of the
Associations of Active Revolutionary Art) in 1924 in Moscow, and
signed the Projectionists group declaration in the catalogue.

In the 1930s designed museum and exhibition interiors and
continued to paint.

*All the works by Nikritin were acquired from the artist's widow. In
addition to those illustrated here, the Costakis collection contains
approximately two hundred sketches by Nikritin.*

693 *PORTRAIT OF A WOMAN, 1918. Oil on
wood. 52 x 36 (Tretiakov Gallery TR159).*

694 *THE CONNECTION OF PAINTING AND ARCHITECTURE: TECTONICS, 1919. Oil on canvas. 175.1 x 131.1 (163.78). Inscribed on reverse:* ''1919, S. Nikritin, Composition.'' The title given above is that of V. Rakitin, who dates the work 1920–21.

694

695 *MOVEMENT OF COLOR, c. 1924. Oil on paper. 36.1 x 46 (171.78).*

696 *MOVEMENT OF COLOR, 1924. Oil on paper mounted on paper. 36.2 x 45.8 (169.78). Inscribed above image: "S. Nikritin." Dated l r: "IX/ 24."*

697 *MOVEMENT OF COLOR, c. 1924. Oil on paper. 34.9 x 42.5 (170.78).*

695

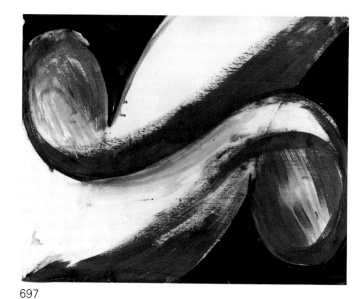

697

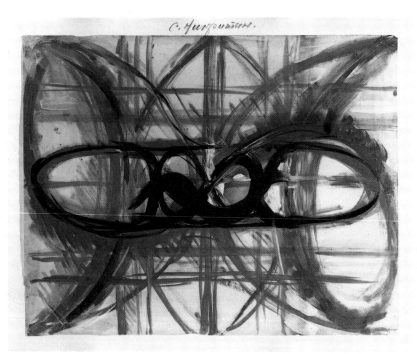

696

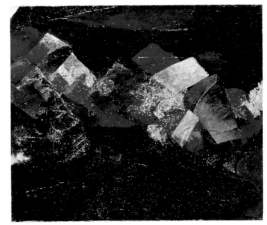

698 *COMPOSITION, 1921. Oil on canvas. 54.3 x 65.2 (166.78).*

699 *FAREWELL TO THE DEAD, 1926. Oil on wood. 87 x 130 (Tretiakov Gallery TR139).*

698

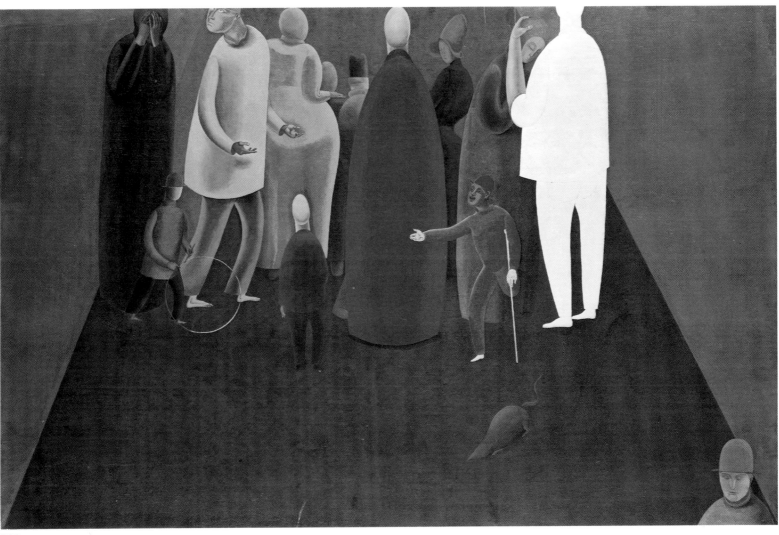

699

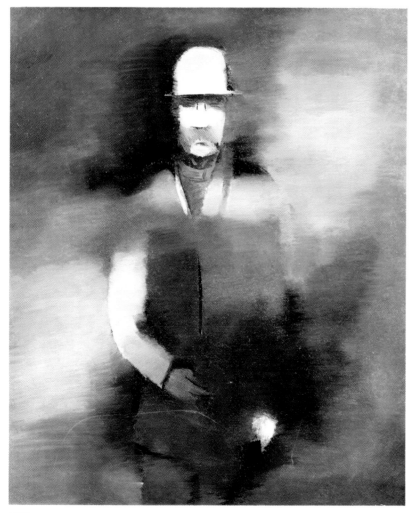

700

700 *MAN IN TOP HAT, 1927. Oil on canvas. 68.4 x 28.2 (162.78).* Nikritin often made several versions of a single composition in different dimensions. There is a large version of this work (180 x 139) in the Tretiakov Gallery, Moscow (formerly Costakis collection).

701 *SCREAMING WOMAN, 1928. Oil on canvas. 176 x 176 (168.78).*

702 *SCREAMING WOMAN, 1928. Oil on canvas. 60.7 x 51.8 (165.78). Titled, signed, and dated on reverse: "1928 S. Nikritin, 'Screaming Woman.'"*

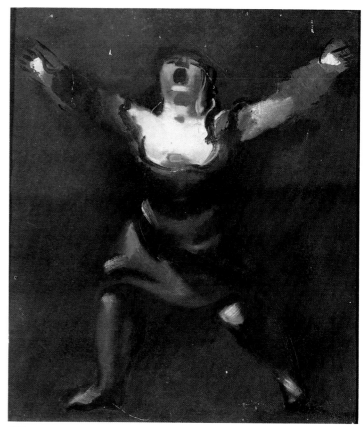

702

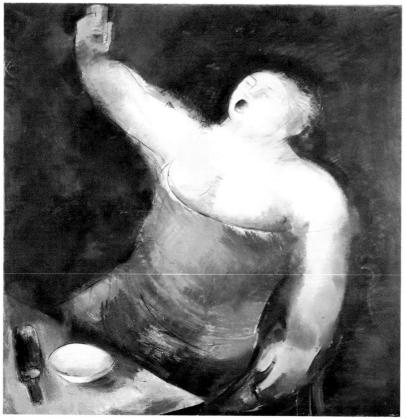

701

703 *UNTITLED, 1920s. Oil on canvas. 39.6 x 49.9 (172.78a).*

704 *UNTITLED, 1920s. Oil on canvas. 39.3 x 49.2 (172.78b).*

705 *SKETCH FOR A PAINTING, 1920s. Oil on plywood. 60.1 x 50.1 (167.78). Signed and inscribed on reverse: "S. Nikritin 'Sketch for a Painting.'"*

706 *FIGURE ON A RED GROUND, 1920s. Oil on paper mounted on plywood. Image: 40.3 x 34.6; mount: 60 x 49.8 (164.78). On reverse: "Nikritin trees and sea."* This inscription probably refers to an earlier work painted directly onto the plywood, now hidden by the present composition.

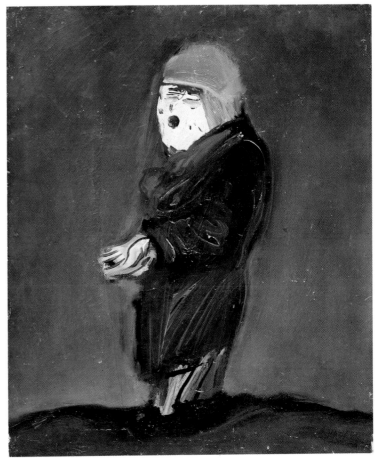

705

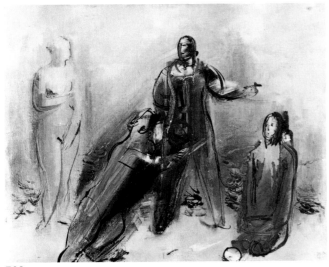

703

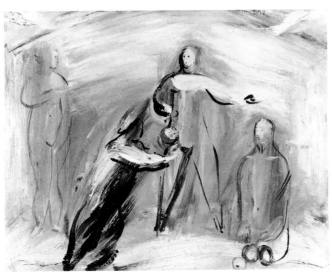

704

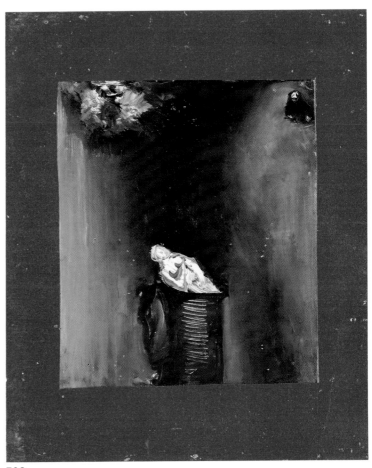

706

707

707 *LANDSCAPE, c. 1930. Oil on canvas (?). Dimensions unknown (Tretiakov Gallery TR141).*

708 *MAN AND CLOUD, 1930. Oil on canvas. 142.3 x 142.3 (160.78).*

708

709 *POET'S MUSE, 1930. Oil on canvas. 116.5 x 79 (161.78). An ink study for this painting is in the Costakis collection (224.80).*

710 *SOLDIERS, c. 1930. Oil (?). Dimensions unknown (Tretiakov Gallery TR135).*

711 *MEETING, 1930. Oil. 67 x 57 (Tretiakov Gallery TR13).*

712 *GROUP, 1930. Oil on canvas. 67 x 57 (Tretiakov Gallery TR136).*

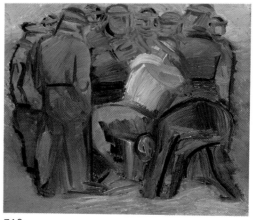

710

709

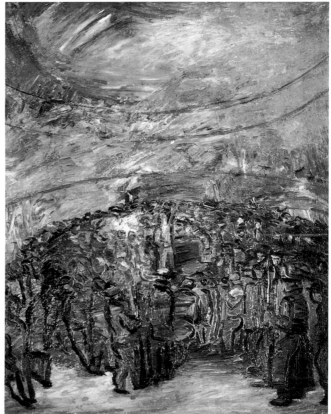

711

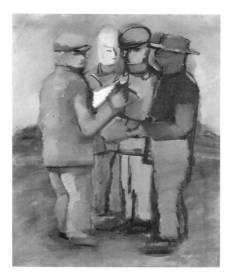

712

713 *PEOPLE'S COURT, 1933. Oil on canvas. 143 x 142 (Tretiakov Gallery TR140).*

714 *SKETCH FOR ORATOR, 1939. Oil on cardboard. 35.5 x 33.5 (Tretiakov Gallery TR12). Signed l r: "S. Nikritin."*

715 *GROUP PORTRAIT, 1930. Oil. 68.5 x 58.5 (Tretiakov Gallery TR137).*

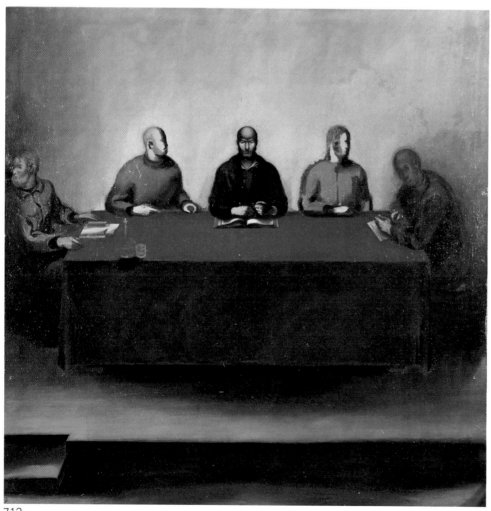

713

714

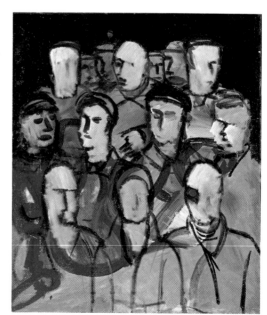

715

VERA EFIMOVNA PESTEL

Born Moscow, May 13, 1886; died Moscow, November 18, 1952.

Daughter of a chemistry teacher; studied one year at the Stroganov Art Institute, then at the private studios of Konstantin Yuon and Egon Kish; also a student of Simon Hollósy. Traveled to Germany, Italy, and France, where she studied in the studios of Le Fauconnier and Metzinger. During World War I, back in Russia, was close to Popova, Udaltsova, and Tatlin. From 1916 to 1917 was a member of the Supremus group and contributed to the journal of the same name, edited by Malevich, which never appeared. Exhibited in "The Last Futurist Exhibition of Pictures: 0.10," in 1915 in Petrograd, and at the "Magazin" (The Store), in 1916 in Moscow. Also contributed to the 1916 "Bubnovyi valet" (Jack of Diamonds) exhibition in Moscow and the 1917 *Mir iskusstva* (World of Art) exhibition in Petrograd. Participated in the 1918–19 "Fifth State Exhibition: From Impressionism to Nonobjective Art," in Moscow.

Toward 1920 moved away from abstract painting and began to work for the theater. In 1922 was represented at the "Erste russische Kunstausstellung" (First Russian Art Exhibition), at the Galerie van Diemen in Berlin. From 1922 to 1927 was a member of the Makovets group (see Chekrygin, page 91). From 1920 on was concerned with the artistic education of children.

All three Pestels were purchased from the artist's daughter, S. B. Pestel, Moscow.

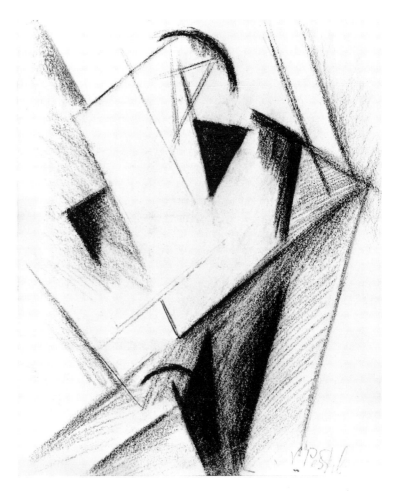

716 *UNTITLED, c. 1915. Charcoal on paper. 20.5 x 16.6 (C331). Inscribed, not by the artist, l r: "V Pestel."*

717 *COMPOSITION, 1916. Oil on canvas. 66 x 35.5 (Tretiakov Gallery TR78). Not signed or dated.* A similar still life dating from the winter of 1915–16 is in the Tretiakov Gallery, Moscow.

718 *STILL LIFE, 1915–16. Oil and newspaper collage on canvas. 66.8 x 45.6 (173.78). Not signed or dated.*

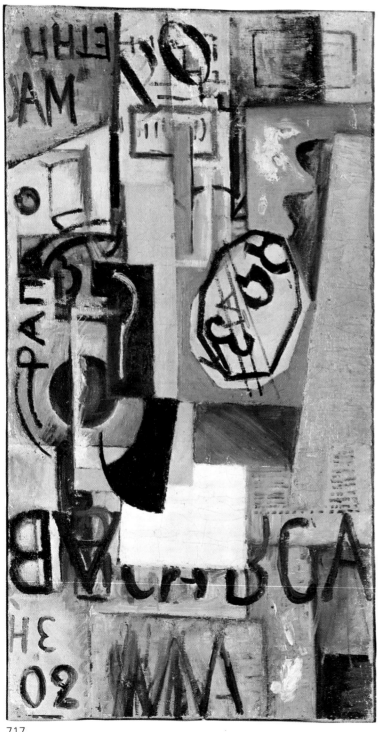

717

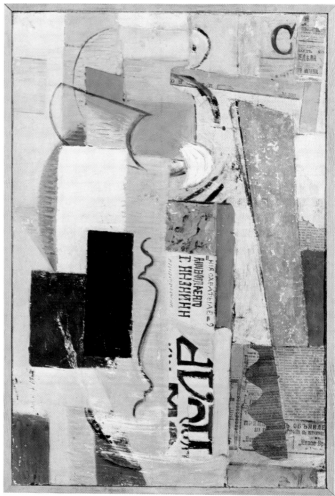

718

MIKHAIL MATVEEVICH PLAKSIN

Born Shlisselburg, near St. Petersburg, May 15, 1898; died Moscow, May 22, 1965.

Began his artistic training as a lithography student; subsequently studied with Nikolai Roerich and Alexandr Yakovlev at the school of the Society for the Encouragement of the Arts in St. Petersburg. In 1916 was mobilized; joined the navy. From 1917 to 1918 designed sets for amateur theatrical productions at Kronstadt, and from 1919 to 1920 was an army artist in Ekaterinburg (now Sverdlovsk) in the Urals; worked on posters and on street decoration for holiday and Revolutionary celebrations. Briefly headed the graphics and printing departments of the local art workshops.

Under the influence of Alexandr Labas, Plaksin became interested in problems of abstract art. In Moscow from 1920 onward, studied at Vkhutemas in Robert Falk's studio. Was a member of the Elektroorganizm (Electroorganism) group, with Redko, Nikritin, and others, and showed abstract paintings at the group's 1922 exhibition at the Museum of Painterly Culture in Moscow. Also participated in the "Pervaia diskussionaia vystavka obedinenii aktivnogo revoliutsionnogo iskusstva" (First Discussional Exhibition of the Associations of Active Revolutionary Art), in Moscow in 1924, and in the catalogue signed the declaration of the Projectionists group. In 1923–24 was a member of the Metod (Method) group.

Gradually gave up painting and worked for the theater, on books, and on setting up agricultural and printing exhibitions. From 1920 on worked on inventions, including a color movie camera and stereo projection systems.

Both the Plaksins are from the collection of the artist's second wife, A. N. Varnovitskaia.

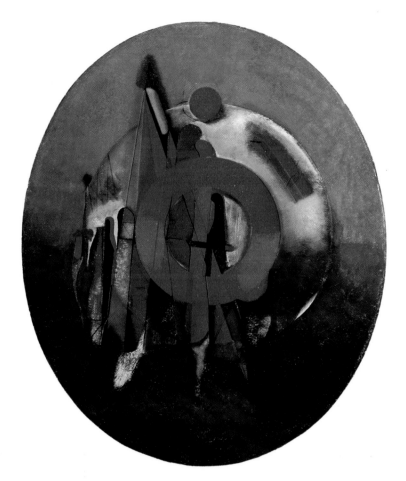

719 *PLANETARY, 1922. Oil on canvas. 71.9 x 61 (174.78). Signed and dated on reverse:* "Plaksin 1922."

720 *SPECTRUM OF GAS, 1920. Oil on canvas.*
81.5 x 81.5 (Tretiakov Gallery TR77). Not signed
or dated.

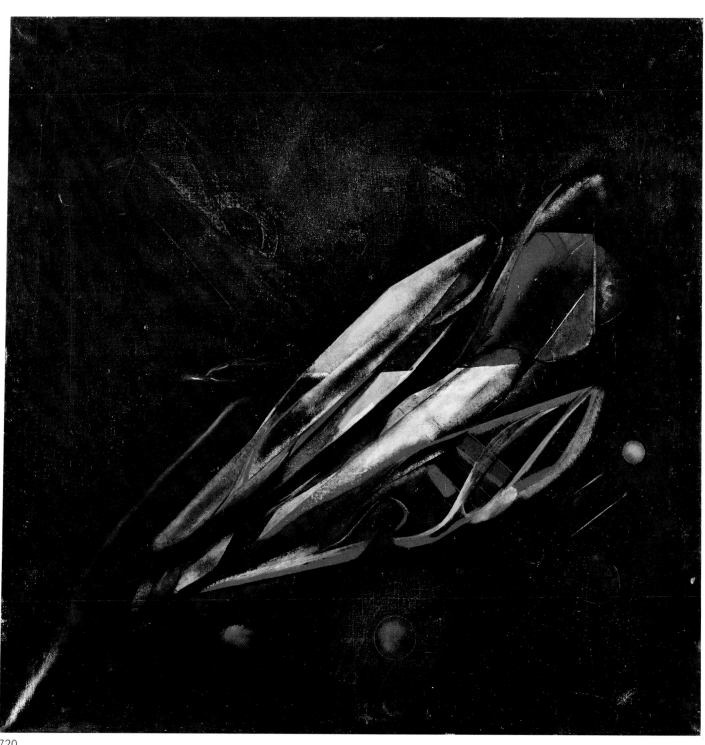

720

SERGE POLIAKOFF

Born Moscow, January 8, 1906; died Paris, October 12, 1969.

Lived in Constantinople, Sofia, Belgrade, Berlin, and Paris, from 1923 onward. Worked as a guitarist. In 1930 started to study at the Trochot and Grande Chaumiére academies in Paris. In 1933 met Kandinsky at the studio of Sonia and Robert Delaunay and began to take part in the Salon des Indépendants. In 1935 – 37 studied at the Slade School in London. Back in Paris from 1937 onward. Had his first one-man show in 1945 at L'Esquisse. Became a French citizen in 1962.

Both the works by Poliakoff were given to Costakis by the artist.

721 *NONREPRESENTATIONAL PAINTING, 1956. Oil. 81 x 65.5 (Tretiakov Gallery TR160). Signed l r: "[Se]rge Poliakoff."*

722 *ABSTRACT PAINTING, 1957. Oil. 47 x 62 (Tretiakov Gallery TR14). Signed l l: "Serge Poliakoff."*

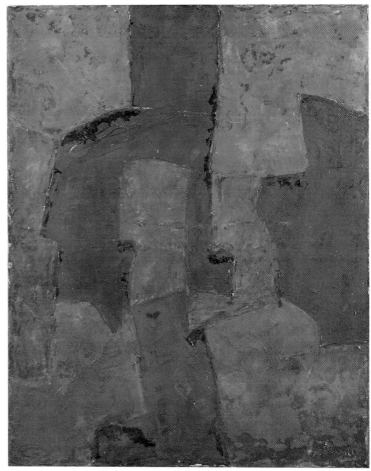

721

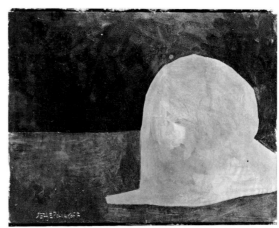

722

LIUBOV SERGEEVNA POPOVA

Born near Moscow, April 24, 1889; died Moscow, May 25, 1924, of scarlet fever.

723 *LIUBOV POPOVA*. Photographer unknown.

After graduation from the Yaltinskaia Women's Gymnasium, attended Arsenieva's Gymnasium in 1907–08 and simultaneously studied in the private studios of Stanislav Zhukovsky and Konstantin Yuon in Moscow. In her travels in 1909–10 was particularly impressed by the works of Vrubel in Kiev, early Italian Renaissance masters such as Giotto in Italy, and ancient Russian church art and architecture in the Russian cities of Novgorod and Pskov.

In 1912 worked in the Moscow studio known as The Tower with Tatlin, Viktor Bart, and Kirill Zdanevich. That winter traveled to Paris and worked in the studios of Le Fauconnier and Metzinger with Udaltsova and other Russian artists. Returned to Russia in 1913, and in 1914 again traveled through Italy and France.

From 1912 to 1915 worked on problems of Cubism as well as on the dynamics of movement and color. In 1915 turned to a nonrepresentational style to which she applied the traditional forms of Russian icon painting. Contributed to the 1914 and 1916 "Bubnovyi valet" (Jack of Diamonds) exhibitions in Moscow, the 1915 "Tramvai V. Pervaia futuristicheskaia vystavka kartin" (Tramway V: First Futurist Exhibition of Paintings) in Petrograd and "Last Futurist Exhibition of Pictures: 0.10" in Petrograd and the 1916 "Magazin" (The Store) in Moscow. In 1916 became a member of the Supremus group and contributed to the journal of the same name, which never appeared. Participated in the 1918–19 "Fifth State Exhibition: From Impressionism to Nonobjective Art" and the 1919 "Tenth State Exhibition: Nonobjective Creation and Suprematism," both in Moscow.

From 1918 onward taught at Svomas and Vkhutemas. From 1920 to 1923 was a member of Inkhuk. Was a member of the Productivist group and one of the creators of the new system of practical artistic instruction. Participated in the "5 × 5 = 25" exhibition of 1921 in Moscow and contributed to the "Erste russische Kunstausstellung" (First Russian Art Exhibition), at the Galerie van Diemen in Berlin in 1922.

During 1922–23 designed scenery for Vsevolod Meierkhold's productions of Fernand Crommelynck's *The Magnanimous Cuckold* and Sergei Tretiakov's *Zemlia dybom* (Earth in Turmoil).

In 1924 began to design textiles and clothing with Stepanova at the First State Textile Print Factory in Moscow.

Unless otherwise indicated, all the works by Popova were acquired either from Pavel Sergeevich, the artist's brother, or from his stepson.
See also pages 120 and 125.

The Costakis collection contains a group of sketchbooks and individual sketchbook pages dating from early in Popova's career, the total number of drawings amounting to over three hundred. Selections from the sketchbooks and from the individual pages are reproduced here. With the exception of sketchbook C313, they are not dated. A certain number of drawings can be dated on the basis of their relationship to paintings or to the works in the dated sketchbook, but a chronology for the majority of the drawings remains to be established. A description of the sketchbooks follows:

1 48 pencil drawings, 36 x 22 (C5). Figure studies, icons, saints, copies of frescoes.
2 66 pencil and ink drawings, some with wash, bound with thread, 36 x 22 (C6). Academic studies of nudes.
3 42 pencil and ink drawings, 36 x 22 (C8). Loosely folded sheets, studies of trees and nudes.
4 52 ink and pencil drawings bound with string, 36 x 22 (C7). Nudes and some portrait drawings.
5 40 pencil drawings, 26.7 x 22.5 (C2). Cubist works and some studies of nudes.
6 77 drawings in a bound notebook dated on cover 1914, 21.6 x 16.8 (C313). Mythological subjects, trees, and studies of nudes related to paintings of 1914–15. Some of the drawings may be from as early as 1913, and some from early 1915.

724

724 *VIEW FROM THE WINDOW, 1906. Pencil on paper. 7.4 x 15.7 (C761). Inscribed within picture:* "1906, View from my window at home"; *inscribed below:* "Apartment 3-B Mitninskaia Boulevard."

725 *STILL LIFE, 1907–08. Oil on canvas. 70.6 x 53.7 (181.78). Dated on reverse:* "1907–08." *Acquired by D. Sarabianov from P. S. Popov, the artist's brother. Present from Sarabianov on Costakis's thirty-fifth wedding anniversary.*

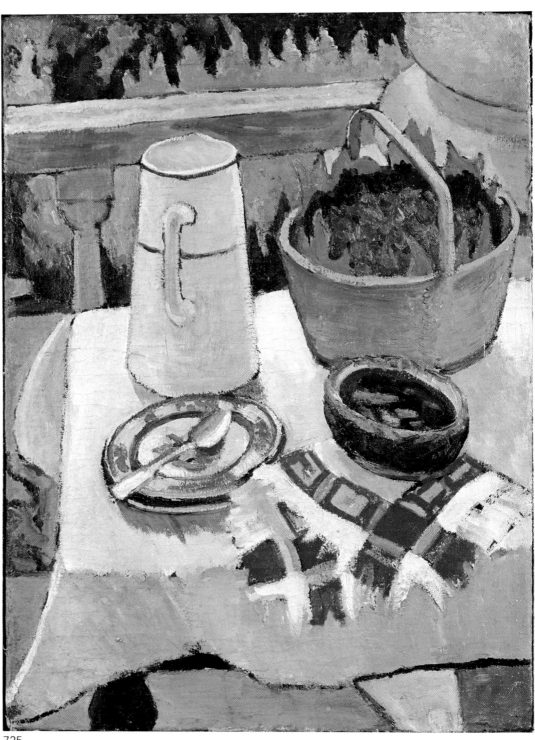
725

726 *Pencil on paper. 26.6 x 20.6 (C688 recto).*
727 *Pencil on paper. 27 x 22.3 (C681 recto).*
728 *Pencil on paper. 27 x 22.3 (C680 recto).*
729 *PAGE 405 FROM SKETCHBOOK C2. Pencil on paper. 26.5 x 20.5.*
730 *Pencil on paper. 35.6 x 22.2 (238.80 recto).*

726

727

728

729

730

731 *MALE MODEL, c. 1909. Oil on canvas. 98 x 46 (Tretiakov Gallery TR68). From A. Vesnin to D. Sarabianov. Gift of Sarabianov to Costakis.*

732 *PAGE 449a FROM SKETCHBOOK C7. Pencil and wash on paper. 35.7 x 22.7.*

733 *PAGE 392 FROM SKETCHBOOK C6. Pencil on paper. 35.6 x 23.*

732

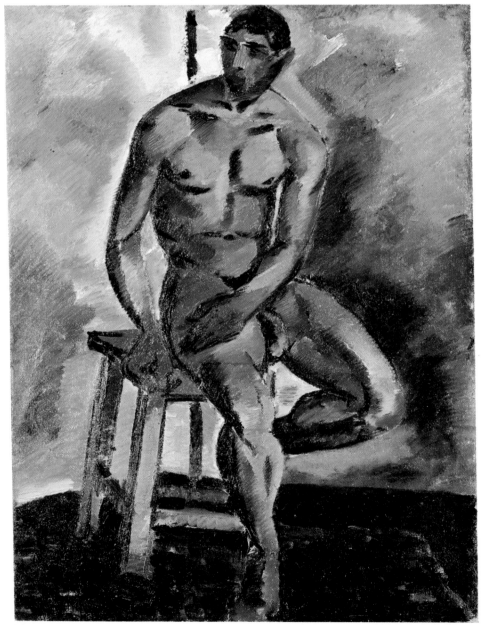

731

733

734

735

734 *PORTRAIT OF THE ARTIST'S SISTER, 1908–09. Oil on canvas. 61.5 x 44.5 (Tretiakov Gallery TR69).*

735 *PORTRAIT OF THE ARTIST'S SISTER, page 463 from sketchbook C7, c. 1909–11. Pencil on paper. 35.7 x 22.7.*

736 *PORTRAIT OF THE ARTIST'S SISTER, page 462a from sketchbook C2, c. 1909–11. Pencil on paper. 26.5 x 20.5.*

737 *PORTRAIT OF THE ARTIST'S SISTER, c. 1910–12. Pencil on paper. 35.5 x 22 (ATH80.5).*

736

737

738 *SELF-PORTRAIT (?), c. 1912. Pencil on paper. 14 x 11 (C660).*

739 *SELF-PORTRAIT, c. 1912. Ink and wash on paper. 24.9 x 23.4 (C54 verso).*

740 *HEAD OF A MAN, c. 1909. Pencil on paper. 27 x 22.3 (C686 recto).*

741 *PORTRAIT OF THE ARTIST'S SISTER, page 460a from sketchbook C7, c. 1910–12. Pencil on paper. 35.5 x 22.7.*

738

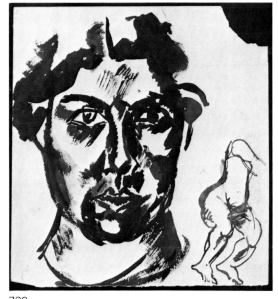

739

740

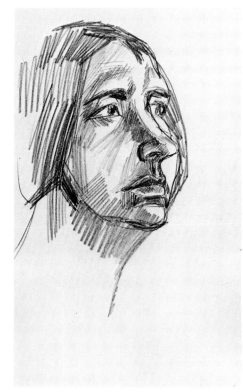

741

742 *Wash and ink on paper. 35.6 x 22.5 (C759).*

743 *Ink and wash on paper. 35.5 x 22.4 (C758).*

744 *PAGE 134a FROM SKETCHBOOK C8. Pencil on paper. 35.4 x 22.1.*

745 *Ink and wash on paper. 35.5 x 22 (ATH 80.3).*

746 *Ink and wash on paper. 35.5 x 22 (ATH 80.4).*

747 *Ink and wash on paper. 35.5 x 22 (C669 recto).*

743

744

742

745

746

747

748 *Ink and wash on paper. 45 x 35 (ATH 80.2).*

749 *PAGE 97 FROM SKETCHBOOK C8. Ink and wash on paper. 35.4 x 22.1.*

750 *Ink and wash on paper. 35.5 x 22.5 (C695 recto).*

751 *Ink and wash on paper. 44 x 35.9 (239.80 verso).*

750

748

749

751

Popova's stylistic development between 1912–13 and 1915 is unusually well documented in the Costakis collection. The works of 1912–13 clearly suggest the influence of French Cubism, especially that of Metzinger and Le Fauconnier (plates 754 and 771). By 1914, the more important influences of Tatlin on the one hand and Boccioni on the other become evident. Popova was working in Tatlin's studio and her treatment of the nude is clearly indebted to his example (see, especially, drawings in his 1913–14 sketchbook in Moscow, plate 772). Boccioni's 1912 *Technical Manifesto of Futurist Sculpture* was published in Moscow in 1914, and had Popova not already encountered his work and theory on her European travels of 1913–14, she would surely have been exposed to them by 1914–15.

Boccioni was especially concerned to deal with the object in relation to its environment—"a translation in plaster, bronze, glass, wood, or any other material of those atmospheric planes which bind and intersect things." His own experiments with the nature of such "intersection"— expressed pictorially in *Horse + Rider + Building*, for example, as well as sculpturally in *Extension of a Bottle in Space*—must have had an influence on Popova's work of 1914–15. Her series of drawings of seated and standing nudes, the *Seated Figure* of 1914–15 (plate 801), and *The Jug on the Table* (plate 817) and *Person + Air + Space* (Russian Museum, Leningrad), the last two of 1915, show an increasingly independent response to the problems raised by Boccioni. Moreover, the "atmospheric planes" that so visibly intersect with figures in her work of 1914–15 become by 1917 the actual subjects of Popova's paintings. It is out of these elements that the 1916–21 *Architectonics* are constructed.

752 *PAGE 13a FROM SKETCHBOOK C313, c. 1913–14. Pencil on paper. 21.6 x 16.8.* Possibly a study for *Two Figures* (plate 754).

753 *PAGE 59a FROM SKETCHBOOK C313, c. 1913–14. Pencil on paper. 21.6 x 16.8.* Two studies for the right-hand figure in *Two Figures* (plate 754).

754 *TWO FIGURES, c. 1913–14. Oil on canvas. 157 x 123 (Tretiakov Gallery TR58).*

752

753

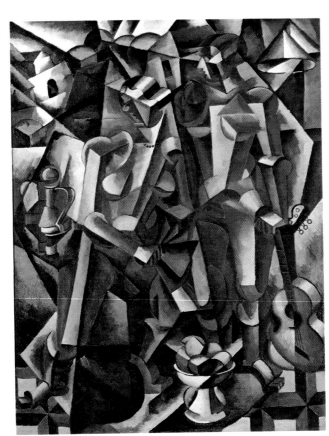

754

755

755 *STUDY, c. 1913–14. Pencil on paper. 20.6 x 26.7 (C3 verso).*

756 *PAGE 42 FROM SKETCHBOOK C313, c. 1913–14. Pencil on paper. 21.6 x 16.8.*

757 *STANDING FIGURE, c. 1913–14. Pencil on paper. 26.7 x 20.6 (C79 verso).*

758 *SEATED FIGURE, c. 1913–14. Pencil on paper. 26.7 x 20.7 (C74).*

759 *ANATOMICAL STUDY, c. 1913–14. Pencil on paper. 26.8 x 20.6 (C49).*

760 *PAGE 268a FROM SKETCHBOOK C2, c. 1913–14. Pencil on paper. 26.5 x 20.5.*

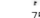

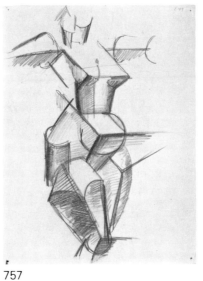

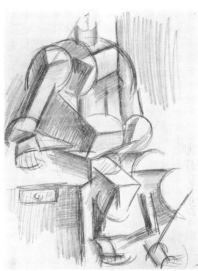

756

757

758

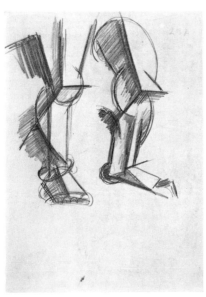

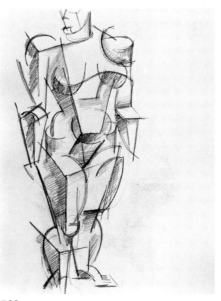

759

760

761 *PAGE 14 FROM SKETCHBOOK C313, c. 1913–14. Pencil on paper. 21.6 x 16.8.*

762 *ANATOMICAL STUDY, c. 1913–14. Pencil on paper. 21.6 x 16.6 (C1 recto).*

763 *SEATED FIGURE, c. 1913–14. Pencil on paper. 21.6 x 16.6 (C1 verso).*

764 *STANDING FIGURE, c. 1913–14. Pencil on paper. 21.5 x 16.5 (ATH80.6).*

765 *STANDING FIGURE, c. 1913–14. Pencil on paper. 26.7 x 20.5 (C68).*

766 *PAGE 263 FROM SKETCHBOOK C2, c. 1913–14. Pencil on paper. 26.5 x 20.5.*

767 *PAGE 274 FROM SKETCHBOOK C2, c. 1913–14. Pencil on paper. 26.5 x 20.5.*

761

762

763

764

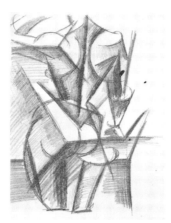

765

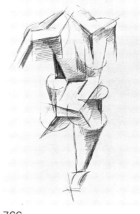

766

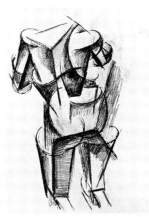

767

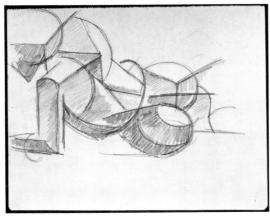

768

769

770

768 *ANATOMICAL STUDY, c. 1913–14. Pencil on paper. 16.8 x 21 (C76 recto).*

769 *ANATOMICAL STUDY, c. 1913–14. Pencil on paper. 26.7 x 20.6 (C4).*

770 *STANDING FIGURE, c. 1913–14. Pencil on paper. 26.8 x 21 (C78).*

771 *FEMALE MODEL, STANDING FIGURE, c. 1913–14. Oil on canvas. 105 x 69.5 (Tretiakov Gallery TR70). From A. Vesnin to D. Sarabianov, Moscow; purchased by Costakis from Sarabianov.*

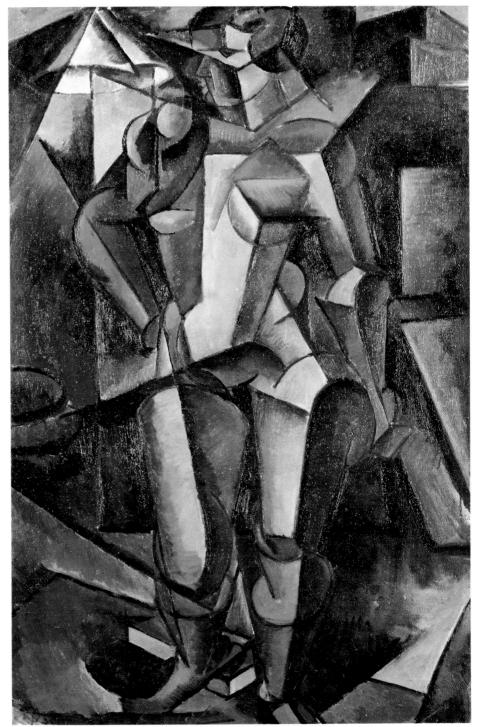

771

772 VLADIMIR TATLIN. *PAGE FROM A SKETCHBOOK*, c. 1913–14. *Pencil on paper. 43 x 26 (Central State Archive of Literature and Art, Moscow, fond 2089, Archive I, no. 2).*

773 *SEATED FIGURE*, c. 1914–15. *Pencil on paper. 21.5 x 16.6 (C70 recto).*

774 *SEATED FIGURE*, c. 1914–15. *Pencil on paper. 21.6 x 16.8 (C76 verso).*

775 *PAGE 60 FROM SKETCHBOOK C313*, c. 1914–15. *Pencil on paper. 21.6 x 16.8.*

772

773

774

775

776

777

778

776 *PAGE 15 FROM SKETCHBOOK C313, c. 1914–15. Pencil on paper. 21.6 x 16.8.*

777 *PAGE 20 FROM SKETCHBOOK C313, c. 1914–15. Pencil on paper. 21.6 x 16.8.*

778 *PAGE 18 FROM SKETCHBOOK C313, c. 1914–15. Pencil on paper. 21.6 x 16.8.*

779 *ANATOMICAL STUDY, c. 1914–15. Pencil on paper. 26.7 x 20.6 (C3 recto).*

780 *PAGE 273a FROM SKETCHBOOK C2, c. 1914–15. Pencil on paper. 26.5 x 20.5.*

781 *PAGE 18a FROM SKETCHBOOK C313, c. 1914–15. Pencil on paper. 21.6 x 16.8.*

782 *PAGE 14a FROM SKETCHBOOK C313, c. 1914–15. Pencil on paper. 21.6 x 16.8.*

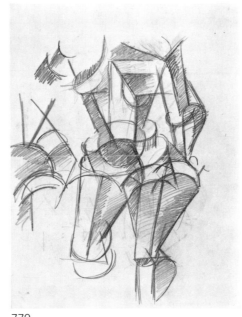

779

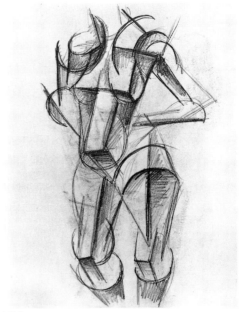

780

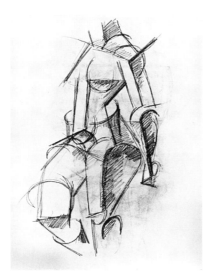

781

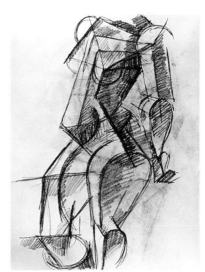

782

783 *PAGE 46a FROM SKETCHBOOK C313, c. 1914–15. Pencil on paper. 21.6 x 16.8.*

784 *PAGE 45 FROM SKETCHBOOK C313, c. 1914–15. Pencil on paper. 21.6 x 16.8.*

785 *PAGE 44a FROM SKETCHBOOK C313, c. 1914–15. Pencil on paper. 21.6 x 16.8.*

786 *PAGE 44 FROM SKETCHBOOK C313, c. 1914–15. Pencil on paper. 21.6 x 16.8.*

787 *PAGE 39a FROM SKETCHBOOK C313, c. 1914–15. Pencil on paper. 21.6 x 16.8.*

783

784

785

786

787

788

789

788 *ANATOMICAL STUDY, c. 1914—15. Pencil on paper. 26.6 x 21 (C85 recto).*

789 *PAGE 265a FROM SKETCHBOOK C2, c. 1914—15. Pencil on paper. 26.5 x 20.5.*

790 *PAGE 64 FROM SKETCHBOOK C313, c. 1914—15. Pencil on paper. 21.6 x 16.8.*

791 *PAGE 47 FROM SKETCHBOOK C313, c. 1914—15. Pencil on paper. 21.6 x 16.8.*

792 *PAGE 48a FROM SKETCHBOOK C313, c. 1914—15. Pencil on paper. 21.6 x 16.8.*

790

791

792

793

793 *PAGE 20a FROM SKETCHBOOK C313, c. 1914–15. Pencil on paper. 21.6 x 16.8.*

794 *PAGE 271 FROM SKETCHBOOK C2, c. 1914–15. Pencil on paper. 26.5 x 20.5.*

795 *PAGE 62 FROM SKETCHBOOK C313, c. 1914–15. Pencil on paper. 21.6 x 16.8.*

796 *PAGE 57a FROM SKETCHBOOK C313, c. 1914–15. Pencil on paper. 21.6 x 16.8.*

797 *PAGE 41a FROM SKETCHBOOK C313, c. 1914–15. Pencil on paper. 21.6 x 16.8.*

798 *PAGE 40a FROM SKETCHBOOK C313, c. 1914–15. Pencil on paper. 21.6 x 16.8.*

799 *PAGE 13 FROM SKETCHBOOK C313, c. 1914–15. Pencil on paper. 21.6 x 16.8.*

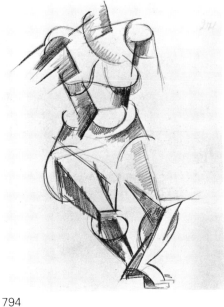

794

795

796

797

798

799

800 *SEATED FIGURE, c. 1914–15. Pencil on paper. 26.7 x 21 (C81).*

801 *SEATED FIGURE, 1914–15. Oil on canvas. 106 x 87 (Museum Ludwig, Cologne; formerly Costakis collection). Not signed or dated.* This painting was followed by *Person + Air + Space* of 1915, now in the collection of the Russian Museum, Leningrad (125 x 107; repr. color, Camilla Gray, *The Great Experiment* [London and New York, 1962], p. 185).

800

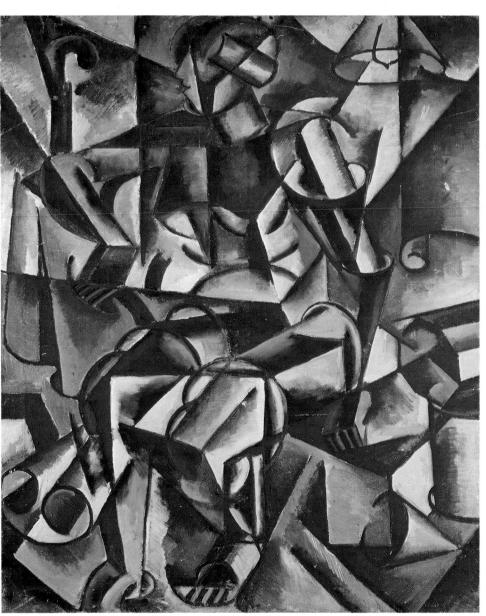

801

802 *PAGE 274a FROM SKETCHBOOK C2, c. 1915.* Pencil on paper. 26.5 x 20.5.

803 *STUDY, c. 1914–15.* Pencil on paper. 26.7 x 20.9 (C69 recto).

804 *STUDY, c. 1914–15. Pencil on paper mounted on board.* 20.5 x 17.4 (C365). Possibly a study for *The Philosopher*, Russian Museum, Leningrad (repr. *Paris-Moscou* [Paris, 1979], p. 137).

803

802

804

In 1915 and 1916 Popova sent post-cards showing her work in progress to a close friend, Adelaide Robertovna Dege, who was living in Birsk, several hundred miles east of Moscow in the foothills of the Urals.

805, 806 *A POSTCARD WRITTEN BY POPOVA to Adelaide Robertovna Dege. 13.8 x 8.7 (295.81). Dated:* "Moscow Oct. 11, 1915. No. 1. Dear Adda Robertovna: I don't know whether you will receive these postcards of mine, but I would like to send them to you so that you will have an idea of some of my works which I plan to send to an exhibition in Petrograd." *Not signed. Picture on verso labeled in Popova's hand:* "Sketch for portrait (of Pavel)." The December 1915 "0.10" exhibition in Petrograd included a work titled *Sketch for Portrait* (no.

87), which is almost certainly the work mentioned in the text of the card.

807 *PORTRAIT, 1914–15. Oil on paperboard. 59.5 x 41.6 (183.78). Not signed or dated.* This work, and two pencil drawings in the collection which precede it (plates 803 and 804), are closely related to Popova's *Philosopher* (portrait of the artist's brother Pavel, Russian Museum, Leningrad). On the postcard (plate 806) dated October 11, 1915, Popova cited this portrait.

805

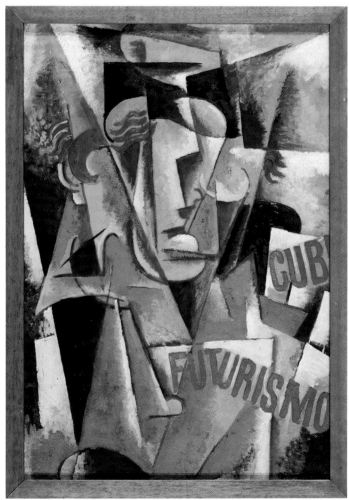

807

806

808 *TRAVELING WOMAN, 1915. Oil on can-vas. 158.5 x 123 (177.78). Not signed or dated.* This work appeared in the ''0.10'' exhibition (no. 92). A second version is in the collection of N. Simon.

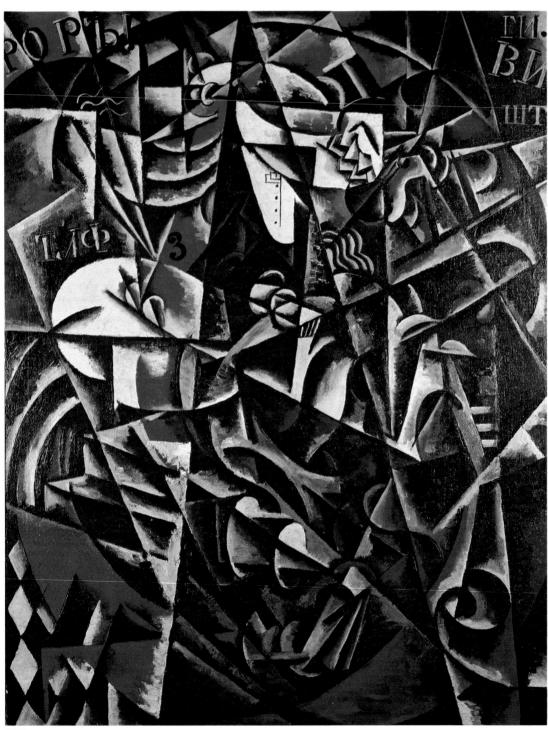

808

809, 810 *A POSTCARD WRITTEN BY POPOVA to Adelaide Robertovna Dege. 13.6 x 8.5 (297.81). Postmarked: 31.3.16. Moscow.* "Christ has risen. My dear Adelaide, greetings my dear. I feel very guilty toward you. I haven't written for such a long long time, but there is so much to do and so many worries. I just cannot find time to write to you in detail about everything. I will soon write you a long letter. I miss you very much my dearest. I would so much love to see you and to share my sadness with you. In a couple of days I might perhaps leave for Turke-stan, to Samarkand. If it will work out, from there I should like to travel to you. I will write to you about all that. Until then be well. I kiss you. Liuba." *Picture on verso labeled in Popova's hand:* "Tray, vase, fruit, L. Popova, 1915." Probably no. 97 in the "0.10" exhibition.

811, 812 *A POSTCARD WRITTEN BY POPOVA to Adelaide Robertovna Dege. 13.7 x 8.6 (299.81). Postmarked: October 17, 1915.* "My dear Adelaide. I received your letter of October 10. Thank you for it. In the next few days I will write you a long and detailed letter; for the moment I want only to send you this photo. I kiss you, also Lissitchka, Aunt Bertha, and your mother.

"Greet all those living in your household and friends. 'Popa' [nickname?] sends you his greetings. Sasha [fem.] also asks me to send you her greetings. She says 'I would have writton myself if I knew how.'" *Picture on verso labeled in Popova's hand:* "'Nature Morte' (plastic painting)."

809

810

811

812

813, 814 *A POSTCARD WRITTEN BY POPOVA to Adelaide Robertovna Dege. 13.7 x 8.7 (298.81). Dated:* "Oct. 19, 1915. Moscow. No. 2. The photographs on these postcards are not good, bad paper. On ordinary [simple] pieces of paper they come out much better, but I'm sending them all the same so that you will have an idea of them. I want to have the large paintings photographed because without a blue filter the 'valeurs' [sic] come out wrong. But these things are mostly black and white. That's why the 'valeurs' are more or less right." *Picture on verso labeled in Popova's hand:* "Portrait (plastic design)." Possibly no. 95 in the "0.10" exhibition.

815, 816 *A POSTCARD WRITTEN BY POPOVA to Adelaide Robertovna Dege. 13.7 x 8.1 (296.81). Dated:* "Moscow June 23, 1916. My dear Adda Robertovna: We just received your card. I kiss you for it. I've been traveling with you in my thoughts through the small Archangelski and onto Galkin Hill. Often, very often, I remember you in the wide horizons of Birsk and the yellow-red slopes. Here everything is as it was. Mother feels a little better now. Tomorrow we move directly to Krasnovodsk. Three aunts and A. T. Soldatova also went traveling on the Volga. I kiss Lissitchka for her p.c. and will soon write her. There are a couple of questions about her commission. Greetings to everyone. The Vesnin brothers are going to build a chapel in our factory yard to commemorate the 100th anniversary of the factory. Liubov." *Picture on verso labeled in Popova's hand:* "Jug on the Table (plastic painting)." This work (no. 96 in the "0.10" exhibition), sometimes attributed to Exter, and often dated to 1916 or even 1917, can, on the basis of this evidence, clearly be identified with the "0.10" catalogue entry.

817 *THE JUG ON THE TABLE (PLASTIC PAINTING), 1915. Oil on cardboard mounted on wood. 58.5 x 45.5 (Tretiakov Gallery TR59).* This work appeared in the December 1915 "0.10" exhibition in Petrograd (no. 96) and also in Popova's posthumous exhibition in 1924 (see installation photographs, plates 941–43). It is one of two or three surviving painted reliefs by Popova.

814

Портретъ.
(Пластическій рисунокъ.)

813

Кувшинъ на столѣ.
(пластическая) живопись.

816

815

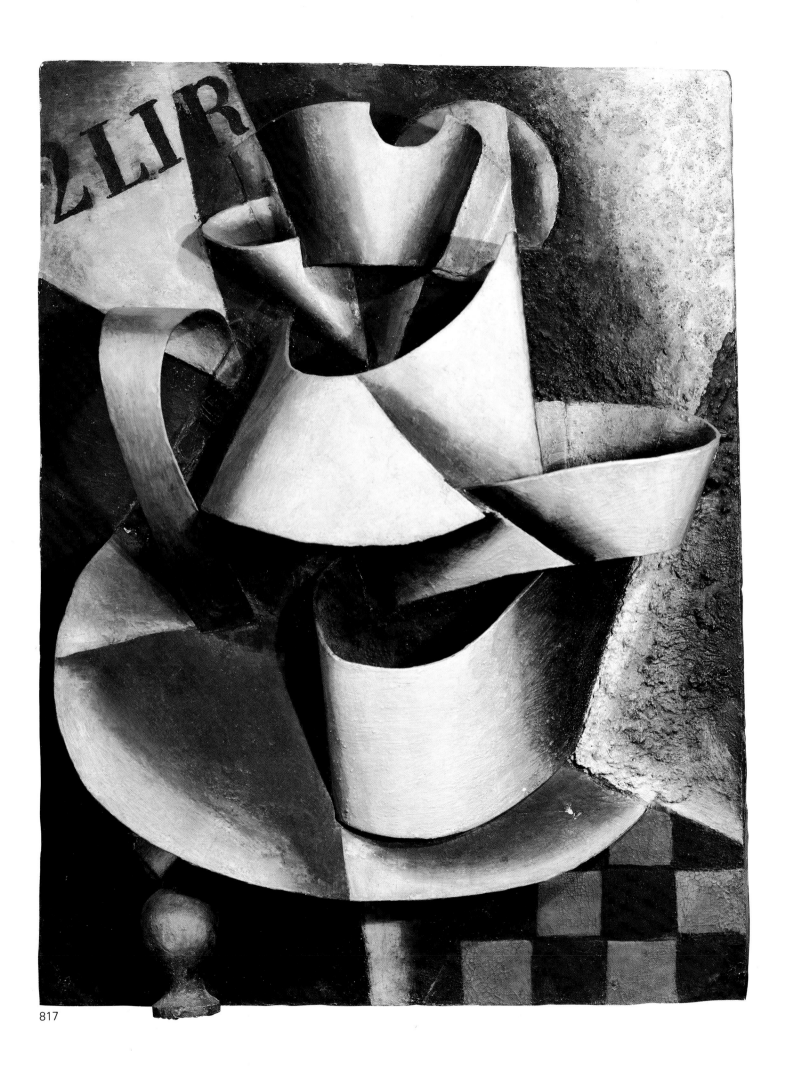

817

818 *LANDSCAPE WITH BUILDINGS, 1914–15.* Pencil on paper. 25.9 x 34.8 (185.78 recto). Dated on reverse: ''Summer 1916.'' This drawing and plate 819 are clearly preparatory studies for the *Landscape* (plate 820) hitherto titled *Head of a Woman.*

819 *LANDSCAPE, 1914–15. Gouache on paper. Dimensions unknown (private collection, Sweden; formerly Costakis collection).*

820 *LANDSCAPE, 1914–15. Oil on canvas. 105.2 x 69.6 (184.78). Not signed or dated.*

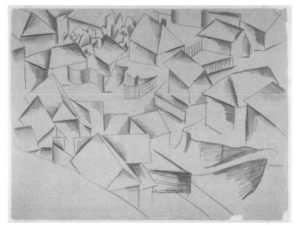

818

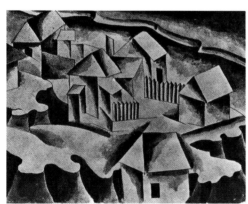

819

820

821 *PAINTERLY ARCHITECTONICS, c. 1917–18. Oil on canvas. 94.1 x 76.3 (sight) (176.78). Not signed or dated. From A. Vesnin to D. Sarabianov; acquired from Sarabianov by Costakis.*

822 *ITALIAN STILL LIFE, c. 1917–18. Oil on canvas. 87.5 x 78 (Tretiakov Gallery TR75).*

821

822

823

823 *COVER DESIGNS FOR THE SOCIETY OF PAINTERS SUPREMUS, 1916–17. Ink on paper. 8.8 x 7.8 (C752).* Costakis owns seven other sheets of sketches for Supremus, some of which carry the date 1916–17. The Supremus group included Popova, Kliun, Davydova, Rozanova, Udaltsova, Exter, and Malevich. They assembled in the studio of Udaltsova during the winter of 1916–17 to plan the publication of a monthly periodical dedicated to literature, music, and art. The first issue was to appear in January 1917, but was never published (A. Nakov, *Kazimir Malevich: Scritti* [Milan, 1977], p. 389).

824 *COVER DESIGN FOR THE BOOK "DELTA" BY S. P. BOBROV, 1917–18. Gouache on paper.*

37.4 x 26.2 (C90). On reverse: stamp of the Federation of Painters. Bobrov's book was apparently not published with this cover, which has also been attributed to Rodchenko.

825 *COVER DESIGNS FOR THE SOCIETY OF PAINTERS SUPREMUS, 1916–17. Ink and pencil on folded paper. Entire sheet: 17.6 x 44.3 (C55).*

826 *PAINTERLY ARCHITECTONICS, 1916–17. Oil on canvas. 43.5 x 43.9 (182.78).*

827 *ARCHITECTONICS, 1916–17. Oil on canvas. 89 x 71 (Tretiakov Gallery TR72).*

824

825

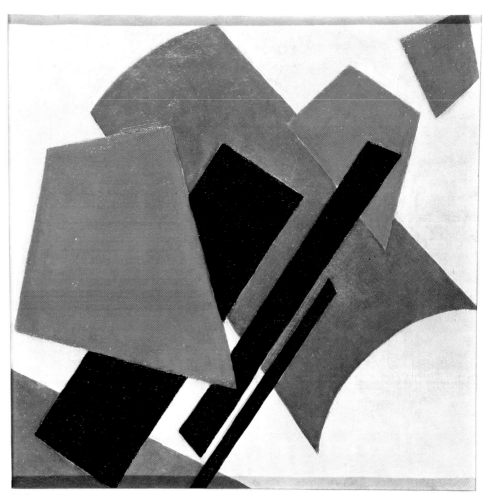

826

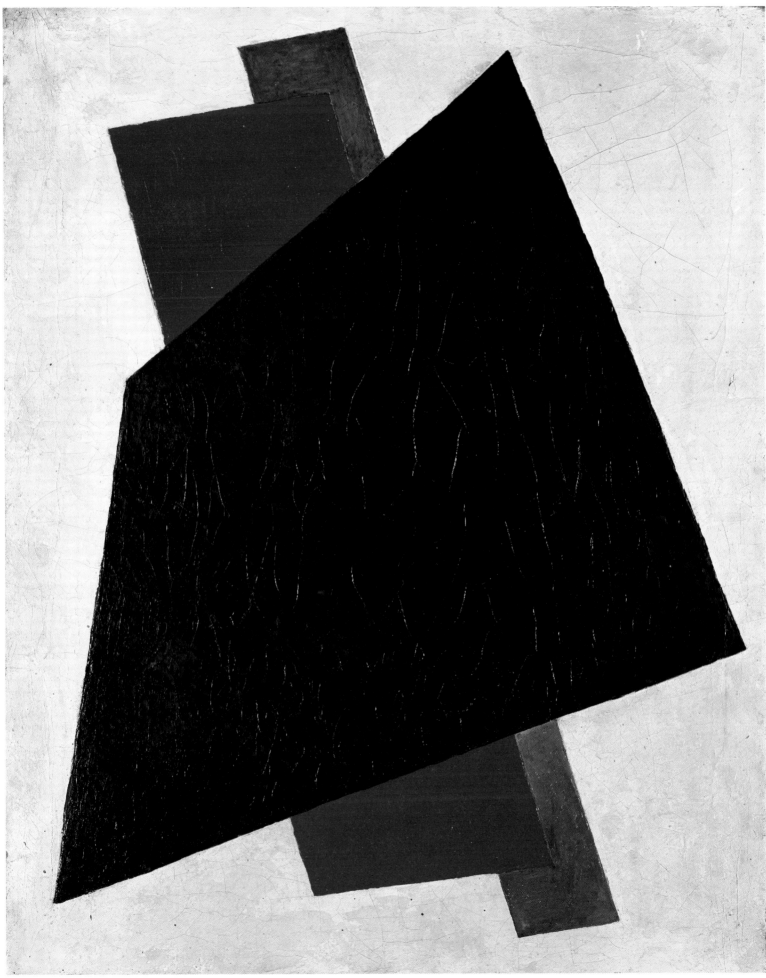

827

828 *DYNAMIC CONSTRUCTION, c. 1917–18.*
Oil on canvas. 159 x 125 (Tretiakov Gallery
TR62a). On reverse of TR62b.

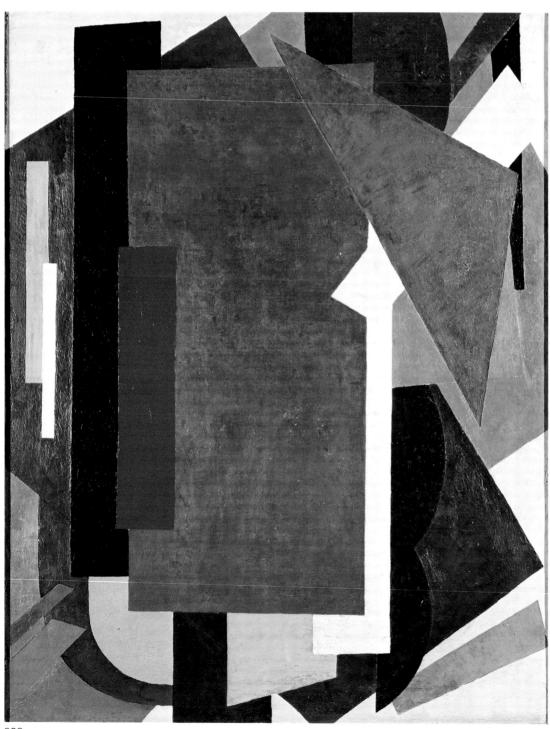

829

829 *UNTITLED, c. 1920. Linocut on paper. 24.4 x 18.1 (C83). Costakis owns several other lino-cuts of this subject, one of which is blue (C82).*

830 *COMPOSITION, c. 1919. Oil on canvas. 159 x 125 (Tretiakov Gallery TR62b). On reverse of TR62a.*

Overleaf: 831 *PAINTERLY ARCHITECTON-ICS, c. 1916–18. Oil on cardboard. 58.5 x 47.5 (Tretiakov Gallery TR65).*

Overleaf: 832 *PAINTERLY ARCHITECTON-ICS, 1918–19. Oil on canvas. 70.8 x 58.1 (178.78). Not signed or dated.*

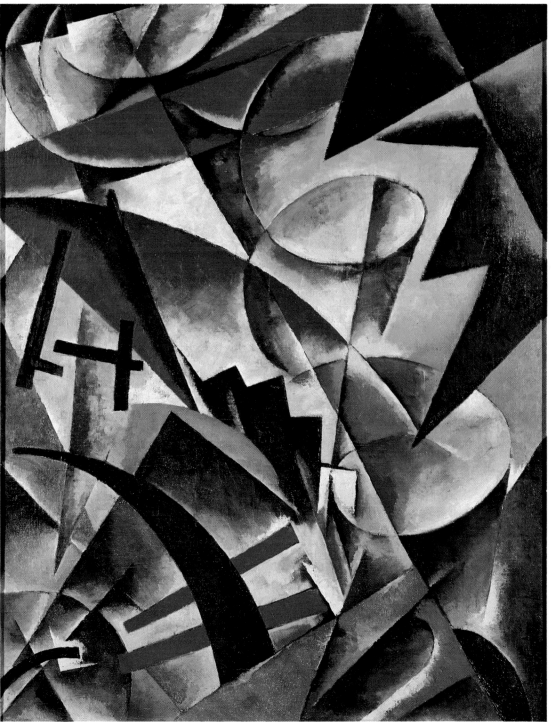

830

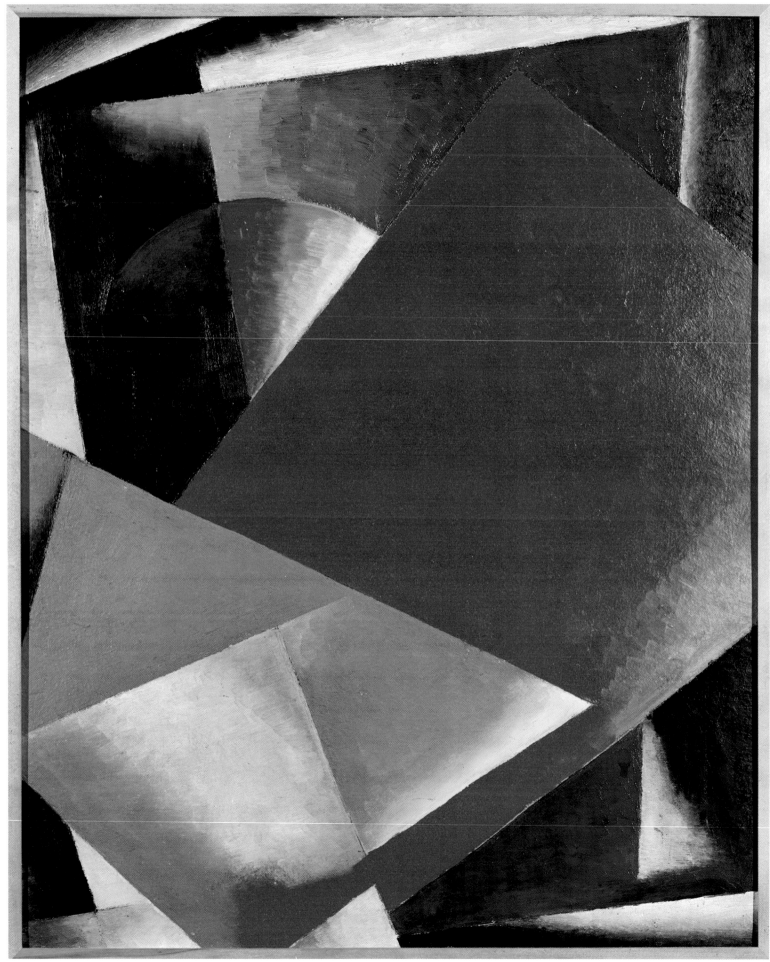

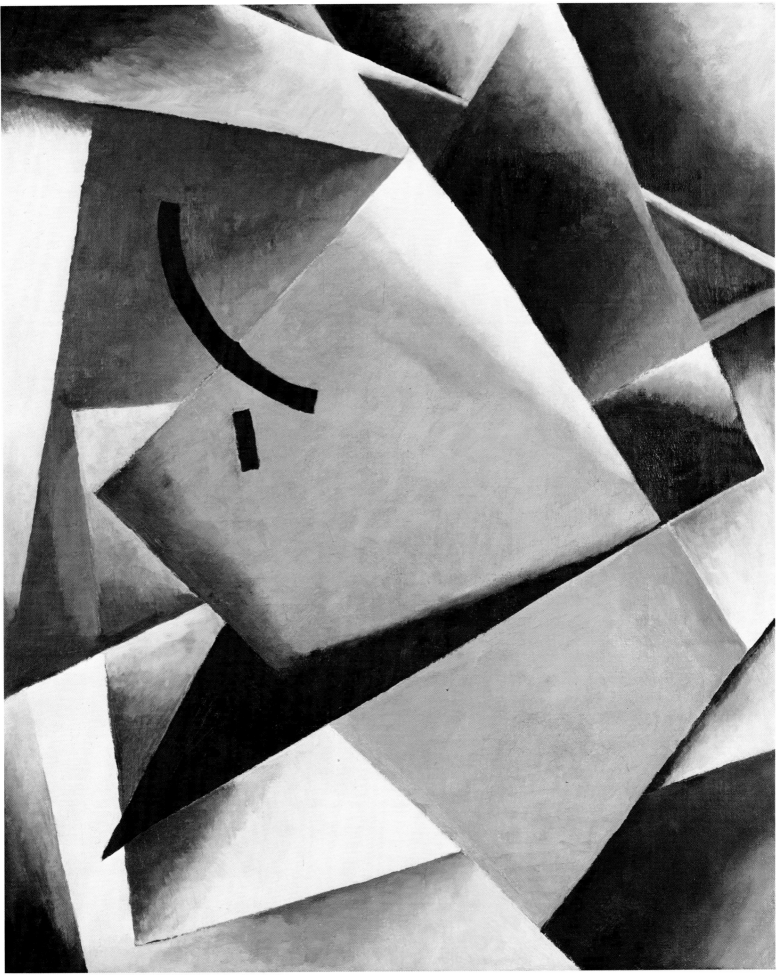

833 *UNTITLED, c. 1917–19. Linocut, ink, and gouache on paper. 35.1 x 26 (190.78).*

834 *COVER DESIGN FOR A SET OF LINO-CUTS, c. 1917–19. Linocut on paper. 41.7 x 29.9 (188.78).*

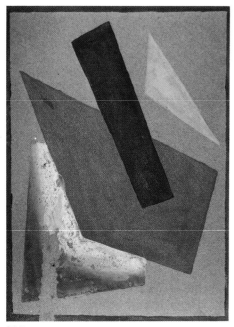

833

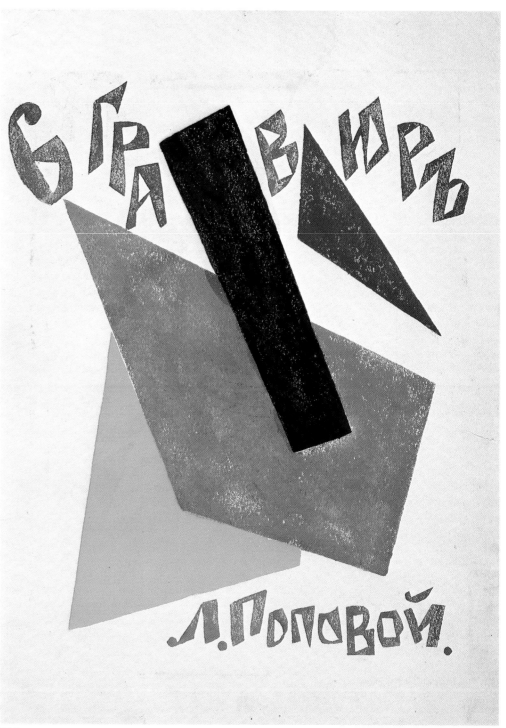

834

835 *COVER DESIGN FOR A SET OF LINO-CUTS, c. 1917–19. Pencil and linocut on paper. 32.6 x 26.1 (201.80 recto).*

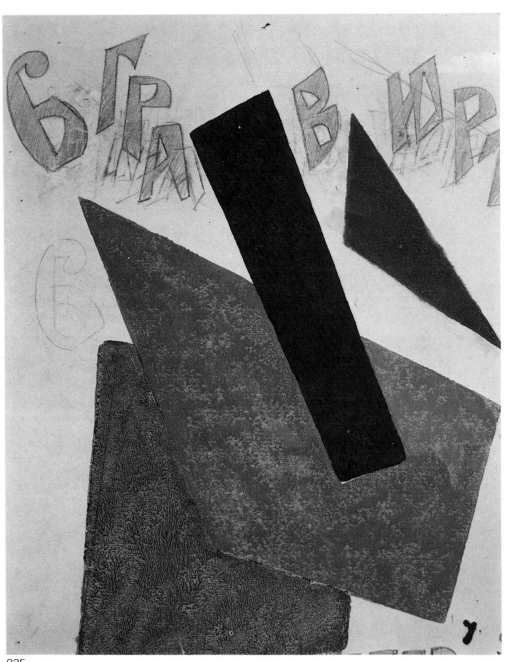

835

836 *UNTITLED, c. 1917–19. Linocut on paper.*
34.5 x 26 (191.78).

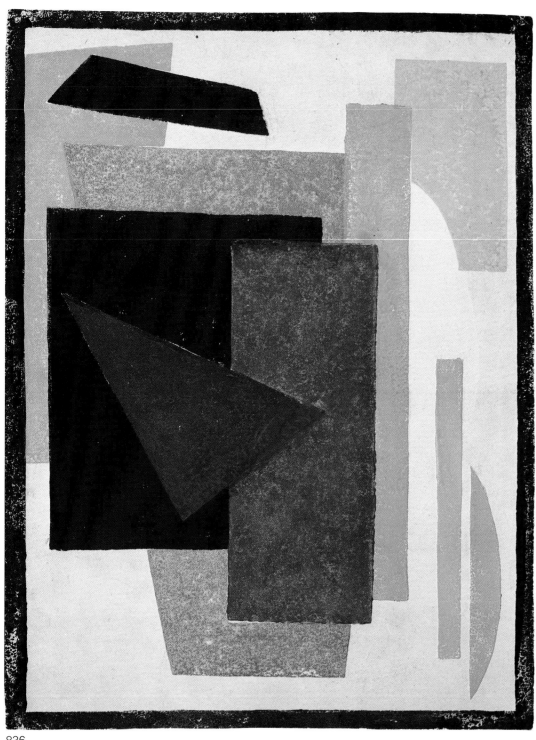

836

837 *UNTITLED, c. 1917–19. Gouache and pencil on paper. 32.9 x 24.3 (187.78).*

838 *UNTITLED, c. 1917–19. Linocut on paper. 35 x 25.5 (194.78).*

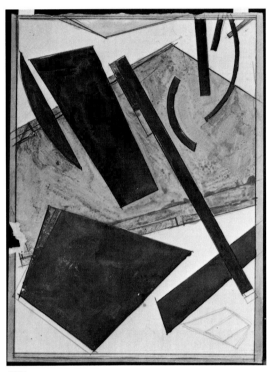

837

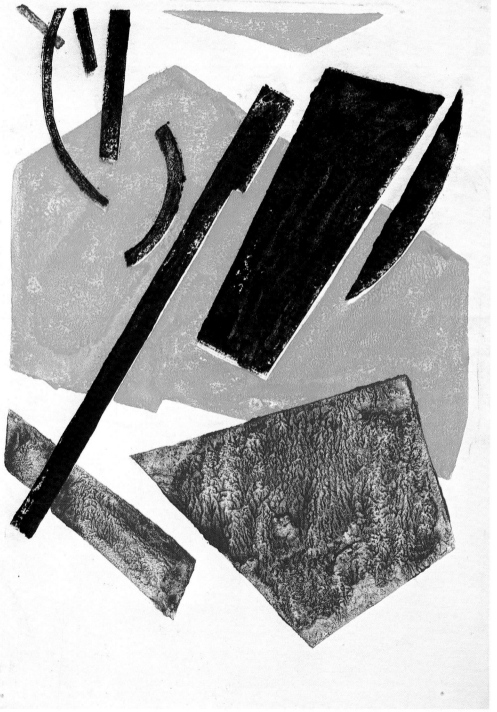

838

839 *UNTITLED, c. 1917–19. Paper collage on paper mounted on paper. 33 x 24.3 (186.78).*

840 *UNTITLED, c. 1917–19. Linocut on paper. 34.4 x 25.9 (193.78).*

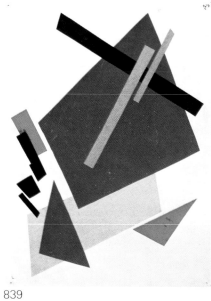

839

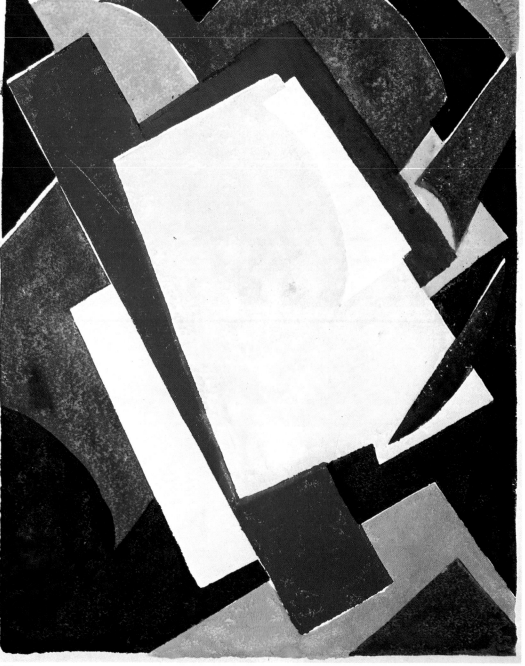

840

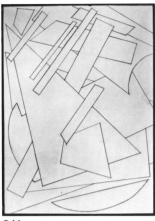

841

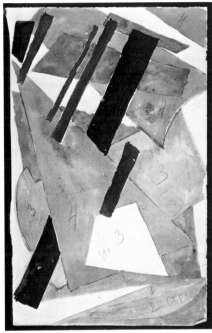

842

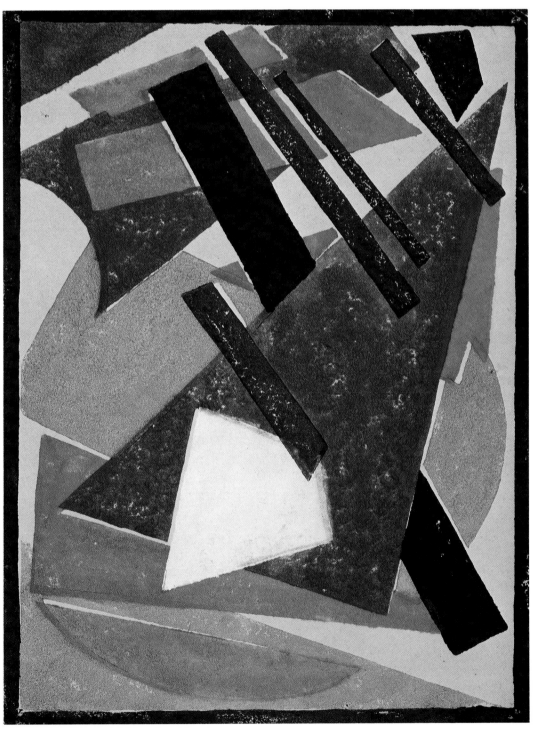

843

841 *UNTITLED, c. 1917–19. Pencil on paper. 33.4 x 24.4 (C72).*

842 *UNTITLED, c. 1917–19. Watercolor, pencil, and ink on paper. 35.3 x 22.2 (202.80).*

843 *UNTITLED, c. 1917–19. Linocut on paper. 34.5 x 25.9 (192.78).*

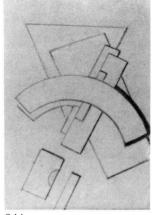

844

844 *UNTITLED, c. 1917–19. Gouache on paper.*
20.5 x 16 (ATH80.8).

845 *UNTITLED, c. 1917–19. Linocut on paper.*
32.9 x 24 (C390).

846 *UNTITLED, c. 1917–19. Pencil on paper.*
33.4 x 24.3 (C71).

847 *UNTITLED, c. 1917–19. Linocut on paper.*
34.1 x 26.1 (189.78).

848 *PAINTERLY ARCHITECTONICS, c.*
1918–19. Oil on canvas. 73.1 x 48.1 (sight)
(180.78).

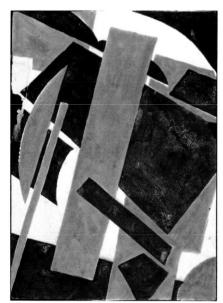

845

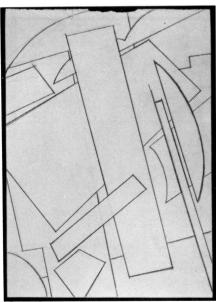

846

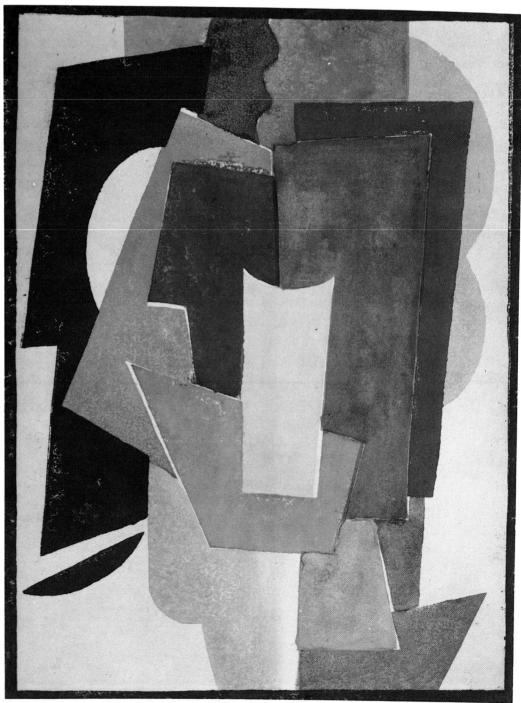

847

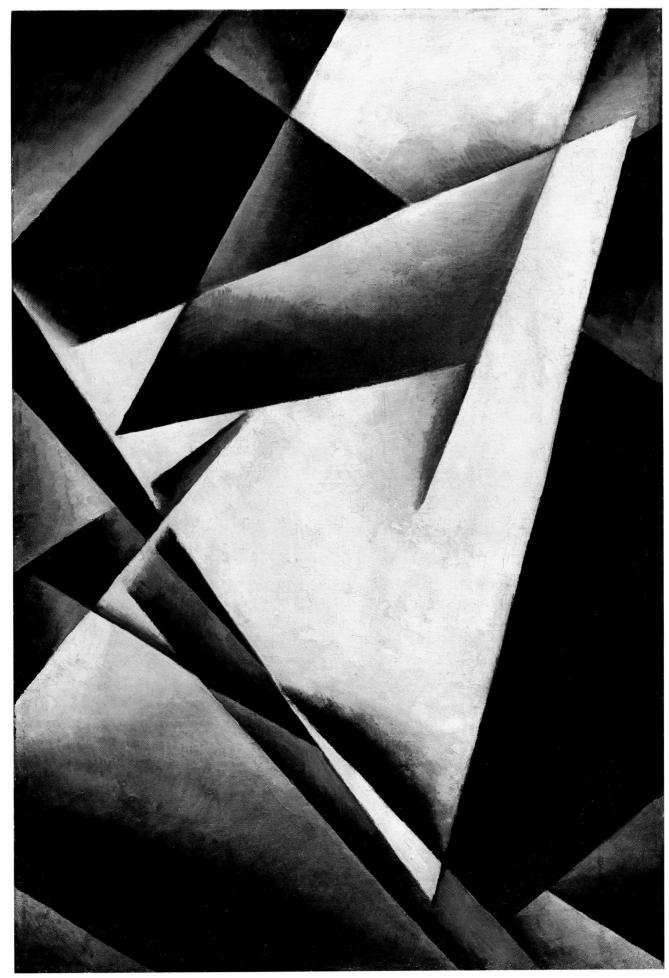

848

849 *SPATIAL FORCE CONSTRUCTION,*
c. 1919–20. Gouache on cardboard. 52 x 39 (Tre-
tiakov Gallery TR67). Signed l r: "L. Popova."

850 *UNTITLED, c. 1919–20. Pencil and water-*
color on paper. 26.7 x 20.5 (189.80). Dated on
reverse in Vesnin's hand: "1921."

851 *UNTITLED, c. 1919–21. Gouache and wa-*
tercolor on paper. 35.1 x 26.5 (195.78). Dated
on reverse in Vesnin's hand: "1921."

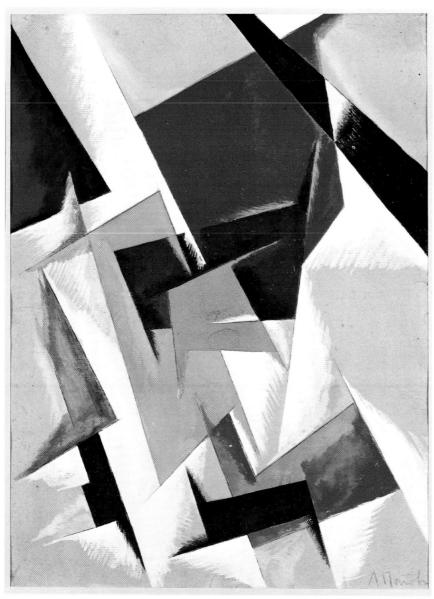

849

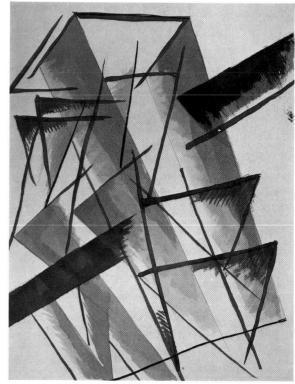

850

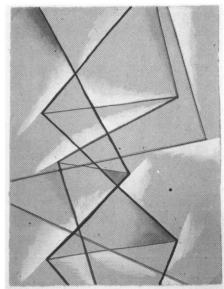

851

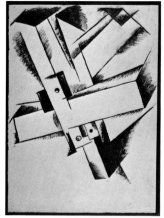

852

852 *UNTITLED, 1921. Pencil and ink on paper. 34 x 25 (191.80). Dated on reverse in Vesnin's hand: "1921."*

853 *SPATIAL FORCE CONSTRUCTION, 1921. Ink on paper. 43.2 x 27.5 (196.78). Dated on reverse: "1921."*

854 *SPATIAL FORCE CONSTRUCTION, c. 1920–21. Oil on plywood. 72 x 63 (Tretiakov Gallery TR71).*

Overleaf: 855 *SPATIAL FORCE CONSTRUCTION, c. 1920–21. Oil on wood. 124 x 82 (Tretiakov Gallery TR64).*

Overleaf: 856 *SPATIAL FORCE CONSTRUCTION, c. 1920–21. Gouache on cardboard. 33.5 x 27 (Tretiakov Gallery TR57).*

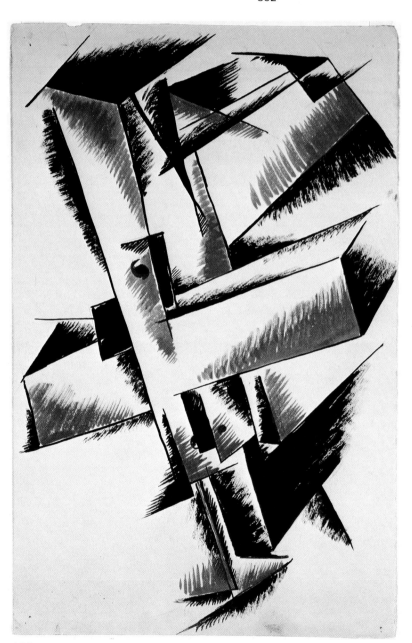

853

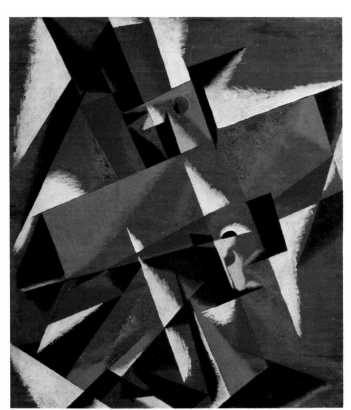

854

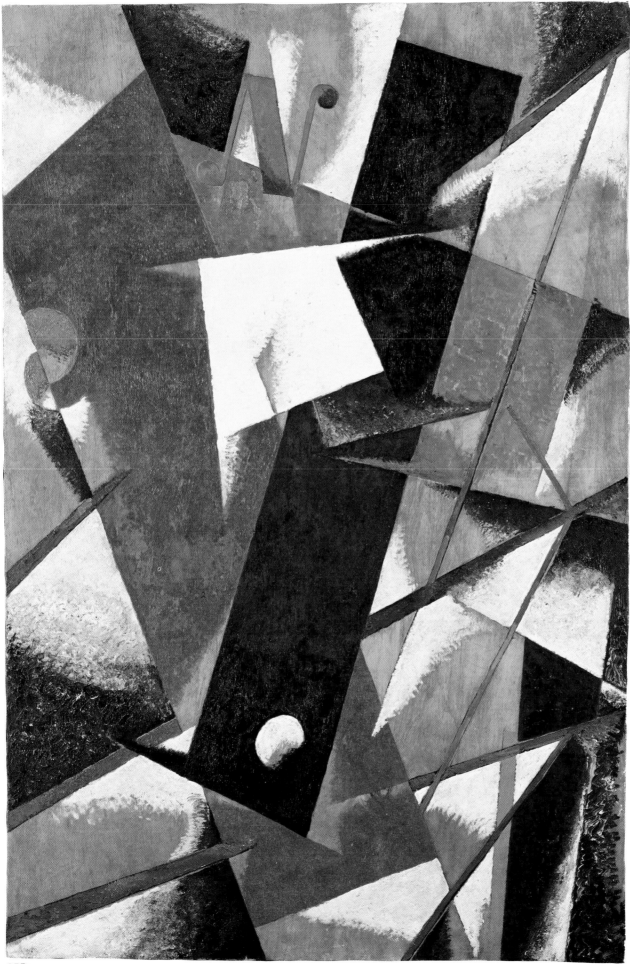

855

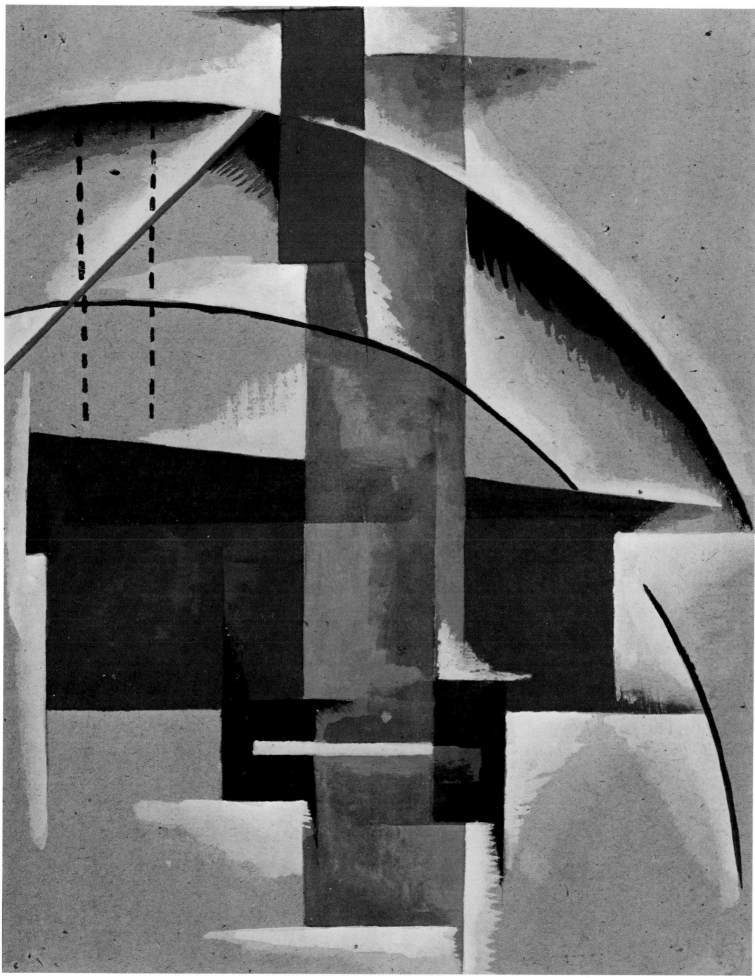

857 ALEXANDR VESNIN AND LIUBOV PO-POVA. *DESIGN FOR THE SET OF THE MASS FESTIVAL "THE STRUGGLE AND VICTORY OF THE SOVIETS," 1921. Ink on paper. 46 x 62 (Tretiakov Gallery TR15).* During the spring of 1921, Meierkhold, Popova, and Vesnin were occupied with preparations for a mass spectacle, to be held in May on Moscow's Khodinsky Field, to celebrate the Third World Congress of the Communist International (Comintern). Though the festival never took place, the plans were ambitious. The drawing shows two dirigibles moored to the ground in the center. From the mooring wires, banners were suspended carrying slogans such as "Third International," "Proletariat Unite," "Long Live the Third C.I.," "Proletarians of All Nations Unite," "Third Comintern." On the left was to be the "Capitalist Fortress," on the right the highly industrialized Communist "City of the Future." Between the two the spectacle was to include 200 riders from the cavalry school, 2,300 foot soldiers, 16 guns, 5 airplanes with searchlights, 10 automobile headlights, several armored trains, tanks, motorcycles, ambulance sections, and detachments of the general recruiting school, the associations for physical culture, and the central direction of military training establishments, as well as various military bands and clubs.

By the time the project was canceled, Popova and Vesnin had produced a number of sketches and maquettes, photographs of which have survived. (See A. Chiniakov, *Bratia Vesniny* [Moscow, 1970], p. 61, and C. A. Lodder, "Constructivist Theatre as a Laboratory for an Architectural Aesthetic," *Architectural Association Quarterly*, 11:2 [1979], pp. 24–35.)

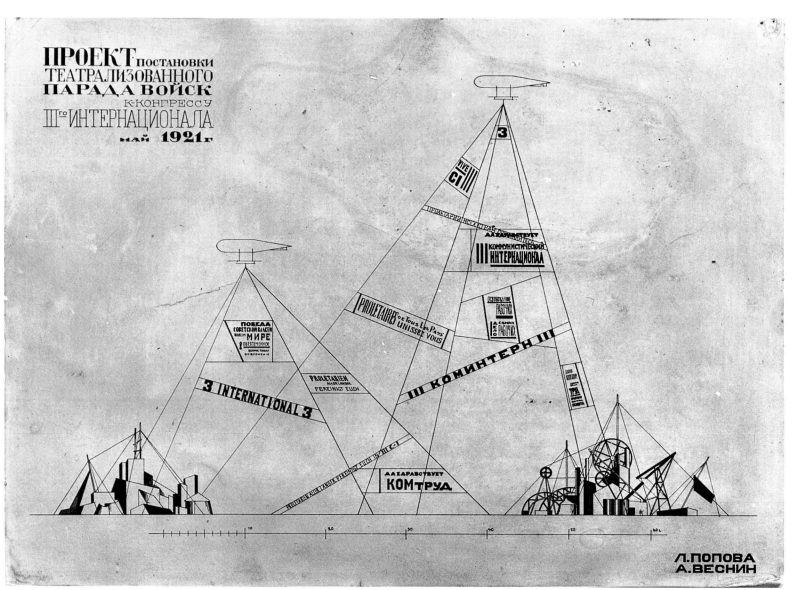

857

858 *PORTRAIT OF ALEXANDR VESNIN(?), c. 1912–13?. Pencil on paper. 26.6 x 20.6 (C77 recto).*

859 *Contemporary photograph of maquette for "Capitalist Fortress," 1921.*

860 *Contemporary photograph of maquette for "City of the Future," 1921.*

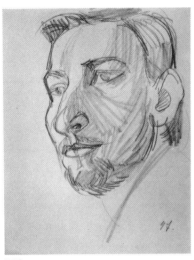

858

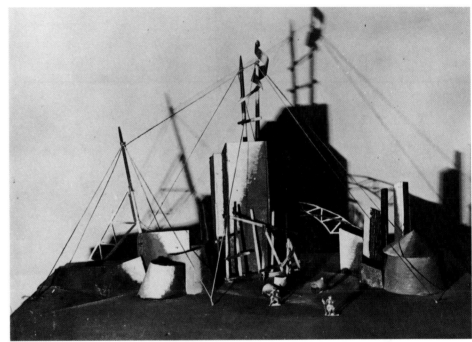

859

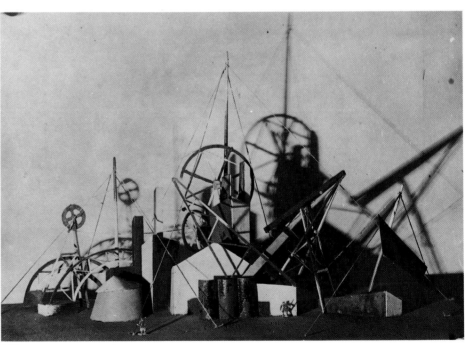

860

861 *PORTRAIT OF NIKOLAI ASEEV(?), n.d. Pencil on paper. 26.7 x 20.7 (C569 verso).*

862 *COVER DESIGN FOR A BOOK OF POEMS, "K NOVYM BEREGAM" (TO NEW SHORES) BY NIKOLAI ASEEV, c. 1920–21. Gouache, ink, and pencil on paper. 15.5 x 22 (C36).* Costakis owns three other designs for the cover of this book of poems, which was apparently not published according to Popova's design. Aseev, a leading Futurist poet, was a close friend of Popova.

863 *DESIGN FOR BOOK COVER FOR "BOMBA" (THE BOMB) BY NIKOLAI ASEEV, 1921. Collage, gouache, and ink on paper. 16.6 x 12 (C50).* Aseev's book, which constituted his endorsement of the Communist Revolution and was published in Vladivostok in 1921, was probably never published with Popova's cover.

862

861

863

864 *DESIGN FOR A BANNER FOR THE VSP, c. 1921. Wash and wax crayon on paper. 16.9 x 95.6 (C52).*

865 *DESIGN FOR A BANNER FOR THE VSP, c. 1921. Colored pencil and wax crayon on paper. 14.9 x 74.7 (C53).* The All-Russian Union of Poets Club (VSP) was located at 18 Tverskoi Boulevard, Moscow. It was organized by 1921, and apparently remained in existence until about 1927. Members included Ivan Ak-senov (its chairman), Andrei Bely, Riurik Ivnev, Anatolii Mariengof, Mikhail Kuzmin, and Georgii Chulkov. Popova's banners were hung over the entrance to the building. At least two other designs for these banners have survived *(The Avant-Garde in Russia, 1910–1930* [Los Angeles County Museum of Art, 1980], no. 252 and 253). An article by Aksenov published in 1926 describes the role of the VSP in sponsoring the exhibition "5 x 5 = 25" in the fall of 1921 ("Spatial Constructivism on Stage," *Teatralnyi Oktiabr* [Leningrad and Moscow, 1926], pp. 31ff.).

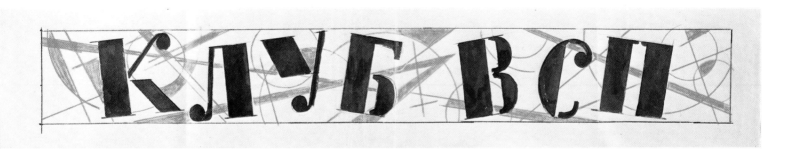

864

865

866 *SPATIAL FORCE CONSTRUCTION, 1921.*
Gouache on paper. 33.5 x 27 (Tretiakov Gallery
TR63).

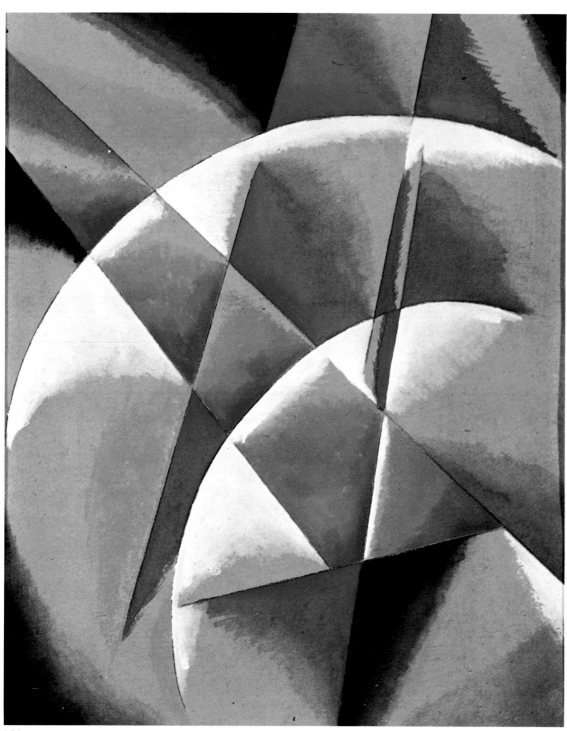

866

867 *UNTITLED, 1920–21. Crayon on paper. 24.9 x 20.8 (C65). Inscribed and dated on reverse: "L. Popova, graphic drawing: 1921." Acquired from the family of N. Tarabukin, who had received it as a gift from Popova.*

868 *SPATIAL FORCE CONSTRUCTION, 1920–21. Watercolor on paper. 46 x 40 (Tretiakov Gallery TR74).*

867

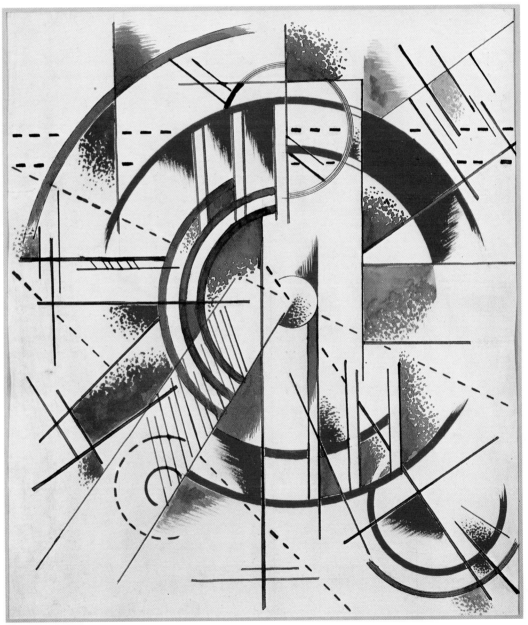

868

869 *UNTITLED, 1920–21. Crayon on paper. 27.5 x 20.6 (C73).* Sketch for a painting formerly in the Costakis collection, now in the Tretiakov Gallery, Moscow (no photograph available). A closely related drawing in a private collection (colored pencil on paper, 27.5 x 20.5, dated on reverse 1922) was reproduced in *Russian Women Artists of the Avant-Garde, 1910–1930* (Cologne: Galerie Gmurzynska, 1979), p. 194, no. 71.

870 *SPATIAL FORCE CONSTRUCTION, 1920–21. Colored pencil on paper. 35.5 x 21.5 (ATH 80.9).*

869

870

871 *SPATIAL FORCE CONSTRUCTION, 1920–
21. Oil with marble dust on wood. 112.6 x
112.7 (175.78). Dated on reverse: "1921."*

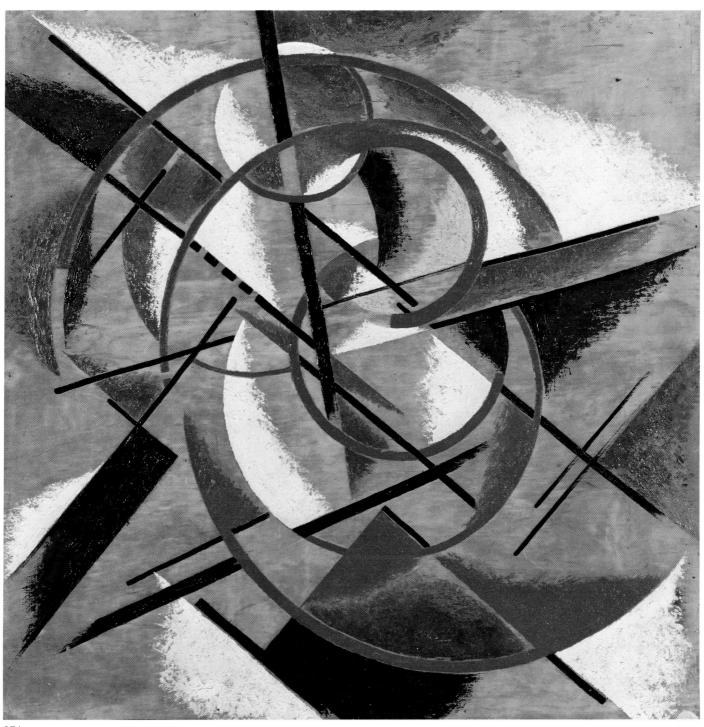

871

872 *SPATIAL FORCE CONSTRUCTION, 1920–
21. Oil on plywood. 83.5 x 64.5 (Tretiakov Gal-
lery TR60).*

873 *LINEAR CONSTRUCTION, 1920–21. Oil
on plywood. 64 x 60 (Tretiakov Gallery TR73).*

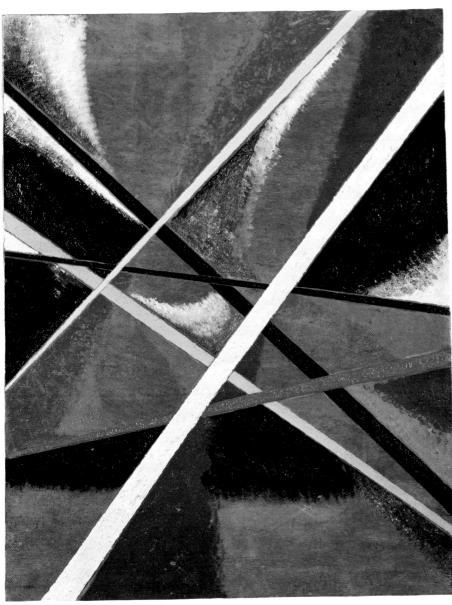

872

873

874 *SPATIAL FORCE CONSTRUCTION, 1921. Oil with marble dust on plywood. 71 x 63.9 (179.78). Dated on reverse: "1921."*

875 *VERN 34, c. 1921. Watercolor and gouache on paper. 35 x 27.5 (197.78).*

876 *UNTITLED, 1921. Ink on paper. 34 x 25.7 (188.80). Dated on reverse in Vesnin's hand: "1921."*

875

874

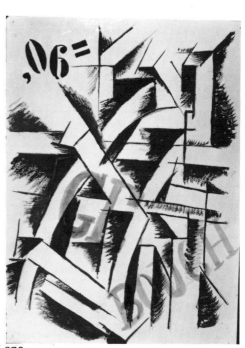
876

877 *SKETCH FOR STAGE SET, c. 1921.* Gouache on paper. 26.5 x 35.5 (C91). Not signed or dated. Gift of D. Sarabianov to Costakis. Closely related to some of Popova's designs for the 1921 Tairov production of *Romeo and Juliet* (which were ultimately not used), this sketch was for Anatolii Lunacharsky's play *The Locksmith and the Chancellor*, performed at the Korsh Theater, Moscow, in 1921.

878 ARTIST UNKNOWN. *STAGE SET FOR PRODUCTION OF "SALOMÉ" BY OSCAR WILDE, 1922.* Watercolor on paper. 22.5 x 17.7 (C717). Inscribed l l: "Construction for a stage platform for Salomé of Wilde/ . . . [illegible] 922."

879 ARTIST UNKNOWN. *COSTUME DESIGNS (?),* late 1920s. Ink and watercolor on board. 24.2 x 21.1 (C642).

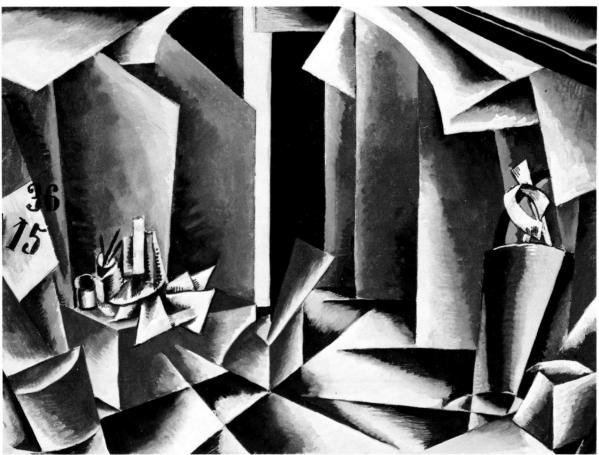

877

878

879

880

In September 1921, Vsevolod Meierkhold found himself in need of a portable stage set that could be erected anywhere. That same year, after his appointment as head of the new State Higher Theater Workshop in Moscow, he also began to develop a system of Biomechanics based mainly on Taylorism, though also on the traditional circus.

In January 1922 Meierkhold began work on his first production in which Biomechanics and the portable stage set could be demonstrated. For this purpose he chose Fernand Crommelynck's tragifarce *Velikodushnyi rogonosets (The Magnanimous Cuckold)*, translated by Ivan Aksenov. Meierkhold found the solution for the set in the work of the Constructivists, particularly that of the Stenberg brothers, Medunetsky, and Popova. After some discussion with the others, he invited Popova to join the staff of the Theater Workshop. Though the sets for the production were already far advanced before she became involved, she did supervise the final resolution of a number of central issues of the design.

The set construction consisted of two mountings of unequal height with stairs leading to a platform on top of each. There were also a slide and revolving doors. Three wheels, one a large black disk bearing the letters CR-ML-NK and the others white and red, rotated clockwise or counterclockwise at erratic speeds, underscoring the "kinetic meaning of each moment in the action" (L. Popova, quoted by A. Law, *"Le Cocu magnifique* de Crommelynck," *Les Voies de la création théâtrale* [Paris, 1979]). The supporting framework was blackened with shoe polish, the ladders and stairway reddened with rouge, paint being in short supply. The rest of the set was of unpainted wood. The versatile set could allude to a windmill's interior, a bedroom, a balcony, or a chute for sacks of flour. The characters wore a loose-fitting blue work uniform *(prozodezhda)*, with each differentiated from the others only by a minor distinguishing mark, such as a red pompon, a monocle, or a riding crop.

Popova's set proved to be totally revolutionary and fostered a wave of Constructivist work in the theater. As E. Rakitina has written: "We will never understand [the set] correctly if we regard it statically. It is not a picture to be admired. Rather, it is a kind of machine which takes on a living existence in the course of the production." (For a full discussion of the set and the production see Law, loc. cit.)

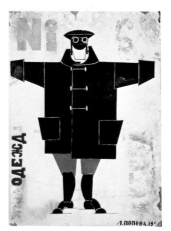

881 *COSTUME DESIGN FOR "THE MAGNAN-
IMOUS CUCKOLD," 1922. Gouache, ink, and
paper collage on paper. 32.7 x 23.8 (203.78).*
Some of the collage lettering has been lost.
Original title: *Prozodezhda aktera No. 6* (Work
Uniform for an Actor No. 6). This costume has
been identified by A. Law as that of the Bur-
ghermaster.

882 *SET DESIGN FOR "THE MAGNANIMOUS
CUCKOLD," 1922. Gouache on paper. 50 x 69*
(Tretiakov Gallery TR66).

881

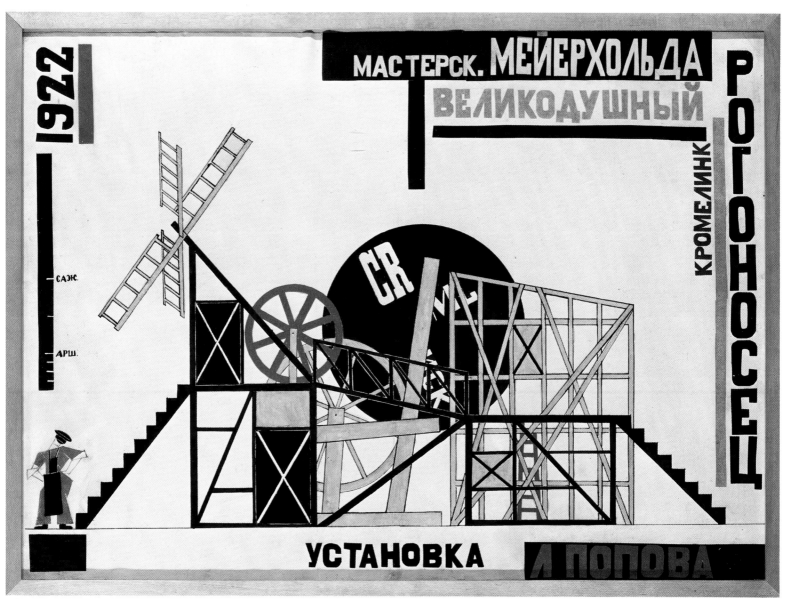

882

883 *UNTITLED, 1922. Ink and pencil on paper. 32.5 x 43 (199.78). Inscribed on reverse, not in the artist's hand: "Cage for the production 'Magnanimous Cuckold.'" This and plates 884 and 886 are drawings for the "cage," which formed the lower part of the right mounting of the set.*

884 *UNTITLED, c. 1922. Black crayon on paper. 20.4 x 25.3 (200.78).*

885 *UNTITLED, c. 1922. Colored pencil on paper. 37 x 23 (198.78).*

886 *UNTITLED, 1922. Crayon and pencil on paper. 20 x 25.7 (201.78).*

883

885

884

886

On March 4, 1923, the fifth anniversary of the founding of the Red Army, Meierkhold staged *Zemlia dybom* (Earth in Turmoil), an adaptation by Sergei Tretiakov of Martinet's verse drama *La Nuit*, which tells of an abortive mutiny during a hypothetical imperialist war.

The production was designed by Popova and was dedicated to the Red Army and its commander, Trotsky. Originally published in 1921, the play was completely rewritten as a propaganda play. The five acts were divided into two parts with eight episodes: Down with War; Attention; Truth in the Trenches; The Black International; All Power to the Soviets; The Revolution Betrayed; Shearing the Sheep; Night. Tretiakov tried to make the dialogue as laconic as agit-placards, and he trained the actors in an aggressive style of declamation. In order to strengthen the agit-source of the production, slogans (both from the Proletarian Revolution and from the Soviet construction industry) were flashed on a screen. The Costakis collection includes the design for part of Popova's stage set, titles for two of the eight episodes, and several of the slogans that were flashed on the screen during the performance.

The stage set for the performance, conceived in the spirit of a mass spectacle, was used on a number of occasions outdoors. Compared to that for *The Magnanimous Cuckold*, the set for *Earth in Turmoil* was simpler, employing real objects instead of props—cars, trucks, motorcycles, machine guns—against the background of a construction simulating a gantry crane. Military searchlights illuminated the performers, who acted without makeup in their street clothes or in military uniforms.

887 *Documentary photograph of Popova's set design for "Zemlia dybom."*
888 *POLITICAL SLOGAN FOR "ZEMLIA DYBOM," 1923. Gouache, ink, and paper collage on paper. 18 x 22 (207.78). Text: "Long live the union of workers and peasants!"*

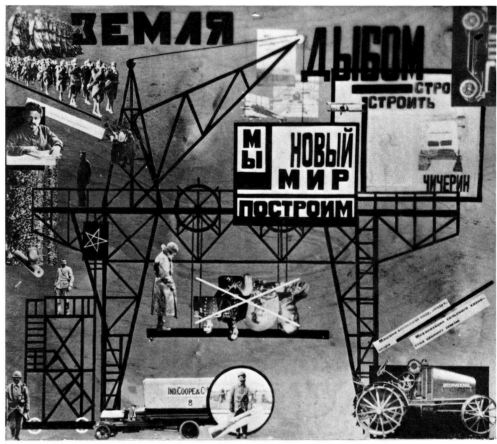

887

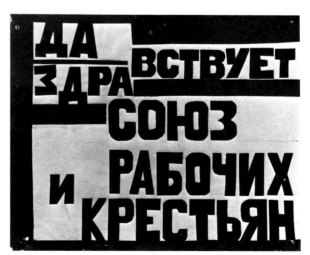

888

889 *PART OF THE DESIGN FOR THE STAGE SET FOR "ZEMLIA DYBOM," 1923. Photomontage, gouache, newspaper, and photographic paper collage on plywood. 49 x 82.7 (204.78). A contemporary photograph (plate 887) records the original appearance of Popova's design. The slogans "Earth in turmoil" and "We will build a new world" are combined on this backdrop with pictures of Tsar Nikolai II and his generals shown upside down and symbolically deleted from society.*

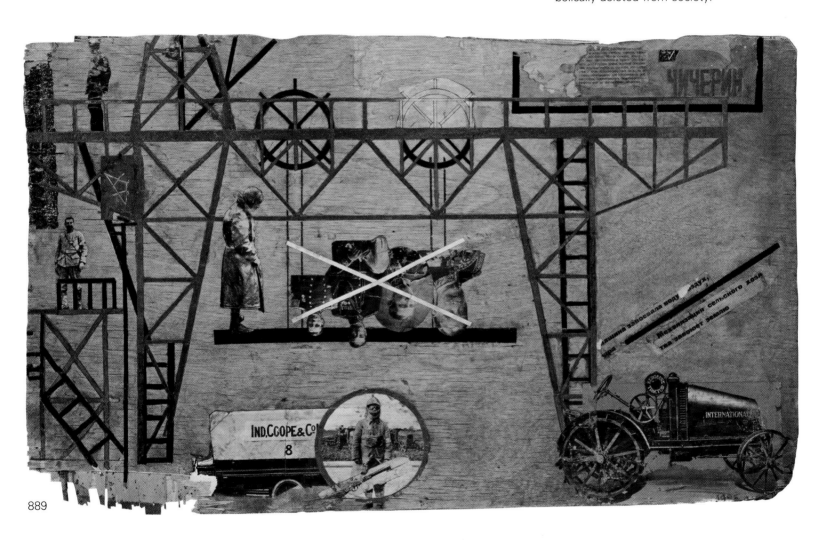

889

890 *POLITICAL SLOGAN FOR "ZEMLIA DYBOM,"* 1923. Gouache, ink, and paper collage on paper. 21.5 x 30 (206.78). Text: "The machine has conquered. Water. Air. Bowels of the earth. Mechanization of agriculture will conquer the earth."

891 *POLITICAL SLOGAN FOR "ZEMLIA DYBOM,"* 1923. Gouache, ink, and paper collage on paper. 18 x 22 (208.78). Text: "Strengthen the bond of rulers and masses."

892 *POLITICAL SLOGAN FOR "ZEMLIA DYBOM,"* 1923. Gouache, ink, and paper collage on paper. 21.6 x 27.7 (205.78). Text: "Youth to replace the oldest. Long live Komsomol!"

893 *POLITICAL SLOGAN FOR "ZEMLIA DYBOM,"* 1923. Gouache, ink, and paper collage on paper. 17.9 x 22.9 (209.78). Text: "Soldiers to the trenches—workers to the factories."

890

892

891

893

894 *POLITICAL SLOGAN FOR "ZEMLIA DYBOM,"* 1923. *Ink and paper collage on paper. 18 x 22.7 (210.78). Text:* "Forward to Communism."

895 *POLITICAL SLOGAN FOR "ZEMLIA DYBOM,"* 1923. *Ink and paper collage on paper. 17.6 x 23 (211.78). Text:* "Do not extinguish the will to victory."

896 *POLITICAL SLOGAN FOR "ZEMLIA DYBOM,"* 1923. *Ink and paper collage on paper.* 17.8 x 22.6 (212.78). *Text:* "He who does not work does not eat."

897 *POLITICAL SLOGAN FOR "ZEMLIA DYBOM,"* 1923. *Ink and paper collage on paper. 18.2 x 24.1 (213.78). Text:* "Education is the sword of the Revolution."

898 *POLITICAL SLOGAN FOR "ZEMLIA DYBOM,"* 1923. *Ink and paper collage on paper. 17.5 x 22.2 (214.78). Text:* "Take care of our leaders."

894

896

895

897

898

899

900

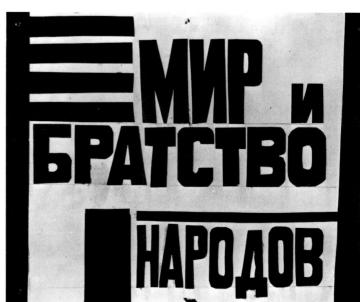

902

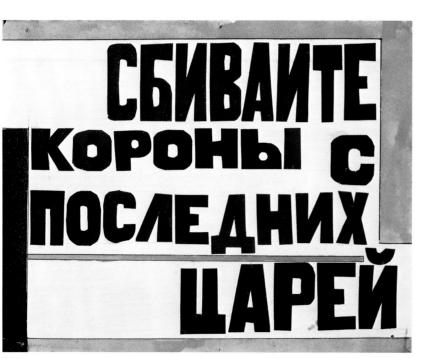

901

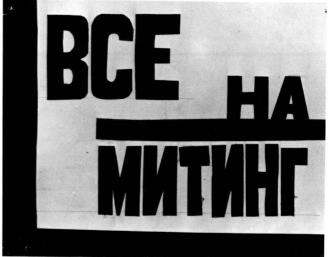

903

899 *POLITICAL SLOGAN FOR "ZEMLIA DYBOM," 1923. Gouache, ink, and paper collage on paper. 17.8 x 24.8 (217.78). Text: "The fight against counterrevolutionary speculation and sabotage."*

900 *POLITICAL SLOGAN FOR "ZEMLIA DYBOM," 1923. Gouache, ink, and paper collage on paper. 18 x 23 (218.78). Text: "Keep up the revolutionary pace."*

901 *POLITICAL SLOGAN FOR "ZEMLIA DYBOM," 1923. Gouache, ink, and paper collage on paper. 18 x 25 (219.78). Text: "Knock off the crowns of the last tsars."*

902 *POLITICAL SLOGAN FOR "ZEMLIA DYBOM," 1923. Ink and paper collage on paper. 17.8 x 22.3 (215.78). Text: "Peace and brotherhood of the people."*

903 *POLITICAL SLOGAN FOR "ZEMLIA DYBOM," 1923. Ink and paper collage on paper. 17.8 x 23 (216.78). Text: "All come to the mass meeting."*

904 *SCENE TITLE FOR THE EIGHTH EPISODE OF "ZEMLIA DYBOM," 1923. Ink and paper collage on paper. 20.9 x 25.8 (222.78). Text: "Eighth Episode: Night."*

905 *POLITICAL SLOGAN FOR "ZEMLIA DYBOM," 1923. Ink and paper collage on paper. 20.7 x 25.5 (221.78). Text: "Freedom Equality and Fraternity."*

906 *SCENE TITLE FOR THE SEVENTH EPISODE OF "ZEMLIA DYBOM," 1923. Gouache, ink, and paper collage on paper. 21.6 x 27.7 (220.78). Text: "Seventh Episode: Shearing the Sheep."*

904

905

906

907 *TEXTILE DESIGN, c. 1923–24. Ink on paper. 19.6 x 14.1 (C44).*

908 *TEXTILE DESIGN, c. 1923–24. Gouache on paper. 32 x 32.5 (Tretiakov Gallery TR16).*

909 *TEXTILE DESIGN, c. 1923–24. Watercolor and ink on paper. 17 x 13.7 (C377).*

Popova and Stepanova probably began to work for the First State Textile Print Factory in Moscow (formerly Emil Tsindel's factory) very early in 1924. Both artists felt strongly that textile design must be justified by linking it to the principles of dress design, the needs of the consumer, the uses to which the fabric would be put after it left the factory, and its adaptability to function. They formulated a theory and methodology linking the two design processes, rejecting purely aesthetic considerations, and emphasizing the functional, while clearly maintaining an interest in the striking nature of their articulated, highly colored geometric forms.

(On the subject of textile and clothing design in the 1920s see T. Strizhenova, *Iz istorii sovetskogo kostiuma* [From the History of Soviet Costume], [Moscow, 1972; London, 1977]; J. Bowlt, "From Pictures to Textile Prints," *The Print Collector's Newsletter*, 1 [1976], pp. 16–20; and C. A. Lodder, *Constructivism: From Fine Art into Design, Russia 1913–1933*, Yale University Press, 1982.)

907

909

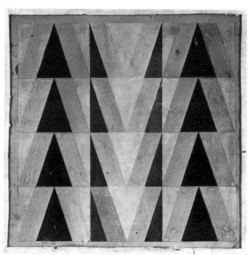

908

910 *TEXTILE DESIGN, c. 1923–24. Gouache and ink on paper. 23.5 x 14.2 (C46).*

The dress-design field throughout the 1920s continued to attract many artists, some of whom, such as Rodchenko, had belonged to the Constructivist group. Others, such as Grigorii Miller, were primarily industrial designers, and others, such as N. Lamanova, V. Mukhina, and Y. Pribylskaia, actually had been trained as fashion designers. Clothing was designed for factory workers, pilots, athletes, the mass public, and together with emphasis on functional practicality, the ornamentation was often Suprematist in inspiration.

911 GRIGORII MILLER. *COSTUME FOR A PILOT, 1923. Ink and gouache on paper. 24 x 9.6 (819.79). Inscribed and dated on reverse:* "Costume for a pilot. 1923." Miller, born in 1900, died in 1958, studied at the Painting Department of Vkhutemas, and worked with Lissitzky on the U.S.S.R.'s pavilion at "Pressa" (the International Press Exhibition) in Cologne in 1928. He spent most of his professional career in industrial design, though he was also a painter and sculptor.

912 ARTIST UNKNOWN. *DESIGN FOR SUPREMATIST DRESS, late 1920s. Gouache, watercolor, and pencil on paper. 24.6 x 8.5 (C698). Not signed or dated. Inscribed on mount:* "K. Malevich." The design, which may be based upon a specific motif by Malevich, Suetin, or Chashnik, has not been securely identified. It is possibly the work of O. Anisimova, a dress designer of the late 1920s, or of Nadezhda Petrovna Lamanova (1861–1941), who was a celebrated couturier in pre-Revolutionary Moscow and later adapted her talents to the production of clothing on a mass scale. From 1918 to 1925 she was in charge of the Studio of Contemporary Costume under the IZO Section of Glavnauka. (For examples of the work of both designers see T. Strizhenova, *Iz istorii sovetskogo kostiuma.*)

913 ARTIST UNKNOWN. *DRESS DESIGN, late 1920s. Gouache and gold paper collage on paper. 31 x 23 (C697). Not signed or dated.*

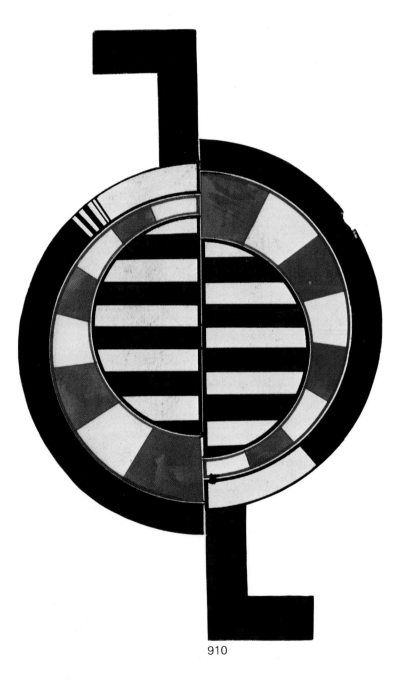

910

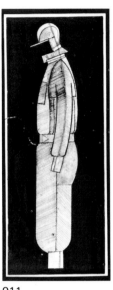

911

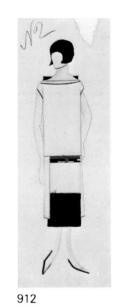

912

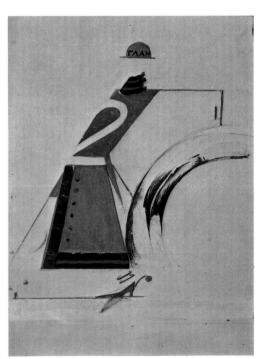

913

914 *TEXTILE DESIGN, c. 1923–24. Gouache and pencil on paper. 28 x 35 (223.78).*

915 *TEXTILE DESIGN, c. 1923–24. Gouache and ink on paper. 13.6 x 5.1 (240.80).*

916 *TEXTILE DESIGN, c. 1923–24. Gouache on paper. 15.9 x 6.9 (241.80 recto). Gouache design on reverse (not reproduced).*

917 *TEXTILE DESIGN, c. 1923–24. Gouache on paper. 16 x 31.6 (C47).*

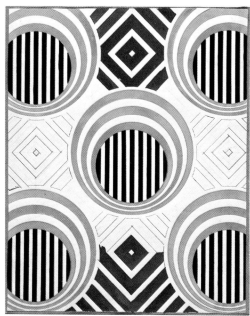

914

915

916

917

918 *DESIGN FOR EMBROIDERED BOOK COVER, c. 1923–24. Colored inks on paper. 17.3 x 4.8 (C84).*

919 *EMBROIDERED BOOK COVER, c. 1923–24. Silk thread on grosgrain. 45.3 x 31.5 (C164).*

918

919

MAQUETTE FOR "EIFFELAIA" BY I. A. AK-SENOV, 1922. *Black and red inks, typescript, and pencil on thin paper. 10 pp., 28 x 22.2 (305.80). Popova's design for Aksenov's book of poems was never published. The thirty odes to the Eiffel Tower were written between 1916 and 1918, and were to be published in Moscow in 1922. Popova's incomplete maquette includes the title page, several pages of notes regarding type sizes and faces, some partially mapped pages, and the second and thirteenth poems fully designed in black and red.*

920 *LAYOUT FOR POEM THIRTEEN OF AK-SENOV'S "EIFFELAIA." Black and red ink, with collaged typed text.*

921 *LAYOUT FOR POEM TWO OF AKSENOV'S "EIFFELAIA." Black and three different red inks.*

922 *PRINTED COVER OF MUSICAL SCORE "VALSE" BY E. PAVLOV, Moscow, 1922. 34.2 x 24.7 (306.80).*

923 *PRINTED COVER OF MUSICAL SCORE "SCHERZO" BY E. PAVLOV, Moscow, 1922. 34.6 x 26.2 (309.80).*

924 *PRINTED COVER OF MUSICAL SCORE "LYRISME" BY E. PAVLOV, Moscow, 1922. 35 x 26.3 (311.80).*

925 *PRINTED COVER OF MUSICAL SCORE "THE SEA" BY E. PAVLOV, Moscow, 1922. 34.3 x 24.5 (310.80).*

920

921

922

923

924

925

926 *DESIGN FOR COVER OF MAGAZINE "KINO" (FILM), c. 1922. Gouache and ink on board. 30.2 x 22.5 (C48).* A collage element has probably been lost from the lower right.

927 *DESIGN FOR TAILPIECE(?), c. 1922. Ink on paper. 8.6 x 24.4 (C45).*

928 *SHEET OF DESIGNS for tailpieces for musical publications, c. 1922. Lithograph. 21 x 33.6 (C713).* Costakis owns five other sheets of related lithographic designs.

929 BORIS BORISOVICH TITOV. *COVER FOR "SONGS, DANCES, BALLADS ... PORCELAIN PIERROT," published by Maski publishing house, Moscow, 1926?. 35 x 26.2 (169.80).* Titov, born in Moscow, 1897, died in Moscow, 1951, designed many Soviet editions of writers such as Demian Bednyi, Gogol, and Boris Pilniak. He also designed several music covers for Maski; three examples, one dated 1926, are in the collection of the Institute of Modern Russian Culture, Blue Lagoon, Texas. The decorative nature of his typography contrasts strikingly with that of Popova.

927

928

926

929

930 *DESIGN FOR COVER OF PERIODICAL "ARTISTY KINO" (FILM PERFORMERS), 2. Gouache on board. 23.4 x 15.8 (C58).*

930

931

931 TYPOGRAPHICAL DESIGN FOR "MUZYKA I REVOLIUTSIIA" (MUSIC AND REVOLUTION), c. 1922. Ink on paper. 8.8 x 25.2 (C37).

932 DESIGN FOR COVER OF THE FIRST ISSUE OF THE MAGAZINE "K NOVYM BEREGAM MUZYKALNOGO ISKUSSTVA" (TO NEW SHORES OF MUSICAL ART), 1923. Gouache and paper collage on paper. 25 x 18.6 (C60).

933 DESIGN FOR COVER OF THE SECOND ISSUE OF THE MAGAZINE "K NOVYM BEREGAM MUZYKALNOGO ISKUSSTVA," 1923. Gouache and paper collage on paper. 29.1 x 22.2 (308.80).

932

933

934 *PRINTED COPY OF THIRD ISSUE OF "MUZYKALNAIA NOV" (MUSICAL NEW LAND), Moscow and Petrograd, 1923. 48 pp. 31.7 x 23.2 (307.80). The gouache design for this cover is in a private collection, Moscow.*

935 *DESIGN FOR A POSTER(?), "LONG LIVE THE DICTATORSHIP OF THE PROLETARIAT," 1922–23. Paper collage, gouache, and ink on paper. 20.2 x 25.1 (C59).*

936 *WALL LABEL FOR AN EXHIBITION, "SKETCHES," 1923. Gouache and ink on paper. 9.7 x 35.5 (C40).*

937 *DESIGN FOR A POSTER(?), "SOCIETY'S STRUGGLE AGAINST ILLITERACY," 1923. Gouache and ink on paper. 10.9 x 29.1 (C38).*

938 *WALL LABEL FOR AN EXHIBITION, "PREPARATORY PERIOD DRAWINGS," 1923. Gouache and ink on paper. 13.8 x 52.6 (C41).*

934

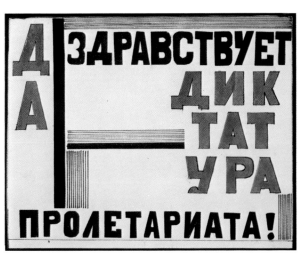

935

936

937

938

It is not known who designed the catalogue and poster for Popova's posthumous exhibition, which opened in 1924. The typographical style is, however, clearly indebted to Popova's own example.

939 *Poster announcing the opening of Popova's posthumous exhibition, December 21, 1924. Color lithograph in red and black. 92.6 x 62.4 (486.80).*

940 *"CATALOGUE OF THE POSTHUMOUS EXHIBITION OF THE ARTIST CONSTRUCTOR L. S. POPOVA, MOSCOW, 1924." 21 pp., with color lithographic cover. 17.1 x 14.1 (147.80).*

940

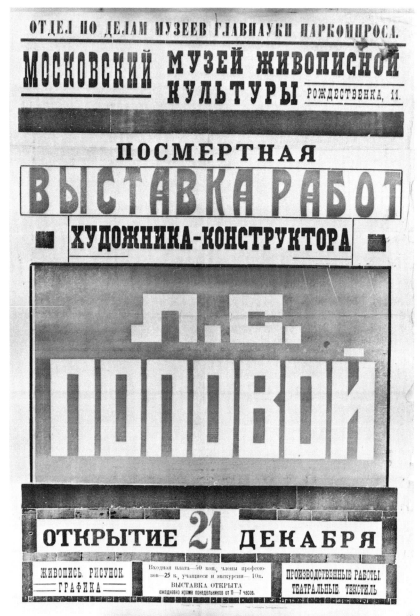

939

941, 942 *Installation photographs of Popova's posthumous exhibition of 1924.* Many of the works in the Costakis collection are clearly recognizable in these photographs.

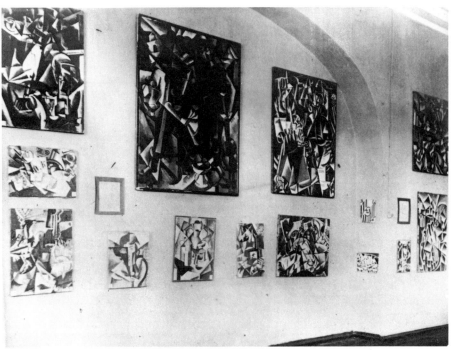

941

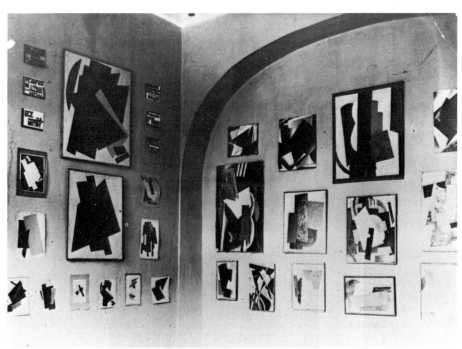

942

943 *Installation photograph of Popova's post-humous exhibition.*

944 *Wedding photograph of Popova and her husband, Boris Nikolaevich Eding (born 1890, an art historian specializing in ancient Russian architecture), taken in the city of Great Rostov, c. 1916. Inscribed on reverse:* "To dearest sister Mashenka in memory of her sympathy for our grief in those terrible times, May 12–15, 1924. S[ergei]. P[avelovich]." Apparently sent by her father to his sister (center) after Liubov's death of scarlet fever in May 1924.

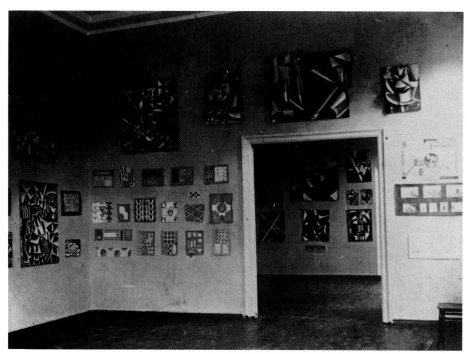

943

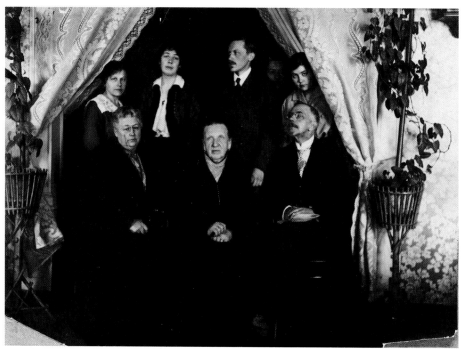

944

POSTERS AND PROPAGANDA

The Costakis collection includes a number of propaganda posters ranging from the early days of World War I to the civil war and the Revolution. All were acquired from the collector Evgenii Platonovich Ivanov. The history of satirical graphics and poster propaganda in twentieth-century Russia is complex: they are indebted stylistically on the one hand to the *lubok* (peasant woodcut) tradition, and on the other to German and French examples of late nineteenth-century poster art. The political motives and ideals exhibited are inevitably diverse and even inconsistent.

At the time of the 1905 revolution, Russian artists became heavily involved in antigovernment satire for the first time; a tradition of satirical commentary began to develop. The enemy for many artists was at that time (as later) the bourgeoisie and the imperial regime, but with the outbreak of war in 1914, the anti-imperialist sentiments of the previous decade gave way in many quarters to a new nationalism, even chauvinism. In August–September 1914 a government publishing house, The Modern Lubok, was established in Moscow entirely for the production of *lubok* propaganda posters. Avant-garde artists such as Lentulov, Larionov, Chekrygin, and Malevich participated, as did Maiakovsky (who is often considered to have been associated with the anti-imperialist left from the time of his school days, but whose political and ideological history is extremely complex). The World War I posters in the Costakis collection, some of which are illustrated here (plates 945–64), illuminate aspects of the *lubok* enterprise.

As the Russian army suffered defeats in 1915, the production of propaganda posters gradually ceased. With the arrival of the Revolution, however, the machinery swung into high gear again, now on behalf of the Bolsheviks and against the tsar. Many of the same artists who had enthusiastically supported the anti-German tsarist cause turned their hands to work for the left against the right.

For further information on the relationship between propaganda and the art of the era, see B. Butnik-Siversky, *Sovetskii plakat epokhi grazhdanskoi voiny 1918–1921* (Moscow, 1960); J. H. Billington, *The Icon and the Axe* (New York, 1966); S. Bojko, "L'Affiche révolutionnaire," *Opus International* 5 (February 1968), pp. 29–33; S. Fitzpatrick, *The Commissariat of Enlightenment: Soviet Organisation of the Arts under Lunacharsky* (Cambridge, Eng., 1970); J. E. Bowlt, "The Semaphores of Suprematism: Malevich's Journey into the Non-Objective World," *Art News*, December 1973, pp. 16–22; A. Nakov, "The Iconoclastic Fury," *Studio* 187 (1974), pp. 281–88; R. C. Williams, *Artists in Revolution: Portraits of the Russian Avant-Garde, 1905–1925* (Bloomington, Ind., 1977); C. A. Lodder, *Constructivism: From Fine Art into Design, Russia 1913–1933* (Yale University Press, 1982); J. E. Bowlt, *Journey into Non-Objectivity: The Graphic Work of Kazimir Malevich...* (Dallas Museum of Fine Arts, 1980).

945 ARTIST UNKNOWN. *RUSSIAN WRITERS, JOURNALISTS, AND ACTIVISTS OF THE THEATER ASKING FOR VOLUNTEERS TO HELP THE WOUNDED, Moscow, 1914. Photoengraving. 66.5 x 46 (86.80).* Some of those sponsoring the cause: M. N. Germanova, a leading actress in the Stanislavsky Theater; the dancers Balashova, Mordkin, and Geltser; the tenor L. V. Sobinov; Skitaletz, a well-known poet and friend of Maxim Gorky; the prominent journalist V. Dorosevich; and the owner of the Moscow Korsh Theater.

946 ARTIST UNKNOWN. *PATRIOTIC POSTER AGAINST THE AUSTRIANS, 1914. Lithograph. 37.2 x 55.6 (110.80). Published by The Modern Lubok, Moscow.*

947 ARTIST UNKNOWN. *PATRIOTIC POSTER AGAINST THE GERMANS, c. 1914. Lithograph. 39.5 x 53.7 (117.80). Published by The Modern Lubok, Moscow. Text:* "Savagery of the Germans. On July 22, 1914, the Russian town of Kalisch was occupied by the German army. The head of the German detachment asked the city treasurer, Sokolov, to hand over the municipal purse. Sokolov answered that he had burned the money according to the instructions of his superiors. For that the Germans shot Sokolov without granting his final wish: that they untie his hands so that he might cross himself before dying."

948 ARTIST UNKNOWN. *PATRIOTIC POSTER AGAINST THE AUSTRIANS, c. 1914. Lithograph. 37.8 x 55.5 (113.80). Published by The Modern Lubok, Moscow.*

949 ARTIST UNKNOWN. *PATRIOTIC POSTER AGAINST THE GERMANS, c. 1914. Lithograph. 37.6 x 55.8 (111.80). Published by The Modern Lubok, Moscow. Text:* "Germans! Although you are mighty, you will not see Warsaw. Better go to Berlin before you perish!"

946

947

948

949

950 ARTIST UNKNOWN. *PATRIOTIC POSTER AGAINST THE GERMANS,* c. 1914. Lithograph. 37.8 x 56.1 (114.80). Published by The Modern Lubok, Moscow. Text: "In the famous forest of Avgustova there were 100,000 dead Germans. The enemy was annihilated and then left to swim in the blue Neman."

951 ARTIST UNKNOWN. *PATRIOTIC POSTER AGAINST THE GERMANS,* 1914. Lithograph. 36.5 x 57.1 (116.80). Published by The Modern Lubok, Moscow. Text: Left: "We are the Russians, and we become more and more numerous, tra la la!" Right: "We are the Germans, and we become fewer and fewer, tra la la!"

952 ARTIST UNKNOWN. *PATRIOTIC POSTER AGAINST THE GERMANS,* 1914. Lithograph. 37.6 x 56.2 (112.80). Published by The Modern Lubok, Moscow. Text: "Ah! How terrifying and how forceful the fat German who was walking on the Vilna, but in the battle near Osovets he was sheared like a sheep."

950

951

952

Англичанъ у Гельголанда Да сломали чресла у
Сторожила нѣмцевъ банда, Гебена и Бреслау,

А турки въ Константинополѣ Какъ бы съ этого у турка
Взяли и заштопали. Не облѣзла штукатурка.

953

Плыли этимъ мѣсяцемъ,
Турки съ полумѣсяцемъ.

Какъ бы турки у Синопа
Не увидѣли потопа.

954

953 ARTIST UNKNOWN. *PATRIOTIC POSTER AGAINST THE TURKS*, 1914. Lithograph. 57.6 x 39.6 (121.80). Published by The Modern Lubok, Moscow.

954 VLADIMIR MAIAKOVSKY(?). *PATRIOTIC POSTER AGAINST THE TURKS*, n.d. Lithograph. 55.9 x 37.7 (119.80). Published by The Modern Lubok, Moscow.

955 ARISTARKH LENTULOV?. *PATRIOTIC POSTER AGAINST THE GERMANS*, 1914. Lithograph. 38.1 x 55.5 (120.80). Published by The Modern Lubok, Moscow. Text: "A crowd of Germans, infantry and cavalry, were moving with their cannons in a train, and the Cossacks

Масса нѣмцевъ пѣшихъ, конныхъ Да казани по опушкѣ И подъ—лихъ казачій гомонъ—
Ѣдутъ съ пушками въ вагонахъ, Раскидали нѣмцамъ пушки Враній поѣздъ былъ изломанъ!

955

Эхъ султанъ сидѣлъ бы въ Портѣ,
Драной рыла не пороти.

956

at the edge of the forest dispersed their cannons and with a cry of triumph destroyed the enemy's train.''

956 VLADIMIR MAIAKOVSKY. *PATRIOTIC POSTER AGAINST THE TURKS, 1914–15. Lithograph. 38.4 x 55.8 (108.80). Signed l l: "Maiakovsk." Published by The Modern Lubok, Moscow.*

957 VLADIMIR MAIAKOVSKY. *PATRIOTIC POSTER AGAINST THE GERMANS, 1914. Lithograph. 38.2 x 55.7 (109.80). Signed l l: "V. M." Published by The Modern Lubok, Moscow. Text:* "A red-haired, uncouth German flew over

Warsaw, but a Cossack, Danilo the Savage, pierced a hole in him with his bayonet, and his wife Pauline now sews pants for him out of the zeppelin.''

958 KAZIMIR MALEVICH(?). *PATRIOTIC POSTER AGAINST THE GERMANS, 1914. Lithograph. 37.1 x 56 (118.80). Published by The Modern Lubok, Moscow. Text: Left:* "Below Warsaw and Grodna we smashed the Germans left and right." *Right:* "Our womenfolk are not bad at getting rid of the Prussians.''

959 VLADIMIR MAIAKOVSKY. *PATRIOTIC POSTER AGAINST THE GERMANS, 1914. Litho-

graph. 38 x 56 (128.80). Signed l l: "V. M." Published by The Modern Lubok, Moscow. Text:* "Come, German, come, come. You will never reach Paris. And, my friend, as you go to Paris, we go to Berlin.''

960 KAZIMIR MALEVICH. *"WILHELM'S MERRY-GO-ROUND," PATRIOTIC POSTER AGAINST THE GERMANS, 1914–15. Lithograph. 37.5 x 56 (124.80). Signed l r: "KM." Published by The Modern Lubok, Moscow. Text:* "On the outskirts of Paris my army is being beaten up. I'm just running around and can't do a thing.''

957

959

958

960

961

961 KAZIMIR MALEVICH. *PATRIOTIC POSTER AGAINST THE GERMANS,* 1914–15. *Lithograph. 55.9 x 37.8 (126.80). Signed l r: "KM." Published by The Modern Lubok, Moscow. Text:* "Look, look, near the Vistula. The German bellies are swelling up, so they don't feel so good."

962 KAZIMIR MALEVICH. *PATRIOTIC POSTER AGAINST THE GERMANS,* 1914. *Lithograph. 40.4 x 57.8 (125.80). Published by The Modern Lubok, Moscow. Text:* "The French allies have a wagon full of defeated Germans and our English brothers have a whole tub of them."

963 KAZIMIR MALEVICH. *PATRIOTIC POSTER AGAINST THE AUSTRIANS,* 1914–15. *Lithograph. 39.9 x 57.2 (127.80). Published by The Modern Lubok, Moscow. Text:* "An Austrian went to Radziwill and landed right on a peasant woman's pitchfork."

962

963

964 DMITRII MOOR?. "WILHELM'S ANI-
MALS," PATRIOTIC POSTER AGAINST THE
GERMANS, 1914. Lithograph. 41 x 58.1 (115.80).
Published by The Modern Lubok, Moscow.
Moor (pseudonym of Dmitrii Stakhevich Orlov,
born in Novocherkassk, 1883, died in Moscow,
1946) was perhaps the leading poster artist
of the Russian Revolution and the civil war.
He had no real training as an artist and his
career was mainly that of a political cartoonist,
but he was typical of the artists of the time in
first lending his enthusiasm to the chauvinisti-
cally anti-German cause, and then later to the
cause of the Revolution.

965 DMITRII MOOR. "BEFORE" AND "NOW,"
1918. Lithograph. 56.8 x 35.9 (105.80). Pub-
lished by VTsIK, Moscow. Text: "Before: The
Aristocrats. Now: The Workers. If all are to
work all must be clothed." In perhaps his most
celebrated poster, Moor contrasts the workers'
misery under the aristocracy with their pros-
pects for the future.

964

965

967

Moor later became one of the leading painters of the agitational trains and trams. These were decorated propaganda vehicles which traveled the country distributing literature, showing films, and providing news from the front (see also Malevich, plates 500 and 501). By 1919 posters were being widely used as substitutes for newspapers and were distributed throughout the country in editions of close to a million. ROSTA (the Russian Telegraph Agency) started to produce the so-called ROSTA windows—magnified poster-sized comic strips which could be hung in shopwindows and be immediately accessible and comprehensible to mass audiences.

966 ARTIST UNKNOWN. *ANTI-TSARIST POSTER, 1917. Lithograph. 45 x 60.6 (129.80). Text:* "The worker buys vodka, the tsar makes money."

967 ARTIST UNKNOWN. *ANTI-TSARIST PROPAGANDA POSTER. Engraving. 29 x 22 (39.80).* A satire of the tsar's monopoly of liquor, while he devours the peasants.

968 AFANASII KULIKOV. *PROPAGANDA POSTER, c. 1917. Lithograph. 26.4 x 34.1 (87.80).*

969 AFANASII KULIKOV. *PROPAGANDA POSTER, c. 1917. Lithograph. 26.4 x 36.5 (88.80). Published by a group of Moscow artists.* The soldier is given little, though much is demanded of him by the merchant class and the intellectuals.

No biographical information about Kulikov has been located.

968

966

969

970 VLADIMIR MAIAKOVSKY. *ANTI-TSARIST PROPAGANDA. Lithograph. 30.5 x 45.7 (107.80). Signed l r: "V Maiakovsky."* The soldier is identified with the worker.

971 VLADIMIR MAIAKOVSKY. *REVOLUTION-ARY POSTER, 1917. Lithograph. 60.9 x 45.5 (106.80). Signed l r: "V Maiakovsky."* Previously the soldiers defended the bourgeois. Now they defend the land, freedom, democracy, revolution.

970

971

During the 1920s and the early 1930s the artists of the avant-garde produced an extraordinary range of agitational posters and other materials in the service of the Revolution, of the fight against illiteracy, and of the war against capitalism (plates 972 and 973). The two unattributed examples owned by Costakis belong to this tradition, which is most powerfully represented by the work of Lissitzky. His poster *Beat the Whites with the Red Wedge* of 1919 (repr. S. Lissitzky-Küppers, *Lissitzky* [London, 1980], plate 40) and other works of this nature had a major impact on poster design in the next decade.

972 ARTIST UNKNOWN. *REVOLUTIONARY PROPAGANDA. Lithograph. 17.9 x 45.5 (139.80). Text:* "Proletariat of the World Unite. Organization of Production Victory over a Capitalist Structure."

973 ARTIST UNKNOWN. *REVOLUTIONARY PROPAGANDA. Lithograph. 22.2 x 60.1 (276.78). Published by the Smolensk branch of ROSTA. Text:* "Create the Week of the Red Gift Everywhere." This poster may have been designed by Wladyslaw Strzeminski. A closely related poster, formerly attributed to Malevich, has also more recently been attributed to Strzeminski (see L. Shadowa, *Suche und Experiment: Russische und sowjetische Kunst 1910 bis 1930* [Dresden, 1978], plate 172).

972

973

974 GUSTAV KLUCIS. *PRINCIPLES OF NOT (THE SCIENTIFIC ORGANIZATION OF LABOR), mid-1920s. Ink, pencil, and watercolor on paper. 50.5 x 59.6 (C479). Not signed or dated.* The "wheel" is divided into four sections, titled "Advertising," "Daily Life," "Agitational Propaganda," and "Entertainment." "Principles of NOT" (Nauchnaia organizatsiia truda) indicate those spheres of the new Socialist society in which the artist can make useful contributions, and relate to the specifically ideological nature of Klucis's concerns during the twenties and thirties. For example, he created a powerful design for a poster to celebrate the announcement of the Electrification Plan at the Eighth Congress of the Soviets in 1920, a work which marked the beginning of his "agitational" production (plate 975). In addition, his work in advertising represented an obvious commitment to furthering the cause of the Revolution, through expansion of the Soviet economy and by other means. These various activities, viewed in connection with a work such as the "Principles of NOT," reveal themselves to be part of the comprehensive scheme or program for the artist in a revolutionary society which Klucis supported.

Text: "ADVERTISING [upper right, outer circle to inner]: Pyrotechnics, electrification, power engineering/ Tents, airplanes, airships, anchored balloons, signal indicators/ Mobile poster, projected announcements, spotlights/ Standard signboard, announcements, equipment/ Rotating, lifting, and sound-effects equipment/ Automobiles, steamships, people, bicycles, motorcycles, trams/ Tags, labels, wrappers, stamps appropriately organized in ceramics/ Advertisement, poster, and visual projection/ Standard advertising/ Transport advertising/ Work in industry itself.

"DAILY LIFE [lower right, outer circle to inner]: Diagrams, shopwindows, kiosks, organization of exhibition materials/ Rostrums, banners, slogans, colors, posters, leaflets/ People's universities open to the public/ Industrial, specialist, sport, hygiene/ Exhibition, public or party, trade union, production reports/ Public places, streets, city squares, Soviet republics, worldwide/ Alphabet books/ Clothing, badges/ House equipment, exhibitions, periodicals/ Revolutionary festivals, spectacles (especially)/ Photography, cinematography, illustrated alphabet.

"AGITATIONAL PROPAGANDA [upper left, outer circle to inner]: Rostrums, squares, organization of public places. Streets, city and station squares, and standard festival equipment/ Cinema, pyrotechnics/ Revolutionary holidays, Congress, Party, progress. Conferences. Cartoon on political theme, mannequin/ Typography, montage, mixed montage (typography), photo, lithography/ Projection lights, changing slogans, electric installations, pyrotechnics/ Poster, caricature, cartoon, leaflets, newspaper, book cover, illustration/ Agitational spectacle, demonstration/ Photomontage, typographical montage/ Color, light, and sound-effect equipment/ Agitational posters, periodicals.

"ENTERTAINMENT [lower left, outer circle to inner]: Decoration, lighting, model, theatrical costumes/ Theatrical stunts, sideshows, sound-effects display/ Newsreels and formation of public opinion on future events of the day/ All our ideas in historical perspective/ Means of production of an actor, theatrical production/ So-called actor is a production worker of speech, so-called theater is a living newspaper with the day's events and/ Theater in historical perspective/ Circus, theatrical stunts, cinema/ Square, street, factory/ Abolition of the theater as an independent form of art."

974

975 *Early photograph of Gustav Klucis's "Electrification of the Entire Country," a poster with photomontage, 1920.*

976 GUSTAV KLUCIS. *SHEET OF INSTRUCTIONS FOR THE BUILDING OF AN ADVERTISING STRUCTURE, mid-1920s. Hectography on paper. 21.8 x 34.9 (C720). Not signed or dated. Text:* "Actual height of the advertising structure: 2–3 times the height of a human being.

"The advertisement is intended as an example for the district around the public library.

"Individual cylinders indicate the way to the advertised store, theater, etc. In addition, arrows can be made, and also addresses indicated, goods listed, etc.

"A loudspeaker for radio advertisements is located in one of the cylinders."

977 GUSTAV KLUCIS. *DESIGN FOR A WORLD WAR II POSTER. Watercolor and pencil on paper. 18.1 x 21.9 (C387). Not signed or dated. Text:* "The enemy is ready/ Battles are at hand/ Learn to march/ in the Left line." At the time of World War II, the artists who had produced such striking agitational posters during the twenties and thirties turned their attention to the new demands of the army. Lissitzky's final creations before his death were of this nature, the most famous being his poster *Make More Tanks* of 1941 (repr. Lissitzky-Küppers, *Lissitzky*, plate 252). Klucis's wartime poster production is not widely known, though several were shown at the Klucis retrospective in Riga in 1970 and appear in the installation photographs.

976

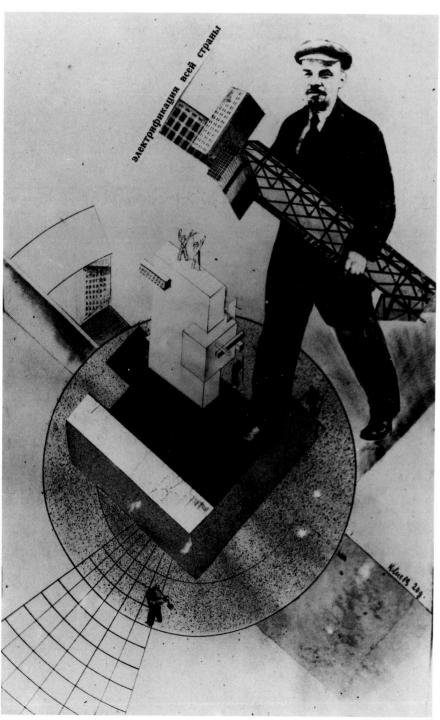

977

975

IVAN ALBERTOVICH PUNI (JEAN POUGNY)

Born Kuokkala, Finland (now Repino, Leningrad District), May 6, 1894; died Paris, November 26, 1956.

From 1900 to 1908 attended the Military College in St. Petersburg; slated to enroll in the Corps of Cadets, but a friend of the family — Puni's grandfather was a composer, originally from Italy, and his father a cellist — the artist Ilia Repin, advised him to study painting. In 1910 left for Paris to attend the Académie Julien; also traveled to Italy. In 1912 returned to St. Petersburg and met Nikolai Kulbin, the Burliuk brothers, and Malevich. Married the artist Ksenia Boguslavskaia in 1913; the Puni home became one of the salons of the new art.

Participated in the 1912 and 1913 – 14 Soiuz molodezhi (Union of Youth) exhibitions in St. Petersburg, and in January 1914 designed the cover of the miscellany *Futuristy. Rykaiushchii Parnas* (Futurists: Roaring Parnassus), which was subsidized by Boguslavskaia. In February traveled with his wife to Paris, where Puni showed at the Salon des Indépendants; that summer they returned to Petrograd.

In 1915 exhibited at "Tramvai V. Pervaia futuristicheskaia vystavka kartin" (Tramway V: First Futurist Exhibition of Paintings) and organized "The Last Futurist Exhibition of Pictures: 0.10," in Petrograd. On this occasion released a Suprematist manifesto with Boguslavskaia, Malevich, and Kliun. Participated in the winter 1916 "Bubnovyi valet" (Jack of Diamonds) exhibition in Moscow.

In 1918 was elected professor at Petrosvomas, but instead went with Boguslavskaia at the invitation of Chagall in January 1919 to Vitebsk, where he taught at the Art Institute. In the fall returned to Petrograd, and late that year went to his parents' house in Finland. In the autumn of 1920, emigrated to Berlin. In February 1921 showed at Der Sturm gallery; emerged as a graphic artist, decorator, and critic. In 1922 showed at the "Erste russische Kunstausstellung" (First Russian Art Exhibition), at the Galerie van Diemen in Berlin; in 1924 settled in Paris.

All the works by Puni were acquired from a relative of the artist in Leningrad.

978 *LANDSCAPE WITH HOUSE, 1912. Oil on canvas. 50.5 x 70 (Tretiakov Gallery TR17).*

979 *LANDSCAPE WITH HOUSE, c. 1912. Oil on canvas. 48.5 x 61.4 (227.78). Not signed or dated.*

980 IVAN PUNI?. *PORTRAIT (V. NIZHINSKII), 1914. Oil on canvas. 54 x 32 (Tretiakov Gallery TR158).*

979

980

981 *BALL FOR FOOLS, c. 1915. Pencil on paper mounted on paper. 9 x 14.6 (230.78). Not signed or dated. Inscribed l r: "Ball for Fools."*

982 *UNTITLED, 1915–16. Pencil, watercolor, and paper collage on paper. 20.4 x 13.6 (C364). Not signed or dated. Inscribed along lower edge: "Theater for Itself."*

983 *UNTITLED, c. 1915–16. Pencil on paper. 15.3 x 10.5 (C297). Not signed or dated. Inscribed u r: "Funeral of Sentiment."*

984 *BALL FOR FOOLS, 1915–16. Watercolor and pencil on paper. 16.7 x 11.2 (C294). Not signed or dated. Inscribed u r: "Ball for Fools."*

981

982

983

984

985 *MAN WITH A PIPE, c. 1915. Pencil on paper mounted on paper. 21.2 x 15 (228.78). Not signed or dated.*

986 *UNTITLED, c. 1915–16. Pencil on paper mounted on paper. 8.8 x 9.6 (C296). Not signed or dated. Inscribed on reverse:* ''Good Old Time.''

987 *COMPOSITION, 1915–16. Pencil on paper. 16.7 x 11.8 (C295). Not signed or dated. Inscribed along lower edge:* ''The Understanding Court.''

988 *THEATER, c. 1915–17. Ink and pencil on paper mounted on paper. 13.9 x 10.7 (229.78 recto). Not signed or dated. Pencil drawing on reverse (not reproduced).*

987

985

986

988

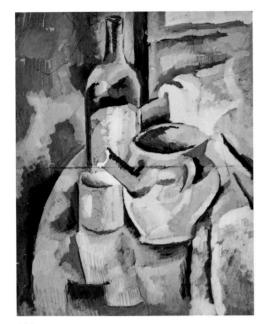

989

990

991

989 *STILL LIFE WITH BOTTLE, 1917. Gouache on cardboard. 34 x 27 (Tretiakov Gallery TR18).*

990 *STILL LIFE: HAT AND FRAME, 1917. Oil on canvas. 76.5 x 69 (Tretiakov Gallery TR56).*

991 *STILL LIFE WITH TOP HAT, 1917. Oil on canvas. 57.8 x 44.6 (226.78). Not signed or dated.*

992 *CHAIR AND HAT BOX, 1917–19. Oil on canvas. 98.1 x 53.3 (225.78). Not signed or dated.*

992

993 *VITEBSK (BUFFET), 1919. Wash and colored pencil. 32.5 x 22 (231.78a). Not signed or dated.*

994 *MAN ON STAIRS, 1917–18. Pencil, colored pencil, and wash on paper. 32.3 x 22 (231.78b). Not signed or dated.*

995 *LANDSCAPE, VITEBSK, 1919. Pencil, colored pencil, ink, and wash on paper. 34.8 x 22.5 (233.78). Not signed or dated.*

996 *TRAIN STATION IN VITEBSK, 1919. Pencil, wash, ink, and colored pencil on paper. 33.8 x 23.5 (232.78). Not signed or dated. Inscribed on mat, not in the artist's hand: "1919."*

995

993

994

996

Y. S. RASKIN

Biographical information has not been obtainable, though it is known that he participated in the "Exhibition of Paintings by Russian Artists" in Pskov, spring 1920.

997 *STILL LIFE, 1920s. Oil on canvas. 85 x 76 (Tretiakov Gallery TR55). Acquired from a private collection, Leningrad.*

997

KLIMENT NIKOLAEVICH REDKO

Born Kholm (now Khelm), Poland, September 15, 1897; died Moscow, February 18, 1956.

In 1910 enrolled in the icon-painting school at the Kievo-Pechersk Monastery. From 1914 to 1915 attended the school of the Society for the Encouragement of the Arts in Petrograd and in 1915 registered as a volunteer in the army; became an air force pilot. From 1918 to 1920 studied at the Kiev Art School, helped decorate the city for Revolutionary celebrations.

Settled in Moscow in 1920. After a short period of Suprematism, lasting until 1921, made a transition in his painting to "engineer organisms" that were intended as new symbols of an industrial-scientific civilization. Was one of the initiators of the Elektroorganizm (Electroorganism) group, with Nikritin, Plaksin, Alexandr Tyshler, and others. The group held an exhibition at the Museum of Painterly Culture in 1922. Defined the direction of his work from 1923 to 1924 as Svechenizm (Luminism).

In 1924 participated in the "Pervaia diskussionaia vystavka obedinenii aktivnogo revoliutsionnogo iskusstva" (First Discussional Exhibition of the Associations of Active Revolutionary Art) in Moscow; in the catalogue signed the declaration of the Projectionists group.

Had a one-man show in Moscow in 1926, and from 1927 to 1935 lived in Paris. Returned to Moscow late in 1935 and turned to landscape painting.

All the works by Redko were acquired from the artist's widow (his second wife).

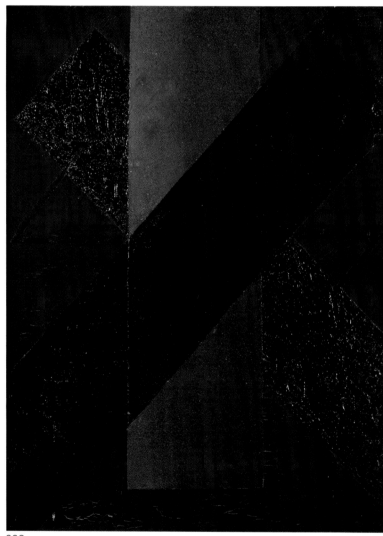

998

998 *SUPREMATISM, 1921. Oil on canvas. 71.2 x 53.2 (235.78). Signed and dated on reverse: "K. Redko 1921."*

999 *SUPREMATISM, 1921. Oil on canvas. 75 x 50 (Tretiakov Gallery TR54). Signed and dated on reverse: "K. R. 21."*

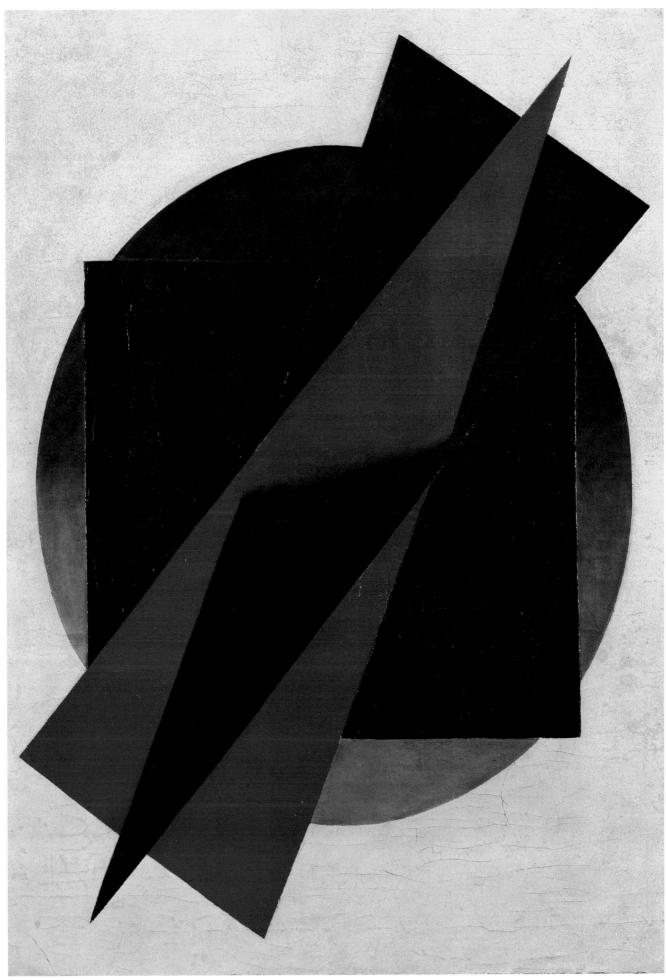

1000 *ABSTRACT SPACE, 1921. Oil on canvas.*
51 x 68 (Tretiakov Gallery TR53).

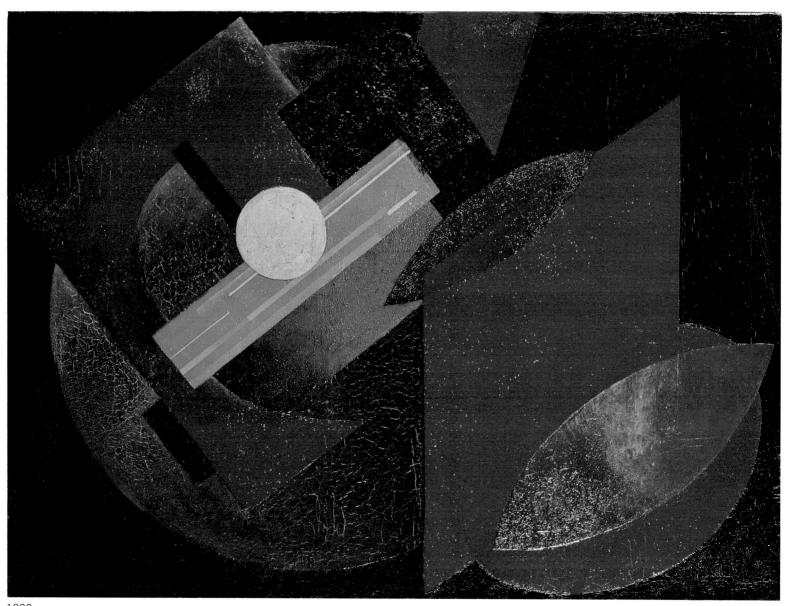

1000

1001

1001 *LUMINISM: DYNAMICS OF FORM AND COLOR, 1923.* Oil on canvas. 44.5 x 44.4 (237.78). Signed and dated on reverse: "K. Redko 1923."

1002 *WIFE AND HUSBAND, 1922.* Oil on canvas. 67.5 x 51 (Tretiakov Gallery TR50).

1003 *LUMINISM: SYNTHETIC LIGHT DEVELOPMENT, 1923.* Oil on canvas. 62.6 x 47 (238.78). Signed and dated on reverse: "K. Redko 1923."

1004 *DYNAMITE, 1922.* Oil on canvas. 62.8 x 47.5 (236.78). Signed and dated on reverse: "K. Redko 1922."

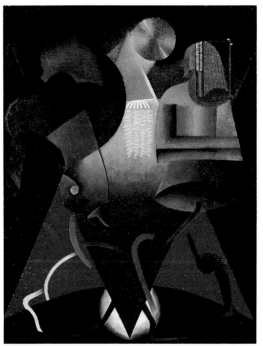

1002

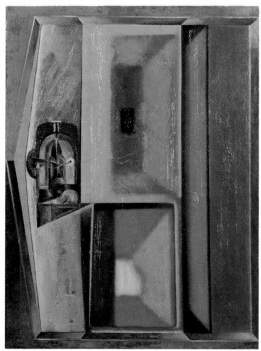

1003

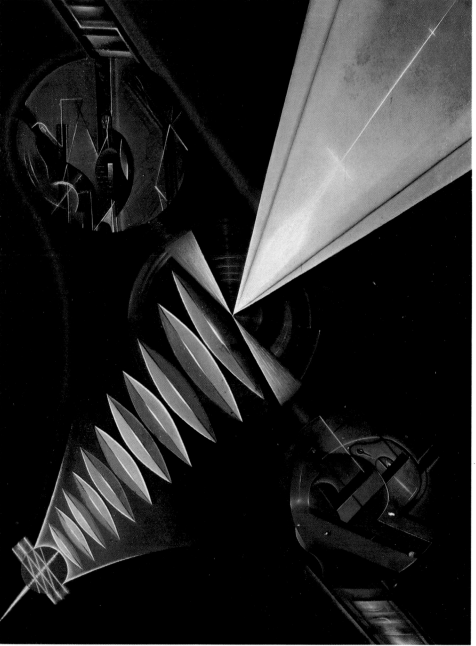

1004

1005 *NORTHERN RAILWAY, 1925. Oil on canvas. 101 x 69 (Tretiakov Gallery TR49). Signed and dated l r: "K. Redko 1925."*

1006 *MECHANICAL MAN, 1923. Oil on canvas. 61 x 46.5 (Tretiakov Gallery TR52).*

1007 *UPRISING, 1923–25. Oil on canvas. 169.5 x 212 (Tretiakov Gallery TR51).* Redko originally intended this work to represent the Russian Communist Party; he later titled the work *Revolution*, and finally *Uprising*. The entire Soviet leadership of the Revolutionary era is identifiably portrayed, and the work was exhibited with many of its preparatory studies at Redko's one-man show in 1926 (no. 169 and 170–78). Some of these are now housed in the Central State Archive of Literature and Art, in Moscow.

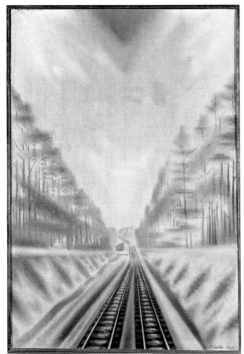

1005

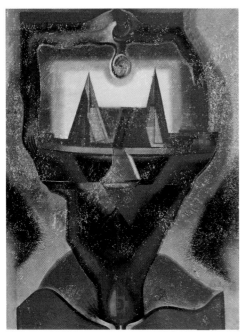

1006

1007

GEORGII GEORGIEVICH RIAZHSKY

Born Ignatievo region, near Moscow, February 12, 1895; died Moscow, October 20, 1952.

From 1905 lived in Moscow with his father, who came from a peasant family. After completing school in 1910 worked as a page in a bank while attending evening drawing classes at the Prechistinsky Workers' Courses. Spent 1915 to 1917 in military service. In 1918 studied at the Moscow Proletkult and from 1918 to 1919 attended the Svomas in Moscow, where he studied with Malevich. In 1919–20 worked in Samara as an army and Proletkult artist. In 1922 was one of the organizers in Moscow of the NOZh, which rejected the principles of nonrepresentational art; participated in the group's exhibition of that year in Moscow.

From the mid-1920s worked in a Realist style; became a member of AKhRR in 1924 and RAPKh in 1930. Gained a reputation as a portrait painter, and painted a series of Socialist Realist works.

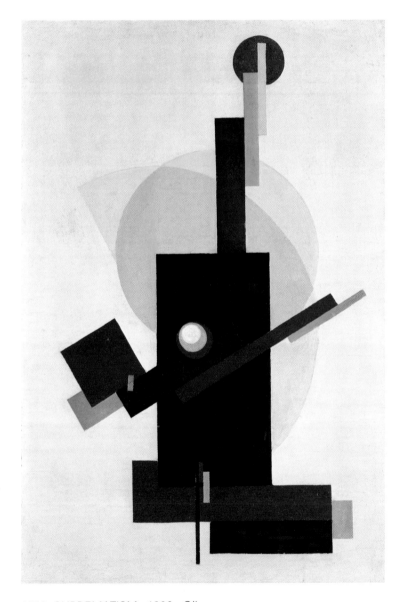

1008 *SUPREMATISM, 1920. Oil on canvas. 105.5 x 70 (Tretiakov Gallery TR48). Acquired from the artist's family.* Riazhsky became an official Socialist Realist painter in the late 1920s and almost none of his nonobjective work has survived. Some of his Suprematist canvases (including possibly this one) were painted in collaboration with A. Ivanov.

ALEXANDR MIKHAILOVICH RODCHENKO

Born St. Petersburg, November 23, 1891; died Moscow, December 3, 1956.

The son of a property man at the theater of the Russian Club; from 1910 to 1914 attended the Kazan Art School, where he met Varvara Stepanova, whom he later married. After graduation, entered the Stroganov Art Institute in Moscow. The first major exhibition in which he participated was "Magazin" (The Store) in Moscow, in 1916, organized by Tatlin. His familiarity with the Suprematism of Malevich and Rozanova, as well as with the counterreliefs of Tatlin and the theories of Kandinsky, played an important role in his formation as an artist.

In 1917 worked with Yakulov and Tatlin on the decor for the Café Pittoresque in Moscow. In 1918 had a one-man exhibition at the Club of the Leftist Federation in Moscow, "Five Years of Art." In that year painted *Chernoe na chernom* (Black on Black) as a polemical response to Malevich's *Beloe na belom* (White on White). Starting in 1915 executed a series of compass-and-ruler paintings and drawings, which expressed his theory of linearism and which from 1920 to 1921 he carried out in three-dimensional folding and hanging mobile constructions.

In 1918 became active as an organizer of artistic life in Moscow. From 1919 through 1922 was a member of a group called Zhivskulptarkh, an abbreviation of Zhivopisno-skulpturno-arkhitekturnyi sintez (Commission of Painterly-Sculptural-Architectural Synthesis), and participated in the group's two exhibitions in Moscow in 1920: "Zhivskulptarkh" and part of the Nineteenth State Exhibition. Was also active in IZO Narkompros in the Subsection of Applied Art, headed by Rozanova. Showed work in the 1919 "Tenth State Exhibition: Nonobjective Creation and Suprematism" and in the 1920 "Exhibition of Four" (with Kandinsky, Stepanova, and Nikolai Sinezubov), both in Moscow. He was a founding member of Inkhuk in 1920 and, that same year, was one of the initiators (with Kandinsky) of the creation of a network of art museums throughout the country. Also became a professor at Vkhutemas/Vkhutein, where he taught for ten years.

In 1921 gave up easel painting to work on poster, book, and textile designs, on film, in the theater (with Vsevolod Meierkhold, among others), and on photography. Became a member of the Productivist group, including Tatlin, Popova, Stepanova, and Vesnin, which denied the notion of pure art and insisted on the incorporation of art into everyday life. In 1920 contributed to the second exhibition of Obmokhu and in 1921 to its third; also in 1921 to the "5 × 5 = 25" exhibition in Moscow. In 1922 participated in the "Erste russische Kunstausstellung" (First Russian Art Exhibition), at the Galerie van Diemen in Berlin.

In 1923 Maiakovsky organized LEF (Levyi front iskusstv — Left Front of the Arts) and in 1927 Novyi LEF (New LEF); Rodchenko was extensively involved with the design and content of their journals, contributing articles, photographs, and typography.

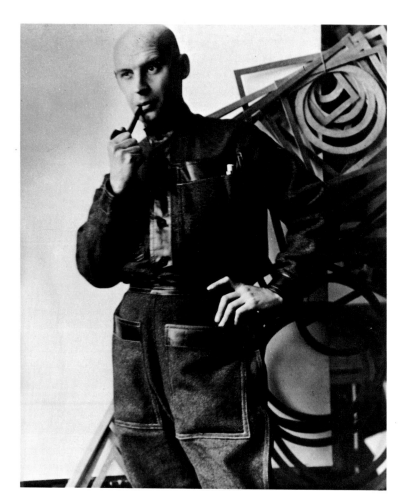

1009 *Alexandr Rodchenko, standing in front of folded constructions.* Photograph by Mikhail Kaufman, 1921.

In 1925 designed a workers' club, which was exhibited in the Soviet Pavilion at the Exposition Internationale des Arts Décoratifs et Industriels Modernes in Paris.

In the 1930s began to paint again.

All the works by Rodchenko were acquired from the artist himself or from members of his family.
See also page 121.

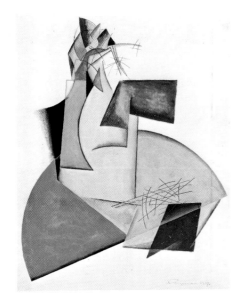

1010

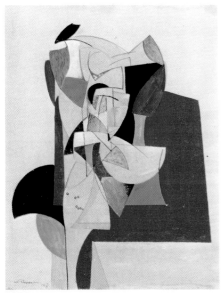

1011

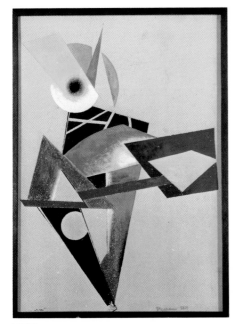

1012

The titles of the next two works were supplied by V. Rakitin and were taken from material in the Rodchenko Archive in Moscow.

1010 *NONREPRESENTATIONAL CONSTRUCTION OF PROJECTED AND PAINTED SURFACES OF A COMPLEX COMPOSITION WITH COLORS, 1917. Varnished watercolor and gouache with pencil on paper. 36.8 x 29.2 (sight) (242.78). Signed and dated l r: "A. Rodchenko 1917."*

1011 *NONREPRESENTATIONAL CONSTRUCTION OF PROJECTED AND PAINTED SUR-*

FACES OF A COMPLEX COMPOSITION WITH COLORS. CIRCLE AND LINE COMPOSITION, 1917. Gouache, ink, and watercolor on paper. 26.6 x 20.3 (sight) (243.78). Signed and dated l l: "A. Rodchenko 1917."

1012 *THE CLOWN PIERROT, 1919. Gouache and ink with pencil on paper. 50.8 x 35.6 (244.78). Signed and dated l r: "Rodchenko 1919."* One of seventeen costume designs by Rodchenko for the revue *We* planned by Alexei Gan. Gan never actually wrote the revue, and the costumes were thus not produced.

1013 *CONSTRUCTION ON WHITE (ROBOTS), 1920. Oil on wood. 144 x 94.3 (249.78). Stenciled signature on reverse: "Rodchenko"; not dated.*

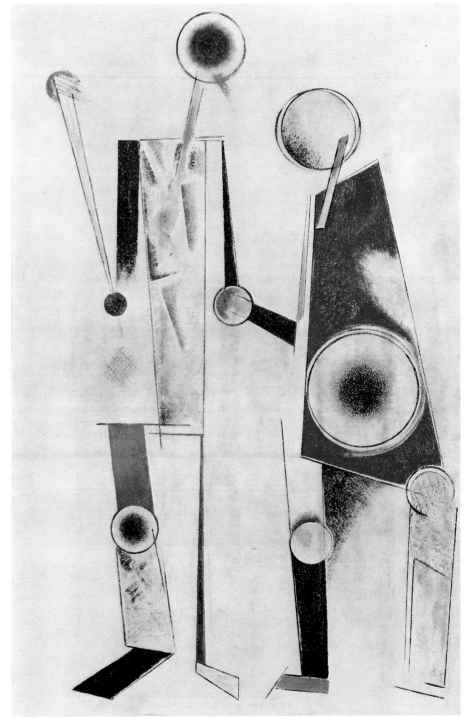

1013

Rodchenko's paintings of 1919–21 are stylistically so varied that the tracing of stylistic development is problematic. It is clear that he was working simultaneously with linear forms, with the beginnings of Constructivism, with the color possibilities of monochrome surfaces, with figuration (see plate 1013), and with something close to an Abstract Expressionist idiom. The eight works from this period in the Costakis collection illustrate some aspects of this experimental diversity.

1014 *COMPOSITION NO. 117, 1919. Oil on canvas. 40.3 x 35.1 (239.78). Stenciled signature and date on reverse, apparently added later:* "Rodchenko 1920"; *in black ink:* "N. 117." A letter from Klucis to Kudriashev, preserved in a provincial museum in Russia, comments upon this work, which he saw exhibited in 1920, as "a black picture with little dots of color . . . extraordinary genius" (information from Costakis).

1015 *UNTITLED, 1918. Oil on paperboard. 25.4 x 21.3 (245.78). Not signed or dated.*

1016 *LINEARISM, 1920. Oil on canvas. 102.9 x 69.6 (240.78). Signed and dated on reverse:* "Rodchenko/1920/No. 104." In an essay on "Line," written in May 1921 as a paper for Inkhuk, Rodchenko analyzed his sense of the importance of line both for painting and for construction. "Putting line in the center of artistic creation, as the only factor possible to construct with, we simultaneously reject the aesthetics of color, surface, texture, and style, for everything that conceals the structure is style (Malevich's square, for example)" (quoted in G. Karginov, *Rodchenko*, trans. E. Noch [London, 1979], p. 64).

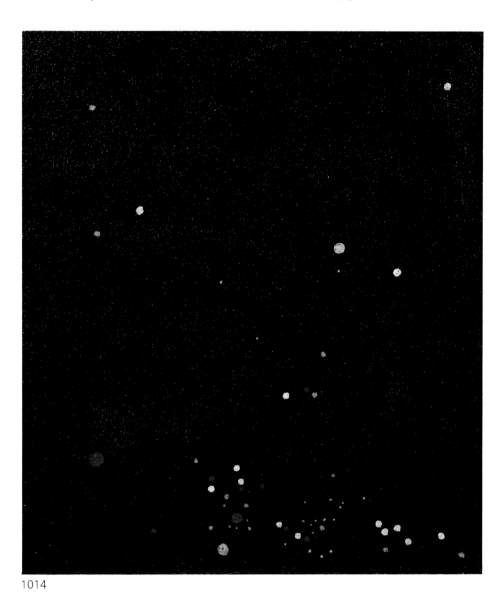

1014

1015

1016

1017 *UNTITLED, c. 1917–18. Charcoal on paper. 66.7 x 52 (246.80). Signed l r: "Rodchenko"; not dated.*

1018 *UNTITLED, October 1921. Red and blue wax crayon on paper. 48.3 x 32.4 (C198). Signed and dated along lower edge: "Rodchenko N3 1921 X." A related drawing (46 x 30) in the collection of Jean Chauvelin, Paris, is similarly signed and carries the number and date: "N7 1921 X."*

1019 *OVAL HANGING CONSTRUCTION NO. 12, c. 1920. Painted plywood and wire. 83.5 x 58.5 x 43.3 (246.78). Not signed or dated. Exhibition: "Obmokhu 3," Moscow, opened May* 21, 1921. Rodchenko made at least five of these constructions in 1920–21, a triangle, a circle, a square, a hexagon, and the ellipse in the Costakis collection. All were made of plywood and painted silver. An often published photograph (plate 1009) of Rodchenko by Kaufman taken in 1921 shows him standing in front of the disassembled, or "folded," constructions, which are hanging flat against the wall. Examination of the oval construction reveals that it was made of concentric strips, cut from a single piece of wood. They could be manipulated after cutting and formed into spatial constructions, wires being used to hold the pieces in place. When not on exhibition, the wires could be removed and the piece folded flat again.

1017

1019

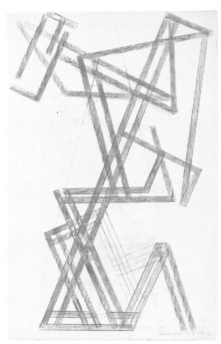

1018

1020 *ABSTRACTION (RUPTURE), late 1920.*
Oil on canvas. 136 x 141.1 (247.78). Stenciled
signature and date on reverse: "Rodchenko
1920."

1021 *COMPOSITION NO. 125, 1920. Oil on*
canvas. 137.2 x 95.7 (248.78). Stenciled signa-
ture and date on reverse: "Rodchenko 1920";
in ink: "N. 125."

1020

1021

1022

1022 *CIRCUS, 1935. Oil on canvas. 53.5 x 69 (Tretiakov Gallery TR47). Signed and dated l l: "Rodchenko 35."*

1023 *UNTITLED, 1940. Gouache on paper. 30 x 26.3 (C392). Signed and dated l r: "Rodchenko 1940."*

1024 *REALISTIC ABSTRACTION, 1940. Oil on cardboard. 26 x 33 (Tretiakov Gallery TR44).*

1025 *REALISTIC ABSTRACTION, 1942. Oil on canvas. 45 x 29.5 (Tretiakov Gallery TR45). Signed and dated l r: "R. 42."*

1026 *SURREALISTIC ABSTRACTION, 1943. Oil on cardboard. 51.5 x 35 (Tretiakov Gallery TR46). Signed and dated l r: "R. 43."*

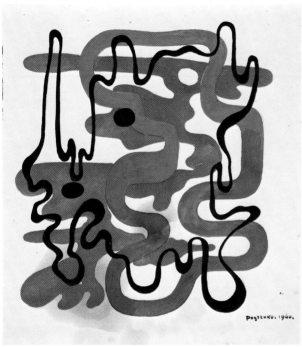

1023

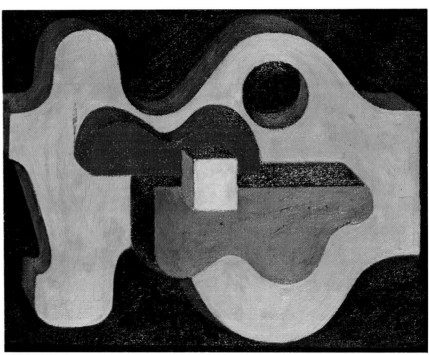

1024

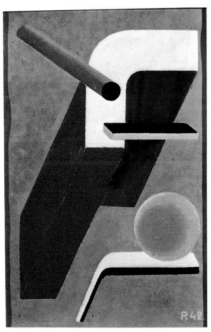

1025

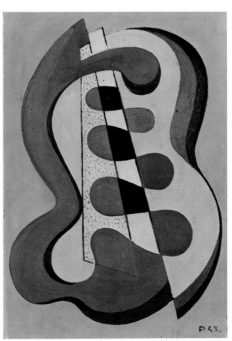

1026

1027 *EXPRESSIVE RHYTHM, 1943–44. Gouache on paper. 61 x 172.7 (241.78). Signed in monogram l r: "A. R."; not dated.*

ALEXANDR RODCHENKO AND VARVARA STEPANOVA. *SCRAPBOOK, 1920–45. 16 pp. of collages, photographs, handwritten notes, drawings, clippings from newspapers and journals, memorabilia. 26 x 36.5 (148.80).* This book, which Kruchenykh gave to Costakis as a present, may have been made by Kruchenykh rather than by Rodchenko or Stepanova. Several of the pages carry notations or comments by Stepanova or Rodchenko, but Costakis believes that Kruchenykh collected the various items over a period of time and assembled them himself, later asking the two artists to identify and date various items.

Items in the book include an undated caricature of Rodchenko by the playwright Igor Terentiev and one by Viktor Kisilev dated 1922; a photograph of Stepanova by Rodchenko labeled by him "This is one of the first photos," and dated by her "about 1923?"; Rodchenko's own copy of Maiakovsky's *Syphilis*, 1926; several pages from the 1924 issue of *LEF* devoted to Popova's memory; the linoleum cut of a jumping figure by Stepanova which appeared in the "5 x 5 = 25" catalogue; V. Grishakin's hostile article about Rodchenko published in *Zhurnalist* 5, and a favorable article by Volkov-Lannit from the *Literaturnaia Gazeta* of May 10, 1935.

1028 *PAGE 5 FROM RODCHENKO-STEPANOVA SCRAPBOOK. Two photographs of Stepanova by Rodchenko (148.80). Inscribed in ink in Rodchenko's hand with arrow: "This is one of the first photos. Rod." Below in pencil in Stepanova's hand: "About 1923? Varst."*

1029 *PAGE 10 FROM RODCHENKO-STEPANOVA SCRAPBOOK (148.80). Partially visible upper left: Rodchenko's cover for Maiakovsky's "Conversations with Revenue Inspector"; lower left: his cover for Maiakovsky's "Syphilis"; right: Stepanova's linocut for the "5 x 5 = 25" catalogue with ink inscription in her hand: "Gravure on linoleum, about 1920. Varst."*

1027

1028

1029

OLGA VLADIMIROVNA ROZANOVA

Born Malenki, Vladimir Province, 1886; died Moscow, November 8, 1918, of diphtheria.

From 1904 to 1910 studied at the Bolshakov Art College and Stroganov Art Institute in Moscow. Lived in St. Petersburg from 1911 onward; attended the Zvantseva School of Art in 1912.

By 1911 was one of the most active members of the avant-garde art movement in St. Petersburg. Was a member of the Soiuz molodezhi (Union of Youth) and contributed to its exhibitions from 1911 to 1914 and to its magazine. Illustrated publications of the Futurist poets Velimir Khlebnikov and Alexei Kruchenykh (who became her husband in 1916) and others, including *Igra v adu* (A Game in Hell), a collaboration between Khlebnikov and Kruchenykh, which was reissued in 1914 with illustrations by Rozanova and Malevich; *Utinoe gnezdyshko durnykh slov* (A Little Duck's Nest of Bad Words), by Kruchenykh, 1913; *Vozropshchem* (Let's Grumble), by Kruchenykh, 1914; the miscellany *Futuristy. Rykaiushchii Parnas* (Futurists: Roaring Parnassus), 1914; *Zaumnaia gniga* (Transrational [B]ook), by Kruchenykh and Aliagrov (Roman Jakobson), 1916; and two 1916 collaborations of Rozanova and Kruchenykh, illustrated with nonrepresentational cut-paper collages — *Voina* (War) and *Vselenskaia voina* (Universal War).

Rozanova exhibited in all the major avant-garde shows of 1915 – 16, including "Tramvai V. Pervaia futuristicheskaia vystavka kartin" (Tramway V: First Futurist Exhibition of Paintings) and "The Last Futurist Exhibition of Pictures: 0.10" of 1915 in Petrograd and the "Magazin" (The Store) and "Bubnovyi valet" (Jack of Diamonds) of 1916 in Moscow. From 1916 to 1917 member of the Supremus group and secretary of the journal of the same name, which never appeared. In 1918 became a member of IZO Narkompros and Proletkult. With Rodchenko was in charge of the Subsection of Applied Art of IZO Narkompros and helped to organize Svomas in several provincial towns.

In 1919 a posthumous exhibition of her work was held in Moscow as well as shown within the framework of the "Tenth State Exhibition: Nonobjective Creation and Suprematism." Her work was also exhibited at the 1922 "Erste russische Kunstausstellung" (First Russian Art Exhibition), at the Galerie van Diemen in Berlin.

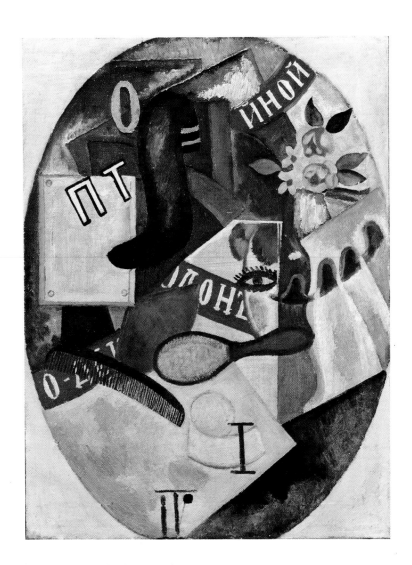

1030 BARBERSHOP, n.d. Oil on canvas. 71 x 53 (Tretiakov Gallery TR43). Not signed or dated. Purchased from N. Khardzhiev.

1031 OLGA ROZANOVA?. *CUBIST COMPOSI-TION, n.d. Oil on canvas. 71 x 52.4 (283.78). Purchased from a private collector, Leningrad.* Attributed to Rozanova by V. Rakitin.

1032 *TAVERN INTERIOR, 1913–14. Pencil on paper. 26.7 x 19.5 (252.78). Dated on reverse: "1913–14." Gift to Costakis from Rodchenko's daughter.*

1033 *Linocut on paper mounted on paper, n.d. Image: 17.6 x 13.5 (C632).* Attributed to Rozanova by V. Rakitin.

1034 *Linocut on rice paper, n.d. Image: 29.8 x 19.1 (C631).* Attributed to Rozanova by V. Rakitin.

1035 *Linocut on rice paper, n.d. Image: 24 x 17.7 (C572).* Attributed to Rozanova by V. Rakitin.

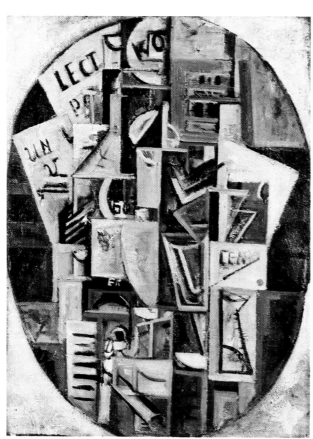

1031

1032

1033

1034

1035

These sketches are the only known surviving documentation for Rozanova's two constructions shown in "The Last Futurist Exhibition of Pictures: 0.10" of December 1915 in Petrograd (no. 121, *Automobile*; no. 122, *Bicyclist*). Both works were reproduced in *Ogonek* (Flame), January 3, 1916 (plate 1040), where the exhibition was reviewed, but they are now presumed lost. The notations on the sketches specify in detail the materials and colors of the works. The abstract pieces and their distinctively descriptive titles manifest a degree of conceptualism comparable to that of Malevich's paintings in the exhibition (see page 57), but in contrast to constructions of an essentially fig-

urative nature such as Kliun's *Cubist at Her Dressing Table*. Rozanova's note in the corner of one of these sketches is significant: "Malevich liked these two things and he asked to have them for his room." Preliminary ideas for two additional constructions, hitherto unknown, are on the lower portion of each page.

1036 *PRELIMINARY SKETCH FOR THE CONSTRUCTION "AUTOMOBILE," 1915. Pencil on paper. 13.5 x 10.1 (C353 recto).*

1037 *Diagrammatic rendering of "Automobile" sketch.*

1038 *PRELIMINARY SKETCH FOR THE CONSTRUCTION "BICYCLIST," 1915. Pencil on paper. 13.5 x 10.1 (C353 verso).*

1039 *Diagrammatic rendering of "Bicyclist" sketch.*

1040 *A page from "Ogonek," January 3, 1916, illustrating works in the "0.10" exhibition. On the far left is Kliun's Cubist at Her Dressing Table; in the center are the two Rozanova constructions Bicyclist (top) and Automobile (bottom); on the right are Puni's Barbershop (top) and Window Dressing (bottom).*

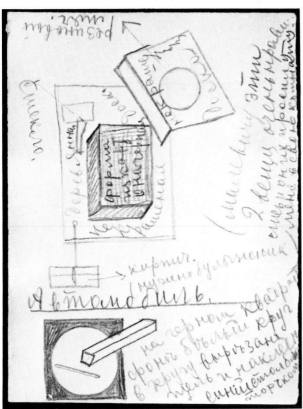

1036

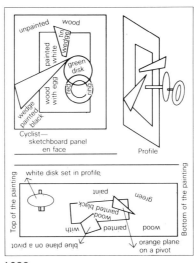

1038

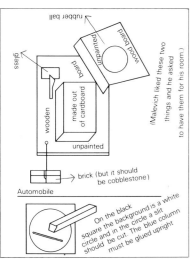

1037

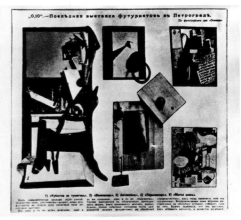

1039

1040

1041 *DECORATIVE COMPOSITION, 1916. Gouache on paper. 34.6 x 34.1 (sight) (250.78). This was dedicated by the artist on the reverse as a present to Rodchenko. His daughter, Mula, gave it as a present to Costakis.* Rozanova apparently prepared a series of similar compositions for the journal *Supremus*, which was never published, and for N. Davydova's decorative exhibitions in Moscow.

1042 OLGA ROZANOVA(?). *UNTITLED, c. 1916. Lithograph on paper. 30.1 x 23.2 (C228).* Attributed to Rozanova by V. Rakitin.

1043 *STUDY FOR "TE LI LE" BY A. KRU-CHENYKH AND V. KHLEBNIKOV, St. Petersburg, 1914. Watercolor on paper. 22.1 x 14.4*

(302.80). On reverse in pencil in Kruchenykh's hand: "For the poetry of Khlebnikov." Gift to Costakis from Kruchenykh. Costakis owns a hectographic print of this page (C721) probably taken from a copy of the book itself. It was published in an edition of fifty copies in 1914 (hectographic process, 17 pp.). The text of this page reads: "To the memory of I. V. I.-A./ and on the way/ between frozen stars/ I will fly not with a prayer,/ I will fly dead terrible/ with a bloody razor blade."

Khlebnikov described Rozanova's "colored handwriting" as expressive of poetic impulse in its own right, and thus capable of conveying the feelings of the artist independently of, as well as parallel with, the poetry.

1044, 1045, 1046 *ADVERTISEMENTS FOR THREE BOOKS BY A. KRUCHENYKH ILLUS-TRATED BY O. ROZANOVA (probably back covers of books), 1913. Color lithography on paper. 18.6 x 24.5 (301.80a, b, c).* Acquired from Kruchenykh. The advertisements are titled "New Books Take the Air." The three books advertised, all of 1913, are *Duck's Nest, Forestly Rapid,* and *Explodity.* The Costakis collection includes three examples: blue-red-black; gold and black; green-gray-black.

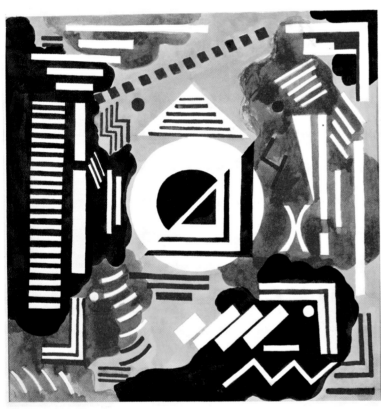

1041

1044

1045

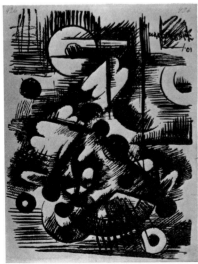

1042

1043

1046

1047 *JACK OF SPADES, 1915–16. Colored linocut. 20.5 x 20 (ATH80.23). Acquired from A. Kruchenykh.*

1048 *JACK OF DIAMONDS, 1915–16. Colored linocut. 20.5 x 20 (ATH80.24). Acquired from A. Kruchenykh. Two pages from "Zaumnaia gniga" (Transrational [B]ook) by A. Kruchenykh and Aliagrov (pseud. for Roman Jakobson), Moscow, 1916 (21 pp., 9 linocuts and 2 collages; 50–100 copies made).* A milestone in Russian Futurist bookmaking, the color linocuts of playing-card figures alternate at irregular intervals with stenciled transrational poetry by Kruchenykh. The final page is a poem by Aliagrov. The cover collage is a red heart to which a white button is attached.

1049 *UNTITLED, 1916–17. Collage on paper. 22 x 33 (253.78). Acquired from A. Kruchenykh.*

1050 *UNTITLED, 1916–17. Paper collage on paper. 21.9 x 33.4 (254.78). Acquired from A. Kruchenykh.* These two collages must originally have been intended as illustrations for the book *1918 god* (The Year 1918) by V. Kamensky, A. Kruchenykh, and K. Zdanevich, published in Tiflis in 1917. This handmade book, a copy of which is in the collection of Alexandre Polonski, included individual collages. The final three pages in the Polonski copy are collages by Rozanova on paper which is identical in size and nature to that of the above two collages. In addition, the paper of the collage elements, including the turquoise embossed paper used in plate 1049, recurs in the examples bound into the book. Whether the two Costakis collages were extra examples, or whether they come from a dismembered copy of the book, is impossible to say.

1051 OLGA ROZANOVA(?). *UNTITLED, c. 1916. Paper collage on paper. 21.2 x 16.9 (C75). Acquired from A. Kruchenykh.*

1049

1047

1050

1048

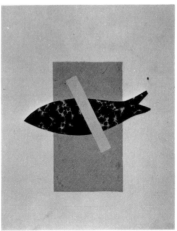

1051

O. ROZANOVA AND A. KRUCHENYKH. *VSE-LENSKAIA VOINA (UNIVERSAL WAR), Petrograd, January 1916. Paper and fabric collage on paper, printed covers, 2 pp. printed text, 11 pp. collage illustrations. Each page: 21 x 29; book: 22 x 33 (130.80). Published in an edition of 100 handmade copies. Gift to Costakis from Kruchenykh.* The preface to the book stresses the historic innovation of Rozanova's experiments in nonobjective art. The twelve poems are printed separately in columns of words on two pages at the beginning of the volume. Based upon Khlebnikov's theory that the periodicity of history can be calculated mathematically, the authors predict an outbreak of war in 1985. The illustrations, sometimes thought to be the re-sult of collaboration between Kruchenykh and Rozanova, but more probably by Rozanova alone, demonstrate the purity and originality of her 1916 nonobjective style. Her conception was clearly developed in conjunction with Kruchenykh's invention of a *zaum* (transrational) language in which the sound of a word is separated from its contextual meaning.

1052 *Front cover.*

1053 *Page 1, poems.*

1054 *Page 2, poems.*

1055 *Collage 1.*

1056 *Collage 2.*

1052

1055

1053

1056

1054

1057 *Collage 3.*
1058 *Collage 4.*
1059 *Collage 5.*
1060 *Collage 6.*
1061 *Collage 7.*

1059

1057

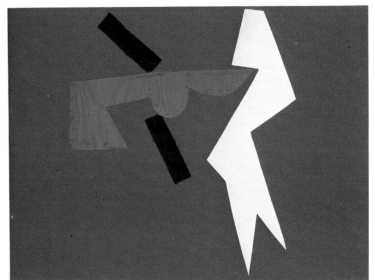

1060

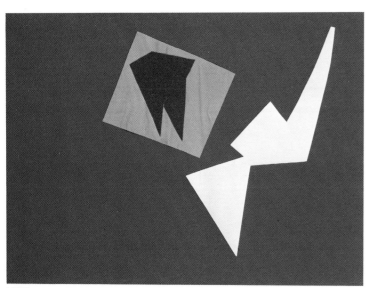

1058

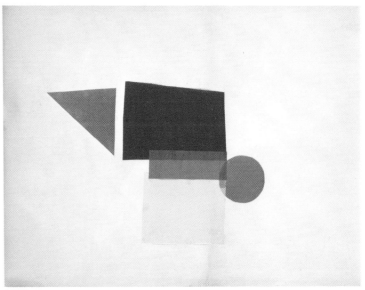

1061

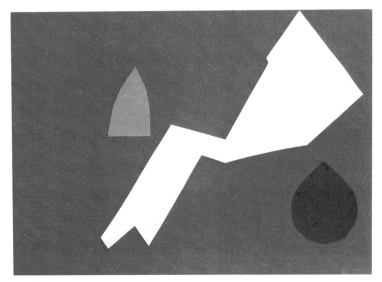

1062

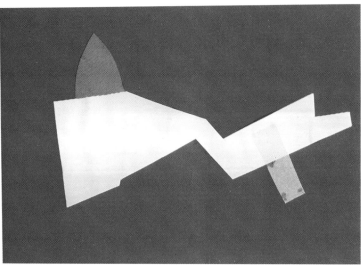

1063

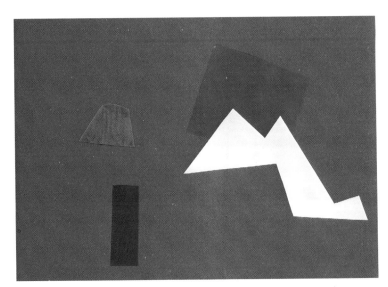

1064

1062 *Collage 8.*

1063 *Collage 9.*

1064 *Collage 10.*

1065 *Collage 11.*

1066 *Back cover.*

1067 *UNTITLED (GREEN STRIPE), 1917. Oil on canvas. 71 x 53 (251.78). Gift of I. Kachurin, who acquired it from a close friend of Rozanova. A composition with a pink stripe by Rozanova is in the collection of a Soviet museum.*

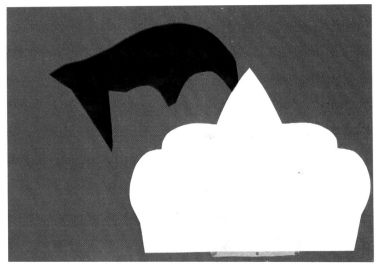

1065

1066

1067

SERGEI YAKOLEVICH SENKIN

Born Pekrovskoe-Stresknevo, near Moscow, 1894; died Moscow, 1963.

1068

In 1914–15 attended the Moscow Institute of Painting, Sculpture, and Architecture. In 1918–19 studied at Malevich's studio at the Svomas in Moscow. Spent several months in 1920 as an artist with the army at Ekaterinburg (now Sverdlovsk) in the Urals. Continued his education at Vkhutemas in 1920.

As a painter from 1918 to 1922 was affiliated with Suprematism, forming, with Klucis and Lissitzky, a special branch based on the formal principles of Malevich's system but not sharing its philosophical underpinnings. During the years 1920–21 produced a series of spatial constructions based on these principles. In 1921 visited Malevich in Vitebsk. With Klucis was a student activist. In 1921, in preparing for his diploma, held an exhibition at the student club Cézanne entitled "Thirty Works. Realism, Cubism, Futurism, Suprematism, and Spatial Suprematism." In 1922 his Suprematist works were shown at the Obedinenie novykh techenii v iskusstve (Association of New Trends in Art) exhibition in Petrograd. From 1923 was a member of LEF and wrote an article with Klucis for the journal of the same name entitled "Workshop of the Revolution."

In the 1920s and 1930s worked as a designer of mass celebrations, as a book designer, and as a magazine and poster artist. Made extensive use of photomontage. In 1928, with Lissitzky, made a large "photofresco" for the Soviet Pavilion at the "Pressa" (International Press Exhibition) in Cologne. During the 1940s and 1950s worked mainly as a designer.

The two Senkins are from the collection of the artist's daughter, N. S. Senkina, Moscow.

1068 *CITY (PHOTOMONTAGE), late 1920s. 70.5 x 62 (Tretiakov Gallery TR157). Signed l l: "Senkin. City" (Cyrillic characters); within image: "SS Senkin" (Latin characters).*

1069 *CONSTRUCTION OF THREE FORMS. UNOVIS, 1919. Oil on plywood. 49.8 x 41 (255.78). Signed and dated l r: "S. 19"; on reverse: "Senkin 1919."*

1069

ANTONINA FEDOROVNA SOFRONOVA

Born Orel, March 14, 1892; died Moscow, May 14, 1966.

In 1913 entered Ilia Mashkov's private studio in Moscow. Contributed to the 1917 *Mir iskusstva* (World of Art) exhibition in Moscow. From 1920 to 1921 taught at the State Art Studios in Tver (now Kalinin). Friend of Nikolai Tarabukin; returned to Moscow and in 1923 designed the cover of Tarabukin's book *Ot molberta k mashine* (From the Easel to the Machine). Did illustrations for newspapers, journals, and posters. In 1931 participated in the "Group 13" exhibition in Moscow; was close to Daniil Daran, Alexandr Drevin, Nikolai Kuzmin, and Lev Zhegin. In 1933 contributed to the exhibition "Artists of the R.S.F.S.R. over the Last 15 Years" in Moscow. From the late 1920s through the mid-1930s painted landscapes; continued to paint until her death.

All the works by Sofronova were acquired from the artist's daughter.

1070

These thirteen works by Sofronova all date from the year 1922.

1070 *Ink and watercolor on paper. 22.2 x 18.2 (261.78). Signed l r.*

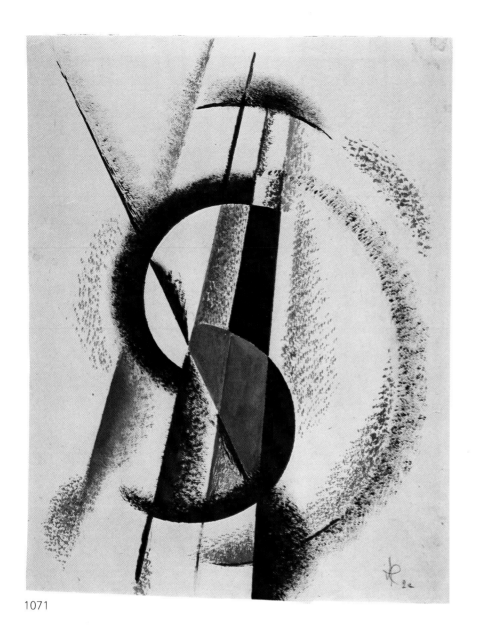

1071

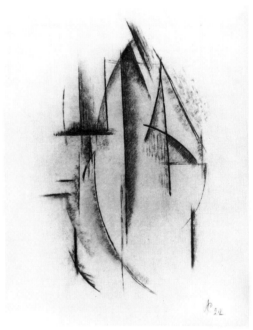

1071 *Gouache on paper. 37.1 x 29.3 (265.78a). Signed and dated l r: "22."*

1072 *Charcoal on paper. 38.8 x 30 (265.78b). Signed and dated l r: "22."*

1073 *Charcoal and gouache on paper. 38.8 x 30.3 (265.78c). Dated l r: "22."*

1074 *Charcoal on paper. 30.3 x 19.1 (C730).*

1072

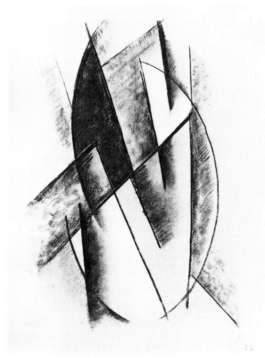

1073

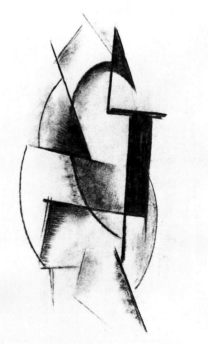

1074

1075 *Charcoal on paper. 23.4 x 15.9 (256.78).*
1076 *Charcoal on paper. 21.3 x 15.4 (257.78).*
1077 *Charcoal on paper. 19.5 x 15.7 (260.78).*
1078 *Charcoal on paper. 20.9 x 14.2 (258.78).*
1079 *Charcoal on paper. 18.6 x 15 (259.78).*

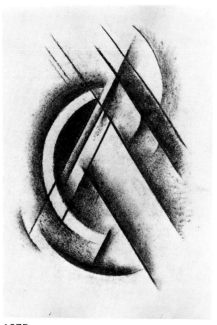

1075

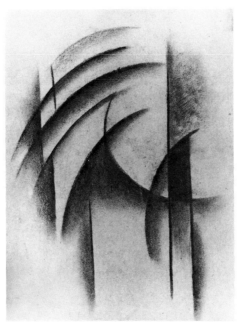

1076

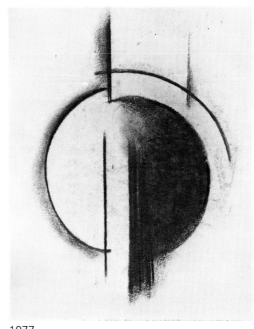

1077

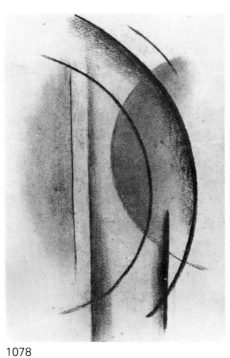

1078

1079

1080 *Watercolor and ink on paper. 24.3 x 22.1 (263.78). Signed l r.*

1081 *Ink and watercolor on paper. 21.6 x 21.1 (264.78). Signed and dated l r: "22."*

1082 *Ink on paper. 24.3 x 22.2 (262.78). Signed and dated l r: "22."*

1080

1081

1082

VARVARA FEDOROVNA STEPANOVA

Born Kaunas (Kovno), Lithuania, November 5, 1894; died Moscow, May 20, 1958.

In 1911 studied at the Kazan Art School; there met Alexandr Rodchenko, later her husband. In 1912 moved to Moscow and studied under Ilia Mashkov and Konstantin Yuon before entering the Stroganov Art Institute in 1913.

Showed work at the 1918–19 "Fifth State Exhibition: From Impressionism to Nonobjective Art" and the 1919 "Tenth State Exhibition: Nonobjective Creation and Suprematism" in Moscow. Also participated in the "Exhibition of Four" (with Kandinsky, Rodchenko, and Nikolai Sinezubov) in 1920, and in the "5 × 5 = 25" show in 1921 in Moscow. Sent work to the 1922 "Erste russische Kunstausstellung" (First Russian Art Exhibition), at the Galerie van Diemen in Berlin.

In 1919 worked with the Futurist poets and wrote *zaum* poetry; also created nonrepresentational collage and calligraphic books, including *Toft, Zigraf*, and *Rtny khomle*.

Starting in 1918 associated with IZO Narkompros and from 1920 to 1923 was a member of Inkhuk. In 1922 designed the costumes and sets for Alexandr Sukhovo-Kobylin's *Smert Tarelkina* (Death of Tarelkin), in which, under the direction of Vsevolod Meierkhold, she worked out variations on mechanical, robotlike constructions of the human figure. Also designed sets for Vitalii Zhemchuzhyi's *Vecher knigi* (Book Evening) in 1924.

In 1924 began to work as a textile designer with Popova at the First State Textile Print Factory in Moscow. From 1923 to 1928 was associated with Maiakovsky's LEF and Novyi LEF. A member of the Productivist group with Rodchenko, Popova, and Tatlin, she stressed Constructivist principles in design and taught in the textile department of Vkhutemas from 1924 to 1925. In 1925 participated in the Exposition Internationale des Arts Décoratifs et Industriels Modernes in Paris. In the late 1920s and 1930s devoted her time to book, typographical, and poster design and to cinematography.

Stepanova signed her work "Varst" and "Agra."
See also page 123.

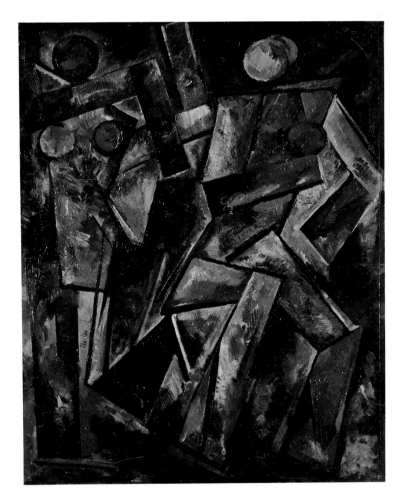

1083 *TWO FIGURES, 1920. Oil on board. 89.4 x 72.3 (266.78). Purchased from the artist. Exhibitions: "5 x 5 = 25," Moscow, 1921 (no. 2); "Erste russische Kunstausstellung," Galerie van Diemen, Berlin, 1922–23 (no. 211).*

1084 *Cover for "5 x 5 = 25" catalogue, 1921. Gouache and collage on paper. 18.6 x 12 (146.80). Signed l r. Gift to Costakis from A. Rodchenko.* Handmade exhibition catalogue with original works by Popova, Vesnin, and Stepanova. Numbered, upper left of cover and title page: "146." Interior: paper collage, gouache, hectography, and ink; sheet size: 17.8 x 11.2. 10 pp. including cover.

1085 ALEXANDR VESNIN. *Cover for "5 x 5 = 25" catalogue, 1921. Gouache and ink on cardboard. 22 x 12.5 (145.80). Signed l l. Gift to Costakis from Varvara Rodchenko.* Interior: original works by Stepanova, Vesnin, Popova, Rodchenko, and Exter; charcoal and colored crayons, gouache, ink, linocut, pencil, and hectography. 14 pp. including cover. Dedication on title verso to Costakis from Varvara Rodchenko.

1086 ALEXANDRA EXTER. *Gouache from "5 x 5 = 25" catalogue. 17.8 x 11.2 (145.80, page 6). Signed l r.*

1087 LIUBOV POPOVA. *Blue linocut from "5 x 5 = 25" catalogue. 17.8 x 11.2 (145.80, page 8). Signed l r.*

The "5 x 5 = 25" exhibition of 1921 included five works each by Exter, Popova, Rodchenko, Stepanova, and Vesnin. The catalogues were handmade, each artist contributing original works, and every copy thus having its own unique identity. In this way the notions of individuality and of collective participation are combined. It is not known how many copies of this catalogue were made, but several survive.

The exhibition took place under the auspices of Inkhuk at the All-Russian Union of Poets Club (VSP) in the fall of 1921, and while clearly representing easel art as opposed to Productivist art, it did constitute, as Rodchenko phrased it in his catalogue contribution, a "farewell to pure painting." Popova stated in her contribution that "All the present experiments are figurative, and must be regarded as a series of preparatory experiments towards concrete material constructions" (trans. in C. A. Lodder, *Constructivism: From Fine Art into Design, Russia 1913–1933*, Yale University Press, 1982). Meanwhile it is interesting to note that Tarabukin had delivered a lecture at Inkhuk, August 20, 1921, titled "The Last Picture Has Been Painted." (For a discussion of the exhibition and its importance as a turning point in the development of Constructivism see I. Aksenov, "Spatial Constructivism on Stage," *Teatralnyi Oktiabr* [Leningrad and Moscow, 1926], pp. 31ff.; also A. Nakov, *2 Stenberg 2* [London and Paris, 1975], pp. 21ff.)

1084

1085

1086

1087

The Futurists had begun in 1912 to "explode" the accepted structure of the book, directly attacking thereby the aestheticism of the Symbolists. They replaced typesetting with manuscript, printing with lithographic processes on wallpaper or cheap coarse stock. They used collage, and increasingly they freed themselves from the whole notion of the printed book. In *Gaust chaba* (1919) Stepanova added a new dimension to this process. By using sheets of newspaper as the "stock" for a manuscript book, she set up several antitheses. She used the typesetting process only in order to deny it, superimposing the artist's personal script. The text of her poems was explicitly *zaum* (transrational), while the text of the newspaper was contrastingly prosaic. The newspaper text, while comprehensible on the most basic level, was made incomprehensible and irrelevant by lateral usage, and by the imposition upon it of the diagonally placed poems and collages. Some of the collages were themselves typographical in nature, thus transposing word into picture. The final page in the book, rather than the initial one, carried the title and author's name. As E. Kovtun has written, all that remained of the book in the old sense was the fact that its pages could be turned. (See *From Surface to Space* [Cologne, 1974], pp. 57–62.)

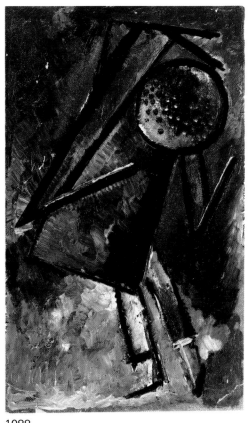

1088 *FIGURE NO. 15, 1919–20. Oil on cardboard. 45 x 28.5 (Tretiakov Gallery TR19). Gift to Costakis from the artist.*

1088

1089

1090

GAUST CHABA, 1919. Handmade book; paper collage and watercolor on newspaper (14 pp.). Page size: 27.5 x 17.5 (C489). Eight poems, six collages, plus cover. Gift to Costakis from A. Rodchenko. The newspaper carries the date 1918. The book appeared in 1919 in Moscow in an edition of 50 numbered copies, plus four separately numbered, priced at 50 rubles each. The present copy is no. 38.

1089 *Page 2, collage "illustration."*

1090 *Page 5, poem.*

1091 *Page 15, title page, with title and author's name written across collage.*

1091

NIKOLAI MIKHAILOVICH SUETIN

Born Metlevsk Station, Kaluga region, 1897; died Leningrad, 1954.

Served his military term in Vitebsk during the 1917 Revolution. From 1918 to 1922 studied at the Vitebsk Art Institute and in 1920 was a founding member of the Posnovis, later Unovis, group at the institute, under Malevich. In 1922 after Malevich's departure for Petrograd, Suetin also left Vitebsk with members of the group, including Chashnik, Lev Yudin, and Vera Ermolaeva.

In 1922 began work as a designer at the Lomonosov State Porcelain Factory, in Petrograd, with Malevich and Chashnik. From 1924 to 1926 was affiliated with Ginkhuk and around this time worked with Malevich on architectural constructions (*arkhitektony* and *planity*). In 1932 was appointed artistic director of the Lomonosov Factory; remained until 1952. Helped design the Soviet pavilions at the Exposition Internationale in Paris in 1937 and at the New York World's Fair of 1939.

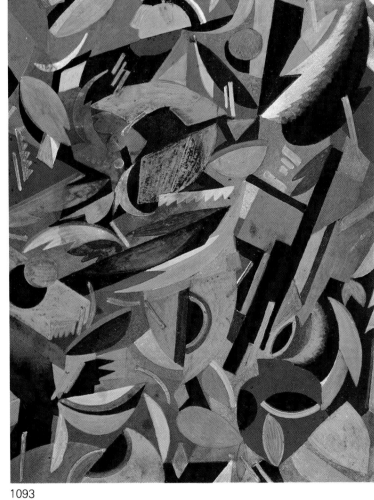

1093

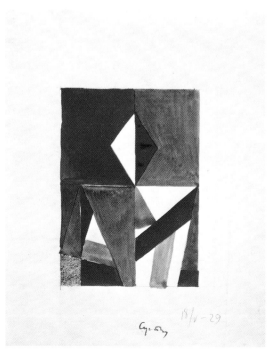

1092

1092 *UNTITLED, May 18, 1929. Pencil, gouache, and ink on paper. 22 x 17.5 (C673). Dated and signed along lower edge:* "18/V–29. Suetin."

1093 *UNTITLED, n.d. Gouache on paper. 39.4 x 30 (267.78). On reverse:* "Suetin."

1094 left. NIKOLAI SUETIN AND V. F. RUKA-VISHNIKOV. *Cup and saucer. Painted porcelain. Height of cup: 6.6; diameter of saucer: 13.5 (C796, C797). Inscribed on reverse of both cup and saucer:* "Drawing by N. M. Suetin, executed by V. F. Rukavishnikov"; *also imperial stamp.*

1094 right. NIKOLAI SUETIN. *Saucer, 1923. Painted porcelain. Diameter: 15.8 (C798). Executed at the Petrograd porcelain factory. Inscribed on reverse:* "474/KNP5 1918–1923"; *with hammer and sickle.*

1095 NIKOLAI SUETIN. *Small coffeepot, saucer, cup, bowl, and large coffeepot, 1923. Porcelain (ATH80.29). Executed at the Petrograd porcelain factory. Each of the pieces carries on the bottom the stamp of the Petrograd porcelain factory* "KNP," *the dates* "1918–23," *with hammer and sickle, the word* "Suprematism," *a black square followed by a number, and the phrase* "after a drawing by N. Suetin."

1096 NIKOLAI SUETIN?. *Inkwell, late 1920s. Porcelain (ATH80.28). Executed at the Petrograd porcelain factory. On bottom: hammer and sickle.*

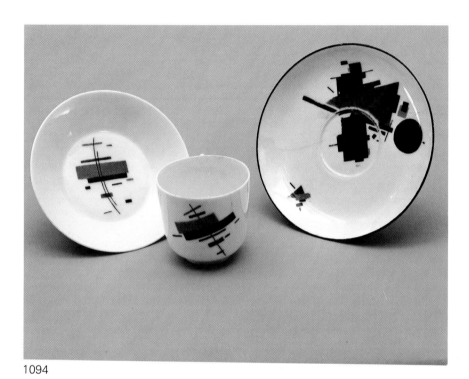

1094

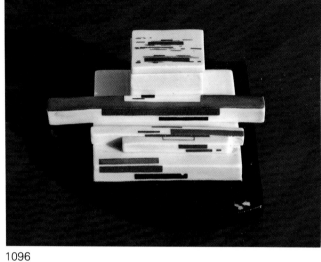

1096

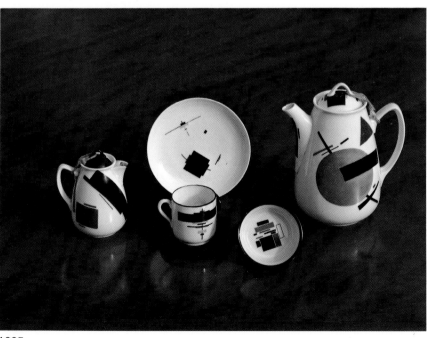

1095

VSEVOLOD ANGELOVICH SULIMO-SAMUILO

Born Veliki Luki, 1902; died Leningrad, May 26, 1965.

In 1922 – 24 studied at the State Art-Industrial Technicum, Petrograd, under Paul Mansurov and Mikhail Bobyshev. From 1926 to 1928 attended the Collective of Masters of Analytical Art, headed by Filonov. As a member of the collective in 1927 participated in shows at Leningrad's Press House. Showed also at "Sovremennye leningradskie khudozhestvennye gruppirovki" (Contemporary Leningrad Art Groups) in 1929 and the "Pervaia obshchegorodskaia vystavka izobrazitelnykh iskusstv" (First Citywide Arts Show) in Leningrad in 1930. Worked later as an exhibition and interior designer and in industrial graphics.

All the works by Sulimo-Samuilo (also spelled Sulimo-Samoilo and Sulimo-Samoilov) came from the collection of the artist's widow, N. Ieratova, Leningrad.

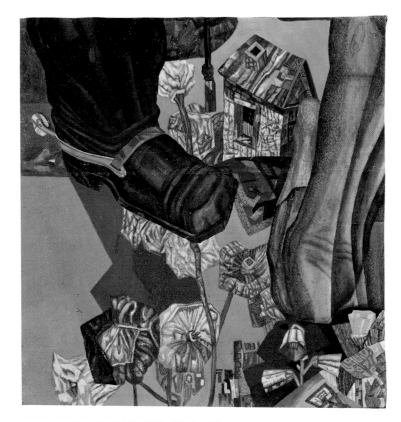

1097 *PANEL FRAGMENT, 1927. Oil on canvas. 70.5 x 67 (269.78).* Each of the fragments in this collection was part of a large project undertaken by Filonov's school for the House of Printing, Leningrad. Filonov himself closely supervised the work of the other artists and often made corrections. The mural was ultimately rejected and was later cut up into sections.

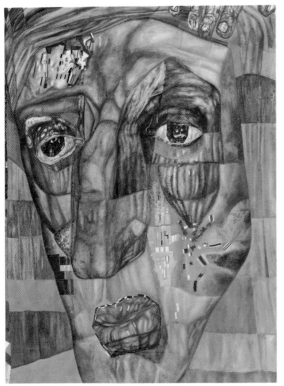

1098

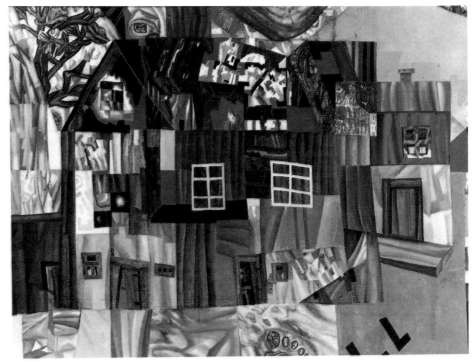

1100

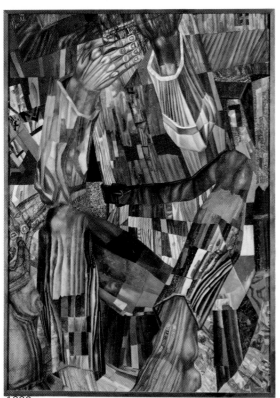

1099

1098 *HEAD (PANEL FRAGMENT), 1927. Oil on canvas. 135 x 95.5 (Tretiakov Gallery TR42).*

1099 *FRAGMENT WITH FIGURE, 1927. Oil on canvas. 136.9 x 97 (268.78).*

1100 *FRAGMENT OF A PANEL (WITH HOUSES), 1927. Oil on canvas. 68.6 x 94 (270.78).*

VLADIMIR EVGRAFOVICH TATLIN

Born Moscow, December 12, 1885; died Moscow, May 31, 1953.

Son of an engineer; spent his childhood in Kharkov, where he completed technical high school. Information on Tatlin's early years is somewhat contradictory, but it has been established that in 1902 he went to sea with the Russian Steamship and Trade Society as a merchant seaman, stopping in Bulgaria, North Africa, the Near East, Greece, and Turkey. About 1904 entered the art school in Penza, but his studies were frequently interrupted by voyages at sea. In 1907 or 1908 visited Larionov in Tiraspol; in 1909, at Larionov's urging, entered the Institute of Painting, Sculpture, and Architecture in Moscow; expelled.

Exhibited at the second Izdebsky salon in Odessa in 1910–11. In the winter of 1911 organized a studio called The Tower in Moscow's Ostozhenka; it was visited at various times by Alexandr Vesnin, Popova, and Udaltsova. From 1911 to 1914 participated in all the Soiuz molodezhi (Union of Youth) exhibitions in St. Petersburg. Also in 1911 designed the scenery for the Soiuz molodezhi's St. Petersburg production of M. M. Tomashevsky's play *Tsar Maximilian i ego neposlushnyi syn Adolf* (Emperor Maximilian and His Disobedient Son Adolph); however, the scene painters executed the designs so carelessly that Tatlin denied authorship. In the period 1912–14 worked on a series of sketches for scenery and costumes for Mikhail Glinka's opera *Zhizn za Tsaria* (*A Life for the Tsar*; in the U.S.S.R. now retitled *Ivan Susanin*). During the years 1911 to 1912 remained close to Larionov and took part in his 1912 "Oslinyi khvost" (Donkey's Tail) exhibition in Moscow. After this exhibition broke with Larionov and participated in the French-influenced 1913 "Bubnovyi valet" (Jack of Diamonds) exhibition in Moscow and St. Petersburg. Also showed work at the 1913 *Mir iskusstva* (World of Art) exhibition in Moscow and St. Petersburg, and at the 1912–13 and 1914 winter "Sovremennaia zhivopis" (Contemporary Painting) exhibitions in Moscow.

In 1913 traveled to Berlin, as a bandore player with a Russian dance group, and later to Paris, where he visited Picasso's studio and, almost certainly, saw Picasso's Cubist constructions. After returning to Russia began to work on his own reliefs and counter-reliefs.

In May 1914, in his Moscow studio, held an exhibition of his first reliefs, "sintetichesko-staticheskie kompozitsii" (synthetic-static compositions). Lived in Moscow but spent long periods in Petrograd, where a circle of young artists formed around him, including Lev Bruni and Petr Miturich, and the critic Nikolai Punin.

In 1915 participated in all the major avant-garde shows, including "Tramvai V. Pervaia futuristicheskaia vystavka kartin" (Tramway V: First Futurist Exhibition of Paintings) and "The Last Futurist Exhibition of Pictures: 0.10" in Petrograd. At the latter distributed his pamphlet on reliefs while Malevich distributed one on Suprematism. Tension began to develop between the two artists. Tatlin also exhibited in the "Vystavka zhivopisi 1915 god" (Exhibition of Painting: 1915), in Moscow, for which reliefs were hastily put together by himself, Larionov, Burliuk, Maiakovsky, and Lentulov.

In 1916 organized the "Magazin" (The Store) exhibition in Moscow, in which Malevich participated, but showed no Suprematist work.

In 1917, after the February Revolution, worked with Yakulov and Rodchenko on the interior of the Café Pittoresque in Moscow. From the summer of 1918 headed IZO Narkompros and in January of 1919 was appointed head of the Department of Painting at the Moscow Svomas. From early 1919 to 1921 he was an instructor in Petrosvomas, where his workshop was called Studio for Volumes, Materials, and Construction. He began work on a plan for a monument with movable parts, which was later transformed into the *Monument to the Third International*. In November 1920 the twenty-foot-high model for this tower was shown in Petrograd and in December in Moscow. In 1921 became head of the Department of Sculpture at the restructured Academy of Arts in Petrograd.

In 1922 showed work at the Obedinenie novykh techenii v iskusstve (Association of New Trends in Art) exhibition in Petrograd. Also participated in the "Erste russische Kunstausstellung" (First Russian Art Exhibition), at the Galerie van Diemen in Berlin. Starting in 1923 was involved with Inkhuk and helped to form the Petrograd Ginkhuk, in 1924; organized the production of Velimir Khlebnikov's poem *Zangezi*. In 1923 also showed work at the "Vystavka kartin petrogradskikh khudozhnikov vsekh napravlenii" (Exhibition of Paintings of Petrograd Artists of All Tendencies).

In the mid-1920s became interested in applied design. In 1925 sent work to the Exposition Internationale des Arts Décoratifs et Industriels Modernes in Paris. From 1925 to 1927 taught formal disciplines in the theater and cinema department of the Art Institute in Kiev; then returned to Moscow to teach the culture of materials in the departments of wood- and metalworking and ceramics at Vkhutein, where he conceived his project for a man-propelled glider called *Letatlin* (*letat* = "to fly"). He continued to work in theater design and later returned to figurative painting.

1101

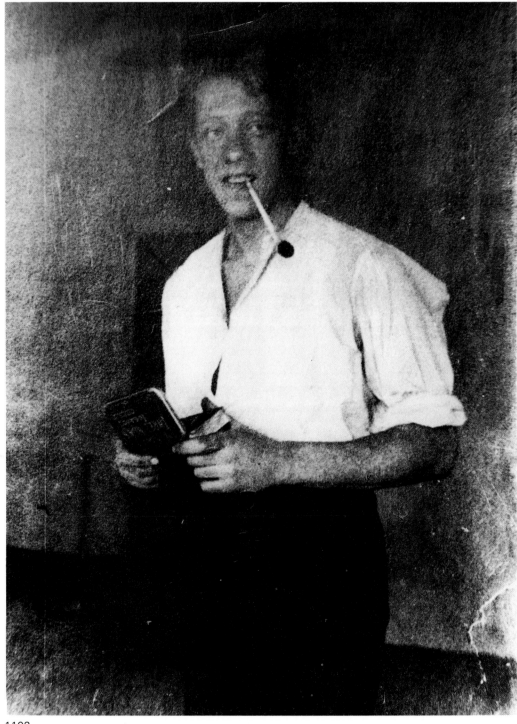

1101 *YOUNG FISHERMAN, c. 1919. Ink wash on paper mounted on oval paper. Diameter at widest point: 32.5 (272.78). Authenticated on reverse by the artist's widow, A. M. Korsakova. Not signed or dated. Acquired from A. M. Korsakova. The design, related to Tatlin's work of 1910–11, is similar to others made after the Revolution for use in the porcelain factory in Petrograd.*

1102 *Undated photo of Tatlin.* Photographer unknown.

1102

1103 *SKETCH FOR STAGE SET OF GLINKA'S "IVAN SUSANIN," 1912–14. Oil on plywood. 54.5 x 98.5 (Tretiakov Gallery TR39). Purchased from a private collection, Moscow.* Tatlin's designs were for a production in Moscow which apparently never took place, and the director who commissioned his work has not been identified. Two studies for the production were already owned by the Tretiakov Gallery when Costakis gave them this third one, and eight additional drawings for the production are in a sketchbook in the Central State Archive of Literature and Art, Moscow (fond 2089, Archive 1, no. 2).

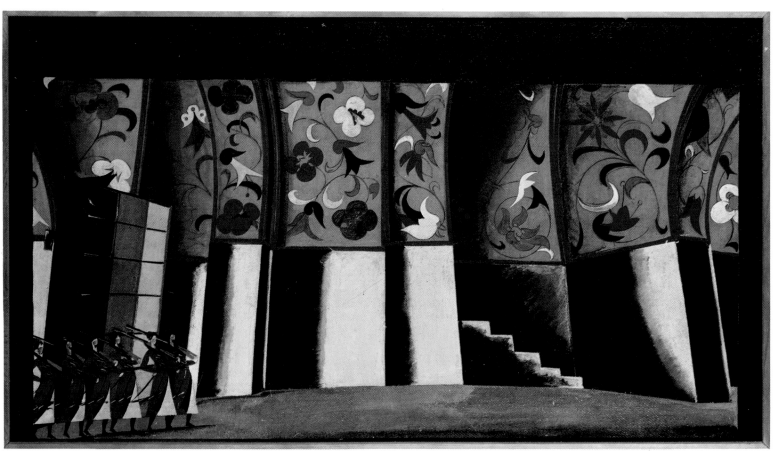

1103

1104 *NUDE, c. 1911–13. Pencil on paper. 42.8 x 25.8 (271.78 recto). Not signed or dated. Acquired from A. M. Korsakova, who attributed the work to Tatlin.*

1105 *NUDE, c. 1911–13. Pencil on paper. 42.8 x 25.8 (271.78 verso).*

1106 *NUDE, 1927. Pencil on paper. 31.8 x 22.4 (C753). Not signed; dated l r: "Jan. 26, 1927."*

1107 *NUDE. Pencil on paper. 22 x 17.2 (C133). Not signed or dated. Acquired from A. M. Korsakova, who attributed the work to Tatlin.*

1104

1105

1106

1107

1108 *RELIEF, c. 1914–17?. Metal and leather on wood. 63 x 53 (Tretiakov Gallery TR38). Not signed or dated. Some elements possibly lost.* This work, purchased about 1960 from I. Sanovich, was acquired by him from K. Zelinsky, Tatlin's pupil and friend. It had been found by Zelinsky in the tower at the Novodevichii Monastery on the outskirts of Moscow, where the *Letatlin* had been constructed and where Tatlin had his studio for several years afterward. According to V. Rakitin, it was shown in Tatlin's first exhibition of painted reliefs, May 10–14, 1914.

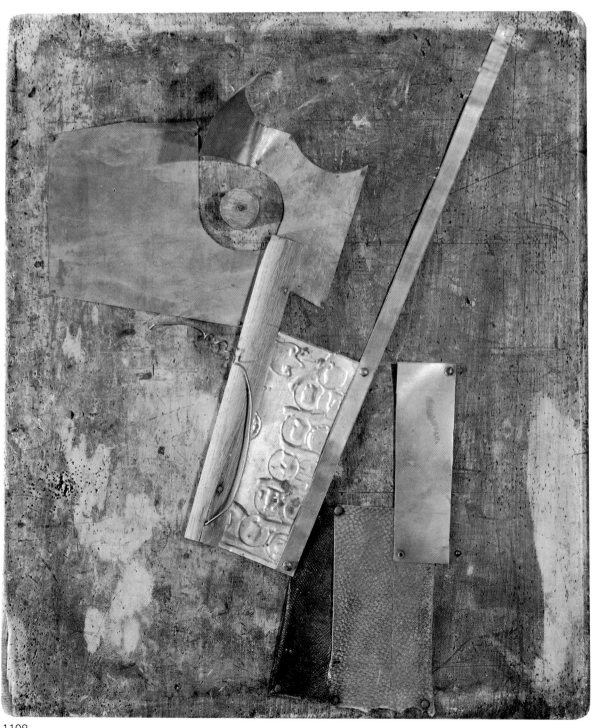

1108

1109 *DRAWING FOR A COUNTERRELIEF (?),
c. 1915. Pencil on paper. 15.7 x 23.5 (300.80).
Not signed or dated.*

1110 *Photograph from printed brochure "No-
vyi zhurnal dlya vsekh" (New Magazine for
Everyone), Petrograd, December 17, 1915.* This
brochure about Tatlin, a copy of which is owned
by Costakis, was distributed at the "0.10" ex-
hibition.

1111 *DRAWING FOR A CORNER COUNTER-
RELIEF, c. 1915. Charcoal on brown paper.
23.3 x 15.7 (299.80). Not signed or dated.* Pos-
sibly a study for one of the corner reliefs exhib-
ited at the December 1915 "0.10" exhibition
(see plate 1110).

1109

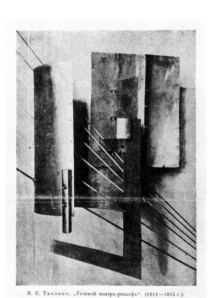

1110

1111

1112

1112 *TREE, c. 1940s. Oil on paper. 35.5 x 49.8 (1083.80). Purchased in New York from a Russian immigrant.*

1113 *PORTRAIT OF A WOMAN, 1933. Oil on wood. 55 x 47 (Tretiakov Gallery TR41). Acquired from Tatlin's stepdaughter, who was the daughter-in-law of the artist-playwright Vasilii Kamensky (see plates 1132ff.).*

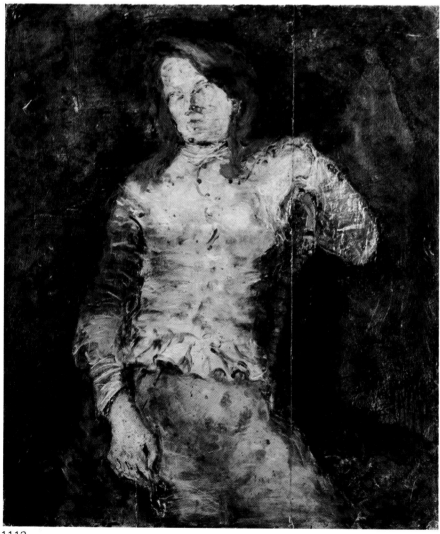

1113

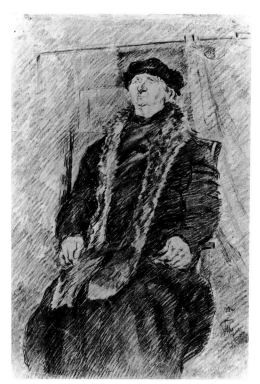

1114

1114 *PORTRAIT OF A MAN, 1939. Pencil on paper. 46.5 x 30.9 (C149). Signed and dated l r: "39 Tatlin." Acquired from A. M. Korsakova.*

1115 *PREPARATORY DRAWING FOR ILLUS-TRATIONS TO "VO-PERVYKH I VO-VTORYKH" (FIRSTLY, SECONDLY) BY DANIIL KHARMS, Leningrad, 1929. Wax crayon, pencil, and ink on paper. 37.9 x 27.9 (C166). Not signed or dated. Acquired from A. M. Korsakova.* The cover and nine illustrations for this children's book were by Tatlin. Several other preparatory drawings from this series were included in Costakis's gift to the Tretiakov.

1116 *MEAT, 1947. Oil on canvas. 56 x 67 (Tretiakov Gallery TR40). Purchased from A. M. Korsakova.*

1117 *PORTRAIT OF ALEXANDR VASILIEVICH SHCHIPITSYN, c. 1940?. Pencil on paper. 44 x 32.3 (195.80). Inscribed on reverse to the art critic Vladimir Kostin, who gave it to Costakis.* Shchipitsyn, who was one of the assistants on the *Letatlin* project, was a pupil of Tatlin and in Tatlin's later years one of his closest friends.

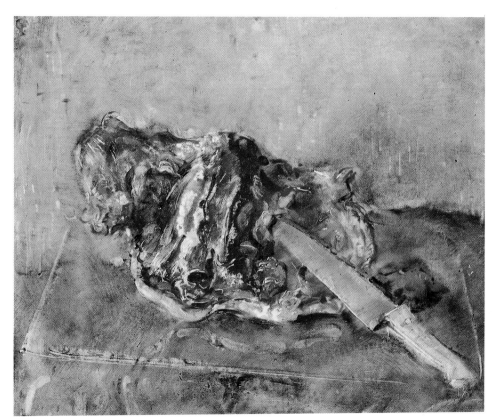

1116

1115

1117

Tatlin worked on his invention, the *Letatlin*, for several years starting in 1929. His intention was that the air bicycle, propelled by man not by motor, would be put into general production and used by ordinary people. The *Letatlin*—a word coined by the artist out of the Russian verb *"letat"* (to fly) and his own name—was thus conceived simultaneously as a utilitarian construction and as a work of art. Tatlin was utterly persuaded of both its practicability and its aesthetic quality: "Now art is entering into technology." He based his technical solutions on his observations of birds, specifically a group of young cranes which he kept and watched closely, and probably on a set of calculations by a leading pioneer in rocket research, K. E. Tsiolkovsky. (See T. Andersen, *Vladimir Tatlin* [Stockholm: Moderna Museet, 1968], pp. 9–10.)

As the pilot K. Artseulov wrote in 1932, the materials were chosen with extreme care, entirely on the basis of their flexibility and their ability to function. The willow wood was split rather than sawed or cut, so that the internal fibers were preserved full length. With the help of steam, the long strips of wood were then molded, pressed, and twisted into complicated octagons of bent wood, giving them strength, elasticity, and powers of resistance to the rotation and movement of the wings. The ratio of the weight of the wings to the weight of the entire mounted machine was 1:6—corresponding to the ratio of wings to body in most birds.

One of Tatlin's pupils, Kornelii Zelinsky, quoted him as saying: "I want to give back to man the feeling of flight.... We have been robbed of this by the mechanical flight of the aeroplane. We cannot feel the movement of our bodies in the air" ("Letatlin," *Vecherniaia Moskva*, April 6, 1932: trans. in Andersen,

op. cit.). As Zelinsky reported, Tatlin rejected the harsh lines of technological machinery, preferring the rounded nature of organic forms. The surviving wing strut in the Costakis collection, though only a fragment, eloquently exhibits these precise qualities.

1118 *Photograph of "Letatlin," c. 1932.*
1119 *Line drawing of "Letatlin" in operation.*

1118

1119

1120 *WING STRUT FOR "LETATLIN," 1929–32. Willow and cork. Length: 240 (273.78).*

1121 *Detail of "Letatlin" wing strut.* Tatlin gave the wing strut, which was apparently one of several extra pieces, to K. Zelinsky, who had helped to build the glider *Letatlin* (plates 1118 and 1119). When Costakis first offered to purchase the strut, Zelinsky refused to sell it, explaining that too many memories were associated with the piece and he could not part with it. He promised that in the event of his death, however, Costakis would be offered the opportunity to buy it. In 1976 Zelinsky's young widow came to Costakis with the offer, which he promptly accepted.

Zelinsky's association with the *Letatlin* is well documented. Together with three other pupils—Sotnikov, Pavilionov, and Shchipitsyn—he worked with Tatlin in a tower at the Novodevichii Monastery. Zelinsky's article on the project, first published in 1932, has become perhaps the main source of information on the undertaking.

1120

Photos: Robert E. Mates

1121

NADEZHDA ANDREEVNA UDALTSOVA

Born Orel, 1886; died Moscow, 1961.

In 1892 her family moved to Moscow. Beginning in 1905 studied at the Moscow Institute of Painting, Sculpture, and Architecture, and in 1906 attended Konstantin Yuon's private art school; there developed an interest in Viktor Borisov-Musatov's lyrical Symbolism. In 1909 worked on the study of space with a group of Simon Hollósy's students, including Vladimir Favorsky and Konstantin Istomin, and attended the private studio of Istvan Kiss. In the winter of 1912, together with Popova, visited the Paris studios of Metzinger, Le Fauconnier, and Segonzac. Also studied the work of Picasso and Poussin, as well as seventeenth-century Dutch painting and medieval stained-glass windows. Was perhaps the closest to the Paris school of all the Russian avant-garde.

In 1913 in Moscow worked in Tatlin's studio, The Tower, and was in contact with Popova, Alexandr Vesnin, and Alexei Grishenko. Participated in the 1914 "Bubnovyi valet" (Jack of Diamonds) exhibition in Moscow and in 1915 in "Tramvai V. Pervaia futuristicheskaia vystavka kartin" (Tramway V: First Futurist Exhibition of Paintings) in Petrograd. Also contributed to the 1915–16 "The Last Futurist Exhibition of Pictures: 0.10" in Petrograd and the 1916 "Magazin" (The Store) exhibition in Moscow. From 1916 to 1917 was a member of the Supremus group, and worked on the journal of the same name, which never appeared.

After the February Revolution of 1917, participated in the interior design of the Café Pittoresque in Moscow with Tatlin and Yakulov and worked in IZO Narkompros. From 1918 onward taught at the Svomas in Moscow — first as an assistant to Malevich and later as a professor of painting. Member of Inkhuk in 1920–21. From 1921 to 1934 taught at Vkhutemas/Vkhutein; there met Drevin, whom she later married. In 1922 sent works to the "Erste russische Kunstausstellung" (First Russian Art Exhibition), at the Galerie van Diemen in Berlin. In the late 1920s returned to painting in a naturalistic style, greatly influenced by Drevin.

All the Udaltsovas were acquired from Andrei A. Drevin, son of the artist and of Alexandr Drevin.
See also page 125.

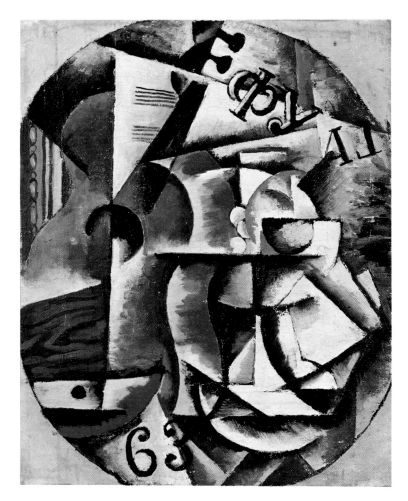

1122 *GUITAR (FUGUE), 1914. Oil on canvas. 53 x 43 (Tretiakov Gallery TR37). Authenticated on reverse by the artist's son.*

1123 *NUDES IN A LANDSCAPE, 1914. Watercolor and pencil on paper. 26.1 x 34.9 (C346).* According to an inscription on the reverse, by the artist's son, this is a study for a painting now in the museum in Perieslava Zalieski. Also on the reverse is a detailed pencil study for the left-hand figure.

Udaltsova's style is less rigorous, dynamic, and sculpturally articulated than Popova's 1914 style, revealing a clearer debt to the French examples of Léger and Le Fauconnier, and less responsiveness to the work of Tatlin.

1124 *SEAMSTRESS, 1912–13. Oil on canvas. 70.5 x 70 (Tretiakov Gallery TR36). Authenticated on reverse by the artist's son.*

1123

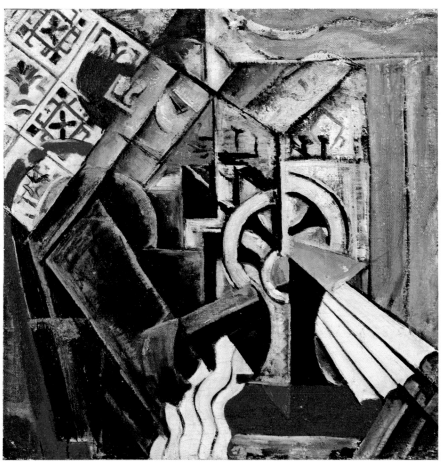

1124

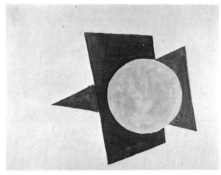

1125

1125 *UNTITLED, c. 1918–20. Watercolor on paper. 18.6 x 24 (199.80). Dated on reverse by the artist's daughter-in-law: "1916."*

1126 *DESIGN FOR FABRIC, c. 1921?. Watercolor and pencil on paper. 27.6 x 20 (198.80). Dated on reverse by the artist's daughter-in-law: "1916."*

1127 *UNTITLED, c. 1918–20. Gouache and pencil on paper. 24.6 x 15.9 (200.80). Dated on reverse by the artist's daughter-in-law: "1916."*

1128 *UNTITLED, c. 1920. Gouache on paper. 64 x 44.5 (ATH80.18).*

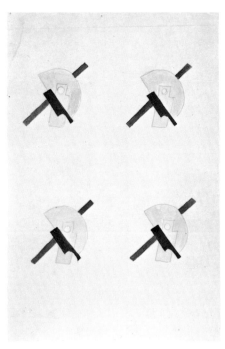

1126

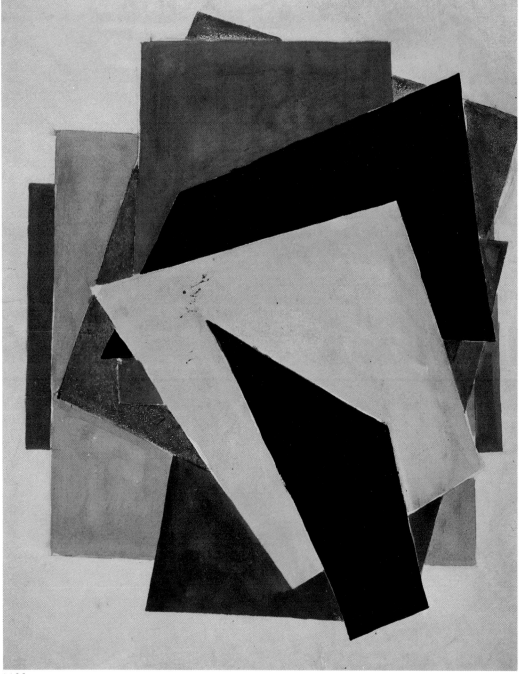

1128

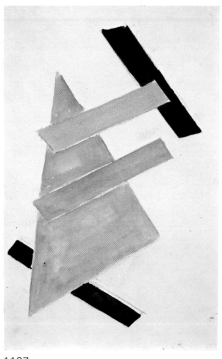

1127

1129 *UNTITLED, c. 1920. Gouache on paper. 32.5 x 24 (ATH80.20).*

1130 *UNTITLED, c. 1918. Watercolor on paper. 48 x 40 (ATH80.21).*

1131 *UNTITLED, c. 1920. Gouache on paper. 48 x 38.5 (ATH80.19).*

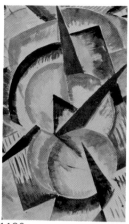

1130

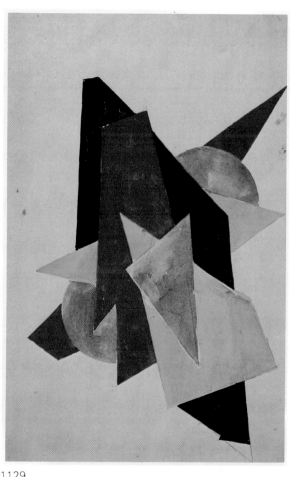

1129

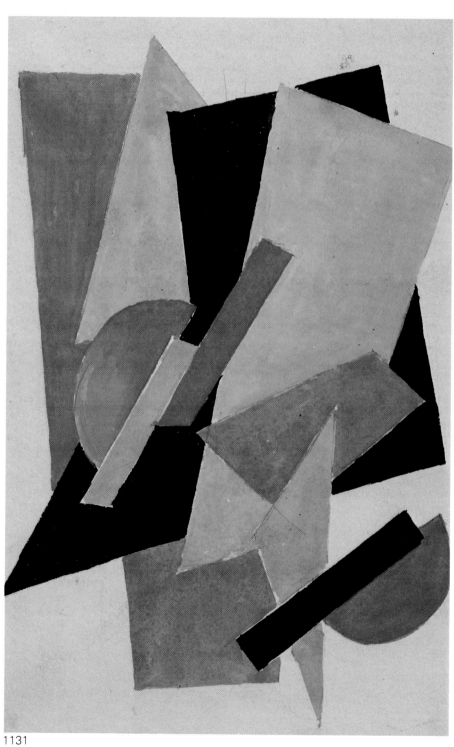

1131

KONSTANTIN ALEXANDROVICH VIALOV

Born Moscow, April 6, 1900; died 1976.

From 1914 to 1917 attended the Stroganov Art Institute in Moscow, specializing there in textile design. From 1917 to 1923 studied in Moscow under Lentulov and Morgunov at the Svomas, later Vkhutemas. In 1925 became a member of OST and participated in its exhibitions from 1925 to 1928.

Worked as a stage designer and contributed to productions such as Vasilii Kamensky's *Stenka Razin* in 1924. Was also a poster designer and book illustrator. At the end of the 1920s turned to painting simple landscapes.

All the Vialovs were purchased from the artist.

1132 *COSTUME DESIGN FOR PRODUCTION OF "STENKA RAZIN" BY VASILII KAMENSKY, 1923–24. Watercolor, pencil, and gold paint on paper. 26.8 x 17.9 (817.79). Signed on reverse. Inscribed u r:* "War leader N. 11. Ageinchinkov"; *l r:* "caftan/ bloomers/ belt/ fur coat/ headgear." E. G. Ageinchinkov was the actor who played the role of the war leader in Kamensky's play, which had its premiere at the Theater of the Revolution in Moscow on February 6, 1924. Vialov was responsible for designing the sets and costumes. The director was Valerii Mikhailovich Bebutov, a student and colleague of Meierkhold.

1133 *COSTUME (OR CLOTHING?) DESIGN, c. 1924–26. Pencil and gouache on paper. 25 x 14.6 (820.79). Illegible inscription across top.*

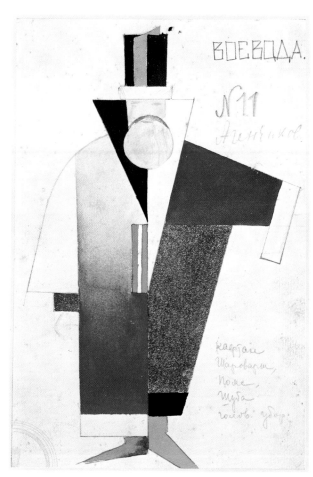

1132

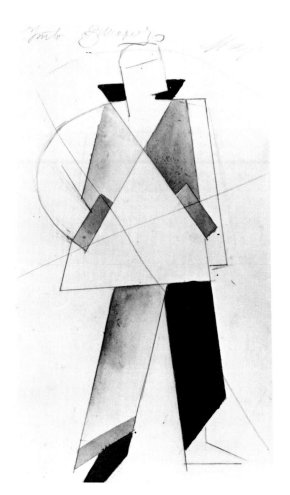

1133

1134 *SKETCHES FOR PRODUCTION OF "STENKA RAZIN," 1923–24. Gouache and pencil on paper. 26.5 x 35.6 (821.79). Inscribed: "Victory banquet on the river"; "Victory banquet on the Volga"; "Feast in Persia"; "Freebooters in Persia."* On reverse some additional sketches in pencil.

1135 *SKETCH FOR PRODUCTION OF "STENKA RAZIN," 1923–24. Gouache and pencil on paper. 15.2 x 14.3 (812.79). Not signed or dated.* This set, in polished final form, is repro-

duced in *Zrelishcha* 74 (1924), p. 4, and the set is identified as Vialov's construction for *Stenka Razin.*

1136 *SET DESIGN, c. 1924–26. Ink and pencil on paper. 16.7 x 14.2 (813.79). Not signed or dated.*

1137 *SKETCH FOR PRODUCTION OF "STENKA RAZIN," 1923–24. Gouache and pencil on paper. 28.4 x 23.8 (811.79). Signed l r: "Vialov." Inscribed u l: "Sarin na kichku!"*

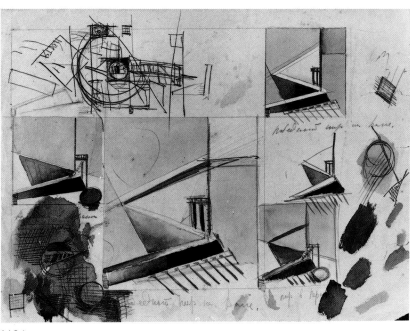

1134

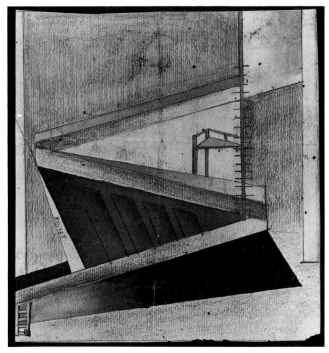

1135

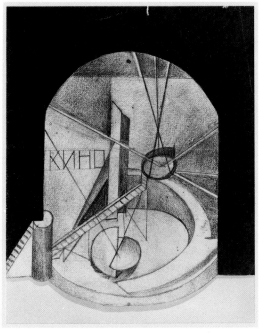

1136

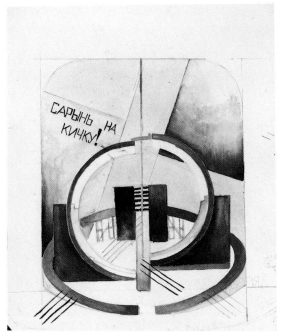

1137

1138, 1139 ISAAK RABINOVICH?. *TWO COS-
TUME DESIGNS PROBABLY FOR THE STATE
JEWISH THEATER, c. 1927–28. Crayon and
pencil on folded paper. 33.9 x 42.5 (C719).
Rabinovich, born in 1894, died in 1961, was a
theatrical designer who studied with Exter and
worked for the State Jewish Theater.*

1140 *UNTITLED. Pencil on board. 26.2 x 17.7
(236.80). Not signed or dated.*

1141 *STILL LIFE, c. 1918. Charcoal and water-
color on paper. 29.6 x 27 (230.80). Not signed
or dated.*

1138

1140

1139

1141

1142

1143

1144

1142 *SEATED WOMAN, c. 1919.* Watercolor, charcoal, and pencil on paper. 24.6 x 15.3 (303.80). Not signed or dated.

1143 *NUDE, 1918.* Charcoal and colored pencil on paper. 36.4 x 27.2 (232.80). Dated l l: "1918."

1144 *NUDES, c. 1918.* Charcoal and colored pencil on paper. 27.1 x 36.5 (234.80). Not signed or dated.

1145 *HEAD OF A MAN, 1919.* Pencil and crayon on paper mounted on paper. 24.3 x 15.2 (304.80). Signed l r: "K. Vialov"; dated l l: "1919."

1146 KONSTANTIN VIALOV ?. *SEATED FIGURE WITH GUITAR, c. 1918?.* Pencil on paper mounted on paper. 32.5 x 20.1 (235.80). Inscribed l r, not by the artist: "Sketch, Vialov, 1922." The inscribed date, added much later, is difficult to accept; the work is stylistically close to Vialov's 1918 student studies after Cubism, but could be by another hand.

1147 *SEATED NUDES, 1918.* Charcoal and colored pencil on paper. 27.2 x 37 (233.80). Signed and dated l c: "1918/ K. Vialov."

1148 *TWO SEATED FIGURES, 1918.* Charcoal and colored pencil on paper. 27.2 x 36.4 (231.80). Dated l r: "1918."

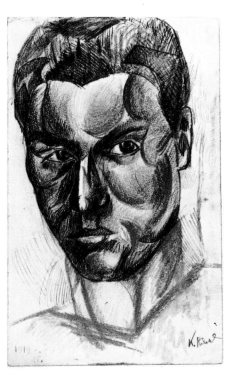

1145

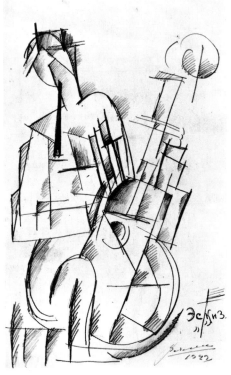

1146

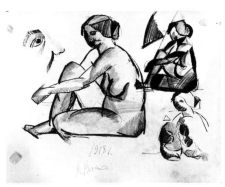

1147

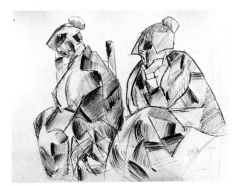

1148

The four watercolors that follow demonstrate Vialov's contact in 1921 with the work of Kandinsky, who left the U.S.S.R. for the Bauhaus by the end of that year.

1149 *UNTITLED, 1921. Three watercolors on paper mounted on cardboard. Left to right: 16.6 x 11.9 (229.80a); 16.7 x 10.6 (229.80b); 17.1 x 12.1 (229.80c), signed: "K. Vialov."*

1150 *UNTITLED, 1921. Watercolor on paper. 24.1 x 26.9 (228.80). Dated u l: "1921"; signed l r: "Vialov."*

1151 *UNTITLED, 1920. Gouache and pencil on paper mounted on board. 19.6 x 17.8 (227.80). Signed and dated along lower edge: "K. V. 1920."*

1152 *DESIGN FOR CLOTHING, c. 1924–26. Pencil on paper. 29.7 x 17 (818.79). Not signed or dated.*

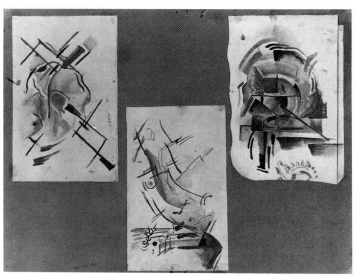

1149

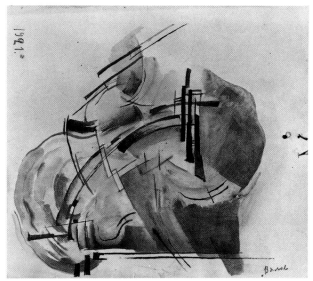

1150

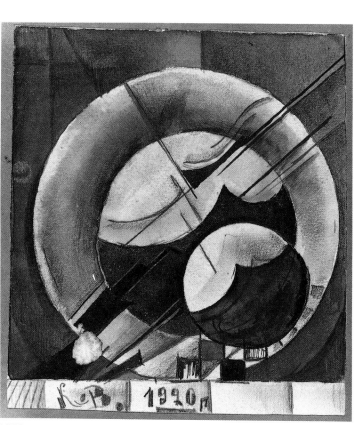

1151

1152

1153 *TWO DESIGNS FOR CONSTRUCTIONS OR RADIO TOWERS, 1922. Pencil on paper mounted on paper. Left image: 20.5 x 9.1, dated "1922"; right image: 23.3 x 11.2 (815.79), dated: "1922."*

1154 *DESIGN, POSSIBLY FOR THEATER SET, 1922. Gouache and pencil on paper mounted on board. 15.3 x 12.8 (814.79). Signed and dated l r: "K. Vialov, 1922."*

1155 *DESIGN FOR CONSTRUCTION OR THEATER SET(?), 1923. Gouache and pencil on paper mounted on purple paper. Image: 25.7 x 16.2 (816.79). Dated and signed l r on mount: "1923 K. Vialov."*

1156 *UNTITLED, 1923. Gouache and pencil on paper mounted on brown paper. Image: 21.2 x 16.3 (810.79). Dated and signed l r: "1923 K. Vialov."*

1153

1154

1155

1156

ALEXANDR NIKOLAEVICH VOLKOV

Born Fergana, Uzbekistan (Central Asia), August 31, 1886; died Tashkent, December 17, 1957.

After graduation from the Corps of Cadets in Orenburg, studied from 1908 to 1911 at the natural sciences faculty of the University of St. Petersburg and simultaneously, from 1908 to 1910, at the Higher Art Institute of the Academy of Arts, with Vladimir Makovsky. From 1910 to 1912 studied at the private studios of Mikhail Bernshtein, Nikolai Roerich, and Ivan Bilibin, and from 1912 to 1916 attended the Kiev Art School, studying with Fedor Krichevsky.

In 1916 returned to Central Asia; took up residence in Tashkent and taught at the Art Institute.

Volkov's paintings of the years 1917 to 1924 unite the traditions of the icon, Oriental art, and the paintings of Mikhail Vrubel with the geometry of stained glass and traces of both Cubism and Suprematism. Showed his works at exhibitions in Tashkent, at the 1922 "Erste russische Kunstausstellung" (First Russian Art Exhibition), at the Galerie van Diemen in Berlin, and at a one-man show in Moscow in 1923. Traveled widely, wrote poetry.

All the Volkovs were acquired from the artist's two children, V. and A. Volkov.

1157 *TEAROOM, 1920. Gouache on cardboard. 22 x 30 (Tretiakov Gallery TR154).*

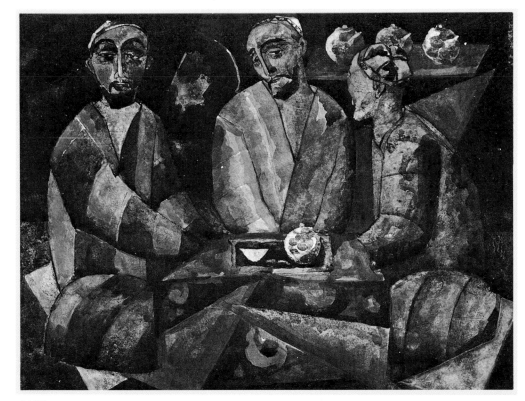

1157

1158 *NUDES, 1920. Gouache on cardboard. 24 x 29.5 (Tretiakov Gallery TR153).*

1159 *CARAVAN, 1920. Tempera on paper mounted on board. 20.5 x 40.3 (279.78). Signed l r: "A. Volkov."*

1160 *THREE WOMEN, 1921. Tempera on paper mounted on paper. 23.4 x 24.2 (285.78). Signed l r: "A. Volkov."*

1161 *HORSE AND RIDER, 1921. Tempera on cardboard. 47.5 x 62 (Tretiakov Gallery TR155).*

1162 *CARAVAN, 1921. Gouache on paper mounted on board. 35.7 x 50.4 (277.78). Not signed or dated.*

1160

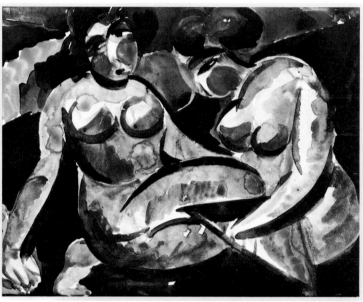

1158

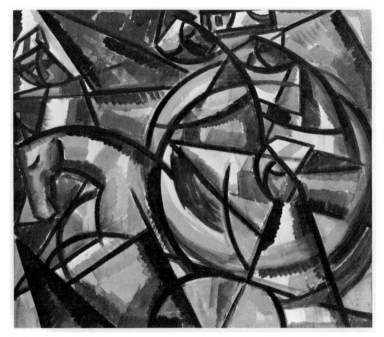

1161

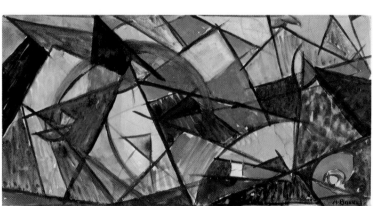

1159

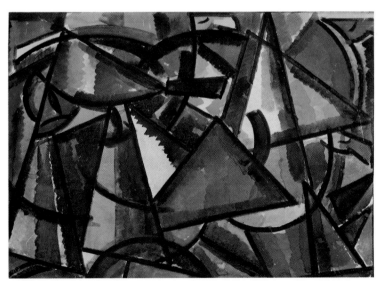

1162

1163 *FACES, c. 1922. Tempera on paper. 32 x 61 (281.78). Not signed or dated.*

1164 *THREE MUSICIANS, 1921. Tempera on cardboard. 30 x 51 (278.78). Not signed or dated.*

1165 *THREE FIGURES, 1922. Tempera on paper mounted on paper. 18.2 x 30.1 (280.78). Dated l l: "1922"; signed l r: "A. Volkov."*

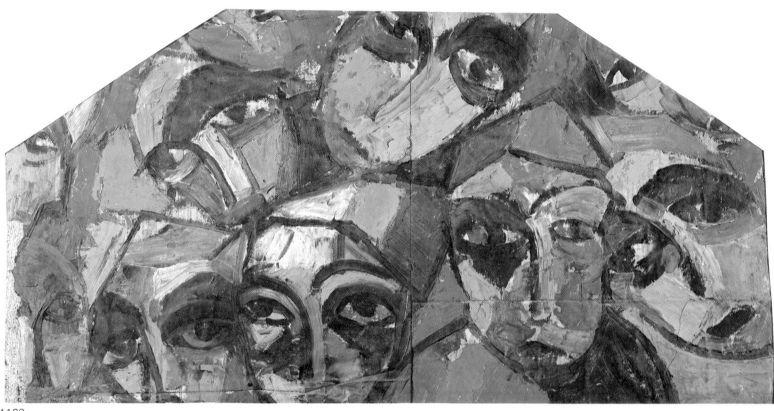

1163

1164

1165

GEORGII BOGDANOVICH YAKULOV

Born Tiflis (Tbilisi), Georgia, January 1, 1884; died Erevan,
Armenia, December 28, 1928, of pneumonia.

1166 *LANDSCAPE WITH AMPHITHEATER, c.*
1911–12. Oil on canvas. 108.5 x 88 (Museum
of Erevan, gift of G. Costakis, TR28). Acquired
from the collection of A. G. Koonen, Moscow.

Yakulov's father, a lawyer, moved the family to Moscow in 1893. From 1893 to 1896 Yakulov attended boarding school at the Lazarev Institute of Oriental Languages, and from 1901 to 1903 the Institute of Painting, Sculpture, and Architecture; expelled for truancy. In the summer and fall of 1903 served in the army in the Caucasus. In 1904 was mobilized and served as an ensign in Manchuria; there had first direct contact with the nature and culture of the Orient, which influenced both his attitudes toward art and the style of his painting.

In 1907 participated in the exhibition of the Moskovskoe tovarishchestvo khudozhnikov (Moscow Association of Artists) and in the first "Venok-Stefanos" (Wreath-Stephanos). In 1908 exhibited at the Vienna Secession and the "Ausstellung moderne russische Kunst" (Exhibition of Modern Russian Art), and in January 1909 at Sergei Makovsky's salon in St. Petersburg. In 1910 showed work at the Soiuz russkikh khudozhnikov (Union of Russian Artists) exhibition in St. Petersburg and that same year traveled to Italy for the first time. Beginning in 1910–11 was active as a decorator of spectacles and private balls. From 1911 to 1913 showed at *Mir iskusstva* (World of Art) exhibitions in St. Petersburg, Moscow, and Kiev, and in 1913 exhibited at the "Erste deutsche Herbstsalon" (First German Autumn Salon), at Der Sturm gallery in Berlin.

Spent the summer of 1913 at Louveciennes near Paris, working on problems of color rhythms with Robert and Sonia Delaunay. These explorations may to some extent have been connected with Lentulov's painting of the years 1912–14 and Larionov's Rayonism. In 1914 published part of his theory of "light rhythms" under the title "Goluboe solntse" (The Blue Sun) in the journal *Altsion* in Moscow. On the occasion of the Italian Futurist Marinetti's visit to Russia, in 1914, published with the poet Benedikt Livshits and the composer Artur Lurie (Arthur Lourié) a leaflet manifesto in Russian, French, and Italian entitled "We and the West." Yakulov participated because he claimed that Robert Delaunay had stolen his ideas.

After 1914 was an officer on active duty. During leave granted him after being wounded, continued to paint and sketch. Participated in the 1915 "Levye techeniia" (Left Trends) exhibition in Petrograd and in the "Vystavka zhivopisi 1915 god" (Exhibition of Painting: 1915) in April in Moscow.

In 1917 worked together with Tatlin and Rodchenko on the interior decor of the Café Pittoresque in Moscow, where dynamic reliefs, ceiling constructions, and electric lamps were installed.

The café represented a synthesis of fine arts, literature, and theater. In 1918 created a nonrepresentational design for Paul Claudel's *L'Echange*, which was performed at the Kamernyi (Chamber) Theater in Moscow under the direction of Alexandr Tairov.

From 1918 to 1920 taught at the theater decoration workshop of the Svomas in Moscow. In 1919, with his students and Lentulov, formed the Obmokhu group. Also that year signed the manifesto of the Imagist poets, headed by Vadim Shershenevich and Sergei Esenin, and participated in a series of their publications.

Starting in 1920 was hailed for his colorful, improvised scenery for a series of productions at the Kamernyi Theater, including E. T. A. Hoffmann's *Princess Brambilla* of 1920 and Charles Lekok's *Giroflé-Girofla* of 1922.

1167 *CAFÉ PITTORESQUE, 1917. Watercolor and gouache on cambric tracing cloth. 109 x 84 (Tretiakov Gallery TR29). Acquired from the collection of A. G. Koonen, Moscow.* The Café Pittoresque was an actors' and artists' café which opened in January 1918. Yakulov directed the work of designing its interior, beginning in June 1917. Tatlin, Rodchenko, Udaltsova, Khodasevich, and others collaborated with him on the project. This particular painting hung in the café itself. Yakulov had intended that the café would lay the foundations of the new style both in painting and other branches of art. An eyewitness gave the following account: "The interior decoration of the Café Pittoresque as-tonished young artists by its dynamism. Fancifully shaped objects of cardboard, plywood, and cloth—lutes, circles, funnels, spiral constructions—were fitted with electric lights. Everything was flooded with light, everything revolved and vibrated, everything seemed to be in motion. Red and orange dominated, set off by contrasting cold colors. These strange objects hung from the ceiling and sprang from the walls, their boldness astounding whoever saw them" (*Agitatsionno-massovoe iskusstvo pervykh let Oktiabria* [Propagandistic Art for the Masses in the First Years after the October Revolution] [Moscow, 1971], p. 129; trans. in G. Karginov, *Rodchenko* [London, 1979], pp. 91 and 92).

Yakulov's curiously conservative painting, which is in stark contrast with the impression given by the passage quoted here, demonstrates to some extent the degree to which the venture failed to produce an integrated and innovative union of the newest aesthetic developments.

1168 *SET DESIGN FOR "SIGNORE FORMICA" BY E. T. A. HOFFMANN, 1921. Mixed media on silk. 62 x 57 (Tretiakov Gallery TR30). Acquired from the collection of V. Fedorov, Moscow.* Inscribed u l as a gift to A. Tairov, who directed the play at the Kamernyi Theater premiere, June 13, 1922.

1167

1168

LEV ALEXANDROVICH YUDIN

Born Vitebsk, October 15, 1903; died in battle, Ust-Tospensk region, near Leningrad, November 9 or 10, 1941.

Father a traveling agent of the Brotherhood of Salt Factory Workers. Was a member of Unovis in Vitebsk from 1919 to 1922; participated in the Unovis exhibitions in Moscow, 1921; Vitebsk, 1920 and 1921; and Smolensk, 1921. Wrote an essay entitled "O natiurmorte" (About Still Life) for the second *Unovis* almanac published in January 1921 in Vitebsk. In 1922 followed Malevich to Petrograd with Chashnik, Suetin, and other Unovis members, when the group was expelled from the Art Institute in Vitebsk. Entered the Academy of Arts in 1923 and from 1924 on worked as a researcher at the Petrograd Inkhuk in close collaboration with Malevich.

Showed his work, together with other students of Malevich, at the exhibition "Obedinenie novykh techenii v iskusstve" (Association of New Trends in Art) in June 1922 in Petrograd, and participated in the "Erste russische Kunstausstellung" (First Russian Art Exhibition), at the Galerie van Diemen in Berlin. Also exhibited at the "Vystavka kartin petrogradskikh khudozhnikov vsekh napravlenii" (Exhibition of Paintings of Petrograd Artists of All Tendencies), in 1923.

Starting in the late 1920s worked as an illustrator of children's magazines and books for the publisher Detgiz, executed a series of paintings on porcelain, and worked on design projects.

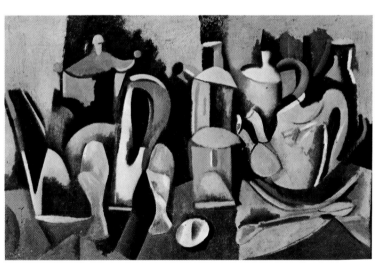

1169

1169 *BLUE STILL LIFE, 1930. Oil on canvas. 36 x 54 (Tretiakov Gallery TR32). Acquired from the artist's family.*

1170 *UNTITLED, n.d. Pencil on folded paper. Image: 23.8 x 21.2 (C373). Attributed to Yudin by E. Kovtun.*

1171 *PORTRAIT OF A WOMAN, 1936–39. Oil on canvas. 53 x 45 (Tretiakov Gallery TR26). Acquired from the artist's family.*

1170

1171

CHRONOLOGY BY JOHN E. BOWLT

This chronology lists only the major political, social, and cultural events in Russia during the period 1894–1934. Although the chronology is divided into three sections—Political Events, Literature and the Performing Arts, and the Visual Arts—the development of painting and sculpture, obviously, receives the most detailed treatment.

During this period artists, writers, musicians, and critics collaborated on many joint projects, so that the division into art, literature, and the performing arts is not always adequate. This is true of the Diaghilev ballet productions in Paris, which involved artists, musicians, and dancers: some of these are listed under Literature and the Performing Arts even though they also relate directly to the Visual Arts. A similar problem is encountered with the numerous booklets of Futurist verse written by poets such as Khlebnikov, Kruchenykh, and Maiakovsky and illustrated by their colleagues—such as D. Burliuk, Goncharova, Larionov, Malevich, and Rozanova: important titles are listed under Literature and the Performing Arts even though they were as much the product of Cubo-Futurist art.

In the history of the Russian avant-garde, exhibitions played a crucial role, and they are described extensively here. A number of exhibiting societies such as the Moscow Association of Artists ran regular exhibitions for many years, and these are mentioned whenever members of the avant-garde contributed to them. However, other societies such as the Union of Russian Artists rarely attracted the avant-garde, so there is no reference to their exhibitions—unless an artist such as D. Burliuk, Lissitzky, or Malevich happened to contribute to a particular session.

For further information regarding particular events in Russian art, literature, and the performing arts, the reader may wish to consult the following publications:

Beyer, Victor, introd. *Les Ballets Russes de Serge de Diaghilev.* Strasbourg: Dernières Nouvelles, 1969.

Bialik, B., et al., eds. *Russkaia literatura kontsa XIX-nachala XX v.* Moscow: Nauka, 1971 (vol.1); 1972 (vol. 2).

Fevralsky, A., ed. *V. E. Meierkhold. Stati, pisma, rechi, besedy.* Moscow: Iskusstvo, 1968.

Kim, M., ed. *Kulturnaia zhizn v SSSR 1917–1927.* Moscow: Nauka, 1975; *Kulturnaia zhizn v SSSR 1928–1941.* Moscow: Nauka, 1976.

Lobanov, V. *Khudozhestvennye gruppirovki za poslednie 25 let.* Moscow: AKhR, 1930.

Markov, P., ed. *A. Ya. Tairov. Zapiski rezhissera, stati, besedy, rechi, pisma.* Moscow: Vserossiiskoe teatralnoe obshchestvo, 1970.

Matsa, I., et al., eds. *Sovetskoe iskusstvo za 15 let.* Moscow-Leningrad: Ogiz-Izogiz, 1933.

Sternin, G. *Khudozhestvennaia zhizn Rossii na rubezhe XIX–XX vekov.* Moscow: Iskusstvo, 1970. German translation: Sternin, Grigori J. *Das Kunstleben Russlands an der Jahrhundertwende.* Dresden: VEB, 1976.

Sternin, G. *Khudozhestvennaia zhizn Rossii XX veka.* Moscow: Iskusstvo, 1976.

Zhitomirsky, D., ed. *Muzyka XX veka. Ocherki.* Moscow: Muzyka, 1976.

THE VISUAL ARTS

LITERATURE AND THE PERFORMING ARTS

POLITICAL EVENTS

1894 MARCH. The twenty-second exhibition of the Society of Traveling Exhibitions opens in St. Petersburg with contributions by Ge, Levitan, Serov, et al. The society continues to hold exhibitions regularly until 1922
APRIL. The First Congress of Russian Artists opens in Moscow
JUNE 1. Death of Ge, one of Russia's most innovative painters of the late nineteenth century
SEPTEMBER. A new statute supported by Kuindzhi, Repin, et al. takes effect at the Academy of Arts, St. Petersburg, allowing for a more liberal art education

JANUARY. Russian society celebrates Stasov's seventieth birthday and the fiftieth year of his career as a literary, music, and art critic

NOVEMBER. Nikolai II ascends the throne. He reigns until March 1917

THE VISUAL ARTS

1896 MAY. The All-Russian Exhibition of Industry and Art opens in Nizhnii Novgorod. Vrubel's panels there create a scandal, and they are placed in a special pavilion constructed by the art patron Mamontov
NOVEMBER. The Moscow Association of Artists is established formally as an exhibiting society. The association continues to hold exhibitions regularly until 1924
A large exhibition of French art opens in St. Petersburg with works by Corot, Courbet, Millet, Monet, Renoir, et al.; it travels to Moscow the following month
DECEMBER. The first Russian exhibition of Japanese art opens at the Academy of Arts, St. Petersburg

1897 JANUARY. The "Exhibition of Drawings" from Princess Tenisheva's collection opens in St. Petersburg with contributions by modern Europeans and Russians
MARCH. Diaghilev organizes his "Exhibition of German and English Watercolorists" in St. Petersburg with contributions by Bartels, Liebermann, Lenbach, Lavery, Paterson, et al.
The Academy of Arts, St. Petersburg, organizes the first in a series of spring exhibitions at which academy students can show their works

1898 JANUARY. Diaghilev organizes his "Exhibition of Russian and Finnish Artists" in St. Petersburg with contributions by Benois, Somov, Vrubel, Edelfeldt, Gallen-Kallela, et al.
MARCH. The Russian Museum of Alexandr III opens in St. Petersburg
MARCH 8. Death of Shishkin, one of the key supporters of the Realist movement
JUNE 25. Death of Yaroshenko, an important Realist
NOVEMBER. The first number of the art magazine *Mir iskusstva* (World of Art) appears in St. Petersburg under the editorship of Diaghilev, Benois, and Filosofov; issues appear regularly until 1904
The first number of the magazine *Iskusstvo i khudozhestvennaia promyshlennost* (Art and Industrial Art) appears in St. Petersburg under the editorship of Sobko with the active support of Stasov; issues appear regularly until 1902
DECEMBER 4. Death of Pavel Tretiakov, the collector and patron

LITERATURE AND THE PERFORMING ARTS

JANUARY. Mamontov's Private Opera produces *Hänsel and Gretel* in St. Petersburg with designs by Vrubel
MAY. For the first time the Russian public sees cinematography—shots of Nikolai II's coronation—at the Aquarium Garden, St. Petersburg
OCTOBER. Chekhov's *The Seagull* premieres at the Alexandrinsky Theater, St. Petersburg

DECEMBER. Mamontov's Private Opera produces *Sadko* in Moscow with designs by K. Korovin and Maliutin, assisted by Vrubel
Chaliapin makes his debut with Mamontov's Private Opera in a Moscow production of *The Tomb of Askold*

FEBRUARY. The Moscow Literary and Artistic Circle is established; it becomes a popular meeting place for writers, artists, and actors of the day
MARCH. Tolstoi publishes the last part of his essay "What Is Art?" in the March issue of the journal *Voprosy filosofii i psikhologii* (Problems of Philosophy and Psychology)
OCTOBER. The Moscow Arts Theater opens its first season with a production of A. Tolstoi's *Tsar Fedor Ioannovich* directed by Stanislavsky

POLITICAL EVENTS

MAY. Coronation of Nikolai II
AUGUST. The Sino-Russian Treaty is signed

MARCH. The first conference of the Russian Social Democratic Party takes place in Minsk

THE VISUAL ARTS	LITERATURE AND THE PERFORMING ARTS	POLITICAL EVENTS
1899 JANUARY. Diaghilev organizes the "International Exhibition of Painting" in St. Petersburg with contributions by Bakst, Benois, Böcklin, Brangwyn, Degas, Moreau, Repin, Somov, Whistler, et al. This is the first of the series of *Mir iskusstva* exhibitions, which lasts until 1906 The exhibition "French Art and Applied Art" opens at the Society for the Encouragement of the Arts in St. Petersburg FEBRUARY. Viktor Vasnetsov, a Neonationalist artist, is given a one-man exhibition at the Academy of Arts, St. Petersburg	OCTOBER. Chekhov's *Uncle Vanya* premieres at the Moscow Arts Theater Mamontov's Private Opera produces *The Tsar's Bride* in Moscow with designs by Vrubel	
1900 JANUARY. The second *Mir iskusstva* exhibition opens in St. Petersburg with contributions by Bakst, Benois, Somov, et al. FEBRUARY. Moscow hosts a major exhibition of German art containing a large group of paintings by Stuck The seventh exhibition of the Moscow Association of Artists opens and includes a contribution by Kandinsky JULY 22. Death of Levitan, one of the younger generation of Russian artists, who pointed away from Realism toward a more lyrical interpretation of art	JULY 31. Death of the philosopher and poet Vladimir Soloviev OCTOBER. Mamontov's Private Opera produces *A Life for the Tsar (Ivan Susanin)* in Moscow with designs by Vrubel NOVEMBER. Mamontov's Private Opera produces *The Sorceress* in Moscow with designs by Vrubel	APRIL. The Exposition Universelle opens in Paris with a large Russian contribution, including an art section of over 400 works DECEMBER. Lenin, Plekhanov, et al. found the revolutionary journal *Iskra* (Spark)
1901 JANUARY. The third *Mir iskusstva* exhibition opens at the Academy of Arts, St. Petersburg, containing a retrospective show of the works of Levitan The first number of the art and antiques magazine *Khudozhestvennye sokrovishcha Rossii* (Art Treasures of Russia) appears in St. Petersburg under the editorship of Benois; issues appear regularly until 1907 FEBRUARY. The eighth exhibition of the Moscow Association of Artists opens and includes a contribution by Kandinsky SEPTEMBER. Korovin and Apollinarii Vasnetsov begin to teach at the Moscow Institute of Painting, Sculpture, and Architecture. Korovin teaches a number of the avant-garde artists DECEMBER. The Society of the 36 opens its first exhibition in Moscow, giving particular attention to young Moscow artists	JANUARY. Chekhov's *Three Sisters* premieres at the Moscow Arts Theater APRIL. The Symbolist-oriented almanac *Severnye tsvety* (Northern Flowers) begins publication with contributions by Balmont, Bely, Blok, Briusov, et al. AUTUMN. Nourok and Nouvel organize the Evenings of Contemporary Music in St. Petersburg; performances of works by modern Russian and European composers are held regularly until 1911	
1902 MARCH. The fourth *Mir iskusstva* exhibition opens in St. Petersburg, then travels to Moscow. A key work is Vrubel's large painting *The Demon Downcast*	DECEMBER. Gorky's *Lower Depths* premieres at the Moscow Arts Theater	APRIL. Sipiagin, minister of the interior, is assassinated by a member of the Socialist Revolutionary Party

THE VISUAL ARTS

LITERATURE AND THE PERFORMING ARTS

POLITICAL EVENTS

The ninth exhibition of the Moscow Association of Artists opens and includes a contribution by Kandinsky
JUNE. Benois publishes his book *Istoriia zhivopisi v XIX veke. Russkaia zhivopis* (The History of Painting in the Nineteenth Century. Russian Painting), in which he strongly criticizes the Realist movement
DECEMBER. The "Exhibition of Architecture and Applied Art in the New Style" opens in Moscow with contributions by Mackintosh, Olbrich, Fomin, Korovin, Polenova, et al.

1903 JANUARY. The store and exhibition premises known as Contemporary Art opens in St. Petersburg under the supervision of Grabar and von Meck. One aim of this enterprise is to propagate the "new style"
The fifth *Mir iskusstva* exhibition opens in St. Petersburg
FEBRUARY. The tenth exhibition of the Moscow Association of Artists opens with works by Kandinsky, Konchalovsky, et al.
DECEMBER. The newly established Union of Russian Artists opens its first exhibition in Moscow, focusing attention on young Moscow and St. Petersburg artists such as V. Vasnetsov, Korovin, and Riabushkin. The union continues to hold exhibitions regularly until 1923 and occasionally includes works by the avant-garde

JANUARY. Wagner's *Die Götterdämmerung* has its Russian premiere in St. Petersburg with designs by Benois and K. Korovin

JULY. The second conference of the Russian Social Democratic Party takes place in Brussels and London

1904 FEBRUARY. The New Society of Artists holds its first exhibition in St. Petersburg. At its regular exhibitions (continuing until 1915) members of the avant-garde—e.g., Exter, Kandinsky, Konchalovsky, and Mashkov—show works occasionally
The eleventh exhibition of the Moscow Association of Artists opens and includes a contribution by Kandinsky
MARCH 31. Death of Vereshchagin, the famous battle painter
MAY. The "Crimson Rose" exhibition opens in Saratov with contributions by Borisov-Musatov, Kuznetsov, Vrubel, et al. This Symbolist exhibition sets a precedent for the 1907 "Blue Rose" exhibition

JANUARY. Chekhov's *Cherry Orchard* premieres at the Moscow Arts Theater
The Symbolist journal of literature and art *Vesy* (The Scales) begins publication in Moscow; issues appear regularly through 1909
JULY 2. Death of Chekhov

JANUARY. Japan attacks Russia at Port Arthur without a formal declaration of war, launching the Russo-Japanese War
JULY. Plehve, minister of the interior, is assassinated by a member of the Socialist Revolutionary Party

1905 JANUARY. The first number of the magazine *Iskusstvo* (Art) appears in Moscow under the editorship of Tarovaty
FEBRUARY. The twelfth exhibition of the Moscow Association of Artists opens with contributions by Kandinsky and many of the young Symbolist artists, such as Kuznetsov

AUTUMN. V. Ivanov and his wife Zinovieva-Annibal establish their "Wednesdays" in their St. Petersburg apartment, known as The Tower. Berdiaev, Briusov, Sologub, and many other writers and artists of the time attend these regular gatherings, which last until early 1906
DECEMBER. Wagner's *Das Rheingold*

Russia is plagued by civil disturbance throughout 1905, contributing to the socalled First Russian Revolution
JANUARY. The Russo-Japanese War ends with an ignominious defeat for Russia
A general strike is declared in St. Petersburg. One result of the unrest is "Bloody Sunday" (January 9)

THE VISUAL ARTS

LITERATURE AND
THE PERFORMING ARTS

POLITICAL EVENTS

1905 MARCH. Diaghilev opens his "Exhibition
(cont.) of Historic Portraits" at the Tauride Palace, St. Petersburg
JUNE. The caricature and cartoon journal *Zritel* (Spectator) appears in St. Petersburg—the first of many such magazines inspired by the revolutionary events of 1905–06. A number of important artists including Chekhonin, Dobuzhinsky, and Lancerary contribute to them
OCTOBER 26. Death of Borisov-Musatov, a leading Symbolist artist

has its Russian premiere in St. Petersburg with designs by Golovin

FEBRUARY. The Grand Duke Sergei is assassinated by a member of the Socialist Revolutionary Party
JUNE. The crew of the battleship *Potemkin* mutinies
OCTOBER. The Bolshevik journal *Novaia zhizn* (New Life) begins publication
Nikolai summons a national legislative assembly—the Duma—in order to implement broader freedoms
The Cadet (Constitutional Democratic) Party convenes in Moscow
The St. Petersburg Soviet of Workers' Deputies holds its first session
NOVEMBER. The Moscow Soviet of Workers' Deputies is established
DECEMBER. A general strike is declared in Moscow

1906 FEBRUARY. The last *Mir iskusstva* exhibition (first series) opens in St. Petersburg with contributions by Bakst, Jawlensky, Kuznetsov, Larionov, Sapunov, et al.
The thirteenth exhibition of the Moscow Association of Artists opens with contributions by Goncharova, Larionov, et al.
OCTOBER. Diaghilev organizes the Russian section at the Salon d'Automne in Paris, displaying many works by young Russian artists. Kuznetsov, Larionov, and Sudeikin accompany Diaghilev to Paris in connection with the salon
OCTOBER 10. Death of Stasov, one of the main supporters of Realism

JANUARY. The Symbolist journal of literature and art *Zolotoe runo* (The Golden Fleece) begins publication in Moscow; it appears regularly until spring 1910, although the last issues are dated 1909

APRIL. The First Duma convenes under Stolypin; dissolved in July

1907 JANUARY. The first issue of the art and antiques journal *Starye gody* (Bygone Years) appears in St. Petersburg edited by Benois; issues appear through 1916
MARCH. The fourteenth exhibition of the Moscow Association of Artists opens with contributions by V. Burliuk, Goncharova, Kandinsky, Malevich, Morgunov, Shevchenko, et al.
The "Blue Rose" exhibition opens in Moscow. This Symbolist exhibition marks a sharp departure from artistic convention
APRIL. The first exhibition of the society known as The Independents opens in Moscow with contributions by Goncharova, Malevich, et al.
DECEMBER. The "Venok-Stefanos" (Wreath-Stephanos) exhibition opens in Moscow with contributions by the Burliuks, Goncharova, Larionov, Lentulov, Yakulov, et al.

The Society of Free Aesthetics opens in Moscow. Until 1917 it serves as a rendezvous for writers, artists, musicians, collectors, and patrons. Frequent visitors are Bely, Briusov, the Girshmans (art patrons), Goncharova, and Larionov
FEBRUARY. The Symbolist-oriented almanac *Shipovnik* (Wild Rose) begins publication in Moscow with contributions by Andreev, Briusov, et al.; issues appear annually through 1916
APRIL. Gorky publishes his novel *Mat* (Mother). In the Soviet period this novel comes to be regarded as a literary prototype of Socialist Realism
MAY. Artsybashev publishes his pornographic novel *Sanin*
Diaghilev organizes five concerts of Russian music for the Paris Salon d'Automne

FEBRUARY. The Second Duma convenes; dissolved in June
NOVEMBER. The Third Duma convenes; dissolved in June 1912

THE VISUAL ARTS

LITERATURE AND
THE PERFORMING ARTS

POLITICAL EVENTS

1908 MARCH. The "Venok" exhibition opens in St. Petersburg with contributions by the Burliuks, Exter, Jawlensky, Lentulov, et al.

The fifteenth exhibition of the Moscow Association of Artists opens with contributions by the Burliuks, Falk, Kandinsky, Malevich, Morgunov, Shevchenko, et al. Later this year the sixteenth exhibition of the association opens with contributions by Shevchenko, Malevich, et al.

APRIL. The *Zolotoe runo* (Golden Fleece) salon opens in Moscow with extensive contributions by Goncharova and Larionov and with a French section that includes Braque, Gauguin, Metzinger, Matisse, and Rouault. The Russian contribution expresses a deep interest in primitive art

MAY. The "Contemporary Trends in Art" exhibition opens in St. Petersburg with contributions by D. Burliuk, Kulbin, et al. At this exhibition Kulbin establishes his so-called Impressionists group

NOVEMBER. The "Zveno" (Link) exhibition opens in Kiev with contributions by D. Burliuk, Exter, Goncharova, Larionov, Lentulov, et al. At this exhibition D. Burliuk issues his first manifesto, "The Voice of an Impressionist: In Defense of Painting"

FEBRUARY. Nikita Baliev opens his cabaret Chauve-Souris (The Bat) in Moscow

APRIL. The first issue of the satirical journal *Satirikon* appears in St. Petersburg with contributions by Bakst, Gorodetsky, Kuzmin, Radakov, et al.; issues appear regularly through 1913

MAY. Diaghilev organizes a "Russian Week" in Paris. Chaliapin sings the title role in the production of *Boris Godunov* there

1909 The Lemercier Gallery opens in Moscow. This private gallery mounts many exhibitions of painting and applied art through 1917

JANUARY. S. Makovsky organizes his salon, a general survey of modern Russian art, in St. Petersburg. Included are D. Burliuk, Kandinsky, Konchalovsky, Jawlensky, Werefkin, Yakulov, et al.

The *Zolotoe runo* exhibition opens in Moscow with contributions by Goncharova, Larionov, Le Fauconnier, Matisse, et al.

MARCH. Kulbin opens his "Impressionists" exhibition in St. Petersburg with contributions by Guro, Grigoriev, Kamensky, Kruchenykh, Kulbin, Matiushin, et al.

The "Venok-Stefanos" exhibition opens in St. Petersburg with contributions by the Burliuks, Exter, Lentulov, et al. Later this year the exhibition travels to Kherson and other provincial cities

DECEMBER. The *Zolotoe runo* exhibition opens in Moscow with Russian contributors only, including Falk, Goncharova, Konchalovsky, Larionov, Mashkov, et al.

MARCH. Guro's collection of poems, prose, and illustrations called *Sharmanka* (The Hurdy-Gurdy) appears in St. Petersburg

MAY–JUNE. Diaghilev opens the first season of his Ballets-Russes in Paris with productions of *Le Pavillon d'Armide*, *Cléopâtre*, *The Polovtsian Dances*, and other pieces. Diaghilev stages regular productions until his death, in 1929, introducing dancers such as Karsavina, Lifar, and Nijinsky to the West

OCTOBER. The first issue of the literary and art journal *Apollon* (Apollo) appears in St. Petersburg, edited by S. Makovsky; issues appear regularly until spring 1918, although the last issues are dated 1917

The miscellany *Kuda my idem?* (Whither Do We Go?) appears in Moscow with statements by Bely, S. Makovsky, some of the Blue Rose artists, et al.

DECEMBER. *Vesy* and *Zolotoe runo* cease publication. Although the last issues of *Zolotoe runo* bear the date 1909, they do not appear until early 1910

Lenin publishes his tract *Materializm i empiriokrititsizm* (Materialism and Empirio-Criticism) in Moscow

THE VISUAL ARTS

LITERATURE AND
THE PERFORMING ARTS

POLITICAL EVENTS

1909
(cont.)

Izdebsky opens his first salon in Odessa—the "International Exhibition of Painting, Sculpture, Engraving, and Drawing," with contributions by Altman, the Burliuks, Exter, Goncharova, Kandinsky, Lentulov, Matiushin, Balla, Braque, Denis, Laurencin, Le Fauconnier, Metzinger, Redon, Rousseau, et al. The exhibition travels to St. Petersburg and other cities during 1910

The seventeenth exhibition of the Moscow Association of Artists opens with contributions by Lentulov, Malevich, Morgunov, et al.

1910

MARCH. The newly established Soiuz molodezhi (Union of Youth) opens its first exhibition in St. Petersburg with contributions by the Burliuks, Goncharova, Filonov, Larionov, Exter, et al. Later this year the exhibition moves to Riga

Kulbin organizes his "Treugolnik" (Triangle) exhibition in St. Petersburg with contributions by the Burliuks, Evreinov, Exter, Guro, Kamensky, Kulbin, Matiushin, et al.
APRIL 1. Death of Vrubel, one of the greatest representatives of the Russian fin-de-siècle and an inspiration to many of the avant-garde
DECEMBER. The first exhibition of the newly established society "Bubnovyi valet" (Jack of Diamonds) opens in Moscow with contributions by the Burliuks, Exter, Goncharova, Kandinsky, Larionov, Lentulov, Malevich, Morgunov, Survage (Stiurtsvage), Werefkin, Gleizes, Le Fauconnier, et al.

The first exhibition of the Moscow Salon opens with contributions by Goncharova, Larionov, Malevich, et al. The Moscow Salon holds exhibitions regularly until 1918

The first exhibition of the revived exhibiting society Mir iskusstva (World of Art) opens in Moscow with contributions by Goncharova, Lentulov, and Yakulov, and with a posthumous retrospective of Čiurlionis. The new series of Mir iskusstva exhibitions, generally shown in Moscow and then St. Petersburg, lasts until 1924

Izdebsky organizes his so-called Salon 2, in Odessa, with contributions mainly by Russian artists including the Burliuks, Exter, Goncharova, Kandinsky, Larionov, Lentulov, Tatlin, and Yakulov. Although dated 1910 in the catalogue, Salon 2 opened in January 1911 and did not travel

JANUARY. Kuzmin publishes his article "On Beautiful Clarity: Notes about Prose" in Apollon. This contributes to the development of a Neoclassical trend in Russian literature and art about this time, reflected, for example, in the establishment of the Acmeist movement
MARCH. The miscellany of drama, prose, poems, and illustrations Studiia impressionistov (Studio of the Impressionists) is published in St. Petersburg. Among the contributions are Kulbin's essay "Free Art as the Basis of Life," Khlebnikov's experimental poem "Incantation by Laughter," and Evreinov's monodrama "Presentation of Love"
MAY. The miscellany Sadok sudei (Trap for Judges) is published in St. Petersburg with contributions by D. Burliuk, Kamensky, Khlebnikov, et al. This collection of experimental literature and art may be regarded as the first Russian Futurist publication

Bely publishes his collection of theoretical essays Simvolizm (Symbolism) and his novel Serebryanyi golub (The Silver Dove) in Moscow
JUNE. Diaghilev produces Schéhérazade and Stravinsky's The Firebird as part of his Ballets-Russes enterprise in Paris
OCTOBER. Tsvetaeva's first book of verse, Vechernii albom (Evening Album), appears in Moscow
NOVEMBER 7. Death of Leo Tolstoi

DECEMBER. The first issue of the legal Bolshevik journal Zvezda (Star) appears in St. Petersburg, edited from abroad by Lenin

THE VISUAL ARTS

LITERATURE AND
THE PERFORMING ARTS

POLITICAL EVENTS

1911 MARCH. The eighteenth exhibition of the Moscow Association of Artists opens with contributions by Kandinsky, Mashkov, Yakulov, et al.
APRIL. The second Soiuz molodezhi exhibition opens in St. Petersburg with contributions by the Burliuks, Goncharova, Larionov, Malevich, Rozanova, Tatlin, et al.
OCTOBER. Matisse visits St. Petersburg and Moscow; leaves in November
 In the fall Larionov and Goncharova break with ''Bubnovyi valet'' and create a new association, ''Oslinyi khvost'' (Donkey's Tail)
 Tatlin designs the Moscow production of the folk drama *Tsar Maximilian i ego neposlushnyi syn Adolf* (Emperor Maximilian and His Disobedient Son Adolph)
NOVEMBER 22. Death of Serov, one of the most respected teachers at the Moscow Institute of Painting, Sculpture, and Architecture
DECEMBER. The third Soiuz molodezhi exhibition opens in St. Petersburg with contributions by Filonov, Goncharova, Larionov, Malevich, Rozanova, Shevchenko, Tatlin, et al.
 The *Mir iskusstva* exhibition shows works by the Burliuks, Goncharova, Konchalovsky, Larionov, et al., and a posthumous retrospective of Čiurlionis
 The Second All-Russian Congress of Artists opens in St. Petersburg; Kandinsky's essay ''On the Spiritual in Art'' is delivered there by Kulbin as a lecture
 Kandinsky and Marc found *Der blaue Reiter* (The Blue Rider) group in Munich

MARCH. Skriabin's *Prometheus* is performed in Moscow
JUNE. Diaghilev produces Stravinsky's *Petrouchka* in Paris with sets and costumes by Benois
DECEMBER. The Stray Dog cabaret cellar opens in St. Petersburg. During its short life (until February 1915) it acts as a meeting place for leading writers and artists, both Russian and European

SEPTEMBER. Stolypin is assassinated

1912 JANUARY. The second ''Bubnovyi valet'' exhibition opens in Moscow with contributions by the Burliuks, Exter, Kandinsky, Lentulov, Braque, Delaunay, Le Fauconnier, Léger, Marc, Matisse, et al.
FEBRUARY. Kandinsky invites the Burliuks, Goncharova, Larionov, and Malevich to contribute to the second show of *Der blaue Reiter*
MARCH. Larionov organizes the ''Oslinyi khvost'' exhibition in Moscow with contributions by Chagall, Goncharova, Larionov, Malevich, Rozanova, Shevchenko, Tatlin, et al.
 The nineteenth exhibition of the Moscow Association of Artists opens and includes a contribution by D. Burliuk
APRIL. The first issue of the journal *Soiuz molodezhi* appears in St. Petersburg car-

OCTOBER. The first of many Futurist books of poetry carrying illustrations by members of the avant-garde appear in Moscow:
 Kruchenykh's book of poetry *Starinnaia liubov* (Old-Time Love) with illustrations by Larionov
 Kruchenykh and Khlebnikov's long poem *Igra v adu* (Game in Hell) with illustrations by Goncharova and Larionov
 Kruchenykh and Khlebnikov's book of poetry *Mirskontsa* (Worldbackward) with illustrations by Goncharova and Larionov
DECEMBER. The Burliuks, Khlebnikov, Maiakovsky, et al. publish their miscellany *Poshchechina obshchestvennomu vkusu* (A Slap in the Face of Public Taste) in Moscow. It carries their manifesto of the same name

APRIL. The first issue of the Bolshevik workers' paper *Pravda* (Truth) appears
NOVEMBER. The Fourth Duma convenes; dissolved in February 1917

THE VISUAL ARTS

LITERATURE AND
THE PERFORMING ARTS

POLITICAL EVENTS

1912
(cont.) rying Matvejs's (Markov's) essay "The Principles of the New Art." This essay is continued in the second issue (June)
NOVEMBER. The *Mir iskusstva* exhibition shows works by Goncharova, Larionov, Yakulov, et al.
DECEMBER. The fifth Soiuz molodezhi exhibition opens in St. Petersburg with contributions by the Burliuks, Goncharova, Larionov, Malevich, Matiushin, Puni, Rozanova, Shevchenko, Tatlin, et al. (The fourth Soiuz molodezhi show, in Moscow in the spring [?], had shown few works)

The first of the "Contemporary Painting" exhibitions opens in Moscow with contributions by Malevich, Tatlin, et al.

The Dobychina Bureau opens in St. Petersburg. This private gallery mounts regular exhibitions of modern Russian art until 1918

1913 The Institute of Archaeology in Moscow organizes a large exhibition of Russian icons
JANUARY. The third "Bubnovyi valet" exhibition opens in St. Petersburg with contributions by D. Burliuk, Lentulov, Tatlin, Exter, Braque, Picasso, Rousseau, Le Fauconnier, et al. In March a smaller version of the exhibition moves to Moscow
FEBRUARY. The "Bubnovyi valet" society organizes a debate in Moscow at which D. Burliuk, Maiakovsky, et al. speak on modern art and literature. Maiakovsky calls for the destruction of museums, the "sarcophagi of art." This is one of many Futurist encounters with the public

The "Bubnovyi valet" publishes a collection of articles and reproductions bearing its name, in Moscow. This includes Aksenov's article "On the Problem of the Contemporary State of Russian Painting"
MARCH. The third and last issue of the journal *Soiuz molodezhi* appears and includes Rozanova's essay "The Bases of the New Creation and the Reasons Why It Is Misunderstood"

Larionov organizes the "Mishen" (Target) exhibition in Moscow with contributions by Goncharova, Malevich, Pirosmanashvili, Shevchenko, and Chagall, as well as himself. "Mishen" also includes displays of children's drawings and signboards. It serves as the first public showing of Rayonism
APRIL. Larionov publishes his Rayonist manifesto as a booklet
MAY. Tatlin travels to Berlin and then to

JANUARY. Shaginian's book of poetry *Orientalia* appears in Moscow
FEBRUARY. *Sadok sudei 2* appears in St. Petersburg with contributions by the Burliuks, Goncharova, Larionov, et al.

Many Futurist booklets start to appear such as *Poluzhivoi* (Half-Alive), *Pomada* (Pomade)
MAY. Diaghilev produces Stravinsky's *Le Sacre du Printemps* in Paris with designs by Roerich
JUNE. Maiakovsky publishes his poem *Ya!* (Me!) in Moscow with illustrations by Chekrygin and Zhegin

Kruchenykh publishes his booklet *Vzorval* (Explodity) with illustrations by Goncharova, Kulbin, Malevich, and Rozanova
JULY. Kruchenykh and Malevich issue a statement on behalf of the First All-Russian Congress of Baiachi of the Future (Futurist Poets) from Usikirkko, Finland, where they had met with Matiushin to prepare *Victory over the Sun*
SEPTEMBER. Kruchenykh uses the word *zaum* (transrationality) in print for the first time in the Kruchenykh/Khlebnikov/Guro booklet *Troe* (The Three), which is published in St. Petersburg with illustrations by Malevich
OCTOBER. Kruchenykh and Khlebnikov publish *Slovo kak takovoe* (The Word as Such) in Moscow with illustrations by Malevich and Rozanova

Bely publishes his apocalyptic novel *Peterburg* (St. Petersburg) in St. Petersburg

This year marks the three-hundredth anniversary of the Romanov dynasty; Nikolai grants an amnesty to many political prisoners

SEPTEMBER. The Beiliss affair in Kiev exposes rampant anti-Semitism in the tsarist government

THE VISUAL ARTS

LITERATURE AND
THE PERFORMING ARTS

POLITICAL EVENTS

Paris, where he sees Picasso's reliefs
JULY. The miscellany *Oslinyi khvost i mishen* (Donkey's Tail and Target) is published in Moscow. It contains a version of Larionov's Rayonist manifesto
AUGUST. A huge one-woman exhibition of works by Goncharova opens in Moscow; a slightly smaller version of the exhibition opens in St. Petersburg the following year
NOVEMBER. The last Soiuz molodezhi exhibition opens in St. Petersburg with contributions by the Burliuks, Exter, Filonov, Kliun, Malevich, Matiushin, Morgunov, Rozanova, Tatlin, et al. It also includes a posthumous show of Guro

Shevchenko publishes his booklet *Neoprimitivizm. Ego teoriia. Ego vozmozhnosti. Ego dostizheniia* (Neo-Primitivism: Its Theory, Its Potentials, Its Achievements) in Moscow; in it he praises the art of Russia and the East while criticizing the modern art of Europe. He adopts a similar attitude in his second booklet *Printsipy kubizma i drugikh sovremennykh techenii v zhivopisi vsekh vremen i narodov* (The Principles of Cubism and Other Contemporary Trends in Painting of All Ages and All Nations), which he publishes the same year
DECEMBER. Maiakovsky's tragedy *Vladimir Maiakovsky* is produced at the Luna Park Theater, St. Petersburg, with designs by Filonov and Shkolnik

The Futurist opera *Victory over the Sun*, with music by Matiushin, texts by Khlebnikov and Kruchenykh, and designs by Malevich, is produced at the Luna Park Theater, St. Petersburg. Malevich later identifies this production as an important step in his move toward Suprematism

The Larionov/I. Zdanevich Futurist manifesto "Why We Paint Ourselves" is published in the Christmas issue of the journal *Argus*

The *Mir iskusstva* exhibition opens with contributions by Altman, Goncharova, Larionov, Tatlin, Yakulov, et al.

1914 JANUARY. Marinetti visits Russia. In spite of his cold reception by the Russian Cubo-Futurists, he invites Exter, Kulbin, and Rozanova to contribute to a Futurist exhibition at the Galleria Sprovieri in Rome

D. Burliuk and Maiakovsky tour provincial cities, lecturing and declaiming. This is the first of their several Futurist tours (e.g., they are joined by Kamensky in

JANUARY. The booklet *Futuristy. Rykaiushchii Parnas* (Futurists: Roaring Parnassus) appears in St. Petersburg with contributions by D. Burliuk, Filonov, Puni, Rozanova, and Severianin

The second edition of the Kruchenykh/Khlebnikov *Igra v adu* appears in Moscow with illustrations by Malevich and Rozanova

JULY. Germany declares war on Russia

THE VISUAL ARTS

LITERATURE AND
THE PERFORMING ARTS

POLITICAL EVENTS

1914
(cont.)
March and make a grand Futurist tour of southern Russia)
FEBRUARY. D. Burliuk and Maiakovsky are expelled from the Moscow Institute of Painting, Sculpture, and Architecture for their scandalous public behavior
MARCH. Larionov organizes the "No. 4" exhibition in Moscow with contributions by Goncharova, Kamensky, Chekrygin, Shevchenko, Exter, K. Zdanevich, et al.

The fourth "Bubnovyi valet" exhibition opens in Moscow with contributions by Exter, Lentulov, Malevich, Morgunov, Popova, Sofronova, Udaltsova, Braque, Picasso, et al.
MAY. Tatlin shows "synthetic-static compositions" in his Moscow studio
JUNE. Guillaume gives Goncharova and Larionov an exhibition at his Paris gallery

Goncharova and Larionov star in the movie *Drama in the Futurists' Cabaret No. 13*
MARCH. Akhmatova, leader of the Acmeist movement, publishes her book of poems *Chetki* (The Rosary)

Futuristy. Pervyi zhurnal russkikh futuristov (The Futurists: The First Journal of the Russian Futurists) appears in Moscow with contributions by D. Burliuk, Exter, Kamensky, et al.
SUMMER. Tairov and Koonen found the Kamernyi (Chamber) Theater in Moscow

1915
The "Exhibition of Paintings of Leftist Trends" opens at Dobychina's Bureau in Petrograd with contributions by Larionov, Malevich, Puni, Rozanova, et al.
MARCH. "Tramway V," subtitled "The First Futurist Exhibition of Paintings," opens in Petrograd with contributions by the leaders of the avant-garde—Boguslavskaia, Exter, Kliun, Malevich, Morgunov, Popova, Puni, Rozanova, Tatlin, and Udaltsova

The *Mir iskusstva* exhibition opens in Petrograd with contributions by Altman, Bruni, the Burliuks, Yakulov, et al.

Kandaurov opens his "Exhibition of Painting: 1915" in Moscow. All the leading members of the avant-garde are represented including Altman, Bruni, the Burliuks, Chagall, Goncharova, Kandinsky, Larionov, Lentulov, Miturich, and Yakulov; Malevich, Maiakovsky, Morgunov and Tatlin contribute ex catalogue. Kamensky tries to show a live mouse in a mousetrap, but the jury rejects it
JULY. Goncharova and Larionov leave Moscow to join Diaghilev in Lausanne
DECEMBER. The first edition of Malevich's essay on Suprematism, *Ot kubizma k suprematizmu. Novyi zhivopisnyi realizm* (From Cubism to Suprematism: The New Painterly Realism), appears

"The Last Futurist Exhibition of Pictures: 0.10" opens in Petrograd with contributions by many of the avant-garde including Altman, Kliun, Malevich, Pestel, Popova, Puni, Rozanova, Tatlin, and Udaltsova. This is the first public showing of Malevich's Suprematist paintings

JANUARY. Goldoni's *The Fan* premieres at the Kamernyi Theater with designs by Goncharova and Larionov
FEBRUARY. Maiakovsky reads part of his new poem *Oblako v shtanakh* (A Cloud in Trousers) at the Stray Dog cabaret in Petrograd

The first issue of Belenson's *Strelets* (The Archer) appears in Petrograd with contributions by D. Burliuk, Kamensky, Kulbin, et al. The Stray Dog organizes a special evening to commemorate this publication
MARCH. Filonov publishes his neologistic poem *Propoved o prorosli mirovoi* (Chant of Universal Flowering) in Petrograd
NOVEMBER. Evreinov publishes the first part of his three-volume tract *Teatr dlia sebia* (The Theater for Itself) in Petrograd with illustrations by Kulbin and Annenkov. Parts two and three appear in 1916
DECEMBER. Maiakovsky publishes his book of verse *Vzial. Baraban futuristov* (Took: Drum of the Futurists) in Petrograd with illustrations by D. Burliuk

DECEMBER. Rasputin is assassinated

THE VISUAL ARTS

The *Mir iskusstva* exhibition opens with contributions by Altman, Bruni, Yakulov, et al.

1916 MARCH. Tatlin opens his exhibition "Magazin" (The Store) in Moscow with contributions by Bruni, Exter, Kliun, Malevich, Morgunov, Pestel, Popova, Rodchenko, Tatlin, Udaltsova, et al. Tatlin shows reliefs, including two corner reliefs, but Malevich declines to show Suprematist paintings
APRIL. The "Exhibition of Contemporary Russian Painting" opens at Dobychina's Bureau with contributions by Popova, Puni, Rozanova, et al. Dobychina organizes a similar exhibition in December
NOVEMBER. The fifth "Bubnovyi valet" exhibition opens in Moscow with contributions by Altman, D. Burliuk, Chagall, Exter, Kliun, Lentulov, Malevich, Pestel, Popova, Puni, Rozanova, Udaltsova, et al. Malevich is represented by sixty examples of Suprematist painting. Popova shows her first "painterly architectonics"
DECEMBER. The *Mir iskusstva* exhibition opens and includes works by Lissitzky

1917 JULY. Yakulov is asked to supervise the interior design of the Café Pittoresque in Moscow. He is helped by Rodchenko, Tatlin, et al.
NOVEMBER. The last "Bubnovyi valet" exhibition opens in Moscow with contributions by D. Burliuk, Exter, Kamensky, Kliun, Malevich, Rozanova, et al.
Narkompros (People's Commissariat for Enlightenment) is established under the jurisdiction of Lunacharsky. It soon begins to reorganize the cultural and educational life of post-Revolutionary Russia
DECEMBER. The *Mir iskusstva* exhibition opens with contributions by Lentulov, Lissitzky, Yakulov, Zhegin, et al.

1918 JANUARY 29. A special visual arts section—IZO—is established within Narkompros. Shterenberg heads the Petrograd division, Tatlin the Moscow division, while Shterenberg is general supervisor of the whole section. Many avant-garde artists and critics take up administrative, pedagogical, or research positions within the various branches of IZO Narkompros during the ensuing months

LITERATURE AND THE PERFORMING ARTS

JANUARY. Kamensky publishes his novel *Stenka Razin* in Moscow
FEBRUARY. Kruchenykh publishes his booklet *Vselenskaia voina* (Universal War) with illustrations by Rozanova
SPRING. Meierkhold, Grigoriev, and Sudeikin found The Comedians' Halt, a cabaret cellar in Petrograd that serves as a favorite meeting place for writers, artists, and patrons until its closing, in the summer of 1917
AUGUST. The second issue of *Strelets* appears in Petrograd with contributions by Khlebnikov, Kuzmin, Maiakovsky, et al.
NOVEMBER. Annensky's *Thamira Khytharedes* (Tamira of the Cittern) is produced at the Kamernyi Theater with designs by Exter

OCTOBER. Oscar Wilde's *Salomé* is produced at the Kamernyi Theater with designs by Exter

JANUARY. Blok writes his poem *Dvenadtsat* (The Twelve), an ambiguous interpretation of Revolutionary events
APRIL. D. Burliuk and Maiakovsky take part in the movie *Ne dlia deneg rodivshiisia* (Creation Can't Be Bought), an adaptation of Jack London's *Martin Eden*
NOVEMBER. Meierkhold produces Maiakovsky's *Mystery-Bouffe* in Petrograd with designs by Malevich

POLITICAL EVENTS

FEBRUARY. A general strike is declared in Petrograd
MARCH. Nikolai abdicates, terminating the Russian monarchy; the Provisional Government is formed under Prince G. Lvov
JUNE. The First All-Russian Congress of Soviets meets in Petrograd
JULY. A coalition government is formed under Kerensky
OCTOBER. The Second All-Russian Congress of Soviets in Petrograd grants total power to the Soviet. The October Revolution establishes the Soviet regime
NOVEMBER. At Brest-Litovsk, Lenin signs the armistice ending Russian participation in the World War
Lunacharsky is appointed to head the Ministry of Enlightenment

Uprisings in Germany and then in Hungary encourage Lenin's hope that the Bolshevik Revolution will shortly become worldwide

JANUARY. The Western calendar replaces the Old Style of dating
MARCH. The Russian capital moves from Petrograd to Moscow
JULY. The imperial family is executed

THE VISUAL ARTS

LITERATURE AND THE PERFORMING ARTS

POLITICAL EVENTS

1918
(cont.)
FEBRUARY. The twenty-fourth exhibition of the Moscow Association of Artists opens and includes works by D. Burliuk

The *Mir iskusstva* exhibition opens in Petrograd with contributions by Boguslavskaia, Miturich, et al.

APRIL. The Academy of Arts in Petrograd is abolished and replaced by the Svomas (Free State Art Studios). The old art schools in Moscow and the provincial centers are also replaced by Svomas

Lenin inaugurates his Plan of Monumental Propaganda, whereby he hopes to replace tsarist monuments

MAY. Many artists, both avant-garde and moderate, help to decorate the streets and squares as part of the May Day celebration. This serves as a basis for the development of agit-prop art

AUGUST. Chagall becomes director of the Vitebsk Popular Art Institute (also known as the Vitebsk Svomas)

NOVEMBER. Death of Olga Rozanova, one of the most important members of the avant-garde

Many artists help to decorate the streets and squares as part of the celebrations of the first anniversary of the October Revolution

The Shchukin collection of modern French art is nationalized

DECEMBER. The Morozov collection of modern French art is nationalized

The first issue of the journal *Iskusstvo kommuny* (Art of the Commune) is published in Petrograd (issues appear regularly until April 1919). It carries provocative, innovative articles on general themes such as art and revolution, as well as on Tatlin. Contributors include Ermolaeva, Kushner, Puni, and Punin

The Museums of Painterly Culture (also known as Artistic Culture) are established in Moscow, Petrograd, and other cities

The first Soviet constitution is adopted by the Fifth All-Russian Congress of Soviets

OCTOBER. The Komsomol (Communist Youth) organization is founded

1919
JANUARY. The first (and only) issue of the journal *Izobrazitelnoe iskusstvo* (Visual Art) appears in Petrograd under the editorship of Shterenberg. With articles by O. Brik, Kandinsky, Malevich, Punin, et al., this journal is meant to serve as the official organ of IZO Narkompros

The Komfut organization publishes its manifesto in *Iskusstvo kommuny*. An alliance of Communists and Futurists, this organization is supported by Altman, Kushner, Punin, et al.

FEBRUARY. The "First State Exhibition,"

FEBRUARY. The Imaginists, led by Esenin, Kusikov, and Mariengof, publish their first manifesto in Moscow

OCTOBER. Prokofiev finishes his opera *The Love of Three Oranges*

Throughout this year the civil war is fought on several fronts as anti-Bolshevik forces led by Kolchak, Yudenich, Denikin, and Vrangel advance from various directions

MARCH. The Third Communist International convenes in Moscow

THE VISUAL ARTS

LITERATURE AND
THE PERFORMING ARTS

POLITICAL EVENTS

a posthumous show of Rozanova's works, opens in Moscow. This is the first of twenty-one State Exhibitions organized during 1919–21. The most important are the "Fifth State Exhibition of the Trade Union of Artist-Painters of the New Art (From Impressionism to Nonobjectivity)," 1919; the "Tenth State Exhibition: Nonobjective Creation and Suprematism," 1919; the "Twelfth State Exhibition: Color-Dynamos and Tectonic Primitivism," 1919; the "Sixteenth State Exhibition: One-Man Exhibition of K. Malevich (His Path from Impressionism to Suprematism)," 1919; and the "Nineteenth State Exhibition," 1920
MARCH. Tatlin begins to design his *Monument to the Third International*
MAY. The first exhibition of Obmokhu (Society of Young Artists) opens in Moscow with contributions by Lentulov, Medunetsky, the Stenberg brothers, Yakulov, et al.

Korolev, Krinsky, Ladovsky, et al. establish Sinskulptarkh (Commission for the Elaboration of Questions of Sculptural-Architectural Synthesis). At the end of 1919 this is changed to Zhivskulptarkh (Commission of Painterly-Sculptural-Architectural Synthesis), when it attracts Rodchenko, Shevchenko, et al.
SEPTEMBER. Malevich replaces Chagall as director of the Vitebsk Popular Art Institute

Lissitzky begins work on Prouns

1920 JANUARY. In Vitebsk, Malevich and his students establish the Posnovis (Followers of the New Art). This group of Suprematist enthusiasts, which includes Chashnik and Suetin, changes its name to Unovis (Affirmers of the New Art) in April
MAY. Inkhuk (Institute of Painterly Culture) is organized in Moscow, and affiliations are soon established in Petrograd, Vitebsk, and other cities at home and abroad. Kandinsky draws up a program for Inkhuk, but this is rejected and replaced by one compiled by Babichev

The second Obmokhu exhibition opens in Moscow with contributions by the Stenberg brothers, et al.
AUGUST. Gabo and Pevsner publish their *Realist Manifesto*
SEPTEMBER. The Svomas are replaced by the Vkhutemas (Higher State Art-Technical Studios)

APRIL. Maiakovsky publishes his poem *150,000,000*

JANUARY. The Western powers end their blockade
APRIL. Vrangel takes command of the White Army
Poland attacks south Russia
OCTOBER. The First All-Russian Congress of Proletkult opens in Moscow
NOVEMBER. Denikin withdraws from Russian territory

THE VISUAL ARTS

LITERATURE AND
THE PERFORMING ARTS

POLITICAL EVENTS

1920
(cont.) NOVEMBER. Tatlin's model for his *Monument to the Third International* is displayed in Petrograd. In December it is transferred to Moscow

1921 JANUARY. Malevich publishes his book of lithographs *Suprematizm. 34 risunka* (Suprematism: 34 Drawings). Although dated 1920, the book is not published until January 1921
 Medunetsky and the Stenberg brothers organize an exhibition in Moscow called "The Constructivists," thereby establishing the Constructivist movement
MAY. The third Obmokhu exhibition opens in Moscow with contributions by Ioganson, Lentulov, Medunetsky, Rodchenko, the Stenberg brothers, Yakulov, et al.
SEPTEMBER. The exhibition "5 x 5 = 25" opens in Moscow with contributions (five works each) by Exter, Popova, Rodchenko, Stepanova, and A. Vesnin. Shortly thereafter, these artists direct their attention to utilitarian art forms
OCTOBER. RAKhN (Russian Academy of Artistic Sciences) opens in Moscow under the directorship of Petr Kogan and with the assistance of Kandinsky
 The *Mir iskusstva* exhibition opens with contributions by Drevin, Kandinsky, Lentulov, Shevchenko, Udaltsova, Zhegin, et al.
DECEMBER. Kandinsky emigrates to Germany

FEBRUARY. The Serapion Brotherhood is founded in Moscow by Expressionist writers such as Fedin, Lunts, Zoshchenko, et al.
MAY. *Romeo and Juliet* is produced at the Kamernyi Theater with designs by Exter
AUGUST 7. Death of Blok
NOVEMBER. Isadora Duncan dances at the Bolshoi Theater, Moscow, as part of the celebration of the fourth anniversary of the October Revolution

MARCH. The New Economic Policy (NEP), allowing for a partial return to the free enterprise system, comes into effect
NOVEMBER. Sailors at Kronstadt mutiny

1922 Lissitzky publishes his book *Pro 2 kvadrata* (About 2 Squares) in Berlin
JANUARY. The *Mir iskusstva* exhibition opens with contributions by Chagall, Drevin, Lentulov, Udaltsova, et al.
MARCH. Ehrenburg and Lissitzky publish the first issue of the journal *Veshch/Gegenstand/Objet* in Berlin, one of the most important early Constructivist magazines. The second and last issue appears in April
APRIL. Malevich moves from Vitebsk to Petrograd. Shortly thereafter he is followed by Chashnik, Suetin, et al.
MAY. The first Makovets group exhibition opens in Moscow with contributions by Chekrygin, Chernyshev, Shevchenko, et al. This group supports a subjective, lyrical interpretation of art and opposes both nonfigurative art and Constructivism
 The "Exhibition of Paintings by Artists of the Realist Tendency in Aid of the Starving" opens in Moscow. This inaugurates the activities of AKhRR (Associa-

FEBRUARY. *Phèdre* is produced at the Kamernyi Theater with designs by A. Vesnin
APRIL. Meierkhold produces Crommelynck's *The Magnanimous Cuckold* in Moscow with designs by Popova
JUNE 28. Death of Khlebnikov
NOVEMBER. Meierkhold produces Sukhovo-Kobylin's *Smert Tarelkina* (Death of Tarelkin) in Moscow with designs by Stepanova

DECEMBER. The Union of Soviet Socialist Republics (U.S.S.R.) is established

THE VISUAL ARTS

LITERATURE AND
THE PERFORMING ARTS

POLITICAL EVENTS

tion of Artists of Revolutionary Russia), a group that opposes the avant-garde and champions "heroic Realism," i.e., episodes from the Revolutionary period
JUNE. The exhibition of the Association of New Trends in Art opens in Petrograd with contributions by Malevich, Senkin, Tatlin, et al.
JULY. Chagall emigrates to Lithuania and then to Berlin
OCTOBER. The "Erste russische Kunstausstellung" opens at the Galerie van Diemen, Berlin. Many members of the avant-garde are represented. Gabo accompanies the exhibition, never to return to Russia
DECEMBER. Gan publishes his manifesto, *Konstruktivizm* (Constructivism), in Tver

1923 The "Exhibition of Paintings by Petrograd Artists of All Tendencies" opens in Petrograd with contributions by Filonov, Matiushin, Tatlin, et al.
MAY. The fourth Obmokhu exhibition opens in Moscow with contributions by the Stenberg brothers, et al.
SEPTEMBER. The "First Agricultural and Handicraft-Industrial Exhibition" opens in Moscow. Exter, Mukhina, the Stenberg brothers, et al. are involved in its design
 The "Exhibition of Russian Painting and Sculpture" opens at the Brooklyn Museum, New York, with contributions by D. Burliuk, Goncharova, Kandinsky, et al.

MARCH. Maiakovsky, O. Brik, et al. found the journal *Lef* (Left Front of the Arts) in Moscow. *Lef* favors a strongly ideological interpretation of art and also champions Constructivism and the Formalist method in literary criticism; issues appear regularly through 1925
 Meierkhold produces S. Tretiakov's *Zemlia dybom* (Earth in Turmoil) in Moscow with designs by Popova
MAY. Khlebnikov's play *Zangezi* is produced in Petrograd with designs by Tatlin
DECEMBER. Chesterton's *The Man Who Was Thursday* is produced at the Kamernyi Theater with designs by A. Vesnin

1924 JANUARY. The second Makovets exhibition opens in Moscow with contributions by Bruni, Chekrygin, Pestel, et al.
MARCH. The "Russian Art Exhibition" opens at the Grand Central Palace, New York. The works are by moderate artists; the avant-garde is hardly represented
MAY. The "First Discussional Exhibition of the Associations of Active Revolutionary Art" opens in Moscow. It is composed of eight sections including the Concretists (Liushin, Vialov, et al.), the Projectionists (Luchishkin, Nikritin, Plaksin, Redko, Triaskin, and Tyshler), and the First Working Group of Constructivists (the Chichagova sisters, Gan, Miller, et al.)
MAY 25. Death of Popova, a leader of the avant-garde. She is honored by a posthumous exhibition in Moscow
JUNE. The Fourteenth Biennale opens in Venice with a Russian section that includes Drevin, the Enders, Malevich, Ma-

MARCH. Ostrovsky's *Groza* (The Storm) is produced at the Kamernyi Theater with designs by the Stenberg brothers—one of several collaborations between the Stenbergs and Tairov, the theater's director
SEPTEMBER. Protazanov produces the space movie *Aelita* with designs by Exter, Rabinovich, and Simov
OCTOBER. Vertov produces his Constructivist movie *Kino-Eye*

Stalin and Trotsky compete for power. Stalin assumes increasing control

JANUARY. Great Britain and Italy establish diplomatic relations with the U.S.S.R.
JANUARY 21. Death of Lenin
OCTOBER. France establishes diplomatic relations with the U.S.S.R.

THE VISUAL ARTS

LITERATURE AND
THE PERFORMING ARTS

POLITICAL EVENTS

**1924
(cont.)** tiushin, Miturich, Popova, Rodchenko, Stepanova, Udaltsova, et al.
OCTOBER. Ginkhuk (State Institute of Painterly Culture) is founded in Leningrad. During its brief life (until December 1926), it operates through various departments such as the Formal and Theoretical Department, led by Malevich (replaced by Isakov and Punin in February 1926), and the Organic Culture Department, led by Matiushin. Filonov, Mansurov, Suetin, and Tatlin also play important roles

1925 Filonov establishes his Collective of Masters of Analytical Art within the restructured Academy of Arts in Leningrad
The Four Arts group opens its first exhibition in Moscow with contributions by Bruni, Kuznetsov, Miturich, et al.; it holds exhibitions annually until 1929
MARCH. The Makovets group organizes an exhibition of drawings in Moscow with contributions by Chekrygin, Pestel, Zhegin, et al.
APRIL. The Exposition Internationale des Arts Décoratifs et Industriels Modernes opens in Paris with a Constructivist Soviet Pavilion designed by Melnikov. The new Soviet design movement is well represented here by Popova, Rodchenko, Stepanova, A. Vesnin, et al.
MAY. The first exhibition of OST (Society of Studio Artists) opens in Moscow with contributions by Kliun, Liushin, Pimenov, Shterenberg, Vialov, et al. This group, led by Shterenberg, believes that the traditional media can still express contemporaneity
SEPTEMBER. The exhibition "Leftist Trends in Russian Painting of the Last 15 Years" opens in Moscow
DECEMBER. The third Makovets exhibition opens in Moscow with contributions by Bruni, Pestel, Shevchenko, Zhegin, et al.

JANUARY. The first issue of the literary journal *Novyi mir* (New World) appears in Moscow, edited by Lunacharsky and Steklov
The first installments of Gladkov's proletarian novel *Tsement* (Cement) begin to appear in the journal *Krasnaia nov* (Red New Earth)
APRIL. Eisenstein produces his movie *Strike*
RAPP (Russian Association of Proletarian Writers) is established in Moscow. Its members call for increased ideological awareness on the part of writers
JUNE. The Party issues the decree *On the Party's Policy in the Field of Artistic Literature*. While encouraging support for peasant and worker writers, the Party still asserts that it does not have the right to monopolize any one literary style
NOVEMBER. Antokolsky's *Kukirol* is produced at the Kamernyi Theater with designs by the Stenberg brothers
DECEMBER. Eisenstein produces his movie *The Battleship Potemkin*
DECEMBER 28. Death of Esenin by suicide

JANUARY. Japan establishes diplomatic relations with the U.S.S.R.

1926 JANUARY. The architectural journal *SA* (Contemporary Architecture), edited by A. Vesnin and M. Ginzburg, begins to appear in Moscow. *SA* serves as a key propagator of Constructivism until it ceases publication, in 1930
FEBRUARY. The "Second Exhibition of Movie Posters" opens in Moscow with contributions by Altman, Rodchenko, the Stenberg brothers, et al.
MARCH. The "State Art Exhibition of Contemporary Sculpture" opens in Moscow

JANUARY. O'Neill's *The Hairy Ape* is produced at the Kamernyi Theater with designs by the Stenberg brothers
JUNE. Diaghilev produces Prokofiev's *Le Pas d'Acier* in Paris with designs by Yakulov
NOVEMBER. O'Neill's *Desire under the Elms* is produced at the Kamernyi Theater with designs by the Stenberg brothers

APRIL. Germany and the U.S.S.R. sign a treaty of friendship and neutrality

	THE VISUAL ARTS	LITERATURE AND THE PERFORMING ARTS	POLITICAL EVENTS

with works by Altman, Korolev, et al.
MAY. The second exhibition of OST opens in Moscow with contributions by Kudriashev, Liushin, Shterenberg, Vialov, et al.
JUNE. A traveling "Exhibition of Soviet Art" opens in Kharbin before going on to Tokyo. Apart from OST members, the avant-garde is not well represented here
SEPTEMBER. Vkhutemas is replaced by Vkhutein (Higher State Art-Technical Institute)

1927

MARCH. Malevich embarks on a trip to Poland and Germany with an exhibition of his work. He leaves a large number of works with a friend in Germany and returns to the Soviet Union in June
APRIL. The third exhibition of OST opens in Moscow with contributions by Liushin, Triaskin, Vialov, et al.
 A group of Filonov's students organizes the "Exhibition of Masters of Analytical Art" in Leningrad. Included are Glebova, Sulimo-Samuilo, and Tsibasov
MAY. An "Exhibition of Soviet Art" opens in Tokyo with contributions by B. Ender, Miturich, the Stenberg brothers, et al. Punin is curator of the exhibition
SEPTEMBER. The "All-Union Printing Exhibition" opens in Moscow with contributions by Klucis, Lissitzky, Senkin, Shterenberg, et al.
NOVEMBER. The "Exhibition of the Newest Trends in Art" opens in Leningrad with contributions by D. Burliuk, Goncharova, Larionov, Miturich, Rozanova, Tatlin, Chagall, Shevchenko, et al.

JANUARY. The Ukrainian avant-garde journal of literature and art *Nova generatsiia* (New Generation) begins publication in Kharkov; issues appear regularly through 1930. While giving attention to the new Ukrainian movements, *Nova generatsiia* also carries articles by Malevich, Matiushin, and other members of the Russian avant-garde
 The journal *Novyi lef* (New Left Front of the Arts) begins publication in Moscow edited by Maiakovsky. *Novyi lef* gives particular attention to photography and the cinema; issues appear regularly through 1928
APRIL. Diaghilev produces *La Chatte* in Monte Carlo and then in Paris (May) with designs by Gabo and Pevsner. Lifar dances the leading role

OCTOBER. Stalin expels Trotsky from the Party

1928

AKhRR changes its name to AKhR (Association of Artists of the Revolution)
MARCH. The exhibition "Photography of the Last 10 Years" opens in Moscow with contributions by Petrusov, Rodchenko, A. Shishkin, et al.
MAY. The fourth exhibition of OST opens in Moscow with contributions by Labas, Liushin, Shterenberg, Vialov, et al.
 Lissitzky designs the Soviet Pavilion for the Press Exhibition in Cologne
JUNE. The "Exhibition of Acquisitions by the State Commission for the Acquisition of Works of Visual Art" opens in Moscow with contributions by Drevin, Malevich, Morgunov, Tatlin, Udaltsova, et al.

Sholokhov publishes the first volume of his novel *Tikhii Don* (And Quiet Flows the Don)
MARCH. Eisenstein produces his movie *October*

APRIL. The First Five-Year Plan is inaugurated at the Sixteenth Party Congress. With this begins the drive toward rapid industrialization and collectivization

1929

Malevich is given a one-man show at the Tretiakov Gallery, Moscow

JANUARY. Vertov produces his Constructivist movie *Man with a Movie Camera*

SEPTEMBER. Lunacharsky resigns as minister of enlightenment

THE VISUAL ARTS

LITERATURE AND THE PERFORMING ARTS

POLITICAL EVENTS

1929
(cont.) Vsekokhudozhnik (All-Union Cooperative of Artists) is established in Moscow as a central agency for the supervision of artists' commissions, supplies, trips, etc. It serves as a precedent to the formation of the Union of Artists of the U.S.S.R., in 1939
Tatlin begins to work on designs for his glider *Letatlin*
During the winter of 1929–30 a retrospective exhibition of Filonov's works is prepared in the Russian Museum, Leningrad, and a catalogue is printed. Because of pressure from conservative artists, the exhibition does not open
FEBRUARY. The "Exhibition of Contemporary Art of Soviet Russia" opens in New York with contributions by Altman, Lissitzky, Morgunov, Shterenberg, Tatlin, et al.
DECEMBER 4. Death of Chashnik, one of Malevich's most talented students

FEBRUARY. Meierkhold produces Maiakovsky's *Klop* (Bedbug) in Moscow with designs by Rodchenko and the three cartoonists known as the Kukryniksy

1930 Vkhutein is dissolved and replaced by the Moscow Art Institute
JUNE. FOSKh (Federation of the Association of Soviet Workers in the Spatial Arts) is established in Moscow. It is one of several attempts to unite the various artistic factions under a single organizational and ideological umbrella before the Party itself abolishes such factions in its decree of 1932
The "Exhibition of Acquisitions by the State Commission for the Acquisition of Works of Visual Art" opens in Moscow with contributions by Lentulov, Malevich, Morgunov, Shevchenko, Tatlin, et al.
The October group holds its single exhibition in Moscow. This group, founded in 1928, encompasses various artistic activities, although it concentrates on the industrial and applied arts. Klucis, Lissitzky, Rodchenko, Senkin, Stepanova, Telingater, et al. are represented
JULY. The exhibition "Sowjetmalerei" opens in Berlin with contributions by Korolev, Lentulov, Malevich, et al.
SEPTEMBER 29. Death of Repin, Russia's greatest Realist artist
OCTOBER. An exhibition of contemporary Soviet art opens in Vienna with contributions by Drevin, Malevich, Shevchenko, Shterenberg, et al.

Shostakovich completes his opera *Lady Macbeth of Mtsensk*
JANUARY. *The Beggar's Opera* is produced at the Kamernyi Theater with designs by the Stenberg brothers
MARCH. Meierkhold produces Maiakovsky's *Bani* (Bathhouse) in Moscow with general layout by Deineka
APRIL 14. Death of Maiakovsky by suicide
NOVEMBER. The Congress of the International Bureau of Revolutionary Literature meets in Kharkov. Many Western delegates are present

1931 MARCH. The Party publishes the decree *On Poster and Picture Production* in which it criticizes artists for creating anti-Soviet

THE VISUAL ARTS

LITERATURE AND
THE PERFORMING ARTS

POLITICAL EVENTS

posters and paintings and demands closer scrutiny of artistic production

MAY. RAPKh (Russian Association of Proletarian Artists) is founded. This organization, encompassing many artists both left and right, recognizes art only as "ideology, as a revolutionary weapon in the class struggle"

1932 APRIL. The Party publishes its decree *On the Reconstruction of Literary and Artistic Organizations* whereby single unions are proposed instead of the many groups

NOVEMBER. The exhibition "Artists of the R.S.F.S.R. over the Last 15 Years" opens in Leningrad with contributions by Drevin, Filonov, Malevich, Morgunov, Shevchenko, Tatlin, Vialov, et al. This impressive exhibition of almost a thousand works stays open until May 1933

1933 The "Exhibition of Works by Artist-Tourists" opens in Leningrad with contributions by Filonov, Malevich, Matiushin, et al.

JUNE. The exhibition "15 Years of the Workers' and Peasants' Red Army" opens in Moscow with almost seven hundred works and lasts until November. Apart from small contributions by former members of OST, the avant-garde is not represented

The exhibition "Artists of the R.S.F.S.R. over the Last 15 Years" opens in Moscow. This is a modified version of the Leningrad exhibition. It stays open until February 1934

The Academy edition of the Scandinavian epic tale *Kalevala* is published in Russian translation with illustrations by members of the Filonov school

AUGUST. *Sovetskoe iskusstvo za 15 let* (Soviet Art of the Last 15 Years), a book of documents, edited by Matsa, appears in Leningrad

OCTOBER 15. Death of Georgii Stenberg

1934 JANUARY. The exhibition "15 Years of the Workers' and Peasants' Red Army" opens in Leningrad. This is a modified version of the Moscow exhibition

MARCH. The exhibition "Artists in Transportation" opens in Moscow with contributions by Tyshler, Vialov, et al.

DECEMBER. The exhibition "The Art of Soviet Russia" opens in Philadelphia with contributions by Drevin, Shevchenko, Udaltsova, Vialov, et al.

JANUARY. Kataev begins to publish his proletarian novel *Vremia, vpered!* (Time, Forward!) in the journal *Krasnaia nov*

Sholokhov begins to publish his novel *Podniataia tselina* (Virgin Soil Upturned) in *Novyi mir*

APRIL. Ostrovsky begins to publish his proletarian novel *Kak zakalialas stal* (How the Steel Was Tempered) in the journal *Molodaia gvardiia* (Young Guard)

AUGUST. Livshits publishes his memoirs of the Futurist epoch, *Polutoraglazyi strelets* (The One-and-a-Half-Eyed Archer), in Leningrad. It meets with harsh criticism

JANUARY 8. Death of Bely

AUGUST–SEPTEMBER. Chaired by Gorky, the First All-Union Congress of Soviet Writers meets in Moscow. It concludes its meeting by advocating Socialist Realism as the exclusive style for Soviet writers and artists

The First Five-Year Plan is completed, and the Second is inaugurated

The White Sea Canal is completed

NOVEMBER. The U.S. restores diplomatic relations with the U.S.S.R.

SEPTEMBER. The U.S.S.R. becomes a member of the League of Nations

INDEX

Bibliographical data, references to George Costakis and the Tretiakov Gallery, and material in the chronology and the acknowledgments have not been included in the index. Since the artists' original titles for their works are often unknown, it has seemed preferable to omit all titles of works of art from the index.

About Still Life. *See O natiurmorte*
About 2 Squares. *See Pro 2 kvadrata*
About Zaum. *See K Zaumi*
Abstract Room. *See Raum der Abstrakten*
Aelita (Protazanov and Tolstoi), 97
Aero, 88
Affirmers (*also* Affirmation) of the New Art. *See* Unovis
Agra. *See* Stepanova, Varvara Fedorovna
Aivazovsky, Ivan Konstantinovich, 31, 69
AKhR (Association of Artists of the Revolution), 115
AKhRR (Association of Artists of Revolutionary Russia), 21, 34, 78, 93, 445
Aksenov, Ivan A., 391, 399, 412, 468
Aliagrov (pseud. of Roman Jakobson), 453, 457
Alipii, Father, 42
All-Russian Congress of Artists, 130
All-Russian Union of Poets Club. *See* VSP
All-Union Society for Cultural Relations, 35
All-Union Spartakiada, 221
Amsterdam, Stedelijk Museum, 57, 262, 268
Anisimova, O., 409
Annensky, Innokentyi, 97
Anthology of New Writers, An. *See Sbornik molodikh pisatelei*
Antokolsky, 69
Antonova, Irina, 71
A, O, U Tragedy. *See Tragedia A, O, U*
Apollinaire, Guillaume, 82, 97
Apollon, 130
Archipenko, Alexander, 115
Armory Show, 12
Arp, Hans, 242
Artistes Indépendants, 97
"Artists of the R.S.F.S.R. over the Last 15 Years," 463
Artisty kino, 415
Artseulov, K., 482
Art of Today, The. *See Iskusstvo dnia*
Arvatov, Boris, 78
Aseev, Nikolai, 390
ASNOVA (Association of New Architects), 116
Association of Artists of the Revolution. *See* AKhR
Association of Artists of Revolutionary Russia. *See* AKhRR
Association of New Architects. *See* ASNOVA
Association of New Trends in Art. *See Obedinenie novykh techenii v iskusstve*
Assotsiatsiia khudozhnikov revoliutsii (Association of Artists of the Revolution). *See* AKhR

Assotsiatsiia khudozhnikov revoliutsionnoi Rossii (Association of Artists of Revolutionary Russia). *See* AKhRR
Assotsiatsiia novykh arkhitektorov (Association of New Architects). *See* ASNOVA
"Ausstellung moderne russische Kunst" (Exhibition of Modern Russian Art), 497
Autumn Dream. *See Osennii son*
Ažbé, Anton, 81, 128, 130

Babichev, Alexei Vasilievich, 78–79, 110, 112, 242
Babicheva, Natalia, 78, 79, 110, 112, 124, 125, 242, 244, 246, 247, 248, 249, 250
Baby Camels in the Sky. *See Nebesnye verbluzhata*
Bakst, Leon, 82, 268, 272
Balashova, Alexandra, 421
"Bal Banal," 109
Barnes, Dr. Albert C., 14
Barr, Alfred H., Jr., 45–46
Bart, Viktor, 344
"Basis of the Construction of a Theory of Architecture" (Ladovsky), 116
Bauhaus, 15, 130, 275, 492
Bebutov, Valerii Mikhailovich, 488
Bednyi, Demian, 414
"Bednyi rytsar" (Guro), 272
Bely, Andrei, 391
Benois, Alexandre, 16
Berlin: Galerie van Diemen, 82, 91, 93, 103, 119, 122, 126, 130, 139, 206, 223, 242, 251, 267, 324, 330, 339, 344, 433, 446, 453, 467, 474, 484, 494; Der Sturm, 81, 82, 106, 128, 233, 433, 497
Bernshtein, Mikhail, 494
Beskin, Osip, 95
Bienert, Ida, 247
Bilibin, Ivan, 275, 494
blauen Vier, Die, 128
blaue Reiter, Der, 81, 106, 128
Blok, Alexandr, 233
Blok, Mariia, 115
Blue Four, The. *See* blauen Vier, Die
Blue Rider, The. *See blaue Reiter, Der*
Blue Rose group, 18, 34
Blue Sun, The. *See* "Goluboe Solntse"
Boards of Destiny, The. *See Doski sudby*
Bobrov, S. P., 370
Bobrov, Vasilii Dmitrievich, 57, 70, 80, 130, 258
Bobyshev, Mikhail, 472
Boccioni, Umberto, 352
Bogaevsky, Konstantin, 124
Boguslavskaia, Ksenia, 55, 433
Bojko, Szymon, 17
Bolshakov, Konstantin, 242
Bolsheviks (*or* Bolshevik Party, Bolshevik Revolution, Bolshevik government), 20, 24, 27, 59, 60, 61, 421

Bomba (Aseev), 390
Book Evening. *See Vecher knigi*
Borisov-Musatov, Viktor, 140, 484
Bosch, Hieronymus, 19
Botkin, M. P., 23, 24
Bourdelle, Antoine, 78
Braikevich, Mikhail, 25
Braque, Georges, 97, 165
Brik, Osip, 78, 124
Briusova, Nadezhda, 110
Broderson, Moshe, 243
Broom, 250
Bruni, Lev, 474
Bubnova, Varvara Dmitrievna, 125, 126
"Bubnovyi valet" (Jack of Diamonds), 17, 56, 81, 82, 97, 106, 128, 130, 139, 146, 233, 240, 251, 255, 326, 339, 344, 433, 453, 474, 484
Budkevich (collector), 135
Burliuk, David, 20, 81, 98, 233, 433, 474
Burliuk, Ludmila, 81
Burliuk, Nadezhda, 81
Burliuk, Nikolai, 81
Burliuk, Vladimir Davidovich, 20, 81, 433, 474

Canova, Antonio, 22
Canterbury Tales, The (Chaucer), 36
Captain's Daughter, The (Pushkin), 234
Cardoza, Lya, 47
Card Players (Gogol), 86
Catherine II, Empress, 22
Cézanne, Paul, 21, 24, 35, 326
Chad Gadya, 242
Chagall, Bella, 69
Chagall, Marc (Mark Zakharovich Shagal), 14, 46, 62, 67–68, 69, 70, 73, 82–87, 88, 242, 251, 433
Chagall, Vava, 46
Chaliapin, Fedor, 28
Chaplin, Charlie, 26
Chashnik, Ilia Grigorievich, 40, 82, 88–90, 251, 260, 409, 470, 499
Chatwin, Bruce, 46
Chauvelin, Jean, 449
Chegodaev, Alexandr, 32
Chekrygin, Vasilii Nikolaevich, 19, 20, 26, 62, 91–92, 421
Chelishchev (Tchelitchew), Pavel, 97
Chemiakin, Mikhail, 42
Chetyre fonetichestikh romana (Kruchenykh), 217
Chichagova, Galina and Olga, 19
Christie, James, 22
Chudnovsky, Abram Filipovich, 44, 51
Chulkov, Georgii, 391
Churchill, Winston, 33
Čiurlionis, Mikalojaus, 140

Claudel, Paul, 497
Cologne: Galerie Gmurzynska (*also* Antonina Gmurzynska collection), 73, 98, 245; Museum Ludwig, 361
Collective of Masters of Analytical Art, 103
Commission of Painterly-Sculptural-Architectural Synthesis. *See* Zhivskulptarkh
Community of Artists. *See* Obshchina khudozhnikov
Conspiracy of Fools. *See* Zagovor durakov
"Constructivists, The" (exhibition), 122
Contemporary Creation. *See* "Sovremennoe tvorchestvo"
Contemporary Leningrad Art Groups. *See* "Sovremennye leningradskie khudozhestvennye gruppirovki"
Conversations with Revenue Inspector (Maiakovsky), 452
Coq d'Or, Le (Rimsky-Korsakov), 106
Costakis, Dionysius, 27, 28
Costakis, Dmitrii, 32
Costakis, Nikolai, 32
Costakis, Spiridon, 28, 32
Costakis, Zina (Zinaida Panfilova), 12, 28, 32, 45, 55, 66
Courbet, Gustave, 323
Croaked Moon. *See* Dokhlaia luna
Crommelynck, Fernand, 18, 344, 399
Crowe, Marshall A., 33, 49

Daran, Daniil, 463
Davis, Douglas, 47, 75
Davis, Frank, 23
Davydova, N., 370, 456
Death of Tarelkin. *See* Smert Tarelkina
Dedenko (collector), 85, 86
Dege, Adelaide Robertovna, 363, 365, 366
Delaunay, Robert, 343, 497
Delaunay, Sonia, 61, 343, 497
Delta (Bobrov), 370
Delvall, Carlo, 97
Denis, Maurice, 24
Derain, André, 40
Dereviannye idoly (Filonov and Khlebnikov), 104
Diaghilev, Sergei, 16, 106, 233
Dlia golosa (Maiakovsky), 242
Dmitriev-Kavkazsky, Lev, 103, 129
Dobuzhinsky, Mstislav, 82, 268, 272
Dobychina, Nadezhda E., 55, 82, 83, 106
Dokhlaia luna, 81
Dolgorukov, Nikolai, 61
van Dongen, Kees, 50
Donkey's Tail. *See* "Oslinyi khvost"
Dorosevich, V., 421
Doski sudby (Khlebnikov), 324
Dostoevsky, Fedor, 19, 23
Drevin, Alexandr Davidovich, 37, 48, 55, 63, 93–96, 110, 259, 463, 484
Drevin, Andrei A., 93, 259, 484

Drama in the Futurists' Cabaret No. 13, 106, 233
Dreier, Katherine, 12
Dubovskoi, Nikolai, 126
Du Cubisme (Gleizes and Metzinger), 268
Dudin, Ivan, 78
Duveen, Joseph, 43
Dvenadsat (Blok), 233

Early Spring. *See* "Ranniaia vesna"
Earth in Turmoil. *See* Zemlia dybom
Eastlake, Charles, 23
Echange, L' (Claudel), 497
Eding, Boris Nikolaevich, 420
Efros, A. M., 84, 85
Egbert, Donald Drew, 35n
Ehrenburg, Ilia, 242
Eiffelaia (Aksenov), 412
Eighth State Exhibition, 126
Eindhoven, van Abbemuseum, 249, 250
Eisenstein, Sergei, 26
Electroorganism. *See* Elektroorganizm
Elektroorganizm (Electroorganism), 40, 330, 341, 440
Emperor Maximilian and His Disobedient Son Adolph. *See* Tsar Maximilian i ego neposlushnyi syn Adolf
Ender, Andrei, 19, 26, 51, 268, 270, 271, 274, 277, 279, 316
Ender, Boris Vladimirovich, 19, 26, 40, 47, 51, 61, 64, 268, 270, 271, 274, 275–79, 280, 301
Ender, Ksenia Vladimirovna, 19, 26, 40, 51, 64, 268, 270, 271, 275, 280–300
Ender, Mariia Vladimirovna, 19, 26, 37, 40, 51, 64, 268, 270, 271, 272, 280, 290, 301–15
Ender, Yurii Vladimirovich, 19, 26, 40, 64, 270, 271, 274, 280, 316–22
Engels, Friedrich, 20
Erevan Museum, 497
Ermolaeva, Vera, 88, 251, 264, 470
"Erste deutsche Herbstsalon" (First German Autumn Salon), 81, 106, 128, 233, 497
"Erste russische Kunstausstellung" (First Russian Art Exhibition), 82, 91, 93, 103, 119, 122, 126, 130, 139, 206, 223, 242, 251, 267, 324, 330, 339, 344, 433, 446, 453, 467, 474, 484, 494, 499
Esenin, Sergei, 497
Espagne (Ravel), 106
"Esposizione Libera Futurista Internationale," 97
Estorick, Eric, 246
Ettinger, Pavel, 31
Evreinov, Nikolai, 82
"Exhibition of Four," 130, 446, 467
Exhibition of Graphic Art. *See* "Vystavka graficheskikh iskusstv"

Exhibition of Modern Russian Art. *See* "Ausstellung moderne russische Kunst"
Exhibition of Painting: 1915. *See* "Vystavka zhivopisi 1915 god"
Exhibition of Paintings of Petrograd Artists of All Tendencies. *See* "Vystavka kartin petrogradskikh khudozhnikov vsekh napravlenii"
"Exhibition of Paintings by Russian Artists," 439
"Exhibition of Soviet Art," 275
Explodity. *See* Vzorval
Exposition Internationale des Arts Décoratifs et Industriels Modernes (Paris), 116, 119, 122, 275, 301, 446, 470, 474
Exter, Alexandra Alexandrovna, 18, 40, 59, 62, 97–102, 366, 370, 468, 490
Exter, Nikolai, 97

Faculty for Workmen. *See* Rabfak
Faktura slova (Kruchenykh), 139
Falk, Robert, 37, 41, 44, 48, 66, 82, 87, 137, 341
Fan, The (Goldoni), 106
Favorsky, Vladimir, 484
Federation of Painters, 370
Fedorov, Nikolai, 19, 91, 498
Fedorovna, Tatiana, 62
Feininger, Lyonel, 128
"Fifth State Exhibition: From Impressionism to Nonobjective Art," 93, 130, 139, 326, 339, 344, 467
Film. *See* Kino
Film Performers. *See* Artisty Kino
Filonov, Pavel Nikolaevich, 19, 20, 26, 36, 37, 61, 64, 103–05, 129, 267, 472
Firebird, The (Stravinsky), 106
First All-Union Agricultural and Home Industries Exhibition, 18
First All-Union Congress of Writers of the U.S.S.R., 34
First Citywide Arts Show. *See* "Pervaia obshchegorodskaia vystavka izobrazitelnykh iskusstv"
First Discussional Exhibition of the Associations of Active Revolutionary Art. *See* "Pervaia diskussionaia vystavka obedinenii aktivnogo revoliutsionnogo iskusstva"
First German Autumn Salon. *See* "Erste deutsche Herbstsalon"
Firstly, Secondly. *See* Vo-pervykh i vo-vtorykh
First Russian Art Exhibition. *See* "Erste russische Kunstausstellung"
First State Exhibition, 223, 224
First State Free Exhibition of Works of Art, 82, 103, 267
"5 x 5 = 25," 97, 344, 391, 446, 452, 467, 468
"Five Years of Art," 446
Florensky, Pavel, 91
Followers of the New Art. *See* Posnovis

Forestly Rapid (Kruchenykh), 456
For a Theory of Painting. *See Opyt teorii zhivopisi*
For the Voice. *See Dlia golosa*
Four Arts Society, 139, 324
Four Phonetic Novels. *See Chetyre foneticheskikh romana*
Fourteenth Venice Biennale (1924), 267, 275, 278, 280, 301, 323
Free State Art Studios. *See* Petrosvomas; Svomas
From Cubism and Futurism to Suprematism: The New Painterly Realism. *See Ot kubizma i futurizma k suprematizmu. Novyi zhivopishnyi realizm*
From the Easel to the Machine. *See Ot molberta k mashine*
Furtseva, Ekaterina A., 48, 49, 71, 74
Futuristy. Rykaiushchii Parnas, 103, 433, 453

Gabo, Naum, 16, 19, 41, 79, 206, 223
Gagarin, Prince, 22
GAKhN (State Academy of Artistic Sciences), 93, 130, 139
Game in Hell, A. *See Igra v adu*
Gan, Alexei, 21, 447
Gauguin, Paul, 254
Geltser, Ekaterina, 421
Germanova, M. N., 421
Getty, J. Paul, 43
Ginkhuk (State Institute of Painterly Culture, Leningrad), 88, 103, 267, 274, 323, 470, 474
Ginzburg, Moisei, 61
Giotto, 344
Giroflé-Girofla (Lekok), 497
Glagol, Sergei (pseud. of Sergei Gloushev), 176
Glavnauka (Main Science Administration), 409
Glebova, E. N., 103, 104
Gleizes, Albert, 268
Glinka, Mikhail, 474, 476
Gmurzynska, Antonina. *See* Cologne
Gogol, Nikolai, 42, 82, 86, 414
Golden Fleece. *See Zolotoe runo*
Goldoni, Carlo, 106
Goloushev, Sergei. *See* Glagol, Sergei
Golovanov, Nikolai, 41
"Goluboe solntse" (Yakulov), 497
Goncharova, Natalia Sergeevna, 17, 36, 48, 61, 62, 73, 82, 106–09, 233, 240
Gorky, Maxim, 23, 421
Gornukh, L. V., 81
Gosudarstvennaia akademiia khudozhestvennykh nauk (State Academy of Artistic Sciences). *See* GAKhN
Gosudarstvennyi institut khudozhestvennoi kultury (State Institute of Painterly Culture, Leningrad). *See* Ginkhuk
Grabar, Igor, 34

Granovsky, Alexei, 82
Gray, Camilla, 46, 62
Great Berlin Art Exhibition. *See* "Grosse Berliner Kunstausstellung"
Green Ring, The. *See Zelenoe koltso*
Grinberg, Nikolai Ivanovich, 64, 274, 314, 323
Gris, Juan, 165
Grishakin, V., 452
Grishenko, Alexei, 484
"Grosse Berliner Kunstausstellung" (Great Berlin Art Exhibition), 242, 251
"Group 13," 463
Guggenheim, Peggy, 12, 43, 83
Guro, Elena, 62, 64, 268, 272–73, 280

Hamburg, Kunsthalle, 69
Hanover, Niedersächsisches Landesmuseum, 242
Hart, Albert, 45
Hermits. *See Pustynniki*
Hirshhorn, Joseph H., 39
Hitler, Adolf, 32, 33
Hoffmann, E. T. A., 497, 498
Hollósy, Simon, 339, 484
House of Architects, 47
Hurdy-Gurdy, The. *See Sharmanka*

Igra v adu (Kruchenykh, Malevich, Rozanova), 106, 256, 453
"Impressionists" (exhibition), 268
Impressionists (group), 268, 272
Inkhuk (Institute of Painterly Culture), 21, 78, 80, 93, 110–27, 130, 139, 206, 244, 249, 251, 258, 344, 446, 468, 474, 484
Institute of Painterly Culture. *See* Inkhuk
Institut khudozhestvennoi kultury (Institute of Painterly Culture). *See* Inkhuk
International Art Exhibition. *See* Internationale Kunst
International Council of Museums (ICOM), 74, 75
Internationale Kunst (Dresden), 242, 247
International Press Exhibition. *See* "Pressa"
Ioganson, Karel, 113–14, 125, 127
Iskusstvo dnia (Tarabukin), 124
Istomin, Konstantin, 484
Ivanov, A., 445
Ivanov, Evgenii Platonovich, 421
Ivanov, Sergei, 326
Ivanova, Serafima, 63
Ivan Susanin. See Zhizn za Tsaria
Ivnev, Riurik, 391
I Want a Child. *See Khochu rebenka*
Izdebsky, Vladimir, 81, 97, 106, 128, 130, 233, 240, 268, 474

IZO Glavnauka (Department of Visual Arts of Glavnauka), 409
IZO Narkompros (Department of Visual Arts of Narkompros), 126, 130, 251, 261, 326, 446, 453, 467, 474, 484

Jack-of-Diamonds. *See* "Bubnovyi valet"
Jakobson, Roman. *See* Aliagrov
Jawlensky, Alexei Georgievich, 128, 130
Jeanneret, Charles Edouard. *See* Le Corbusier
Josephson, Matthew, 250

Kabakov, Ilia, 41
Kachurin, I., 460
Kakabadzé, David Nestorovich, 37, 129
Kalevala (Academy edition), 103
Kalf, Willem, 68
Kállai, Ernst, 244
Kalmakov, 224
Kamensky, Vasilii, 98, 457, 480, 488
Kandaurov, K. V., 85
Kandinsky, Nina Andreevskaia, 130
Kandinsky, Wassily (Vasilii) Vasilievich, 14, 16, 21, 26, 36, 37, 41, 50, 51, 62, 63, 66, 69, 70, 80, 93, 110, 111, 128, 130–38, 233, 343, 446, 467, 492
Kardovsky, Dmitrii, 240
Kaufman, Mikhail, 446, 449
Kazan Museum, 70
Keaton, Buster, 26
Kennedy, Edward, 73
Kestner Society, 242
Khardzhiev, Nikolai, 255, 257, 260, 268, 273, 453
Kharitonov, Alexandr, 42
Kharms, Daniil, 481
Khidekel, Lazar, 88
Khlebnikov, Velimir, 98, 104, 106, 233, 268, 324, 453, 456, 458, 474
Khochu rebenka (S. Tretiakov), 242
Khodasevich, Valentina M., 498
Khrushchev, Nikita, 46, 72, 73
Kino, 414
Kish, Egon, 339
Kisilev, Viktor, 452
Kiss, Istvan, 484
Klee, Paul, 128
Kliun (Kliunkov), Ivan Vasilievich, 37, 40, 46, 51, 56, 59, 60–61, 63, 65, 70, 93, 110, 139–205, 223, 251, 253, 324, 326, 370, 433, 455
Klucis, Gustav Gustavovich, 19, 37, 38, 40, 47, 59, 61, 206–22, 431, 432, 448, 462
K novym beregam, 390
K novym beregam muzykalnogo iskusstva, 416
Kobro, Katarzyna, 223

"Koltso" (The Ring), 97
Koonen, A. G., 98, 101, 102, 497, 498
Korin, Pavel, 41
Korolev, Boris Danilovich, 115
Korovin, Konstantin, 69, 326
Korsakova, A. M., 475, 477, 481
Kostin, Vladimir, 47, 481
Kovrigin, V. V., 64
Kovtun, Evgenii, 64, 104, 259, 469, 499
Krakht, Konstantin, 326
Kramarenko, L. Y., 266
Kramer, Hilton, 47
Krasnopevtsev, Dmitrii Mikhailovich, 42
Kravtsov, Sergei, 219
Krichevsky, Fedor, 494
Kropivnitzky, Lev, 267
Kropotkin, Petr, 20
Krotkov, Vasilii, 129
Kruchenykh, Alexei, 106, 129, 139, 146, 158, 176,
 216, 217, 233, 242, 248, 251, 256, 268, 452,
 453, 456, 457, 458
Krylov, E. I., 130
"Kuda idet 'novoe' iskusstvo" (Kandinsky), 130
Kudriashev, Ivan Alexeevich, 40, 60, 223–32, 261,
 262, 263, 264, 448
Kulagina, Valentina I., 37, 206, 207
Kulbin, Nikolai, 81, 130, 268, 272, 433
Kulikov, Afanasii Efremovich, 428
Kunstismen, Die (Les Ismes de l'art/The Isms of
 Art) (Lissitzky and Arp), 242
Kustodiev, Boris, 69
Kuzmin, Mikhail, 391
Kuzmin, Nikolai, 463
Kuznetsov, Pavel, 48, 71, 140, 324
K Zaumi (Tufanov), 274

Labas, Alexandr, 330, 341
Ladovsky, Nikolai Alexandrovich, 116, 117
Lamanova, Nadezhda Petrovna, 408, 409
Larionov, Mikhail Fedorovich, 20, 48, 61, 62, 73, 81,
 82, 91, 106, 233–39, 240, 251, 326, 421, 474,
 497
"Last Futurist Exhibition of Pictures: 0.10, The," 14,
 55–56, 57, 139, 251, 257, 258, 339, 344, 363,
 364, 365, 366, 433, 453, 455, 474, 479, 484
Lavrov, Igor, 72, 73
Law, Alma H., 399, 400
Lebedev, Vladimir, 324
Le Corbusier (Charles Edouard Jeanneret), 61, 165,
 166
LEF (Left Front of the Arts), 21, 446, 452, 462, 467
Le Fauconnier, Henri, 240, 339, 344, 352, 484, 485
Left Front of the Arts. See LEF
Left Trends. See "Levye techeniia"

Léger, Fernand, 48, 165, 485
Léger, Nadia, 48
Lekok, Charles, 497
Lenin, V. I., 20, 21, 25, 26, 47, 249, 260
Leningrad: Hermitage, 43, 44; Russian Museum, 13,
 37, 70, 71, 72, 181, 238, 259, 361, 363; State
 Institute of Painterly Culture (see Ginkhuk)
Lenin Prize, 73
Lentulov, Aristarkh Vasilievich, 81, 106, 233, 240–41,
 421, 424, 474, 488, 497
Lentulova, M. A., 240
Leonidov, Ivan, 61
Let's Grumble. See Vozropshchem
"Levye techeniia" (Left Trends), 497
Levyi front iskusstv (Left Front of the Arts). See LEF
Liebknecht, Karl, 249
Life of Art. See Zhizn iskusstva
Life for the Tsar, A. See Zhizn za Tsaria
Link. See "Zveno"
Lipchitz, Jacques, 35
Lissitzky, El (Lazar Markovich Lisitsky), 13, 19, 35, 37,
 40, 45, 82, 128, 206, 242–50, 251, 324, 409,
 430, 432, 462
Lissitzky-Küppers, Sophie, 245, 247, 248, 249, 250,
 258, 262
Little Duck's Nest of Bad Words. See Utinoe gnez-
 dyshko durnykh slov
Livshits, Benedikt, 497
Lloyd, Harold, 26
Locksmith and the Chancellor, The (Lunacharsky),
 398
London: Christie's, 22; Grafton Galleries, 106, 233;
 Grosvenor Gallery, 118; National Gallery, 23; Soth-
 eby's, 49; Tate Gallery, 48
Lopatin, Boris, 55
Los Angeles County Museum of Art, 48
Lourié, Arthur. See Lurie, Artur
Luchishkin, Sergei, 330
"Luchisty i budushchniki. Manifest," 106, 233
Lunacharsky, Anatolii, 20–21, 25, 48, 398
Lurie, Artur (Arthur Lourié), 323, 497
Luxemburg, Rosa, 249

Magaril, Evgenia, 259
"Magazin" (The Store), 57, 59, 97, 139, 251, 326,
 339, 446, 453, 474, 484
Magnanimous Cuckold, The. See Velikodushnyi ro-
 gonosets
Maiakovsky, Vladimir, 91, 98, 103, 233, 242, 251,
 421, 425, 429, 446, 452, 467, 474
Main Science Administration. See Glavnauka
Makovets group, 91, 339
Makovsky, Sergei, 497
Makovsky, Vladimir, 69, 494

Malenkov, Georgii, 43
Malevich, Kazimir Severinovich, 13, 14, 15, 16, 18, 19,
 20, 26, 35, 36, 37, 40, 54, 55, 56, 57, 59, 60, 61,
 62, 63, 64, 65, 82, 88, 106, 139, 140, 176, 206,
 223, 233, 242, 251–66, 267, 268, 323, 326, 339,
 370, 409, 421, 425, 426, 428, 430, 433, 445,
 446, 448, 453, 455, 462, 470, 474, 484, 499
Malevich, M. S., 252, 253, 254, 266
Manet, Edouard, 326
Manin, Vitalii, 74
Mansurov, Paul (Pavel Andreevich), 21, 61, 64, 267,
 472
Mariengof, Anatolii, 330, 391
Marinetti, Filippo Tommaso, 97, 251, 497
Markov, Vladimir (pseud. of Waldemars Matvejs), 268
Marshack, Alexander, 72, 73
Marshak, Samuil, 72
Martinet, Marcel, 402
Marx, Karl, 20
Masetti, Zoia Ender, 301
Mashkov, Ilia, 115, 139, 463, 467
Matisse, Henri, 24, 35, 41, 44, 128, 254
Matiushin, Mikhail Vasilievich, 19, 26, 37, 40, 47, 62,
 64, 65, 139, 242, 251, 255, 267, 268–71, 272,
 274, 275, 280, 291, 301, 304, 321, 323
Matiushina, Olga, 255, 268
Matiushin school, 268–323
Matvejs, Waldemars. See Markov, Vladimir
Me! See Ya!
Medunetsky, Konstantin Konstantinovich, 119, 122,
 399
Meierkhold, Vsevolod, 18, 344, 388, 399, 402, 446,
 467
Melnikov, Konstantin, 61, 116
Meshkov, Vasilii, 115
Metaxa, Fedor, 28
Method group. See Metod
Methods of Lenin's Language. See Priemy leninskoi
 rechi
Metod (Method) group, 330, 341
Metzinger, Jean, 268, 339, 344, 352, 484
Meyer, Franz, 86
Miasnikov, Alexandr, 44
Mikhóels, Solomon, 67, 68, 87
Mikoyan, Anastas, 43
Milhau, Denis, 86
Milioti, Nikolai, 140
Milk of Mares. See Moloko kobylits
Miller, Georgii, 408, 409
Ministry of Culture, 48
Mir iskusstva, 16, 34, 78, 93, 106, 128, 233, 324,
 326, 339, 463, 474, 497
Mirskontsa (Khlebnikov and Kruchenykh), 106, 233
"Mishen" (Target), 17, 82, 106, 233, 251
Missal of the Three. See Trebnik troikh

Misteriia-buf (Maiakovsky), 251
Miturich, M., 324, 325
Miturich, Petr Vasilievich, 324–25, 474
Molchanov, Andrei, 31
Moloko kobylits, 81
Mondrian, Piet, 34, 35
Monolith group, 78
Moor, Dmitrii (pseud. of Dmitrii Stakhevich Orlov), 427, 428
Moore, Henry, 35
Mordkin, Mikhail, 421
Morgan, J. P., 24
Morgunov, Alexei Alexeevich, 326–29, 488
Morozov, Ivan, 14, 24, 35, 41, 46, 59
Moscow: Art Salon, 106; Art Theater, 330, 421; Author's Press, 217; Bolshoi Theater, 78; Café Pittoresque, 446, 474, 484, 497, 498; Central State Archive of Literature and Art, 444, 476; Club of the Leftist Federation, 446; First State Textile Print Factory, 344, 408, 467; Historical Museum, 61; Institute of Painterly Culture (*see* Inkhuk); Kamernyi (Chamber) Theater, 97, 101, 102, 106, 119, 122, 497, 498; Korsh Theater, 398, 421; Kurchatov Institute, 48; Literary and Artistic Circle, 106; Maiakovsky Library-Museum, 47; Mikhailova Art Salon, 85; The Modern Lubok, 421, 422, 423, 424, 425; Museum of Painterly Culture, 330, 341, 440; Poets' Café, 119, 122; Pushkin Museum, 43, 44, 50, 71; Rodchenko Archive, 447; State Higher Theater Workshop, 399; State Jewish Theater, 67, 82, 87, 490; Theater of the Revolution, 488; Tsvetkov Gallery, 91
Moscow Association of Artists. *See* Moskovskoe tovarishchestvo khudozhnikov
Moscow Salon, 139
Moskovskoe tovarishchestvo khudozhnikov (Moscow Association of Artists), 81, 106, 130, 233, 251, 326, 497
Mukhina, V., 408
Münter, Gabriele, 128, 130
Musical New Land. *See Muzykalnaia nov*
Music and Revolution. *See Muzyka i revoliutsiia*
Mussorgsky, Modest, 23, 106
Muzyka i revoliutsiia, 416
Muzykalnaia nov, 417
Mystery-Bouffe. *See Misteriia-buf*

Nakov, A. B., 255, 259
Narkompros, 139. *See also* IZO
Nebesnye verbluzhata (Guro), 268, 272
Neratova, Nina Petrovna, 36
Neue Künstlervereinigung (New Artists' Association), 81, 128, 130

Nevzorov (collector), 68–69
New Artists' Association. *See* Neue Künstlervereinigung
Newman, Barnett, 54
New Society of Artists. *See* NOZh
New Trends. *See* "Sovremennye techeniia"
New York: Metropolitan Museum, 48; Museum of Modern Art, 57; Sidney Janis Gallery, 247. *See also* World's Fair
Night on Bald Mountain (Mussorgsky), 106
Nikolsky, Alexandr, 88
Nikritin, Solomon Borisovich, 40, 330–38, 341, 440
Nimukhin, Vladimir, 41
"Nineteenth State Exhibition," 130, 446
"Ninth State Exhibition," 126
"No. 4," 91, 97, 106, 233
Nonparty Society of Artists. *See* "Vnepartiinoe obshchestvo khudozhnikov"
Novoe obshchestvo zhivopistsev (New Society of Artists). *See* NOZh
Novyi LEF, 446, 467
NOZh (New Society of Artists), 97, 445
Nuit, La (Martinet), 402

Obedinenie novykh techenii v iskusstve (Association of New Trends in Art), 462, 474, 499
Obektivnyi analiz (Objective Analysis) group, 110, 326
Objective Analysis group. *See* Obektivnyi analiz
Obmokhu (Society of Young Artists), 114, 119, 122, 240, 449, 497
Obshchestvo khudozhnikov-stankovistov (Society of Studio Artists). *See* OST
Obshchestvo molodykh khudozhnikov (Society of Young Artists). *See* Obmokhu
Obshchestvo moskovskikh khudozhnikov (Society of Moscow Artists). *See* OMKh
Obshchestvo svobodnoi estetiki (Society of Free Aesthetics), 233
Obshchina khudozhnikov (Community of Artists), 103
October group, 206
Okhtensky Workers' Theater, 206
Old-Time Love. *See Starinnaia liubov*
OMKh (Society of Moscow Artists), 93, 115, 240, 326
O natiurmorte (Yudin), 499
One Kid. *See Chad Gadya*
On New Systems in Art. *See O novikh sistemakh v iskusstve*
On the Spiritual in Art (Kandinsky), 130
O novikh sistemakh v iskusstve (Malevich), 251
Opyt teorii zhivopisi (Tarabukin), 124
Orenburg: First Soviet Theater, 223, 224, 225, 227; Summer Red Army Theater, 223
Orlov, Dmitrii Stakhevich. *See* Moor, Dmitrii

Osennii son (Guro), 268, 272
"Oslinyi khvost" (Donkey's Tail), 17, 82, 103, 106, 233, 251, 326, 474
Oslinyi khvost i mishen, 106, 233
OST (Society of Studio Artists), 223, 230, 231, 232, 488
Ostroukhov, I. S., 41
Ostroumova-Lebedeva, Anna, 32
Ostrovsky, A. N., 23
Otdel izobrazitelnye iskusstva. *See* IZO
Ot kubizma i futurizma k suprematizmu. Novyi zhivopishnyi realizm (Malevich), 251, 268
Ozenfant, Amédée, 61, 165, 166

Painted Pictures. *See Sdelannye kartiny*
"Paintings from the People's Democracies," 44
Panfilova, Zinaida (Mrs. George Costakis). *See* Costakis, Zina
Papini, Giovanni, 97
Paris: Bernheim-Jeune, 22; Le Brun, 22; Galerie Paul Guillaume, 106, 233; Gersaint, 22; Hôtel Drouot, 22; Daniel Henry Kahnweiler, 22; Musée National d'Art Moderne, 48, 253; Ambroise Vollard, 22. *See also* Exposition Internationale
Pavelovich, Sergei, 420
Pavilionov, J. V., 483
Pavlov (choreographer), 41
Pavlov (sculptor), 266
Pavlov, E., 412
Pen, Yurii, 82, 88
Perfilov (collector), 42
Permanent Exhibition of Contemporary Art. *See* "Postoiannaia vystavka sovremennogo iskusstva"
"Pervaia diskussionaia vystavka obedinenii aktivnogo revoliutsionnogo iskusstva" (First Discussional Exhibition of the Associations of Active Revolutionary Art), 15, 119, 330, 341, 440
"I. gosudarstvennaia svobodnaia vystavka proizvedenii iskusstv" (First State Free Exhibition of Works of Art), 82, 103, 267
"Pervaia obshchegorodskaia vystavka izobrazitelnykh iskusstv" (First Citywide Arts Show), 472
Pestel, S. B., 339
Pestel, Vera Efimovna, 15, 40, 60, 251, 339–40
Peter the Great, 22
Petritsky, Anatolii, 97
Petrograd: Lomonosov State Porcelain Factory, 88, 470; Museum of Painterly Culture, 26, 267; Russian Museum, 48. *See also* Leningrad; Petrosvomas; St. Petersburg; "Vystavka kartin petrogradskikh khudozhnikov vsekh napravlenii"
Petrosvomas (Petrograd State Free Art Studios), 21, 64, 268, 275, 280, 301, 433, 474

Petrov, Stepan Gavrilovich. *See* Skitaletz

Petrov-Vodkin, Kuzma, 275, 323

Pevsner, Antoine, 206, 223

Phalanx, 130

Piano in the Nursery, The. *See Roial v detskoi*

Picasso, Pablo, 16, 19, 21, 24, 35, 36, 43, 44, 97, 165, 474, 484

Pilniak, Boris, 414

Plaksin, Mikhail Matveevich, 330, 341–42, 440

Plan for Monumental Propaganda, 249

Pobeda nad solntsem: Kruchenykh, Malevich, Matiushin, 242, 251, 255, 261, 268; Lissitzky, 242, 248

Pörzgen, Hermann, 46, 74

Poliakoff, Serge, 73, 343

Pollock, Jackson, 64

Polonski, Alexandre, 457

Poor Knight. *See* "Bednyi rytsar"

Popov, Pavel Sergeevich, 344, 345, 363

Popova, Liubov Sergeevna, 17, 18, 19, 26, 39–40, 51, 55, 60, 63, 64, 70, 120, 125, 206, 251, 339, 344–420, 446, 467, 468, 474, 484, 485

Posnovis (Followers of the New Art), 88, 242, 470

Postnikov, A. M., 41

"Postoiannaia vystavka sovremennogo iskusstva" (Permanent Exhibition of Contemporary Art), 130

Pototskaia, Anastasiia Pavlovna, 67–68

Pougny, Jean. *See* Puni, Ivan

Poussin, Nicolas, 97, 484

Povelikhina, A., 64

"Pressa" (Cologne), 242, 409, 462

Pribylskaia, Y., 408

Priemy leninskoi rechi (Kruchenykh), 216

Princess Brambilla (Hoffmann), 497

Principles of the New Art, The. *See* "Printsipy novogo iskusstva"

"Printsipy novogo iskusstva" (Markov), 268

Productivist group, 206, 344, 446, 467

Pro 2 kvadrata (Lissitzky), 242

Projectionists, 330, 341, 444

Proletarian Culture. *See* Proletkult

Proletarskaia kultura (Proletarian Culture). *See* Proletkult

Proletkult (Proletarian Culture), 21, 323, 445, 453

Propaganda, 421–32

Propoved o prorosli mirovoi (Filonov), 103

Protazanov, Yakov, 97

Prouns, 242, 244–50

Puni, Ivan Albertovich (Jean Pougny), 55, 324, 433–38, 455

Punin, Nikolai, 275, 474

Purvit, Wilhelm, 93

Pushkariev, Vasilii, 47, 70–71

Pushkin, Alexandr, 42, 234

Pustynniki (Kruchenykh), 106, 107

Rabfak (Faculty for Workmen), 78

Rabin, Oskar, 41

Rabinovich, Isaak, 97, 490

Rabochii fakultet (Faculty for Workmen). *See* Rabfak

Rakitin, Vasilii, 26n, 47, 146, 149, 159, 207, 245, 254, 266, 273, 331, 447, 454, 456, 478

Rakitina, E., 399

"Ranniaia vesna" (Guro), 272

RAPKh (Russian Association of Proletarian Artists), 445

Raskin, Y. S., 439

Raum der Abstrakten, 242

Ravel, Maurice, 106

Rayonists and Futurists: A Manifesto. *See* "Luchisty i budushchniki. Manifest"

Razumovsky, Prince, 22

Redko, Kliment Nikolaevich, 40, 43, 62, 330, 341, 440–44

Reid, Sir Norman, 50

Rembrandt, 31

Renard, Le (Stravinsky), 233

Repin, Ilia, 128, 433

Rerberg, Fedor, 115, 139

Revolution and Art, The (Lunacharsky), 20

Reynolds, Sir Joshua, 68

Riabushinsky, Nikolai, 106, 233

Riazhsky, Georgii Georgievich, 445

Ribakov collection, 238

Richter, Sviatislav, 42

Rimsky-Korsakov, Nikolai, 106

Ring, The. *See* "Koltso"

Rivera, Diego, 44

Rockefeller, David, 73

Rodchenko, Alexandr Mikhailovich, 26, 35, 36, 40, 45, 46, 47, 48, 60, 63–64, 65, 70, 110, 114, 121, 124, 130, 206, 370, 408, 446–52, 453, 467, 468, 469, 474, 497, 498

Rodchenko, Mula, 64, 456

Rodchenko, Varvara. *See* Stepanova, Varvara Fedorovna

Rodin, Auguste, 115

Roerich, Nikolai, 69, 341, 494

Roial v detskoi (Lurie), 324

Rome, Galleria Sprovieri, 97

Romeo and Juliet, 97, 398

Romm, A. G., 82, 137

Rosenberg, Harold, 15

Rossiiskaia assotsiatsiia proletarskikh khudozhnikov (Russian Association of Proletarian Artists). *See* RAPKh

ROSTA (Russian Telegraph Agency), 428, 430

Roth, Emil, 242

Rozanova, Olga Vladimirovna, 25, 36, 54, 62, 63, 65, 106, 118, 144, 191, 251, 256, 370, 453–61

Rozenberg, Bella, 82

Rubenshtein, Yakov Evseevich, 44

Rukavishnikov, V. F., 470

Rules of the Variability of Color Combinations: A Manual, The. *See Zakonomernost izmeniaemosti tsvetovykh sochetanii. Spravochnik po tsvetu*

Russian Association of Proletarian Artists. *See* RAPKh

Russland: Architektur für eine Weltrevolution (Lissitzky), 242

Sachs collection, 86

Sadok sudei, 81, 268, 272

St. Petersburg: Hermitage, 22; Russian Museum, 24; Stieglitz Museum, 23, 24. *See also* Leningrad; Petrograd

Salomé (Wilde), 97, 101, 398

Salon d'Automne, 82, 106, 128, 233

Salon des Indépendants, 82, 97, 433

Samokish, Nikolai, 324

Sanovich, I., 253, 478

Sarabianov, Dmitrii, 44, 47, 345, 347, 355, 369, 398

Savrasov, Alexei, 326

Sbornik molodikh pisatelei, 272

Scheper, Hinnerk, 275

Scherzo (E. Pavlov), 412

Schulenburg, Count von der, 32

Schwartz, E. G., 25

Scull, Robert, 14

Sdelannye kartiny (Filonov), 103

Sdvigologiia russkogo stikha, 158

Sea, The (E. Pavlov), 412

Seaborn, Mrs. Blair, 42, 45

Secession, 128

"Second Post-Impressionist Exhibition," 106, 233

Secret Vices of Academicians. *See Tainye poroki akademikov*

Section d'Or, 97

Segonzac, André Dunoyer de, 484

Seligman, Germain, 29

Semienov, I., 17

Semonov, Vladimir, 48

Senkin, Sergei Yakolevich, 40, 63, 206, 462

Senkina, S., 462

Sermon on the Universal Flowering. *See Propoved o prorosli mirovoi*

Serov, Valentin, 73

Seventh Venice Biennale (1907), 233

Shadowa, Larisa, 47, 264

Shagal. *See* Chagall, Marc

Sharmanka (Guro), 272

Shchipitsyn, Alexandr Vasilievich, 36–37, 481, 483

Shchukin, Sergei, 14, 24, 35, 38, 41, 44, 46, 51, 59, 254

Shekhtel, Lev. *See* Zhegin, Lev

Shenshin, Alexandr, 41

Shershenevich, Vadim, 497

Shifrin, Nisson, 97

Shiftology of Russian Verse. *See Sdvigologiia russkogo stikha*

Shkolnik, Iosif, 103

Shor (violinist), 41

Shostakovich, Dmitrii, 104

Shriver, Sargent and Eunice, 73

Shterenberg, David, 45

Shuster, Solomon, 44, 85, 272, 273

Sidorov, A. A., 50

Signore formica (Hoffmann), 498

Sihat holin (Broderson), 243

Simon, N., 364

Sinezubov, Nikolai, 130, 446, 467

Siqueiros, David, 44

Sitnikov, Vasilii, 41

"Sixteenth State Exhibition: K. S. Malevich, His Path from Impressionism to Suprematism," 251

"Sixth State Exhibition," 126

Skitaletz (pseud. of Stepan Gavrilovich Petrov), 421

Smert Tarelkina (Sukhovo-Kobylin), 467

Smith, Arnold, 45

Sobinov, L. V., 421

Société Anonyme, 12

Society for the Encouragement of the Arts, 125

Society of Free Aesthetics. *See Obshchestvo svobodnoi estetiki*

Society of Moscow Artists. *See OMKh*

Society of Russian Sculptors, 115

Society of Studio Artists. *See OST*

Society of Young Artists. *See Obmokhu*

Sofronova, Antonina Fedorovna, 463–66

Soiuz molodezhi (Union of Youth), 17, 81, 97, 103, 106, 129, 139, 233, 251, 268, 272, 326, 433, 453, 474

Soiuz russkikh khudozhnikov (Union of Russian Artists), 128, 233, 497

Solntse na izlete: Vtoraia kniga stikhov 1913–16 (Bolshakov), 242

Solntsu (Maiakovsky), 233

Somov, Andrei, 31, 69

Somova-Mikhailova, Anna Andreevna, 31–32

Sotnikov, A. S., 483

"Sovremennaia zhivopis" (Contemporary Painting), 330, 474

"Sovremennoe tvorchestvo" (Contemporary Creation), 240

"Sovremennye leningradskie khudozhestvennye gruppirovki" (Contemporary Leningrad Art Group), 472

"Sovremennye techeniia" (New Trends), 97

Spartakiada. *See All-Union Spartakiada*

Spent Sun, The. *See Solntse na izlete*

Stalin, Josef, 26, 28, 29, 30, 31, 32, 34, 39, 41, 42, 43, 44, 46, 68

Stanislavsky Theater. *See Moscow, Art Theater*

Starinnaia liubov (Kruchenykh), 233

State Academy of Artistic Sciences. *See GAKhN*

State Exhibitions. *See First, Second, Third, etc., State Exhibition*

Stein, Gertrude, 12

Stein, Leo, 12

Stenberg, Georgii Avgustovich, 19, 37, 61, 119, 122, 212, 399

Stenberg, Vladimir Avgustovich, 19, 61, 119, 122, 212, 399

Stenka razin (Kamensky), 488, 489

Stepanova, Varvara Fedorovna, 18, 26, 35, 60, 110, 123, 124, 130, 206, 344, 408, 446, 452, 467–69

Stijl, De, 244

Store, The. *See "Magazin"*

Stravinsky, Igor, 14, 46, 73, 106, 233

"Struggle and Victory of the Soviets," 388

Strzeminski, Wladyslaw, 223, 430

Stuck, Franz, 130

"Studio of the Revolution," 206

Stuttgart, Staatsgalerie, 188

Suetin, Nikolai Mikhailovich, 61, 88, 251, 260, 409, 470–71, 499

Sukhovo-Kobylin, Alexandr, 467

Sulimo-Samuilo, N. Ieratova, 472

Sulimo-Samuilo, Vsevolod Angelovich, 36, 472–73

Supremus, 139, 251, 339, 344, 370, 453, 456, 484

Sverdlov, Y. M., 78

Svomas (Free State Art Studios), 21, 78, 122, 139, 224, 240, 251, 275, 326, 344, 445, 453, 462, 497

Syphilis (Maiakovsky), 452

Tainye poroki akademikov (Kruchenykh), 139, 176

Tairov, Alexandr, 97, 98, 101, 106, 119, 122, 398, 497, 498

Tarabukin, Nikolai Mikhailovich, 124, 393, 463, 468

Target. *See "Mishen"*

Tatlin, Vladimir Evgrafovich, 14, 15, 16, 18, 19, 26, 35, 36, 37, 45, 47, 47n, 48, 54, 56, 59, 60, 62, 63, 64, 79, 81, 251, 267, 339, 344, 352, 446, 467, 474–83, 484, 485, 497, 498

Tchelitchew. *See Chelishchev, Pavel*

Te li le (Kruchenykh and Khlebnikov), 456

"Tenth State Exhibition: Nonobjective Creation and Suprematism," 139, 344, 446, 453, 467

Terentiev, Igor, 129, 452

Thamira Khytharedes (Annensky), 97

"Thirty Works. Realism, Cubism, Futurism, Suprematism, and Spatial Suprematism," 462

Thompson, Mrs. Llewellyn, 45

Three, The. *See Troe*

Timofeeva, 224

Titov, Boris Borisovich, 414

Tolstoi, Alexei, 97

Tomashevsky, M. M., 474

To New Shores. *See K novym beregam*

To New Shores of Musical Art. *See K novym beregam muzykalnogo iskusstva*

Toskin, Filip Pavlovich, 30–31

To the Sun. *See Solntsu*

Tournament of Poets. *See Turnir poetov*

Tower, The, 344, 474, 484

Tragedia A, O, U (Mariengof), 330

"Tramvai V. Pervaia futuristicheskaia vystavka kartin" (Tramway V: First Futurist Exhibition of Paintings), 17, 56, 57, 97, 139, 251, 255, 326, 344, 433, 453, 474, 484

Tramway V. *See "Tramvai V"*

Transrational (B)ook. *See Zaumnaia gniga*

Trap for Judges. *See Sadok sudei*

Trebnik troikh, 81

Tretiakov, Pavel, 23, 24

Tretiakov, Sergei, 23, 242, 344, 402

"Treugolnik" (Triangle), 81, 268

Triangle. *See "Treugolnik"*

Troe (Guro, Khlebnikov, Kruchenykh, Malevich), 268, 272

Trotsky, Leon, 402

Trubetskoi, Pavel, 106

Tsar Maximilian i ego neposlushnyi syn Adolf (Tomashevsky), 474

Tselkov, Oleg, 41

Tsindel, Emil, 408

Tsiolkovsky, Konstantin, 223, 482

Tsionglinsky, Yan, 268, 272

Tufanov, A., 274

Tugendkhold, Yakob, 83

Turnir poetov (Kruchenykh), 146

Twelve, The. *See Dvenadsat*

1918 god (Kamensky, Kruchenykh, Zdanevich), 457

Tyshler, Alexandr, 97, 330, 440

Udaltsova, Nadezhda Andreevna, 18, 37, 55, 60, 63, 93, 110, 125, 251, 259, 339, 344, 370, 474, 484–87, 498

Ulianov, Nikolai, 115

Unholy Story. *See Sihat holin*

Union des Artistes Russes (Paris), 109

Union of Artists of the U.S.S.R., 21

Union of Russian Artists (St. Petersburg). *See Soiuz russkikh khudozhnikov*

Union of Writers of the U.S.S.R., 47

Union of Youth. *See Soiuz molodezhi*

Universal War. *See Vselenskaia voina*

Petrov, Stepan Gavrilovich. *See* Skitaletz
Petrov-Vodkin, Kuzma, 275, 323
Pevsner, Antoine, 206, 223
Phalanx, 130
Piano in the Nursery, The. *See* Roial v detskoi
Picasso, Pablo, 16, 19, 21, 24, 35, 36, 43, 44, 97, 165, 474, 484
Pilniak, Boris, 414
Plaksin, Mikhail Matveevich, 330, 341–42, 440
Plan for Monumental Propaganda, 249
Pobeda nad solntsem: Kruchenykh, Malevich, Matiushin, 242, 251, 255, 261, 268; Lissitzky, 242, 248
Pörzgen, Hermann, 46, 74
Poliakoff, Serge, 73, 343
Pollock, Jackson, 64
Polonski, Alexandre, 457
Poor Knight. *See* "Bednyi rytsar"
Popov, Pavel Sergeevich, 344, 345, 363
Popova, Liubov Sergeevna, 17, 18, 19, 26, 39–40, 51, 55, 60, 63, 64, 70, 120, 125, 206, 251, 339, 344–420, 446, 467, 468, 474, 484, 485
Posnovis (Followers of the New Art), 88, 242, 470
Postnikov, A. M., 41
"Postoiannaia vystavka sovremennogo iskusstva" (Permanent Exhibition of Contemporary Art), 130
Pototskaia, Anastasiia Pavlovna, 67–68
Pougny, Jean. *See* Puni, Ivan
Poussin, Nicolas, 97, 484
Povelikhina, A., 64
"Pressa" (Cologne), 242, 409, 462
Pribylskaia, Y., 408
Priemy leninskoi rechi (Kruchenykh), 216
Princess Brambilla (Hoffmann), 497
Principles of the New Art, The. *See* "Printsipy novogo iskusstva"
"Printsipy novogo iskusstva" (Markov), 268
Productivist group, 206, 344, 446, 467
Pro 2 kvadrata (Lissitzky), 242
Projectionists, 330, 341, 444
Proletarian Culture. *See* Proletkult
Proletarskaia kultura (Proletarian Culture). *See* Proletkult
Proletkult (Proletarian Culture), 21, 323, 445, 453
Propaganda, 421–32
Propoved o prorosli mirovoi (Filonov), 103
Protazanov, Yakov, 97
Prouns, 242, 244–50
Puni, Ivan Albertovich (Jean Pougny), 55, 324, 433–38, 455
Punin, Nikolai, 275, 474
Purvit, Wilhelm, 93
Pushkariev, Vasilii, 47, 70–71
Pushkin, Alexandr, 42, 234
Pustynniki (Kruchenykh), 106, 107

Rabfak (Faculty for Workmen), 78
Rabin, Oskar, 41
Rabinovich, Isaak, 97, 490
Rabochii fakultet (Faculty for Workmen). *See* Rabfak
Rakitin, Vasilii, 26n, 47, 146, 149, 159, 207, 245, 254, 266, 273, 331, 447, 454, 456, 478
Rakitina, E., 399
"Ranniaia vesna" (Guro), 272
RAPKh (Russian Association of Proletarian Artists), 445
Raskin, Y. S., 439
Raum der Abstrakten, 242
Ravel, Maurice, 106
Rayonists and Futurists: A Manifesto. *See* "Luchisty i budushchniki. Manifest"
Razumovsky, Prince, 22
Redko, Kliment Nikolaevich, 40, 43, 62, 330, 341, 440–44
Reid, Sir Norman, 50
Rembrandt, 31
Renard, Le (Stravinsky), 233
Repin, Ilia, 128, 433
Rerberg, Fedor, 115, 139
Revolution and Art, The (Lunacharsky), 20
Reynolds, Sir Joshua, 68
Riabushinsky, Nikolai, 106, 233
Riazhsky, Georgii Georgievich, 445
Ribakov collection, 238
Richter, Sviatislav, 42
Rimsky-Korsakov, Nikolai, 106
Ring, The. *See* "Koltso"
Rivera, Diego, 44
Rockefeller, David, 73
Rodchenko, Alexandr Mikhailovich, 26, 35, 36, 40, 45, 46, 47, 48, 60, 63–64, 65, 70, 110, 114, 121, 124, 130, 206, 370, 408, 446–52, 453, 467, 468, 469, 474, 497, 498
Rodchenko, Mula, 64, 456
Rodchenko, Varvara. *See* Stepanova, Varvara Fedorovna
Rodin, Auguste, 115
Roerich, Nikolai, 69, 341, 494
Roial v detskoi (Lurie), 324
Rome, Galleria Sprovieri, 97
Romeo and Juliet, 97, 398
Romm, A. G., 82, 137
Rosenberg, Harold, 15
Rossiiskaia assotsiatsiia proletarskikh khudozhnikov (Russian Association of Proletarian Artists). *See* RAPKh
ROSTA (Russian Telegraph Agency), 428, 430
Roth, Emil, 242
Rozanova, Olga Vladimirovna, 25, 36, 54, 62, 63, 65, 106, 118, 144, 191, 251, 256, 370, 453–61
Rozenberg, Bella, 82

Rubenshtein, Yakov Evseevich, 44
Rukavishnikov, V. F., 470
Rules of the Variability of Color Combinations: A Manual, The. *See* Zakonomernost izmeniaemosti tsvetovykh sochetanii. Spravochnik po tsvetu
Russian Association of Proletarian Artists. *See* RAPKh
Russland: Architektur für eine Weltrevolution (Lissitzky), 242

Sachs collection, 86
Sadok sudei, 81, 268, 272
St. Petersburg: Hermitage, 22; Russian Museum, 24; Stieglitz Museum, 23, 24. *See also* Leningrad; Petrograd
Salomé (Wilde), 97, 101, 398
Salon d'Automne, 82, 106, 128, 233
Salon des Indépendants, 82, 97, 433
Samokish, Nikolai, 324
Sanovich, I., 253, 478
Sarabianov, Dmitrii, 44, 47, 345, 347, 355, 369, 398
Savrasov, Alexei, 326
Sbornik molodikh pisatelei, 272
Scheper, Hinnerk, 275
Scherzo (E. Pavlov), 412
Schulenburg, Count von der, 32
Schwartz, E. G., 25
Scull, Robert, 14
Sdelannye kartiny (Filonov), 103
Sdvigologiia russkogo stikha, 158
Sea, The (E. Pavlov), 412
Seaborn, Mrs. Blair, 42, 45
Secession, 128
"Second Post-Impressionist Exhibition," 106, 233
Secret Vices of Academicians. *See* Tainye poroki akademikov
Section d'Or, 97
Segonzac, André Dunoyer de, 484
Seligman, Germain, 29
Semienov, I., 17
Semonov, Vladimir, 48
Senkin, Sergei Yakolevich, 40, 63, 206, 462
Senkina, S., 462
Sermon on the Universal Flowering. *See* Propoved o prorosli mirovoi
Serov, Valentin, 73
Seventh Venice Biennale (1907), 233
Shadowa, Larisa, 47, 264
Shagal. *See* Chagall, Marc
Sharmanka (Guro), 272
Shchipitsyn, Alexandr Vasilievich, 36–37, 481, 483
Shchukin, Sergei, 14, 24, 35, 38, 41, 44, 46, 51, 59, 254
Shekhtel, Lev. *See* Zhegin, Lev
Shenshin, Alexandr, 41

Shershenevich, Vadim, 497

Shifrin, Nisson, 97

Shiftology of Russian Verse. *See Sdvigologiia russkogo stikha*

Shkolnik, Iosif, 103

Shor (violinist), 41

Shostakovich, Dmitrii, 104

Shriver, Sargent and Eunice, 73

Shterenberg, David, 45

Shuster, Solomon, 44, 85, 272, 273

Sidorov, A. A., 50

Signore formica (Hoffmann), 498

Sihat holin (Broderson), 243

Simon, N., 364

Sinezubov, Nikolai, 130, 446, 467

Siqueiros, David, 44

Sitnikov, Vasilii, 41

"Sixteenth State Exhibition: K. S. Malevich, His Path from Impressionism to Suprematism," 251

"Sixth State Exhibition," 126

Skitaletz (pseud. of Stepan Gavrilovich Petrov), 421

Smert Tarelkina (Sukhovo-Kobylin), 467

Smith, Arnold, 45

Sobinov, L. V., 421

Société Anonyme, 12

Society for the Encouragement of the Arts, 125

Society of Free Aesthetics. *See Obshchestvo svobodnoi estetiki*

Society of Moscow Artists. *See OMKh*

Society of Russian Sculptors, 115

Society of Studio Artists. *See OST*

Society of Young Artists. *See Obmokhu*

Sofronova, Antonina Fedorovna, 463–66

Soiuz molodezhi (Union of Youth), 17, 81, 97, 103, 106, 129, 139, 233, 251, 268, 272, 326, 433, 453, 474

Soiuz russkikh khudozhnikov (Union of Russian Artists), 128, 233, 497

Solntse na izlete: Vtoraia kniga stikhov 1913–16 (Bolshakov), 242

Solntsu (Maiakovsky), 233

Somov, Andrei, 31, 69

Somova-Mikhailova, Anna Andreevna, 31–32

Sotnikov, A. S., 483

"Sovremennaia zhivopis" (Contemporary Painting), 330, 474

"Sovremennoe tvorchestvo" (Contemporary Creation), 240

"Sovremennye leningradskie khudozhestvennye gruppirovki" (Contemporary Leningrad Art Group), 472

"Sovremennye techeniia" (New Trends), 97

Spartakiada. *See All-Union Spartakiada*

Spent Sun, The. *See Solntse na izlete*

Stalin, Josef, 26, 28, 29, 30, 31, 32, 34, 39, 41, 42, 43, 44, 46, 68

Stanislavsky Theater. *See Moscow, Art Theater*

Starinnaia liubov (Kruchenykh), 233

State Academy of Artistic Sciences. *See GAKhN*

State Exhibitions. *See First, Second, Third, etc., State Exhibition*

Stein, Gertrude, 12

Stein, Leo, 12

Stenberg, Georgii Avgustovich, 19, 37, 61, 119, 122, 212, 399

Stenberg, Vladimir Avgustovich, 19, 61, 119, 122, 212, 399

Stenka razin (Kamensky), 488, 489

Stepanova, Varvara Fedorovna, 18, 26, 35, 60, 110, 123, 124, 130, 206, 344, 408, 446, 452, 467–69

Stijl, De, 244

Store, The. *See "Magazin"*

Stravinsky, Igor, 14, 46, 73, 106, 233

"Struggle and Victory of the Soviets," 388

Strzeminski, Wladyslaw, 223, 430

Stuck, Franz, 130

"Studio of the Revolution," 206

Stuttgart, Staatsgalerie, 188

Suetin, Nikolai Mikhailovich, 61, 88, 251, 260, 409, 470–71, 499

Sukhovo-Kobylin, Alexandr, 467

Sulimo-Samuilo, N. Ieratova, 472

Sulimo-Samuilo, Vsevolod Angelovich, 36, 472–73

Supremus, 139, 251, 339, 344, 370, 453, 456, 484

Sverdlov, Y. M., 78

Svomas (Free State Art Studios), 21, 78, 122, 139, 224, 240, 251, 275, 326, 344, 445, 453, 462, 497

Syphilis (Maiakovsky), 452

Tainye poroki akademikov (Kruchenykh), 139, 176

Tairov, Alexandr, 97, 98, 101, 106, 119, 122, 398, 497, 498

Tarabukin, Nikolai Mikhailovich, 124, 393, 463, 468

Target. *See "Mishen"*

Tatlin, Vladimir Evgrafovich, 14, 15, 16, 18, 19, 26, 35, 36, 37, 45, 47, 47n, 48, 54, 56, 59, 60, 62, 63, 64, 79, 81, 251, 267, 339, 344, 352, 446, 467, 474–83, 484, 485, 497, 498

Tchelitchew. *See Chelishchev, Pavel*

Te li le (Kruchenykh and Khlebnikov), 456

"Tenth State Exhibition: Nonobjective Creation and Suprematism," 139, 344, 446, 453, 467

Terentiev, Igor, 129, 452

Thamira Khytharedes (Annensky), 97

"Thirty Works. Realism, Cubism, Futurism, Suprematism, and Spatial Suprematism," 462

Thompson, Mrs. Llewellyn, 45

Three, The. *See Troe*

Timofeeva, 224

Titov, Boris Borisovich, 414

Tolstoi, Alexei, 97

Tomashevsky, M. M., 474

To New Shores. *See K novym beregam*

To New Shores of Musical Art. *See K novym beregam muzykalnogo iskusstva*

Toskin, Filip Pavlovich, 30–31

To the Sun. *See Solntsu*

Tournament of Poets. *See Turnir poetov*

Tower, The, 344, 474, 484

Tragedia A, O, U (Mariengof), 330

"Tramvai V. Pervaia futuristicheskaia vystavka kartin" (Tramway V: First Futurist Exhibition of Paintings), 17, 56, 57, 97, 139, 251, 255, 326, 344, 433, 453, 474, 484

Tramway V. *See "Tramvai V"*

Transrational (B)ook. *See Zaumnaia gniga*

Trap for Judges. *See Sadok sudei*

Trebnik troikh, 81

Tretiakov, Pavel, 23, 24

Tretiakov, Sergei, 23, 242, 344, 402

"Treugolnik" (Triangle), 81, 268

Triangle. *See "Treugolnik"*

Troe (Guro, Khlebnikov, Kruchenykh, Malevich), 268, 272

Trotsky, Leon, 402

Trubetskoi, Pavel, 106

Tsar Maximilian i ego neposlushnyi syn Adolf (Tomashevsky), 474

Tselkov, Oleg, 41

Tsindel, Emil, 408

Tsiolkovsky, Konstantin, 223, 482

Tsionglinsky, Yan, 268, 272

Tufanov, A., 274

Tugendkhold, Yakob, 83

Turnir poetov (Kruchenykh), 146

Twelve, The. *See Dvenadsat*

1918 god (Kamensky, Kruchenykh, Zdanevich), 457

Tyshler, Alexandr, 97, 330, 440

Udaltsova, Nadezhda Andreevna, 18, 37, 55, 60, 63, 93, 110, 125, 251, 259, 339, 344, 370, 474, 484–87, 498

Ulianov, Nikolai, 115

Unholy Story. *See Sihat holin*

Union des Artistes Russes (Paris), 109

Union of Artists of the U.S.S.R., 21

Union of Russian Artists (St. Petersburg). *See Soiuz russkikh khudozhnikov*

Union of Writers of the U.S.S.R., 47

Union of Youth. *See Soiuz molodezhi*

Universal War. *See Vselenskaia voina*

Unovis (Affirmers [*also* Affirmation] of the New Art),
 13, 14, 88, 206, 207, 223, 242, 245, 251, 259,
 263, 470, 499
U.S.S.R. in Construction, The, 35
Utinoe gnezdyshko durnykh slov (Kruchenykh),
 453, 456
Utverditeli (*also* Utverzhdenie) novogo iskusstva. *See*
 Unovis
Uzbensky, Petr, 41

Valse (E. Pavlov), 412
Varnovitskaia, A. N., 341
Varst. *See* Stepanova, Varvara Fedorovna
Vasiliev, Yurii, 72
Vasilieva, M., 59
Vasnetsov, V. M., 41
Vecher knigi (Zhemchuzhyi), 467
Velikodushnyi rogonosets (Crommelynck and Ak-
 senov), 18, 60, 344, 399, 400, 401, 402
Velikovsky, Boris, 242
Venice Biennale. *See* Fourteenth Venice Biennale;
 Seventh Venice Biennale
"Venok" (Wreath), 97, 128, 233
"Venok-Stefanos" (Wreath-Stephanos), 81, 97, 106,
 233, 240, 497
Verbal Texture. *See* Faktura slova
Veshch/Gegenstand/Objet, 242, 244
Vesnin, Alexandr, 61, 206, 347, 355, 369, 384, 385,
 388, 389, 397, 446, 468, 474, 484
Vialov, Konstantin Alexandrovich, 488–93
Victory over the Sun. *See Pobeda nad solntsem*
Viner, I., 83
Vkhutein (Higher State Art-Technical Institute), 93,
 116, 446, 474, 484
Vkhutemas (Higher State Art-Technical Studios), 15,
 21, 25, 60, 70, 78, 93, 115, 116, 117, 130, 139,
 206, 219, 242, 324, 330, 341, 344, 409, 446,
 462, 467, 484
Vladimir Maiakovsky (Maiakovsky), 103
"Vnepartiinoe obshchestvo khudozhnikov" (Nonparty
 Society of Artists), 103
Voina (Kruchenykh and Rozanova), 453
Volkov, A., 494
Volkov, Alexandr Nikolaevich, 26, 494–96
Volkov, V., 494
Volkov-Lannit, L., 452
Volnukhin, Sergei, 106, 115
Vo-pervykh i vo-vtorykh (Kharms), 481
Vordemberge-Gildewart, Friedrich, 166
Vozropshchem (Kruchenykh), 453
Vrubel, Mikhail, 16, 34, 69, 124, 140, 324, 344, 494
Vselenskaia voina (Kruchenykh and Rozanova), 453,
 458
VSP (All-Russian Union of Poets Club), 391, 468

Vyshnevsky, Felix Evgenevich, 30, 31
"Vystavka graficheskikh iskusstv" (Exhibition of
 Graphic Art), 130
"Vystavka kartin petrogradskikh khudozhnikov vsekh
 napravlenii" (Exhibition of Paintings of Petrograd
 Artists of All Tendencies), 88, 103, 267, 275, 280,
 316, 323, 474, 499
"Vystavka sovremennikh techenii v iskusstve" (Exhibi-
 tion of Contemporary Trends in Art), 272
"Vystavka sovremennoi russoi zhivopisi" (Exhibition of
 Contemporary Russian Painting), 130, 324
"Vystavka zhivopisi 1915 god" (Exhibition of Painting:
 1915), 81, 82, 84, 106, 130, 233, 240, 324, 474,
 497
Vzorval (Kruchenykh), 256, 456

Wanderers, 16, 21, 23, 25
War. *See Voina*
Warhol, Andy, 25
Washington, D.C., Kennedy Center, 50
Watkins, John B. C., 45
We (Gan), 447
"We and the West" (Livshits, Lurie, Yakulov), 497
Wedding (Gogol), 86
Weisberg, Vladimir, 41
Werefkin, Marianna, 128
Whither the "New" Art. *See* "Kuda idet 'novoe' iskus-
 stvo"
Wilde, Oscar, 97, 398
Willgress, Dana, 33, 45
Wooden Idols. *See Dereviannye idoly*
World of Art. *See Mir iskusstva*
Worldbackward. *See Mirskontsa*
World's Fair (New York, 1939), 275, 301, 470
World Youth Festival, 44
Wreath. *See* "Venok"
Wreath-Stephanos. See "Venok-Stefanos"

Yagodkin, Vladimir N., 73, 73n, 74
Yakovlev, Alexandr, 341
Yakulov, Georgii Bogdanovich, 121, 240, 446, 474,
 484, 497–98
Yalden, Max, 45
Ya! (Maiakovsky), 91
Yankelevsky, Vladimir, 41
Yaremich, Stepan Petrovich, 31
Year 1918, The, 457
Yevtushenko, Evgenii, 47
Yudin, Lev Alexandrovich, 88, 251, 470, 499
Yuon, Konstantin, 78, 339, 344, 467, 484

Zagovor durakov (Mariengof), 330
*Zakonomernost izmeniaemosti tsvetovykh soche-
 tanii. Spravochnik po tsvetu* (Matiushin), 268,
 301
Zangezi (Khlebnikov), 324, 474
Zaumnaia gniga (Aliagrov and Kruchenykh), 453,
 457
Zdanevich, Ilia, 129
Zdanevich, Kirill M., 108, 344, 457
Zelenoe koltso, 330
Zelinsky, Kornelii, 37, 478, 482, 483
Zemlia dybom (Martinet and S. Tretiakov), 60, 344,
 402–07
"0.10." *See* "Last Futurist Exhibition of Pictures: 0.10,
 The"
Zhdanko, I., 266
Zhdanov, Andrei, 35, 43
Zhegin (Shekhtel), Lev F., 91, 106, 107, 109, 233,
 235, 463
Zhemchuzhyi, Vitalii, 467
Zhivskulptarkh (Commission of Painterly-Sculptural-Ar-
 chitectural Synthesis), 116, 446
Zhizn iskusstva (Mansurov), 267
Zhizn za Tsaria (Glinka), 474, 476
Zhukovsky, Stanislav, 344
Zilbershtein, Ilia, 32, 50
Zolotoe runo, 106, 233
Zorkoe vedanie (See-Know). *See* Zorved
Zorved (See-Know), 40, 64, 65, 268, 275, 280, 323
"Zveno" (Link), 81, 97, 106, 233, 240
Zverev, Anatolii Timofeevich, 42, 73